The Villa Wolkonsky in Rome

This edition © Scala Arts & Heritage Publishers Ltd, 2021
Text © Sir John Shepherd, 2021

First published in 2021 by
Scala Arts & Heritage Publishers Ltd
10 Lion Yard
Tremadoc Road
London SW4 7NQ, UK
www.scalapublishers.com

ISBN 978-1-78551-325-1

Edited by Patrick Taylor
Designed and typeset by «L'ERMA» di BRETSCHNEIDER, Rome
Printed and bound in Turkey

10 9 8 7 6 5 4 3 2 1

John Shepherd

THE VILLA WOLKONSKY IN ROME:
HISTORY OF A HIDDEN TREASURE

With contributions from

Raffaella Bucolo
Sue J. Williams
Julia Toffolo

SCALA

CONTENTS

PRINCIPAL ABBREVIATIONS USED

Italian

INA	Istituto Nazionale delle Assicurazioni – Italy's principal insurance company
RSI	Repubblica Sociale Italiana (Mussolini's state in N. Italy Sept '43 – May '44)

German

AA	Auswärtiges Amt (Foreign Ministry)
BA	Bundesarchiv (National Archive)
Gestapo	Geheime Staatspolizei (Secret State Police – under Himmler's control but not integrated with the SIPO)
NSDAP	Nationalsozialistische Deutsche Arbeiterpartei (National Socialist German Workers' Party or Nazi Party)
RBD	Reichsbaudirektion (Reich Building Directorate)
RM	Reichsmark (German currency until 1945)
RSHA	Reichssicherheitshauptamt (Reich Security Head Office)
SD	Sicherheitsdienst (Security Service)
SIPO	Sicherheitspolizei (Security Police, part of the SD)
SS	Schutzstaffel (lit. Protection Squadron), the NSDAP's paramilitary organisation under Himmler's control, comprising Waffen-SS – the military wing – and the Allgemeine or general SS, including both SD and Gestapo

UK and other

ACC	Allied Control Commission
AFHQ	Allied Forces Headquarters
BSR	British School at Rome
CIA	(US) Central Intelligence Agency
FO/FCO	Foreign Office, later Foreign and Commonwealth Office
DSAO	Diplomatic Service Administration Office (part of FCO after the merger)
GAC	German Assets Committee (a Four-Power Allied committee in Rome established to decide on disposal of confiscated German assets)
HMG	Her Majesty's Government – the formal name for the UK government

Successive designations of UK ministry responsible for government property:

MoW	Ministry of Works
MPBW	Ministry of Public Building and Works
DoE	Department of the Environment
PSA	Property Services Agency – the agency created to manage public property

Titles within the ministry:

CA	Chief Architect
CIAM	Chief Inspector of Ancient Monuments
DGW	Director General of Works
Secretary/PUS	Permanent (Under-) Secretary, the chief civil servant or official in a UK ministry

PREFACE

'Conservation always involves worrying about tomorrow.
But it's also about revelling in what's left.'
Simon Barnes in *The Times*, 20 Dec. 2013

How does the residence of the British ambassador to Italy come to be called the 'Villa Wolkonsky'? Rome, like the rest of Italy, is full of beautiful houses and *palazzi* with mellifluous Italian names. This one sounds angular and Russian, and it is; but there is more to it than an odd-sounding name. The bare bones of the Villa's story are easy enough to find in this internet age. The site was already important for imperial Rome's water supply from the first century AD, so its history is long. In its modern, post-1800 guise, it has been Italian, Russian, German and British. Below that general level many of the detailed 'facts' in past accounts, Italian or British, need to be taken with a goodly pinch of salt: they have tended to be recycled versions of the mistakes of the last person to repeat them.

Mark Bertram, for many years in charge of the Foreign and Commonwealth Office's estate, began the work of remedying this situation. He included a fine summary in *Room for Diplomacy*, a splendid survey of Britain's embassies abroad, fully researched in official UK files.[1]

Other surveys of fine houses include short chapters on it, too, for instance James Stourton's beautifully illustrated *British Embassies: Their Diplomatic and Architectural History*. Many other volumes dedicated to Rome also purport to cover the history of the Villa, usually in cursory fashion.[2]

So we should not be surprised that myths have arisen and been repeated, embellished or fused. That adds to its mystique, but the truth is remarkable enough in its own right. Yet, oddly, the full story of its nearly two centuries as an identifiable property has not previously been researched and recounted.

My late wife and I had the great good fortune to spend two periods of our shared Diplomatic Service career at the Embassy in Rome. Our second sojourn was hugely enhanced by the privilege and happiness of being, all too briefly, the 'tenants' of that magnificent Villa, one of the finest and professionally most effective of the UK's embassy residences.[3]

On our arrival in 2000 we bit the bullet and gave the green light to a major programme of works, long overdue, to the private living quarters and to some of the fine 'public' rooms, working closely with the enthusiastic estate managers in London. During our tenure my wife also devoted enormous time and energy to the garden, which had never thrived on 'benign neglect'. Invidious though it is, I should here pay tribute to two other British ambassadors' spouses who made a particular mark on the garden: (Lady) Rachel Bridges, who from 1983 to 1987 gave it much-needed structures and a planting scheme that was to last 25 years, and Nina Prentice, who from 2012 to 2016 oversaw a wide-ranging redesign as well as the restoration, conservation and display of the collection of antiquities it contains.

Those three years of intimate engagement with building and grounds gave us a strong appreciation of the quality of the engineering, most of it German, and the sheer functionality of the layout, again

mainly German, even though it was not originally built as an embassy but as a Russian-Italian family home. The building is by no means graceful. But it has a certain grandeur, not unlike that of the Italianate Foreign Office itself in London; and its situation, its garden and its history make it a very special pile.

We had no time then to delve into how the place came to be what it is. A fair amount seemed to be common knowledge, and our predecessors had created a summary history for the early, primitive website about the Embassy. We updated and expanded that, but, although it was obvious that there were significant gaps and mists, we too were guilty of simply repeating some of the myths.

Retirement did not quickly bring me the hoped-for space to embark on the research needed to explore those myths. At the start, I was able to draw on the papers my wife had copied and collected together, with the tireless help of Jo Trippa, then the social secretary at the Residence and a veritable walking memory bank. Nina Prentice and the current ambassador, Jill Morris, have been generous with access to other papers, to many of which I had paid little heed while I lived there, and to parts of the park which had not previously interested me.

Thanks to the late Maria Fairweather (who lived in the Villa a few years before us, when her husband, Sir Patrick Fairweather, was ambassador), we could read in fascinating detail about the extraordinary life and times of the Russian princess, Zenaïde Alexandrovna Wolkonsky, whose name lends such an air of alien romance to this almost secret place in the heart of Rome.[4]

My brief account in this volume of how she came to leave Russia for Rome, acquire the property in 1830 and construct the original 'casino', and of the role it played for her and her friends for the next 15 years, draws extensively and unashamedly on that biography, though it too strays occasionally from the historical record. The modest summer house the princess built passed to her family, and has later been enlarged and used in various ways over the years. It still exists, though I doubt if she would recognise it now.

Like a diva who does not come on stage till Act II, it is the much later and larger residence which today plays the lead. The history of its construction, its subsequent ownership and, finally, enlargement by the German Reich, has been only sketchily known, and often incorrectly summarised. Too much attention has been paid to what was alleged to have happened during the nine-month German occupation of Rome in 1943–4 and not enough to the rest of the place's life.

Making the book has been a source of joy, derived principally from the experience of delving in archives. I had not foreseen quite how much fun I was going to have. But, to justify a claim to be reconstructing the Villa's full story, I needed to resolve two mysteries at its heart: the first, caused by the almost total lack of any record of the construction in the 1890s of the core of the present house, and, second, the lack of records of why, how and when the Germans decided finally to expand the 1890s villa into the grand edifice we know today. The second of those challenges was made difficult by the lacunae in the German archives both for the 1920s and the crucial decision year 1938–9. Fortunately, and with a lot of help, I found plans and documents which, though often skimpy, do partly fill in the holes. In addition I found much that was new and hitherto unknown.

The Villa's story has revealed itself as a lens through which many aspects of the history of Europe in the nineteenth and twentieth centuries can be viewed – if sometimes from a peculiar angle. So I make no apology for the fact that my biography of a property has led me – and will, I hope, lead the reader – to stray down some of the highways and byways trodden by characters who accompanied the Villa on its journey.

I cannot yet claim to have told the whole story. Some riddles – including new ones – remain unresolved. I will be very happy to take on board contributions from anyone who can shed light on those still-dark corners or demonstrate where I have drawn the wrong conclusion from the evidence.

Acknowledgements

In the meantime I want to thank the chief among the many people who have encouraged and helped me during the long gestation of this study, some of whom I have already mentioned. In London Mark Bertram's generosity with his own research notes and file lists, his expertise, memory and sense of proportion have been crucial: without his constant help and friendship I would probably not even have started. The Foreign and Commonwealth Office Historians, especially Richard Smith, have found abstruse files and given me space to study them. In Berlin Dr Gerhard Keiper of the Auswärtiges Amt's Political Archive has been ever-helpful and courteous, as were staff at the Bundesarchiv. Several of my former German colleagues encouraged me to tell the tale of Germany's years in possession of the Villa without skating over the difficult episodes.

In Rome I found an expert, willing and generous guide on that period in the person of Dr Lutz Klinkhammer of the German Historical Institute. I could not have embarked on my early researches into the nineteenth-century portion of the story in the Italian State Archives without the patient help of Dottoressa Antonella Parisi and her colleagues. The staff at the Rome City Historical Archive were equally good-humoured and helpful. I am indebted also to my friend and former diplomatic colleague Ambassador Giancarlo Aragona who facilitated my access to the Foreign Ministry Archive. I relied to a great extent on two Directors and the library and archive staff of the British School at Rome, unerring in pointing me to the material I needed – archivist Alessandra Giovenco being especially willing to go beyond the call of duty. They also enabled my meetings with Professor Amanda Claridge at Royal Holloway College, University of London, and Dr Thea Ravasi of the School of History, Classics and Archaeology at Newcastle University, who both helped me to avoid too many elementary mistakes in the earlier part of the book; and Professor Julia Hillner of Sheffield University who shared her insights into the story of Helena, mother of Emperor Constantine. My thanks go also to Dr Alessia Glielmi, Historical Adviser to the Museo Storico della Liberazione for her frankness on the paucity of evidence of the commission of acts of brutality at the Villa during the German occupation. At the British Embassy I have found a keen interest in the research and a great deal of help not only from Ambassadors Prentice and Morris but also from the Residence Manager, Allegra Serrao.

I have benefited much from exchanges with others studying aspects of the Wolkonsky story: Edward Kasinec, Visiting Fellow at the Hoover Institution at Stanford University, Laura Schlosberg also at Stanford, Lorenzo Grassi, journalist in Rome, my late friend and colleague Charles de Chassiron, and Eric Chaim Kline, bookseller in Los Angeles – all of them lent or showed me material relevant to the story to which I would not otherwise have had access, or simply brought a new light to bear. I owe a particular debt of gratitude to those who have worked with me on parts of the book: Danilo Campanari, who gave me access to the remaining historical material available to his family; Sue Williams, who allowed me to resuscitate a delightfully illustrated paper she prepared 30 years ago on the memorials which Princess Wolkonsky erected to important people in her pre-Roman years (Appendix II) and to use some of her photographs from the 1980s; Julia Toffolo, formerly Deputy Director of the UK Government Art Collection, who tracked down more information about the pictures which had hung in the Villa when it was the German Embassy (Annex I). Above all I thank the immensely resourceful and assiduous Dottoressa Raffaella Bucolo. Already expert on the antiquities conserved in the Villa and their history, she has provided her expert summary of the research, now published in book form, in which she is engaged on the antiquities at the Villa (Appendix I), given me permission to use some of the fruits of her own research in the section on Travellers' Tales (see Chapter 3), as well as rooting out documents, images and other information

when I did not have the time or the skill to scour the archives myself – to say nothing of encouraging me to emulate her own rigorous academic standards.

Lastly, I record my gratitude to Alison, my wife over the last five-plus years, who has not known me without this book looking over my shoulder; she has shown amazing patience at my distorted sense of priorities.

Notes

[1] Mark Bertram's *Room for Diplomacy* is complemented by an online catalogue and covers most of the UK's diplomatic residences. Its author has given me unstinting encouragement and practical help, not least access to his research notes and lists of relevant files in TNA.

[2] See Callari, Zaccagnini/Hoffmann and others.

[3] In my career I had the opportunity to visit many of them, so the comparison is not frivolous.

[4] Maria Fairweather, *Pilgrim Princess: A Life of Princess Zinaida Volkonsky*.

INTRODUCTION

'Villa Wolkonsky' is the name given since the late nineteenth century to an unusual and largely unknown property on the eastern fringe of classical Rome but now in the heart of the modern city. It lies at the eastern end of the ridge known as the Caelian, one of the Seven Hills of Rome, at the spot indicated by the arrow between the red and black lines in the map at Plate 1.

Many Romans who live, work or study in the area remain unaware of what lies behind the Villa's gates and high retaining wall. The thousands of visitors who annually travel to that part of the city direct their eyes mainly at the nearby great Basilica of St John in Lateran (San Giovanni in Laterano) just within the third-century Aurelian Wall, and at a second fine basilica, the Holy Cross of Jerusalem (Santa Croce in Gerusalemme), a few hundred metres north-east along the Wall. Because it has been home to two embassies for most of the last one hundred years, it rarely features on modern tourists' lists. That is a mixed blessing, as this narrative will explain. The paradox is that only by remaining largely private and therefore unknown for the last hundred years has the Villa retained its character and been lovingly looked after.

Within the Villa's grounds are two principal buildings and numerous smaller houses and other structures, contained within a walled park of mixed woodland and garden, all dominated by 36 spans of a first-century imperial Roman aqueduct. In 1830, the property, then simply a vineyard, the Vigna Falcone, was bought as a going concern by a remarkable and gifted Russian princess, Zenaïde Wolkonsky. She transformed its single small cottage – built onto the aqueduct – into a summer house, modest by the standards of the Russian and Roman nobility. Thanks to her son's further judicious purchases between 1868 and 1878, the land area of the property grew to be much larger than it is now. It soon shrank again, as some northern tracts and much of the new additions to the east were sold off, partly for road realignment but mainly to finance the costs of building a new, large mansion on the estate between 1886 and 1891. The boundaries by 1920 were much as they remain to this day: enclosing a still substantial 11 acres, or 4.5 hectares (see Plate 3).

After the princess's purchase the Villa Wolkonsky was not sold again until the German government bought it for use as its embassy to the then Kingdom of Italy in 1922. In the meantime the name Vigna Falcone had been replaced at various times by 'Vigna Celimontana', 'Villa Celimontana' and 'Villa delle Rose'. The name 'Villa Wolkonsky' only began to appear in travellers' tales, guides and maps in the 1860s. The first appearance I have found on a map is from 1869, in an English map by John Murray. References in Baedeker in the 1870–80s and Augustus Hare, writing in the 1870s and, later, in 1902, suggest that by then the name was in general use. Even so, the permission to build the new *villino* (mansion) in 1886 referred to the Villa Celimontana, presumably its official designation at the time.

Part of the Villa's special charm now is that it is almost hidden from the city by apartment blocks, tucked away behind its walls and trees – paradoxically – on the top of its ridge. It is officially designated a private park (*parco privato*). Its unique feature is a long and well-preserved stretch of imperial Roman aqueduct, forming a central roughly north-east–south-west axis through the estate, which since the early twentieth century has been roughly kite-shaped. Along the Roman road that ran beside the northern flank of the aqueduct are several Roman tombs – 6 m or more below today's ground level – a few of which have been excavated. One remains exposed within the property, and three more can be seen from outside.

Antiquity apart, the story can be divided into four separate phases:

1. the Wolkonsky years in the first summer house or *casino*, 1830–78
2. the Campanari-Wolkonsky years, 1878–1922, from 1891 in the new, larger mansion or *villino*
3. the German years, 1922–44, during most of which the estate was the embassy of the Reich, with the *villino* being enlarged between 1938 and 1940 into a veritable *palazzo*
4. the British years, 1947 to the present, during which it has been and remains the UK's Embassy to the Republic of Italy, though since 1971 only the residence and other accommodation remain there, as the offices returned to their former site at Porta Pia.

The Villa's successive owners have had to work hard to create and maintain the buildings and the extensive grounds. That effort has yielded a very special by-product: the preservation and conservation of a historic estate in the heart of Rome, with many of its Roman and later contents, in spite of the impact of two world wars and dramatic economic and political upheavals. The owners have adapted the buildings and grounds to their purposes but by and large respected the conservation ground rules laid down first under papal rule and subsequently codified and watched over keenly by the Italian authorities.

The achievement of that conservation has been a mix, sometimes uncomfortable, of passion and effective rules, certainly far from wholly accidental. It has to be said that the papal authorities' acquiescence in the grafting of the princess's little country villa directly onto the aqueduct (and, even more, her son's later modifications to it) would not have passed muster in later years. The Italian authorities have often reminded the successive owners about the '*vincoli*' (chains) which limited what they could do to the estate without permission, displaying very little flexibility, but in practice allowing some, not least in the 1930s, a stance from which all parties have by and large benefited. In the British years, however, many of those in London responsible for the public purse could not accept, in the face of much evidence, that realisation of the apparent capital value of one or other of the two sites the UK had come to own in Rome could or would be frustrated by precisely that insistence on the rules – even as they became gradually stricter. They did not realise the depth of the sense of responsibility for the country's cultural heritage the Italian authorities had developed.

An especially significant feature of the story is the dedication of four German ambassadors to the upkeep of the house(s) and the grounds during a period when, at least until the very late 1930s, the German economy was in a parlous state and the government strapped for cash, to say nothing of the preoccupations of ambassadors in the 1930s, as Germany moved Europe, including a reluctant Italy, towards war. The first of the four, Konstantin von Neurath, who acquired the Villa for the Reich in 1922, is credited with having spent a good deal of his own money on it, especially the garden. Some of the others may have done so too. All certainly strove to ensure that the government in Berlin did at least the minimum needed to prevent the main residence from crumbling and, finally, to enlarge and

modernise it. Particularly in Neurath's case this sensitive, almost romantic engagement clashes with the course of his career after leaving Rome, during the Nazi period: he ended up a convicted war criminal, held responsible for the atrocities committed in Czechoslovakia after that country was annexed to the Reich.

The Axis between Mussolini's Italy and Hitler's Germany and the brief period when it was transmuted into a harsh occupation loom over that period of the story. While the Villa's story sheds a light on some aspects of that political history, this narrative makes no attempt to take political and moral positions about individuals, just as it does not try to summarise the two hundred years of European history, which have washed over or past it and its occupants. Indeed, if there is a theme for the second part of the tale, it is more modest: how, through the turbulent twentieth century there seems to have been a dogged undercurrent of determination to do well by the place, come hell or high water, when with hindsight we may judge many individuals' moral compasses to have been defective, and resources were practically always insufficient. This has applied also to the years of the UK's tenure, though the moral (as opposed to financial) pressures have not been comparable.

I.
AQUEDUCTS, BASILICAS AND CHAPELS

The Roman aqueduct

The Villa Wolkonsky is defined by the Neronian branch or spur of the major aqueduct known as the Aqua Claudia. Thirty-six of its spans stride for 350 metres from north-east to south-west (the direction of the water flow, right to left in the image in Plate 13) across the Villa's park, forming its main axis. The branch was built around AD 62 to a plan probably conceived under Emperor Claudius but executed by Nero (AD 54–68). It has defined, dominated and shaped the landscape of the Caelian ridge. Princess Zenaïde Wolkonsky might well not have bought the property nearly 1,800 years later, had those dramatic arches not stimulated her vision of the garden she could create around them. The aqueduct is the first star of this tale and cannot be left out. Nor can the spread of the city to the south-east over the centuries following its construction, as that (in spite of 1,000 years of decline and neglect) also shaped the environment which made attractive to nineteenth-century sensibility the patch of land we now call the Villa Wolkonsky.

Paradoxically, the aqueduct we see still standing after nearly 2,000 years was not very sturdily built. From its early years it needed frequent repair. Its arches were regularly reinforced by infilling, sometimes crude. That was sufficient to give it the strength to survive for many centuries. After a major conservation exercise, led by the antiquities team at the UK Ministry of Works (MoW) in the late 1950s, it might well stand for another few. Such optimism is based partly on the main reason why it has withstood the ravages of time so well: although its two tiers of arches were originally too weak to support a double channel on the top, the lower tier has for centuries been almost entirely buried – and protected – by the accumulation of detritus of various kinds. With very minor exceptions the lower tier within the Villa grounds has never been excavated. By some accounts the aqueduct remained operational on and off for as many as 800 years, though 400–500 seems a more likely, yet still remarkable figure. All who live in, work at or visit the Villa, itself barely 200 years old, cannot but be conscious that they are in the presence of 2,000 years of history – and of a monument to the engineering skills of imperial Rome.

How the aqueduct fitted into imperial Rome's extraordinary and complex water system is illustrated in the map at Fig. 1.1. It was built alongside an earlier, underground section of the republican city's water supply – several conduits (spechi) known as the Rivus Herculaneus of the Aqua Marcia – some of which ran along the Caelian ridge, serving properties at its western end, but not apparently reaching its high point. Sections of it have from time to time come to light. Later additions to the Aqua Marcia and the Aqua Julia serving the central parts of the city also almost certainly ran partly in underground channels to the Caelian's highest point.[1] The development of the city as an imperial capital under Augustus and his successors, with the demands of their palaces, gardens, fountains and lakes on and around the Caelian and Palatine Hills, rendered that system obsolete.[2]

Emperor Claudius (AD 41–54) completed two aqueducts begun by Caligula in AD 38: the Aqua Anio Novus and the Aqua Claudia, both of which came from near Tivoli; when they joined some 7 km from the city walls they were carried by the same arches but remained in separate channels, passing through

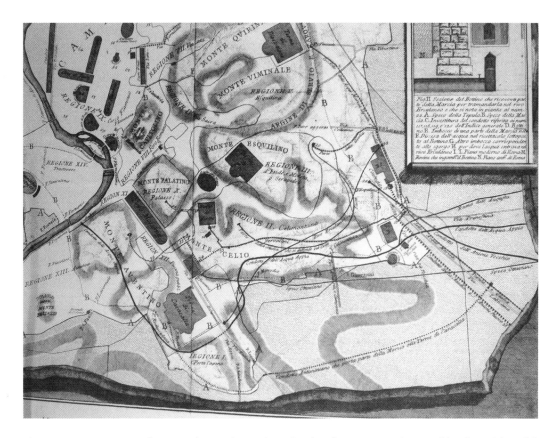

Fig. 1.1. Rome's water supply system in Frontinus's time, showing the Aqua Neroniana snaking from right to left along the Caelian ridge to the huge cistern at Claudius's Temple, then across the valley to the Palatine Hill. Extract from a map by Piranesi (1756).

what is now known as the Porta Maggiore, where they were joined on a monumental triumphal arch – which was still well outside the city walls. The arch to this day carries an inscription recording completion in AD 52. Immediately before that arch a branch channel was led westwards (through what became the grounds of the Villa Wolkonsky). Most of the work on that branch is ascribed to Nero, a widely accepted view supported by the statement of Frontinus (the great second-century Roman manager and historian of the city's water supply) that Nero took it as far as Claudius's Temple, i.e. not all the way to the Palatine.[3]

Historians and archaeologists are unsure of several key aspects of the origins of the branch aqueduct:

a) when it was built, though it is widely acknowledged as being built by Nero, with AD 64 now being replaced by AD 62 as the likeliest date;
b) whether the extension to the Palatine formed a part of Emperor Claudius's original scheme to bring additional water to the city from the mountains to the east, the most likely explanation for its great height;

c) whether the 'bridge' across to the Palatine was contemporary with the original design and construction or a later addition, its construction being traditionally ascribed to Domitian (AD 81–96);

d) by what hydraulic engineering techniques the water was moved across the valley between the Caelian and Palatine Hills – free-flowing water carried on conduits held up on four levels of arches or an inverted siphon, perhaps on two levels of arches.

In modern times the seminal work on the city's aqueduct system was carried out by Thomas Ashby and John Ward-Perkins, successively Directors of the British School at Rome (BSR). A summary relating to the Palatine and Caelian Hills was incorporated in the report by Baillie Reynolds and Bailey on the UK-led restoration project of 1959–60.[4] But they understandably skated over many of the uncertainties not relevant to their mission. Since their day much more work has been done, but the riddles remain largely unresolved.

Some useful ground-clearing was done in a 2003 survey by Ian Madelin.[5] He noted that the spur had often been referred to as the Arcus Neroniani by archaeologists, but the only ancient evidence for the name itself was Frontinus's reference to the arches 'which are called Neronian'. Rather, it had normally been dubbed the Arcus Caelimontana or Caelian Aqueduct.

Madelin found equally little basis for the habitually cited completion date of AD 64. Frontinus and other sources had neither dated it nor offered evidence about its purpose. Madelin judged improbable the notion that Nero built it in AD 64 after the disastrous fire of that year to improve fire-fighting supply to the Palatine where his new palace was being built: it would have taken longer than the remainder of the year to build, and was anyway unnecessary because the existing supply was adequate for fire-fighting. Furthermore neither the remaining structure nor the nearby properties showed traces of the AD 64 fire, which contemporary accounts suggested had started at the south-east corner of Circus Maximus and spread northwards. That reasoning would allow for the aqueduct's existence before the fire.[6] Furthermore, the AD 62 date is related, as Madelin pointed out, to the inscription on the Porta Maggiore which claims that 'Vespasian in AD 71 at his own expense restored to the city the [Claudia] waters tapped by the deified Claudius but interrupted and in ruin for nine years'. That clearly suggested that Nero did something in AD 62 which interrupted the Aqua Claudia and allowed it to fall into disrepair for a long time, covering the very period when the Caelian spur was thought to have been constructed. Madelin suggested that Nero had merely completed in AD 62 the project started by Claudius and perhaps took more water from it for his own uses than originally envisaged, as he built his own new palace, the Domus Aurea, on the Caelian after abandoning the Palatine and also wanted a reliable way to fill the artificial lake he had built to stage mock naval battles – where the Colosseum now stands. If this deprived the main Aqua Claudia of its full supply for any length of time it could have fallen into disrepair, and so Vespasian opportunistically claimed credit for doing the neglected essential maintenance occasioned by the weak construction of the original, thus making a bit of self-serving propaganda at the expense of Nero's reputation. Madelin also noted that Herschel (the first to translate Frontinus into English and a hydraulic engineer), had recorded that all the aqueducts, even new ones, were constantly out of commission for repair. Work on the Claudia was recorded in AD 52, 71, 80 and 84.

A similar approach was advanced by Tucci in 2006, adding that 'to compensate' for Nero's diversion of the Claudia to the Caelian and beyond, the supply to the Caelian through the Marcia and Julia aqueducts was diverted to supply the area north of the Porta Maggiore.[7]

The scheme drawn up by Claudius for a spur aqueduct off the Claudian along the Caelian ridge was on a scale and with a water quality that pointed to it being primarily designed to improve the

general water supply on the Caelian, not only increasingly densely populated but popular as a place for the wealthy to build large properties. The Caelian was also where Claudius's ancestors had settled when they came to Rome and was his choice as the site of his temple at the western end of the Caelian ridge, where a large reservoir (*castellum*) was built – and this scheme probably came to dominate the project.[8] Only as a secondary purpose would the aqueduct continue westward to supply the Palatine Hill, where there was no ready source of fresh water for the growing number of imperial palaces and mansions. Nero might have given greater priority to the extension to the Palatine once he had decided to build himself a proper palace there to replace Augustus's informal aggregation of houses.[9] He could have had in mind other purposes, including feeding his artificial lake (for mock battles, etc.) on the site now occupied by the Colosseum – but that too could have been achieved without the additional supply, and it would not have justified the great height and capacity of the spur. Only extension to the Palatine could do that.

Achieving that extension has usually been attributed to Domitian (AD 81–96) – but that is no longer taken as gospel. At least one modern archaeologist thinks it likely that Nero himself constructed the 'bridge' across the valley between the Caelian and Palatine.[10] This view is developed by Schmölder-Veit, who first assumes that the Ashby/Gismondi thesis of free-flowing water carried on four arches is right, but then (having discovered an identification by Esther van Deman of a Neronian core to the arches remaining on the Palatine slope) notes in a positive tone that many scholars since 1944 have reckoned that Nero might first have built a two-arch structure with an inverted siphon, possibly reusing the route made earlier for the Marcia and Julia to make the crossing; and that this was later rebuilt with a four-arch bridge in the Severan makeover of Rome's water supplies.[11] If this seems to leave out Domitian's accredited intervention, I would suggest that Nero's initial solution to the complex problem might already have proved defective, requiring reworking by his Flavian successors.

As for the aqueduct's great height, my guess is that Claudius's scheme was more modest in height and ambition and that it was Nero, in taking it over, who decided to increase its height by building a second tier of arches, so that it could feed the Palatine. By AD 62 Nero was building his new house there, so a proper water supply could have been significant. If this was the case it might account for the slenderness of the lower arches in relation to the overall height, especially if the lower course had already been constructed at the start of the spur (i.e. where the Villa now is) before Claudius died.

Arguments continue about how the engineers contrived to get the water across the San Gregorio valley that divides the Caelian from the Palatine Hills. The choice is between

a) free-flowing water in open channels atop four levels of arches, on which some maintain that the remaining low-level structures demonstrate that they would not have been strong enough to carry the weight of masonry implied.[12]
b) an inverted siphon, probably carried on a two-arch structure. The photographs by Ashby and Gismondi, after studying what remained shortly after 1900 of the part of the aqueduct which crossed between the two hills, show a two-level structure (Fig. 1.2) much like the section through the Villa Wolkonsky.

In the absence of decisive archaeological remains factors adduced in aid of the favoured choice include the head of water and pressures involved as well as the height of the cisterns (*castella*), the strength of stone pressure conduits, and other technicalities. Much mystery remains: the story has its own fascination, but its resolution is unlikely to have a marked effect on the tale of the Villa Wolkonsky.

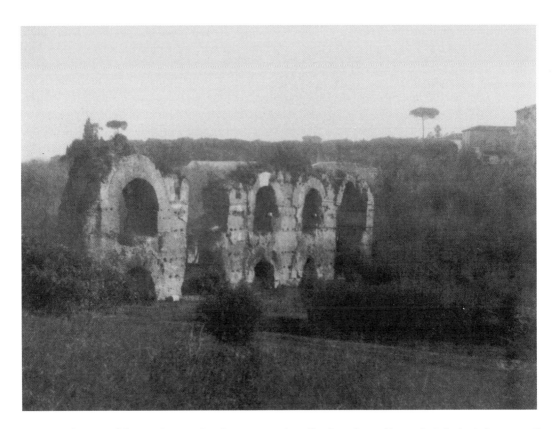

Fig. 1.2. *The ruins of the aqueduct crossing the San Gregorio valley from the Caelian to the Palatine before most of it was demolished in the twentieth century.*

What did have an effect was the frequent repair and rebuilding the aqueduct needed. The requirement for access would have soon occasioned the laying down and maintenance of a roadway alongside. Because of the spur's poor original construction, the first reinforcements were made even in Nero's time: especially around Bays 10/11 and 2 (see Fig. 17.1) – this would be consistent with Nero being the one who added the extra height.[13] Whether Domitian was responsible for the extension to the Palatine or not, when he oversaw the general repair of the whole spur, more extensive repairs were needed. These mainly consisted in the insertion in many bays of a secondary arch within the original arch, supported by a lower-level arch. Whether this in turn rested upon or replaced the original Neronian lower arch could only be tested by excavation. Indeed, Frontinus records further frequent repairs thereafter, including those associated with Emperors Nerva and Trajan (who was also consul – directly responsible for water supplies). Bays 30–25 had needed complete rebuilding, with longer piers and shorter arches, and in a couple of cases with buttresses too. The facing brickwork of the whole repair project was judged of high quality. The work was well enough done to make further major repair unnecessary for over a century, but the structure had been allowed to decay by the latter years of the second century.

It fell to Septimius Severus (193–211, who died in York after regaining Rome's control over Scotland) and Caracalla (198–217) to have the whole length refurbished (but not rebuilt), apparently

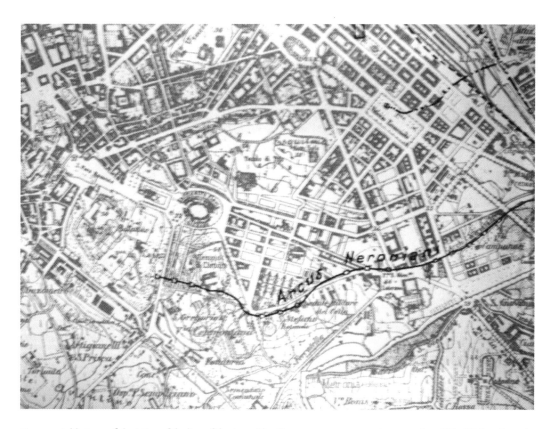

Fig. 1.3. Ashby's 1906 depiction of the line of the Aqua Claudia on a contemporary city map, from Villa Wolkonsky to its extension to the Palatine Hill.

at their own expense, in AD 201, probably in connection with new palace buildings on the Palatine – the one arch of the aqueduct to survive on the Palatine is of Severan work.[14] This was characterised by the use of yellow-ish brick, the core being predominantly of tufa, very different from the techniques in Nero's and Domitian's days. By 1956 most of the Severan brick facing on the Villa Wolkonsky section had disappeared, but enough remained to allow dating. Interestingly the bays Domitian had rebuilt required almost no new work in Severus's repair. Some poor-quality later (probably fifth century) repair work was also identified, to Bay 2 and Pier 8/9, 'perhaps a final effort to keep the aqueduct in working order'. It may have carried water until falling into disuse in the fifth or (more likely) sixth century, after the invading Goths cut off much of the city's water system.

In the context of the Villa Wolkonsky this somewhat abstruse mix of recorded facts and hypotheses about the origins of the aqueduct and its early repair and rebuilding is not of purely academic interest. The way in which the Caelian spur was constructed – especially its unusual height – had much to do with its survival through the centuries in a form which gave a special attraction to the landscape which Zenaïde Wolkonsky chose to buy and exploit. And it also explains why it was found to need attention both by the princess and, 130 years later, more radically by the British government. It seems to be accepted that the aqueduct fell into disuse during or shortly after the fifth century AD. It must have been a fine source of bricks for other structures in its neighbourhood; but it was otherwise neglected and

allowed to decay until just before Princess Zenaïde bought the property in 1830.[15] That does not detract from the durability over nearly two millennia of this remarkable example of Roman hydraulic engineering, to say nothing of its more recent picturesque contribution to the fabric of the modern city.

The line of the whole spur can still be traced from Porta Maggiore to the east as far as the Palatine to the west, including the reservoirs into which it flowed, and fragments can be seen at various points on its route – though none as complete as the section within the Villa Wolkonsky, the largest single surviving stretch of aqueduct within the walls of Rome (Fig. 1.3). Where excavation has taken place within the Villa, it has revealed the existence of a paved road laid parallel and close to the aqueduct as it was built. It became a part of the network of country roads beyond the south-eastern gates of the city (in this case starting at the Porta Capena), and as such attracted the building of tombs alongside it (in the same way as we can see on the via Appia and the via Cassia).

The tombs

The site was initially well outside the 'republican' walls of Rome (in red in Plate 1). On the east side of Rome that wall was located close to the great Basilica of Santa Maria Maggiore on the Esquiline – and is in places still visible. The Caelian ridge and the surrounding land were only enclosed within the city walls when Aurelian built the new much extended wall in AD 270–75 (black in Plate 1), which was raised a few metres in the early fourth century by Maxentius. Those are the walls visible nearby between the great Basilicas of San Giovanni in Laterano and Santa Croce in Gerusalemme – a scene Princess Wolkonsky would have seen when she decided to acquire the property. Once the new wall was commissioned tomb-building along roads within the city would have had to cease; this accounts for the absence of any such structures dating to the fourth and later centuries. Excavation has also shown that the road beside the aqueduct was rebuilt from time to time at different levels. The levels of the tombs beside the road are similarly varied. This suggests that there were periods of disuse and that the road was perhaps only intermittently maintained or remade when major maintenance of the aqueduct occurred. In the intervals the build-up of detritus would doubtless have begun. The road itself would have fallen into disuse once the aqueduct ceased to be maintained. The nineteenth-century excavations of the main tomb (or columbarium) should have revealed the nature of the accumulated detritus, but no record seems to have been made of the findings.

Most of the tombs are from the first century AD. Detailed accounts are to be found in Colini[16] and in the contemporary official reports.[17] It is safe to assume that the remains of other tombs are preserved at the old street level along the aqueduct and would come to light were the site ever to be fully excavated.

Rome's expansion to the east in the third and fourth centuries: Constantine and Helena

The aqueduct, with its nearby road and tombs, helps to set the area now forming the Villa Wolkonsky into the wider framework of a part of the city which, from the second to fourth centuries, was spreading eastwards, and the origins of many of the structures which frame the Villa date back to this time. For some two centuries excavations beneath the Basilica of St John Lateran have exposed – working backwards in time – the remains of Rome's oldest church buildings, the barracks of Castra Nova where Septimius Severus housed his horse-guards, a bath complex, a marketplace and a second-

century palace complex (where fragments of highly coloured frescos and some walls have been identified in the area between where the baptistery and the western end of the basilica now stand).[18]

In Trajan's time a new barracks (Castra Priora) was built for the imperial cavalry guards (*equites singulares*) just north of the aqueduct, on a site straddling what is now via Emanuele Filiberto, the late nineteenth-century road from the Basilica of Santa Maria Maggiore to the Basilica of San Giovanni in Laterano. That was quite likely the site used to build the later Villa Massimo. Remains of a Hadrianic villa with mosaics were also found in that area when that road was built (see also Appendix I). Colini even recorded the finding during building works of walls and columns at the corner of via Conte Rosso (near the Villa Wolkonsky's entrance) and via Emanuele Filiberto.[19] Clearly by the second century AD the Caelian was considered a desirable place for the wealthy to live. The availability of water, thanks to Claudius and Nero, would have been part of the attraction. Much of what became the Lateran area was imperial property.

At the end of the second century Septimius Severus, having occupied Rome with military force, doubled the size of the imperial guard, and excavations have revealed that he built a second fort (Castra Nova) for them almost exactly where the Basilica of San Giovanni stands. The existing large residence there (on its different alignment) was used as foundations or storage for associated market buildings and baths (a level beneath where the baptistery stands). These buildings remained the home of the imperial guards up to the time of Emperor Maxentius (306–12). By then they were within the fortified walls of the city. Such had been the confidence in the Pax Romana that, even though the imperial city had outgrown the old republican walls (fourth century BC), it had not been thought necessary to fortify it. The barbarian invasion of northern Italy in AD 270 changed that, causing the emperor Aurelian (270–75) to start building his more extensive wall. The Lateran quarter was for the first time enclosed along with the late second-century imperial Palatium Sessorianum (Sessorian Palace) a short distance north-east, where the Basilica of Santa Croce in Gerusalemme now stands. The palace seems to have fallen into disuse by then, and the new wall actually cut the palace off from its private racetrack! Aurelian's wall was completed in five years and, in the interests of speed and economy, incorporated many existing structures. When Maxentius doubled the height of the walls in the early fourth century, he did not change the alignment.

After Constantine overthrew Maxentius in AD 312 and eliminated his imperial guards (as recorded on the Arch of Constantine near the Colosseum) he may initially have housed his own elite troops in the Castra Nova.[20] His victory over Maxentius resulted in the 'un-banning' of Christianity, but there was still much opposition to it, and the pagan temples in the old heart of Rome were still active. He seems to have decided very early in his reign to allow the now encouraged Christians to consecrate the site of the barracks and build a large church there. Work on it started around AD 320. Constantine's wife, Fausta, may have had her *domus* (home) at the nearby *Castra* of the *equites singulares* built by Trajan, living there until around 324, when the Lateran was taken over as the first papal residence, though not necessarily incorporating her residence.[21] When Constantine departed for the Eastern Mediterranean he was able (in 316) to bring his mother, Helena, into his court after many years in which she seems to have had no public role. Around 318, already some 70 years old, she was sent to Rome by her son, to be an imperial presence – in the Sessorian Palace – representing him and strengthening his dynastic position, while he focused on conquest duty in the East. In 324, when Constantine concluded his campaigns of conquest, he gave her the title Augusta, and she was in Rome when Constantine celebrated his twentieth anniversary in 326.[22] This was one of only three occasions when Constantine himself visited Rome between AD 312 and 331, when he founded Constantinople; thereafter he did not return.

When Helena took over the Sessorian Palace it became a bustling statement of the imperial presence on a high point of Eastern Rome. She incorporated and enlarged the neighbouring *Ad Spem Veterem* gardens (also associated with Septimius Severus) and the baths within them, which lay between the palace and what is now the Villa Wolkonsky. The small amphitheatre attached to the palace later became – and remains – the garden of the Cistercian monastery formerly attached to the basilica. In spite of her political role Helena is mainly remembered as the person who brought back from the Holy Land many important relics, including a sizeable fragment of the Holy Cross (*Santa Croce*) and a part of the Title of the Holy Cross. One other treasure was the Holy Stairway (*Scala Santa*, which features on some maps as *Sancta Sanctorum*) – the marble stairway up which Christ is supposed to have climbed on his knees when arraigned before the Roman governor Pontius Pilate. She is said to have had it carefully reassembled near the Lateran Palace. It has been a resort of pilgrims ever since.[23] As an old lady of 79, she did indeed travel in the eastern Mediterranean, especially Palestine, on Constantine's behalf in AD 327–8. To early historians (of the Church) this journey was a pilgrimage, but it may have been more of an extended imperial *acte de présence*. She is however not thought to have returned to Rome after completing her travels but died in AD 329. Her body was later taken to Rome. According to the author of a new biography, it is widely accepted that she also did not acquire the relics associated with her name.[24] During late antiquity it was believed that it was Constantine who founded the church of Santa Croce in Gerusalemme after Helena's death and gave it the relic of the true cross – perhaps in her memory (not excluding the possibility that it was she who had acquired it).

Whatever the truth, the myth of Helena has proved more powerful than the facts, for it has survived nearly 1,700 years! And it is the myth that influenced the subsequent development of the Lateran/Santa Croce area. It holds that on return from that shopping spree she converted part of the great hall of the Sessorian Palace into a chapel to house the relics of the cross – an act on which scholarship now throws much doubt. As she is thought to have died in AD 329, whether in Rome or in the East, the myth in any case demands quite a lot of an old lady. One can surmise that dynastic politics found it useful to build up the myth and the relevant monuments after Helena's death, without being too particular about whether she contributed the relics to begin with. In spite of becoming a place of Christian pilgrimage the Sessorian Palace remained formally an imperial palace until the sixth century. In the twelfth century the chapel was enlarged into a Romanesque basilica, the bell tower and Cosmatesque floor of which were incorporated into the later baroque Basilica of Santa Croce, just east of the Villa Wolkonsky.

Between them, Constantine and his mother (by holding court in imperial fashion, if not by actually supplying the objects for later pilgrim veneration) triggered the transformation of the area from a quarter of large houses and military barracks into a focus of the newly permitted Christian faith. Soon the area between the two basilicas was thriving, not only thanks to its imperial connections but also because of growing numbers of Christian pilgrims, well away from the pagan temples and palaces of the old Rome, which, without imperial investment and protection, enjoyed no further development. It is not yet clear whether the Lateran baths, with their water supply, were initially transformed into a baptistery for the new basilica or were put to some other use. The relationship between the baptistery, the basilica we now see and the baths is complex. Recent studies suggest that the baptistery is indeed Constantinian in origin with later interventions, mainly in the fifth century. (It is in any case unquestionably one of Rome's gems, as is another early Byzantine-style circular church not far to the west: Santo Stefano Rotondo, from the late fifth century.) Many centuries later the Lateran area, with its several major religious attractions, retains this flavour of pilgrimage, especially at times of the Holy Year (*Anno Santo*).

There is no evidence that the land later to become the Villa Wolkonsky, lying between the two basilicas and only a few hundred metres back from the Aurelian Wall, was directly touched by all this activity. Given the extensive development of the area, the road beside the aqueduct and the nearby location of military barracks, it is likely that the ground which now constitutes the Villa for a time carried buildings of some sort – a probability increased by the discovery, during excavation of the swimming pool in 1942, of five substantial fluted columns some 40 m from the southern side of the aqueduct.[25] But the period may have been short, as the papacy incorporated much of the area into its Lateran property when it established itself there in the fourth century, and succeeding centuries brought invasion and plague.

The Middle Ages, a chapel, maps and a new aqueduct

Once Constantine moved the centre of the empire east to Constantinople, Rome gradually shrank. Invasion (capture in 410), plague (especially in 590) and finally take-over in the sixth century by Justinian, emperor in the mother city's Eastern rival, Constantinople, deprived Rome of its position as a city of imperial power and prosperity. But, being outside the heart of the city (and not prey to its poor sanitation), yet within the Aurelian Wall and close to two or three main gates, the area around San Giovanni did not lose all of its attraction to pilgrims and others. It remained for a considerable time the centre of the one remaining functioning authority in Rome: the papacy. Nonetheless the nearby land seems to have reverted in due course to largely agricultural/horticultural use or even light woodland. And the aqueduct ceased to be maintained.

Some authorities have suggested that there was a hospital and/or church of San Nicolò de Hospitale on the site in the fourteenth century. Mariano Armellini in the nineteenth century asserted that this was identical to the Venerable Ptochium Lateranense, '*presso agli altri fornici dell'acqua Claudia nella villa ora Wolkonsky*' ('near the other arches of the Claudian aqueduct in the villa now called Wolkonsky'), mentioned in a Papal Bull of Pope Onorio III.[26] But this is contested. The Ptochium, dating back to Charlemagne and alleged to be the oldest hospital in Rome, was indeed mentioned in Onorio's Bull, but there was no evidence that it was located on land within what is now the Villa. Santangeli Valenzani identified the Ptochium with the church/hospital by the Lateran Palace.[27] And Huelsen described San Nicolò as '*iuxta portam S. Iohannis*', but he also referred to a Bull of Pope Benedict IX in 1033 which mentioned '*vinea ecclesiae S Nicolai nelle vicinanze del Palazzo Lateranense*'.[28] Some link is not impossible, but none of the (later) maps consulted shows a vineyard of that name. Nonetheless the Armellini assertion has been enough to generate firm guidance to visitors, such as that in the *Guida ai Misteri e Segreti di Roma*.[29] Whether or not San Nicolò was on what is now Villa Wolkonsky land, there seems sufficient evidence that there was still activity in the neighbourhood, possibly throughout the Middle Ages, sustained by the governance of the Church, the flow of pilgrims and the traffic in and out the city: the hospital at San Giovanni was founded on its present site in 1204 and much commerce to and from the Alban Hills and beyond would have come through the gates.

Over those few hundred years the occasional map or illustration showed the remains of the aqueduct in the Lateran area, but usually in a sketchy fashion. Map production developed particularly in the sixteenth century, as the papacy began to reassert its control over Roman life. Cartaro's map of 1576 (Fig. 1.4) traces the line of the remains of the aqueduct along the natural ridge and shows how that related to the topography before the main late Renaissance works of filling in the valleys. By then,

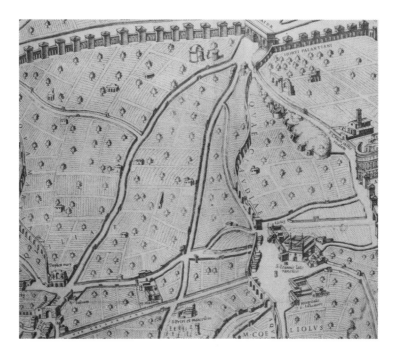

Fig. 1.4. *Cartaro's 1576 map of Rome shows the aqueduct following the Caelian ridge and a small structure which could be a chapel or church.*

however, the ground level would already have been much as it is now, 56 m above sea level at its highest, some 8–10 m above its first-century AD level, the natural result of the accumulation over some 1,400 years of soil and debris blown by the prevailing winds up against this considerable barrier (and the tombs along it) exposed on the crest. The lower tier of arches is barely visible.

Pietrangeli in his 1973 essay noted (without documentary attribution) that the properties in the area are first recorded in a map of Rome (focused on its water supplies) by Leonardo Bufalini in 1551.[30] He deduced that what is now the Villa Wolkonsky was separate parcels of vineyard ground owned by Camillo Rustici and Lorenzo Corvini (whose names – preceded by 'V', probably an abbreviation of *Vigna* – are certainly legible on 1748 maps based on Bufalini, Fig. 1.6). Further south-west along the Caelian ridge (in the next section of the map) the word *Plantationes* appears, suggesting that part may then have been a nursery or woodland possibly originally attached to the old barracks. The first map to show a building (i.e. a possible church or chapel) on the relevant land was by Camocio, dated 1569: it may be a chapel of some sort, but it does not look like one (Fig. 1.7).[31] Cartaro's 1576 map (Fig. 1.4) clearly shows a building which could be a chapel or church, standing near but away from the aqueduct; but Cartaro is in other respects inaccurate, so this should not be taken too seriously. The 1577 map by du Pérac and Lafréry (looking from north-east to south-west, Fig. 1.8) shows four buildings of different sizes along the relevant stretch of the aqueduct. At least two of them could conceivably be a church or chapel, yet all but one are adjacent to the aqueduct, so it seems unlikely that any of them actually was a church. The outlier is a building on lower ground below the Caelian ridge. As that part

Fig. 1.5. Colini's plan (Tav. XXIII) of the relationship of the Servili tombs (top-right quadrant), excavated in 1881, and the streets at the eastern end of the Villa Wolkonsky also shows the tombs discovered in 1916/17, top right on via Celimontana (n.b. south is towards the top of the page).

of the valley between the basilicas was filled in during the eighteenth century, any trace of it would at that time have been obliterated or at best buried.

Map production was just one activity which took off in the sixteenth century: Rome was again flourishing under a series of highly political and competitive popes such as Sixtus V, who took Rome's infrastructure very seriously. Amongst other achievements he built the first major aqueduct in Rome since antiquity, the Aqua Felice, begun in 1586. One branch of it was destined to supply his summer palace at the Lateran. He had a new tunnel excavated to bring water in four pipes to the Lateran from a *castellum* at Porta Maggiore. Although it ran in places along a line similar to the old Rivus Herculaneus it was built from scratch. In the stretch through the Villa Wolkonsky it was dug roughly 4 m below current ground level alongside the southern flank of the aqueduct support footings and with a slight east–west slope. It was 75 cm wide, 1.60 m high with an arched roof. An inspection in March 1985 during restoration work on one of the houses on the property (and with access through a shaft within the house, subsequently filled in) revealed some 375 metres of tunnel, interrupted at each end by the perimeter wall of the property.[32] (Recent research showed that this aqueduct's entire course had been charted in a map of Roman water supplies produced in 1937, which seems then to have been lost from sight.)[33] At one point the tunnelling work had caused the foundations of one of the aqueduct's pillars to subside part-way into the new tunnel – though without obstructing the flow of water or access along the tunnel.[34] The pier is shown intact in a map by du Pérac of 1577, but a gap appears in later maps, e.g. Nolli's of 1736. At the time of its construction

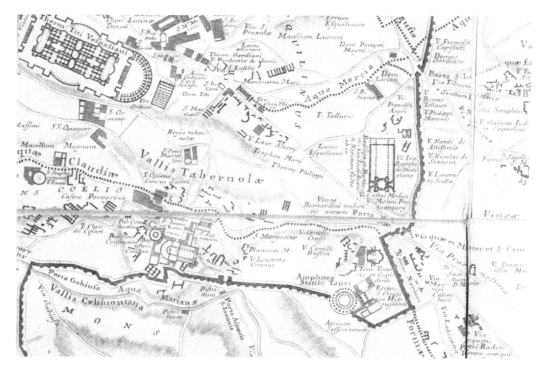

Fig. 1.6. Nolli's 1748 version of Bufalini's 1551 map shows the ownership of two parcels of vineyard later to become part of the Villa Wolkonsky.

two concessions to draw water from it are recorded for nearby villas: Altieri and Giustiniani (later Massimo). The original lead pipes were swapped for cast iron early in the nineteenth century, possibly in 1833, when some dated graffiti were left on the walls near the access shaft. (There is no suggestion that the work had anything directly to do with Princess Wolkonsky and her purchase of the Villa, but the subterranean water supply does feature in the transaction – see Chapter 2.)

Between Sextus V's pontificate (1585–90) and the years 1718–35 the Basilica of San Giovanni (originally dedicated in AD 324) was replaced by the magnificent structure we see today, which bears the name of Clement XII (1730–40). The Basilica of Santa Croce nearby also dates in its present form from the eighteenth century. With Rome's revived prosperity there would have been a market for the produce of a vineyard within the walls, and land values would have risen. History does not so far relate who the Giangiacomo Acquaroni was who owned the Vigna Falcone at the end of the eighteenth century. But we do know that, no doubt like other landowners on a modest scale, he had used his land as surety for loans and paid some of his taxes in kind to the Basilica of San Giovanni.

There is certainly evidence that the land which Princess Zenaïde Wolkonsky bought in 1830/31 had at least one dwelling of some sort. It may seem unlikely that the same building was already in existence 250 years earlier, but the use of buttresses at the corners of the building Zenaïde converted in the 1830s has been taken by some historians as evidence that the basic structure could be dated to the fifteenth or sixteenth centuries – it could even have been connected with the creation and

Fig. 1.7. Detail of Camocio's map of Rome (1569) showing a structure between the two basilicas, which could have been on the land which is now the Villa Wolkonsky but looks nothing like a church.

Fig. 1.8. Du Pérac's (ed. Lafréry) 1577 map shows several structures on the land now comprising the Villa Wolkonsky, mostly by the aqueduct. The larger structure in the centre at the foot of the ridge was probably buried when the valley was filled in, but there is no reason to identify it as a church (n.b. this view is from the north-east).

maintenance of Sixtus V's new aqueduct. But there is no suggestion in the Deeds of Sale from the early nineteenth century that there was anything more than a cottage of unspecified size. By the eighteenth century maps do show the property as a vineyard (Vigna Falcone) within the same boundaries as in the nineteenth century – but do not show any structures. The best example is G.B. Nolli's map from 1748, a time when major earthworks were filling in the valley between the Basilicas of San Giovanni and Santa Croce in Gerusalemme. A map by Uggeri dated 1800 also shows no structure on the land; but later editions (e.g. 1826) and an 1829 census map (both before the sale to Princess Wolkonsky) do show a structure built onto the aqueduct which is likely to be that mentioned in the early nineteenth-century land registry and the several notarial documents relating to the sale and purchase of the land.[35] However the British archaeologists who supervised the twentieth-century conservation of the aqueduct on the site reported evidence that

a dwelling of sorts was at some time erected against the south side of Pier 20/21 [Fig. 17.1], that is east of the building erected by Princess Zenaïde. A fireplace and flue were cut into the Roman work, and

likewise an oven to the east of it; and joist-holes were to be seen in the brickwork above. This building probably belonged to the seventeenth or eighteenth century, and was demolished when Princess Wolkonsky built her villa. The oven has now been filled up.[36]

The joist-holes were also filled in during the 1959/60 conservation work. It would take much further detailed site investigation to establish a convincing history of the early structures there.

Notes

[1] See Tucci, p. 96, and Schmölder-Veit, p. 3.

[2] A list of relevant Roman emperors is included in Annex V.

[3] Quoted in Baillie Reynolds and Bailey (BR & B), 1966. Their paper on the restoration and conservation, with plans and photographs, was published by the Society of Antiquaries in 1966.

[4] See note 3.

[5] A former air attaché at the British Embassy, who later became head of the RAF Historical Branch, in an essay privately researched, originally as a MA thesis, and produced under the auspices of Royal Holloway College, University of London, in April 2003 – see Bibliography, Madelin.

[6] In any case Nero abandoned his palace project after the fire.

[7] Tucci, p. 96.

[8] There were originally two, for the Marcia and Julia aqueducts, which were re used for the Aqua Claudia spur. Tucci, pp. 119–20, basing himself on new evidence from fragments of the Forma Urbis or Marble Plan, puts forward the possibility that there was a third high-level open tank in addition to the two known *castella* near the temple – relevant to the attempts to work out how the water was subsequently led to the Palatine.

[9] Schmölder-Veit, pp. 4–5, contains an account of these growing pressures on the water supply to the Palatine.

[10] Tucci, p. 111.

[11] Schmölder-Veit, p. 7.

[12] Ward-Perkins, the archaeologist of note who was then Director of the BSR.

[13] For detail see the off-print of the report by Baillie Reynolds and Bailey – note 3 above.

[14] Quoted in Ashby (2), p. 245.

[15] She caused to be done some repair work identified as necessary by the previous owners, mainly to some piers near her new summer house (*casino*) – see Chapter 2.

[16] Colini, pp. 374–93.

[17] NdS 1881, p. 137; 1889, p. 222; 1917, pp. 174, 274.

[18] The Lateran is a complex archaeological treasure-trove, the subject of a large-scale long-term project in which the BSR is much involved, which is intended to improve understanding of the area's history – see https://research.ncl.ac.uk/rometrans/.

[19] Colini, pp. 380–86.

[20] He may also have quartered himself there with them, in preference to the Palatine, possibly in the area now identified as market and bath buildings. Or he may have revived the Sessorian Palace, which his mother later took over, and never finished his own palace.

[21] The only known reference to the *domus Faustae* is as a place where a bishops' conference was held in 313; so whether Fausta ever lived there and for how long is conjecture.

[22] Constantine had shared the imperial role with other members of the tetrarchy from AD 306. From 313 only Licinius remained, and Constantine defeated him in 324.

[23] The lane behind it became in the eighteenth century the access road to properties to the east of the *Scala Santa*, including the Vigna Falcone, the main component of the Villa Wolkonsky, and remained the entrance to the Villa until late in the nineteenth century. The property's entrance was usually recorded as being 'at No 4 behind the Scala Santa'.

24 The biographer, Professor Julia Hillner (Sheffield University), gave a talk to the British School at Rome on 1 July 2020. Her forthcoming biography, entitled *Helena Augusta: An Interrupted Life* (OUP), is expected in 2021/22.

25 These columns were erected to form a replica Roman temple in the garden of the Villa in 1942 – see Chapter 8.

26 Armellini, p. 991, quoted by Huelsen, p. 401, n. 16. Onorius III was pope from 1216 to 1227.

27 *Riv. Ist. Naz. D'Archaeologia e Storia dell'Arte SIII, XIX–XX,* pp. 203–26.

28 Huelsen, p. 401, n. 16.

29 Spagnol. The entry translates as: 'CONTE ROSSO, Via. The oldest hospital. According to Armellini, in the park of the Villa Wolkonsky, near the arches of the aqueduct, there stood until the 16th century a church said to be St Nicolas of the Hospital. As the name suggests it was annexed to a hospital; and it appears that this hospital was the oldest built in the West after the fall of the Roman Empire.'

30 Pietrangeli, p. 427.

31 Reproductions of sections of maps of Rome are, unless otherwise indicated, taken from the collection in the BSR (see also http://www3.iath.virginia.edu/waters/bufalini.html or www.info.roma.it/pianta_di_roma_1551_leonardo_bufalini.asp).

32 See Claridge, p. 193 et seq.

33 Quoted by Claridge, with reproduced photograph (her Fig. 4) of map in G. Corsetti, 'Acquedotti di Roma', 1937, tav. 5, Rete dell'Acquafelice.

34 The pier in question, which Claridge identifies as Pier LIX in Colini's numeration (see Colini op. cit., Tav II) was at the point where the modern access road/driveway passes across the course of the aqueduct (probably that between Bays 4 & 5 in Fig. 17.1, but conceivably that between Bays 5 & 6), and was possibly dismantled at the time it collapsed. A photograph from 1880, reproduced by Claridge, shows the extent of the obstruction within the tunnel.

35 Intriguingly it appears on the south side, at the spot later occupied by the princess's summer house.

36 BR & B, p. 97. These bays are to the east of the location of the princess's summer house. The structure might have been where the Gaffis (with their separate entrance and address) lived while tending the vines, and then been demolished when they no longer rented that vineyard. Or they could be the traces of the illegal structure added by Prince Alexander which he could have pulled down after falling foul of the papal authorities – see Chapter 3.

2.
A VINEYARD TRANSFORMED BY A PRINCESS

An estate takes shape

Most modern writings on the Villa Wolkonsky take as their source or at least starting-point a review of the story as it was then taken to be in a paper written in 1973 by the authoritative and celebrated archaeologist and art historian, Carlo Pietrangeli, later director-general of the monuments, museums and pontifical galleries of the Vatican, 1978–95 – to which reference has already been made. He noted correctly in his paper that little work had been done on the history of the property, and what there had been was 'often confused and contradictory'.[1] Yet he fell straight into the trap of lending his authority to one 'presumably' correct version of the story of its acquisition by Princess Zenaïde Wolkonsky: that the 'heirs of Acquaroni' sold the property to Prince Alexander Beloselsky-Belozersky, who gave it to his daughter.[2] That account was wrong on at least three counts, as a glance at her Deed of Purchase would have made clear.

Pietrangeli was right to record that the early nineteenth-century Land Registry showed the property as owned by the heirs of the late Giangiacomo Acquaroni and that it was described as an 'orto, casaleno e annessi' (market garden or vineyard, cottage and outhouses): in other words there were structures there, including some sort of dwelling.[3] The accompanying map is reproduced at Plate 2. The extent of the property at various phases is better seen on a sketch map, such as Plate 3. While we do not know who the said Acquaroni was, we do know that the heirs, Maria Teresa Acquaroni (Giangiacomo's daughter) and her husband Tommaso Panzieri, bought the property on 12 February 1816, and Panzieri had assumed responsibility for various obligations (donazioni, dues) to local parishes, with which the property was burdened. From there the record diverges from the version cited by Pietrangeli.

On taking possession in 1816 the new owners found that, five years earlier, in 1811, a nine-year lease had been granted on the land to Angelo and Luigi Gaffi (presumably the occupants of the cottage). Acquaroni and Panzieri evidently regarded it as an investment rather than somewhere to live or even cultivate themselves: in 1820 they renewed the lease to the Gaffis for a further 18 years – to 31 March 1838 – for 110 Scudi and three and a half barrels of wine a year, with Acquaroni and Panzieri continuing to pay the various dues.[4] But their tenants did not pay up regularly, claiming that the income from the land was insufficient, so they decided to sell. When they sold the property it was not in 1830 to the princess but on 15 September 1823 to the Marchese Carlo Massimo.[5] The contract was for the sale of an 'orto casaleno', on the via di Santa Croce 'dietro a Sancto Sanctorum' – behind the holy of holies, i.e. Helena's Scala Santa. The price paid by Carlo Massimo was 2,000 Scudi.

The new ownership – Massimo, resident at via di San Pantaleo 18, Rome (not far from the Gesù church) – was registered in the Catasto (Land Registry) on 13 January 1824.[6] The property was assigned a more specific address, via di Santa Croce 20, and defined in the register by the numbers 269 for the land and 270 for the house with courtyard (Plate 3).[7]

The taxable value was given as 2,214 Scudi on the basis of area measured in tavole – 1 tav = 38 sq. m:

	Area	Scudi
269 – garden first part (north of aqueduct)	24.73 tav	1323.55
269 – garden second part (south of aqueduct)	17.77 tav	868.60
270 – *caseggiato* (buildings)	0.41 tav	21.94
Total		2214.09

These figures suggest that any dwelling was very modest. The contract of sale incorporated as an addendum an earlier document of 1 July 1823 in which Luigi Gaffi (was Angelo by then dead?) renounced his right of *prelazione*, i.e. his right as a sitting tenant to buy the land; for which the Marchese agreed to pay him a separate sum of 2,000 Scudi (spread over 39 years), while in the meantime lending the same sum to Maria Teresa Acquaroni through her husband; for which the couple renounced their right to income from the land. One can only speculate that nineteenth-century tax law in the Papal States was as complex as modern taxes in Europe – and that lawyers did very well out of the legal gyrations needed to arrange one's affairs, in this case to reduce death duties on the value of the land in the event of Don Carlo's death, as became clear from the contract drawn up when Princess Zenaïde Wolkonsky stepped into the story.

Zenaïde did not, however, buy from Marchese Carlo Massimo, for he died in January 1827. The property passed to his brother, Prince Don Camillo Massimo, as *usufruttuario* (beneficiary of the income), and Camillo's son, Monsignor Don Franco Massimo, as owner, both residing at the Palazzo Massimo in via di San Pantaleo. The June 1831 contract of sale to the princess showed that Carlo's precautionary loan to Acquaroni had been a wise move, the amount of the loan being subtracted from the declared value of the property.

The contract gave further detail of the location and boundaries of the property. The addresses were: for the market garden, via Labicana 4 (a street later realigned and renamed via Statilia), and for the cottage, via Santa Croce 20 (i.e. at the eastern end of the property), a distinction which might have been intended to ensure the Gaffis did not use the same entrance as the new owners. The main entrance was later moved to the lane behind the *Scala Santa* off what is now via Amedeo VIII, roughly at the point where that street is now blocked off some 70 m from the main via Emanuele Filiberto – which, however, did not exist at the time. It remained there until 1889, when the current entrance on via Ludovico di Savoia/via Conte Rosso was created.

The boundaries were listed as a) the *orto* of Giovanni Battista Sterbinetti (273 on the *Catasto* map, see Plate 3), the land of the parish priests of Santa Maria in Campitelli (267) and the via Labicana. The charges payable to church institutions, including the great basilica nearby, were:

	Scudi
Chapter of San Giovanni in Laterano	7.97 ½
Chierici Beneficenti of Santa Maria Maggiore	1.90
The Certosa	0.75
Total	10.62 ½

Zenaïde agreed to take on half the outstanding loan (by then 890 Scudi) to Acquaroni, the Massimo heirs retaining the other half. (This loan comes back into the picture later in the story.) She also took over the right to receive rent (now 125 Scudi plus the wine) from the Gaffis, though their reliability did not seem to have improved. And provision was made for her to take a water supply for the house she was (already) building. The Gaffis clearly had the right to remain, whatever the new owner's

plans for the property. (History does not relate what happened to the Gaffis or their vineyard, including whether their lease was renewed in 1838. But someone was tending vines at least until the end of the century, as photographs from that time show that vineyards still formed part of the vista southwards from the Villa.) Zenaïde paid 2,890.31 Scudi for the property and an extra 150 Scudi for the water supply. The Massimos retained the right to inspect the 'conduit of the Villa San Giovanni, which passes alongside the ancient aqueduct'.[8]

Although the sale to Princess Zenaïde Wolkonsky was agreed in 1830, it was not notarised until 11 June 1831.[9] But even then it could not be instantly completed. Camillo Massimo had forgotten to get the property and the debt transferred to his son Franco's name when his brother Carlo died; he was given six months to do so. So the *Catasto* entry of 17 September 1831 was not formally registered until 1832.[10]

That Land Registry document may well have been the source of one of the most durable myths which embellish writings about the princess's acquisition of the property: that it was bought for her by her father, Prince Alexander Beloselsky-Belozersky. His name does appear, but only in order to identify the princess as the daughter of the prince. In all notarial documents of the time parties to a contract are identified in this way, viz. '*Wolkonsky Principessa Zenaïde della Ch. Me. Pr.pe Beloselsky Alessandro*', where the abbreviation 'Ch. Me.' stands for 'Chiara Memoria', indicating that a person is dead. Her father had died 21 years earlier, in 1809, and neither this nor the contract of sale nor any other related document contains any suggestion that anyone other than Zenaïde paid for the property (though she may have inherited much of her wealth from her father in the first place). The first (maybe only) person to look into the documents before relating the story of its acquisition perhaps read them rather hurriedly, and thus started a false stone rolling, which has gathered much moss.

The odyssey of a Russian princess

Who was this exotic Russian princess who suddenly acquired a well-positioned vineyard in the Roman near-*campagna*? Her multi-faceted story has intrigued writers, travellers, students of European history and others since her youth. This short account of her long and complex road to Rome and the world she brought with her cannot do her full justice. The full tale is told in Maria Fairweather's comprehensive biography;[11] and some useful additional information and interpretation is assembled in a doctoral thesis by Marta Valeri in 2015.[12]

Zenaïde Alexandrovna was born in Dresden on 3 December **1789**[*].[13] Her father, Prince Alexander Mikhailovich Beloselsky-Belozersky (Plate 18), was at the time Catherine the Great's envoy to Saxony. Of a distinguished family, close to the Tsar's court, he was greatly respected as a man of intellect and culture. Some writers, including Pietrangeli, state that Zenaïde was born in Turin. Her father had indeed been assigned in 1789 to lead the Russian diplomatic mission there, but for health and other reasons he delayed his move from Dresden. The delay was probably prolonged by the fourth pregnancy of his wife, Barbara Jakovlevna Tatischev, who then died in **1792** not long after the birth of Zenaïde's younger sister, Natalia, in 1791. He also seems to have indulged in a spot of touring with friends before reaching Turin in the same year. But the family's stay lasted little more than a year, before they returned to St Petersburg.

[*] Bold dates mark the first mention of a new year, to help readers locate easily which year is under discussion.

PLATES SECTION I

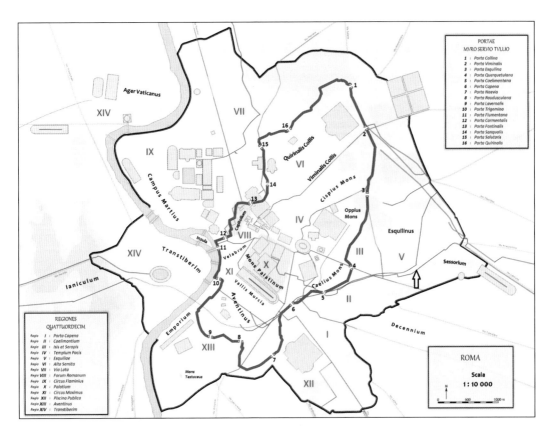

Plate 1. Outline map showing Republican (red) and Antonine (black) walls of Rome, the Seven Hills and the principal aqueducts (blue). The Villa Wolkonsky lies towards the eastern end of the Caelian ridge (arrowed).

Plate 2. Sheet 15 of the Rome Land Registry map of 1816–21. While the property numbers are barely legible, most of the land bought by Princess Zenaïde Wolkonsky is traceable (top-right quadrant, where the pattern representing vegetation is laid parallel/perpendicular to the aqueduct).

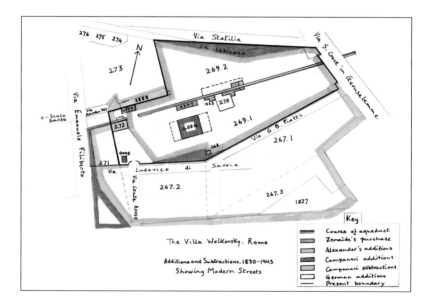

Plate 3. Author's diagram of the Villa, showing the different parcels of land and structures (and their numbers) during the ownership of Princess Zenaïde Wolkonsky from 1830/31, her son, Alexander, her granddaughter, Nadeïde (when the new street layout was introduced), and the German Embassy.

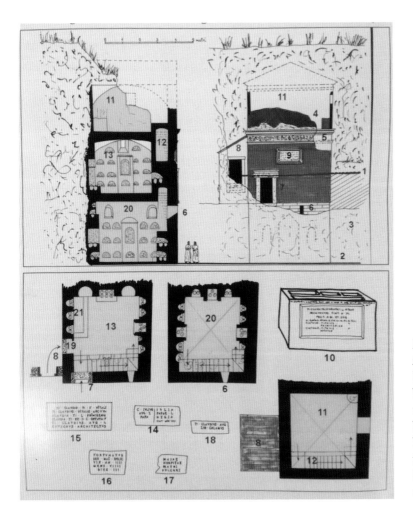

Plate 4. An archaeologist's sketch plan of the colombario of Tiberius Claudius Vitalis discovered and excavated in the grounds of the Villa in 1866. (In papers in Villa Wolkonsky; it appears to be adapted from a plan by Colini in turn based on work by Gismondi.)

Plate 5. A sketch map made by the Rome City offices in 1884 depicting the areas the city needed to acquire from the Campanari-Wolkonskys (yellow) to accommodate their road-building plans and (in red) the areas fronting on via Emanuele Filiberto the family were to get in exchange.

Plate 6. The 1942 plans to expropriate land for the new Chancery building discussed in late 1942 with the Rome Governorato.

Plate 7. Mertz's plan of the added office accommodation built on the second-floor roof terrace of the Chancery in 1943.

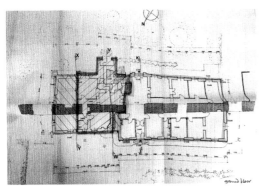
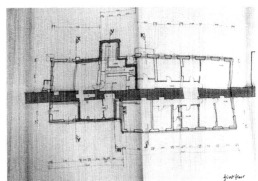

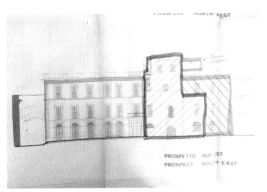
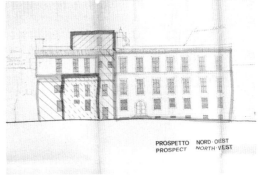

Plate 8. The author's attempt, using the architects' drawings for the conversion of the old chancery, to show the various phases of the development of the original casino, now in use as embassy staff accommodation.

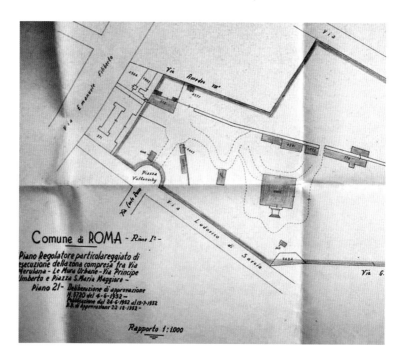

Plate 9. Partial excerpt from the 1932 Rome City Plan showing the German-owned property's boundary and Land Registry numbers.

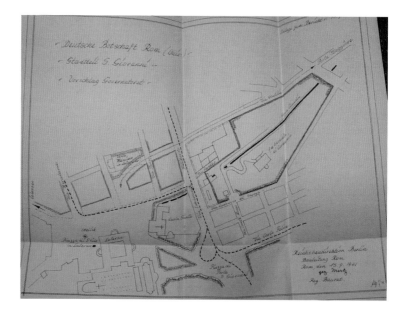

Plate 10. Mertz's new Chancery proposal on 15 September 1941 accepted by the City authorities. The dotted red line shows the land to be expropriated.

Plate 11. Sketch plan, dated 18 May 1939 and signed by Mertz in Berlin, of the extension of the German Ambassador's Residence at the Villa Wolkonsky, showing also the newly extended offices (top right).

Plate 12. The design of the marble entrance-hall floor installed in 1943 by the Medici firm.

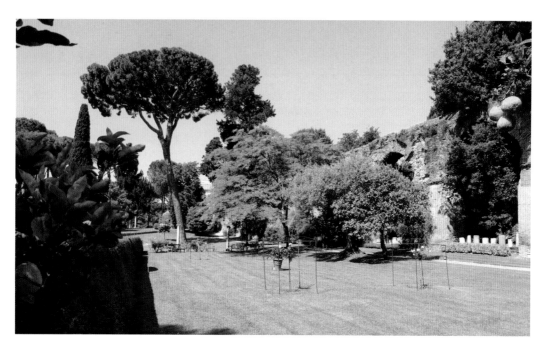

Plate 13. The Neronian aqueduct in its modern role as archaeological monument and dominant garden feature.

Plate 14. Zenaïde Wolkonsky by J.D. Muneret, 1814.

Plate 15. Portrait of Zenaïde Wolkonsky by Benvenuti, 1815.

Plate 16. Zenaïde Wolkonsky as Tancredi, by Fyodor Bruni, 1821(?).

Plate 17. Portrait of Zenaïde Wolkonsky by Rossignol, 1831, bought by a London bank, given to the Moscow Museum of Literature.

Plate 18. Prince Alexander Beloselsky-Belozersky, diplomat and man of letters, portrait by Anton Graaf, c.1790.

Plate 19. Prince Nikita Wolkonsky, who married Princess Zenaïde Beloselsky-Belozersky in 1811, aide-de-camp to Tsar Alexander I, in due course reached rank of major-general.

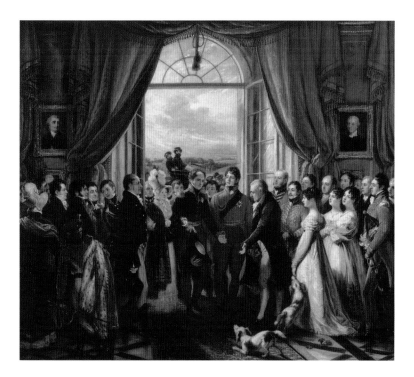

Plate 20. Petworth, England, June 1814: The Prince Regent (in red jacket), Tsar Alexander (to his right), Grand Duchess Catherine, and the King of Prussia (in black jacket) with Lord Egremont (owner of Petworth) and his daughters. Princess Wolkonsky is at far left wearing the large hat.

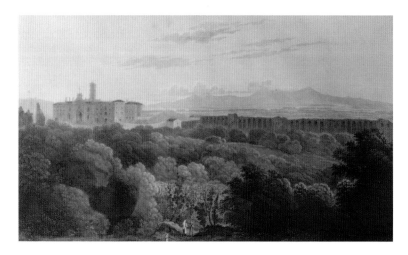

Plate 21. Miss E.F. Batty's painting (1819) of the view from where the Villa Wolkonsky now stands, showing the view of the Basilica of Santa Croce in Gerusalemme, the Aurelian Wall and the Alban Hills beyond.

Plate 22. Pushkin and friends listen to Mickiewicz in the salon of Princess Zenaïde Wolkonsky in Moscow, painted by Grigoriy Myasoyedov. Zenaïde is in the big white hat facing the painter.

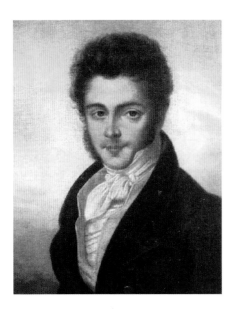

Plate 23. Count Miniato Ricci, unknown artist.

Plate 24. The Italian Embassy in Berlin, built 1938–41, restored 1997, as it is in the twenty-first century.

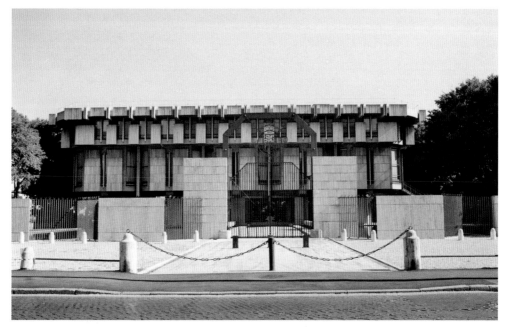

Plate 25. Sir Basil Spence's 1971 Chancery building for the Rome Embassy.

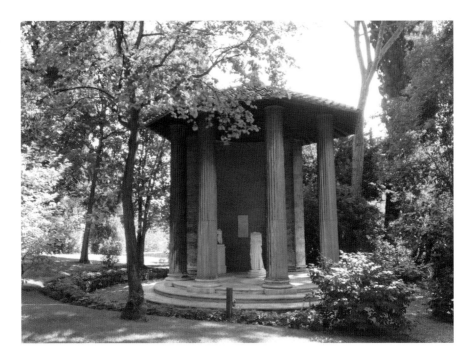

Plate 26. *The tempietto erected in the garden of the Villa Wolkonsky.*

Plate 27. *The second-century BC Temple of Hercules Victor in the Forum Boarium in Rome, a possible model for the tempietto erected in the Villa Wolkonsky in 1942.*

Plate 28. The fragment of pillar excavated in 1942, at the same time as the pillars now forming the tempietto.

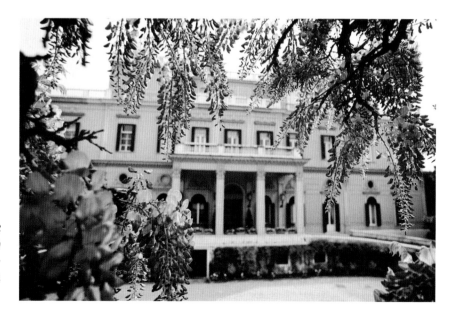

Plate 29. The main entrance to the Villa Wolkonsky Residence in 2000.

Plate 30. Julian Karczewski, The Casino at the Villa Wolkonsky, *watercolour on card, 1831. The earliest extant image of the casino, seen from the north-west.*

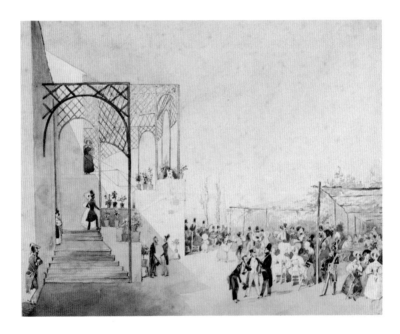

Plate 31. A Summer Reception at Villa Wolkonsky, *watercolour by unknown painter, 1834. This view looks north-east.*

With her father's encouragement and guidance, Zenaïde grew to be a highly educated (mainly in French), talented and by all accounts attractive young adult, gifted in recitation and above all singing. She attracted the attention of Tsar Alexander I's highly influential mother, Dowager Empress Maria Feodorovna, who in **1808** appointed her and her older sister Maria as ladies-in-waiting.[14] The sisters were assigned to look after Queen Louise of Prussia, a refugee after the Battle of Jena in 1806. This formidable lady, educated, refined and determined, had won the hearts and loyalty of the Prussian people for standing up to Napoleon. She evidently broadened Zenaïde's horizons, not least in teaching her that a woman could be a source of wise political advice to a man. At court Zenaïde soon attracted the Tsar's attention, to an extent that became obvious to all at a ball to celebrate the marriage of the Grand Duchess Catherine to the Duke of Oldenburg in **1809**. Their relationship grew stronger after Zenaïde's beloved father's sudden death of a stroke on 26 December that year. She found in the Tsar more than a substitute father-figure. When Alexander grew tired of his current mistresses, Zenaïde, unabashed by his status and able to engage him with her wit and talent, became a close confidante.

Alexander, initially focused on internal reforms, had at the outset of his reign abandoned the alliance with France (which had placed him in opposition to Britain). But he developed an admiration for what Napoleon was doing for France, which had an echo in some of the changes he was contemplating for Russia. French influence and presence in St Petersburg, especially at court, grew. French, in which Zenaïde was fluent, thanks to her father, was the language of the court and of fashionable St Petersburg society. And Alexander, not unwillingly, found himself increasingly sucked into European diplomacy and warfare. Napoleon, victorious at Austerlitz in 1805 and at Jena in 1806, routed the Russian army at Friedland in June 1807 and quickly exploited the chance to detach Alexander from the anti-French alliance. The two emperors concluded at Tilsit an entente mainly in the form of a trade blockade against Britain (but also for the time being confirmed the subjugation of Prussia). As the agreement was believed also to require Denmark to hand over control of its fleet to the French, the British tried and failed to persuade Denmark to breach its neutrality and declare for Britain. The British Navy then famously (or infamously) took forestalling action in August, setting Copenhagen ablaze and capturing the Danish fleet. This led to a formal Russian break with Britain and in effect a war which lasted until 1812, but consisted of only occasional naval skirmishes against British ships, mainly in the Baltic. The Tilsit agreement itself did not last long, but the Tsar's admiration for Napoleon endured for some time, even though Alexander began to view the Frenchman's intentions, especially over Poland, with growing cynicism.

In the maelstrom of foreign and Russian figures at court Zenaïde thrived and acquired influence of her own from her known closeness to the Tsar. But after her father's death, the Dowager Empress (who retained the position of 'First Lady' in the hierarchy even after her son and his wife Elizabeth acceded) sensed that Alexander's attachment to a 'vulnerable', orphaned and single girl of good family would create scandal. She therefore advised that Zenaïde marry – and that was the sort of advice that people followed.

So, on 3 February **1811** Zenaïde dutifully (but without enthusiasm) married 30-year-old Prince Nikita Grigorevich Wolkonsky, an aide-de-camp to the Tsar, and master of the Imperial Hunt, also of a distinguished family (claiming origins back to Sviatoslav II, Grand Prince of Kiev in 1076). The Tsar had four Wolkonsky princes as aides-de-camp simultaneously, of whom Nikita was far from being the brightest and best, or even the most senior: best known as a successful philanderer, he was also clearly a useful 'fixer' for his master (Plate 19). Zenaïde was a young lady of great artistic talent and un-conventional ways, a singer and writer (mainly in French until 1825). She did not find her marriage to the errant Nikita satisfying, and over the years they often went their separate ways for long periods,

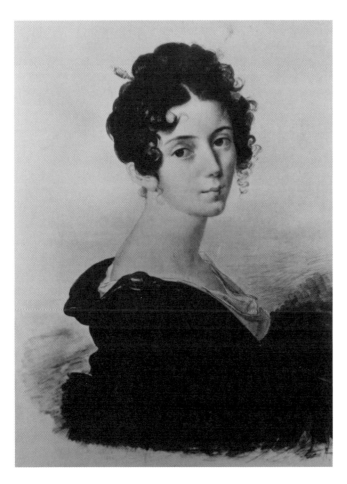

Fig. 2.1. Portrait of Zenaïde Wolkonsky by an unknown artist, probably around 1820.

without leaving the court environment. Zenaïde, too, apart from her long relationship with Tsar Alexander, was later known to have had other lovers, whom she did not cast off but retained as close friends. This glittering existence was not without its dark side. Her way of life generated much gossip among the idle at court. She was often subject to long bouts of depression, which seemed to bring out a latent religious fervour, but she managed to recover from the bouts of depression and ride out the gossip and scandal-mongering of the court, on the strength of her recognised talents and, no doubt, the Tsar's known affection and respect for her.

In 1810, as Napoleon lost prestige through his repeated failures to defeat the British in the Iberian Peninsula, the Tsar reneged on his Tilsit entente with Napoleon, withdrew from the 'Continental System' and restored the right to trade with Britain (having not enforced the blockade for some time). In late 1811 Napoleon, by way of retribution for that humiliation, launched his ill-fated invasion of Russia, leading a force of 600,000 men to disaster. At just that moment, on 11 November 1811, Zenaïde's son, Alexander (named after her father, not the Tsar, we may suppose) was born.[15] Her husband was constantly on the move as the French forces advanced into Russia – and then retreated. The Tsar joined his army for a time, harrying the retreating French in the frozen vastness of western Russia. Napoleon left the remnants of his invasion force to fend for themselves, with their way home blocked by the Prussians, and sped home to Paris in December 1812.

In spite of the disaster, Napoleon's support was such that he was able quickly to build a new army of some 350,000 men, which he led east into the field. The anti-revolutionary alliance of Russia, Prussia, Austria and Britain saw their opportunity. Tsar Alexander led his army in person, with a headquarters at Töplitz in Bohemia (now Teplice), where the three monarchs signed a Treaty of Alliance. As the run of war improved, the Tsar invited wives to join their husbands at court. In the spring of 1813 Napoleon enjoyed a brief winning streak, and the wives were sent off to Prague. But the Allies changed tactics and turned the tide; the wives joined their menfolk again in south-west Germany as the march on Paris

became imminent. In recognition of Alexander's role a British delegation from the Prince Regent located him at Töplitz and presented him with the insignia of a Knight of the Garter on 27 September. In October the allies, under Alexander's overall leadership, were able to confront and roundly defeat Napoleon at Leipzig. (The campaign took the Russian armies all over central Europe: the author, while walking in the Black Forest, quite by accident stumbled upon a touching memorial to the Russian soldiers who lost their lives a little later in this 'liberation' campaign – see Fig. 2.2).

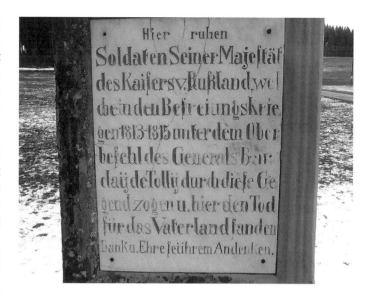

Fig. 2.2. A monument in the Black Forest, south-west Germany, to Russian soldiers who lost their lives in the long campaign to defeat Napoleon, which brought a Russian army deep into Western Europe.

The Tsar, scenting the chance to occupy Paris, led the Allies' combined force of 300,000 men into France in January 1814. He insisted they make for Paris, and the Allied force arrived at the walls just a day before Napoleon. After brief resistance by the few National Guard units left in the city, Paris surrendered on 30 March. Alexander and the (restored) King of Prussia entered the city the next day – revelling in their humiliation of Napoleon, who had to set up his base at Fontainebleau. The Tsar established himself in Talleyrand's house in Paris (Talleyrand having abandoned Napoleon and mounted a coup against him the day before the Tsar arrived). This total victory was a high point for Alexander, who proceeded to rule his empire from Paris for some months, surrounded by his court. Napoleon's backing at home, even among his faithful marshals, evaporated: he was forced to abdicate with the consolation of the 'sovereignty' of Elba, to which he was shipped.

Zenaïde's position at court meant that she found herself, with her baby son and her sister-in-law Sophia, moving in the Tsar's (and their husbands') wake not just to Bohemia and Paris, but to London, Vienna and other cities, as the Napoleonic adventure drew to a close, with Tsar Alexander playing a major role. Nikita and others of the Tsar's staff were sent on to London in the spring to prepare a visit the Tsar intended to make as part of the celebrations of victory over Napoleon. The Tsar's sister, Grand Duchess Catherine, was already settled there as an advance guard, and kept up pressure on the Tsar to make the trip. This he did, accompanied by the King of Prussia, for three weeks in June, to great popular acclamation. But he misjudged his approach to the Prince Regent (reflecting his sister Catherine's scathing opinion of him) so the political benefit of the visit was slight or even negative, seriously affecting the atmosphere at the subsequent Congress of Vienna.[16] In spite of that, the tour, which included Oxford and two weeks in London, was a PR triumph. After the finale, reviewing the fleet at Portsmouth, the sovereigns' last stop before setting sail from Dover on 27 June was at Petworth, where they overnighted on 25 June. Zenaïde and Nikita preceded them, and her presence is recorded in a painting of the sovereigns' formal

reception by the Prince Regent and their host, Lord Egremont, which hangs there still – as a sort of 'group photograph' (Plate 20). The contemporary list of those pictured includes Princess Zenaïde Wolkonsky – though, perhaps because of her somewhat ambiguous role or her (three months) pregnant condition, she appears only in back view, but wearing a remarkable hat.[17] From today's perspective it is odd to realise that just over two hundred years ago Britain played host to a victorious Russian Tsar with a large army camped just across the Channel, with whom the country had been at war only a year or two earlier.

The Tsar left for Holland, where he was much feted, visited Waterloo and then Karlsruhe, where his wife Elizabeth had been staying for the last two years with her family, before heading for home in St Petersburg. By November he was off again, this time to the Congress of Vienna. Zenaïde however returned with Nikita for the summer to London, where they had taken a house. One morning Zenaïde, in an act of instinctive kindness, took in a baby left on their doorstep, whom she must have assumed to have been the result of one of Nikita's flings. With extraordinary generosity and tolerance (of Nikita) she treated the baby as her own son, naming him Vladimir Pavey (or Pavé, as in pavement), having him baptised into the Orthodox faith in London, and educating him alongside her own Alexander. Neither Zenaïde nor the family appear to have referred to the child in any (surviving) correspondence, but they remained close, and Pavey successfully undertook delicate tasks on behalf of the family, both during Zenaïde's life and subsequently for Alexander. (He does however feature in one family photograph – Fig. 3.3). Like Zenaïde, Vladimir later converted to Catholicism in Rome and at some point was appointed to the honorary papal office of *Cameriere d'Onore di Spada e Cappa Supernumerario* (Supernumerary Chamberlain of Honour of the Sword and Helmet).[18] Alexander, on the other hand, never did convert, as that would have been incompatible with his position as a senior imperial diplomat.

Now more heavily pregnant and travelling slowly, via a week in Paris, Zenaïde re-joined the court in Vienna for the duration of the Congress. She planned then to return to St Petersburg with her growing family. In spite of her pregnancy (which by some reports she masked by using tight corsets) Zenaïde quickly resumed her role as a focus for social and intellectual activity among the assembled delegates as they waited for the delayed Congress to start. Her second son was born in December 1814, perhaps named Grigori.[19] But he died a few days after his birth. Zenaïde saw his weakness and death as punishment for her unremitting political and social lifestyle – and the corsets.[20] The weight of Zenaïde's parental affection was to rest entirely on her one son, Alexander.

Feeling guilty and depressed after her infant's death, Zenaïde suddenly changed her plans. On the recommendation of Cardinal Consalvi, who led the papal delegation at the Congress, she made her first visit to Rome. This was the start of nearly a decade or more of restless wandering, much of it spent in Rome, often dominated by her quest for some form of spiritual fulfilment which she felt the Orthodox faith could not provide. The trip (accompanied by her sister-in-law, Sophia, and escorted by Nikita) was delayed until after Easter **1815** by the news of Napoleon's escape from Elba, which kept the delegates in Vienna. Renewed campaigning forced Nikita and Sophia to return north of the Alps, but Zenaïde was determined not to leave Rome so soon and stayed for three months. She made friends quickly, especially in the musical world, including with the young Gioachino Rossini, and a young Italian artist and tenor, Michelangelo Barbieri.

After the Battle of Waterloo Zenaïde re-joined the court in Paris (and later went home to Russia), taking Barbieri with her as secretary and to teach Alexander Italian. In Paris she performed in a private performance of Rossini's *L'Italiana in Algeri* (The Italian Girl in Algiers), bringing Rossini's music to a French audience for the first time, and sang frequently with Barbieri. She did not however mix as wholeheartedly as before with the court. This may have had something to do with her growing interest in the Catholic Church, but she could simply have been put out by the dominance of the court's social life by

Fig. 2.3. The view (in 2018, now partly obscured by trees) from the top of Mont Aimé, from which the Tsar and the King of Prussia, with their courts, watched the 1815 review of the Allied armies after their defeat of Napoleon and capture of Paris – which Princess Wolkonsky attended.

one Madame de Krüdener, a 'spiritual adviser' to the Tsar. Instead she threw herself into the artistic and intellectual life of the city, singing and performing; and she took a strong interest in some of the injustices stirred up by the rivalries in France and with the allies. In one such affair she greatly displeased the Tsar by pleading the cause of the condemned Comte de la Bédoyère, who had misguidedly sided with Napoleon when he escaped from Elba, breaking his oath of loyalty to the new King of France. She did however accompany the Tsar when he and the King of Prussia presided over a massive allied victory review at Mont Aimé near Vertus, east of Paris, on 10 September 1815 (Fig. 2.3). One hundred and fifty thousand men paraded and exercised before the Tsar and his guests.

After a second – but brief – visit to Rome (with Barbieri) Zenaïde returned to Russia in the spring of **1817**, first to St Petersburg and Tallinn, then along with the court to Moscow for the dedication of the new cathedral. She remained then in Moscow, living in the family mansion, which Barbieri helped to redecorate. With Nikita away in London on the Tsar's business, Barbieri became inevitably a source of gossip, scandal and reproof. But that did not keep the Tsar from calling to see her on 8 October.

Tired by the winter and the gossip she went to Odessa, partly to consult a French Jesuit abbot Nicole noted for his ideas about education. He drew up a programme of 12 years of study for her son Alexander, then eight years old, starting the following year, which Zenaïde would supervise herself. Vladimir Pavey was to share in the programme. It involved studying classical languages and texts, modern languages, especially Russian and French, as well as (to a lesser extent) Italian, English and German, and various sciences. Inevitably she drew around her a lively artistic and liberal circle; even the Tsar dropped in on his first ever visit to Odessa. In early **1819** she returned to St Petersburg to concentrate on her literary activities (Nikita was away buying thoroughbred horses for the Tsar); she published her *Quatre nouvelles*, exotic tales written in French, one of which was clearly autobiographical in its description of a girl who married young in high society and, becoming bored with its emptiness, set off on her travels.[21] In the

autumn she headed west once more towards Europe, spending the winter with friends in Warsaw (which the Tsar was also visiting). An old friend, the 'Poet Prince' Peter Viazemsky, was living there and introduced her to all the key literary and artistic personalities, as a result of which she enjoyed her stay. But Warsaw's winter freeze drove her on in February **1820** for her third visit to Italy.[22]

Zenaïde had clearly intended to travel on to Rome in due course: she had sent a maid there in advance even before she left Odessa. Her first brief stop was Milan where Rossini was living. There she met Stendhal, who took an immediate liking to her, writing in a letter to a friend an admirable and frank pen-picture:

> Madame Volkonsky is quite a remarkable woman, utterly unaffected, who sings contralto like an angel. She is herself bringing up her son, whom she adores; she writes passable French and has recently published novels. She is thirty-two, ugly, but with a pleasant kind of ugliness, and she composes lovely music. She is charming and mad beneath the mask.[23]

She was indeed schooling Alexander all the while, though not, apparently, in the organised way recommended by the Jesuit abbot. She placed much emphasis on ensuring that, unlike herself, Alexander was brought up to write Russian and to know and love his country. They went on to Naples in March and reached Rome in May, with no fixed idea about how long they might remain. A lively salon of Russian artists and students quickly grew around Zenaïde, attracting leading Italian artistic and aristocratic figures as well. She had also been accompanied from Russia by the painter Fyodor Bruni, who reportedly lived in her house. The circle included the painters Bruilov and Shchedrin and the sculptor Galberg, who wrote of being enchanted by her eyes. The soirées developed into performances of plays and operas. Barbieri was in attendance and designed costumes and sets.

Nikita, after an 18-month separation on the Tsar's business in London, caught up with his wife and son, and harmony seemed to prevail. Early **1821** found the Wolkonskys playing host to an English writer and traveller, whom Nikita had met while in London, Mary Berry.[24] She attended two of Zenaïde's soirées in the new year, on 6 and 9 January, plus several more in the coming weeks, and wrote of her hostess in terms remarkably similar to Stendhal – though without reference to Zenaïde's disfigurement. The second evening was for a performance of *Tancredi*, which Miss Berry evidently enjoyed, admiring Zenaïde's talents, both acting and singing. That year Zenaïde joined the Accademia Filarmonica and studied singing and composition, writing an opera, *Gianna d'Arco* (Joan of Arc), initially for performance in her private theatre with her in the title role, but it was later published. She was noted too for her performances there not only as Rossini's *Tancredi* (as Bruni painted her; see Plate 16) but also *L'Italiana in Algeri*. Her friendship with Cardinal Consalvi, now Secretary of State of the Vatican and the Papal States, deepened. He was a frequent guest at her house. He became a father-figure, ready to enjoy her music, and to interest himself in her affairs and the welfare of her son. No doubt he had in mind the possibility of her conversion to Catholicism.

Eighteen twenty-one was a year of rebellion and disturbance in Europe. Austrian soldiers marched through Rome at Carnival time (observed by Mary Berry) on their way to quell a revolt against the Bourbons in Naples; while a Russian (an aide-de-camp to the Tsar) led a group of rebellious Greeks calling for independence from the Ottomans, placing the Tsar in a quandary as the Austrians and British offered conflicting advice. British and Russian popular opinion was strongly pro-Greek – with Byron and others flocking to the cause – but for the Tsar and Europe's statesmen things were more complex. Alexander had ambitions in relation to the Persian and Turkish empires, as well as in Spain, where civil war had broken out.

In 1822 Tsar Alexander promoted the convening of yet another congress, this time in Verona, to deal with both Spain and the East. In October he summoned Zenaïde to join him there. She was quickly the talk of the town. As usual, friends and even representatives of other participant states, especially France, frequently sought to engineer an approach through her to the Tsar (whose demands were considered generally unreasonable). Even as he sensed that he was not getting his way, she still staged gatherings for him which managed to cheer him up. And she enjoyed herself among so many friends and influence-seekers. But the Congress broke up in failure in December, and the system of congresses came apart. The Tsar returned to St Petersburg, disappointed and depressed. It proved to have been his last journey to Western Europe.[25] After a parting meeting with the Tsar, at which she had pleaded the cause of various friends and relations affected

Fig. 2.4. One of the urns given to Princess Wolkonsky by Cardinal Consalvi, inscribed to her, as it stands (in 2019) in the garden of the Villa Wolkonsky.

by his increasingly repressive behaviour, Zenaïde went back to Rome. There she was joined early in 1823 by her sister Maria (often referred to as Madeleine) with her husband, Prince Alexander Sergeyevich Vlasov, who unexpectedly died. Barbieri was on hand to organise the funeral. Afterwards Madeleine went to live with Zenaïde and never left her, acting for the rest of her life as housekeeper and companion, and converting to Catholicism.[26]

During this time Zenaïde's friendship with Consalvi continued to flourish. He presented her with two enormous Roman urns (still in the garden at the Villa Wolkonsky: see Fig. 2.4), as an expression of his hope that she would return to settle in Rome – where he presciently reckoned she would have a garden, he himself being a passionate gardener. For all his wisdom and statesmanship his friends loved him for his kindness. The memory of that may have helped to bring Zenaïde in due course to Catholicism. In the summer of 1823, for some reason depressed and restless, she left Rome for Paris, where she continued work on her new interest in Slav history, acknowledging her over-concentration on matters French. Her salon in Paris sprang back into life, and she regained her vivacity. In an emotional correspondence with Consalvi the latter was devastated to learn that she would spend the winter in Paris, fearing he would not live to see her return. Zenaïde promised that she would return to Rome permanently, but Consalvi did indeed not live to see that: he died in January 1824, shortly after

the election of Pope Leo XII, no friend of his. Shortly afterwards she published anonymously and to wide acclaim in Paris her fictional *Tableau slave du cinquième siècle*, written in French. She remained in Paris until June 1824 when she bowed to the Tsar's wishes and returned, via Vienna, to Russia.

The Tsar welcomed her with warmth and affection. But, as Maria Fairweather observed, their roles were now reversed. Fifteen years earlier he had lent strength to a young woman struggling to find a way through unhappiness and depression at court; now she, a successful woman of the world, was able to encourage an ageing, disappointed and guilt-ridden monarch, increasingly lonely and autocratic. After a disastrous flood in St Petersburg in November, which the Tsar saw as punishment for his sins, she moved to her family residence in Moscow, the Beloselsky-Belozersky Palace, parts of which Barbieri had been busy redesigning and decorating. Moscow was the centre of artistic and intellectual activity, and her salon once again quickly became a focus for the intelligentsia and the literati, including many from Moscow University – those whose ideas would later have been sat on by the repressive regime of Tsar Alexander's successor, Nicholas, were they to be publicly expressed. Questions of Russian identity and culture and the artist's role in society as the keeper and discoverer of national identity dominated debate among a group of elite intelligentsia who found themselves increasingly alienated from the repressive authoritarianism of the dying Alexander and the new Nicholas and yet out of touch with the mass of the people. 'Literature became the only medium for the free expression of philosophical or political opinion.'[27]

Zenaïde, whose reputation as a writer had been limited to her novellas in French, had made a sustained and serious effort not only to master her own nation's language but also to study Russia's history and folklore under the Swiss historian Baron André Mérian. She was now able to add Russian literary skills to her other talents. Her *Tableau slave* was published in Russian and won critical recognition in an atmosphere where the nature of Russian identity was a hot topic. That led to her election in late 1825 as an honorary member of the Society of History and Russian Antiquities. Her *Letters from Italy* were also published in her own translation (to rather less acclaim). Among those who encouraged her most fervently on this path were Professor Stepan Shevyrev (a leading Slavophile, seated slightly in the background to Zenaïde's right in Plate 22) and her old friend Prince Viazemsky. Here she was in full bloom, not only a hostess of charm and generosity, but a participant in discussion and writing, as well as a singer and performer.

A list of the habitués of Zenaïde's salon reads like a who's who of the Russian intelligentsia of the time. Many of them were or became firm friends. Nearly all would in a later context have been thought of as left-wing anti-monarchists, though many coupled their liberalism with a strong sense of Russian nationalism and cultural identity.[28] They would have been less radical had Tsar Alexander not strayed from an idealistic, even democratic approach to an increasingly repressive conservatism, capped in severity only by his successor, Nicholas.

At Easter-time 1825 Zenaïde paid a short visit to St Petersburg, during which, on Easter Day the Tsar came to call on what would be the last time they would meet. Back in Moscow, she resisted pressure to make yet another journey to Paris, sensing that the situation in Russia was too volatile for her to leave. Members of the Wolkonsky family, in common with other aristocrats who had travelled to the West with the Tsar at the end of the Napoleonic Wars, had been impressed by the contrast between the autocracy of Tsarist Russia and the more liberal governance in Europe. Alexander I, though increasingly wayward, autocratic and repressive, managed to keep the lid on this incipient dissent. But on his death (from typhus) in November 1825 the confusion over the succession (resolved by the eventual confirmation of his secret pact with his two brothers that the younger, Nicholas, should inherit the crown) was the occasion for the dissent to turn into action. The groups involved, later known as the 'Decembrists' after

the timing of their failed uprising, included many of Zenaïde's friends, the closest being the Polish poet Adam Mickiewicz. (Pushkin avoided being involved because he had already been exiled in 1824. He was allowed to return to Moscow in 1826.)

More importantly, several of the Wolkonskys, especially Zenaïde's favourite brother-in-law, Sergei Grigorevich Wolkonsky, were caught up in the debacle of the rising, to which the new Tsar responded with repression. The five leaders of the plot were executed in July 1826, the first such sentences for a long time. Sergei (after a winter imprisoned in the Peter and Paul Fortress) was forced

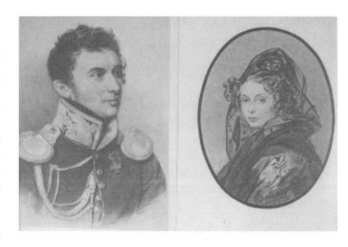

Fig. 2.5. Sergei Wolkonsky and his wife Maria (Rajevsky).

to watch the executions and sentenced to hard labour for 20 years and life exile, plus loss of rank, title, property and name (including married status) and sent to Siberia (Fig. 2.5).

Sergei's young wife, Maria, was allowed by the Tsar to join him, after much pleading, not least from Zenaïde. Her own family were distraught: most of the Wolkonskys, embarrassed and angered by her devotion to their rebel, offered little help, but her mother-in-law discreetly asked Zenaïde to take Maria in when she stopped in Moscow in the middle of the 1826–7 winter to see the wives of other exiles. Zenaïde gave an emotional musical send-off party for the young Maria, who was forever grateful for her warm support and friendship when the rest of the family had virtually abandoned her. She left from Zenaïde's house before dawn on 27 December, with so many gifts from her friends (including a clavichord from Zenaïde hidden among the baggage) that she had to hire an extra sledge cart for the month-long journey from Moscow to Irkutsk and beyond. Her sacrifice was the greater because she had had to leave her baby son in the care of the Wolkonsky family in St Petersburg and never saw him again: he died there aged two. The couple spent 30 years exiled in Siberia; they were finally released on the day of Alexander II's coronation in 1856. Three years later they travelled to be with Zenaïde for a time in Rome. They stayed with Prince Alexander at the Villa Wolkonsky, as by then his mother had abandoned her palatial life in the Palazzo Poli, making her own sacrifice.

The Decembrist uprising and its aftermath appalled Zenaïde and her friends in Moscow. In spite of her reservations Zenaïde had to participate in the celebrations following Nicholas's coronation in August 1826; she held several concerts at her house. After the festivities many of her friends were able to continue meeting in her house – as opposed to doing so as organised groups watched over by the secret police. Nonetheless the secret police had quickly identified Zenaïde as a leading opponent of the Tsar and her friends as a threat to the regime.[29] Apart from those already mentioned, they included poets and writers Baratinsky, Vieligorsky, Zhukovsky and Viazemsky's close friend Pushkin (allowed back from the exile imposed on him already by Alexander).[30]

Among Zenaïde's neighbours in Moscow were an Italian, Count Miniato Ricci (Plate 23) from Florence, and his Russian wife. Both were talented singers – he with a fine bass voice – and frequent

participating guests at her salon between 1826 and 1828. Zenaïde's romantic duets with Ricci and their frequent dealings on other literary and artistic matters turned into real romance and led, in 1827, to the break-up of the Riccis' marriage. (This serious affair seems not to have affected Barbieri's place in her household or affections.) Ricci went home to Italy in 1828, and this may have contributed to Zenaïde's decision the next year to leave definitively for Rome. The young poet Dimitri Venevitinov, 16 years Zenaïde's junior, admired by Pushkin and others, also fell in love with her. Although his love went unrequited (no doubt improving the quality of his verse), she clearly cared for him and arranged a position for him in St Petersburg. But he soon fell ill and died there. Zenaïde later set up a memorial to him among those in her Allée des Mémoires at the Villa Wolkonsky, where others of her friends and family were also remembered.[31]

The death of Zenaïde's friend Tsar Alexander, the consequences for the family of the Decembrist debacle, the subsequent oppression of free thinking and the return to Italy of her lover, Ricci, all combined to induce in Zenaïde another period of depression. As on previous such occasions she found no comfort in the Orthodox Church, nothing in which to sublimate her spells of religious fervour. She felt that 'Russia had become a prison'.[32] Rome, which she by then knew well, was the natural place for her to go. After one last party on her 39th birthday, 3 December 1828, attended by many of her closest friends, she left her house in Moscow, spent a month in St Petersburg saying her goodbyes to her family and taking leave of Tsar Nicholas (who declined her request to allow Nikita to leave with her). She left Russia on 28 February 1829. She returned briefly twice thereafter, but never lived there again. With her went her widowed elder sister, Maria (Madeleine), who remained with her until her death in 1857 and is buried – with Nikita – in Zenaïde's tomb; Alexander, now 17; Pavey; Professor Stepan Shevyrev from Moscow University, now Alexander's tutor; and Barbieri – though he left once they got to Rome. The party, which included five servants, made something of a grand tour of Italy before reaching Rome in the autumn.

The tour was partly designed for Alexander's education, to introduce him to some of the artistic and historical wonders of the Europe in which his mother had travelled so extensively. Indeed travel had been a leitmotif of Zenaïde's life since early childhood. She had rarely spent more than a few years in any one place since her teenage years at court in St Petersburg. Travel seemed often to be an antidote to her depressions and seeking after spiritual comfort. Some writers have gone further and suggested that her travels were linked to a sense of mission – to bring together Europeans from Moscow to Paris and places in between and to place Russia firmly in the European cultural context, through the interchange of artistic, literary and philosophical exchanges, such as she so assiduously fostered in her salons wherever she went.[33] Whether that was consciously Zenaïde's purpose or whether it was simply a by-product of her search for spiritual fulfilment and the huge talent that she brought to her environment, it is hard to say. But there can be little doubt that she achieved much in that direction by the time she arrived, a well-known and much-admired 40-year-old, to re-establish herself in Rome, this time for good. For the next 15 years she continued in the same manner and with her habitual generosity to inspire others who frequented her salons in Rome, not least at the Villa Wolkonsky.

Coming home to Rome

Zenaïde initially set up house in part of the Palazzo Ferrucci at via di Monte Brianzo 20, near the Tiber – possibly where she had stayed during earlier visits to Rome, but there is no evidence on this

point. She lived there at least until 1832 and possibly until 1834.[34] Here the household, including Alexander and Vladimir – and their tutor Shevyrev – would have had space to flourish. Alexander had accompanied his mother throughout his childhood, though Nikita always showed an affectionate and interested – if in Zenaïde's view somewhat wayward – concern for his progress and welfare. By the time they reached Rome in autumn 1829, the young man was cultured and serious (Fig. 2.6). He would have benefited from at least listening to the discussions over which his mother presided, intensified by the tutorial attentions of Shevyrev.

But in **1831** Zenaïde acknowledged that he must return to Russia for formal higher education and training, for her an enormous emotional wrench. At the age of 20 he left Rome for Russia, as his mother wished, travelling with Shevyrev by a roundabout route. Nikita had tried for once to assert his own preference as the boy's father: that he study in St Petersburg, near the court. But Zenaïde was determined

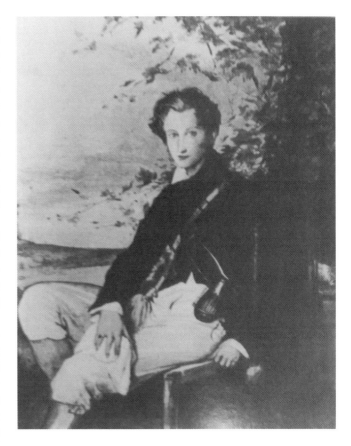

Fig. 2.6. Prince Alexander Wolkonsky, aged 19, a portrait by F. Bruni, 1830.

that her son should not fall under his father's influence and that he study in the more Russian environment of Moscow. In the row which ensued, Zenaïde, already upset by her son's departure, suffered (induced?) a nervous breakdown, had her way, and Alexander departed for Moscow. After much prevarication she decided to catch up with Alexander and accompany him for part of the way, but the depression induced by the first real separation from her son was so debilitating that she was forced to abandon the plan while she recovered in Bolzano, in northern Italy, surrounded by friends concerned for her life. This experience seems to have intensified her sense of the mystical and spiritual, developing as the years went by into a fervour that was to lead to major change in her life after Nikita's death.

After completing his studies Alexander joined the imperial Russian diplomatic service in **1834** and was in post in Warsaw in the early 1840s (where Zenaïde visited him on her way back to Rome after her final visit to Russia). Alexander's studies and career meant that he would have been absent from Rome for most of the time during which his mother was holding court to Italians and foreigners alike – the 1830s and early 1840s. He had grown up a model son and student, a mature member of

the aristocracy, largely because of the great attention Zenaïde had always lavished on his upbringing, not least ensuring that he spoke and wrote good Russian, avoiding what she regarded as her handicap of having been educated in French, no longer well regarded in the new Russia.

Miniato Ricci was soon in attendance in Rome and became effectively the manager of Zenaïde's affairs. But the reunion did not ease her sense of spiritual turmoil and guilt: conversion to Catholicism (along with Madeleine, Pavey and five servants) followed, probably in **1835** but maybe as early as 1833, but was only registered in her parish church in 1836, after her move to the Palazzo Poli in **1834**.[35] This strengthened focus on the spiritual, combined with the serious eye ailment which struck Ricci in 1835, placed their relationship onto a more stable basis of friendship – as had happened with Tsar Alexander and Barbieri. Ricci lived until 1860. It is not known whether they had remained in close touch after Nikita's arrival in 1840 and his death four years later.

Perhaps the Russian dacha habit instinctively led Zenaïde to decide early after arriving in Rome to acquire a country retreat; perhaps she had already so decided and even been told in advance of the opportunity to buy the Vigna Falcone. How she hit upon the property is not recorded. Her friends in high places in the Vatican may well have introduced her to one of the Massimo family of papal princes, just at a time when the young *monsignore* might have been wondering what to do with the land inherited from his uncle, which looked as if it might be more trouble than it was worth. For all the intellectual and artistic stimulus to be found in the centre of Rome, at least in the stifling, fetid summer months it would have been a good place to get out of, without going so far as to be inaccessible to friends visiting from Northern Europe. She started her project in **1830**, even before the property became legally hers, by commissioning an architect, Giovanni Azzurri, to create for her a *casino* (literally 'little house', but 'summer house' gives a better flavour) by the aqueduct which was so conspicuous a feature of the property. Indeed by her own account – on a stone tablet she had made and erected in the garden – she regarded it as hers already.

The moment the contract of sale was notarised in June 1831 she asked the papal authorities responsible for antiquities to get on with the repair of three spans of the aqueduct which were in danger of collapse. This request was passed from the papacy's official architect, none other than the well-known Valadier, to a Cardinal Galletti on 16 June. They would not have been surprised at such a request, because a special commission had reported in 1826 (after visiting the site on 8 August that year at Massimo's bidding) that four or five piers of the aqueduct (to a length of 1,490 palms – about 115 m)[36] in what was then still the 'Vigna Massimo' were in a dangerous state and needed urgent repair. This had been authorised in 1827 at a cost of 287 Scudi, but then the money had been held back in an effort to force Valadier to produce costings and accounts for other works due. Zenaïde's request was agreed and the repair was carried out in summer 1831 at a cost of 294 Scudi; later analysis shows it to have been confined to the facings, not the underlying structure.[37] In April 1833 the treasurer-general, checking up on the work, was not sure whether to charge the cost to the Antiquities sub-head or that for Water Supply, thinking that the aqueduct might still have been in use – an uncertainty which later had an echo in a curious episode which embarrassed Zenaïde's son, Alexander – see Chapter 3.

Then, as so often now, the prior existence of an edifice, however modest, seemed to be enough to ensure that Zenaïde would not be prevented from building herself a summer house there. There is no trace of her having sought or been given formal permission to build. Nor is there any suggestion that there was a set rule book to follow. But there was a growing sense that monuments, not just churches and church property, should be respected. In this case, the aqueduct was a significant feature of Rome's monumental landscape, and some of the aqueducts might have been still capable of supplying

water to the city; the authorities could hardly ignore it, so must have turned a blind eye. When, 31 years later, Prince Alexander had a brush with the papal authorities over additional unauthorised construction, one official actually recorded his suspicion that the house had been illegally constructed in the first place – but not pinning responsibility on Zenaïde.

These matters were then controlled by the Papal Minister of Commerce – a responsibility which later, in a united Italy, passed to the Minister of Education (*Pubblica Istruzione*) – which set up the institution tasked with preservation and conservation of antiquities, monuments and fine arts, 'Belle Arti' for short, which has played a large role in the tale of the Villa Wolkonsky. Zenaïde's excellent Vatican connections, reinforced by the agreement to repair the aqueduct explicitly so that she could safely build her *casino*, could all too easily have led her simply to assume a *nihil obstat*; or maybe she never even thought about it at all. In any event she had Azzurri build her summer house – a place for summer parties, not for many people to live in – on to the primitive dwelling/store already built into the aqueduct. That it absorbed at least some of the existing (and possibly quite old) structure is demonstrated by a contemporary watercolour (Plate 30).

The role the *casino* played in Zenaïde's life has to be seen in conjunction with the reputation she had established in Rome's cultural life and as a hostess there, as previously in Moscow and Paris. Before she left Russia she had distanced herself from court and acquired more of a following among the liberal, more Russia-centred academic and literary world of Moscow; she had become a known collector of art and antiquities; and she had taken to writing serious historical works in Russian about Russia in the place of novellas in French. Her move to Rome did not reduce her renown or her following; indeed she quickly built on it, adding to her foreign visitors those figures of Italian cultural and artistic life she had come to know during her visits before 1829. In **1834** she moved her home to more spacious apartments in the Palazzo Poli (on to which the Trevi Fountain had been grafted in the mid-eighteenth century), where she was closer to the city's artistic life. Her salon quickly became a place where visiting and resident foreign artists and literary figures could meet each other and their Italian counterparts. Her visitors in Rome included Thorvaldsen, Donizetti, Sir Walter Scott (possibly – but they certainly met in Naples) and Mickiewicz.

Not surprisingly, there exist many portraits of Zenaïde, painted over these heyday years. They show a slim, erect and pale figure, with large eyes, dark hair hanging in curls around her face, sometimes a coquettish look, sometimes a slightly sad gaze at the artist/viewer; in some she is in fancy dress, either for a performance or out of whimsy. A few honest artists show the scar on her lip caused by what we might now consider an episode of self-harm during a fit in the early years of her marriage and her relationship with the Tsar.

The *casino* was generally a quieter place of resort, where she and her guests could while away the hours, seek inspiration, enjoy friendly company, and stroll in the grounds admiring the *campagna* beyond, far from the smells and noise of the city. During the next 15 years Zenaïde evidently spent much time there, surrounded by many friends, among them key figures from her last years in Russia, of which the Villa still bears many traces. Her visiting foreign guests often recorded accounts of her hospitality: Gogol, Turgenev, Scott and Fanny Mendelssohn are but the most distinguished. But it is hard to gauge what the *casino* looked like. No original architect's or other plans have come to light.

Two sketches by the poet Vasily Zhukovsky from 1839 look fairly convincing. In the first the lady in it is said to have been Zenaïde – and Gogol one of the men (Fig. 2.7 – the second man being Pavel Krivtsov, a member of the Russian diplomatic mission and the official supervisor of the Russian artistic community in Rome). In the second, located on the lower terrace looking in the same direction, only

Fig. 2.7. Zenaïde, Gogol and P. Krivtsov at the Villa Wolkonsky, by Vasily Zhukovsky, 1839.

Gogol appears (Fig. 2.8). But they do not show much detail of the building itself. Such other pictures as exist, including a well-known 1834 watercolour in the Museo di Roma, show a light structure of terraces looking across the park, where guests are strolling, and an outside staircase, but tell nothing about the façade or interior spaces (Plate 31).

Several visitors, including Ruskin, drew or painted the views from the building but did not include the building itself. Whatever the appearance of the *casino*, however modest it was, it is clear that Zenaïde had begun to direct much energy to transforming a good part of the Vigna Falcone. From the outset she and her guests had been able to enjoy tremendous views, especially to the south-east, where the distant Alban Hills were bracketed between the grand façades of San Giovanni in Laterano to the right and Santa Croce in Gerusalemme to the left, joined by the line of the Aurelian Wall. A good part of that view was captured in an etching made in 1819 (of course, before Zenaïde's house was built) by the English artist Miss E.F. Batty (Plate 21).

Before her summer house had been completed, Zenaïde set about turning the land near the house on the top of the ridge into a garden to add an extra dimension to those views. She adorned the aqueduct itself and increasing areas of garden with her favourite roses. She added statuary and memorials beside the paths she laid, as well as Roman fragments discovered while her house was being built or acquired subsequently, some of which she attached to the aqueduct itself in ways which modern conservation rules would certainly not permit! (See Fig. 2.9.) (No serious excavations had at that stage been done, though late nineteenth-century archaeologists had to acknowledge that, during preceding centuries, tombs they uncovered had been comprehensively robbed.) She also brought to the garden the two very large ancient Roman amphorae given to her earlier by Cardinal Consalvi (Fig. 2.4). In effect she was a serious collector of antiquities, though she treated them and the aqueduct as a source of charm and interest in a garden, not as revered historic monument to be preserved for their own sake, an approach shared by her son. This attitude strongly influenced the approach to the British-led restoration in the late 1950s (see Chapter 17). (The story of the antiquities collection is summarised in Appendix I by Raffaella Bucolo, a scholar much involved in researching the back-history of the individual pieces still preserved at the Villa.)

Many of the memorials in the garden were of her own making, evoking her Russian past: to her family and to Russian figures whom she had loved and admired as a young adult, not least Tsar Alexander. They were connected by paths in the woodland on the north side of the aqueduct,

referred to variously as the Allée des Morts, the Allée des Souvenirs or the Allée des Mémoires. Over the years many memorials were moved from their original positions, and it is no longer at all clear where the original paths were, even whether there were two or simply one walk known at different times by different informal names. One stretch of path remains visible with its memorials (in poor condition) between the *casino* and the boundary wall in the northern, wilder part of the garden. (It turned east towards the north-east corner of the garden, possibly passing there under the most north-easterly arch of the aqueduct.) This is the portion in the sketch plan in the best available modern record: an illustrated description dated 1990 by Sue J. Williams, wife of a senior member of the embassy staff, then living in the *Casa del Arco* (the then current name for the 'German Minister's House'). She wrote that the Allée des Mémoires had been 'until recently lost in deep undergrowth and a forest of bay and cypress and pine'. Her evocative opening quotation from Turgenev, written after he visited Rome in 1832–3,

Fig. 2.8. Gogol on the terrace of the Villa Wolkonsky in Rome, by Vasily Zhukovsky in 1839, showing the side of the house looking south-west from the small terrace on the external stairs overlooking the garden, including an outhouse with pergola.

demonstrates that Zenaïde had already done enough to her garden to impress visitors:

> Corinne-Zenaïde took me round her charming villa on the ruins of an aqueduct. She has brought the desert of her villa to life with memories of the living and the dead ... There, in a Russian hut, stands an urn to the Emperor Alexander, a Greek vase bears the name of Capo d'Istria, and there is a French epitaph to her nurse ...[38]

Mrs Williams listed and made charming sketches of the inscriptions, tombs and other items. (A newly revised version of her record is reproduced at Appendix II.)[39]

The largest of the memorials in the Allée des Mémoires was that which Zenaïde's son, Alexander, later erected to his mother. Others (Fig. 2.10) were to friends, including Goethe whom she had met

Fig. 2.9. An instance of whimsy in Princess Zenaïde's arrangement of the antiquities in her garden.

in Weimar in 1812 and again in 1829 en route to Rome; Walter Scott who died after visiting Rome in 1832; the first recorded memorial to Pushkin who died in 1837 in strong disfavour; Baratinsky and Zhukovsky – the last of whom spent much time at the villa sketching, including the pictures at Figs. 2.7 and 2.8; to Byron (which did not survive); and family (maternal grandparents Jakov Athanasevich and Maria Dmitrievna Tatischev; father; the mother she never really knew – Barbara Jakovlevna Tatischev – and nurse; sister Natalia who had died in her teens; and servants. Many recorded Tsar Alexander I and his wife, Empress Elizabeth; and one is to his mother, the Dowager Empress Maria Feodorovna, for whom Zenaïde had been a lady-in-waiting. One slightly mysterious memorial is to Peter Dimitrievich who 'saved his native town in 1771' – this was Eropkin, the military governor of Moscow who quelled the riots during an outbreak of plague in the city. Over the years Russian visitors to and residents in Rome have shown a continuing interest in these memorials. But their current condition suggests that they are not now much sought after.

Tsar Nicholas's refusal to let Nikita go with Zenaïde lasted until **1839**. Even then all was not plain sailing. Once Nikita was in Rome, she returned to plead with the Tsar to exempt the family from new draconian laws expropriating the property of Russians living abroad. But her conversion to Catholicism had only increased the Tsar's doubts about her; now he feared she would try to convert Nikita. So he summoned Nikita back home and threatened to force Zenaïde to reconvert to Orthodoxy, but relented again the following year after she had put on a hysterical fit. In **1840** Nikita was finally free to move permanently to Rome; and on 28 June that year the family succeeded (with much help from Vladimir Pavey) in transferring its Russian property (mainly an estate at Urussovo in Tula) by deed to Alexander, by then en poste in Warsaw, who remained an Orthodox. The Tsar's fears were however justified: Nikita did convert, a year before his death in Assisi in **1844**. Unsurprisingly, having squandered much of the family fortune before being allowed to leave Russia, Nikita left a financial mess there which it took the assiduous Pavey several years to sort out, paying off all the debts, possibly through a loan raised against one of the family's properties.[40]

Zenaïde's interest in the welfare of the poor had been growing for some time before Nikita died. Thereafter she became increasingly reclusive from society, devoting her life and much of her remaining wealth to good works, mainly with an order of nuns focused on the education of poor girls. It might have seemed that in her generosity in this cause she was taking on from where the profligate Nikita had left off. Alexander's marriage in **1844** or **1845** gave him a pretext to protect the family's assets

from Zenaïde's charitable irre-
sponsibility.[41] She made over
the Villa and other assets to
him (on certain conditions) in
1848 and made little further use
of the summer house she had
built there. In short she lost in-
terest in her Villa, its garden
and the society who had shared
her love of them. Once her de-
voted sister Madeleine died she
devoted herself almost full-
time to her beloved nuns.

Fig. 2.10. *A part of the Allée des Mémoires in 2019, probably showing items 9–11 from the memorials listed in Appendix II.*

The garden had ups and
downs, but Alexander did not
neglect it. Indeed, once he made
it his own, he spent consider-
able sums on adding fashion-
able structures to it, as well as
supervising excavations of some
of the antiquities on the property
– see Chapter 3. Augustus Hare
saw it in the 1870s, describing it in his *Walks in Rome* as

> a most beautiful garden, running along the edge of the hill, intersected by the broken arches of the Aqua Claudia and possessing exquisite views over the Campagna, with its lines of aqueducts, to the Alban and Sabine mountains.[42]

But by the 1902 edition of *Walks in Rome* he was led to lament how 'thirty years of Sardinian rule – 1870–1900 – have done more for the destruction of Rome than all the invasions of the Goths and Vandals',[43] citing among others an authoritative criticism by Lanciani, who had fired off at the Roman aristocracy in general, for allowing great villas to be completely or partially destroyed, including the 'Wolkonsky villa'.[44] But that would have been more a criticism of the new blocks overlooking the garden from the surrounding new streets than the state of the garden itself – though the building of the new *villino* in the 1890s probably did little for the garden in the house's vicinity. A 1934 guide claims the gardens were but a shadow of their former selves, but it is unclear whether the author had any idea what they had looked like in their heyday or had access to what was by then the Residence of the German Ambassador.

The few images which have survived from the early twentieth century do not entirely support these downbeat judgements; but too little is known of the garden's history for the debate to be worth pursuing. In any case, gardens are in their nature living things, not dead museum pieces; the key to their fate is nearly always the inspiration and care of an individual, if temporary, custodian. For nearly 100 years several ambassadors from two great European nations and their wives have fitted the bill perfectly! But if, as a result, the garden of today has evolved some way from that which Zenaïde would have recognised at her death in 1862, she would probably be gratified to see that the spirit of her

garden, the intermingling of nature with romantic antiquity, has survived and been respected, forming a little piece of paradise in the heart of the city.

Notes

1 Pietrangeli, p. 425, n. 1.
2 Ibid., p. 428.
3 Pietrangeli cites 'Archivio di Stato di Roma, Archivio del Censo, Catasto Urbano, Rione Monti, foglio 11, nn 269–270', but the relevant sheet of the map in question is 15 (Plate 2).
4 This shows that the word '*orto*' encompassed a vineyard and that the vineyard produced at least some wine.
5 Contract of Sale by Not. Petrus Diamilla (Via degli Offizi del Vicario 36 Rome) p. 490 of n. 11 in 30 Notai Cap. Uff.31 Vol. 807Arch d St.
6 *Cancelleria del Censo, Volture* Vol. 286, Doc 2141, Governo Pontificio, Comune di Roma.
7 Author's sketch map based on *Catasto* map Rione Monti Folio XV.
8 The villa in question was presumably the almost neighbouring property across the square from the Lateran Palace, described on several nineteenth-century maps as the Villa Massimo or Massimi; this part of the contract remained without explanation until Amanda Claridge drew my attention to her article (Claridge op. cit.) on Pope Sextus V's construction in 1586/7 of the Aqua Felice over which the Massimo family had evidently acquired some rights, such that Princess Wolkonsky needed to secure the right to take a share of the water as it passed through what was now her land.
9 In her signature 'Pssa. Z Volkonsky' she spelled the name with a V, which was often the case, as the Italian alphabet did not naturally include a W. This variation of spelling makes for some complication when searching indexes.
10 Voltura 5571 of 17 September 1831, executed in 1832.
11 Fairweather (MF), *Pilgrim Princess*, 1999.
12 Marta Valeri, 'Ambasciatrice di Russia', 2015.
13 Trofimov says 3 December 1791, but that was the date of birth of her younger sister, Natalia; another source gives 1792 (André Trofimov, *La Princesse Zenaïde Wolkonsky*, Rome: Staderini, 1966).
14 Alexander I: born 1777, reigned from 1801, on the assassination of his father Paul I, until 1825.
15 Mistakenly recorded as 18.11.1811 in the records of Alexander's wife's burial at the Teutonic Cemetery beside Santa Maria della Pietà in Camposanto in the Vatican.
16 Mikhail Kizilov, 'Between Leipzig and Vienna', www.academia.edu.
17 One unproven source (see note 3.10) relates that she was thought to be carrying the Tsar's child.
18 He appears in the *Gerarchia Cattolica* almanac – listed as Valdamaro Cav. Pawey – in the years 1866, 1869 and 1873 and possibly others. Another source, Count Michail Dimitrievitch Boutourline, a Russian contemporary of Zenaïde, who was in Rome at the same time, says Pavey was English and had been converted from Protestantism before becoming Orthodox and later Catholic! Boutourline also described him as a papal standard-bearer in the 1840s. See Buturlin, pp. 117–18.
19 See website quoted in note 3.10.
20 Valeri, p. 20.
21 The author by chance picked up a copy, printed in Naples in 1828, on a bookstall in Rome in 2000.
22 'Italy', in its early nineteenth-century context, did not exist as a state – much as in the case of 'Germany'; but the name was clearly understood by foreigners and many residents of the peninsula's several states, principalities and kingdoms as shorthand for what was recognised as a cultural identity. That is the sense in which it is here rather loosely and prematurely applied to the political entity properly called Italy only after unification.
23 Stendhal, *Correspondence*, Vol. V, p. 229; quoted by MF, p. 148. He was clearly not shy of mentioning the consequence of Zenaïde having disfigured herself by biting through her upper lip during a breakdown in the very early years of her marriage.
24 Berry, Vol. III, pp. 274–6. Frustratingly, this word-spinner of a traveller failed to record where Princess Wolkonsky was living.

25 Tsar Alexander tried to hold another Congress in St Petersburg in January 1825 to discuss Greece, but it did not happen, not least because the British refused to attend.

26 Recorded in the inscription on the family memorial in the church of Santi Vincenzo e Anastasio near the Trevi Fountain in Rome.

27 MF, p. 174.

28 The guiding spirit was the philosopher Schelling; other regulars at Zenaïde's house were Prince Vladimir Odoevsky and the poet Küchelbecker, founders of the first of the influential literary journals; from the university, Prince Golitsyn and Count Stroganov attracted many professors and their circles. Odoevsky's circle contained the philosopher Kireevsky, poet Dimitri Venevitinov and his brother, and Professors Shevyrev, Pogodin, Melgunov, Sobolevsky and Chaadaev.

29 MF, p. 199.

30 Others were philosophers Khomiyakov and Chaadaev; publishers Delvig and Polevoi and several professors from the university.

31 This memorial can no longer be identified; see Appendix II.

32 Letter in Wolkonsky Archives, HLHU, quoted by MF, p. 215.

33 Valeri.

34 By one account she lived from 1832 to 1834 in the Hotel Minerva; Gasperowicz quoted in *Zinaida Volkonsky – Une Belle de Bal* by Yuliya Glushakova, p. 3. See also: https://docplayer.ru/63633775-1-zinain-volkonsky-une-belle-de-bal-ya-3-andenken-an-gogol-i-s-h.html – in section 7.

35 There is uncertainty about when Zenaïde converted to Catholicism, detailed in Valeri op. cit. Gasperowicz (quoted by Glushakova) favours 2 March 1833, a date given on a stone in the *palazzo* of the Ricci family. Aroutunova (p. 34, cited in Valeri, p. 40, n. 75) argues that it could not have been before 1835, based on the 1836 entries in the register of Zenaïde's parish church of Santi Vincenzo e Anastasio, following her move to Palazzo Poli and a communication from the Vatican reporting that the princess converted in 1835.

36 In Rome a palm was 76.2 mm or 3 inches.

37 BR & B recorded (p. 85) that it was Zenaïde who had applied for the repair work in 1826 and that a committee visited the site on 8 August that year; the authorised repairs were carried out between 1826 and 1833. Following Ashby (2) (p. 247, n. 5) they cite *Atti del Camerlengato Tit iv, fasc. 941* (now renumbered), but they clearly misread the footnote, as it tells the story as in the main text here. The property did not in 1826 belong to the princess. Zenaïde's petition for the repair is in documents from 1831 (*Camerlengato Parte II Tit iv, Busta 213, doc 1534*).

38 Corinne was the heroine of a novel by Mme de Stael, a character on whom Zenaïde may have modelled herself, a thought she may have shared among her friends. Mme de Stael had sent Zenaïde a copy of the book when she was recovering from her depression and self-harm in 1812; Capo d'Istria was Russian foreign minister of Greek origin whom Zenaïde would have met at Tsar Alexander's court.

39 S.J. Williams, *The Allée des Mémoires at the Villa Wolkonsky*, unpublished, 1990. When checked against the contents of the garden in 2000 most items were found to be 'present and correct'. The same may not be true now. See Appendix II.

40 MF, p. 259.

41 1844 is the date given in the directory of the burials in the church of Santa Maria della Pietà in Camposanto in the Vatican, where Louise, Zenaïde's daughter-in-law, was first buried, but others of the dates in that work do not tally with dates in other sources. 1845 has been the generally accepted date of the wedding, but, as we have seen, 'generally accepted' is no guarantee of accuracy.

42 Hare, 1871.

43 Hare, 1902, p. 10. On the life and work of Hare, see Ragni, 2013, pp. 159–61, quoted in Bucolo (3), and in particular on his criticism of the destruction of the villas see pp. 179–80.

44 Hare, 1902, p. 11.

3.
AFTER ZENAÏDE: ALEXANDER AND THE CHAINS

The family and the Villa in Zenaïde's last years

After Nikita died in **1844** Zenaïde progressively withdrew from society, increasingly preferring the company of philanthropists, priests and nuns. With the help of her son, Alexander, she moved out of her Palazzo Poli apartments to a more modest dwelling in via degli Aragonesi, up the Quirinal Hill towards the Quattro Fontane. Alexander in due course adopted the *casino* at the Villa as his Roman home, when he was not on duty in the Russian diplomatic missions such as Dresden (1858–60),[1] Naples (1860–62)[2] and Madrid (1862–8).[3] When he moved in (and how completely) is not recorded. He would have had the legal right to do so in **1848**, when Zenaïde passed the property on to him by means of a Deed of Gift, which she applied for in November 1846 and had notarised on 22 February 1848.[4] The 1848 deed recorded his domicile as in via degli Aragonesi (as for his mother). Adding to the uncertainty, a separate deed of 1861 recorded his domicile as Piazza Barberini, in the centre of Rome. The choice of official domicile addresses may in practice not have indicated where he actually lived. It is conceivable that Alexander, like his mother, actually used the *casino* more as a summer house or guest house and retained a principal residence in the centre. If so, we do not know where it was.

For all that the portrait of the 19-year-old Alexander (Fig. 2.6) shows him as slim, something of a dandy, and clearly self-confident, little of his character emerges from the facts about the milestones of his life. His upbringing must have reinforced his princely sense of being a cut above the fray, reliant on his position and ancestry to assure he got what he wanted. He would have had all the necessary social and cultural graces, from his mother's example and tuition, then his own diplomatic environment and training. He understood that legal process could be useful in order to protect his and his family's interests, clearly being at least a willing participant in his mother's wish to transfer the Villa to his name. He could also be careless. Like his mother he did not bother to get permission to enlarge the *casino* on the aqueduct, but unlike her he was found out.

He was also astute with money, unlike his father – and latterly his mother. His purchase of land about to be scheduled for development in **1868** was finely judged.[5] He not only devoted time and energy to his (unauthorised) expansion of the *casino*; he also encouraged the excavation of antiquities accidentally discovered in the Villa grounds and worked to give structure to the garden, creating (with an architect's help) a gardener's cottage and making other improvements, partly in response to emerging public interest in the antiquities. He inherited his mother's interest in collecting antiquities over and above anything discovered on the site – see Appendix I. His interest in culture, especially Italian, manifested itself also in writing a two-volume book, *Rome and Italy of Medieval and Modern Times, in Historical, Moral and Artistic Relations*, based on the travels around the country he undertook with his mother on their arrival in 1829/30.[6] While he repaid his mother's devotion to him by looking after her in her later years and supporting her growing focus on good works, he evidently

worked hard to prevent her dissipating the family's assets through her philanthropic activity as religious obsession strengthened in her final years. That may have been a motive for his disregard of one condition of the 1848 transfer of the property to him – that a Catholic chapel be erected on it and maintained in perpetuity. But then he had remained a Russian Orthodox.

In late **1844** or early **1845** Alexander married Aloisia Wilhelmina von Lilien (referred to in the family papers as 'Baronne' Louise de Lilien but also, in Italian legal and other documents, as Luisa).[7] To Zenaïde's delight, Louise/Luisa was Catholic (but not French, as Maria Fairweather states).[8] How, where or when she and Alexander met is not recorded: it could well have been in Warsaw, while Alexander was serving there. But as Nikita penned a poem (presumably of welcome) to his son's betrothed in 1843 it would have been in the early 1840s.[9] (There is also a surviving poem to her from Alexander, from 1844.) One unproven source simply states that they were married in Bern, Switzerland, on 17 September 1844 (and that they were in Warsaw in 1849).[10] Where in Rome the newly-weds made their home is also not clear. The marriage must, however, have spurred Zenaïde to decide (or given Alexander the pretext to persuade her) to launch the procedure in November 1846 to make over the Villa to Alexander, an act in line with her decision to move from the Palazzo Poli and concentrate on charitable work. By then Alexander and Louise had a one-year-old daughter, Zenaïde. From Alexander's point of view the transfer was also a useful means of avoiding have her donate the Villa to a charity or, failing that, leaving him to pay death duties.

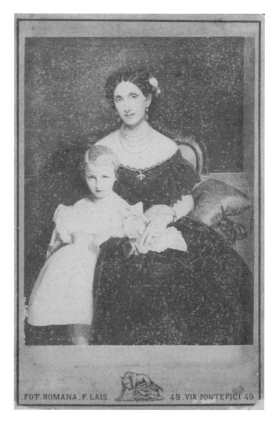

Fig. 3.1. Princess Louise/Luisa Wolkonsky in a photograph taken around 1850. The young girl in the picture is almost certainly her daughter, Princess Zenaïde, but this is uncertain; the pencil inscription on the reverse does not identify her.

Pietrangeli reported as fact (but quoting no sources and citing no documentary evidence) that the couple had had a daughter, Zenaïde, who died in infancy.[11] In that statement he was right. But none of the family tomb inscriptions made any mention of such a child. Maria Fairweather's extensive study of the extant Wolkonsky family papers in the Houghton Library for her biography yielded nothing. She had to look elsewhere to find her only reference, a telling one: in a letter dated 4 December 1845 to the nun whom Zenaïde supported in establishing schools for poor girls Princess Zenaïde herself recorded that Alexander and Louise had a child to whom they had given her name.[12] Now more evidence has come to light. A photograph of Louise with a fair-haired little girl of, maybe, three or four years old, with neither date nor inscription, is preserved in the Houghton Library collection (Fig. 3.1). A website article on Princess Zenaïde contains a coloured version of the same photograph, with the unconditional identification of the little girl as Louise's daughter, Zenaïde. The article contains information which

repeats and possibly draws on a French-language genealogical website which offers another clue, by giving dates: a birth date of 1849, which must be wrong (see below), and a death date of 1853 for which there is so far no confirmation.[13] The clinching proof of the child's existence (and well before 1849 at that) is that both Zenaïde's handwritten application of 21 November 1846 and the consequent 1848 Deed of Gift of the property to Alexander show explicitly that Alexander and Louise did by then have a daughter, named Zenaïde. Those documents can also be taken to prove that the girl was alive at the date of both documents, i.e. at least until February 1848. Princess Zenaïde's Deed of Gift stipulated that, if Alexander, his wife Louise and their daughter Zenaïde (described as Princess Zenaïde's granddaughter (*nipote*), to avoid any confusion) were to die without issue, the property, described as her delight (*delizia*), should pass to a (named) charitable institution.

That was one of several conditions Zenaïde laid down in her application for authority to make the gift, and Alexander accepted them on execution of the deed, 18 months later. They were that

a) he assume all the obligations encumbering the property, especially the mortgage of 2,000 Scudi and the interest on it in favour of Teresa Acquaroni-Panzieri (the surviving widow of the couple who sold the property originally to Marchese Carlo Massimo in 1823);
b) he erect and maintain in perpetuity on the property a chapel of the Roman, Apostolic Catholic faith dedicated to the veneration of the Madonna del Carmine;
c) (as already mentioned) if there were no descendants, the property pass to the missionaries of the Blood of the Holy Lamb; and
d) if Alexander or his heirs should ever need to sell or mortgage the property it should only be done to the benefit of a 'charitable place' (*luogo pio*), so that the chapel could be guaranteed to continue to exist.

The conditions, despite being repeated in full in the 1848 deed, made no further appearance in any subsequent deeds related to the property, and the chapel was never built. But the point about descendants became a major concern.

As the 1849 date of little Zenaïde's birth on the quoted website is wrong, there must also be doubt about the accuracy of her date of death, given as 1853, though it could be correct. But a curious transaction involving Alexander in 1861 suggests the possibility of a different, more complex story, perhaps explaining why these dates remain unconfirmed.

For a property-owner to buy back a mortgage on his asset does not seem like a major event. But as the mortgage in question had been set up in 1823 (by the Massimos) under a notarial Deed of Sale, any change to it required a similarly authoritative document, so such a transaction and its motivation had to be recorded accordingly. Thus there exists a deed notarised by Torriani setting up a Life Annuity (*Censo Vitalizio*), dated 3 June 1861, for a Signora Elisa Mickayloff (or in some documents Mickeloff), wife of Raimondo Ermetes. The Massimo-Acquaroni mortgage of 2,000 Scudi (apparently restored to being a single sum after earlier division) had changed hands in 1851.[14] It had then been acquired for Signora Ermetes and her daughter Zenaïde by Alexander's lawyer, Filippo Ricci, and divided between her (1,200 Scudi) and her daughter, Zenaïde Ermetes (800 Scudi to be a part of her dowry, when the occasion arose). Subsequently, by her own admission in her application dated 3 May 1861, Signora Ermetes had been constrained to dispose of part (700 Scudi) of her mortgage to meet certain obligations, contrary to the terms of the 1851 transfer, and thus losing the interest on that sum. She had turned to Prince Alexander, who being 'well aware of her economic situation and delicate state of health' had generously agreed to make an annuity of 84 Scudi a year to her, while she was ready to hand in to him the mortgage and derive

no further benefit from it, though, under the terms of a special loan taken out by Alexander on 6 November 1844 – for which the mortgage was possibly a security – he could not cancel the mortgage as long as the annuity lasted (i.e. until her death).[15]

At this point, with due caution, we enter the realm of speculation. This document is, to put it mildly, enigmatic. First, the name Mickayloff/ Mickeloff (perhaps Mikhailov) is almost certainly Russian. And the daughter's name suggests that Elisa Ermetes knew the Wolkonsky family. So does the fact that she was aware of an 1844 loan taken out by Alexander. And why should Alexander be well aware of her financial and health situation? Had Alexander's and Louise's little daughter Zenaïde perhaps been handicapped or ill to an extent that she needed permanent care outside the family, provided by Signora Ermetes from 1851 in exchange for the interest on the mortgage? Had she inherited a virulent form of the disturbances suffered by her grandmother – perhaps even a type of epilepsy – and the family wanted to let it be assumed that she had died? Did the Wolkonskys have their delicate little Zenaïde adopted by Signora Ermetes so that there should be no further financial obligation, beyond the

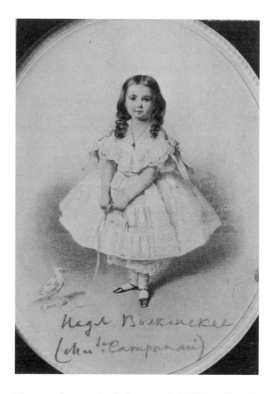

Fig. 3.2. Photograph of Princess Nadeïde Illijn Wolkonsky as a child, pictured probably in the late 1850s.

mortgage, or risk of her inheriting the Villa Wolkonsky, had she lived on incapacitated? Was the annuity perhaps even hush-money to dissuade Signora Ermetes from revealing the little girl's fate? These unanswered questions underline the odd vagueness about her date of death. What had happened to Zenaïde Ermetes' share of the mortgage (her dowry) was not recorded, but if she had still needed ongoing care in 1861 it is strange that there should have been no reference at all in the legal documents to Signora Ermetes' responsibilities, unless Alexander was being ultra-careful over what appeared in the legal documents. The stronger probability is that by then she had indeed died. The circumstantial evidence is temptingly suggestive even of action by Alexander to remove her existence from the record, in order to ensure that the Villa should pass undisputed to his adopted daughter Nadeïde, just as he is reported as having filleted his mother's papers to remove potentially scandalous evidence of his mother's relationship with Tsar Alexander I.

Apart from the emotional hurt at the loss of their only child, little Zenaïde's death, whether in 1853 or some other date, would have presented Alexander with a different and very practical problem: without a child to succeed to the property it could have been lost to the family under the terms of his mother's still recent Deed of Gift. It must have been clear that Louise was unlikely to bear further children. So the request he is reported (in the Campanari family account) to have received from a distant Russian relative and neighbour, General Basil Illijn and his wife, Caterina, that he adopt their first-born daughter, Nadezhda or Nadeïde, born in 1855 (Fig. 3.2), would have come as a double blessing.[16]

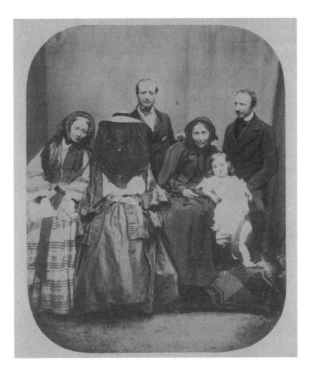

Fig. 3.3. Wolkonsky family portrait, probably taken in the late 1850s: from left Maria Vlasov, Louise Lilien-Wolkonsky, Prince Alexander Wolkonsky, Princess Zenaïde Wolkonsky, Nadeïde Wolkonsky-Illijn and Vladimir Pavey.

The timing of the request is uncertain, but it seems most likely that it was accepted in 1857, and that Nadeïde was in Rome later that year.[17]

A family group photograph (Fig. 3.3), said to have been taken in 1857 (according to one source)[18] shows Princess Zenaïde Wolkonsky (senior), seated holding Nadeïde who is standing on a chair, a relatively young-looking Alexander behind her, and his wife Louise seated under a dark veil; on either side of the central group stand Zenaïde's sister, Maria Vlasov, and Vladimir Pavey. Nadeïde in this image looks very like the little girl in Fig. 3.2, even to the dress, suggesting that the two photographs may have been taken about the same time, conceivably on the same day.

The evidence so far identified does not readily amount to a provable sequence of events. But a bit more analysis strengthens the probability that it is correct, whatever the dates given in the family's account. Louise's veil suggests she may have been in mourning for her own lost child, which in turn indicates that the photograph was made at a date fairly near little Zenaïde's death, though mourning periods may have been long. The veil might also suggest that Alexander was acting quite quickly to establish that he had an heir, and one that his mother acknowledged by her participation in the photograph. Vladimir's inclusion could indicate that he had a hand in brokering Nadeïde's adoption with the Illijn family in Russia. But all that only works if the adoption occurred much earlier than the 1867 reported in the family account. By that year Princess Zenaïde had been dead for five years. Moreover, Maria (assuming that she is correctly identified in the picture) died in 1857. On the other hand, in that year (the attributed date of the photograph) Nadeïde would have been at best somewhat less than three years old – and it could be argued that the girl in the photographs looks older than that.

The simplest way to resolve the inconsistencies is to postulate that the Campanari family account of Nadeïde's adoption is out by ten years (probably the result of a simple copying error) and the other dates are broadly correct. Otherwise it would be necessary to assert that Maria is incorrectly identified and the family photo is mis-dated, being actually taken in 1860 or 1861 shortly before Zenaïde (senior)'s death, when Nadeïde would have been around six years old – but then who is the 'Maria' figure? Another rather remoter possibility is that Nadeïde had already come to live with the Wolkonskys in 1857, and that the formal adoption process took ten years.[19]

So, while we can conclude that a daughter named Zenaïde was born to Louise and Alexander, we still cannot be sure when she lived and died, though 1853 is a plausible date for her death, nor

precisely when Nadeïde was born or appeared on the Wolkonsky stage in Rome, though 1855 and 1857 appear to be the most likely.

Louise died on 1 February **1870** and was buried in the church of Santa Maria della Pietà in Camposanto in the Vatican, known as the Teutonic Church and Cemetery. The directory of the burials there records her date of death as 13 February 1871 and burial 15 February; it adds that her remains were exhumed and reburied on 9 June 1881 beside her husband in the Campo Verano cemetery – as an Orthodox Christian, Alexander could not be buried at the Catholic Camposanto.

In 1857 the senior Princess Zenaïde gave her property in via degli Aragonesi to the order of nuns with whom she had been working, establishing girls' schools, and shared her quarters with the nuns.[20] (Once that happened, at least, Alexander and his family could not have been living with her at the same address!) Late in life she took the poverty vows of a Franciscan tertiary, under which she subjected herself to rules similar to those of the ordained orders but without the commitments and duties of the latter. She died on 5 February **1862**, having, according to legend, contracted pneumonia after giving her warm skirt to a poor woman in the street. She was buried alongside Nikita and her sister Maria, whose bodies she had placed in a tomb she had bought three years earlier in her parish church of Santi Vincenzo e Anastasio near the Palazzo Poli at the Trevi Fountain in Rome. Alexander had respected her wish to give her house to the nuns; but he was already legally the owner of the Villa. Not only does the 1848 Deed of Gift testify to that, but a document of late 1862, written on his behalf by his lawyer Filippo Ricci, described Alexander as heir and *donatario* (beneficiary) of the property, confirming that his mother had in fact given it to him at the earlier date, in accordance with the deed.[21] The transfer was not, however, documented in the Land Registry until 1868 – perhaps coinciding with need to register the gift of the property to Nadeïde.

Zenaïde's unstinting search for fulfilment had led her finally to renounce worldly goods and devote herself and her remaining property to helping the poor, especially girls. Her marriage had not been a success, though she was reconciled with Nikita in his last years; after moving to Rome her travel in the Russia and Europe of culture, art and philosophy, to which she had devoted so much energy, had palled as the environment became less tolerant and open, and she had felt constrained to stay away from her home country and most of her family. Alexander, for whom she had worked so hard, must have been a source of pride. Although his disregard of her wishes in relation to a chapel at the Villa Wolkonsky suggests that he did not take her passions entirely seriously, he had helped her (up to a point) in dedicating much of her wealth to her charitable work, contributing to the likelihood that she would have died more at peace with herself than she had been during much of her earlier lifetime. The Villa, preserved and enhanced by Alexander and his successors, remains a formidable monument to the life of an extraordinary spirit.

Alexander takes the Villa in hand

During Alexander's tenure six episodes or events, some recorded in notarial and other documents, are worth noting:

i) erecting a ceremonial gateway to the property, probably after 1848;
ii) a repair of the aqueduct in 1858/9;
iii) Alexander's addition to the house, and the trouble that got him into in 1862, plus the resulting papal solution;

Figs. 3.4 & 3.5. The state of the family crests (Beloselsky above, Wolkonsky left and Lilien right) on Alexander's entrance arch in 2019, after years of being covered and damaged by ivy. The inscription 'VIGNA CELIMONTANA' remains just legible along the lower edge.

iv) the excavation of the tomb nearest the house and the subsequent growth of travellers' interest in the Villa;

v) his conditional gift of the property to the 12-year-old Nadeïde in 1868; and

vi) his purchase in 1868 of additional contiguous parcels of land.

The gateway

Alexander erected a ceremonial neo-Gothic archway (Plate 39) at the Villa's entrance from the access lane (then via della Scala Santa, the last stretch of which later became the present via Amedeo VIII), on which were displayed the name 'Vigna Celimontana' and the arms of the Wolkonsky, Beloselsky-Belozersky and Lilien families (Figs. 3.4 and 3.5), as Pietrangeli correctly recorded.[22] This structure could have been erected to mark Alexander's formal possession of the property in **1848**; in any case it would not have been before his marriage to Louise in 1845. Since the stable building then outside it was only added to the property in 1868 it would have been a natural place to mark the entrance to the Villa during the years 1848–68. Now it only marks (on the wrong side) an access point to the house built where the stable previously was – the 'Old Minister's House', also occasionally known as the *Casa del Arco* or the *Casa del Acquedotto*.[23] Although Pietrangeli implied that it was no longer in evidence in 1973, the arch still stands, an almost forgotten nineteenth-century monument among so much grand antiquity. It had been allowed to become overgrown with ivy, and its condition has deteriorated since the 1980s when it was uncovered for a period. It is now (2019) uncovered again but in need of restoration.

1858 – Repairing the aqueduct

On 27 October 1858 the *Beni Culturali* (the Vatican predecessor of the *Belle Arti*, still in use by the City of Rome) received the report of the committee they had appointed to examine the aqueduct following reports (presumably from Alexander) of its dangerous state. Two places gave concern. The first was

the fall of the inside of the arch (*fornice*) of the first support on the right as you enter the Villa from via Scala Santa.[24] (This would have been at the western end of the stable buildings, subsequently converted into the 'Officials' House' or 'Minister's House' (272 on the sketch plan at Plate 3) – a point in the aqueduct which needed yet further attention as the years passed.) Columns and supports remained, but one showed signs of further disintegration.[25] If conservation was the aim, it had to be repaired.[26] The second place was ten arches further eastwards – just before reaching what is now the garage complex – where the facing had become detached from the core at the top because of the ivy and other plants growing into the structure.[27] This would need consolidation at some cost: but the aim should be to stop further falls, not to restore. The committee concluded by reasserting the principle that the work should be at government expense to avoid creating private rights over public monuments, a principle also applied to the repairs carried out at Zenaïde's request in 1831. On 3 November the government agreed to pay. The inspector/surveyor, fittingly named Francesco Fontana, was unable to estimate costs when he called on 22 December, because access to the first arch was blocked by the fallen rubble. Ten Scudi were paid in February 1859 to have the rubble moved. And the work was then carried out.[28]

1862 – Adding to the *casino*; trouble with the Pope

Not only do we not know when or even whether Alexander (and his wife) moved into the *casino*, we do not know precisely when or by how much he had it extended. Pietrangeli notes that the 'second casino, built in brick, beside the first must date from' the time when Alexander and Louise lived there. The truth, in any case more complex than Pietrangeli suggested, is masked by the subsequent, substantial German additions to the building. City maps of the period give little clue. They vary widely in their representation of the structures attached to the aqueduct – some show something on both sides of the aqueduct, some show nothing at all. Many of them would have been produced by map-makers who would not have bothered to survey in any detail such an insignificant building on private land, and just copied from earlier maps. Some maps from the years just before the construction of the current residence (1886–91) show a quite large structure. A print in the author's possession shows the *casino* in 1864, still modest but quite substantial (Fig. 3.6). When Alexander died in 1878, it was listed in the Land Registry as a summer house having 18 rooms on four floors. (But of Alexander's troublesome improvement project itself no trace has come to light.)

A rational deduction from the presence on site of a committee (or some members of it) looking at work to be done on the aqueduct in 1858/9 would be that Alexander had, at that stage, not enlarged or altered Zenaïde's original *casino*. Whether he had the work done before he left for his post in Dresden or commissioned it on his return, it must have been completed before 1862, because that is the year in which the project got him into serious trouble with the papal government, involving the Pope himself. The tale is related with great immediacy in the 1862/3 files of the Ministry of Commerce and the *Belle Arti*.[29]

By unfortunate coincidence, the shortage of water for Rome's growing population had led the authorities to survey the ancient aqueducts, to see if any could be reconditioned to relieve the demands on the Aqua Felice, a Roman-era aqueduct and channel still providing water to the city – then and today. So the inspector/surveyor from the water department, the same Francesco Fontana, visited the site in August 1862. He reported to his superiors that he had found a structure not in his records. It contravened the rules about the correct distance from the monument (aqueduct). (This implies that by then there

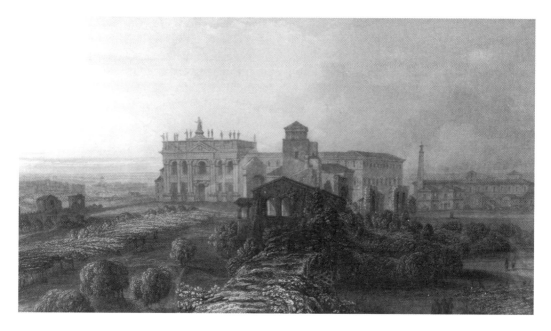

Fig. 3.6. An engraving from 1864 showing the casino at the Villa Wolkonsky after its enlargement by Prince Alexander (drawn by W. Brockedon from a sketch by Wolfenberger).

was a code of practice for the interpretation of the rule that nothing should be built so close to a monument as to interfere with it.) He recognised that the foreign prince might have acted in ignorance of the law, but he was in contravention both in fact and for not having sought prior permission.

Alexander was about to take up his post in Madrid. He did not delay his departure (on 23 September, according to his safe conduct, preserved in the Houghton Library), but on 20 September gave his lawyer, Filippo Ricci, his power of attorney, with full authority within the Papal States for all sums and acts relating to the vineyard behind via Scala Santa 4, including selling or mortgaging it to meet family expenses or other unexpected reasons, setting the sale price or the size of the loan, and to represent him in court as necessary. He got Ricci to write a grovelling letter to Pope Pius IX himself, through a senior member of the Vatican staff.[30] The letter related how Alexander, heir and beneficiary of his late mother, who had bought it from the Princes Massimo, was owner of a vineyard on which existed, apart from the *casino*, several other structures (*manufatti*) which 'with permission or toleration have since time immemorial leaned against the arches which used to serve as an aqueduct'. The *casino* had no wood store, stabling or housing for the vine-keeper, so he had added a small structure (*fabbricato*). He had used as one of the walls an arch, long since closed with brickwork, but without touching the wall, simply covering it with pleated textile interior hangings (*arricciatura interna*). Whatever the technical arguments, it looks suspiciously likely that Alexander had added a good deal more to the *casino* than the submission to the Pope would lead one to believe.

Ricci naturally protested to the Pope that his client had acted in good faith and wished to conform to the law. He argued that many breaches of the rules had been allowed, including the building of the *casino* itself, which was bisected by the aqueduct. He claimed that the ministry officials were hesitating because the law required the offender to make good the damage (i.e. pull down the new structure).

They wanted a committee to assess the damage; but there had been no damage, apart from covering over a tiny part of an enormous wall, which remained visible and intact and was anyway not itself a monument. (Presumably the wall was assumed to be much later infill to the original arch than twentieth-century investigation showed to be the case.) The prince wanted the matter dealt with before leaving to take up his post in Madrid (where the Russian Mission had just been upgraded to a full embassy). If the matter could be settled he would have every incentive then to look after the wall, which he had conserved rather than damaged.

Ricci's appeal was at first not judged ripe for submission to the Pope. The minister was asked instead to commission a report by a senior inspector/surveyor: he turned to none other than Francesco Fontana, by then promoted a knight (*cavaliere*). Fontana reported bluntly on 13 November that there was now an unauthorised structure where before there had been a primitive wine-press (*torchio*). The hole made in the wall where the press had stood had been filled in with antique bricks from those lying about on the site.[31] He recommended acceptance (*rassegnarsi*). But that did not convince the minister either.

A committee was appointed to give a legal view, which it did on 22 November. (The speed when the Pope was personally involved is notable.) The committee did not like the situation at all. The wall covering made the place base and common (*vile e comune*). New holes had been made to take the beams supporting the new structure. Of course the aqueduct was a monument, and there was a law on damaging monuments. And if it were to be used for water again the whole unauthorised (*abusivo*) dwelling would have to go. The law would require its destruction. Private building on public property (the aqueduct, not the land) without express permission was illegal. The incontrovertible conclusion was that that the building should be demolished. A public aqueduct which could return to use could not fall into private hands. (As much of this bombastic tirade was based on the false premise that the aqueduct might be needed to carry water, it may have been designed deliberately to give the minister or the Pope an excuse to follow Fontana's recommendation, given the enormity of the proposed penalty.)

Ricci was asked in February 1863 if he wanted to comment further before submission to the Pope. He responded with a full acknowledgement from the prince that he had erred and several undertakings of good behaviour. On 15 April Ricci was notified that the Pope, having reassured himself that, if he exercised his clemency (*grazia*) he would not undermine the law, had duly delivered his *grazia*. All this to a Russian Orthodox diplomat, not even appointed to Rome, who had not followed his mother in converting to Catholicism, and had with careless arrogance ignored the rules applying to his property! The recent death of his mother, so conspicuous a convert, so well connected in the Vatican and renowned for her good works – but equally cavalier in her disregard for the rules – must have played a part in the dénouement of this little drama. The outcome was all the more remarkable given the backdrop of rapidly deteriorating relations between the Pope and the Tsar over control of the Catholic Church within the Russian sphere of influence, especially in Poland, which came to a head in the 1863 Polish uprising and its suppression. Perhaps the Pope hoped to score a point or two with the Tsar in that context.

The story did not end there. It had one more important consequence. The Pope's *grazia* was translated by one of the prelates in the Curia into a strict set of conditions imposed on the prince. These were:

1. No further extension of his habitation at the monument: he was restricted to occupying only what was depicted on the plan submitted (sadly not extant). He must declare the plan correctly represented his current occupation and that he would not extend it even by the simple closure of an arch.

2. There must be no damage or demolition of the monument.
3. If the aqueduct were reactivated there could be no claim for indemnity for demolition of the houses or the walls, and he must not object to the reactivation.
4. Any repair to the new construction must be submitted in advance for approval by the minister.
5. He would be responsible for making good any damage to the monument but work could only be carried out with the advance approval of the minister.
6. He must bind his heirs and successors to respect the same conditions and to maintain the modern structures; and these conditions must be incorporated in any contract of sale in case of alienation; and the minister must be informed of any such sale.

The list may sound like the shutting of stable doors after the horse had bolted. The conditions, now called *vincoli* (literally, chains) may or may not have been applied already in similar form elsewhere before they were visited upon Prince Alexander. But they not only show the authorities trying to prevent yet another abuse of the monument at the Villa – not unreasonable in the light of the actions of both mother and son – they contained the basic elements of subsequent Italian laws (especially that of 1909) and rules on monuments and their conservation and other obligations of private owners of such public monuments.

Alexander (and his lawyers) did not seem to have been overly impressed by the final condition. The transfer document of 1868 recording the gift *causa mortis* to Nadeïde did not explicitly mention the *vincoli*. The sale contract when Nadeïde finally sold the property in 1922 to the German Reich did do so, though only because by then they had been embodied in legislation of which the Campanari-Wolkonskys had been formally notified. Those *vincoli* have, throughout the UK's tenure, been a constant and often determinant element in any consideration of how best to organise the country's diplomatic estate in the city. So this instance in 1862 of insouciance by Alexander (like his disregard for his mother's wish that a chapel be built at the Villa) was not only a seminal moment in the history of the property but may have been an important stepping stone for the authorities as unified Italy tried to come to grips with the challenges of preserving the country's huge cultural heritage while labouring under a growing public deficit (which led the Finance Ministry to dispose of many monuments and antiquities). Perversely, therefore, Alexander's actions triggered one of the building blocks for Italy's formidable armoury for the conservation of monuments, antiquities and art treasures, thus helping to ensure that the Villa itself has remained remarkably well preserved and cared-for over the following 150-plus years.

1866 – Excavating the tomb of Tiberius Claudius Vitalis

Alexander had plans to improve the gardens. From 1860 to 1870 he employed (perhaps intermittently) an architect of some note, Gioacchino Ersoch, to embellish the gardens with appropriate small buildings. Ersoch had recently been appointed architect to the city authorities for the Campidoglio (Capitoline Hill): he was known for restoring buildings and marbles from antiquity. It is not clear whether he was able to realise many of his schemes, with Alexander absent for much of the decade in Madrid. The gatehouse eventually built in the 1890s on via Conte Rosso was also his design, though whether he supervised it himself is not known. One scheme which he did complete was the construction of a 'small wooden Swiss-style cottage'. It seems likely that this was the tiny cottage known in the twentieth-century as the gardener's cottage, located at the point where the access drive

from the modern entrance to the *casino*/chancery offices has passed through the aqueduct and turns right. (The building survives, though is neglected and overgrown almost to the point of invisibility – see author's photo at Fig. 3.7).

In the course of his work on the gardens in 1865, Ersoch stumbled on some remains, not far from the gardener's hut, when 'a vault collapsed'.[32] Given Ersoch's interest in restoring antiquities, the possibility cannot be excluded that he was in fact searching for more of the sort of fragments revealed by Zenaïde's work on the garden. The discovery diverted him from other work in the grounds, and he was able to ensure that he got much of the credit for the excavation, which he led. On 1 January 1866 Alexander applied for permission to have excavations made 'in his villa at the Laterano'.

Fig. 3.7. Side-view of the now abandoned and overgrown gardener's cottage, designed and built by Ersoch for Alexander Wolkonsky in the 1860s, showing its elaborate decorative scheme. The roof at top right is part of a neighbouring structure.

The application aroused no objection on the grounds that nothing was visible above the ground other than the aqueduct, and it would not be affected. Nonetheless the minister issued the licence on 16 February on condition that no digging took place closer than 20 '*palmi*' from the aqueduct and that a report be submitted weekly to the minister.[33] The dig had to be supervised by the ministry and begin within three months. Visconti, the head of the Antiquities Department, was instructed to monitor the dig personally. Alexander's past misdemeanours were too recent to have been forgotten. The excavation uncovered a well-preserved tomb, which had been erected for himself by one Tiberius Claudius Vitalis, an apparently wealthy freedman architect of the first century AD, and the nearby section of roadway, all of which can be seen today. And Ersoch was reported to have worked with great care and skill and taken all the necessary precautions to ensure conservation of and access to the tomb.

As early as 3 March Visconti reported the discovery of the tomb (*colombario*), which had clearly been found in the distant past and stripped of every movable object. But a large part was intact and bore an inscription, unusual in that it celebrated the memory of two architects, one a freedman of Emperor Claudius. Visconti told his minister that 'Pavey (representing Alexander Wolkonsky) has taken praiseworthy care of everything found, including other inscriptions and unimportant objects'.[34] He had done all he could to persuade Pavey not to refill the excavation, which could destroy the find, but to restore it and leave it open and accessible as 'an adornment of the Villa'. He thought Pavey would agree, but Visconti intended to write to Alexander himself, as he knew him well. In May the press reported the find of the inscription, and on 1 June the ministry asked for a report. By then Pavey also had Alexander's power of attorney, but it was Alexander's lawyer, Filippo Ricci, who replied formally to the top official in the ministry: the excavation had been suspended and a decision on its

future would have to await Alexander's return to Rome.[35] One can surmise that Alexander duly agreed, as the tomb remains open to this day, very much 'an adornment to the Villa', but by the time the UK acquired the property it was in serious need of conservation work. A modern sketch gives some idea of the scale of this discovery (Plate 4).

Travellers' tales

News of the excavation of the *colombario* brought a new, wider level of fame and interest to the Villa, especially its antiquities. It had become well-enough known to begin to feature in guidebooks to the city (e.g. Murray, Baedeker), but principally for its gardens. Travellers' diaries, memoirs and pictures referred to the gardens, though generally briefly, as there was no grand house or art collection to inspect. Although the grounds contained a substantial collection of Roman and other marble sculptures and artefacts, little or no attention had been paid to them. In spite of her reputation as a collector, both in Russia and later in Rome, Zenaïde seems not to have made an inventory of what she had amassed and displayed around the gardens and on the aqueduct, in spite of the promise contained in the 1848 Deed of Gift to Alexander.

In the 1860s the Villa started to be identified as the 'Villa Wolkonsky', Alexander's entrance arch (with the name Vigna Celimontana) notwithstanding. A conspicuous early example of it in a map is in the 1869 edition of Murray's guidebook.[36] The earliest reference so far found to the use of the name is in an account published in 1862 by one Miss Elizabeth Missing Sewell:

> We have paid a parting visit to a Villa – the Wolconsky [sic] – Russian or Polish of course. It is a complete bit of Rome, modern and ancient combined; acacias, ivy and roses twining together and forming a long avenue, and the Claudian Aqueduct being part of the garden wall. It will be my last Reminiscence of Rome, and a most lovely one.[37]

The location, on the ridge looking out to the two basilicas, Santa Croce and San Giovanni, had been on visitors' itineraries for decades, but it can initially have been no more than a simple country walk through vineyards and woodland, as depicted in the splendid view Miss E.F. Batty included in her collections of drawings, later etchings, dated 1819, of her travels in Italy and elsewhere in that decade (Plate 21). Zenaïde had invited many of her guests, foreign and Italian, to the gardens and the *casino* between 1830 and the 1840s. Fanny Mendelssohn was one such fairly frequent visitor; she was one of the first, in May 1840, to record the existence of a collection of marble sculptures and other objects, as well as providing us with an early – and famous – description of the *casino*.

> The Villa itself is no mansion but a simple house in the irregular Italian style which I find so charming, with the staircase standing free and visible from the outside. Through the garden lengthways run the ruins of the aqueduct, which they have turned to account in various ways, building steps inside the arches, putting seats at the top, and statues and busts are placed all over the old ivy-mantled walls. Roses climb up as high as they can find support, and aloes, Indian fig trees, palms, capitals of columns, ancient vases, and fragments of all kinds live, grow and tumble over and under one another. And millions of roses, in bushes and trees, arbours and hedges, all flourish luxuriantly enlivening the whole; they never look more lovely than when clinging to the dark cypress trees. The beauty here is all of a serious and touching type, with nothing small and 'pretty' about it. ... Nature designed it all on a grand scale, and

so did the ancients, and the sight of their joint handiwork affects me almost to tears.[38]

The way nature and ruins combined to charm writers and artists alike is epitomised by an etching by a Hanoverian artist, Georg Busse, from 1843–4 (Fig. 3.8).

Such accounts and pictures had spread the word, ensuring that some visitors were drawn to the Villa even after Zenaïde ceased to entertain there and Alexander and his family had taken over. It appears to have been possible for such visitors to walk freely over the grounds. That was the case for a German diplomat, Kurd von Schlözer, who wrote in 1864:

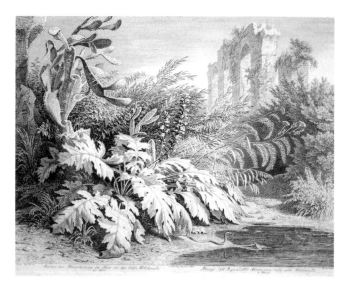

Fig. 3.8. Etching by Georg Busse (1810–68) in 1843–4 showing how the vegetation in Zenaïde's garden blended with antiquity.

We had at this time further garden pleasures in the Villa Wolkonsky, which one always enters with new delight. It was laid out by the late Princess Wolkonsky, mother of the Russian Minister in Madrid, who rarely visits the property. One can go in whenever one wishes. The park is divided in two by the splendid high ruins of the Neronian aqueduct, whose crumbling arches, covered with ivy, march clear through the summer house. On the South side of the garden, protected by the aqueduct, truly tropical vegetation has grown up, giant cacti nestle against the ruined walls; nearby waft wallflowers (Levkojen) and lilies; here and there, between mighty aloes one comes across an ancient sarcophagus with enchanting bas-reliefs or a fallen marble column over which glistening lizards scuttle. On the other side of the aqueduct stretch high bay laurels through which climbing roses raise their heads; then higher up white-flowering acacias are criss-crossed by roses and ivy climbing up together through them. The picture of a path through this scene, its green walls thick with roses, is indescribable. One Prince Trubetskoi in his Petersburg essay thought it looked as if the best Paris couturière had, with tasteful hand put each rose in its appointed place.[39]

Another German visitor in 1866 was the artist Albert Hertel who recorded his visit in a sketch (Fig. 3.9) showing the Basilica of Santa Croce in the background.

Alexander was probably used to seeing occasional strangers on the property in the years after he married and began to use it. The guidebooks suggest that it remained freely accessible throughout the 1860s. But if, after their return to Rome from Madrid Alexander and his wife were living there with their nubile daughter, and the attractions of a visit included the by then well-publicised find of the colombario very near the house, which the guidebooks began to include as a matter of course, following the lead given by Murray in 1867, the impact on their privacy can be easily imagined. By and by some precautions needed to be taken, first by charging for entrance and later by arranging for permits to visit the Villa to be issued on application to the Russian consulate in Rome.

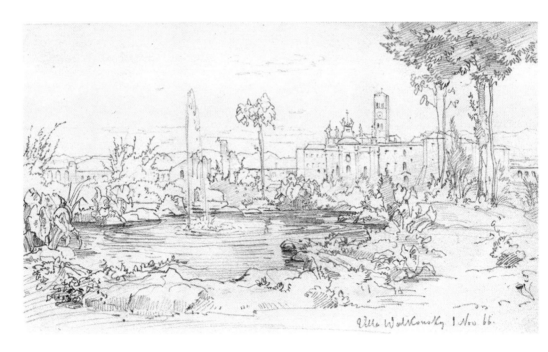

Fig. 3.9. Albert Hertel's sketch Im Park der Villa Wolkonsky, *1 November 1866. The pond is still there: the view is not.*

Murray's 1867 book duly recorded the excavation of the *colombario*:

> The villa Wolkonski, formerly Palombara [sic], on the Esquiline, occupies with the villa Massimo, a considerable extent between the two roads leading from Santa Maria Maggiore to the Basilicas of the Lateran and of Santa Croce; it is now the property of a Russian princess. The grounds are handsomely laid out. From the highest point there is a fine view over the Campagna, the Alban Hills and the line of the Claudian Aqueduct, which carried its waters from the Porta Maggiore to the Caelian. A curious Colombarium, consisting of 3 chambers superposed, has been opened in the grounds of this villa, near the aqueduct; on the front which faced the ancient via Labicana is an inscription in fine Roman characters, stating it to have belonged to a certain T. Claudius Vitalis, an architect, and erected by Eutychius, one of the same trade; it is of brick, and supposed to date from the time of Nero. The terracotta sarcophagus in the lower chamber, with bones, is of a much later period. Strangers are admitted into the grounds at all hours. The Casino is a mere garden-house, and devoid of interest.[40]

The erroneous reference to Villa Palombara was removed from the 1888 and subsequent editions, which also expanded on the gardens: '... arches of the Neronian Aqueduct, which carried the Claudian water from the Porta Maggiore to the Caelian'.[41] The glancing reference to the *casino* is interestingly dismissive, even after Alexander's enlargement of it.

In the same year (1867) the first English edition of Baedeker's *Central Italy and Rome* included the following brief reference (being translated from the German edition of 1866 it had no reference to the *colombario*):

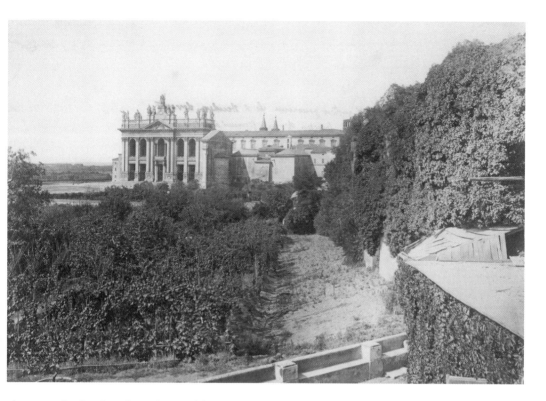

Fig. 3.10. The view from the top loggia of the casino probably taken between 1860 and 1890, showing vineyards and part of the Scala Santa structure (though without the tower shown in the print at Fig. 3.6; in the foreground is the wall of the original casino garden enclosure seen on many contemporary maps.)

Villa Wolkonsky accessible daily; the street to the l[eft] by the buildings adjoining the Scala Santa, pursuing a straight direction beyond the 3rd arch of the aqueduct, leads to the entrance-gate. The tastefully laid out grounds are intersected by the Aqua Claudia, on and near which various antique fragments are immured. Fine view of the Campagna and mountains.[42]

Subsequent Baedeker editions were expanded: in 1872 it read

Villa Wolkonsky accessible on Wednesdays and Saturdays. The street to the l[eft] by the buildings adjoining the Scala Santa, pursuing a straight direction beyond the 3rd arch of the aqueduct, leads to the entrance-gate (fee ½ fr.). The tastefully laid out grounds are intersected by the Aqua Claudia, on and near which various antique fragments are immured. Several Roman Tombs of the early period of the empire have lately been excavated here. Fine view of the Campagna and mountains, especially toward sunset, from the roof of the small casino, to which the gardener conducts the visitors if desired (fee ½ fr.)[43]

The view from the roof would also have allowed a fine view of the façade of the Basilica of San Giovanni and the Scala Santa complex beyond the vineyard and the ivy-covered aqueduct (Fig. 3.10). Finally, in the 1877 edition, came the addition of a reference to the need for permission:

Wednesdays and Saturdays, from an early hour till dusk. Permesso for 6 persons obtained through a consul or banker ...[44]

Augustus Hare in his *Walks in Rome* of 1876 picks up on the need for permission and speaks warmly of the Villa:

Behind the Scala Santa a narrow lane leads to the Villa Wolkonski (a 'permesso' may be obtained through your banker), a most beautiful garden, running along the edge of the hill, intersected by the broken arches of the Aqua Claudia, and possessing exquisite views over the Campagna, with its lines of aqueducts to the Alban and Sabine mountains. No one should omit to visit this Villa.

Where the aqueducts, just about to enter the city, most nearly converge, and looking across the Campagna ... towards Albano and the hills, stands the Villa, embosomed in Olive and Ilex trees, it is rich in hoar cypresses, in urns, and in those pathetic fragments of old workmanship which an undergrowth of violets and acanthus half hides, and half reveals.

Fig. 3.11. *A version of a statue of Athena Parthenos of Fidia, photographed at the Villa Wolkonsky in 1905.*

The late nineteenth century saw the Villa feature as a setting for romance in *Daniele Cortis*, a novel by Antonio Fogazzaro (see also Chapter 4, note 19) and in *Italian Hours*, Henry James's 1909 collection of his Italian diaries:

You may watch the whole business from a dozen of these choice standpoints and have a different villa for it every day in the week. The Doria, the Ludovisi, the Medici, the Albani, the Wolkonski, the Chigi, the Mellini, the Massimo – there are more of them, with all their sights and sounds and odours and memories, than you have senses for.[45]

The historian Giuseppe Tomassetti visited the site in 1870 and recorded how the 'villetta' had become 'a small museum of sculptures and stones' and had 'yielded ancient marbles in enormous quantity and even the ancient paved roadway [*lastricato*] of the Via Labicana'. A German scholar, Friedrich von Duhn, completing in 1881 work of cataloguing collections of antiquities in Rome – including private ones – begun by his late friend Friedrich Matz (between 1867 and 1870), included a list and brief description of the marbles in the Villa, the first inventory of the antiquities on the site.[46] Another German, studying a statue of Athena Parthenos by Phidias, used the version in the Villa to illustrate his work in 1883 (Fig. 3.11). (An expert summary account of the collection by Raffaella Bucolo is at Appendix I.)

The extracts from guidebooks (especially the ½ franc tip to the gardener to conduct visitors to the top of the stairs) strongly suggest that Alexander and his family, while possibly using the

Villa as their summer retreat, were not in permanent residence, even in the 1870s. Yet it is clear that he had spent time and treasure on enlarging it to form a reasonably substantial dwelling – though it would have been cold in winter! One possible way to square this circle would be to surmise that he used it regularly as a guest house: that would be consistent with family records suggesting that the Villa became a pole of attraction for the Russian community in Rome during the 1870s. But it leaves unsettled the question whether Alexander and his family did in fact use it in those years as their main home. Only one image, claimed to be of a living room (*salotto*) in the Villa, has come to light. It

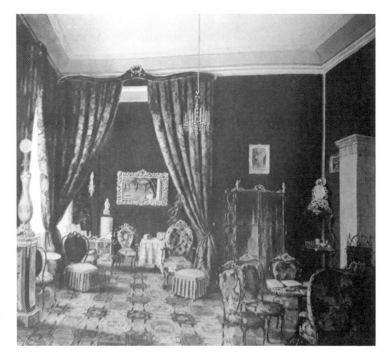

Fig. 3.12. Watercolour by an unknown artist of a reception room at the Villa Wolkonsky, designed to impress rather than be comfortable and giving few clues about the room or house (probably 1850–60, reproduced in Praz op. cit., p. 62).

is a watercolour, presumably painted on site, reproduced in a book about interior decoration styles.[47] While the photograph (Fig. 3.12) is black and white, the book's author wrote that the walls were of a dark turquoise, and the curtains a deep red which was also the dominant colour of the carpet and the table at the far end of the room. He also commented that the balloon-back chairs were typical of the period 1850–70 and the style as a whole of the 1850s. But while it tells of a lavish furnishing style it offers no clue to whether the house was lived in or only used to entertain. It could have been the main reception room on the *piano nobile*, an extension by Alexander of the small room beyond the curtain, with the windows on the left looking over the southward panorama.

1868 – The gift to Nadeïde

In 1868, while away in Madrid as Russia's Envoy Extraordinary and Minister Plenipotentiary – presumably with his wife Louise and the 12-year-old Nadeïde – Alexander drew up a deed of *Donazione Causa Mortis*, a sort of trust document relating to the Villa. In the event of his death the Villa and the buildings left him by his mother plus any extensions etc. would pass to Nadeïde in the state they were in on his death, unless revoked directly or indirectly.[48] The rationale for this

action is uncertain. Perhaps as a minor Nadeïde would not have been eligible to inherit property simply on the basis of a will; additionally her status as an adopted child might lead to her inheritance through his will being contested by other members of the large Wolkonsky family, leaving her homeless and penniless. One possible ground for a challenge could have been a claim that Alexander had not fulfilled his mother's conditions, there being no Catholic chapel on the property; or that Nadeïde, not being a Wolkonsky by birth did not qualify under Zenaïde's conditions of gift, thus consigning the property to the named charity. There may have been an element of avoidance of death duties too. He was only 57, so unless he was ill – and there was no evidence that he was – there was no obvious reason for the urgent timing of this action, other than pure caution. Nonetheless the eventual passage of the property to Nadeïde was secured. The odd feature, by comparison with a modern trust (at least in the UK), was that in the meantime all Alexander's rights in the property – including disposal – were preserved in full until such time as the gift was proved to be in full force because of his death.

Alexander appointed as special trustee or executor of the Deed of Gift Vladimir Pavey, his presumed half-brother, who had supervised the excavation of the *colombario* in 1866. Pavey's appointment ensured that Nadeïde's future would be safe in the hands of someone Alexander could trust completely and was well connected in the Vatican.[49] The deed was signed in Madrid by Alexander on 19 March 1868, witnessed by a member of his staff, Prince Galitzine, countersigned by the papal nuncio and registered in Rome on 28 May 1868. Because Nadeïde was a minor, the deed had to be accompanied by the appointment of guardians for her, to safeguard her interests in the property. The chief among them was Giulio Vera, a lawyer, who formally accepted the charge. These subsidiary documents were completed in May and the deed notarised (by Torriani) on 29 May. It is a bit of a mystery that the transfer of the property from Zenaïde to Alexander was only registered in Rome on 20 March that year: perhaps just another example of Alexander's inattention to the legal niceties, revealed when he was working on the Deed of Gift.

1868 – Alexander buys more land

Later that year, on 6 November, Alexander (back in Rome from his Madrid posting) bought from the Chapter of the St John in Lateran Basilica five parcels of land adjacent to the Villa (Land Registry numbers 267, 267.1, 268, 271 and 272 – see Plate 3), and on 30 December they were consolidated into the property. This proved a very smart move, as with the arrival in 1871 of the Savoy royal family and their court to Rome from Florence, the city developed rapidly, not least towards the south-east. Alexander's heir, Nadeïde, and her husband were able to finance the building of a much larger house on the property through the proceeds of later sales of much of Alexander's acquisition (but not 272 which remains a part of the property).

1878 – Alexander dies, Nadeïde inherits and marries

Alexander's wife Louise died on 1 February 1870, not long after the family's return from Madrid, and was buried in the 'German Church' on the edge of the Vatican.

In May 1873 Alexander made his own will, which not only confirmed the gift of the Villa Wolkonsky to Nadeïde but also explicitly incorporated in the bequest the additional properties around

it which Alexander had bought on 6 November 1868.[50] Family records suggesting that during the 1870s he was appointed Russia's envoy to the papacy are not reflected in Vatican directories of the decade. That does not exclude an informal role, and he has been credited with working hard to promote good relations between Russia and the papacy.[51] He would in any case probably have had time to oversee work on the garden and to spend time with Nadeïde. A photograph of him, with Nadeïde (then a teenager), suggests a kindly, avuncular figure, alert but not sharp (Fig. 3.13). At that stage he might have taken naturally to the role of grandee of the Russian community in Rome, as family records suggest. Her pose hints that it might have been taken on the occasion of her engagement.

Alexander died on 14 April 1878, aged 66; his will, confirming the Deed of Gift to Nadeïde, was read with due formality on the 18th. Nadeïde inherited the Villa and the additional land. But it took time to execute: Nadeïde, having had her father 'provisionally' buried in the Verano cemetery, had to apply for an extension of that provisional arrangement until the end of the

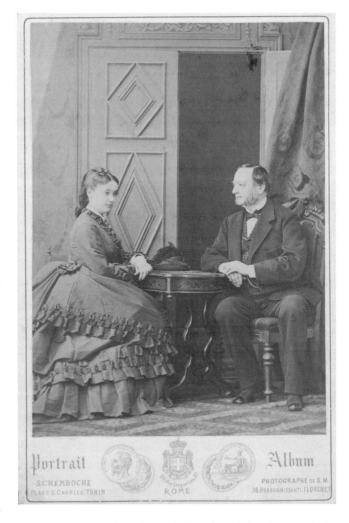

Fig. 3.13. Prince Alexander with his adopted daughter, Nadeïde, possibly in the Villa Wolkonsky in the 1870s.

following April while she 'dealt with succession issues in Russia'.[52] She promptly appointed the lawyer Giulio Vera as her attorney in respect of all her property, including the Villa, 'in the interests of Nadeïde Wolkonsky', i.e. protecting the property against any claims or other challenge to her rights of ownership. The transfer of the Villa was registered by the Land Registry on 20 October 1878, following an application (certificato di denuncia) dated 13 October, and the property is defined as land plus a summer house (casino di villeggiatura, implying incidentally that it was not Alexander's main residence) of 18 rooms over four floors and garden (orto) at via di Santa Croce 20 and via Labicana 4.

In the same year Nadeïde married Wladimiro Campanari. The family was originally from Veroli near Frosinone, south of Rome; its head in 1753, Agostino, had been appointed by the Pope Marchese of Castel del Massimo nearby. Wladimiro's father, Francesco, had married a

Russian, Barbara Polivanov, related to Nadeïde's Illijn family. Wladimiro was their second son (born on 18 August 1852), and thus at least a distant cousin to Nadeïde. Surviving family records have them probably meeting at the Villa Wolkonsky, which during Alexander's later years had become again something of a gathering point for Russians in Rome. The received wisdom about Wladimiro has been that he was a banker; that may be true, but there is no evidence to support it. The family now only know him as an artist: among other subjects he painted a portrait of his own son Alexander. One report has him described as a wastrel, dissipating the Wolkonsky fortune; but in the circumstances that seems a bit harsh.[53] However he seems to have left little trace of the person he really was.

Campanari, the artist, continued the family interest in the antiquities on the property. Two excavations were carried out. In **1881** the excavation and uncovering, probably by Lanciani,[54] was reported of the Servili tomb, then within the Villa but 20 m from the new via Santa Croce in Gerusalemme and 10 m north of the Neronian aqueduct. It was a three-storeyed tomb. Over its doorways on the street side was a 2-m-long travertine bas-relief with six busts all (possibly except the child) of the same Servili family. Further epitaphs were discovered inside.[55] In **1889** G. Gatti reported on the find of two burial 'cippi' (low funerary columns with an inscription), near each other and probably forming a single monument.[56] The location was not given, but Lanciani[54] appeared to place them on the same line as the *colombario* of Tiberius Claudius Vitalis and about 20–30 m to the west of it. Apart from some interesting lists of names, there were few clues to the tomb's origins.

The Campanari-Wolkonskys left their principal mark on the property by their decision that the old villa, even as surreptitiously expanded by Alexander, was not suitable as a family home. As they eventually had four children (Caterina, Zenaïde, Alessandro and Wladimiro), they would sooner or later have needed a larger house, not least because they would not be allowed to extend the *casino* any further. They must also have been able to reckon that they could finance a new project from the sale or prospects of sale for development of much of the additional land bought by Alexander in 1868. But it took them more than a decade to complete the project.

Notes

[1] He was awarded a medal by King Johann on his departure in 1860 – HLHU.

[2] He obtained a diplomatic safe conduct from Moscow to Naples on 15 March 1860 – HLHU.

[3] His laissez-passer from Rome to Madrid was dated 23 September 1862. A document in the HLHU has him still there on 29 September 1869, but that seems unlikely to be correct.

[4] AdS. Torriani 1848.

[5] The source of the funds is, however, not clear.

[6] Referred to as 'by A. Volkonsky, Member of Rome Academy. Parts 1–2. Moscow, 1845 (2 volumes)', by Olga Solodiankina, in *The Journal of Regional History* 2017, Vol. 1, No. 1, p. 16 at http://hpchsu.ru/3896c5479174dc7be161ef7bf2050f5d.pdf.

[7] See note 41 to Chapter 2.

[8] She was born in 1807 in Werl, Westphalia, the daughter of Leopold von Lilien, a Chamberlain to the Grand Duke of Hesse, and Charlotte Freiin (or Freyin) from Aachen. She had been married to a Freiherr von Herding, but that marriage had been dissolved.

[9] HLHU Wolkonsky papers.

[10] A website named https://clever-geek.github.io/articles/918810/index.html [accessed in April 2020].

[11] Pietrangeli, p. 432.

[12] Quoted by MF (p. 258, n. 26, from the archive of Order of the Sisters, Adorers of the Most Precious Blood, Rome).

[13] The website https://gw.geneanet.org/kondratieff?lang=fr&n=von+lillien&oc=0&p=louise+leopoldovna notes of Louise that she died on 1 Feb 1870; that she married [no date] 'Alexandre Nikititch VOLKONSKY, Prince, né le 18 novembre 1811, décédé le 2 avril 1878 à l'âge de 66 ans (Parents: Nikita Gregorievitch VOLKONSKY, Prince 1781–1841 & Zinaïda Alexandrovna BELOSSELSKY BELOZERSKY, Princesse 1789/1792–1862)' and their children were:
- Zinaïda Alexandrovna VOLKONSKY, Princesse 1849–53
- Nadejda Alexandrovna VOLKONSKY, Princesse
The error in Nikita's date of death does not increase one's faith in the accuracy of the other information, but precision is, as the author has discovered, elusive.

[14] AdS. Torriani: two deeds dated 21 February 1851.

[15] AdS. Torriani 1846.

[16] The main source here is the Campanari family account. The speculation is the author's own. One wonders why Illjn should have wanted to have his eldest child adopted. 'Hard times' seems an unlikely explanation: the couple went on to have 11 more children. Was it perhaps to ensure that his legal first-born and heir to the property was a boy?

[17] The Campanari account has Alexander receiving the request from Illjn in 1866 and agreeing to it in 1867, with Nadeïde joining the family in Madrid at the age of 11 or 12. That account does not, however, stand up well under scrutiny. It is thrown into doubt first by references in sources such as the website mentioned in note 10 and second by the photograph of her as a very young girl with Prince Alexander and the other relatives. A communication from a Russian expert consulted by Danilo Campanari stated that Nadeïde was adopted as a new-born infant in 1855 (which is corroborated by the website mentioned at note 10), as well as repeating little Zenaïde's birth and death dates as 1849 and 1853; see note 13.

[18] Wikimedia Commons, Public Domain: search 'Zinaida Volkonskaya'.

[19] This last possibility could explain the timing of Alexander's decision in 1868 to make his gift of the Villa to Nadeïde.

[20] A loan she had taken from one Salvatore Gauttieri in 1855 in connection with some house purchase was paid back in 1856, probably with Alexander's help, perhaps so that it could be passed on unencumbered to the nuns.

[21] AdS. Min Commercio/Belle Arti, Sez 5 Tit 1 (Antichità & Belle Arti) B361 doc 43.

[22] Pietrangeli, p. 430.

[23] See also Chapter 21.

[24] 'fornice interiore della prima armazione che si trova a destra entrati nella villa'.

[25] 'scillegati e piedritti'.

[26] Bailey, while scathing about the quality of the repair, seemed uncertain about the date it was carried out.

[27] Bay 10 – see Fig. 17.1.

[28] AdS. Min Commercio/Belle Arti, Sez 5 Tit 1 (Antichità & Belle Arti) B355 doc 49.

[29] AdS. Commercio/Belle Arti, Sez 5 Tit 1 (Antichità & Belle Arti) B361 doc 43.

[30] AdS. March 1868 Uff 8 Rep 39, p. 458.

[31] This account may be true, but it raises a question: Bailey (1956) recorded evidence of space for a shed, possibly containing an oven, having been carved out of a pillar of the aqueduct to the east of the casino. The location described does not fit easily with the tale told on Alexander's behalf by Ricci. The resolution of this small riddle may depend on the eventual tracing of lost German records from the 1920s, when they converted the casino into their embassy office/chancery.

[32] Publicity by a German archaeologist, Bergau, R. (1866) Sepolcro antico scoperto nella villa Wolkonski in Bullettino dell'Istituto di Corrispondenza Archeologica: 112–17, quoted by Bucolo (2), p. 5, quickly drew attention to the find and ensured that it would be properly excavated.

[33] See note 36 to Chapter 2. Whether these palmi are still of the same dimension as those referred to earlier is not possible to say; 1.5 m might seem rather close in the circumstances.

[34] Cav. Wladimiro Guglielmo Pavey, described as a property owner, resident in Rome at via della Maschera d'Oro 21, the son of Guglielmo, under a general and wide-ranging power of attorney which Alexander drew up in Madrid

on 19 May 1866, and Pavey had notarised by Torriani on 28 June 1867. 'Guglielmo' was likely to have been a convenient fictional father, ascribed to him years earlier, probably by Princess Zenaïde, when obtaining documents for him.

35 More of the story can be found in AdS. *Min Lav Pub & B Arti Sez 5 Tit 1 Art. 5a Scavi b* (407 – now 411) (28) for 1866 + b 359 & 363 *Monumenti* – for 1862 & 1866.

36 BSR Lib.

37 Sewell, Elizabeth Missing (1815–1906), *Impressions*, 1862, pp. 241–2, quoted in Bucolo (2), p. 1. The book was not published in her own name but used the formula '*By the author of Amy Herbert*', her best-known work (see Halkett, Laing, *Dictionary of Anonymous and Pseudonymous English Literature*, Vol. III, New York: Haskell House, 1971, p. 140).

38 Mendelssohn F., Weissweiler E. (ed.), 1983, pp. 114–15. Quoted in Bucolo (2), p. 3 (English translation is from: MF, 1999, pp. 228–9). I am indebted to Dott.ssa Bucolo for permission to use here some of the extracts which she had chosen for her own work.

39 Schlözer, p. 52, quoted in Bucolo (2), p. 4.

40 Murray, 1867, p. 336.

41 Murray, 1888, p. 412.

42 Baedeker,1867, p. 239. Taken from the English edition, as are subsequent quotations, a faithful rendering of the 1866 German edition *Mittel-Italien und Rom. Handbuch für reisende.*

43 Baedeker, 1872, p. 305.

44 Baedeker, 1877, p. 118.

45 James, H., *Collected Travel Writings: The Continent*, New York: The Library of America, 1993.

46 Matz, F., von Duhn, F., *Antike Bildwerke in Rom mit Ausschluss der Grösseren Sammlungen*, I–III, Leipzig: Breitkopf-Härtel, 1881–2, quoted in Bucolo (2), p. 5, n. 18.

47 Praz, p. 62, description at p. 40, painting (Anonimo, *Interno di Villa Wolkonsky*, acquarello c.1850/60), said to be in the Lemmerman collection; see also Chapter 4.

48 This differs markedly from the superficially similar gift from Princess Zenaïde in favour of Alexander himself in 1848, which was deliberately made irrevocable.

49 It is just conceivable – if unlikely – that, on the contrary, it was designed to tie Pavey's hands should he himself (possibly half a Wolkonsky) have had designs on the property.

50 By some reports he also left to Nadeïde all the family's Russian property (though this may have been executed only in the case of the main property at Urussovo), and the income from it. But the will opened in Rome on his death contained no mention of that. It is more likely that any such transfer or bequest would have been made separately under Russian law. Nadeïde certainly made over such as remained of that property to her son, Alessandro, during their stay in Russia before the Great War – see Chapter 4.

51 See note 10.

52 How long the 'provisional burial' of Alexander's remains in the Verano lasted is unclear, as the records at Santa Maria in Camposanto show that Louise's remains were transferred there to lie beside his in 1881.

53 It could be argued that he managed a difficult balancing act in selling parcels of land bought by Alexander to finance the construction of a grand mansion.

54 Rodolfo Lanciani, the foremost archaeologist in Rome in this period, notable especially for his lifelong work in compiling a splendid archaeological atlas of Rome entitled *Forma Urbis Romae* – see Bibliography.

55 NdS 1881, p. 137 (and noted on Lanciani's *Forma Urbis Romae*) and Fornari in NdS 1917, p. 174.

56 NdS 1889, p. 222.

4.
TIME FOR A PROPER MANSION,
BUT THE DREAM CANNOT LAST

Construction of the 'new' Villa Wolkonsky (1886–92) amid much local development

By 1880 the area around the Villa was beginning to change. The unification of Italy and the official move of the capital (and with that the King and court) from Florence to Rome in June 1871 were a stimulus to the city's economy, and property development was a natural outcome. The city was expanding, not least to the south-east. The railway had already come into the city (at the main Termini station) in the early 1860s, with the line passing a few hundred metres from Villa Wolkonsky, visible in Murray's 1869 map. A map of 1873 shows the first new post-unification City Plan (*Piano Regolatore*) agreed in 1871: the development line stops well short of the Villa Wolkonsky and Prince Alexander Wolkonsky's 1868 land purchases (Fig. 4.1). But the 1871 Plan soon needed revision. A second City Plan was approved in 1883, delineating further areas for development, this time including the immediate surroundings of the Villa. That also meant that new streets needed to be driven through and old ones widened (Fig. 4.2).

Development posed risks to the archaeology of the area, as everywhere in Rome. The *Comune* had set up its Committee for Archaeology (*Commissione Archeologica Comunale*) in 1871 to ensure that development respected the city's history and antiquities. The accelerating pace of building work in the Lateran area was accompanied by a frenzy of archaeological exploration of the sites about to be built upon before they were lost for good. This affected the area around the Villa and the property itself.

The Campanari-Wolkonskys could not have chosen a better moment to finance the building of their new house by selling off land. A consolidation of parts of the freehold plots, into which the existing *casino* is merged, is recorded in February 1883/4.[1] This coincided with the publication of the 1883 City Plan.

On the ground the *Comune*'s road-building plans were already causing a problem for the Campanari-Wolkonskys. In 1884 Wladimiro had to complain to the mayor, none other than Duke Leopoldo Torlonia, that the new via Emanuele Filiberto (being built to link the Porta San Giovanni with Piazza Vittorio Emanuele II) made it impossible to reach the main access to his property along the old via della Scala Santa which the new main road would cross at a much higher level. This received no response, but when the *Comune* needed Wolkonsky land for their further road-building in nearby streets, Campanari was able to do a deal with them. In 1885 they agreed a swap under which the Wolkonskys ceded a long thin strip of land to allow the construction of via Ludovico di Savoia along the south-east flank of the property in exchange for an odd-shaped piece of land surplus to the city's needs alongside the via Emanuele Filiberto, thus giving the Wolkonsky estate a valuable frontage along the new main road (Plate 5).

So good was the outcome for the Wolkonskys that an attempt by an assiduous *Comune* valuer in 1886/7 to overturn the deal as too favourable to them had to be seen off by the mayor. But the issue of the road level still held up the deal for months, and Campanari had to open legal proceedings against

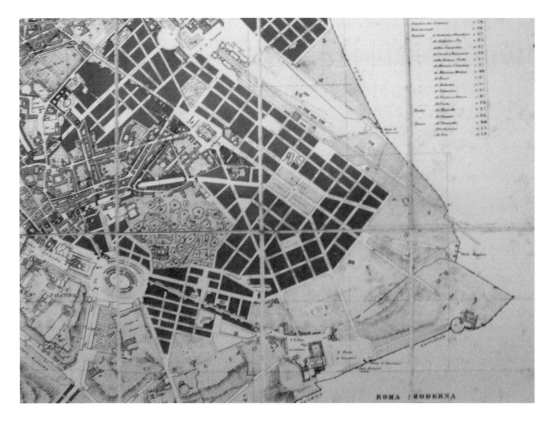

Fig. 4.1. A map of 1873 by Micheletti, showing the Rome City Plan of 1871: the Villa Wolkonsky (bottom right) is well beyond the development line, but the alignment of the new via Emanuele Filiberto is shown.

the Comune for deprivation of his right to free access to his property. As a result, in addition to rectifying the street level at the main road, Campanari obtained the creation at public expense of a new piazzetta on via Ludovico di Savoia where he could build a new entrance (where it still is). The Comune agreed the package on 10 March 1886, and the contract for the roadworks was let on 28 May.[2] The result is visible in the map at Fig. 4.2.

One of the earliest street realignment plans to affect the Villa Wolkonsky directly was when via Statilia was built in 1888 on a slightly different line from the earlier via Labicana. This involved some loss (through compulsory purchase) of small parcels of Villa Wolkonsky land, but some gain as well (see Plate 3). The work caused a portion of the Villa's external retaining wall to be moved. While new foundations were being dug the remains were discovered, 3 m below the street level, of 2.5 m of three channels – two as a pair, one superimposed – of the old underground water channel known as the Rivus Herculaneus of the Aqua Marcia (visible but not labelled in Fig. 1.5).[3] The finds sent to the Commissione Archeologica Comunale included the sculpted head and torso of a monkey with blue spheres for eyes, and white-painted pebbles for teeth. (Where those items finished up is unknown.)

A small avalanche of sales of fractions of Plot 267 through Notaries Polidori and Capo took place, first in July 1886 (almost certainly the swap with the Comune), then in June 1887, February and July 1888, and March, May, June and July 1889, providing land for the series of building projects in the

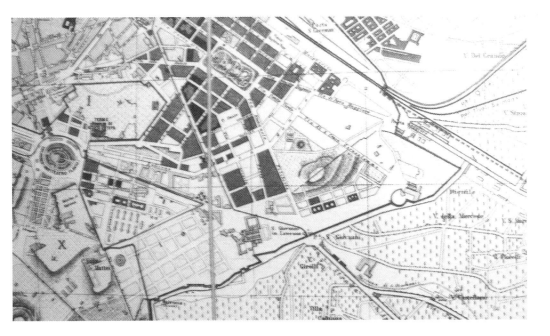

Fig. 4.2. *Part of a map by Virano (1889) showing the result of the 1883 City Plan, also the first blocks of apartments to be built in the new streets south of the Villa Wolkonsky.*

new streets.[4] In 1886 a developer obtained a contract from the *Comune* to build a new quarter on land 'sold by private owners' – some later maps even name it as the '*Quartiere di Villa Wolkonsky*' (Villa Wolkonsky Quarter – see Fig. 4.3).

The Campanari-Wolkonskys applied for permission to build a gatehouse (to the design done for Alexander by Ersoch) by the new entrance to their property (identified then as via Conte Rosso 25). But the main driver of the non-compulsory sales of land must have been to finance the new mansion they wanted to build. The first apartment block to be built on the south-east side, on via Ludovico di Savoia opposite the new main gates, bears the date 1887. Virano's 1889 map (Fig. 4.2), based on the second City Plan, shows both the Villa's new entrance *piazzetta* and the building opposite as the first to be completed, with three more under construction out of the many blocks provided for along via Ludovico di Savoia and neighbouring streets, some overlooking the Villa's land.

Having pocketed the swap deal the Campanari-Wolkonskys themselves applied to the *Comune* in September 1886 for planning permission for a '*villino*' (which in this case we might translate as 'mansion') within their property, the 'Villa al Celio'. It was to be on the highest point of the ridge, some 30 m from the *casino*. The Housing Committee approved it on 21 October 1887.[5] The *Comune* files contain no word about the *vincoli* or the newly created *Direzione Generale di Antichità e Belle Arti*. But the rules were still unclear at that time, and the new building was a safe distance from the aqueduct.

The conventional wisdom noted by Pietrangeli was that the architect was Giovanni Azzurri. But Pietrangeli, to his credit, doubted this, only to suggest that this was possibly a confusion with the architect of Zenaïde's *casino*.[6] He speculated that it was more probably Francesco Azzurri (1827–1901), nephew – *nipote*, which can also mean grandson – of the Giovanni Azzurri who had designed the *casino* and a figure of considerable stature in the architectural profession; but also admitted that

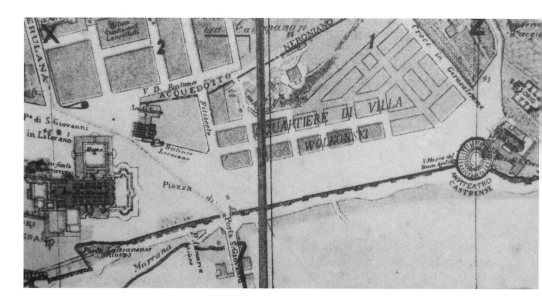

Fig. 4.3. Antonelli's map of 1895, showing the description 'Quartiere di Villa Wolkonsky' and the position of the new villino.

he had no evidence to support that. No design for the new Villa is listed among Francesco Azzurri's principal works. The drawings submitted in 1886 (elevation and floor plan, Figs. 4.4 and 4.5) bear the signature of architect Vincenzo de Righi, who certified that he was in charge of the project for the Campanari-Wolkonskys. So the romantic notion that the new mansion was designed by a descendant of the *casino*'s architect, which Pietrangeli could not entirely resist, must almost certainly be added to the list of myths to be erased from the record.[7]

The relationship between de Righi and the contractor, Caffoni, on the one hand and their clients on the other was stormy. Early signs emerged in October 1886, but de Righi was still warning the building inspector of trouble in June 1887 and seems to have walked off the site definitively, along with Caffoni, in October 1887. In the light of the timing of the recorded land sales it is a fair bet that they were not being paid promptly, but there is no statement to this effect other than where the contractor said he was going '*per ragioni d'interessi*' (roughly 'to protect his own interests').[8] While it is not clear when the project was eventually finished, Campanari obtained a certificate of habitability of all but the ground floor (which may actually mean the semi-basement where the kitchen was) with effect from 15 September 1890 – a certificate which was only issued on 14 December 1892! So we can surmise that the family moved in between 1889 and 1892.

The delay may have had its roots in the intervention of another branch of government. An element of the conventional wisdom has it that, at this point, the authorities (the Ministry of Education, i.e. the *Belle Arti*) had become concerned for the future of the Villa Wolkonsky estate and stepped in to prevent its further break-up. Ashby (after repeating the canard about the Villa having been a gift to Zenaïde from her father) claimed that the block on further sales was imposed in 1886 by Minister of Education Ruggero Bonghi.[9] This is another tale which does not quite add up. First, Bonghi was only minister from 1874 to 1876, and second, it sets up a conflict with the evidence of the Land Registry record of sales, quoted above, which could only be resolved if there had been long

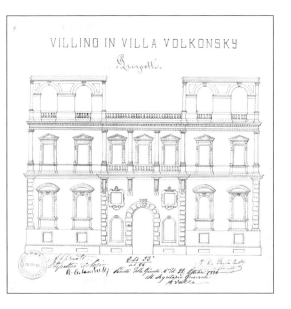

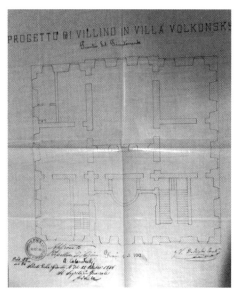

Fig. 4.4. The front (north-west) elevation of the new villino at the Villa Wolkonsky, by V. De Righi, as approved by the City Planning Committee on 22 October 1886.

Fig. 4.5. The ground-floor plan submitted with the elevation for planning approval in 1886. It shows a quite different configuration from today's of the hallway (lower middle) and of three or four small rooms (left) where the dining room is now located. The staircase layout was also modified in 1938–40.

delays in registering sales agreed before the ban was imposed – not impossible, but unusual, and in any case the Land Registry would show the dates of actual sale.[10] If there had been such a block (and no official document has come to light to confirm it) those sales are hard to explain, and at best the ban must have been either very short-lived or applied with great flexibility, e.g. because developers had already been granted planning permission on the basis of contracts already signed with the Campanari-Wolkonskys. As seven sales were registered in the three years between 1887 and 1889, funds must have been released to keep up payments to the contractor and architect, but their bills may have arrived at a faster pace than the sales could maintain.

One odd-shaped parcel of land on the northern side was sold in June 1889 to a property company which was then building the retaining wall around the Villa Wolkonsky. It may have been a barter transaction in part-payment for the wall-building, recognising that the Campanari-Wolkonskys did not want to own any land outside that particular part of the perimeter wall. Unfortunately it was nonetheless mistakenly included in the 1922 sale to the Germans, which had to be rectified when the property had to be sold on (and later leased by the government for the police, who still have barracks on the plot) and the owners' lawyers discovered that they did not have valid title.[11]

If a block on further sales of land belonging to the estate was imposed, perhaps after 1889 and instigated by Bonghi as a member of parliament but not executed by him, it could have forced the Campanari-Wolkonskys to borrow more or to bring more funds from the income of their estates in Russia, either of which would have taken time. The family's version of the history, however, is that

their finances were sufficiently over-extended to enable them to appeal successfully to the *Comune* to have the ban lifted in 1895/6, a process which required a rare decision by the full City Council.[12]

By that time the city authorities needed land to allow proper sewage pipes to be built for the new blocks of flats being put up south of the property. The Land Registry shows a series of small sales between 1898 and 1907.[13] Their dates broadly match the addition of blocks of flats on or near via Ludovico di Savoia shown in contemporary maps. They also suggest a family in need of income, a deduction confirmed by their need to take out a mortgage on the Villa in 1908, of which the sum of L.163,165 was outstanding at the time of the sale to the German government in 1922.

Until 1890 the buildings on the Villa's remaining land kept the Land Registry numbers given to them in 1883 (though some had acquired them earlier). Entries show a general revision of the details of the outlying or additional properties (and the sale of several of them) taking place from 1890 up to 1903, including renumbering the fractions of Plot 267, which makes following the various sales transactions problematic. But the entries allow the sure conclusion that by 1899 the new house was well established: it had the number 4004 on the plans, a taxable value of 4,200 Scudi, was described as a detached house (*villino*) of 37 rooms over five floors and is specifically referred to as taxable from 15 December 1892 (but, as we have seen, that certificate of habitability did not cover the ground floor). German evidence, albeit partly oral, recorded that the kitchen in the basement was kitted out in 1891, which seems a more likely indicator of roughly when the house was in practice ready for occupation.[14]

The inventory of other buildings on the property at that time showed that the estate as a whole had become roughly what it is now, though some of the descriptions were not officially ratified until July 1893 (registry numbers in brackets), and the new mansion was not yet formally registered:[15]

Summer house (270) as already described, i.e. the original *casino*, by then of 4 floors and 18 rooms
Greenhouses (4005–7)
Gardener's house (268) – later demolished, probably 1942
Porter's house (4008) of 3 rooms – later known as the gatehouse
Family house and stable (1828) – 2 floors, 12 rooms, later the residence garage and staff flat
Stable and garage (272) – 2 floors, 9 rooms, later to be expanded and become successively the Officials' House, the Consul's House, the Old Minister's House (OMH), the German Minister's House and the House of the Arch.

As the Urban Land Registry (*Catasto Urbano*) in that period only detailed buildings on a property, this list ignores the garden and the rest of the park/vineyard remaining in the hands of the Campanari-Wolkonskys, which would have needed some restoration after the building works. But it clearly remained a feature as did the panorama it looked out on, even though it was now restricted. While Augustus Hare had lamented the effect that the extended period of sales and development had had on the charm of the property,[16] other writers noted in more positive vein that the development of the Esquiline had resulted in the total loss of the Giustiniani, Astalli, Altieri and Gentili villas, while the *casino* at the Villa Wolkonsky alone survived – a point well worth making, though it did not guarantee the longer-term survival of the *casino* or the estate as a whole. At the turn of the century the Basilica of Santa Croce and the Alban Hills could still be seen from the rear terrace (Fig. 4.6). By the start of the First World War further apartment blocks along via Giovanni Battista Piatti and via Ludovico di Savoia had obscured most of the view (see Figs. 9.2 and 9.3). But even now it can still be enjoyed from the highest terrace on the roof of the new, post-1940 Villa Wolkonsky.

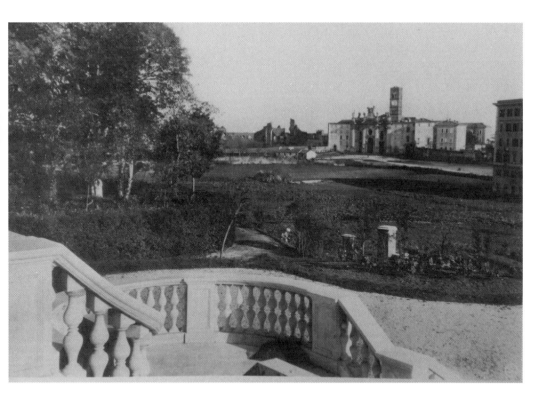

Fig. 4.6. A photograph showing the view from the southern terrace of the villino in the late 1890s, as apartment blocks (right) encroach on the view.

Later revisions and Land Registry renumberings make it ever harder to follow what was happening to peripheral parcels of the estate. As they were carved out (mainly from Plot 267) each was given a new number, and no single map exists on which they can all be easily located. But a shop in Piazza di Santa Croce was sold in June 1911 to the Bank of Italy (possibly a euphemism for a repossession against a loan). In 1912 the whole property, including the new *villino*, was registered anew in Nadeïde's name. This may have been a further general revision to tidy up the effect of multiple purchases and sales since 1868 rather than the record of any new transaction or transfer, as all the previous Land Registry entries had been in her name from the time she registered her inheritance from Prince Alexander. Whether she was in Rome in 1912 is unclear; it is more likely that she was in Russia.

The re-registration was accompanied by a formal notification (addressed to Wladimiro Campanari, perhaps because Nadeïde was known to have been abroad) on 9 December 1912 of the *vincoli* imposed on the property, the equivalent of 'listing' in the UK. Given that one of the tenants of the Villa at that period was the foreign minister, it may be that the government suspected that the absent owner, Nadeïde, might want to sell. But it was more probably a routine formal act required under the new legislation passed in 1909 (see Chapter 15), rather than any sort of pointed warning.[17] Between 1912 and 1918 a further series of compulsory purchases were made to allow the building of the streets designated in the *Piano Regolatore*. The last recorded sale is a compulsory purchase (for a new stretch

of road at the eastern end) in July 1916. By then the estate had reverted to something probably less than half the size of the land Alexander had passed on to his adopted daughter (but still roughly the same size as the property Zenaïde had bought), and the financial position of the family had undergone major change.

A Russian interlude: war, revolution and the decline of the family's fortunes

By the turn of the century at least some of the Campanari-Wolkonsky family had moved to Russia. Why and when they did so remains unclear, but possible reasons include a need to occupy and be seen to use their Russian property; a need to engineer the retention of a greater share of the income from their estates; or even the transfer of assets to Italy. From the information in the 1922 contract of the sale of Villa Wolkonsky to the German Reich one can infer that the family finances were not good: the house had been mortgaged anew in 1908.

During 1900, according to one source,[18] the Villa became the home of a French cardinal, F.D. Mathieu, who achieved notoriety by leaking in 1904 the proceedings of the complex and highly political conclave which followed the death of Pope Leo XIII in 1903. Mathieu wrote that he had found, in a novel by Antonio Fogazzaro (*Daniele Cortis*) which he was reading to learn Italian, a description of 'his house', including this passage:

> I had myself taken to the Villa Wolkonsky, where there are roses, ruins, crows and as much silence as one could wish for at certain psychological moments which I know well. I sat in the shade of an arch of the Acqua Claudia, facing Santa Croce in Gerusalemme and the Roman 'desert', and began to meditate ... Close by me, projecting from the bricks of the ancient arch support, I saw a small marble hand with its shapely (*tornito*) forearm.[19]

Some photographs of the Villa at the turn of the century show the house in its setting looking well established (Fig. 4.7). In 1904 the Villa was rented to a cabinet minister, Tommaso Tittoni;[20] and from 1907 to 1911 to the Franchetti family, Baron Leopoldo Franchetti and his German wife, Baroness Alice Hallgarten Franchetti, who died in October 1911.[21] In this decade, the property, including the garden, was no doubt somewhat neglected in the owners' absence. However Rome *Comune* records reveal that in 1912 a member of the Campanari family (one Ingegnere P. Campanari, presumably administering the property on behalf of the absent owners) had some work done – perhaps in response to a new tenant's wish – enlarging window apertures and changing the arrangement of some doors, whether interior or to the exterior is not clear.[22] The house, at least, was in someone's care, though not necessarily occupied.

While they were in Russia Nadeïde went to live in the main family property at Urussovo. Her son Alessandro, who had previously passed out from the Italian Military Academy, attended the Military School of the Imperial Guard (most unusually for an Italian citizen, not holding Russian nationality; but he was a Wolkonsky prince, even if he carried no Wolkonsky blood). Nadeïde then presided over his marriage to Anna Illijn (the daughter, born in 1885, of one of Nadeïde's natural brothers, Dimitri, whose family country property was close to Urussovo); the young couple's first son, also called Alexander, was born in Moscow in June 1910. In 1911 Nadeïde passed ownership of the Urussovo estate to Alessandro, who lived there with his young family until 1918 – the revolution had not yet disturbed country life in Urussovo. Their return to Rome in 1918 was occasioned by his call-up to the Italian army. The journey was made with other Italian draftees and their families. They travelled from

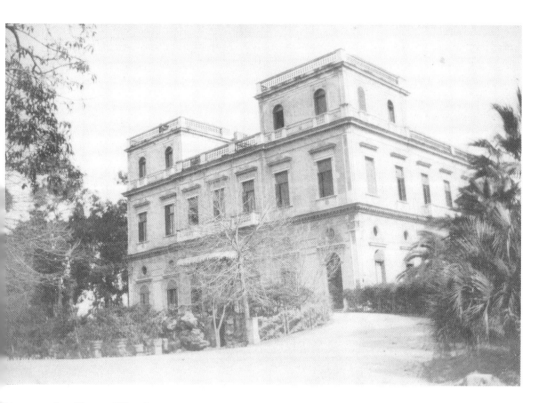

Fig. 4.7. *The still new villino in 1905.*

Murmansk in an Allied vessel escorted by two ships of the Royal Navy, a voyage of nine days, avoiding German submarines. After a stay in London they crossed the Channel ('wearing life-jackets') to Paris and then travelled on to Rome, taking two months over the whole trip and arriving too late for Alessandro to be sent to the front.[23]

Nadeïde had earlier returned to Rome, but when is not recorded. She was at the Villa Wolkonsky to take in the members of the family arriving from Russia as defeat and revolution overcame them, and remained there until the house was sold.

More antiquities

War, revolution and the absence of the owners notwithstanding, a further archaeological find of some note was made in 1916/7.[24] At the far eastern end of the Villa, via di Santa Croce in Gerusalemme was being widened, and at the junction with via Statilia on the Villa's northern flank, three tombs built of tufa were uncovered not far from the Servili tomb and proved to be 'of considerable interest' (Fig. 1.5). (A fourth tomb was discovered later but in poor condition.) They contained inscriptions; tiles under which were found skeletons, cremated ashes, ointment pots and a coin; and bas-relief portraits on the front of two of the tombs. The first was of a family of man, woman and child; the second a man and woman – all clearly named. The interest was not only in

the detail but also because they resembled Roman and earlier Greek tombs in the form of little buildings, with little arch-shaped cupboards inside. In this case the use of tufa was thought to have been intended to make them look like rock-tombs in Asia Minor and Etruria. Other similar tombs were said to have been found at other times along the same 'suburban road of Republican Rome, linking via Labicana with via Merulana' (a main road out of Rome). The tombs were therefore attributed to the end of the republic, but their interiors showed much subsequent reuse. The busts were found to resemble those found in the 1881 excavation within the Villa, recorded as 'preserved at the Villa'. They were judged of the same style as contemporary domestic altars depicting ancestors.

These finds and those made from 1865 onwards add up to an impressive list of tombs at the Villa: Pietrangeli (drawing on Colini)[25] summarises it as follows:

1866 The colombario of Tiberius Claudius Vitalis, discovered by chance, excavated on behalf of Prince Alexander Wolkonsky by Gioacchino Ersoch. Still exposed.

1881 Three tombs, including that of the Servili, excavated by the Marchese Campanari, at the eastern end of the retaining wall by the via Statilia (see Fig. 1.5).

1885 Tombs of the Ottavii, Tullii and Domizie, on the line of via Statilia then under construction. Demolished. Another tomb (of the Synodus magna psaltum) was demolished at an unknown date.

1916/7 Tombs of the Cesonii, Gemino and Quinzii, at the junction of via Statilia and via di Santa Croce in Gerusalemme, found when the latter road was being widened; preserved and exhibited at the junction, in the eastern end of the retaining wall of Villa Wolkonsky.

1926 On the other side of via Statilia a stele in memory of a married couple, from the Caesariar period, now in the Capitoline Museums.

The decision to sell the Villa

The revolutions of 1917 in Russia and the subsequent or threatened confiscation of assets of the nobility and other landowners resulted in a further flow of members of the family to the relative safety of the Villa Wolkonsky and brought about a radical change to the financial situation of Nadeïde and Wladimiro, who, since its passage to Alessandro in 1911 no longer benefited directly from income from Urussovo. The family relates that in order to be rid of the 'refugees' they in effect bought them out by helping them to acquire a villa divided into flats in Monteverde, a newly developed part of town (property may have been cheap at the end of the war) and by giving them cash sums to cover some living expenses. They were then able to put the whole Villa on the market, which they did during 1919 without exciting much interest.

The German consular representative in Rome (Herff) became aware of its availability in the same year, and saw its potential as a replacement for the confiscated German Embassy of the pre-war years. But the Italian Foreign Ministry (then known as the 'Consulta', after the Renaissance building it occupied in the centre of the city) advised that it would be 'too far from the centre', and the Germans were not keen on taking on such a large area of land. As German impatience mounted with the Italian government's inability to provide them with a suitable new embassy (a titanic saga in itself – see Chapter 5), their interest in the Villa, never entirely put aside, grew. Negotiations for the sale to the German Reich for use as their embassy did not open until 1921, and were only concluded with signature of the deed in August 1922 and full notarisation in October that year.

Before the sale Nadeïde had a struggle with the tax authorities as she attempted to obtain a relief from tax on grounds which foreshadowed the difficulties faced by the British government after it acquired the Villa 30-odd years later. She argued that the imposition of the *vincoli* (notified formally in 1912) meant that the property could only be sold as a single lot and could no longer be built on; whether with success is not clear. It certainly took a long time to sell. Once the sale was agreed, many of the contents of the Villa, including pictures, books, family papers and even some of the antiquities were hastily sold to a variety of dealers and dispersed, very much against the spirit and the letter of the *vincoli*. A good number of the family papers and letters, however, finished up, via a dealer, Baron Lemmerman, in the Houghton Library at Harvard University. They can now be consulted there, but for a long time were not open to outside researchers.[26] There is still some residual bitterness among members of the family about the way Lemmerman and others achieved hurried sales of what amounted to a century of the family's history as well as its formidable collection, exploiting the family's precarious financial position.[27]

After the sale the family became dispersed. Wladimiro (presumably with Nadeïde) moved out to a property he owned in via F.D. Guerrazzi.[28] Nadeïde died the following year, **1923**, which suggests that her health may also have influenced the timing of the sale. She still owned more than one apartment block near the Villa Wolkonsky on the via Emanuele Filiberto frontage. Her estate was divided equally between Wladimiro and the four children. Wladimiro, by then 80, was clearly still in reasonable health: he quickly got married again to a young lady of 20, called Pia, and lived on with her at Anzio until he died on 19 May 1931. Alessandro could not settle down and moved frequently, much to the detriment of his son's schooling. He finally bought a small house on the outskirts of Rome, where he died in 1928 – followed by his wife, Anna, in 1931. Their son, the young Alexander (also known confusingly in the Campanari family records by the Italian version of his name, Alessandro, like his father), an orphan at 21, inherited through his father from his great-grandfather Francesco, the Campanaris' 20 hectares of land at Castel del Massimo di Veroli. So he sold the house near Rome and settled at Veroli, well away from the 'big city'. This young Alexander was the father of the present doyen of the Campanari family, Danilo, who, in spite of retaining the papal title of Marchese, has been the (Communist) mayor of their town, Veroli.

None of Alessandro's three siblings left heirs. Wladimiro (jr) died in 1926 in Germany; Caterina died a nun in Holland, and Zenaïde married another Campanari and died in Veroli. By virtue of Nadeïde's adoption into the Wolkonsky family, Alessandro Campanari's grandson Danilo is the only known direct descendent of Princess Zenaïde. He has provided priceless written and oral details of the family, whose archives were lost when German forces requisitioned their home in the dark winter of 1943/4.[29] That material has informed much of this chapter.

Notes

[1] (AdS at via Galla Placidia 93). Partita No. 5372, p. 9962, records on 13 October 1878 the succession to Nadeïde from Alessandro Principe Volkonsky, after his death of the *casino* (4 floors and 18 rooms, value 900 Scudi). And Partita 7129 No. 843, registers the property in Nadeïde's name on 30 October 1878. The same volume shows at No. 146) a variation in the form of the sale of some freehold (*diretti domini* notarised by Apolloni) to one Petroni on 18 February 1883 (registered – No. 146 – exactly a year later), but its scale is not shown in the *Catasto*. The entry was rewritten as Partita 10629, again in Nadeïde's name. At this stage the property consists of parcels 267–72, 827 and 1828.

² ASC, PR Pos.21 Busta 228 fasc.10 – Wolkonsky Nadeïde e Campanari Wladimiro – Permuta.

³ NdS 1917, Fornari, p. 274.

⁴ AdS (Via Galla Placidia 93 store) Catasto Urbano Rustico 2687, 3037, 5190–92 from 1886 to 1889 and 1893; further entries are in 3867 (1903 sale for road-building); and in Partita 27596 for sales in 1908 of individual plots largely containing shops on the newly built surrounding streets. The new mansion was added to the Registry (Partita 3731) in 1903, where it was noted that it had been declared taxable in December 1892) and the change of use of its (newly designated) parcel of land, no. 4004, reported in July 1893. Further transactions can be traced in these volumes of the Catasto, including in Partita 47119 the sale of the property to the German government – Voltura 3973 of 1922 and 353 of 1923 – see Chapter 5.

⁵ Most of the records relating to the design and building of the villino are in the ASC (the Rome City archive) in Tit. Postunitario 54 Edilizio e ornato 1871–1922 72531/1886 Via Ludico di Savoia 1022 Volkonsky-Campanari and PR Pos.21 Busta 228 fasc.10 – Wolkonsky Nadeïde e Campanari Wladimiro – Permuta.

⁶ Pietrangeli attributed the Azzurri credit to Callari, quoting Oriolo.

⁷ The only reference in the files on the project to Francesco Azzurri, so often credited with the design of the new villino, is in the printed minutes of the session of the Council when the application was approved, where he is simply listed as one of numerous advisers to the Council, with no suggestion that he was present or otherwise involved.

⁸ The possibility that this might have led to the employment, belatedly, of Francesco Azzurri is not supported by any documentary evidence.

⁹ Ashby (1), p. 163.

¹⁰ But Bonghi did set up the first institution under his ministry for the conservation of excavations and museums in 1875 and might have still been in a position to intervene even if not to act.

¹¹ For complicated reasons (see Chapter 5) a correction had to be made in 1925 to the 1922 Deed of Sale to the Germans: it confirms the sale in June 1889 of the parcel of land bearing the number 3888 (new numbering – see Plate 3), on via Statilia (to the property company, Società di Credito Industriale Romano).

¹² No evidence of this decision has so far come to light.

¹³ In 1898 of one plot to the Società di Credito ed Industria Edilizia (a mortgage bank developing the area between via Emanuele Filiberto and the Villa), one plot on 29 April 1903 (to Zavelloni), a large sale of small plots for building and road-construction in May 1903, 6 plots on 18 January 1906 (to Salvatore Gallinucci), 3 plots on 26 April 1906 (to Leone Ascarelli), and 2 plots in January 1907 (to Marotti).

¹⁴ Ambassador Schubert so reported to Berlin when arguing the case for urgent updating of the kitchen which was still the original from 1891 – see note 2 to Chapter 7.

¹⁵ Some consolidation of these numbers took place in May 1900, but curiously (and confusingly) the old numbers survived for use in the 1922 sale contract to the German Reich and later documents.

¹⁶ Hare, 1902, p. 10.

¹⁷ Those vincoli were confirmed in 1933 when the Germans asked permission for alterations, having been told that 'nothing can be demolished, removed, modified or repaired without the permission of the Ministero della Pubblica Istruzione'.

¹⁸ Buseghin, pp. 559–61.

¹⁹ Fogazzaro, Daniele Cortis, pp. 148–9, quoted in Buseghin (see n. 18). The forearm in question was probably that in Fig. 2.9.

²⁰ Tittoni was foreign minister from 1903 to 1905. In March 1905 he was for 12 days prime minister then until December interior minister. In 1906 he was for three months ambassador in London but returned to the post of foreign minister in May, where he remained until 1909. As the Villa was rented to other tenants by 1907, it is possible that he left it on moving to London, but he may have retained the lease until the following year.

²¹ Buseghin, see note 18.

²² ASC IE Catena 237 Prot 5614/1912.

²³ This account is based on the manuscript record of an interview given by Alexander (later known as Alessandro Campanari (grandson of Wladimiro and Nadeïde), kindly given to the author by his son Danilo Campanari, the current doyen of the family.

24 NdS 1917, Fornari, p. 174.

25 Colini, pp. 380–93.

26 Lemmerman clearly retained some items himself: Pietrangeli records his gratitude to Baron Basil de Lemmerman for showing him certain items in the early 1970s – see note on his p. 428.

27 The grievances were set out with some asperity in Bočarov and Glušakova, 1985.

28 Across the River Tiber from the Testaccio non-Catholic cemetery.

29 See note 23.

5.
THE GERMANS FIND A NEW EMBASSY

If the Wolkonsky era went out with a whimper, the Villa's new German owners hardly came in with a bang. With the new century the Villa had already become more exposed to the backdrop of a unique series of events in European and world history, not least the Russian Revolution and the 'Great War'. After the war its association with Germany connected the property more closely still to events on the European stage.

Why the German government needed to buy such a property and then what they managed and failed to do with it make a story which illustrates how the grand sweep of history can weigh upon mundane, everyday business such as owning and running an embassy – and how the humdrum can be transformed into the grandest of schemes to assert a nation's standing. This part of the narrative strays unashamedly beyond the confines of estate management and will follow the tracks of some of the chief characters connected with the Villa Wolkonsky before and after their involvement with it. It must also address the problematic reputation acquired by the Villa during the brief but intense German occupation. It does not seek to judge those characters, whose actions have been copiously examined by courts of law and historians, though some shading may be applied to otherwise black-and-white figures.

Losing a German Embassy – the Palazzo Caffarelli

Before the First World War the German Embassy was housed in the Palazzo Caffarelli, atop the Tarpeian Rock on Capitoline Hill.[1] The short version of how the Germans came by such a special spot for their embassy was that the *palazzo* had been given by Pope Pius IX in 1854 to the then King of Prussia as a personal gift; but that the King (later Kaiser) never used it, and it became the Prussian, then German Embassy. While papal influence, at least behind the scenes, cannot be discounted, that version is at best an over-simplification.

The Palazzo Caffarelli was first rented by Prussia's diplomatic representative in 1829. In 1838 the Crown Prince of Prussia expressed an interest in it. Nothing much happened until the Rome *Comune* gave notice in 1853 that it intended to take it over 'in the public interest' and 'to improve public access to the Capitoline Hill' – an argument which became a familiar theme as, later in the century, united Italy developed its policies on heritage protection. Some Italian archaeologists and politicians claimed the spot as the site of the main Temple of Capitoline Jupiter, the holy of holies in ancient Rome. The widowed Duchess Caffarelli discreetly and quickly agreed a sale to the Prussian chargé, von Arnim, on behalf of the by now King Friedrich Wilhelm IV of Prussia on 1 November 1853, a deal notarised on 27 February 1854. For this she received L.400,000 (82,720 Scudi), plus a pension of 40 Scudi a month for herself.[2]

The sale to a foreign sovereign effectively forestalled further action by the *Comune*. While they decided to assert their right of first acquisition and went to court, the case languished (under a papal

hand?) and was still open in 1870 when papal rule over Rome ended. In December 1895 the Rome City Council confirmed the cession of the *palazzo* to the (by then) Kaiser Wilhelm II – i.e. gave up its right to buy – in a deal which included the exchange of the Palazzo Clementino (part of the Caffarelli complex) for a garden: a good example of the Italian practice of doing a deal to sort out conflicts of interest which cropped up in the efforts to preserve and make accessible monuments of various sorts.[3] But when the contrary minority view on the Council opposed to the German presence in such a sensitive location began to seem like a majority, the Germans sensibly and sensitively let it be known that they would not be opposed to moving off Capitoline Hill, provided equivalent accommodation was found for them – a flexibility later much emphasised in the liberal parts of the Roman press when the issue came to a head. The proviso was significant, as the Germans had gathered around the *palazzo* a portfolio of other buildings, housing their hospital, the German Archaeological Institute and several staff houses. The fact that their property went beyond their diplomatic mission only strengthened the hand of the nationalists who wanted to see them off the hill altogether and restore it to its rightful status as a Roman holy place (Fig. 5.1).

When Italy entered the war in 1915 against Austria and Germany, the Germans were obliged to vacate their embassy and associated property, leaving it and other private and official property to the protection of the Swiss government – but

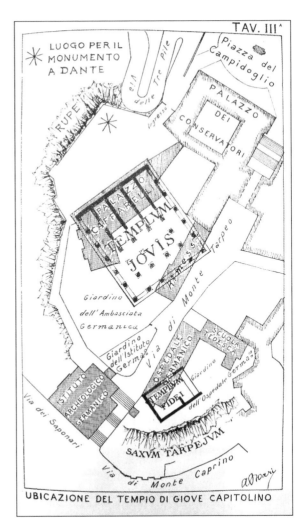

Fig. 5.1. A map purporting to show the ruins of the Temple of Capitoline Jupiter directly underneath the German Embassy in Palazzo Caffarelli; the German Archaeological Institute, Hospital and School are also shown (shaded).

nonetheless vulnerable to political action.[4] Custom would have led them to expect at least to get their diplomatic property back again at the end of hostilities, as they did in both London (Carlton House Terrace) and Paris (where they had also regained their Hôtel Beauharnais after the 1870 Franco-Prussian War). But the atmosphere of nationalism pervading the combatants in the Great War weakened and in some places swept away the accepted doctrine in international law that protected public and private ownership rights of nationals of countries at war with each other. This occurred during the warfare itself and was not simply an after-effect of the post-war treaties. Italy for example indulged in a large-

Fig. 5.2. The map annexed to the decree by which, under a law of 1914, the government declared the extension to the Capitoline Hill of the protected zone in which only Italian state property was allowed.

scale campaign of confiscation and *'nostrisazione'* (literally 'making our own') of German and Austro-Hungarian property, including industrial and commercial assets, from 1915. With the exception of some low-value assets these actions were sanctioned ex-post in the Treaty of Versailles.

When it came to Germany's diplomatic and official property, the Italian government did not simply confiscate it. Their approach was different, more subtle. Inspired by the campaign among nationalists to have the Germans evicted from Capitoline Hill, a 1914 law had already enabled the extension of the perimeter of the Rome Monumental Zone, a move widely assumed to be aimed very precisely at the Palazzo Caffarelli.

By 1916 the Swiss protecting power were reporting to Berlin a campaign in the Roman press for the confiscation of the *palazzo*. Although in January 1917 negotiations achieved the release of Ambassador von Flotow's personal effects (but not his furniture, etc.), a parliamentary question from a nationalist MP about the future of the *palazzo* was answered ambiguously by the minister for education (responsible for culture and arts); and this was duly reported by the Swiss. The minister's equivocation accurately reflected the uncertainty over the outcome of the war.

The Italian government's hand was forced because its power under the 1914 law to extend the Monumental Zone was to run out on 31 July 1917, and the war was not obviously going to be over by then, let alone with a German defeat. A decree was finally passed on 19 July and confirmed by the Chamber of Deputies on 29 July (Fig. 5.2). The *Consulta* (the Foreign Ministry) confirmed to the Swiss on 2 October that the decree did affect the Palazzo Caffarelli. According to Italian files, the Swiss raised no objection.[5] The *Comune* was however still discussing the question of expropriation nearly a year later, in May 1918. At that stage Germany's defeat was still by no means certain, and caution remained the order of the day in Rome. Impatience with the indecision spurred a mob to ransack the *palazzo* in June 1918. In the confusion the inventory was 'lost'. But known losses included general damage to fabric and furnishings, the removal of much crystal and fine silver plus four paintings of the Kaiser, his wife and two predecessors – and 1.5 kilos of beef.

The *Comune* only brought itself to act on 30 November, by when there was at last no longer any risk of Germany finishing the war victorious. Naturally the German government, through the Swiss, protested (on 13 December 1918) at the confiscation of their embassy, claiming diplomatic immunity. Equally naturally the Germans found inadequate the compensation named in the decree of 19 July 1917 (L.2.5m, 'negotiable'). The Italian reply on 29 December stated that the expropriation had not yet been carried out; but announced that the Ministry of Public Education intended to expropriate all

private property on the Capitoline (into which category an embassy was clearly deemed to fall), a decision ratified by the Prefect on 23 December 1918. This apparently non-discriminatory measure concealed the fact that the German government was the only owner of property in the specified area, other than the Italian State and local authority. The Italians added the debatable assertion that diplomatic immunity of buildings lapsed when diplomatic relations ceased on the outbreak of war, as it was only a function of the immunity of persons. Meanwhile the Swiss should proceed with the removal of the contents of the Palazzo Caffarelli, including the ambassador's furniture. The Germans successfully argued that they and the furniture should remain

Fig. 5.3. A photograph of a press cutting of an article in a Rome newspaper critical of the act of knocking down a fine palazzo and finding no temple beneath it.

until the peace was concluded. The Treaty of Versailles came into force on 10 January 1920. The contents were finally moved on 3 February 1920 to premises the German mission had taken as a temporary residence at Piazza della Navicella 5 on the Caelian Hill. There they were damaged shortly afterwards in a fire, which investigation revealed (at least officially) to have been started accidentally by the son of a gardener.

The Palazzo Caffarelli formally passed to the City of Rome, and excavations started on a part of the property in an attempt to reveal the Temple of Capitoline Jupiter. The part of a wall that was uncovered did not convince expert opinion. And after the Palazzo Caffarelli was demolished in 1922 the liberal press began pointing out that Rome had lost a fine Renaissance *palazzo* and not found the Temple of Jupiter (which some by then insisted was actually under the nearby Basilica di Santa Maria in Ara Coeli – excavation of which would be a deal more problematic) – see Fig. 5.3.

By 1926 the remains of the buildings and the Roman ruins under them were incorporated in what became the Capitoline Museums. (A modern visitor to the museums can take a break, sit on the Caffarelli Terrace and sip an espresso looking out over the roofs of Rome to St Peter's, as the German ambassador might have done from his terrace-garden a century and more ago.) The Palazzo Caffarelli was no more, and for the Germans its memory had been reduced to being the object of a long and frustrating campaign for compensation, intimately bound up with the Germans' search for a new embassy.

Italy fails to provide a substitute

Led initially by their consul-general, Herff, still under the Swiss flag, the German mission in late **1919** had temporary offices in the house of the German Evangelical Community in via Sardegna. Once the

Treaty of Versailles was signed and pending its ratification, the Italians encouraged the German government to select a chargé d'affaires to take over as soon as possible after the formalities allowed Germany's diplomatic rehabilitation. But in the aftermath of the loss of their embassy they were not keen to do any such thing, so Herff in due course found himself discussing politically sensitive issues with the Consulta – e.g. the Germans' specifications for a new embassy, received on 19 December 1919 – in spite of having only consular credentials. (The Swiss complained to Berlin that he was doing work which was strictly theirs.) Herff reported his findings to Berlin on 29 December, including the Villa Wolkonsky among the options. He noted that that the Italian Foreign Ministry thought it was too far away from the centre, while he considered it easily accessible on several tram lines.

For the Germans the contrast between Italian behaviour and that of the British and French was particularly galling. In Rome they no longer had an embassy to move back into, and they depended on the Italian government, still hostile to Germany, to house them and fully compensate their loss. Herff's advice to Berlin on 26 January 1920 was to be firm but not take on another Caffarelli, i.e. a property which would set off another wave of nationalist resentment. Thus, he had doubts about the three lead contending palazzi, Aldobrandini, Torlonia and Altieri. A month later he reported being reminded by his legal adviser of the availability of the Villa Wolkonsky, but noted the large land area involved. Herff had also picked up some suggestion of public sensitivity – presumably on the same grounds as with the Palazzo Caffarelli: that Germany would own a large slice of Italy's ancient, monumental history, in this case the aqueduct. But he did not go into detail.

Herff's key point was that the Germans must show the Italians they were waiting for them to solve the problem, e.g. by keeping any new ambassador in a hotel until there was a residence. The Villa Aldobrandini seemed the best bet. While the Italians knew they had a duty to find a suitable building, the task was objectively not easy, given the scale of German requirements. Both sides needed to appoint new ambassadors. The two issues became intertwined. In the climate of distrust after such a bitter war the normal diplomatic rituals provided plenty of scope for procrastination and point-scoring on both sides. In this case it took the best part of two years before the Germans could break the deadlock and four more years thereafter before they received compensation (and then in a peculiar manner).

The political conjuncture did not help. Both countries were grappling with the aftermath of a crippling war. In both, extreme opinion on the right and the left took direct action in attempts to overturn treaty terms or diminish the power of the elected politicians who had agreed to those terms. In Italy 1919 and 1920 became known as the Biennio Rosso (Red Biennium). They were marked by strikes, factory occupations, workers' councils on the one hand and on the other by the irredentism of Gabriele D'Annunzio's action in September 1919 to annex Fiume to Italy. The Liberal-led coalition of the immediate post-war lost power in the 1919 election to a left-ish coalition under the Radical leader, Francesco Saverio Nitti. He in turn was displaced on 15 June 1920 by a new coalition including socialist parties led by Giovanni Giolitti (his fifth term as prime minister), in which Carlo Sforza was foreign minister. While apparently condoning action by Mussolini's Fascist militias to combat the actions of the extreme left, Giolitti attempted to sort out the Fiume problem through a treaty with Yugoslavia (12 November 1920) making Fiume an independent Free State; but D'Annunzio was having none of that and declared war on Italy. Giolitti sent in the army and navy on 24 December, and D'Annunzio's force quickly capitulated. (The wheel turned full circle when Italy, by then led by Mussolini, did annex Fiume in the Treaty of Rome in 1924.) This turbulent background was not likely to favour energetic action to sort out the detail of the re-establishment of full diplomatic relations with Italy's recent principal foe.

The Germans had initially intimated informally to the Italians at Versailles in the summer of 1919 that they were considering nominating as chargé (who might become ambassador after a suitable

interval) Count von Bernstorff; but the Italians thought him too much a representative of the old Germany which had lost the war. After a few months the Germans tried again (first through the delegation at Versailles on 17 January 1920, then through the Swiss in Rome on 23 January); their nominee would be Baron Helmuth Lucius von Rosen, then chargé in Stockholm. But the Italians, at the behest of Prime Minister Nitti, indicated that Rosen would not be appropriate, as he was reported to have had close contacts in Sweden with the Bolsheviks, indeed to have paid them a secret visit in St Petersburg.[6] Rosen's formal denial of 3 February 1920, which pointed a finger at the UK ambassador in Stockholm, Buchanan, as responsible for the canard, was relayed in a memorandum to the Italians but with the oral message that the Germans would of course not appoint someone not welcome in Italy, even if formal agreement was not required in the case of chargés d'affaires.

Having thus half-sold the pass (and displayed their sense of weakness to the Italians), the Germans, to Rosen's annoyance, decided they would formally propose a new nominee, Johannes Zahn, and did so through the Swiss on 24 February 1920. The Italians thought he was not up to the task, but in early March they accepted him in the hope that the Germans would accept their nominee for Berlin, De Martino. But Nitti, playing to a different score from the Consulta, told Herff on 27 March that he was ready to resolve the Rosen affair. The Germans must have seen the chance to improve their bargaining position over their continuing lack of an embassy, so did not give up on Rosen.

Anxious still about their own position in Berlin, the Italians also seemed inclined to change their position, but procrastinated further until 'the political position in Germany has calmed down'.[7] Germany was experiencing much the same sort of disruptive direct action from left and right as Italy. March had witnessed in quick succession a right-wing monarchist coup in Berlin, reacting to the damaging territorial and economic conditions now imposed on Germany by the Treaty of Versailles, quickly quashed by a government-inspired general strike, and the same strike turning into an extreme left-wing attempt to overthrow the government. The strikers were active not only in the east but also in the neutral zone (essentially the industrial Ruhr) where the Treaty permitted the government only a small police presence; and when the government, with some support from Lloyd George and Nitti, ignored French objections and sent troops into the zone, France occupied Frankfurt. While the Allies squabbled at San Remo (excluding the Germans at French insistence) the German government re-established control over the Ruhr, formed a new coalition and announced elections; calm was restored by late May.

Nitti had also made a link with De Martino being accepted in Berlin, reducing the value of the Germans' insistence on having an embassy before they could nominate an ambassador. On 11 April he asked De Martino to resolve the Rosen question. De Martino suggested he talk to Rosen. This left the Germans in a quandary with two competing nominations. Zahn continued to lobby for his posting to be confirmed. Efforts to sort out the muddle petered out. In May Nitti had to try to construct a new coalition but failed, and Giolitti returned to office on 15 June 1920. Rosen, on the other hand, still in contention, met De Martino on 6 June but reported that, while De Martino had been very pleasant and claimed that both he and Nitti were in favour of Rosen's appointment, he had concluded that the Italians were leading the Germans by the nose and formally asked for a different posting. On 22 July the Germans said they could not appoint an ambassador if there were no 'seat'. Curiously at this point, 30 July, the new Italian government, in an unusual search for tidiness, formally rejected Rosen (whose reputation was by then badly damaged by these shenanigans).

Finally, in August, when the Germans sensed, prematurely, that a solution to their need of an embassy was in sight, they cut the knot and nominated as full ambassador a 'very conservative' Hamburg banker, with no political or diplomatic track record, John von Berenberg-Gossler (1866–1943) (Fig. 5.4). On 14 August, Italy gave its agreement, and the appointment was announced on 24 August. Berenberg-

Fig. 5.4. John von Berenberg-Gossler, Germany's first post-war ambassador to Italy (1920–21).

Gossler was the elder son of Baron Johann, head of the Berenberg-Gossler private bank. When he had become a Hamburg Senator in 1908 he had been passed over as head of the bank in favour of his younger brother, Cornelius. His appointment raised some eyebrows because he was a personality without diplomatic 'schooling', as the *Deutsche Allgemeine Zeitung* put it. But later press assessments noted his energy and his ability to create a relationship of trust with Italians. His efforts were, however, not to be rewarded by the achievement of a new good relationship with an Italian government bent on extracting reparations beyond the capacity of their former antagonists.

In parallel with this stumbling diplomatic minuet Germany had informed Italy in March that they proposed to use a German-owned church and social building in via Toscana (near the via Vittorio Veneto) as a temporary chancery. The *Consulta* at that time seemed to have been considering offering the Germans the use of the Villa Torlonia (later used by Mussolini), but the Torlonias had asked to have the plans returned, perhaps when they discovered who the likely occupant was to be. In April the *Consulta* was also worrying belatedly that it was offering less good treatment to the Germans than the French and British had, and was looking for additional financial cover from the Finance Ministry.

By this point a possible way out of the difficulty had appeared in the form of the Palazzo Vidoni, as Nitti told Herff on 11 April 1920. The side of this large nineteenth-century block of flats with several shops on the ground floor ran along the Corso Vittorio Emanuele II, the main east–west thoroughfare in the centre of the city (Fig. 5.5). The *Consulta* hoped to take it over by compulsory purchase and in late March offered L.5m compensation to the owner, Guglielmi. In April Guglielmi let it be known that the Brazilians had offered him L.6m for it, and this gave the government a greater sense of urgency.

The German Embassy officially informed the *Consulta* that Herff had been appointed temporary chargé d'affaires on 6 May, the Swiss having given up their protection duty on 1 May. On the 8th Herff told Prime Minister Nitti that the Palazzo Vidoni could be acceptable to the Germans. In parallel the Germans' Italian legal adviser received the plans of the Villa Wolkonsky. But Herff fell ill and spent a month in bed, so the handover by the Swiss did not take place, and Herff's conversation with Nitti was not followed up till July, by which time Nitti's government had been replaced by Giolitti's new, broader coalition. By then Ulrich von Hassell, a diplomat of lower rank than the nominees so far in contention, had arrived (on 6 June) to take over as temporary chargé with the normal full diplomatic (as opposed to consular) functions. He reported to Berlin on 23 June that

a) he had formally taken over responsibility from the Swiss;
b) the Swiss had handed over some furniture, carpets, etc.;
c) there was no cash in the kitty;

d) the Swiss had in theory handed back the Palazzo Caffarelli and other property including the Villa Bonaparte (near Porta Pia), but 'subject to any measures taken by the Italians'; and
e) the Swiss had also reported on the break-in and ransacking in June 1918.

Hassell stayed less than a year in Rome, leaving for a post in Copenhagen in the following March (but returning as ambassador in 1932). In that short time he played a key role in taking the search for a new embassy into the Germans' own hands, and specifically for grasping and not letting drop the possibilities offered by the Villa Wolkonsky. After the Germans, on 22 July 1920, tetchily repeated to the Italians they could not appoint an

Fig. 5.5. *The Palazzo Vidoni on Corso Vittorio Emanuele II (after a modern clean-up from the sooty black front it presented in 1920).*

ambassador if there was no German embassy, the Italians moved things forward: on 25 July they reduced their offer to Guglielmi to L.4m and added a threat of expropriation for good measure. In the same month Hassell reported to Berlin a press article alleging some historical objection (again unspecified) to the Villa Wolkonsky solution, but argued that in his view there was none. The pendulum swung again: on 29 August a surveyor opined that the Palazzo Vidoni was in good condition, though overpriced. It looked as if things might reach a satisfactory conclusion. Hassell advised Berlin that, if the Vidoni option were pursued, the new ambassador (announced but not yet on the way) should stay in a hotel and arrive in late October, as the Parliament did not reassemble until November.

Berenberg-Gossler chose to arrive on 30 September – a good month too soon – and took up his post on 1 October. While he was immediately received by the foreign minister, Sforza, presentation of credentials was delayed until 5 November, because of the King's prolonged absence from Rome, which did not please him at all. (There is no trace of Hassell's reaction to this justification of his – ignored – advice, but it is not hard to guess.) Hassell meanwhile recommended that the Vidoni option should be pursued but that other solutions also continue to be sought. The Germans formally told the Italians on 27 October 1920 that the Palazzo Vidoni was deemed suitable but that a) they would need the whole building except the shops and b) much repair work would need to be done first. Berenberg-Gossler must also either have sensed that the way forward on the Palazzo Vidoni deal did not look promising, or he didn't like what he saw – quite understandable to anyone looking at the building now, even after its clean-up. At any rate on 23 October 1920 an upmarket estate agent, G. Mosca, wrote to Sforza, to report that he had on his books the 'Villa Wolkonsky-Campanari' which he had discussed the previous day with the German ambassador, and that other embassies were also showing an interest. Neither Sforza personally nor his Ministry replied, the government being caught up in the Fiume crisis. The *Consulta* was probably still convinced that the Germans' problem was on its way to a (Vidoni) solution, while Mosca's letter revealed that the Germans were already working on the Villa Wolkonsky possibility seriously enough to reveal their hand at ambassadorial level to the Italians.

The Fiume crisis did not stall everything. Reacting to the increasing German pressure over the delay, the Consulta on 20 November asked the Treasury for permission to reopen negotiations with Guglielmi for the Palazzo Vidoni, 'the only choice'. Berenberg-Gossler had a go at the Consulta in person on 16 December: he demanded speedy completion of the purchase of Palazzo Vidoni, and insisted that compensation must include the cost of him staying in hotel accommodation, which he seems to have done at his own expense. Sforza responded on 30 December declining responsibility for expenses beyond acquiring Palazzo Vidoni. The next blow was an obviously deliberate leak in the press to the effect that the Germans would only get the use of the Palazzo Vidoni, not full ownership. On 7 January 1921 Sforza explained that this was only being said in order to ease the deal and to avoid public discussion of reparations (about which the Germans were sensitive). Berenberg-Gossler recommended to Berlin that this could be accepted only on the basis that the issue of compensation for the Palazzo Caffarelli remained unsettled. That position was communicated to Sforza on 7 February, with a heavy overlay of German disappointment. He refused to promise eventual ownership and warned against stirring things up, as that might jeopardise the passage of the budget law, authorising the funding of the compulsory purchase. Berenberg-Gossler was instructed by Berlin not to respond to this line from Sforza.

A new price for Palazzo Vidoni was agreed with Guglielmi, L.4.2m, and agreement on the sale (to the Italian government) was ready for signature on 24 February 1921. But Guglielmi failed to show up. The tax authorities were demanding L.1m tax on his speculative gain – he had only paid L.1.1m for the building in 1918. And he claimed he wanted to accept a cash offer of $200,000 from 'an American' – perhaps to be paid offshore, out of the taxman's reach. The Chamber of Deputies had not yet authorised the budget law to cover the deal, and the tenants were insisting on their rights and refusing to leave (i.e. at best demanding to be bought out).

In the face of these signs that the plan was unravelling, the Italian authorities pressed on regardless with their self-inflicted 'only option'. On 1 March Guglielmi was informed that he had to execute the sale by 31 July. In March the Germans insisted that the Italians must bear the costs of repairs needed to the Palazzo Vidoni roof and boilers, amounting to some L.30,000 which the surveyor seemed to have missed; the Italians eventually agreed to this. In early April the Senate approved the purchase of the Palazzo Vidoni; only the King's signature remained to be added. In the real world, however, the tenants were still holding out: on 12 May the Consulta had to tell Berenburg-Gossler that the Italian State would take over responsibility for the (unspecified) parts of the palazzo still occupied by tenants including the shops on the ground floor. Yet, on the 17th the law was published in the Official Gazette authorising the expenditure of L.4.25m, including L.50,000 for extras, and the contract of sale was ready by 28 May. On 17 June the State property agency (Demanio) authorised the payment of L.4.2m to Guglielmi. On the 24th the Belle Arti declared the building of no artistic and archaeological value, as it was to have been pulled down! And the Public Accounts Court (Corte dei Conti) approved the transaction on 9 July. The Italian government was at last getting through its own procedures in good order.

Sforza approved the contract between the two governments for a 30-year lease on the Palazzo Vidoni on 1 July and sent it to Berenberg-Gossler on the 11th. The Consulta also announced they were authorised to pay the L.23,000 estimate for the roof and boiler repairs. But Berenberg-Gossler, exasperated, refused to recommend the draft to Berlin: the tenants had stayed put. It was formally rejected in a Note dated 19 July. Berenberg-Gossler spent much of the next three months absent 'on holiday', leaving his number two, Prittwitz, in charge, while the Italians argued among themselves about how to evict the tenants. The Consulta wanted the Cabinet to decide, as the issues were not within their competence. Berenberg-Gossler returned on 10 October. The Demanio pleaded it was doing all it could (which was not very much). In an attempt to keep the Germans happy the Consulta announced

on the 28th that repairs were to start. They also sought on 11 November to involve the Prime Minister's Office, and on 29 November informed the Finance Ministry that the Germans could not even get access to the first floor, were demanding compensation and were complaining that the rents from the shops at the Palazzo Vidoni were not being passed on.

But it was too late. On that same 29 November Germany's President Ebert communicated to the King the recall 'at his own request' (a most unusual step) of Berenberg-Gossler, thus making clear in the most authoritative way possible the discontent in Berlin at the Italians' mishandling of the whole affair. On 30 November the Vidoni tenants were threatened with legal proceedings. Berenberg-Gossler's last word on the subject – on 12 December – was that clarity would take a long time to achieve. He left Rome on 23 December. Italian agreement for his successor, Neurath, had been sought on 14 December. He arrived soon after Berenberg-Gossler's departure, suggesting that his appointment had been set up while Berenberg-Gossler had been away from Rome in the autumn. As press speculation in Germany – already rife in November – had suggested, the embassy farrago was not the only cause of Berenberg-Gossler's request to be relieved of his duties. He himself used the formulation that 'conditions were not right for him to achieve the objectives he had set himself'. He had let it be known in Berlin that, the embassy apart, the Italians had taken an extreme view on the issue of German property (unlike the English); and were too demanding on reparations generally to allow the creation of a new, better relationship. After his farewell call on the Pope, the latter was quoted in the press as affirming that, while Germany must pay reparations, all former enemies should show moderation and not make demands beyond Germany's capacity to pay. Some subsequent press comment also alleged that there had been scheming against him in Berlin; but Ebert's published letter to him on his resignation was warm and generous, if brief.

As Italy's fateful year 1922 began, the Germans were still without an embassy, and the Italian ministries were stuck with a law which authorised them to spend the money due for compensation to the Germans for their eviction from the Palazzo Caffarelli only on the Palazzo Vidoni; at the same time they were unable to pass it unencumbered by tenants to the Germans. With increasing desperation they decided to follow the advice of the Advocate General that the *Consulta* get a decree passed to enforce the eviction of the tenants. A draft was duly produced, but the *Consulta* dithered about the date for implementation. A senator insisted on remaining in the building (perhaps as his price for not opposing the decree). The Germans were told on 4 February 1922 what was proposed. But the tenants mustered a wave of protests in the street in defence of their legal rights and took their case to court. The Germans were informed of this on 25 February. Neurath asked what the *Consulta* proposed to do about that; the only answer he got (and not till 19 March) was that the outcome of the case could not be predicted.

Neurath then took two weeks' holiday, returning in time for the court hearing on 7 April. The judges upheld the objections to the decree, and their decision was ratified by the Council of State on 9 May. With that route firmly blocked, Italian ministers began arguing about how to compensate the Germans, and on 14 June they told the Germans that compensation would be paid once the monies had been transferred. Not surprisingly that was another case of easier said than done: the law sanctioned the expenditure only for purchase of the Palazzo Vidoni.

The Germans go their own way

The Germans, after two years of intense frustration, had however finally taken matters into their own hands, and negotiations had proceeded far enough for them to tell the *Consulta* on 8 June 1922 of their

intention to buy the Villa Wolkonsky. Neurath, on arrival in December 1921, had been quick to recognise the opportunity presented by the availability of the Villa Wolkonsky, undeterred by its relative distance from the centre of the city and its run-down condition.[8] Writing in 1930, he recorded that he had 'acquired the Villa Wolkonsky for the Reich'. In many German documents it is described as '*Reichseigen*' (Reich-owned) to avoid any doubt about its status which might arise from its acquisition in a private sale. While there is no contemporary evidence of the purchase on AA files, a copy of the sale contract is in the Library of the Villa Wolkonsky, annexed to the Note transmitting the Presidential Decree on the UK's purchase in 1951.

The *Consulta* on 20 June sought the opinion of the *Belle Arti* on the planned sale at a price of L.4.5m. The *Belle Arti* reply of 12 July contained a list of conditions – an updated version of Alexander's chains (*vincoli*):

a) Complete respect for the monuments, including the aqueduct and the tomb of Tiberius Claudius Vitalis;

b) No construction in the zone north-west of the aqueduct as between it and the [via Statilia] there was probably a line of important tombs from the late republican era and early empire, some hundreds of metres long (further details being added of recent finds)[9] – so these could not be damaged or covered by construction work, and the Italian State could, when it wished, excavate them;

c) Various archaeological items had been brought on to the site, but some funerary pieces were from tombs from the property or neighbouring area. The minister had ordered a catalogue to be made. The Wolkonsky heirs should be asked if they were prepared to donate four or five of the best pieces to the National Roman Museum – and the minister would indicate which items;

d) These conditions needed to be incorporated in the contract of sale.

The Prime Minister's Office agreed the Wolkonsky solution in principle on 19 July. The contract was duly drawn up and agreed on 19 August, when the Germans paid a deposit of L.500,000. But the *Consulta* had sat on the *nihil obstat* from the *Belle Arti* and had to be reminded on 22 September. The *Consulta* still had the Palazzo Vidoni on its books and had no interest in moving the Villa Wolkonsky solution forward. But things were not going their way, and the contract of sale was finally signed before Notary Buttaoni on 5 October 1922, without the full incorporation of the *Belle Arti* conditions or even reference to them.

The contract was between Signora Nadeïde Wolkonsky, Marchesa Campanari, daughter of the late Prince Alessandro [Wolkonsky], of via Conte Rosso 25, and the German Reich. On the German side, it was signed by Friedrich Wilhelm von Prittwitz, the administration counsellor and number two of the embassy (of the Villa Celimontana at via della Navicella 4, a kilometre or so down the road from Villa Wolkonsky) on behalf of 'Baron Constantin von Neurath of via Toscana 7', who had been 'duly authorised by his government to enter into the contract'.

The contract was repetitive and complex. Its main elements were:

a) Definition of the property by reference to familiar numbers on the Land Registry plan: 4004, 268, 270, 272, 1828, 4005–8, 4297, 4577 and part of 267; the boundaries being via San Quintino (north), via Santa Croce (east), land belonging to a company Lampertico and Nadeïde herself (west), and 'another Wolkonsky property' (south). Nadeïde also transferred any rights she retained over contiguous plots of land, intended as private roads, etc. (3514, 4399, 4396, 4394, parts of 267 and 3888 – see Plates 3 and 9.)[10]

b) The total price to be paid of L.4.5m. The buyer assumed responsibility to pay L.163,165.27, being the remaining monthly instalments of a mortgage on the property from the *Cassa di Risparmio* dating from 20 May 1908, the date on which the property had been formally registered in her name. A further L.2,336,834.73 above the deposit of L.500,000 was paid on the spot. The remaining L.1.5m was to be paid within two years, provided that the seller had within that period paid off all outstanding property taxes due on the property or could produce a guarantee that the German government would not be held liable for any failure on her part to pay such unpaid tax.

c) A requirement on Nadeïde to deposit (presumably from the sale proceeds) the sum of L.250,000 with the notary in substitution for the surety the property represented for her dowry invested in it in 1894 (i.e. while the ban on sales of parts of the property remained in force), to be held until the couple declared the guarantee extinct, so that the property should not be encumbered. The Germans were clearly very determined not to be liable for any consequences of the family having overreached their financial capacity.

d) An undertaking by Nadeïde that two cellars (*grotte*) at 272 (soon to become the Officials' House) on the property, access to which was through a neighbouring property of hers (4544 and 5287 in the land registry), would be blocked off once the lease on that property fell in.

e) The inclusion in the sale of all immovable objects, including the antiquities, fragments and memorabilia at the Villa and the German government's agreement to conserve them and, in accordance with the seller's wish, leave them in their existing positions, to the extent that the needs of the buildings allowed.

f) Declarations by Nadeïde that the property was subject to the '*vincoli*' of the City's development plan (*Piano Regolatore*); and by the German government that the property was only for use as the German Embassy to Italy.

Signature before the notary was not the final move. The Finance Ministry put the *Consulta* up to saying that, as the sale of the Villa Wolkonsky was by private contract, taxes would have to be paid. But the issue of compensation had still not been addressed, and the Germans needed to cover the cost of the Villa Wolkonsky, taxes, repairs and in-goings, two forced moves and temporary accommodation; and the loss of the Palazzo Caffarelli, including the old German hospital there.

Suddenly Italy was under 'new management': Mussolini had become prime minister on 31 October. In an attempt to break the deadlock Neurath wrote to him (presumably having spoken to him first) on 5 December, by which time the embassy's consular section had moved into the Villa Wolkonsky. Even the German president intervened on 30 December, urging resolution of the dispute. The *Consulta* advised refusal, on the grounds that the Germans had acted unilaterally and the law related only to Palazzo Vidoni.

The disastrous state of their own economy meant that the Germans could not just sit back and let time take its course. The question of compensation for the Palazzo Caffarelli could not be put aside. Local press criticism in 1922 of the demolition of the Palazzo Caffarelli and the failure to find the Temple of Capitoline Jupiter underneath was helpful to the Germans, especially as it recalled Germany's pre-war flexibility on moving off Capitoline Hill. Naturally any compensation would have to be based on an agreed sum for the value of the property the Germans had been kicked out of. Valuers for the Germans could not finish their task when the Palazzo Caffarelli was demolished. The 1918 decree had contained a figure of L.3.5m, and the Germans' valuers had put it at L.4.89m; the Germans were sure that by 1922 it was higher. On 23 October Neurath advised Berlin that compensation must cover the cost of the purchase of Villa Wolkonsky, temporary accommodation

and two moves. There should be no claim for the German Hospital, because the Germans would then be obliged to establish and pay for a new one. So the Italians were told that

a) a year had passed since passage of the law on the Palazzo Vidoni without any action by the government;
b) the question of finding a residence and offices had been resolved by the purchase of Villa Wolkonsky on 5 October;
c) the question of compensation for the German Archaeological Institute was still open, as was the overall compensation for the costs of Villa Wolkonsky, dealt with in a separate Note of 17 October, Germany having rejected the 'use in perpetuity' of Palazzo Vidoni as inadequate; and
d) the Italian government should compensate Germany for the total expenditure caused by the loss of the Palazzo Caffarelli.

The Germans put the total cost of the Villa at L.5.5m, including fees and the interest they were having to pay on the outstanding loans they had been required to take over. So, Neurath reckoned they should seek a cash sum of L.7m, adding L.1m compensation for the Archaeological Institute to a round L.6m for the rest. But other voices in the embassy thought they would do better to go for the offer still on the table (and sanctioned by law), i.e. the right to use of the Palazzo Vidoni with certain rights over rents and any sale proceeds, and use the rental income to pay the interest on the Villa Wolkonsky loans. Berlin duly approved this second course, and Neurath sent Mussolini (as foreign minister) a Note formally accepting the Italians' draft previously rejected (though not on paper), subject to approval by Italy's parliament – which Neurath assumed to be no longer a problem, given Mussolini's authority. The agreed there should be no publicity. On 5 May 1923 the Auswärtiges Amt (AA) in Berlin approved this 'reasonable' outcome and saw no need to rush for a sale (of which Germany would get a large share of the proceeds); the embassy should get the best rents possible, and should report parliament's agreement.

Parliament, however, did not take the draft law (and still had not when, on 24 July, it recessed till November). But the story had by then taken a distinctly Italian twist. On 28 May a senior Ministry of Foreign Affairs (MFA) official, Lo Iacono, introduced to the embassy one Alessandro Segreti, Secretary-General of the Rome *fascio* (league) of the Fascist Party, who expressed an interest in buying the Vidoni (nearby to Mussolini's headquarters in the Palazzo Venezia). Neurath, reporting to Berlin could not divine why Mussolini should want to intervene in this way: helping to unblock a tedious situation deriving from Italy's legal and parliamentary system or helping the Party to get a bargain or both – a win-win. But he had expressed interest in principle so as to avoid unnecessary parliamentary opposition. He teed up the embassy legal advisers Boseli and Hüber to receive an approach and to net L.6m from any sale, recommending to Berlin that the funds be used first to pay off the loans on Villa Wolkonsky. In July Berlin however reverted to their figure of L.7m to cover the German Hospital as well. Neurath tried to speed things along by suggesting to Mussolini that he bypass parliament and pass a decree. While Mussolini declined that route, the *Consulta*, warming to the task, surprisingly said they had it in hand. On 15 August the Finance Ministry duly announced that it was preparing royal decree. Amazingly it was passed in a relative rush on 24 September, bearing the names of the King and Mussolini. The Germans were officially informed on 11 October; and the decree was gazetted on 14 December 1923. But not a peep had yet been heard from the Rome *fascio*.

Wheels turned nonetheless. Just over a year later, on 4 February 1925 (in a contract drawn up by Notary Felice Santi) the Palazzo Vidoni was sold to a developer, Compagnia Fondiaria Regionale in Milan, which went bankrupt ten years later. On 26 February Mussolini (also foreign minister at the

time) formally acknowledged to Neurath the sale for L.1,227,284 gold or L.5.7m paper (Fig. 5.6). Four months later the press reported that it had been sold to the Fascist Party. A figure for the Germans' share of the proceeds has not surfaced, but there is no suggestion that they were let down. In 1926 the *Demanio's* sale to the developer was recorded in the Land Registry, with a contract date of 19 July 1924.

Issues of taxes (L.15,308) on the Vidoni rents (L.75,506) took a couple more years to resolve; and the Land Registry were still demanding but not getting some unpaid fees (L.51,000) in 1935. But the book had finally been closed on the Palazzo Caffarelli, and in 1925 the Germans had some money to spend belatedly on the Villa Wolkonsky.

One further loose end came to light. For all the complexity of the 1922 contract of sale, the lawyers did not do their due diligence properly. A deed to amend it had to be drawn up and signed on 14 May 1926. A state-owned developer, Società Immobiliare per la Compravendita di Beni Immobili nel Regno d'Italia, intending to develop a parcel of land 3888, on the via Statilia side – see Fig. 5.7), which it had owned for 30 years, discovered that it had mistakenly been omitted from the registration of its sale

Fig. 5.6. Mussolini (as foreign minister) acknowledged to the German ambassador on 26 February 1925 the sale of the Palazzo Vidoni (the proceeds from which the German government would take as compensation for the loss of their previous embassy in Rome).

in the Land Registry in 1889 and thus Princess Nadeïde had retained certain (unspecified) residual rights over it, which had been transferred in the 1922 sale to the German Reich, even though the plot itself was not listed among those which made up the property sold, an error neither party had then noticed. As the Land Registry showed the certain rights over the plot now rested with the German Reich, the plot was judged encumbered and the developer was unable to obtain the loan finance he needed for his plans. The Germans agreed to release it for a token sum of L.1,000, by a declaration that it lay outside the retaining boundary wall of the land that went with the Villa, and the developer paid the legal costs. That was the last change to the boundaries to have been made, though a spectacular effort to do so in 1943–4 was frustrated by the course of the Second World War (see Chapter 10).

During those years the property was in the charge of four of Germany's five post-war ambassadors: Konstantin von Neurath (1921–30), Carl von Schubert (1930–32), Ulrich von Hassell (1932–8) and Hans Georg von Mackensen (1938–43). The time and effort each of these ambassadors, their wives

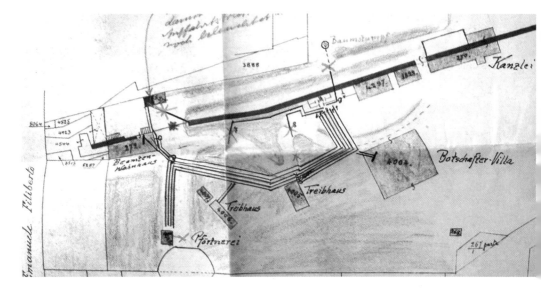

Fig. 5.7. The loose end: the parcel of land (3888) sold by the Campanari-Wolkonskys in 1889 and wrongly included in the Deed of Sale to the German government appears (top, middle) in this German sketch-map of re-wiring work from 1935.

and senior staff put into the maintenance, conservation and, eventually, enlargement of both the main house and the *casino*/Chancery, even in years of crisis and war, is striking. Their lengthy exchanges of correspondence with Berlin, the annual circulars about expenditure cuts and the arguments why this, that or the other work needed to be done regardless, bore the strongest possible resemblance to those exchanged with London in my day – and no doubt still by my successors.

Notes

[1] The main sources for this saga are as follows: <u>German</u> (i) Palazzo Caffarelli AA (a) (Pol) R130761, Vols 1–3 (b) Rom 1265a Caffarelli 1920–26, (c) Rom 428g Caffarelli 1920–21; (ii) Palazzo Vidoni AA (a) Rom 428d Vidoni 1920–22, (b) Rom 1265a Pal. Vidoni 1923–5, (c) 1265a Vidoni 1921–35; and (iii) on the personnel involved AA (Pol) (a) 009214 Vol 7 Rep IV Pers.162 , (b) Pers g Box 3 file 6/3. <u>Italian</u> Foreign Ministry (Farnesina) files (iii) X Personale Germania I and (iv) X Personale Germania I Legazioni Esteri in Italia.

[2] See (i) (b) at note 1 above.

[3] See (i) (a) Vol. 1 at note 1.

[4] See (iii) at note 1.

[5] Recorded in a paper dated 20 December 1918.

[6] While Rosen was being asked for his account, the AA produced an interesting memorandum on German-Russian contacts at the time of the Bolshevik Revolution.

[7] De Martino to Herff on 6 April 1920.

[8] 1928–31 (AA file 429a).

[9] NdS 1917, Fornari, p. 174.

[10] The plan annexed to the contract did not survive, but a later internal German use of a copy of the Land Registry plan of 1934 reveals what most of these numbers represent.

6.
THE TWENTIES:
PENNY-PINCHING YEARS FOR NEURATH

In 1921/2 Germany's parlous economic condition, not helped by the expected impact of reparations, did not allow the government even to contemplate spending large sums on rebuilding embassy residences abroad. In pushing the purchase, primarily in order to bring to an end the long wait for a new embassy building, Neurath did warn that much work needed to be done to bring the Villa up to scratch after years of relative neglect as a rented property during difficult times. But he may have judged it counterproductive to make too much of this before the purchase had gone through. Correspondence with Berlin had also not focused on its likely annual running costs. Inevitably, little money was available to run the house during Neurath's tenure, contrary to the myth prevalent in many post-war accounts of the period, which assumed that the Germans had from the start set about embellishing and enlarging both residence and offices.

1923 was nonetheless a year of some ambition, which may go some way to explaining the myth. Bickel of the *Reichsbaudirektion* (Reich Building Directorate) submitted a plan to the *Belle Arti* that year. No trace of it has yet been found in either German or Italian accessible archives.[1] We do know that it included a floor plan of a planned expansion of the Residence, dated 1 February 1923, but frustratingly no copy has come to light. We do not even know whether it covered the whole estate or only the Residence. The *Belle Arti* was subsequently recorded as having approved in that year the addition to the Residence of two wings, presumably the main feature of the 1923 plan. It would not have been unreasonable to draw the conclusion – as many have – that they had therefore been built. But that is not what happened.

The Officials' House

One relatively minor project does seem to have been successfully executed at the outset. The building situated against the far western boundary of the property and, like the *casino*, incorporating a (small) portion of the aqueduct was described in the Land Registry until the sale to the Germans as stables and garages – and bore the registry number 272. But by 1930 it was described in the inventory submitted to Berlin for the 1931 financial year as the 'Officials' House' (*Beamtenhaus*), comprising two flats, totalling 250 square metres (Fig. 6.1). Other evidence (for a fuller account see Chapter 21 on the refurbishment by the British government of the secondary buildings at the Villa in the 1980s) strongly indicates that the Germans converted and enlarged the existing stable block into two flats in 1923/4; but that conclusion cannot be substantiated by any identified bids for or records of such expenditure in that poorly documented period.

The Italian architect involved in the British refurbishment of this house in the mid-1980s opined in a historical note that it had probably been built (new) by the Germans between 1934 and 1939. This view was based on its 'absence' from certain maps up to that of 1934. But we know that part of the building

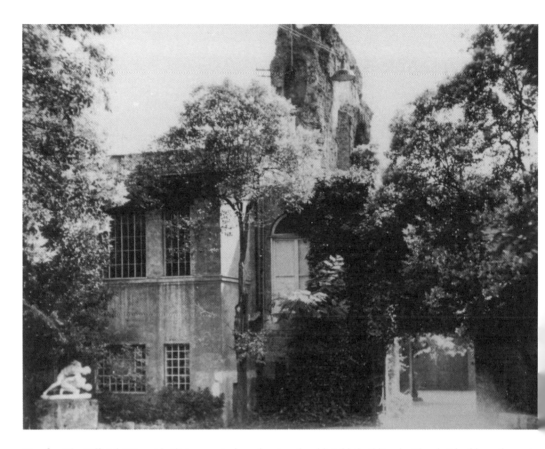

Fig. 6.1. The 'Officials' House' built in 1923/4 by enlarging the old stable building beside what had been the main entrance to the property until the 1890s – viewed from the north-east (almost certainly a German photograph).

had existed as a stable-block with that Land Registry number at least since the 1880s, before the time of the construction of the *villino*. And indeed a rectangular building on that site, up against both the boundary and a stretch of the aqueduct, features on older maps from before its acquisition in 1868 by Prince Alexander Wolkonsky. The building was also clearly marked on a copy of the 1932 official survey map of Rome, which showed its expanded size (Plate 9) and as the *Beamtenhaus* on a 1935 German plan (Fig. 5.7) for a rewiring contract. We do not know if Bickel's 1923 plan included this project, but that may have been simply because it was regarded as insignificant. Nonetheless the German scheme enlarged the structure considerably, while incorporating the original elements in a new and useful building.

The Chancery (*casino*)

The same did not apply to the *Kanzleigebäude* (chancery, i.e. the *casino*). Staff numbers and workload at the Embassy increased dramatically from the low point after the First World War, through the Weimar years and then into the rapidly developing alliance with Mussolini's Italy after 1933; expansion

was most marked on the economic and commercial front and with the addition of new defence and other sections. The old *casino* was soon to prove inadequate to the demands of the mission. By the 1930s additional premises elsewhere had to be hired (or after 1938 simply taken over). They were eventually supplemented by ugly prefabricated single-storey huts in the woodland north of the Chancery. But there is no record of major works to accommodate additional staff in the *casino* itself until Hassell came back to the scene.

In different economic circumstances enlargement of the office block would have been a natural priority during Neurath's long tenure. Not all its 18 rooms were of a size to be made into offices. But the evidence points to ambassador and staff having had to put up with it as it was for over a decade. In 1927 Neurath sought authority for an automatic Siemens telephone exchange at a mere L.10,700, to stop the operators of the Italian manual exchange listening to all their calls; and the restoration of the ambassador's cramped office to its original size by the removal of an unventilated, un-sound-proofed cubicle with no natural light, used by the Private Secretary ('Attaché').[2] Nothing was revealed about where the Private Secretary would be accommodated instead, but Dahms in the Reich Building Authority (*Reichsbauverwaltung* – RBV: note the change of name if not of function of the office which, under the control of the finance minister, was responsible for the Villa Wolkonsky) approved on the basis that Neurath would finance it by not resurfacing the chancery approach road (a bid which therefore reappeared for 1929).

Such minor adjustments strongly suggest that no major extension project had yet been launched by 1929. In a letter to Berlin in early 1930 Neurath pointed out that much had been saved in terms of later repair by the fact that the windowsills were replaced at the outset – implying that the building was otherwise little changed. The same letter described it as a three-storey office building: Alexander's own enlargement of the house, described in the Land Registry as four-storey with 18 rooms, might in practice have made it a three-storey building, as the top floor was little more than a roof-terrace. Unfortunately when Hassell began to campaign for its enlargement he did not say how many rooms it had by then, but we do know that after enlargement works of the 1930s it had 26.

The eventual and inevitable enlargement of the *casino* may have been foreseen and applied for in the 1923 application to the *Belle Arti*. But it could equally have been the subject of a second, cursorily documented application to make 'alterations' submitted in 1933. But the budget application for 1934 gave no detail other than listing the 'minor' (further?) extension to the Chancery to be carried out that year, and then, after Hitler's assumption of the Chancellorship in 1933, there was an immediate expenditure freeze. However, Hassell in 1937 did propose the *Heraufstockung* (addition of one or more floors) of the Chancery. And more clarity is to be found in a 1942 memo which states that the old Villa Wolkonsky chancery had a) been enlarged by the addition of a cellar and an upper floor between autumn 1933 and autumn 1934; and b) had two storeys added between late autumn 1936 and summer 1937. Any work before 1934 had been mere tinkering.

The Residence (*villino*)

Whatever the plan submitted to the *Belle Arti* and approved in 1923, the two large wings at the east and west sides of the *villino* were not added until the major extension project was carried out under Mackensen in 1939–40, just as the Second World War began. It is important to be clear about this, given the received wisdom, based on the submission of the request to the *Belle Arti* in 1923, that the work began from the outset. A British plan of the Residence from 1948 (updated in 1966) shows the

two wings dating from 1938 – a little early, but substantially correct. German photographs from 1923/4 show the towers without the top floor and no wings/terraces extending on the two sides (Fig. 9.1), as in 1905 (Fig. 4.7). Even though AA files are missing, Finance Ministry files give sufficient information for the scale and timing of the extension (and the long overdue re-engineering of heating, hot water, etc.) to be beyond doubt.

We know the extent of the 1890s building and can therefore assume that the house Neurath and his successors actually lived in was basically the Campanari mansion. We also know that some minimal essential work was carried out on the Residence in the early 1920s; but we do not know the extent of that work. It certainly fell far short of a major alteration. On the contrary the *villino* proved from the outset ill-adapted to the demands increasingly expected of the German ambassador: putting up senior visitors from Berlin and staging large functions, as well as housing an ambassador and his family. The dining room was far too small, and the other reception rooms did not match the scale of entertaining which successive ambassadors judged they needed to lay on – even allowing for the use of the garden for the biggest gatherings (mainly of German residents) in the summer months. The heating and hot water systems were not 'fit for purpose' – a constant bleat – and updating the kitchen generated an almost constant flow of correspondence and eventually two major refits.

Work done to the Residence in the early 1920s barely went beyond a touch-up to the paintwork. In-goings in 1922/3 such as they were had only included some patching to the dining room, nothing structural. There is no record of whether it was enlarged when the ceiling was replaced in 1925. It probably was: later correspondence does imply that the small room beside it was incorporated at that time – see floor plan at Fig. 4.5. But the job was poorly done, and the ceiling fell down after a few months, indicating that the removal of the dividing wall had not been compensated by the insertion of an adequate supporting beam. This story emerges from later files because in 1930 the Audit Court in Berlin demanded an explanation for the unauthorised and unbudgeted expenditure Neurath had incurred in the 1927 financial year on repairing a room which had only recently been reconstructed. The Embassy's response (from the chargé, as Neurath had by then just left post) explains with some force that Berlin's failure to allocate the necessary funds at the time had meant they had had to take on a poor-quality contractor who used cheap materials, and it was therefore no surprise that some of the work had proved shoddy.

Neurath and his two immediate successors battled on. After some years of procrastination it became obvious that providing new heating and hot water systems could no longer be put off just because of the enormous disruption that would entail for the whole fabric of the house and for the ambassador's capacity to do his job. But ambassadors continued to insist on being able to continue to live and operate in the Residence. Schubert's relatively short tenure focused (thanks to his wife) on the needs of the kitchen in the basement. Hassell and Mackensen faced new political challenges creating extra demands on the Residence and office facilities once Hitler had become Chancellor (1933) and the two countries moved to alliance in 1937. But they all had to continue to scrimp and shiver or sweat.

Neurath (Fig. 6.2) did however have some success (and spent a good deal of his own money) with the garden in the eight years he lived there. His feeling for the garden could well have been important in persuading him that the Villa would not just be a way out of the impasse over the Palazzo Vidoni but also a long-term asset of real distinction. With its aqueduct, the tombs and the romantic Wolkonsky tale, in which grand personalities of nineteenth-century Germany figured among others, the property could legitimately have been judged a very suitable place to represent the Germany of the post-First World War years. But to achieve that it needed much tender, loving care so as not to have the opposite effect of that intended. Neurath had the advantage of the experience and knowledge

of the head gardener, Gherardi, who by 1930 had been working there for 45 years, since before the new *villino* had been built. But he did much of the supervision himself (partly because Gherardi had become old and lazy, even if still valuable). There is no reason why Neurath should not have displayed such sensibility, yet that makes it all the harder to square the Neurath of the 1920s with the Neurath who, after two years as ambassador in London (1930–32), became foreign minister from 1932, remaining in that position under Hitler until 1937 and, because of his subsequent role as 'Protector' in Czechoslovakia, was sentenced at Nuremberg to 15 years in jail.

During most of their tenure ambassadors had to argue with Berlin for every penny, for the garden (and the gardeners), the house, on which so little could be spent when it was purchased, on household furnishings and equipment – even on newspapers for the Chancery. In the 1920s the state of the economy and the devaluation of the Reichsmark as hyperinflation took over made financing the Embassy very difficult, and the crash of 1929 only made things worse. Once the NSDAP (*Nationalsozialistische Deutsche Arbeiterpartei* – National Socialist German Workers' Party or Nazi Party) regime took over, resources were mainly devoted to other priorities. So those who held the purse strings in Berlin were constantly trying to impose and sustain expenditure cuts or freezes, and the tone of the ambassadors' correspondence with them, the arguments they used, the complaints they made, all bore a strong resemblance to those of the British

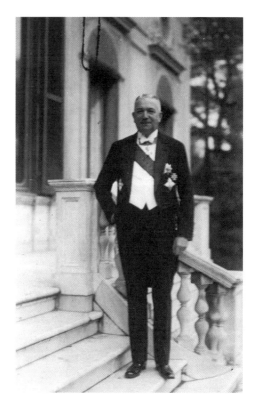

Fig. 6.2. Konstantin von Neurath, German ambassador to Italy 1921–30, on the terrace steps of the Villa Wolkonsky, leading down to his beloved garden.

years, also marked by a succession of (British) economic crises and financial cuts.

Personal relationships, then as now, could play a role. Neurath must have been particularly well supplied with contacts in the various administrative departments, as he had been the senior official responsible for administration in the AA for the year before his posting to Rome in December 1921. He clearly had a good relationship with Curt Schaefer, the senior official in the RBV. Schaefer was in post for many years, though not perhaps as long as Neurath. He came to stay at the Villa on a private visit with his wife before leaving the job in 1929. His successor, Dahms, was also in post for years and evidently took his responsibility for the upkeep of the Villa seriously in spite of the economic chaos of the times. In 1930 a separate, more powerful body, the *Reichsbaudirektion* (RBD), was set up – yet another change of name; and its Berlin office dealt with government buildings in Berlin and abroad. The RBD Berlin became the crucial department for practically all technical and cost aspects of work on the property, including design, need, cost estimates and specifications (e.g. for a new main electricity cable). Without their green light (including authorisation to the AA to spend specified sums from its own budget on specified works/purchases) nothing could happen.

Such detailed supervision, while necessary, was bound to make things slow. Once Hitler came to power the RBD was also the body used by the architect Albert Speer to carry out his plans for the new, triumphalist Berlin and other such schemes. But its Berlin department also retained responsibility for the overseas estate, i.e. embassies and cultural institutions. With or without Speer, the RBD had considerable clout. Occasionally the supervising Finance Ministry was directly involved, e.g. in authorising expenditure on the major projects being considered for the Villa in 1938/9 and the early 1940s. The RBD sometimes needed to get clearance from the Finance Ministry for lesser works as well, when the government's budget was under particular pressure. But normally the RBD was the deciding authority. The AA administrative officials could of course be important allies of the ambassador in securing funding and authorisations.

Neurath would have needed all the help he could get. Diplomatically he was in fairly hostile territory as the enforced move of the German Legation from the Palazzo Caffarelli on the Campidoglio and the subsequent mess-up had so emphatically demonstrated. Neurath's posting may have been occasioned by the need for someone with a grasp of administration and finances to oversee the move into the Villa. His career spanned the two world wars, and he played roles in both. He was a lawyer by training (like many of his contemporaries), brought up and schooled near Stuttgart, followed by university at Tübingen and Berlin, in the days when it was normal for German students to attend several universities in the course of gaining a degree. He first joined the AA in September 1901 but left in 1916 for 'war service' as Private Secretary to the King of Württemberg. After the war he returned to the AA in February 1919 and served briefly as minister in Copenhagen.

When Neurath finally left Rome in 1930 it was for London as ambassador. He had served there in the consulate from 1903 to 1908. His tenure was shorter on this occasion. In 1932 he was appointed foreign minister by Chancellor Franz von Papen. Having joined the NSDAP and later the SS (the latter against his will, he claimed at Nuremberg), he retained the post under both von Schleicher and Hitler, until 1938. He was widely regarded as lending some respectability to Hitler's expansionist policies. Whether during his time as foreign minister his affection for the Villa meant that he was prepared to help his successors squeeze the necessary resources out of a tight budget is not revealed. Eventually his overtly expressed concern that Hitler was leading the country into war exasperated the Führer and allowed the 'champagne salesman' Ribbentrop (also ex-London) to manoeuvre to replace him. Ribbentrop had in any case been running a parallel policy as foreign affairs chief within the party hierarchy, leaving Neurath with little more than the formal side of the job. In 1939 Hitler made Neurath 'Protector' of Bohemia and Czechoslovakia following the German invasion; but in spite of presiding over many acts of repression he was again sidelined in 1941, when Hitler concluded he did not deal severely enough with local opposition to German rule. He was suspended (after a personal interview with Hitler) and effectively replaced by Heydrich, though he remained nominally in office until 1943. Heydrich was assassinated in Prague in June 1942. At Nuremberg in 1946 Neurath was found guilty on all four charges against him, including crimes against humanity as *Reichsprotektor*, his defence that the acts of repression were the affair of the police, especially once Heydrich had taken effective control, having failed to protect him. Neurath was released in 1954 on health grounds and died in 1956.

None of this later history can easily be associated with the passion Neurath reportedly showed for the Villa and its garden. After his departure the temporary chargé, Smend, recorded in a letter of 30 August to Berlin that Neurath 'always oversaw the garden work himself and regarded it as very important'. (Explanations were constantly needed, not least in the annual submission of the budget for the following year, about why an embassy residence needed to employ a team of four or five gardeners. Similar repetition was required to get across the message that the German Reich had bought

in the Villa Wolkonsky not a sumptuous palace beautifully maintained and luxuriously fitted out, but rather a neglected pile going cheap after a succession of wayward tenants and little interest on the part of the owners over the previous 20 years in either the house or the gardens. One of Neurath's last letters from Rome (15 May 1930) explained for the umpteenth time that the estate contained the Residence, the three-storey office, the 'Officials' House', the gatehouse and passport-office, garages and servants' quarters and amounted to 45,000 square metres. (The garden and its team of gardeners have remained a major feature of ambassadorial intervention, expenditure and lobbying from 1922 to the present. Officials in Berlin – and London for that matter – seem always to have found it hard to grasp the scale and condition of the property, or indeed the number of people resident on it, instinctively comparing it no doubt with residences in the town palaces in Paris, Moscow, Vienna, etc.)

The cases being made to Berlin in Neurath's last two years (1928–30) are a good indication of how little creative work could be done during this time. In spring 1928 he wrote that the slate cornicing on the villa walls was 'kaput' and had caused damage to the walls themselves, necessitating much repainting as well as repairing leakage around the two towers and the terrace. In 1929 the roadway from the gatehouse to the chancery office needed relaying at the point where it turned a right angle. Double windows and/or shutters were needed to give the master bedroom respite from the heat of the terrace baking in the sun outside. A Siemens hot water heater was needed for the bathroom, as there was only the kitchen water-heater and Junkers gas stove, which prevented two baths being taken in succession (there was only one bathroom then). At the same time the ambassador reported that he had had to replace some 60 square metres of wall-cladding at the base of the building near the marble stairway down to the garden with travertine – imitation (finto), not real like the original, to show due economy – and needed ex-post authorisation.

On 27 January 1930, as none of these jobs had been authorised, they were resubmitted, with a list of new furniture, curtains and kitchen equipment that were needed. The dressing room and guest room needed wallpapering, the bathroom needed painting, and the main bedroom needed what we would call a makeover. This is a picture of making-do in a shabby, run-down establishment, putting on a poor show for Italian guests and Berlin visitors alike. By this time Germany's relations with Italy were less fraught, and the Residence was being put to more use, so its condition must have been increasingly irksome to Neurath. In addition the old office furniture from the Palazzo Caffarelli, now in the Chancery, was worm-ridden and needed replacing.

To make matters worse Neurath received in April an instruction to comment on a report by the Reich Audit Court on unauthorised overspends in the 1927 financial year. The court was especially exercised by an unauthorised outlay of 3,118 RM to replace the dining-room ceiling which had fallen in after having only been put up in 1925; oh, and an overspend of 19,000 RM on the garden. This gave Neurath the opportunity not only to repeat the scale of the estate (see above) but also to tell headquarters some home truths he must have been keen to get off his chest for some time. He reminded Berlin that he had warned them at the time of the purchase that it would need a lot of money to make good the years of neglect the estate had suffered. He had always been given too little money (though he did recognise the problems caused by Germany's inflation). This had led to savings being made in the wrong places – cheap paint, so it had to be repainted too often, cheap pinewood for the windows had rotted, delays in authorising work had resulted in more damage. Everyone had acknowledged that the dining room had been too small but it wasn't dealt with in the incoming works in 1922 and had to be done cheaply in 1925, by a contractor who had used poor materials: the contractor was to blame for the fact that the roof had fallen in after a year. This document clearly did the rounds: several files in Berlin contain copies of it!

The court also queried an overshoot of L.100,000 on a bill for the erection of a retaining wall to protect the estate (and of course the secret archives and codes) and the gatehouse in the same year. This work formed part of what makes the property the almost hidden oasis it has become, especially as the trees have grown up so much in the intervening years. The Embassy's response was a narrative with some charm. The quarter of the city around the Embassy was gaining a newly planned street layout, and the authorities wanted the steep sides of the Villa's grounds to be held back from sliding onto the new streets. The Embassy had been fortunate to have the contractor building the new streets (De Rossi) do the wall and associated works at a considerable saving to the Reich. But that had involved cutting down or reducing numerous trees, making a new internal path, building new drainage (and a toilet for the gardener's little house, poised almost on top of the wall). The drainage works had extended to another part of the estate to meet the (unspecified) complaints of a neighbour and avoid further claims for damages. All this had been authorised by the good *Herr Regierungsbaurat* (a rank, literally 'official building counsellor') Dahms to the tune of 20,000 RM, at that time L.120,000; but unfortunately by the time the bills had to be paid the 'rise of the Lira' (i.e. crash of the RM) meant that there had been an overshoot.

The episode of the retaining wall had brought a small additional – and almost comical – silver lining, which the court also queried. Neurath had been authorised in 1926 to build a walled compost heap in the garden. But the street works and the retaining wall meant there was a ready supply of stone to hand, and craftsmen to work it. So the walled heap had been converted into a stone-lined pit, which Dahms had also authorised.

The AA refused to send on to the Audit Court Neurath's vigorous response to their query. This was partly because they did not like Neurath's washing of ten years of dirty linen in public and partly because he had not confined himself to the queries about the 1927 financial year. By this time Neurath had moved on; his deputy repeated his case at even greater length. It contained interesting additions. The Villa had been known before the German purchase as 'Villa delle Rose' because of its splendid rose beds. No resources had been allocated for the garden at the outset. Neurath, 'with love and knowledge and from his own resources, saw to the improvement of the garden'. The employment of the gardeners was justified simply on grounds of the need for constant watering to keep the garden alive. The retaining wall construction had taken into the estate a semicircular area known as Piazza Sclopis (the junction of via Ludovico di Savoia and via Giovanni Battista Piatti, which had required extensive extra earth-moving and drainage works. With the arrival of Neurath's successor, Schubert, the niggling seemed to stop – probably because Schubert could simply draw a line under the past and was not interested in the garden – but he was followed by a circular announcing a strict 10 per cent cut in the household equipment budget.

Notes

[1] AA file 1541a Vol. 2, covering 1929–31, provides the main documentary source for this chapter, supplemented by references to the period in later documents. This reflects the lack in official German archives of papers relating to the Foreign Ministry and its embassies abroad in the 1920s, as a result of the dispersal of the archives at the end of the Second World War.

[2] This room may have been that shown in Fig. 3.12, if that was indeed the principal reception room of Alexander's house.

7.
THE THIRTIES: THE HITLER–MUSSOLINI ALLIANCE

Schubert and the Year of the Kitchen

Carl von Schubert (Fig. 7.1), who arrived in Rome in the autumn of 1930, was the son of a Prussian general. He had joined the Diplomatic Service in 1906 and by 1921 was head of the UK-US Department of the AA, a high-profile post as Europe and the USA attempted to create a new order out of the debris of war. At the age of 42 he was selected as State Secretary (the senior official in the AA), a position in which he served from 1924 to 1930. He became the right-hand man to Gustav Stresemann, the foreign minister: together they worked to restore international trust in Germany. He was a familiar figure at every international conference of the period, never without a cheroot or cigarette in his hand. After Stresemann's death in 1929 and the change of government in 1930 when Heinrich Brüning became Chancellor, he was replaced as State Secretary and appointed Ambassador in Rome. Whether he relished this as a reward for distinguished service is not related. But there was serious work for him to do: in 1930 he was already recorded as discussing with Foreign Minister Dino Grandi possible Italian–German collaboration on infrastructure projects in Iraq, to which the British were about to give independence. He also had to get his hands dirty by dealing with the requirements of his new residence.

Schubert had struck a deal with the AA before travelling to Rome – or so he thought, as well he might, given the position he had held in Berlin.[1] He put in the routine bid for **1931** on quite an ambitious scale: a makeover for the Red Salon, a reception room (tables, sofa, chairs, lamps, carpets); new helmets here and there; an upgrade of the kitchen (washing boiler – *Waschkessel* – and cooking range) which was described as urgent and essential; and extra electric heating because the existing boilers could not provide heat for the living quarters upstairs. He had a clear expectation of getting his wish. He seems to have had an undertaking that, as a new ambassador moving in (the first since Neurath had bought the Villa and moved in himself) he could count on 17,000 RM to cover refurbishment costs. That followed a visit to Rome by (*Baurat*) Bickel from the RBD. But when Schubert's list hit desks in Berlin, he was told by Frenssen (of the AA) that they could only manage 9,000 RM, so would Schubert kindly prioritise his list? He did so on 3 December. A circular of 24 January 1931 then imposed a freeze on all new works till 1933. But things were not quite as they seemed.

Nineteen thirty-one turned into the Year of the Kitchen, starring Frau von Schubert in a way which would have had strong resonance for some of the Schuberts' latter-day British successors. Frenssen, writing to her in March 1931 to introduce his successor, Pannwitz (who knew the Villa Wolkonsky well, having signed the purchase contract in 1922), announced that the tidy sum of 3,000 RM was available for the priority list plus a 'secret' 7,000 RM for residence equipment to make up the shortfall in 1930. But that was not enough to make things happen on the kitchen front. In June Schubert himself complained to Pannwitz that permission to go ahead with the range, promised for May by Frenssen before his departure, had still not come through; and the work needed to be done in the summer

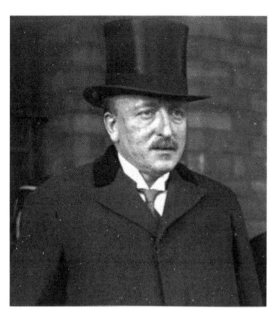

Fig. 7.1. Carl von Schubert, German ambassador to Italy 1930–32. (Photo dated 1929, when he was State Secretary.)

months when there would be no guests to entertain. He had established that the range had not been changed since it was originally installed by the Campanari-Wolkonskys when they completed building the house in 1891 (at least that was what the soon-to-retire head gardener, Gherardi, had told him).[2] He also resubmitted his priority list of December. He wrote similarly to Bickel. Evidently cash was short, whatever the promises. Then his wife, who was at home in Germany for the summer, weighed in with a well-organised handwritten letter making all the points again with considerable force.

Part of the delay was caused by separate arguments over the heating of the house. The Schuberts were both involved, with Frau von Schubert especially trying to get some practical additional heating, while the Berliners thought the time had come to redo the central heating altogether. Since such a project would involve 'massive redecoration', the Schuberts were determined that it should not happen, however necessary it might be: it would ruin their time in the house, and the money allocated (apparently 1,200 RM) would be insufficient to ensure that the new system would be powerful enough to heat their apartment, which is where the problem was worst felt. So it would be best to boost the supplementary electrical heating.

Pannwitz accepted this view in early July, but by late July there had still been no advance on the kitchen, and Schubert complained that the Embassy was on 24-hour working (because of the banking collapse in Germany, it seems) and everyone was having to eat cold food. By this time the Schuberts had changed the specification of the range to a dual-fuel (coal and gas) model and identified the equipment they wanted – a *Sparkochherd* (economy cooking range) made by Küppersbusch and supplied through a German firm, Horn, in via Alessandria in Rome. The order was finally placed on 1 September for delivery on 26 September, with installation to be done by the manufacturer's own people from Gelsenkirchen. This way of doing things – equipment purchases from Germany to guarantee quality – set a pattern for the future. But it very nearly had the opposite effect. The files show that the firm had not been paid by the Embassy on 19 November. This was because the final costs were well above the sum approved in Berlin. Why? Because the Embassy's project management had been woeful. The Embassy had assured everyone that the new range could be manoeuvred through the narrow doorway down to the semi-basement kitchen. When the truck turned up that proved incorrect – no one had thought to measure again after the choice of model was revised. So transport costs spiralled while workmen were brought in to widen the doorway. Then the flue was found to be too narrow; and further costly work had to be done to widen the outlet in the wall. Finally, the footprint of the new range was different from the old one, and a new marble floor had to be laid. At least, once installed, the range seems to have served its purpose for some ten years.

After that torture the Schuberts focused the 1932 works programme elsewhere.[3] At this point, at last, a change of budget procedure allows us to have an overview of the Villa Wolkonsky: each year's bid had to be preceded by a description of the buildings, including an inventory of rooms and their condition.

The first example of the new document shows that, after the refurbishment of 1930/31 on the change of ambassador the house, which 'had been built in 1890 on a 26m x 26m floor plan', was made up of the following accommodation:

Fig. 7.2. One of the two main greenhouses for which Ambassador Schubert won permission to provide heating in 1932.

Cellar: kitchen, staff dining room, heating room, laundry, ironing room, storage cellars.
Ground floor: Hall, antechamber, dining room, green salon, grand red salon, yellow salon, library, 'office' and toilets.
Mezzanine: accommodation (above the kitchen) for servants, including a bathroom.
First floor: ambassador's flat.
Two tower structures (Turmaufbauten): accommodation for household staff.

The major equipment inventory is as follows:

Heating: a) combined air and water heating by 'a Strebel boiler linked to a large heat exchanger (Heizschlange) over which an electrically-powered fan draws cold air from outside, which passes through air-shafts to the rooms'. (This system can still be seen.)
b) additional electric heating foreseen for three first-floor rooms (author's italics).
Linen hoist, electrically-powered.[4]
Kitchen: Küppersbusch range, coal- and gas-fired.
Hot water: uses the kitchen range and a Junkers boiler.

In addition we have some minimal description of other buildings:

- Chancery: an 'older building' of three floors, 270 square metres, comprising offices and a small apartment (of two rooms, kitchen and bathroom) for a 'first assistant' (presumably a junior clerk). This required refurbishment of the room used by the confidential courier from Berlin (estimate 950 RM).
- Officials' House: in good condition, on two floors, 250 square metres, divided into two flats, the senior one being upstairs.

c) Garage block: never touched, even by Campanari.

This needed doing up, especially raising the roof, partly to accommodate the senior gardener who was getting married in 1932 (estimate 1,580 RM).

The files do not relate whether the supplementary heating was ever provided. Both the courier room and the garage project were rejected in May 1932. Yet approval was obtained in January that year for two emergency boilers to heat the greenhouses at a cost of L.2,730 (Fig. 7.2), but this project came back to haunt Schubert's successor when the Audit Court got its teeth into it in June 1933.

On the other hand we learn that the ambassador's quarters had their own electricity meter and the ambassador had to pay for the electricity consumed – an irony, given the reluctance in Berlin to approve supplementary heating for the flat. The Schuberts anyway left for retirement, after less than two years of struggle to upgrade even a small part of the house.

Unlike his predecessors and successors Schubert at this point disappears from the record. His name does not crop up in any of the normal reference works for the period. His AA official biographical entry simply says he retired; he died in 1947, still only 65. It is tempting to speculate whether his early retirement was a choice on political or health grounds (that cigar/ette!); politics seems the more likely, as he lived another 15 years.

The edgy Hassell years

Ulrich von Hassell (Fig. 7.3) arrived as ambassador on 23 September 1932. His tenure at the Villa coincided with a period of great political change, not least the increasing, if bumpy, rapprochement of the National Socialist and Fascist regimes, which might have been expected to see a flowering of the role of German ambassador in Rome. But Hassell was quite openly sceptical (at the very least) about what Hitler was doing to Germany and its foreign relationships. He stayed in Rome until February 1938; but these were edgy years, both in the German–Italian relationship and for Hassell himself.[5]

Like his predecessor Hassell was the son of a Prussian officer, and he volunteered for military service in 1906 before entering the Consular Service in 1909. Back in uniform in 1914 he was soon wounded and invalided out, returning to the civil service. The Foreign Service sent him to Rome briefly in 1921 to do economic work (in which position he had and took the opportunity to influence the choice of the Villa Wolkonsky as the new German embassy, as Chapter 5 related). After a series of other postings, during which he married Ilse, daughter of the famous Admiral von Tirpitz, he was appointed ambassador to Italy. While he and his family appear to have enjoyed life in Rome, at least initially, they found it increasingly hard to support the militaristic and hegemonic tone of the growing alliance between Germany and Italy.

Hassell had joined the NSDAP in 1933 (as did many in the AA) but struggled intellectually and emotionally. As ambassador in 1934 he lectured (in Italian) to an audience in Florence which included Mussolini. The 'woe of discontent' after the First World War could only be resolved by the peace which unity would bring. To make that unity happen would require leadership by single individuals, 'not to be confused with autocracy' but rather representing a 'businesslike pacifism'. He claimed that the spirit of Prussia was not fruitless militarism but subjection to the welfare of the whole; and invoked Dante with suitable quotations. Il Duce was apparently well pleased. Indeed he seemed to develop respect for Hassell, who found it possible to engage in real discussion with him. Mussolini, too, was wary of the direction Hitler was leading Germany and Europe and persistently disagreed with Hitler

merging of party and state and with his attitudes to the Church and to the Jews.

Hassell played host to many leading Nazi figures, including von Papen, Goebbels, Goering and Ribbentrop, exposing them where possible to the views of Mussolini and senior Italians. But each came with his own view of policy, and Hassell sought in vain to persuade Hitler to restrain these purveyors of mixed messages. He contrived Hitler's first meeting with Mussolini (in Venice in 1934), hoping that might moderate Hitler's course. Hitler was initially impressed by Mussolini, but the relationship never flourished at the personal level. Mussolini's opposition to Hitler's aggressive policies (until he needed Hitler's backing for his invasion of Ethiopia), and his annoyance at Hitler's (and France's) refusal to ratify the 1933 Four Power Pact (which Hassell strongly supported as the way forward for Germany in Europe) gave Hassell much common ground with Il Duce. But Mussolini found himself obliged not to oppose Hitler's designation of Austria as a German state and less willing to share Hassell's policy. When in 1937 Hassell openly opposed Italy's joining the German–Japanese Anti-Comintern Pact of 1936,

Fig. 7.3. Ulrich von Hassell, German ambassador to Italy 1932–8.

Ciano, now foreign minister, and Ribbentrop, newly appointed German foreign minister in place of Neurath, began to work for his removal: they saw him, and especially his influence on Mussolini, as an obstacle to their ambition of closer German-Italian cooperation against France and the UK.

In 1937 in a brave speech in Cologne, to a mixed Italian-German audience Hassell suggested that, while National Socialism argued against a united Europe, the concept of Europe could be given life by Italy and Germany leading to a new order. Hitler and Mussolini were carrying forward the visions of Goethe, Dante, etc., to fulfil a historic duty and hold the balance between East and West. The aim was not to march to European primacy but to enable European cooperation, economic, cultural and in due course political, putting aside the cause of war (i.e. the First World War). In private Hassell was also increasingly critical of the way things were going. Many in the party hierarchy in Berlin had long had their doubts; when Ciano, with Ribbentrop's backing, started to complain in Berlin, it was to be only a matter of time before Hassell was replaced, in February 1938. For all his five-plus years in post, his farewells from Ciano and Mussolini were perfunctory, out of tune with the increasing closeness portrayed to the public in both countries. The Italian press made little of his going. In an interview Hassell praised Mussolini for inventing and implementing the Axis – a remark perhaps unlikely to endear him to his own Führer.[6]

For all the high politics, there was no escaping the attention Hassell, like any ambassador, must give to housekeeping. His early bids came up against a circular dated 1 March **1933** imposing not only a freeze and some cuts but also a regime of monthly allocation of twelfths of the annual budget. Hitler had become Chancellor on 30 January but did not assert dictatorial powers until 24 March. So there

was as yet no budget. In June Hassell found himself caught up in yet another Audit Court challenge to past expenditure: this time on the heating for the greenhouses, on the grounds that decorative flowers for the house were a charge to the ambassador, so he needed to pay to heat the greenhouse (Fig. 7.2). Hassell wisely agreed to limit the heating to one greenhouse – and a few months later successfully argued that the Embassy should keep the savings to spend on the garden! In September the retaining wall of the estate fell down all too close to a passer-by in via Statilia, needing rapid attention – and expenditure. In November Hassell's bid for 1934 included L.11,800 to do up the gardener's little house (Fig. 3.7), taking advantage of the retirement of Gherardi, the head gardener. This was approved in January, amazingly fast, perhaps because security was becoming an issue and the successor was to be a German.

The rest of Hassell's formal bid for work in **1934** focused on the Chancery,[7] an extension of which was nearly complete;[8] whether this minor project was cleared with the Belle Arti or was deemed part of what they had approved in 1923 is not known. When it was nearly complete (in February) he bid for (re)furnishing/equipping the waiting room, the antechamber (ambassador's outer office), cash office and the press office toilet on the ground floor plus a further waiting area, the registry and toilet on the first floor. The scale of this bid seems to have provoked officials in Berlin to visit Rome to assess what was needed to bring the Chancery up to scratch: a seed had been sown which was to have remarkable consequences (set out in Chapter 10).

Hassell then turned his attention to the Residence and on 6 March bid for refurnishing of the Red and Green Salons. External windows, shutters and doors all needed overhaul and repainting. He claimed that all the furniture and furnishings dated back to 'before the war' (i.e. came from the Palazzo Caffarelli) and, while he had spent his own money having springs repaired, he was unable to stop the silk covers from falling to shreds. The bid included new curtains for the Music Room (Musikloge) probably the little room beyond the dining room. Hassell's wife, Ilse, was reported to be in touch with Pannwitz (AA): between them they did a great job, as the furniture/furnishing bid (L.16,900) was approved just a week later on 14 March.

Hassell kept up a successful drip feed of small bids:

- 2 June: L.160 for a ventilator for the kitchen
- 29 June: re-asphalting the road to the Chancery, damaged by the traffic associated with the early works (probably incorporating the several earlier unrequited bids for resurfacing part of the roadway)
- 5 July: replacing silk curtains in the hall (L.7.50 per metre, no quantity specified!)

However a bid in September for repair of broken windowpanes was turned down and Hassell had meet the cost (L.171) himself.

The **1935** bids, made in February, once more met the lack of an agreed budget. Hassell's prior was a hardy annual: the hot water system. Hard water was blamed for the ineffectiveness of the boiler. Berlin tried again to push for the replacement of the plumbing throughout the house. Hassell stuck to his guns and got a new boiler in January 1936. In the same month he bid to have the roof over the garage block replaced (and raised to make the accommodation over the garage tolerable – evidently the 1932 bid for this had failed. He repeated the successful but unimplemented bid refurbish the Residence's external doors, windows and shutters. And he began a campaign to have the central heating completely replaced as soon as the present dodgy heat exchanger gave up the ghost, with estimates and plans being worked up in the meanwhile. In May **1936** the RBD reach

by deciding to undertake a full heating survey: maybe there was money available at last for this sort of expenditure.

For **1937** (submitted in December 1936) Hassell noted that the devaluation of the Lira would affect cost estimates: a good moment to spend! Indeed the rate which had been 1 RM to L.6 in 1927 and 1 RM to L.4.54 in 1930, had fallen by the end of 1936 to 1 RM to L.7.60, where it was to stay until 1943. A major requirement was the replacement of the rusted iron balustrade around the roof with reinforced concrete (cost L.40,000 = 5,242 RM). As a complete replacement of the central heating systems would cost over 25,000 RM and require the shutting down of the house, the bid was for 6,000 RM to 'repair' both systems. A new guest bathroom was needed on the first floor, as the current one was accessible only through the private flat (2,359 RM). A new tiled roof was needed for the laundry room across the front courtyard. The road to the Chancery still needed resurfacing.

Hassell also included a new architectural element for the first time in years: as the representational rooms had become too small for their function he wanted to have the external marble stairway to the garden rebuilt with a new, larger terrace area at the top of it, at the doors of the main salon. Plans had been drawn up by an architect called Steinhausen. The files reveal very little about reaction to these bids. In June 1937 Berlin agreed to the scheme – though the work was not done till 1939/40, becoming submerged in more far-reaching works. They also announced a visit to look at adding one or more floors to the chancery building, over and above those recorded as being carried out in 1936/7.

After Hassell's recall from Rome in February **1938**, he was placed on provisional retirement and given occasional temporary assignments in Berlin, including managing the link between von Weizsäcker (then State Secretary in the foreign ministry) and the British ambassador, Henderson.[9] He was formally retired on 10 February 1943. But he did not disappear. He remained in Berlin, in touch with many members of the increasingly disaffected nobility and some senior military officers, as well as travelling a good deal (under cover of one of his shadow posts) trying to persuade the Allies to take seriously the opposition to Hitler; he was warned that his activities were causing him to be watched by the Gestapo.[10] How closely involved he was with the group directly responsible for the July 1944 attempt to assassinate Hitler is unclear; but he had been sufficiently close to many of them for his arrest to follow their failure. He was interrogated, tried for treason and executed by hanging on 8 September 1944. He was posthumously denied the status of retired official.

Mackensen and the ambition to impress

Hassell's successor in Rome, Hans Georg von Mackensen (Fig. 7.4), arrived in March 1938 – a very different man from his predecessor. He had served in the army from 1914 to 1917, was wounded and out of action for a year but rose to the rank of captain as personal adjutant to Prince August Wilhelm of Prussia. He too served in Rome in the 1920s, from 1923 to 1926. At the end of his posting in August 1926 he married the boss's daughter, Winifred von Neurath. From 1933 to 1937 he had had a successful post as ambassador to Budapest;[11] his father, August, a very distinguished and popular First World War field marshal, enjoyed a big reputation there. He joined the NSDAP in 1934 (and in 1942 was made *Gruppenführer* in the SS). On 1 March 1937 he returned to Berlin as State Secretary in the AA (i.e. the senior official), where his father-in-law Neurath was still minister, though rapidly losing ground there to Ribbentrop. But just a year later he replaced Hassell in Rome, where he stayed until 6 August 1943. During Mackensen's brief tenure as State Secretary decisions were being taken on the construction of a grand new Italian embassy. He would no doubt have been struck by the contrast with the rather dilapidated abode he took over on arrival in

Fig. 7.4. Hans Georg von Mackensen, German ambassador to Italy 1938–43.

Rome in March 1938 – if not before. The more so, as, in matters of residential status, he had form.

On his appointment as State Secretary he had found that Neurath (as minister) had chosen no to live 'over the shop' in the Wilhelmstrasse, presumably because he did not want to be always available; instead he lived in his own house in the suburbs. Mackensen thought the flat inadequate if he was to perform the minister's representational duties, which was what Neurath wanted as he sensed his growing political weakness; at his son-in-law's request Neurath put in for him to have an official residence at Bendlerstrasse 34, near the Ministry. While waiting for the finance minister and Hitler to approve Mackensen went ahead and rented it himself then bid to have it refurbished at public expense which his father-in-law could approve without further reference, including the cost overrun of 100,000 RM. In February 1938 Hitler ordered that the costs should be met provided that the interior minister occupied the flat at Wilhelmstrasse (the Foreign Ministry) which Mackensen had found inadequate. Later the Finance Ministry approved the purchase of a house at Schroederstrasse 34/36 from its Jewish owner, Hans Fürstenberg, a merchant b then resident in London, as the permanent official residence.[12]

This tale shows Mackensen as status-conscious, fond of high-class official accommodation and free-spender of the state's money – and a man who liked to get his way. But he had hardly moved t Bendlerstrasse when Neurath was finally replaced by Ribbentrop, and Mackensen found himself e route to Rome. By the time the purchase of the Schroederstrasse house was authorised in August 1938 Mackensen was fully occupied elsewhere with other matters.

In Rome he put his name to the 1938 budget bid, prepared by his predecessor. He added refurbishment of his office and the building of a new safe room into the old aqueduct, reusing the old door on a secure cash store also built into the aqueduct. (These last elements appear not to have been authorised, as they appear again on a project sketch plan dated January 1943 – see Plate 7 – which was carried out.) His bid for the Residence was nothing dramatic. It did no more than reassemble some old friends, though in financial terms it was quite ambitious:

- Overhaul the façades, windows and doors (965 RM)
- The heating and terrace works not yet implemented (10,484 RM) – subject to a technical visit k the RBD
- Proper drainage around the Villa (769 RM)
- The road to the Chancery (yet again!) (697 RM)

Something happened between the submission of this bid (which may itself have been the trigger) an the end of 1938, by which time a project to (roughly) double the volume of the Residence was on the

table. The source of this marked change in the dynamic in Berlin remains a mystery, the solution to which can only in part be inferred from a knowledge of other things going on at the time, as no available archival material offers real evidence. The project was approved in early **1939**, with a speed which tells of high-level interest.[13] The AA budget for Rome in 1939 suddenly had in it 50,000 RM for maintenance of buildings and gardens, plus 110,000 RM for the management (*Bewirtschaftung*) of various buildings (unspecified – possibly the ex-Austrian and ex-Czechoslovak embassies). Furthermore a note in 1939 recorded that the freeze on embassy building did not apply to Rome; and that there was a secret fund of 3.5m RM, which Ribbentrop had personally increased to 8m RM![14] For the Villa Wolkonsky the tectonic plates had at last begun to shift, with almost volcanic force.

Notes

1 The years 1929–31 are covered in AA file 429a.
2 Schubert reported this on 18 June 1931 to the AA – file 429a.
3 The years 1931–3 are covered by AA file 429b.
4 Still in perfect operational order in my time in 2000–2003 and in 2019!
5 In addition to official files we have some insight into his life from the book by his daughter, Fey (*A Mother's War*), and more tangentially from personal accounts of wartime Berlin such as Marie Vassiltchikov's *Berlin Diaries: 1940–45* as well as Hassell's own diaries. I have also benefited from sight of an early draft of a book by Hassell's grandson, Corrado Pirzio-Biroli, which draws on an unpublished memoir by his grandmother, Ilse von Hassell.
6 This paragraph draws on BA: AA Press Department file R/8034/III/179.
7 The years 1934 to January 1939 are covered in AA file 429c.
8 Whether this was the major addition of offices or only a small addition is not clear, but the latter seems more likely, as the files show no reference to any such major project during Schubert's tenure, and later files refer to the main extension as having taken place in 1936–7.
9 Henderson's memoirs, *Failure of a Mission* (London: Hodder & Stoughton, 1940), make no reference to him.
10 Hassell, pp. 165–6 and elsewhere.
11 He had however suffered a stress fracture which required two operations while in Budapest – BA: AA Press Department file R/8034/III/297.
12 This story is recorded in BA: Finance Ministry file R2 11510.
13 AA files are deficient at this period. Finance Ministry files held in the Bundesarchiv, Berlin, provide some of the missing information: see BA: file R2 11581 Italien Fiche 1.
14 BA: Finance Ministry file R2 – 11496 of 1939. There is no AA or Finance Ministry file covering mid- to end-1938.

8.
THE VILLA AT LAST ENLARGED AND REVAMPED

Italy moves up Germany's scale of priorities

One reason for the sudden change of direction may have been the construction in Berlin of a grandiose new Italian Embassy (residence and offices) as part of the grand scheme dreamed up by Speer for Hitler's new capital, 'Germania'. With the Italians pleading lack of resources, the German government paid the 5.8m RM cost. The new resources available from the Austrian Anschluss in 1938 (not least the reserves in the Central Bank) and envisioned from the intended takeover of Czechoslovakia may have influenced the timing of these extravagant plans. Hitler turned down the first design (by an Italian architect) for a Tuscan-style villa, and Speer assigned the work to Friedrich Hetzelt. Ground was broken in 1938 on a well-placed site in the Tiergarten, on which a splendid new embassy was built in the fascist style (with elements of the Roman villa of antiquity incorporated, as well as carefully carved 'fasci' – Plate 24). A similarly grand Japanese Embassy was erected nearby. Both are there to this day.

Although the building was finished in 1941, the ceremonial opening by Hitler and Mussolini planned for January 1943 never took place. The German defeat at Stalingrad rendered such a ceremony inappropriate. Then in July Mussolini was dismissed. But the building was used, also by the representatives of the rump Salò Republic (during whose time it was bombed). When Berlin again became post-war Germany's capital, Italy, starting in 1997, restored the exterior and redesigned the interior (leaving a colonnade damaged by the bombing unrepaired as a memorial). This time, in 2003, it did receive a proper opening, with Presidents Ciampi and Rau officiating.

In 1938, feelings about the inadequacy of the residence and offices in Rome would have taken on a new dimension against the background of the Italian project in Berlin. The idea of Germany at least matching in Rome the grandeur of Mussolini's new embassy in Berlin would have made people in Berlin more receptive, or may even have been at the heart of the change of approach. Mackensen's own predilection for grand housing and first-hand awareness of the state of the Villa Wolkonsky may also have helped to account for the decision being finally taken on his watch to refurbish and extend it, with priority for the residence. It was, after all, the place that most visitors would see, rather than the offices which had in any case just been somewhat enlarged. Mackensen knew the ropes.

The Auswärtiges Amt and Federal Archives lack the key files covering the process of decision taking in late 1938. The coverage of the subsequent work of major refurbishment done mainly in 1939–40 but in part continuing through to 1943 is also very patchy. So the extent of Mackensen's influence on the gear-change remains, for now, a mystery. Only Finance Ministry files in the Federal Archive (Bundesarchiv) allow one to pick up some official traces of the project. They do show that Mackensen lost no time.

A decision in principle to proceed was taken in the last months of 1938 – though there is no single document to substantiate that assertion or illuminate the process. On 9 January 1939 Mackensen recorded the economics minister Walther Funk as ruling that a freeze on all new building

would not affect the enlargement of the Rome residence. He asked the AA to inform the Finance Ministry, so that work could begin on 1 April.[1] On 2 February Ribbentrop duly asked for the work to be completed with great speed. Voss, new Head of the RBD in Berlin, promptly appointed a senior figure, Soppart, to supervise the project and sent him to see Mackensen. Funk allowed for 275,000 RM to be transferred to Rome through the 'German-Italian Clearing' mechanism, but the finance minister took some time to release the funds. As no architect is recorded as having designed the extension (and some criticism of the basic design was uttered within the RBD but overruled in Berlin in March) it is a reasonable working assumption that Bickel's 1923 'two wings' project was dusted off and executed in 1939/40 with little alteration. But complete revamps of heating, plumbing and wiring were incorporated.

That was too hasty for some. On 1 March someone in the Buildings Department at the RBD, mindful of that department's aesthetic duties, judged that the design of the enlargement was 'totally unacceptable': the exterior would lose its form, and the project was no more than adding on space to double the surface area without any adjustments. Access to the new 'Festsaal' (ballroom) was inadequate, and the dining room, at 7 m x 26 m, was long and thin (both true). The allocated 320,000 RM for 1939 was not nearly enough: at least 500,000 RM would be needed. The AA considered and rejected the changes the RBD proposed and on 27 March announced that 320,000 RM had been put into its budget for 1939. However after exactly two months' silence the AA told the Finance Ministry that the RBD had come up with an improved design, which pushed the cost up to 730,000 RM! No compensating savings could be made by the AA: building must start immediately. The only preserved drawing of the project is a very general sketch drawn on the (almost three-dimensional) printed ground plan of the estate dated 18 May 1939 and approved on the 24th by Soppart, at the RBD (Plate 11). It shows the two new wings and the extension of the south terrace and staircase, the latter on the design originally proposed by Hassell in 1936/7. In summary the two symmetrical wings would contain a) to the east, the ballroom, double height, and b) to the west an extra salon, the study and cloakrooms, with mezzanine guest suites on the two floors above; and an additional top floor of bedrooms for house staff would be inserted between the two towers.

By 12 June the Finance Ministry had agreed. The relationship between political muscle and financial discipline had clearly changed. Hitler's approval can be inferred from a document of 18 August, but it is not clear whether work had been held up to await that approval or had already begun. In any case, at that point Mackensen moved out – to occupy, unhappily, the former Czechoslovak residence, by then, like the Austrian Embassy, part of the German diplomatic estate in Rome.

Given the scale and sensitivity of the project, Soppart had seconded a senior technical official from the RBD to the Embassy to supervise the work. *Regierungsbaurat* Carl Mertz had already been much involved in Berlin's management of works at the Rome embassy, and the 'improved design' bears his name. His arrival must have been a godsend for the ambassador and staff, given their mounting workload, as first Germany and later Italy went to war. Mertz, indeed, emerges as the man mainly responsible for the new, enlarged residence, and it is his legacy we see today.

These facts and inferences are enough to put to rest one major myth about the Villa Wolkonsky: that the Germans extended and embellished the Residence in stages throughout their tenure. Apart from the minor works in the early 1920s, that is not the case. We can see why it was never likely to have been. The German economy was, through most of the 1920s and 1930s, in no condition to bear the costs of such a prestige project. Freezes on public expenditure were frequent and sudden. In the 1920s Italy would have had a low priority politically. In the early 1930s the economic priorities were domestic. But with the growing alliance between the Nazis and the Fascists, culminating in the Axis

of 1937, both countries realised that their respective diplomatic representations did not match the grandeur and ambition of the alliance; and suddenly, after the success of the Anschluss of Austria and the focus on taking over Czechoslovakia (on both of which Mussolini was a less than whole-hearted supporter) the resources were available.

One of the other persistent myths about the enlargement of the Villa residence has been that Speer at some point intervened personally in the project. The remarkable and rapid turn of events in late 1938/early 1939 may well point to such an intervention, but the available files reveal no support for that inference. Speer undoubtedly had much to do with the erection of the new Italian Embassy in Berlin. That could be either a source of confusion or an indication that he might also have been involved in discussion of the need for an equally impressive German diplomatic presence in Rome. He was, after all, in overall charge of the RBD. The secondary idea that the late addition (1942/43) to the scheme of a new marble floor and other marble embellishment to the entrance hall (see below) originated with Speer, in pursuit of more grandeur, has rather more credibility; but again there is no evidence for that speculation other than the sudden unexplained appearance of a costly add-on to the overall scheme.

Implementing the project

The formal decision to do the work had been taken in early spring 1939: it was to have taken six to seven months.[2] In March Schwager (AA) had written to ask the Finance Ministry (Reichle in the *Bauabteilung*, building department) to intervene with the RBD about the delays. He had made much of the fact that the ambassador was still having to camp out in the former Czech Legation, 'a monster of bad taste' ('*ein Monstrum an Geschmacklosigkeit*').

Inevitably, given the approach taken to the original construction in 1890 and the mini-refurbishment of 1925, problems developed or were identified during the enlargement works, causing delay and additional expense. After a visit to Rome in January 1940 Soppart reported in February:

- 'Unforeseen' work was required on the dining room.
- The interior furnishing required much discussion and thought.
- The use of tufa in the walls was responsible for much of the delay. Slow work on the roofs and terraces had allowed water to leak into the tufa walls, so that a complete new covering was needed.
- The approach ramp was too narrow and had to be extended using travertine instead of tufa (which could not take the weight).
- The gardener's cottage (i.e. Ersoch's 'Swiss Chalet') had been condemned and was being demolished. In March the Finance Ministry intervened, as this demolition had not been authorised and demanded estimates. (As far as can be deduced from the documents, the demolition never took place, as the cottage is still there.)

In May the AA and Finance Ministry agreed to spend 60,000 RM on a new layout for the garden. But also in May, after a row with the RBD over the need for new double windows on the first floor, Schwager had had to go to Rome to smooth things out. During that visit Schwager had asked Mackensen if it might be possible to get foreign decorations for Burmeister and von Manteufel, the two key officials in the Finance Ministry, to help things along! Mackensen thought it would; but it probably made no difference. In July someone had asked Mackensen to provide a new inventory

incorporating furnishings, etc., taken over from the Austrian Embassy (for some time used by the Germans because of the inadequacy of the chancery building): he replied that he could not do so until the works at the Villa Wolkonsky were finished. By August 1940 the work was way behind schedule: ceilings were having to be replaced as unfinished work on the roofs and terraces had let in water, and all the paving had had to be taken up and relaid (as Soppart had foreseen in February).

Mackensen reviewed progress – or lack of it – in a telegram dated 19 August. He was still in the old Czech Legation residence and complained about its increasing unsuitability, requiring him to spend much money on entertaining in hotels. With all the work caused by the war the problem would only get worse. The main hold-ups were in delivery of equipment and materials, some of which could take a further six or seven months. Mackensen's list of the items still to be delivered included the air-conditioning, heating, kitchen range, laundry equipment, gas-proof doors (for the air-raid shelters in the basement), blinds, sanitary ware, tiles, parquet floors – all ordered from Germany.

Things would doubtless have been much worse but for the presence of *Baurat* Mertz to supervise and organise the work. The main project was in fact delivered within 1940. In late 1940 Mertz produced a handsome leather-bound volume with a set of the elevations and plans of the completed new residence (translated and reproduced at Annex II).[3] The cover page bears the date '1940 xix'. The 'xix' signifies that it was in the nineteenth year of the Fascist era; so although no month is mentioned it must have been in November or December, as the nineteenth year began in late October 1940. Mackensen himself, in later correspondence about the Chancery, confirmed that the Residence project had been completed in October 1940.

The volume has an introductory page describing the works and claiming that Germany now had a residence worthy of the nature of the relationship between Italy and Germany. Mertz is named, as is the contractor, Eugenio Miccone of Turin.[4] No separate architect is mentioned. Although it gives little detail of the work done, Mertz's claim that Germany by that date had an embassy residence worthy of the Reich allows the firm inference that the main project was complete. Succeeding pages display the new floor plans. The grandeur of the new façade is emphasised and, most attractive for the accuracy of this story, a plan and bird's-eye view of the whole site show in detail its state in late 1940, including the huts (*Baracken*), the extended Chancery, the Officials' House; and not showing swimming pool, dolphin fountain or *tempietto* – relevant negatives in pinning down when these structures were added.

Mackensen may or may not have been able to move straight back into his residence. If he did, it is inconceivable that any further major structural work would have been done thereafter. The new floor plans were made operational in 1941 with the addition of room numbers, but they only appeared in the German official files (as opposed to Mertz's celebratory album) in 1943. By then a plan of the swimming pool had been added – see below in this chapter.

The major additions show up clearly: the north-east wing (mainly the ballroom, enlarged dining room and terrace with family apartment above) and the south-west wing (guest cloakrooms/toilets and an additional reception salon, plus the terrace and two new guest suites above), all, according to a 1948 British plan, built on piles.[5]

Beneath them we see a hugely enlarged kitchen (north-east) and a new ironing-room and two air-raid rooms with anti-gas doors (south-west).

A new top floor of household staff rooms between the two original towers had been added, on top of which is the roof terrace, a vantage point providing a 360-degree panorama over Rome and the surrounding countryside, taking full advantage of the Villa's ridge-top position. The main staircase shows up as part of this project, though by some accounts the baluster – a feature remarkably similar to its counterpart in the Italian Embassy in Berlin – was not installed until 1943. In August 1941, with

the bulk of the work done, a full inventory (which constitutes a treasure-trove for anyone curious about the way a major German embassy was expected to function during the period) was made.[6] But it was clearly done before all the furniture and furnishings, stored during the works, had been placed in their destined positions and does not help one to imagine the appearance of the interiors.

Mackensen would not have entirely avoided enduring some further works, though mostly outside.[7] In May 1940 he had agreed with the RBD, AA and Finance Ministry on plans to spend the further 60,000 RM on the southern garden after the work on the house and the new terrace/staircase (at that time still not complete) was finished. This was for:

- A fountain in a 5 x 20 m travertine-lined pool opposite the new stairway down to the garden (not to be confused with the swimming pool!)
- New travertine-lined drainage
- Gravel paths
- New 5-metre high hedging (ten cedars)
- Roses and shrubs

Anyone who knows the garden today can still see that his plan was eventually carried through – though of course much more has been done since. The work was done in 1941/2.

By the end of 1942 the transfers into the project account from Berlin had totalled 200,229 RM, but expenditure was only 136,518 RM. It may be that the account was also being used to transfer through the Italian-German exchange agreement mechanism sums destined for other purposes. There was, for instance, a project to strengthen the floor of the second floor of the Chancery so that it could take the weight of new teleprinters. To avoid this expenditure Pannwitz, who should have known better, had tried to have the machines placed in the Villa's cellar, with the night guard positioned in the kitchen, or in one of the huts. Not surprisingly both were vetoed by the ambassador.

The final elements of the main project completed and/or paid for in 1942 and 1943 were:

a) The garden works and fountain installation, the building of the swimming pool (see below), a terrace repair (unspecified, possibly on an upper floor), the external electrical works and the planning (presumably a consultancy fee), all paid for in January–March 1942.
b) The fountain (i.e. the sculpture and the basin beyond the new terrace stairway on the south side), for which the firm of Medici were paid L.22,078 in October–December 1942.
c) A new parquet floor in the 'Mittelsalon' (likely to have been for Raum 8 on the contemporary German plan – see note 5) was also paid for in the October to December account.
d) The new central heating boiler, etc., which had only been ordered on 31 October 1942. Pumps and filters for the heating fuel system, supplied by Nothegger in Lösch were installed and paid for in the first quarter of 1943.
e) In January 1943 a bid was made to deal with the still inadequate hot water system.
f) In early 1943 Medici were paid L.6,426 for seven marble lunettes (over the doors) in the main hall; and the company's own published history shows that the magnificent marble floor was also installed then (Plate 12). It seems to have been paid for from a different account: the company's record shows the German Finance Ministry as the client, and the main Villa Wolkonsky project account was closed on 5 May without showing a figure for what would have been a high-value project. Can the shadow of Albert Speer and NSDAP funds be seen hovering over this piece of extravagant splendour?

g) A contract was let to the local contractor Castelli for more work on the retaining wall (L.50,966) and for a pump house for the deep well (L.33,000, possibly a wartime precaution, but more likely intended to ensure adequate water for the garden or the swimming pool – see below). It is not clear whether these items were outside the accounting for the main project.

One effect of all this work (and the tidying up after the swimming pool was built) was that the garden had by 1943 regained something of its splendour. One account describes 'roses, peacocks and crickets (*grilli cantarini*)'.[8] Weeks later the peacocks had been eaten by German troops and the gardens had been turned into a military bivouac, as the German forces secured Rome in the first days of the occupation after 8 September.

The swimming pool

The long list of works contains no mention of the swimming pool. In the absence of reliable evidence its origin has been the subject of much myth-spinning since the British acquired the Villa. In a well-known version of the myth (with one or two sub-variants) the swimming pool was built in a great rush before a short-notice official visit by Hitler to Rome. In the most colourful variant the ambassador of the moment, on receiving the instruction from Berlin that the Führer required a swimming pool if he was going to stay at the Residence, had explosives used to create a hole in the garden, which was then lined with concrete. Time being short the basin was filled with water before the concrete had set. The gardeners were set to fill the pool continuously as the water inevitably leaked out. That visit did not take place, and Hitler never did stay at the Villa. If such a hole in the ground had been created it can never have functioned as a pool. None of the German files nor their many ground plans of the property contain a shred of evidence for this Durrell-esque tale or any other version involving the creation of a swimming pool before 1942. Yet Mackensen was able to get a pool made properly in 1942.

Buried in a series of microfiche documents in the Federal Archives in Berlin is a brief memorandum dated 18 August 1939 (not long after clearance had been given – and only three weeks before the invasion of Poland) in which Ribbentrop's office communicated to the finance minister the Führer's order (*Führerbefehl*) endorsing Ribbentrop's wish that a swimming pool be incorporated in the Villa Wolkonsky enlargement project, which we can infer that Hitler had otherwise approved.[9] The RBD had estimated that, if that was done straight away rather than in 1940, it would 'only' cost an extra 25,000 RM. At that, on 4 September 1939 (again, note the date), the Finance Ministry salved some honour, after having been forced to endorse the idea in principle, and put its foot down. That would have to wait till 1942. The swimming pool and its associated buildings were duly built that year, along with other major works in the garden – a ground plan, dated 1942, is preserved in the files, but strangely there is no record of it at all in the financial accounts that have survived, in spite of the earlier official correspondence and implied approval. But there is at least some collateral for a key part of the myth: Hitler was involved – even though marginally – and we have Ribbentrop's word for it!

Hard evidence for the construction work itself has however now come to light. A loose-leafed vellum-covered folio of photographs, plans and sketches of the completed pool (and of a circular 'temple' (*tempietto*) – see below), bearing Mertz's name and the date 15 December 1942, was produced by the RBD (i.e. by Mertz) to mark the completion of that phase of the project (Figs. 8.1 to 8.5).[10] (He even signed and dated the tiny pen-and-ink sketch on the front cover.)

Fig. 8.1. Title page of Mertz's 1942 album reporting on construction of the swimming pool complex and the tempietto (see note 10).

Fig. 8.2. Design for cottage-style swimming-pool changing rooms.

Fig. 8.3. Swimming pool design – section.

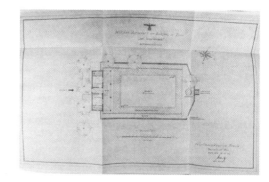

Fig. 8.4. Swimming pool design – plan.

All this material corresponds to what is still to be seen to this day. But the absence of evidence for payment of its cost remains a puzzle. Moellhausen, the resident consul during the 1943–4 occupation, wrote in 1948 that it had been a gift from Hitler to Frau Mackensen. That would not have been inconsistent with the Führer's order. On the other hand officials of the UK Ministry of Works picked up and relayed in 1949 to the then ambassador (Sir Victor Mallet) that the pool had been a gift to the German ambassador by Mussolini. Given that the Germans had paid for the new Italian embassy in Berlin and the contractor on site in Rome was a loyal Fascist, the story does not seem too improbable. Was Mackensen even smart enough to get Mussolini to foot the bill (even unknowingly) for the tempietto as well?

The tempietto

The erection of the tempietto (Plate 26) was passed over completely by the official files and accounts, even though its creation was covered by the Mertz folio on the pool (of which German archives appear

to have no copy). It is a small-scale imitation circular Roman temple on the lines of the second-century BC Temple of Hercules Victor in the Forum Boarium (Plate 27) or (less similar) the Temple of Vesta in the Forum. It comprises five apparently Roman pillars under a modern tiled roof. The provenance of the pillars themselves has been a mystery, and therefore the subject of considerable speculation. Some accounts have dated the structure to the second half of the nineteenth century or even later dates in the twentieth. A brief review of the theories about the *tempietto*'s origins is needed in order to understand the importance of the new evidence. Five versions can be distinguished:

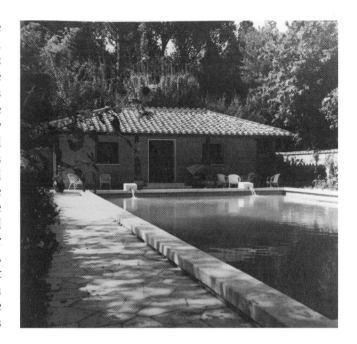

Fig. 8.5. *Swimming pool: the finished product 1942, photo accompanying Mertz's designs.*

a) Pietrangeli's account noted the 'tradition' that the five pillars that now form the 'little temple at the eastern end of the garden' were uncovered 'in situ'. While not wildly inaccurate, the remark's context implies that they could have been found in Princess Zenaïde's time, or even that the temple was built then, which would not have been out of character. Neither official papers nor subsequent writings support this interpretation: it is hard to imagine the pillars, even if converted into a small temple, being overlooked (or concealed) in all the ground plans and accounts of the gardens, given the scrutiny of the authorities, even if it was intermittent. It is for example not likely that, had they been excavated in 1866 when the *colombario* was uncovered, the careful official accounts would have remained silent about such a conspicuous find.

b) The AA Archive includes among a group of photos dated to pre-1925 an image of an overgrown and rather dilapidated bower-like structure, which could have been a dilapidated imitation miniature temple (Fig. 9.3). This led to a suggestion that the Germans reconstructed it with modern pillars. But Mertz's three-dimensional panorama of the estate in his 1940 report on completion of the residence extension does not show the *tempietto* or the bower (or indeed the swimming pool). It seems likely that the photo in question was of a romantic creation from the Alexander years, possibly erected by Ersoch, which may even have been demolished by 1940 – given that Mertz did not record its existence.

c) The version at b) could have been a reflection of the idea that the temple had been erected during the early British years. Two pillars (no description) were thought to have been transported from the demolished embassy at Porta Pia, one at the behest of Sir Victor Mallet (1947–53), the second when Sir Ashley Clarke (1953–62) was given the green light to do so by the senior Ministry of Works official, Sir Edwin Muir, on a visit in 1956 in connection with repair of the aqueduct.

These pillars could possibly have been the two thin free-standing columns in the garden, but the could also, just conceivably, have been the two rectangular section pilasters framing the rear wa of the *tempietto* against which the statue is displayed; those are, however, more likely to b modern – made of cement/concrete.

d) In this vein James Stourton attributed the *tempietto*'s 'assembly' to Ashley Clarke, based on th plaque affixed to its inner wall, which records (somewhat ambiguously) Clarke's presentatio of the statue of the Torso of Aphrodite which stands in front of the plaque.[11] The documenta record does correctly relate that 'the *tempietto* was refurbished and embellished with a fine statu of the Torso of Aphrodite, given by Sir Ashley Clarke in the period 1953–62'. But that was in fa in 1954, i.e. two years before the visit of the senior Ministry of Works (MoW) official (Muir referred to at c) above). The plinth made then for the statue needed repair in the late 199c because of water damage. There is also some speculation that Clarke had the *tempietto* move from an earlier position, but the British files contain no such record, and there is no evidence t suggest that he had such a major change made.

e) The new evidence which has come to light in the course of research for this narrative make untenable all the theories except Pietrangeli's vague and undated reference to the pillars bein found in situ. A more precise version of Pietrangeli's statement, recorded by Sir Alan Campbe (ambassador from 1976 to 1979) but not hitherto given much credence, must now be led forwar into the limelight, in spite of being based in the first instance only on hearsay. According t Campbell, Giordano Battista, a gardener at the Villa in 1942 and later the head gardener in the ear years of the British tenure, told him that 'all five pillars were excavated in the course of constructin the pool'.[12] If one assumed that a project of that nature would, in modern times at least, have bee premeditated and budgeted, this explanation would seem unlikely. But turn the proposition roun and one can imagine that the project was dreamed up on the spur of the moment when the pilla were found unexpectedly, as Battista's tale suggested. That would be consistent with the lack of ar evidence that the work was planned or budgeted for in advance, or indeed accounted for at all.

Mertz's 1942 album lends credence to Battista's story. What is more, it is – crucially – accompanie by additional loose but mounted photographs of the work on the pool as it progressed. The first tw among them (Figs. 8.6 and 8.7) show the pillars as they were discovered, buried in the soil bein excavated to form the pool and wrapped around by ancient roots. The third (Fig. 8.8) is of a pilla being lifted out. The fourth (Fig. 8.9) shows five circular-section pillars in good condition laid out o the lawn plus an additional broken pillar of a different type, which is now preserved elsewhere in th garden – see Plate 28. The sequence also contains photos showing the hole – beside the hole for th pool – from which it is probable that the pillars were removed (not reproduced here), one of th circular platform of the *tempietto* under construction, and others of its finished structure, with th circular pillars erected round the front and rectangular pilasters on the back wall. The photos bea no inscriptions, but they are, at the very least, highly suggestive circumstantial evidence.

The inclusion of the photographs in Mertz's folio, to say nothing of its title, '*Das Schwimmbad un der Rundtempel, gebaut im Jahre 1942 im Garten der deutschen Botschaft Rom*', are further unambiguou indication that the *tempietto* was constructed at the same time as the pool. Mertz does not seem to hav been a person to make things up in order somehow to garner greater personal credit. The way th two structures were combined in a single folio shows that he at least must have considered it in som sense a part of the same project. It could also hint that the cost was 'sunk' in the (still unidentifiec pool costs, whether or not they were paid for by Mussolini!

The narrative that best fits the evidence so far available, therefore, starts with the Germans taking the opportunity of the discovery of the five pillars to erect them in a permanent structure in the form of an imitation temple at the eastern end of the garden (as the photograph in the folio indicates). The contractors on the site for the pool would have conveniently been able to undertake the little construction work involved. And, when Ashley Clarke had the *tempietto* restored, he did not move or alter the composition of what the Germans had made but embellished it with his fine gift of the statue of Aphrodite.

Finance apart, the story leaves one crucial loose end: no one tried in 1942 to establish why five columns of similar size were lying deep under the soil at the spot chosen for the construction of a swimming pool, some 30 m from the aqueduct. And since then no one has studied the origin of the pillars. The world of archaeology, official or academic, does not record the wartime find. No analysis seems to have been done subsequently, probably because the general assumption has been that the *tempietto* is simply a

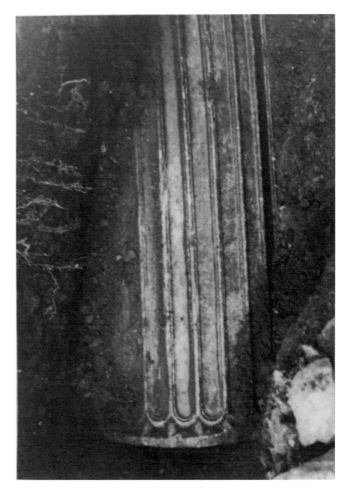

Fig. 8.6.

modern imitation. The pillars could have been the front of a rather grand tomb or building originally beside the aqueduct but long ago dismantled or ransacked, and simply moved well out of the way. But their discovery also opens up the interesting possibility that in Roman imperial times there was substantial building on the site with a decent-sized portico of at least five pillars. Perhaps the current highly technical archaeological survey of the area will unravel this new mystery.

The finishing touches

No other new work was commissioned. The annual bid for 1943 included only small items of regular maintenance expenditure. But there is little suggestion that the progress of the war was reducing the embassy's attention to the estate. The garden team was up to five (two gardeners and three helpers)

Fig. 8.7.

Fig. 8.8.

Fig. 8.9.

at an annual cost of 14,742 RM. The temple received a coat of paint in the early spring (the only mention of it apart from Mertz's report) – presumably the finishing touches after its construction, addir
to the impression that it was all new. From January to June Mackensen was in detailed corresponden

Fig. 8.11.

ith the RBD about the construction of a display cabinet for fine china and glass in place of a super-
uous doorway between the 'Empire Salon' and the newly added salon in the south-west corner. As
bit of non-essential frippery this is hard to better. It went ahead, but not until the RBD had insisted
n detailed drawings and pointed out that having a single glass door would place too much strain on
ie frame, so the design had to be changed. The display case in that position remains to this day a
easing feature – still with two sliding glass doors.

By the summer of 1943 priorities had of course changed. Fearing aerial and artillery bombardment,
ie Embassy in June had to chase up the construction of gas-proof air-raid shelters and supply of first-
d kits for the economic and military sections – 52 people in all – housed in the old Czech Legation,
via Luisa di Savoia 18. The same went (perhaps with more force) for the old Austrian Embassy (via
ergolesi 3), where the NSDAP had its 'Landesgruppe' (country group, i.e. overseas representative
fice). Not surprisingly, given the dramatic events of that summer in Rome and the rest of Italy, the
cord then shows a period of inactivity as far as the Villa is concerned – more than the usual summer
rpor.

After the inability of all three previous German ambassadors to have more than essential mainte-
ince work done, it was a gross irony that the modernisation work they all craved but could not stom-
h 'on their watch' was finally undertaken, in conjunction with a major enlargement, only as
ermany drove into war, and fully completed only in 1943 when it had already begun to seem possible
at Germany would lose that war. Mackensen, the ambassador who did suffer the inconvenience
id discomfort of living elsewhere for a couple of years, had building work going on around him dur-
g the rest of his tenure. And not long after it was really finished he left under a cloud. Yet Rome and
e British government owe Mackensen a debt: for it was on his watch and through his pressure that
e Villa Wolkonsky was transformed into the splendid diplomatic facility that it is today. The British
vernment would never have been able to make an investment on the same scale, as succeeding

chapters will show. So it would have been a much less attractive (but perhaps more easily defensible) long-term proposition as an embassy residence when the decision was taken in 1949 to buy it. On the other hand, had the war not turned against Italy and Germany, scotching the realisation of the further grand plans of the vision Mackensen and Ribbentrop shared, the Villa Wolkonsky would have taken on a completely different aspect in the shadow of the large office building the Germans had high hopes of constructing there.

Notes

1 BA: file R2 11581 Italien Fiche 1.
2 These paragraphs rely on AA file R128950.
3 A copy is in the Villa Wolkonsky's own library. The Embassy's copy was offered to Sir Ashley Clarke in April 1957 out of the blue by a German named Max Schupp, resident in Stuttgart, who wrote that it had come into his possession from a French member of the forces occupying Rome after the war (the letter is preserved in Embassy file 9053 of 1957). The Embassy took a month to accept the offer of this valuable piece of the historical record!
4 Miccone, a Fascist Party supporter in Turin, moved to Rome and was available to British officials surveying the Villa Wolkonsky before it was acquired by the British government. But he went bankrupt not long after that and sadly appears to have left no records.
5 In fact only the western half of the addition was built on piles.
6 AA file R128951.
7 This section is taken from AA file R128218: 132 – 43 & 47.
8 Dollmann (2), which contains several anecdotes relating to the Villa Wolkonsky at the end of the German tenure.
9 BA. Memo from AA to Finance Ministry, in BA: Finance Ministry file R2 11581 Italien Fiche 1.
10 I found online an original copy (maybe the original) for sale from an antiquarian bookseller in the USA (Eric Chaim Kline, P.O. Box 829, Santa Monica, CA 90406, info@klinebooks.com) at a price, which I declined to pay. He generously volunteered these photos via email and permitted their use in this work. He later agreed to sell the folio to me at a much reduced price, so that I could donate it to the British School at Rome, where interested scholars can freely study its contents. The AA Archive in Berlin has been made aware of the existence of this folio.
11 Stourton, p. 300, n. 14.
12 Campbell, 1979.

9.
THE NEW GRAND RESIDENCE

Before 1938

After such a major change, it is worth pausing to see if it is possible to visualise what the building would have looked like to a visitor. Up to this point in the story, any attempt at a verbal picture of its interior would have been bound to fail. The historical record offers no help (other than the 1886 ground-floor plan) before or after the point when the Germans bought the Villa in 1922. So complete and rapid was the dispersal of the family's accumulated goods and chattels that almost nothing remains of their life in the house. Furnishings, decoration, style of life remain a mystery. The loss of many German official files from the 1920s accentuates the problem. No inventory has survived except that most of the items listed in the 1941 inventory probably were already there before the enlargement project), no visual or verbal description of what the Germans had bought, no record or plan of what they did to the interior in the 1920s. The only hints are in a set of five photographs, taken in or before 1925.[1] Only one shows an interior, the main reception room (between the hall and the terrace).

The exterior is not all that problematic (Fig. 9.1). The main approach to the front entrance was most likely unchanged from that which the Campanari-Wolkonskys would have seen and used. Even in the early 1920s the façade at first glance would have made much the same impression as it does nearly 100 years later, though, before its 1939–41 reincarnation the whole house was obviously smaller and the façade more modest. The views of the garden (Figs. 9.2 and 9.3) suggest a feel not far from that of its 'back lanes' today, though after some 20 years of relative neglect it looked unkempt and there were fewer trees. Earlier images of the terrace and grand stairs down to the garden would have been still valid. The setting, with roses growing up the aqueduct, the Basilica of San Giovanni to the west, and the apartment buildings – then quite new – restricting the southern aspect, would also seem familiar.

The grandiose exterior would by 1922 have masked considerable dilapidation and inadequacy inside, which, as we have seen, successive German ambassadors struggled to rectify. The single extant photograph of the interior from the early 1920s shows the main reception room as it was in the time of the first German ambassador to live there, Neurath (Fig. 9.4). We can deduce from it nothing of the state of repair, decoration and furnishing of the rest of the house. The furniture in the room would most likely have been the best pieces the Germans managed to salvage from the looted Palazzo Caffarelli and the subsequent fire at their store. So it would give no clue to the room's appearance when it was the main room at the heart of the Wolkonsky home. The furniture arrangement is odd,

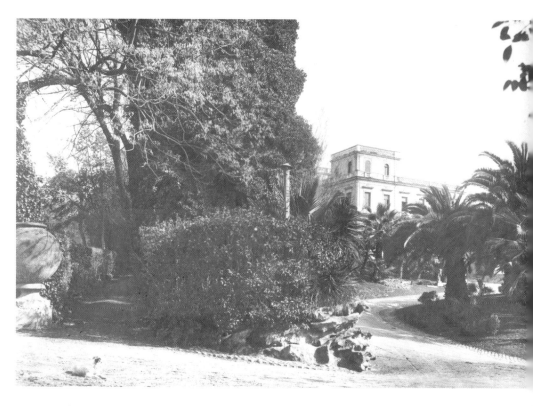

Fig. 9.1. *The approach to the villino after the German government bought it (probably 1924), showing th*
approach to the original casino to the left, the aqueduct covered in vegetation and one of Consalvi's urns.

even by ambassadorial standards: not much encouragement for conversation. The chief impression i
of overcrowding and dark colouring, exacerbated by an over-abundance of large potted plants – one a
least the size of a small tree. The oil painting on the wall remains a mystery (see Annex I). The roor
looks better adapted to providing cool in summer than warmth in winter. It may also give us som
help in visualising the room at the end of the 1930s, as we can incorporate in our mind's eye the fev
changes of curtains, upholstery, etc., which ambassadors prised out of the Berlin staff. In any case
shows the way out to the terrace (of which there is also a photograph in the archive) through th
windows on the right of the picture, and to the pair of small rooms between dining room and garde
through the rather narrow half-door to the left of them.

German ambassadors from the outset found the dining room too cramped and small eve
though it gave directly on to the garden to the east, with a bay possibly covering stairs down to th
garden level, but also adding more light. The repairs they had done in the 1920s may have include
knocking the little dining room and the small rooms to its south together in an attempt to make
decent-sized room (see the 1886 floor plan at Fig. 4.6). But later insistence on the enlargement a
the dining room casts doubt on that. A principal feature of the ground floor was the entrance hal
conceivably oversize for a family house (even though smaller than the 1940/43 version) but usefu
in an official residence. We know little about its appearance, as that was obliterated by the makeove

Fig. 9.2. *The south-east corner of the Villa's garden in 1924, showing the overlooking apartment blocks which had obscured the view to the Basilica of Santa Croce in Gerusalemme.*

Fig. 9.3. *The Villa's garden towards the south-east corner, some 50 m beyond the view in Fig. 9.2, with the bell tower of the Basilica of Santa Croce just visible beyond the apartments and the remnants of a bower probably designed by Ersoch for Prince Alexander Wolkonsky, later demolished (see Chapter 8).*

of 1943. But the floor was probably of marble. To the right was a study, which gave access to a second drawing room. Upstairs accommodation seems to have been both limited and poorly articulated. A master bedroom, two or three other bedrooms, one or two rooms of indeterminate purpose were all interconnected in a way unlikely to have promoted privacy, especially with guests having to make their way through them to the one bathroom (with an untrustworthy hot water supply). The upper rooms were cold in winter and stiflingly hot in summer, and offered no protection against mosquitoes. Given what we can infer about the Campanari-Wolkonsky finances, it is safe to assume that they carried out little major work on the house after it was completed, especially as they decamped to Russia for several years at the turn of the century. They would have been subject to the same positive and negative features of the house as their German successors, though they may have been less fastidious.

Neurath, of course, was aware of the inadequacies when he took on the house in 1922. But, as the man who had done the deal, he would have known that he had to tolerate its discomforts, up to a point. His successors were not under such limitation and became ever more demanding. Finally, in the atmosphere of diplomatic and military success in 1938/9, the coffers were unlocked, and the residence could be transformed, even as the course of the war prevented any real exploitation of the resulting grand residence.

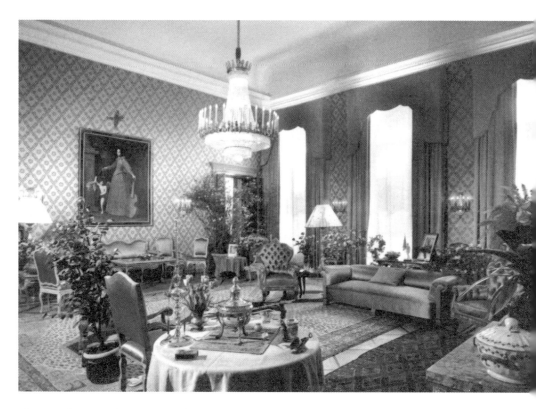

Fig. 9.4. The main salon in 1924, when Baron von Neurath was German ambassador.

After

For about a year and a half the house was an uninhabitable building site. In the aftermath of the enlargement project, new floor plans were drawn by the project manager, Mertz, and a full inventory was drawn up in 1941 – and preserved in the AA Archive.[2] The inventory included glass, china, silver, linen, etc., and even listed the pictures then in the main rooms on loan from German public collections (which did not include the one featured in Fig. 9.4). The principal omission from the copious detail is of any description of wall-coverings, presumably as they were not 'movable'; that handicaps an attempt to imagine a colour-scheme. One exception is the ambassador's ground-floor study, described in July 1943 as having a deep-red damask wall covering.[3]

We cannot say how much of the contents originated from the Palazzo Caffarelli (as its inventory was lost), or were purchased when the Germans moved in, or were newly bought as part of the upgrade – which was, after all, designed to show off the greatness of modern Germany under Hitler. At least we can be fairly sure that the additional rooms would have been newly furnished. With those provisos and with the help of a contemporary floor plan with numbers which match the inventory, the inventory goes some way towards guiding us on a 'walk-through' of the house in all its new glory – i.e. including the last major item, the marble floor and door surrounds in the main entrance hall, completed in 1943 (Plate 12).

As a guest you would arrive, whether by car or on foot to get a good look at the garden on the way in, by climbing up the curving driveway from the main gate and the ramp leading to the main entrance, now embellished with fine new polished double-doors of wood from Germany, picked out, like all the main internal doors, with brass inlay beading. This gave straight on to the large and impressive entrance hall. The hallway was (and still is) striking. You would step onto an amazing geometrical assemblage of polished marble in many colours, roughly 11 x 9 m. Each of the six new double-doors in dark, polished wood imported from Germany and inlaid with brass[4] was set in an arched surround of yellow-orange Siena marble. Between each pair of double-doors on the side walls was a large black marble Empire-style console table on a gilded base, each bearing a large Chinese vase. Staring at you in the middle of the far side and dominating the otherwise empty floor area was a polished black plaster bust of the Führer, mounted on a green marble column.[5]

To leave your coat you would be ushered to the right where the first doorway led past the main stairs to the newly added cloakrooms, one each for men and women. On your way back to the hall you could take a good look at the new grand stairway to the upper storeys. Facing it was another gilt console table, but with a patterned marble top. The stairs were carpeted in green 'velour' – 55.5 m of it, held by 44 brass rods. On the stairway the handrails and supports were also of brass, in a severe modern style, not unlike the similar staircase in the Italian Embassy in Berlin (Plate 32). (These features gave the first British ambassadors after the war some difficulty as being too redolent of the styles of Nazi pomp and ceremony – but now seem rather to represent something refreshingly modern in an otherwise old-fashioned, if high-quality, refurbishment scheme.) Around the foot of the stairs the waiting area for the cloakrooms had seats and another smaller console table with carved wooden base and black marble top.

Now you would be led across the hall to one of the two doors opposite the front door which led into the main reception room – the room in the 1924 picture, but now with a brand new parquet floor, also from Germany (Plate 33).[6] (The inventory calls this the Yellow or Middle Room, but the floor plans use Reception Room (Empfang); both use the number 7.) Its main Empire console table had an appropriately yellow marble top. While the walls were possibly also yellow, the sofas, chairs and benches were mostly pink, and much of the wooden furniture was painted pale grey. The colour of the large (7.1 x 4.4 m) Turkish carpet is not revealed – it could be the one in the 1924 photograph, but that photograph is black and white. Apart from two further console tables with red-and-white marble tops there were seven other tables, a sofa, nine chairs and two window-seats (all pink), a glass display-case and a folding screen. The 18 additional grey and gilded chairs may have been in the room at the time or attributed to it but cannot have been permanent fixtures.[7] Lighting was from a central chandelier and eight wall lights. One picture hung on a wall: Kerrinx's *Woodland Way over a Small Hill* (*Waldweg über eine kleine Anhöhe*), one of the loans from Dresden.[8] Other adornments included a white porcelain clock, two vases, two 'antique' marble columns and two white porcelain parrots! It is hard to avoid a sense of overcrowding, even if some items would not normally have been in the room.

In fine weather the open glass doors would draw you out to the terrace, newly enlarged to allow more flexible use for entertaining, not least an al fresco meal for small numbers, and admire the garden and the newly built marble dolphin fountain and basin on the lawn below or descend by the fine double sweep of the newly reworked stairway for a closer look (Plate 34).

Depending on the occasion, guests might be invited into one or more of the other rooms on the ground floor. The first, the Small Salon, was indeed small by comparison, particularly suitable for a breakaway private conversation. Against a grey carpet the dominant colours would have been

the red of the silk covers of the sofas and chairs and the green of the silk curtains, in each case with gold detail. The room was not much larger than the 6 x 6 m carpet, but the inventory taken literally suggests it was massively over-furnished. Two more Empire console tables, these with white marble tops and brass fittings stared across the room at each other. A small cupboard and five occasional tables were dotted about amongst the two sofas, eight armchairs and a dozen other chairs. Somehow space was found for a Blüthner grand piano, shipped from Berlin in 1938 at a cost of 2,580 RM.[9]

Two large green vases with gilt highlights and four flower-bowls with bronze feet completed the show, all lit by a crystal chandelier. Given the paucity of furniture attributed to the next two rooms one can only conclude that the scribe who drew up the inventory was simply listing all the pieces stacked in this small room while the following two rooms, both new, were being decorated or otherwise finished off.

That logic may also apply to the placing in this small room of three paintings on loan from the Gemäldegalerie in Dresden and two small views of Naples. The paintings (all assigned values in pencil on the inventory, perhaps for insurance purposes) were:

a) School of Ludovico Carracci, *Rest on the Flight to Egypt*; sent back to Dresden, probably destroyed in the 13 February 1945 bombing.
b) Anton Graff, *Portrait of Frau Riquet*; sent back to Dresden, listed as in the AA, but missing since the war, presumed removed by Soviet forces.
c) Thomas Wouvermann, *Rest on the March*; sent back to Dresden, listed as in AA, but missing since the war.

None of the paintings recorded in the inventory remained in the Villa at the end of the war. The known information about them is at Annex I.

The first of the two rooms at the new south-west corner of the house was a library which may also have been intended as a ladies' drawing room. It had red taffeta curtains, plus flower-patterned muslin on the windows, and a bronze-coloured porcelain figure of a magpie ('Elster') on a walnut-inlaid bureau. A door northwards led to the ambassador's newly enlarged private study/office, possibly also intended for use as a smoking room. Its windows, decked out with red damask curtains, gave on to a well-shaded recessed terrace or loggia, which by 2000 had become a protective home for some of the antiquities and statuary from the garden. The only feature placed here in the inventory was an 'antique' (presumably classical) head.

In the other direction, were you a dinner guest, you would be shown into the dining room, now dubbed 'Breakfast Room' even if enlarged by the incorporation of a serving area (which also had to function as an access route to the new ballroom beyond). The Breakfast Room, though formal, was less elaborate than the other rooms. A round mahogany table (with leaves to extend it to an oblong with rounded ends) stood on a blue-edged grey carpet in two pieces (10.3 x 7.5 m and 6.5 x 1.75 m). On the table was a bronze centrepiece. (The relative proliferation of bronze in the house may reflect Germanic taste at the time or might just be an accident of accumulation.) Three console tables at the kitchen end were available for flowers and serving. Only four chairs were listed, gilt with beige-patterned upholstery. The blue in the carpet was picked up in the blue satin curtains. Lighting was from a modern crystal chandelier and six three-candle wall-plates/sconces plus two Empire-style bronze 'angel-lights' (possibly standard lamps). Again, wall-covering is not specified, but the long narrow room with only two external windows was now quite dark. Th

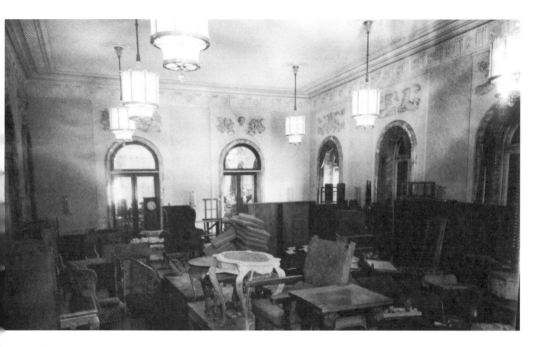

Fig. 9.5. The ballroom (Festsaal) as it was when taken over by the British Embassy in 1947, presumably as decorated when added on in 1939/40.

windows and bay looking out over the garden to the east had been replaced by two further beautiful but dark double-doors, providing the only access (other than for serving) to the main new addition, the *Festsaal* or ballroom.

How the walls and ceiling of this huge new reception room were decorated is not recorded, though an early British photograph (Fig. 9.5) may in fact record the scheme as it was in 1943, suggesting a rather orthodox combination of pale paintwork and darker highlights in the plasterwork. In any case, with a half-glazed double-door and six window bays looking out onto the gardens to the east and south it can only have seemed a dazzling contrast to the gloom of the dining room. Each window bay was framed by a dark-yellow/orange Siena marble surround with a semicircular arch at the top. (Matching arches were added to the doorways of the entrance hall in 1943.) Each window bay had curtains of green taffeta, to keep out the cold in winter and the light when films were to be shown.[10] The huge carpet (17.55 x 8.6 m) was also green. To furnish the room the Embassy bought locally four new console tables, eight small round mahogany inlay tables and eight window-seats covered in beige silk – at a total cost of L.4,550. Two antique long-case clocks (one adorned with angels) completed the scheme, the whole being lit by eight chandeliers and 14 wall-lights.

The relative sparseness of the furnishing suggests an expectation of large stand-up receptions, dances, films and other gatherings, though with additional tables and chairs there was space for up to 100 guests to be seated for a meal. Whether much use was made of the room in the deteriorating wartime climate is unclear. But it undoubtedly transformed the house's suitability as an ambassadorial residence with an assessed need to entertain an ever-increasing number of guests – this, of course, predicated on the victory of the Hitler–Mussolini Axis in war.[11]

The reception room on the east side and the new rooms at the western end (except the cloakroom area) were, like the rest of the ground floor, double-height. Above each the flat roof was paved and formed an extensive terrace. To the west the terrace faced the façade of the Basilica of San Giovanni and the sunset; to the east it overlooked the main extent of the gardens, providing a perfect spot for open-air breakfast. The new wings on the front of the house met the need for better accommodation for the ambassador's official guests and family. At the western end were two fully equipped guest suites, one on a mezzanine half-way up the main stairs (accounting for the cloakroom area below being only single-height, and equipped with rather small, porthole-like windows to meet the architectural exigencies) and the other at first-floor level, with direct access to the new western terrace. At the eastern end was a self-contained family or private guest suite of two bedrooms and sitting room, with access to the eastern terrace over the garden. As each of these units had good-sized bathrooms, at last the house had adequate facilities, and guests no longer had to walk through the ambassador's dressing room to take a bath. The hot water supply remained initially a problem but was finally fixed in 1942.

The private ambassadorial apartment on the first floor – dining room, sitting room, study, main bedroom and bathroom – was almost certainly little changed in the early years of the UK's tenure. Indeed they may have remained much as the Campanari-Wolkonsky family had arranged them.[12] They had been built as traditionally interconnecting rooms with separate access, mainly for servants, from a corridor on their north side – hence, in the pre-enlargement building, the guests' route from their rooms (off the other side of that corridor) to the bath. Properly equipped they would have provided the Mackensens with more than adequate private space. But they had little time to enjoy them or the finished fine rooms below.

Notes

[1] AA Archive, whose historian told me the photographer died in 1925.

[2] AA file R128951.

[3] By Dollmann, see Chapter 11.

[4] Which was well restored during the author's tenure.

[5] It is not clear where the companion-piece bust of Mussolini was displayed.

[6] The splendour of the inlay is visible again, as of 2019, as the incumbent UK ambassador has removed the carpet which covered it for many years.

[7] Indeed they may have been the dilapidated chairs we found in a basement storeroom in 2000!

[8] Now recorded as missing since the war. The portrait of the woman with a stringed instrument in the 1920s photograph is none of those listed. Four other listed paintings were not on display:

 a) Carl Kayser-Eichberg *Im Walde* ('In the Wood') from the National Gallery in Berlin, hung in the Chancery; fate unknown.

 b) Johan Hendrik Van Mastenbrock *Dampf und Rauch* ('Steam and Smoke'), from the National Gallery in Berlin; listed in the inventory as given to the German Academy of Arts in Rome.

 c) Eduard Hildebrandt *Schloss Kronborg bei Helsingör*, from the National Gallery in Berlin, fate unknown.

 d) *Blinder Tobias* (artist unknown) from the Prussian Academy of Arts in Berlin; listed in inventory as sent back to AA, subsequent fate unknown – the Prussian Academy was badly bombed in 1945.

 See Annex I by Julia Toffolo for more on the pictures hung in the Villa during the German tenure.

[9] Item 8 in Section VI (*Kleiner Salon*) of the inventory.

[10] It is not clear whether those curtains would have largely obscured the marble surrounds or were tucked in behind them, as shown in the 1947 photograph. When, in 2000/2001, we had the room completely refurbished we scrapped the main curtains which were there as they did obscure the fine marble – but not the muslin ones within each bay.

[11] The case for the enlargement of the Residence always emphasised the need to entertain the growing number of Germans living and working in Rome, including doing business with Italy; little weight was placed on Italian guests. The modern British ambassador and staff tend to see such facilities in terms of attracting nationals of the host country, not least to meet British ministers and officials and to give British companies and institutions a platform on which to present their products or services in the Italian market. The building the Germans created has proved ideally suited for these modern purposes, even allowing several events to take place simultaneously.

[12] This surmise is based on the fact that when we moved in in 2000 nearly all the electrical wiring in the apartment was tacked to the surface of the walls, not chased in.

10.

THE EVEN GRANDER PLAN: THE NEW CHANCERY THAT NEVER WAS

Something else was going on during these last German years at the Villa of which post-war writers, diplomats (myself included) and others had no inkling until a reading of the files about the Villa in the archives of the German Foreign Ministry in 2012 began to reveal papers clearly not about the enlargement of the embassy residence.[1]

War and its aftermath had blotted out any memory of the fact that the Residence was not alone in receiving the attention of those in the hierarchy who thought Germany needed to have a grander face in the Rome of Mussolini. Germany was thinking and acting 'big'. Mackensen, having obtained approval from the Reich finance minister in early 1939 for the rebuilding of the Residence, began to campaign for the construction a completely new, grand embassy office or Chancery (*Kanzlei*).

Hassell's bid for work on the chancery offices in 1936/7 had provoked some recognition in Berlin that the woeful inadequacy of the Embassy's offices could no longer be concealed by the few alterations that had been or could yet be made to the original *casino* and the addition of temporary huts. Their impact was the reverse of what the new political constellation required. Mackensen seized the moment offered by the more receptive views of the decision-takers in Berlin. The idea may already have formed in his mind when the decision was taken in early 1938 to fund the new Italian Embassy in Berlin (Plate 24) – before his move to Rome. In any event it became a collective response to the realisation that the new image of Italy in Berlin would present a serious challenge to the German presence in Rome.

With war looming, the number of military attachés needed to increase, but there was no room for them; Mackensen used the sensitivity of this example of the inadequacies of the office block in the face of the staff increases already effected to launch his comprehensive case for a wholly new office block in a letter to the AA on 11 July 1939.[2] He listed ten defects of the existing building, many with a security aspect:

a) the entrance was obstructed by couriered packages lying about and open to public view, as there was no storage;
b) there was nowhere for the public to wait so they hung around in the hallway where they could hear the telephonist putting calls through;
c) because of this the public wandered off into the garden;
d) ground-floor trade and press section space was too small;
e) the clerk's flat was damp and unhealthy but could not be given up because someone needed to sleep near the secret archive;
f) the staircase was too narrow and as there was nowhere there for VIPs to wait they had to mingle with members of the public and/or hang around in the corridor outside the ambassador's door;
g) the registry was too small; with the new security rules in force at least one more room was needed
h) the second-floor corridor was only 90 cm wide;

i) there was nowhere to hold press conferences or to gather to listen to radio broadcasts (i.e. those by Hitler, Goebbels, etc. – a neat touch!);
j) there was no reserve of space for additional emergency staff.

He continued that the building had been a summer house, not designed for its current purpose. The changes already made were never going to be more than a stop-gap, as sooner or later new offices would have to be built. It was now so shabby that it was not fit for purpose, in no way reflecting its importance. With Italy – <u>now with a model embassy in Berlin</u> (author's underlining) – holding a world exhibition in Rome 1942, there would be a substantial increase in work, traffic and official visits. Add-ons (viz. the huts) would not solve the problem. The AA should start considering forthwith with the RBD a new building situated near the present main entrance to the Villa.

While the case was strong, it did seem to indicate that there was in practice no staff member with no office to go to. And the outbreak of a general state of war distracted attention – momentarily, at least. No doubt confident that the war would soon be won, Mackensen returned to the charge while in Berlin on 30 December 1939 to discuss the residence works. His record of 8 January 1940 tells us that he had met Minister Rohde, and Counsellors Saller and Frau von Ungelter at the AA as well as Soppart at the RBD. He argued that money needed to be in the budget immediately so that work could start on 1 April. His case rested not on extra wartime staff but on the extra personnel needed to service the Rome–Berlin axis in the following peace; but it was true that the war had brought a huge increase in personnel from 'authorities' (*Behörde*), i.e. security and defence agencies, whose presence had been much smaller when the Villa had been bought. The embassy staff list as specification for the space requirement of the new peacetime chancery, with each office graded according to the number of windows its occupant would be entitled to, totalled exactly 100, including the service attachés and one (!) Gestapo official and secretary.

Adding to his earlier letter Mackensen pointed out that the office-block's main stair was only 110 cm wide: no building authority in the world would license it for use as an office building, because of fire-risk. The waiting-room issue was now a calamity. The demands of the war were no reason to put off resolving these issues. The need was for a building of 22,500 cubic metres, 182 windows on three floors, implying a ground area of 1,500 square metres. He put the cost per cubic metre at L.200 (the lira was then relatively strong). The precise location would be governed by security factors, on which he would follow up. He did not, and Saller had to remind him in February. In April word came that Manteufel, the deputy secretary equivalent in the Finance Ministry, would not put anything to his minister for approval without a fully worked-up project.

This crossed with Mackensen's next salvo, dated 6 April. Anyone who had seen the Villa would agree that a new office block was needed – urgently. The huts were only a stop-gap. The third, for the office of the ambassador's deputy, Prince Bismarck, was near completion; a fourth for the culture and propaganda section was now requested.[3] But they were separated from the other sections and lacked any security for documents or equipment. As for the choice of site, there was nothing suitable on the present property. It would be necessary to take in a neighbouring plot: only the western plot, with frontage on via Emanuele Filiberto south of via Amedeo VIII was suitable. It had been part of the Wolkonsky property (after 1868) and contained more elements of the aqueduct. The current apartment block on the site was in any case a security risk as it overlooked the main entrance to the Villa. To add the next (north-west) plot would be too costly. He put the total cost at L.10–11m, of which building costs would be L.5–5.5m, including L.400,000 to compensate evicted tenants.

Like its Italian counterpart in Berlin the new Rome chancery was to be built in a grand style to match that of Mussolini's 'new Rome'. As originally conceived, it would have been a mammoth project, dwarfing the other buildings on the property, as the new office was to house all the departments of the German Embassy by then spread around Rome. It would have considerably increased the property's land area, by reincorporating some land south-west of the aqueduct originally retained by Nadeïde Wolkonsky when she sold the rest of the property to the German government. It would have formed a single architectural complex, with an open formal garden behind a three-sided office, with direct but limited access between residence and offices but its main access directly off the main road.

There would almost certainly have been a more direct impact. Whatever the eventual outcome of the war, had the project been implemented following the first, early 1940 design, or even the more sensitive later versions, at least one vital element of the historical site would have been lost: the *casino* which Princess Wolkonsky built (already absorbed into the Germans' chancery) would have been demolished. A document dated 23 April 1940 containing Reichle's costings for the project commented that the project would 'enable' demolition of the old chancery, costed at 70,000 RM. Likewise a paper by Mertz of 16 March 1942, addressed to the Italian Foreign Ministry, said that it would be demolished (along with all the other existing secondary buildings) and the aqueduct carefully preserved. The first design in early 1940 would also have swept away the *Beamtenhaus* (Officials' House) and then absorbed (or destroyed) the portions of aqueduct attached to it. The only sketches preserved are a ground plan and side elevation, produced in-house at the RBD or more likely by Mertz in Rome and signed off by Reichle, the supervising official in the Finance Ministry on 23 April 1940 (Figs 10.1 and 10.2).

Later versions also show the *Beamtenhaus* disappearing and the spans of the aqueduct into which it is built standing exposed (and presumably conserved) next to the new office building. But Italian officials resisted that on the grounds that demolishing the house would damage the aqueduct. It is odd that the same sense of conservation did not seem to be applied initially to the idea of demolishing the existing chancery and 1830 *casino* within it! Perhaps that would have satisfied purists for whom the *casino* had always been an illegal structure. However, since demolition costs in the neighbouring streets formed one large element of cost over-runs, the Germans just might have had to think again and continued at least to use the *Beamtenhaus*, perhaps for staff accommodation, as the British eventually did after their chancery moved back to Porta Pia in 1971.

Whatever the design, the ambitious first stage would have to be the purchase and demolition of a motley collection of apartment and office blocks, offices and shops, plus the police barrack round the corner on via Statilia. But with complaisant city authorities, led by the Governor Prince Borghese, and the need anyway to accommodate a new grander street plan which he had in mind for the district, the Embassy argued that such a golden opportunity (affording the German Embassy a direct view to/from the Basilica of San Giovanni in Laterano) would not be repeated. Not surprisingly Mertz in Rome was tasked with taking this new and much larger project forward.

The initial plan was to allow only very limited access to the new offices from the existing Wolkonsky estate, for security reasons: it was not to be one grand estate. The style of the building was to represent the new Germany and the new Italy; an example was the offices near the Temple of Vesta by the Tiber, housing the Central Registry office (*Anagrafe*) (Fig. 10.3).

Reichle's costings at this early stage were modest – and quickly overtaken (all figures in thousands of RM).[4]

Land purchases		800
Demolition of neighbouring buildings	114	
Demolition of Chancery	70	
Other demolition and levelling	46	
Sub-total		230
New building		2,800
Equipment	60	
Office machinery & installations	170	
Design and supervision	100	
Fees & freight	120	
Sub-total		450
Total (4,280,000 RM, rounded down)	**4,250**	

On the basis of these figures Schwager (AA) made the case to the Finance Ministry for approval of the plan and for clearance to transfer of funds to Italy on 25 April 1940, adapting Mackensen's arguments. The Villa had been bought in 1922. Given Italy's importance the Residence had proved inadequate, and its extension was in hand, indeed nearly finished. The Chancery, with the gatehouse and the huts were totally inadequate to accommodate all the people needed to staff the Embassy, and there was no security, given the surrounding properties. So the proposal was to build a new chancery; and for that the Finance Ministry was asked to authorise use of the South Tyrol exchange account – effectively an authorised loophole in the exchange control arrangements reflecting the view that South Tyrol was an integral part of Germany, given the annexation of Austria. The German finance minister approved the plan in principle on 21 May 1940 and authorised a provisional 2.5m RM, but subject to a reduction in the amount of land it was planned to purchase. (The finance minister had to be consulted twice more, as cost estimates rose, in October 1941 and April 1942.)

Use of the South Tyrol exchange account was not considered appropriate in this case, but in June money began to be transferred to Rome through the complex exchange control mechanisms then in force. The AA estimated that the Embassy would need 1m RM up front to pay for the buildings to be bought on the chosen site. Work on negotiating the expropriations and assessing compensation began but unsurprisingly proved long, tedious, complex and costly. Italy's entry into the war alongside Germany cut both ways: it enhanced the political case for the new embassy project, but it also meant that Italy's own economic priorities would change making more difficult a number of aspects, including availability of material and the ability to expropriate the owners of the condominium at via Emanuele Filiberto 116. Eugenio Miccone, the contractor working on the enlargement of the *villino*, was commissioned to approach the current 400 occupants, in no fewer than 70 flats.

By July 1940 when the outlines of the plan were presented to Manteufel in the Finance Ministry, the land purchase costs had already risen to 3.6m or 3.7m RM. Adding in building costs of something over 3.45m RM gave a total cost of 9–10m RM. But the project, officials argued, still represented a good opportunity: the Rome authorities were realigning the roads in the area and were ready to alter their plans to accommodate the project. However in Rome Consul Reisinger, the locally employed administration officer, told Mackensen that the version under discussion would not do, not least on security grounds; he proposed an alternative incorporating the aqueduct. The RBD was asked in late July to produce a revised design. On the brighter side news arrived that the tenants to be evicted were all not opposed in principle to selling; but they wanted to know the price. Stiller, a counsellor on

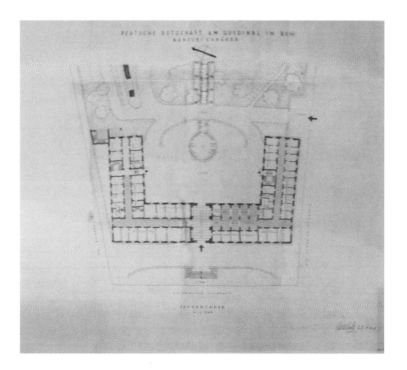

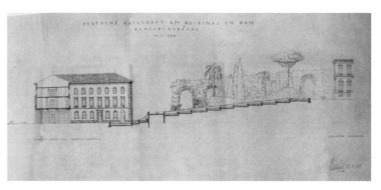

Figs. 10.1 & 10.2. The April 1940 design for a new German chancery on via Emanuele Filiberto.

Mackensen's staff, told Ciano (Mussolini's son-in-law and foreign minister) about the trouble h foresaw with the tenants, and Ciano assured him that influence would be brought to bear on th tenants. In September Stiller persuaded Prince Borghese (in effect the boss of Rome city) to offer combination of compulsory purchase and eviction.

The need for a face-lift for the German diplomatic presence in Italy was not limited to Rom While the negotiations there crept forward, the AA sought and obtained in December 1940 Finan Ministry approval to purchase for its consulate in Naples the Villa Crispi from Princess Monterodu

t a cost of L.600,000 (in the 1941 budget) plus L.115,000 for ongoing works (in 1942).⁵ Between June and August 1941 authority was also obtained to buy land for a new consulate in Milan near the German School, to create a small German 'Heim' (home) in that quarter. This involved the larger sum of L.5.362m (=706,000 RM). Money was not short for schemes in Italy.

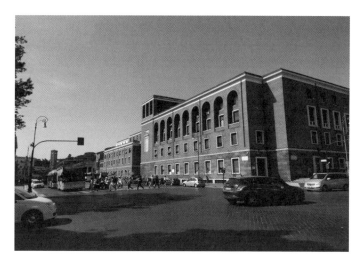

Fig. 10.3. The Central Registry office (Anagrafe) in Rome, taken by the German Embassy in 1940 as a model for the design of their new embassy offices.

Yet in Rome things were not straightforward. The new building's specification was adjusted in the autumn of 1940 to take account of a 50 per cent increase (over figures given to the finance minister in April) in the space required for staff. The design to accommodate the increase would require the demolition of the Kanzlerwohnhaus (alias the Beamtenhaus). But Soppart (BD) judged in January 1941 that to do so would endanger the arches of the aqueduct which it currently supported. Two courageous Italians, Professor Hermanin from Palazzo Venezia (Mussolini's office) and Professor Bartoli, curator of the Roman Forum, were, he said, 'very keen to avoid any damage'. The house and the aqueduct would have to be retained, and that would limit the size and shape of the new building. The threat of reducing the scale of the new offices brought Mackensen back into the fray, advising the AA on 6 March that they could not assume that staff numbers would reduce significantly after the war. Ribbentrop would then want to increase the size of the Culture Section. Any idea of out-housing the Consular Section could not be approved. An additional floor would have to be added to the design.

Ten days later Mackensen tried to persuade Prince Borghese to approve the design Soppart and the Italian experts did not like, but after two months had received no feedback. On 1 July Borghese admitted to problems with the City Council which he hoped to resolve with a new City Plan. (The limits to the power of the Fascist regime when faced with issues of great import for local city authorities differed little from those faced by the government in the early 1920s.) Borghese consulted Ciano, who thought the Embassy should choose the method by which the new scheme should be made legal – a Special Law, a decree in the framework of the City Plan or a War Law. On the 21st Mackensen told Borghese that all in Rome agreed the project should proceed; it was not for the Germans to choose which method the Italian authorities should follow. Consulting Ciano again, Borghese received on 6 August the instruction to use a decree. On the 11th the Foreign Ministry asked the Embassy to submit their plan and on the 14th Borghese sent the Ministry of Public Works a declaration of public utility to cover the plans.

Mackensen must have been on holiday when Mertz sent on to Berlin on 27 August the City's new road layout design alternatives, dated 25 August (Figs. 10.4 and 10.5), involving a loss of the land the

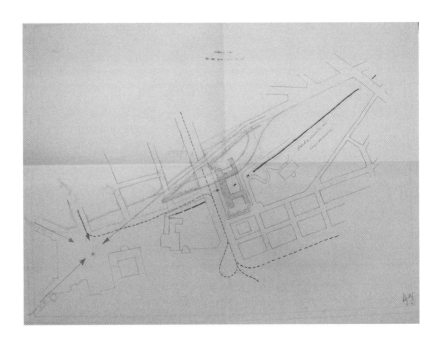

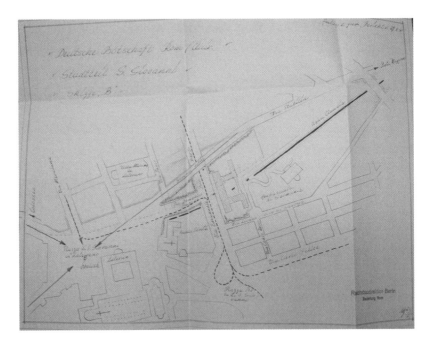

Figs. 10.4 & 10.5. First and second (unacceptable) proposals by Rome City on 25 August 1941 for layout of new roads, infringing on existing Villa Wolkonsky land and relying on flyovers which would dominate the Villa and obstruct the building plan – which involved demolition of two of the Villa's 'secondary' buildings.

Embassy hoped to use. Mackensen felt obliged to intervene personally. Such was the insensitivity of the City's ambition for flyovers and other intrusive structures that he objected to Borghese that the plans would have affected Embassy land, including the garden of the house on the aqueduct. On 15 September Mertz produced a revised version (Plate 10), showing what the *Governorato* (i.e. Prince Borghese's office) would accept.

On 22 September Mackensen told Berlin that the Embassy had submitted this 'risky counter-proposal', involving the Embassy expropriating all the land on the via Emanuele Filiberto frontage and no change to the layout of via Statilia. The City had approved on the condition that the aqueduct remain visible. This restored the Embassy's once-off opportunity, preserving the precious view of San Giovanni and the *Scala Santa*. It also met Italian wishes to avoid the demolition of the *Beamtenhaus* and the *Casino*. The 16 parcels of land to be expropriated were valued at L.15.2m. He sought authority to proceed and for the RBD to produce a new plan based on the new scale of expropriation: it reached the Finance Ministry on 6 October. It showed the main plot to be appropriated becoming mainly garden and an approach route to the Residence. On 24 October approval was given by the finance minister; but that was withdrawn six weeks later.

To make matters worse a meeting on 23 December with a majority of the tenants of the principal building to be acquired revealed that compensating them would now cost between L.8–9m. Schwager wrote on 12 January **1942** that such an increase would require the AA to go back to the finance minister, who might cancel the whole scheme. Mackensen was asked if the new high figure was justified. He said 'yes' twice and added in February that everything pointed towards expropriation as the only way forward. On 14 February Mertz was summoned to Berlin for talks on how to proceed. The problems were not only in Rome. Hitler was about to order a wholesale delay on projects, so that the needs of the war could be given priority.

On his return to Rome, Mertz prepared a paper (incorporating a plan) for the Italian Foreign Ministry setting out the Germans' intentions – a sure indication that official Berlin was confident enough that the project would go ahead to share them with the Italians. The description of the building which it contained (the only such document to survive) related most closely to the plan produced in late September/October after Mackensen's intervention with Borghese. After explaining that the present office building was too small and that the aqueduct made it impossible to find on the Villa Wolkonsky a sufficiently large area for a project of this scale, he stated that the project would be situated on the via Emanuele Filiberto, in conformity with the new City Plan which included a new street layout, the demolition of several buildings and the creation of a monumental area on the approach to the Basilica of San Giovanni. (The precise location and shape he gave may not have been definitive, but the general description would have been.) It would be three sides of a rectangle with the main entrance on the via Emanuele Filiberto frontage, a short lateral wing parallel to via Statilia and a longer third wing at the rear. Here are some key passages (author's translation):

> The Chancery will house on its four floors – three in the two wings – all the departments of the embassy ... It would be set back 23 m from the road to allow the garden to extend to the front of the building as far as the boundary wall on the street. The main entrance would be formed of three grand portals giving on to the hallway. Access to the ambassador's residence would be through a grand gateway on a roadway to the right side of the building, with a porter's lodge. ... An underground garage with access from via Statilia would accommodate 40 staff cars so that the access to the main entrance could be kept clear for visitors.

From the main entrance you would reach the hallway with a view of the courtyard to the rear (42 x 56 m) with its fountain. To the left the principal stairway would lead to all the floors. There would be two other stairways, a 'paternoster' lift and three other electric lifts.

After completion of the new building the old chancery built against the aqueduct would be demolished, with the greatest care being taken to preserve the historic monument itself. All the other secondary buildings would also be demolished, and the internal roadways of the Villa would be restored to garden. This would show off the aqueduct to greatest advantage.

The Chancery would be built in brick with floors and stairs of reinforced concrete. The walls would be clad in Roman travertine up to mezzanine height, as would the apertures of all the windows. ... A central air conditioning plant would provide for both winter heating and summer cooling.

The total volume would be 80,000 cubic metres; and the cost would be L.30–40m. Construction should start as soon as the existing properties had been cleared, if possible in the same year (1942) and would take three years.

(signed) Mertz,
Engineer, Embassy Technical Department
16 March 1942

On 1 April Mertz sent to Berlin a revised estimate of the building cost (11.3m RM) based on a new complete report and specification for the project. The style was to be 'Massivbauweisen', which might be best rendered as 'solid': mainly brick with a roof of reinforced concrete (Eisenbeton or Steineisen). The façades and window surrounds would be in travertine. The hall and stairs would be in marble (instead of reinforced concrete).

Meanwhile someone in Berlin must have picked up Mussolini's plan to develop the area to the north of the city, near the Villa Madama, where Italian ministries, the NSDAP office and sports stadia would be sited. Should the new embassy offices not be there? Mackensen dealt with this threat at length in a letter to Schwager on 28 April 1942. The Villa Wolkonsky was very well placed in relation to Mussolini's intentions to extend Rome southwards through an area unglamorously known as 'E42' (the site of the 1942 world exhibition which never happened – now EUR) to the sea, as demonstrated in the new City Plan and his intention to replace the buildings opposite the new chancery site with something monumental. So the Villa Wolkonsky was the right place to transform into 'a worthy seat of the future representation of the Greater German Reich'. He ended by reminding Berlin that it was Mussolini who had made possible the acquisition of Villa Wolkonsky, one of the finest positions in Rome – one of only five such villas within the walls – with its aqueduct, tombs, splendid gardens; an ensemble of special value. It would be right to enlarge the estate by buying in land 'sold from the original estate'. This was duly passed on 1 May to the Finance Ministry, who did not demur. The RBD (Badburger) reduced Mertz's revised costings to 10.5m RM, and allocated them: 5m RM to 1942, 4 RM to 1943 and 1.5m RM to 1944. It was now up to Ribbentrop to give the green light.

While they waited the Embassy submitted to Borghese a formal application for expropriation of the required properties so that demolition could begin on 1 October. The March total cost estimate (L.26–27m) seemed likely to be consumed by the costs of the land alone, so demanding were the sitting tenants. Avallone (in Borghese's office) estimated the expropriation cost at L.24m, and pronounced that demolition could only begin after the building restrictions had been formally lifted. The Germans might have been forgiven at this point for feeling that they were being given the run-around in the same way as their predecessors in the 1920s had been. By June, not having had any reassurance from Berlin

on the issue of where the office should be built, Mackensen was about to fire off direct to Ribbentrop. But Pannwitz in the AA advised against that, presumably on the grounds that things had moved on, and a sleeping dog should be left to sleep. On 10 June Mackensen accepted that. That was just as well, as Mertz had reported on 27 May (somewhat belatedly) that at a meeting he had attended on 8 May in the Finance Ministry in Berlin he had been told that an order issued by Goering on 13 April meant that material for the project must be 90 per cent Italian origin and that German material would only be available at the soonest at the end of 1943 or early 1944. The finance minister was however inclined to make Rome an exception. On 25 June Pannwitz asked Mackensen to produce a complete report for submission to Ribbentrop for approval; the document was duly despatched on 9 July.

Mackensen's submission repeated the arguments in his two earlier letters, but added a few new elements. He began by saying that on his arrival in Rome he had concluded that realising Ribbentrop's vision for the future Greater German representation to Axis partner Italy would require the rebuilding of both the Residence and the Chancery. The former had been dealt with in the project begun in summer 1939 and completed in October 1940. The Chancery would have to suffice as it was until it proved possible to realise that vision, which was not yet established in spite of his two earlier submissions. He stressed how much greater would be the peacetime workload of the Embassy than the pre-war load, as the Axis would be the basis of the new Europe'. For instance Ribbentrop wanted the Culture, Radio and Press departments to be at least as big as the wartime units. He reminded Ribbentrop that Ciano (his Italian counterpart) had promised his support if there were difficulties over the expropriations; and negotiations with the tenants were proving slow. However the City of Rome, in the context of its road realignment scheme, had undertaken to make available the former Wolkonsky properties to the north and north-west of the current boundaries; and their promise to erect a monumental building on the other side of the main road incorporated an undertaking to preserve the new embassy's view of the *Scala Santa*. The design incorporating all this and a plaster model awaited Ribbentrop's approval. The finance minister had already transferred 1.6m RM. (The total needed was 3.55m RM for the land and 7.75m RM for the new building, altogether 11.3m RM.) The Italian Ministry of Public Works was nearly ready to issue the public interest declaration needed to allow expropriation to commence. If the course of the war permitted the new offices could be ready by the end of 1944.

On the day Mackensen sent off his report he received a confidential sealed note recording a talk between Borghese and Mussolini in which the latter had offered to contribute to the costs of the project from 'special funds' (*aus besonderen Mitteln*). Mackensen declined but asked that such resources be used to deal with the odium caused by the expropriations. Borghese had agreed to pass that on up the line. (Perhaps Mussolini at that point also offered to finance the building of the swimming pool at the Villa. The timing is plausible, but there is no record of such an offer.)

While Ribbentrop's response was awaited things went quiet for the summer. On 24 August Mackensen complained that he had not heard back from Ribbentrop. A few days later Schroeder in the AA told him Ribbentrop had approved; but Mackensen said he needed that in writing. At least the money continued to be transferred. By the end of September the balance was L.7,758,045, and a further 600,000 RM was transferred (bringing it up to the equivalent of L.12,311,530). Acknowledging receipt in a letter to the AA on 13 October Mackensen estimated that, when all of the promised 2m RM (L.15m) had arrived, the balance would be around L.27m; as the whole cost of acquiring the land would be roughly that amount it should be possible to proceed without resort to credit.

At the coal-face a few days earlier Avallone in Borghese's office had told Stiller (counsellor in the embassy) that not only could the expropriations not begin until after the war was over, as all new building work had ceased, but the tenants were demanding a further year's grace after the war to find

alternative accommodation. Stiller had replied that a longer delay could be accepted for the main building (via Emanuele Filiberto 166), but not 'until the end of the war'; and this could not apply also to the other properties where building had to start sooner – also on the road schemes. They were discussing a plan on which the various blocks involved had been designated I, II, III and IV (Plate 6), the last referring to the police barracks, on which Avallone foresaw particular difficulty. A week later Avallone conceded that IV might not be such a problem. Stiller and Mertz insisted that both III and IV be released soon, closely followed by II, so that building could get under way. Two weeks later the Italian government claimed to have 'lost the plans'. A month after that Stiller was told that the tenants' demands were now about double the September 1941 estimate. (The Germans appear to have been content to leave these negotiations to the Italian authorities.)

Even by December Ribbentrop, who had been spending most of his time at Hitler's eastern HQ, had not seen let alone approved the model of the scheme which had been made. Mackensen extracted a promise from him on the telephone on 23 December that he would look at it on his next visit to Berlin. In practice there was no need for greater urgency. As Mackensen had reported to the AA earlier in December, Borghese was having a hard time negotiating about the expropriations, especially the police building on via Statilia. The City was looking after the expropriation of the properties along via Emanuele Filiberto which would be affected by the road scheme. He thought that process would be finished by the end of March 1943. But the demolition of No 166 (Block I) would probably not begin for another two years. The Italian Foreign Ministry added to the gloom by confirming to Mackensen in January 1943 the warning that mass expropriations would not be approved, a point the Germans must have begun to grasp by then.

Yet positive signals continued to arrive. The many occupiers of the via Emanuele Filiberto 166 properties were ready to sell, and the police were prepared to move out of the police station. The Embassy asked for authority to negotiate prices: prospects were still quite promising. Their estimate for the police station was 5,456 RM; in the flats one owner had agreed L.1.3m (5,532 RM) on a property valued at L.1.446m, another owner had privately agreed L.200,000, a quarter of his original bid. But all these figures now needed testing in negotiation. As war demands were raising building material costs all the time, speed was essential. On 21 January news came that the police would be out of the barracks within a few weeks. Two days later the Embassy submitted a detailed schedule in Italian of the new building's material needs. On 2 February the AA argued to the Finance Ministry that although costs in Lire were rising with inflation this did not affect the Reichsmark value; and in April they added that even with the further cost increases the land would still be worth more than the amount they would be paying for it. In February Mertz was called to Berlin again to discuss the project. On 2 February permission arrived from Berlin to conclude contracts with the occupants of Block I.

On 5 March the Embassy asked the Italian government for permission to own the land about to be acquired. In April the Italian Finance Ministry communicated a provisional price for the police barrack site as L.6.275m (but by June had still not formalised that). In a rare glimpse of the new sources of funds the German regime had acquired since they began their occupations and annexations, Pannwitz told the Embassy in May that they could add to the special account the princely sum of L.156,250 (20,470 RM), proceeds of the sale of the Czech Embassy in Tirana. On 18 June a further tranche of 200,000 RM for April–June was transferred by the Finance Ministry into the Embassy's special account.

On 21 April Ribbentrop decided that an architect should be hired to ensure that the new building was of the right sort: he would speak to Hitler, and negotiations would be entrusted to the RBD. The next day Schmidt in Ribbentrop's office told the Finance Ministry that his minister had turned down the design presented to him (presumably the one Mackensen had commended in the previous July

Whether this reflected personal rivalries or whether the two were in fact delivering the same message is hard to divine. The RBD duly chose an architect (no name survives). He started work and took his preliminary design to Mackensen, who dismissed it instantly as too florid. On 24 June Mackensen asked whether Ribbentrop wanted to make a personal choice of architect or wished the Finance Ministry or the Embassy to make proposals. On the 25th Pannwitz (AA) replied that Ribbentrop had appointed Paul Bonatz, apparently at his wife's suggestion.

Of course more immediate and compelling issues were being discussed that June as the Allies prepared to land in Sicily. On the 4th Schwager, who had taken over lead responsibility at the AA, at the same time as Reichle had assumed charge at the RBD, relayed to Mackensen Reichle's doubts about the availability of materials for the building before the end of the war, unless the Italians could divert materials – though that could arouse criticism. He asked whether Mackensen thought the project could still be completed 'before the end of the war': the Finance Ministry was prepared to pay for it (an indication of the political priority still at that stage), but was beginning to wonder. Mackensen replied that it all depended on the supplies which had to come from Germany: there might well be difficulties, but no one could foresee how long the war might last, so work should be accelerated in the meanwhile and problems should be dealt with as they arose. The project was urgent, especially on security grounds, and could not be put off because of the war. Failure to proceed would arouse Italian criticism: Prince Borghese (who had undertaken to adapt the street plans, etc.) had said as much; though such criticism could be rebutted by reference to the sensitive way the occupants' rights were being respected. It would be noted that the much grander new Italian embassy in Berlin had been completed even in wartime. Mertz separately estimated that the project needed 1,200 tons of iron; he had 100 and could get 500 more from 'Agram' (the German name for Croatia), but 600 had to come from Germany. Schwager relayed to the Finance Ministry that Mackensen judged it could be done, at least spread over several years. Clodius in the Finance Ministry agreed to continue the transfers.

In a normal peacetime environment the twin strands of difficulty – the issue of material shortages and the tenacity of the occupants of the key physical obstacle to the project – could have led to a sense of pessimism if not the abandonment of the whole enterprise. For all the accumulated routine steps being taken nothing had actually happened by the beginning of June 1943. It was by then obvious, too, that things were not going well in the war. The Russian front had turned, and the Allies were threatening a landing in Sicily. Mussolini had been unwell but was reported to be recovering. A meeting with Hitler was due shortly. We now know what was about to happen in Italy: but the Germans in Rome and Berlin did not sense it coming, and their failure to foresee the fall of Mussolini or even to ensure they were in contact with a range of opinion beyond their friends in the Fascist Party is testimony to their conviction that the Thousand Year Reich and the Axis were the future. Since they had been brought to accept that the project would not be finished quickly, they could acknowledge the practical difficulties but continue to think in terms of making such progress as they could and seeking ad hoc solutions as problems arose. They were not envisaging defeat in war. Indeed on 28 June Mackensen made the case to Berlin for a 50 per cent increase in the Rome cost of living allowance.[7]

So all seemed ready for the next phase: a worthy design to the building whose specifications and requirements were known. Bonatz (from Stuttgart, the homeplace of Ribbentrop and his wife) flew by Lufthansa) to Rome on 13 July to present his ideas to Mackensen.

Bonatz was an architect who had made an impact early in his career with the main station in Stuttgart – a neo-Romanesque creation in 1927. He did not join the Nazi Party, having been a member of the Social Democrat Party (SPD) during the Weimar Republic. He did accept the position of architectural expert and adviser to Fritz Todt, then general inspector for German road building. This

job gave him large-scale commissions related to Third Reich infrastructure, many bridges (including two major Autobahn bridges), and the huge railway station planned for Munich. He would have been known to the Ribbentrops not only for Stuttgart Station but also as the architect of a villa they had built in the 1920s in Berlin-Schmargendorf.

Bonatz stayed in Rome until 18 July, but Mackensen was 'too busy with Mussolini' to spend as much time with him as he would have liked. He did report himself impressed. Bonatz likewise reported that he was content but that he feared the Embassy had given too little attention to the costs and duration of the demolition of the neighbouring properties. Bonatz sent in his draft contract to the AA on 28 July. But by then Mussolini was out of office, and the real world imposed a halt, which proved permanent. Mackensen too was to be removed a few days later. At the end of August Bonatz acknowledged that he could not expect to continue with the project. In practice this was not the most important challenge he faced. Bonatz was considered a loose cannon, not afraid to criticise perpetrators of what he considered to be architectural horrors produced by the Nazi regime, including Albert Speer. Because of his vocal opinions, he had been investigated twice by the police, who accused him of aiding Jews and, very recently, being openly critical of Adolf Hitler for insisting on his requirement that the Munich station have a monumental dome. As a result of this last misdemeanour he found it expedient to take flight to Turkey in September. He worked and lived there until returning in 1954 to Stuttgart, where he died two years later. No more was heard of his project for Rome, except that on 2 December 1943 he told the Foreign Ministry that he could not send his plans to Berlin as there was by then a ban on parcel post from Turkey. The plans never surfaced.

Thus was the Germans' grand scheme to give the Reich an impressive presence in Rome submerged by the flood of the war they had unleashed. The German occupation of much of Italy soon made the very idea of an embassy redundant. The use they made of the Villa Wolkonsky during the occupation ensured that they would be deprived of it. And the defeat of the Third Reich made pretentious grandeur irrelevant. The end of the war amounted to such a complete break that, afterwards, no one seemed aware that such a scheme had been developed at all, let alone advanced so far. Part of the reason must be that nothing was done on the ground. The building at via Emanuele Filiberto 166 is still there. The police facility on via Statilia is still there. The road scheme was never implemented. The secondary buildings were never pulled down. It all looks much the same as it was when the Residence enlargement was completed in 1943. The plan in itself would not have changed the main residence building at the Villa (though Mackensen did at one moment indicate that he thought the next step might be a grand new, purpose-built residence). But, had it not been so comprehensively shelved by history, it would have ensured that the property and the buildings on it would have lost the charm of surprise: no longer a semi-rural paradise separated from a bustling city-scape by a concealing wall, they would have become the backdrop to a grandiose statement of the power and influence of Italy's victorious ally in a world where much else had changed – more imposing but with far less charm. And, while the existing ensemble would still have softened the impact of the large new office building, in the process the original dacha built by Princess Zenaïde would in all probability have vanished.

★ ★ ★

It is worth pausing for a moment to revert to the role of Carl Mertz, who had so much to do with these ambitious projects. He remained involved in the administration of the new 'embassy' in Fasano though whether he spent much time there is not clear. He probably did, as he is recorded as having remained in Italy, practising as a project manager or architect, before returning to Berlin in 1956, a

director of the Berlin Office of the *Bundesbauamt* (Federal Building Office, successor to the RBD, responsible for 'restoring all important state building in [West] Germany after the war'), then later as head of the whole organisation. In that capacity he is credited with responsibility for rebuilding or rehousing many state buildings in the Federal Republic and abroad. One report says he also ran the German railways for a period. In 1969 at the age of 61 he was appointed from the *Bundesbauamt* to take over the 1972 Munich Olympics *Baugesellschaft* (Construction Company). The company had got itself in a severe financial mess, mainly through conflicts of responsibility between city, land and federal governments and the ambitions of the Olympic Committee, having had no overall manager. Mertz's job was to restore financial sense and deliver the project on time for the opening in August 1972. He seems to have been remarkably successful in that super-heated context, though he did better at the second objective than the first, but his achievement was widely recognised and appreciated. He was obviously from a family of survivors and achievers: his grandfather had been similarly in charge for the 1936 Berlin Olympics![8] Carl Mertz died in 1978.

Notes

[1] The main sources for this chapter are AA files 1541a Vol. 1 1939–41; 1541a Vol. 2 1943–; 1541b Vol. 1 1941–2 & Vol. 2 1942–; BA files R2 11581, R128950 and 128218.

[2] In AA file 1541a Vol. 1.

[3] The senior staff of the Embassy, as declared in September 1942 to the Italian Foreign Ministry, comprised: Minister Prince Otto von Bismarck; Second Minister von Plessen (not otherwise recorded); Counsellor Stiller (also responsible for administration, like the then British role of Head of Chancery); and Military Attaché General von Rintelen and his deputy.

[4] These figures are in BA file R2 11581 Italien.

[5] The Villa Crispi was then sold to the UK by the Italian government after the war as part of the package which included the Villa Wolkonsky.

[6] *Sonderabrechnung Kanzlei-Neubau (Kap. IVE5, Titel 8v 1940).*

[7] BA: Finance Ministry file R2 11535.

[8] Mertz, *Planung der Bauten und Anlagen der Olympischen Spielen 1972 in München* (with Beharsch and Heinle), Stuttgart: Karl Krämer Verlag, 1972; and 'Drei Jahre Olympia-Bau', in *Architektur + Wettbewerbe 3*, Sonderband, 1972.

II.

A SUDDEN AND MESSY END TO AN EMBASSY

By the summer of 1943 the Allied successes in North Africa and their invasion of Sicily led some in Rome to feel (or hope) that the war was already lapping at Rome's gates. The turn in the fortunes of the Axis was in any case enough to give Mussolini's opponents in the Fascist Party and elsewhere, including the King (after much vacillation), the courage finally to move against him in late July. In August the new government led by Badoglio opened secret negotiations in Sicily for an armistice with the Allies, who seemed to be moving rapidly northwards from their landings in Sicily and the south of Italy. The German Embassy was caught almost wholly unawares by these events, which suggests that their observation and reporting of the internal political and popular mood in Italy was heavily distorted by the relationship between the two allies at the top, both of the military and of the two leaders. Not that it was good; but it was sufficiently intense to obscure the level of unrest even among long-time supporters of Mussolini. One or two of the latter were in frequent touch with the German Embassy, but they, too, would have been unwilling to share their innermost thoughts about the diminishing support at the highest levels for Il Duce.[1]

Of course, in the run-up to those dramatic events, the Embassy was at full stretch as the conduit for all the routine business transacted between two governments allied in a war of global reach.[2] Much of the work in 1942 and 1943 was related to supplies, fuel, oil and food for both the German population and for German troops; transport and shipping; the fraught business of German requirements of Italian labour on various fronts; and similar aspects of their conduct of war, which by then included the relationship with Japan. When these issues required government-to-government input, it was generally Prince Otto (Christian) von Bismarck, the minister (deputy to the ambassador) who intervened through the foreign ministry. Bismarck was the grandson of the Iron Chancellor: he had joined the AA in 1927 and served in Stockholm (his wife was Swedish) and London. Although a member of the NSDAP since 1933, by the time of his posting to Rome in 1940 he had developed strong doubts about the regime. He accepted the post reluctantly; he may have thought himself safer in an embassy than in Berlin, and personal ambition may have contributed. In Rome his name assured him good access to senior Italians, and he accumulated a wide range of political contacts. He also had his periods as chargé when Mackensen was away, including a final brief stint after Mackensen's sudden departure.

Bismarck, however, shared perforce (or could not circumvent) Mackensen's unwillingness to report explicitly to Berlin any analysis which cast doubt on the inevitability of Germany's victory, with Italy by its side. In private (even with Count Ciano) he did not conceal his frustration with the regime in Berlin, but in public he was its loyal proponent.[3] The trouble with the Mackensen approach which Bismarck was obliged to follow was that Berlin had other sources of information about Italy and took a more sceptical view of the military and political strength of the Alliance. One crucial side effect of this state of affairs was that Ribbentrop, who relied heavily on the intelligence from his own people (i.e. ambassadors), was taken wholly by surprise when Mussolini fell, which caused him great embarrassment with Hitler and the other top figures in the leadership. He lost no time in taking his

revenue. Both Mackensen and Bismarck had left within a month. (Bismarck was put in charge of the AA's Italy Committee for a year then returned home to run the family estates.) And General Rintelen was also replaced as military attaché by General Toussaint.

The end of Mussolini's regime – and of Mackensen's mission

Mackensen had bet all his personal capital on the Hitler–Mussolini alliance and thus on his own relationship with Mussolini and those around him in the Fascist hierarchy, especially those with the strongest belief in the alliance with Germany, such as Farinacci and Buffarini Guidi.[4] They, not surprisingly, were kept in the dark by those seeking to persuade the King to act against Mussolini. Bismarck had well-developed lines to the Foreign Ministry and to many in political life who were perhaps not so committed to Mussolini and the German alliance. Dollmann (in charge of the NSDAP office, an SS colonel with his own line to Himmler) also had good contacts in the Fascist Party and military elements of Mussolini's entourage at the Villa Torlonia. He (like Kappler – see below) was one of the very few senior Germans in Rome who warned Berlin (Himmler in this case, on 19 July, the date on which Mussolini met Hitler at Feltre) to expect action against Mussolini – a warning Himmler had passed on to the AA, and one assumes, Hitler's staff if not the Führer himself. Rintelen, the military attaché, was well in with the military High Command, but those few in the know kept their secret well, and Rintelen was not party to it. Of the senior personnel only Bismarck had good contacts with any of those who could see the increasing disenchantment with Mussolini. But Bismarck himself, a professional from the Prussian old guard, did not have the ear of the senior Nazi hierarchy and most of the time had to follow his chief's lead and conceal the truth from the leadership.

In May the Allies' expulsion of the Axis forces from Tunisia sent to those in Rome, Fascist and non-Fascist, who had tired of Mussolini's bombastic and disastrous military adventurism, a signal which they grasped. They began to work out how they could be rid of their leader. Some were Fascists who thought Mussolini had strayed too far from the party's roots. Others were monarchists who had been lying low or playing along. They had the ear of the King, whose involvement would be crucial to success. In June Mussolini had been unwell, possibly with a heart problem. On the 21st, the Embassy reported to Berlin that, 'feeling better', he had chaired the Council of Ministers (cabinet). But the Foreign Ministry had already told Bismarck that Mussolini would not be fit to travel to meet Hitler as had been planned, because of his strict diet and determination not to take risks with his health. On 10 July the Allies landed in Sicily, meeting little Italian opposition. By the 16th Dollmann was reporting that the 'inner circle' at the Villa Torlonia was very concerned. Mussolini had been shocked by the performance of his officers and leaders in Sicily. He had called Ciano in from Livorno (where he had been sulking). The concern had been heightened by the news that General Ambrosio (a respected retired military figure) had spent 45 minutes on 18 June with the King. While such advisers, doubting Ciano's reliability, hoped that Germany would take on more of the military responsibility, they had no doubts about the King's 'loyalty to' Mussolini as long the crown was not threatened by 'a new Caporetto'.[5]

Nonetheless, by 18 July, the Embassy did report that Mussolini was under pressure from some ministers to aim for an 'honourable capitulation'. Mussolini had declared himself totally opposed to any such thought. But Ciano, back in Rome, and the inner circle judged that the loss of Sicily would be catastrophic for the internal situation (i.e. Mussolini's hold on power). Against that background of growing unrest within the hierarchy, Mussolini did after all travel to Feltre in northern Italy to meet Hitler on 19 July, hoping to obtain a German commitment to strengthen their forces in the south, but

also under pressure from the High Command to persuade Hitler to let Italy abandon the military alliance. Mackensen and Rintelen were present, among a handful of other senior figures on both sides. Early on the meeting was interrupted by news that the Allies had bombed Rome. The air raid was aimed at the railway marshalling yards at San Lorenzo, but it inflicted heavy damage on the basilica, the university and the residential area nearby. Many civilians died or were badly hurt. The Pope was quick to visit the scene; Mussolini was of course out of Rome. For the King, this may have been the trigger he needed to act against Mussolini.

Not for the first time Mussolini was subjected to a long harangue from Hitler, which he barely interrupted when news of the Allied bombing of Rome reached the meeting. Part of it was a frank review of the military and supply/resource position of Germany. Presumably trying to set an example, Hitler told Mussolini how he personally was prepared to sacrifice his time and his comfort to lead as long as he lived; he was ready to take hard decisions. Part was a rant against Italian incompetence, e.g. allowing the Allies to destroy Italian aircraft on the ground and then expecting Germany to increase its commitment of men and machines to the Italian/Sicilian front; or failing to ensure that Italian airfield runways were long enough for bombers to take off. In Germany officers guilty of such errors met with 'barbaric toughness'. If Italy could not hold Sicily, so be it, but Germany would not be in a position to counterattack as long as fuel and other supplies were lacking and its forces were needed in higher-priority places, e.g. Crete and Greece. Successful defence meant being ready to shoot deserters; more Italian troops must be sent to the 'heel' of Italy. Mussolini, dismayed by news of the bombing, barely got a word in edgeways and left without raising with Hitler the idea of an amicable divorce, which had been the plan urged by his advisers. When Ambrosio returned from the Feltre meeting to report Mussolini's failure, the King's determination can only have grown.

Back in Rome on 21 July Mackensen reported to Ribbentrop news from a long talk with Roberto Farinacci, a senior radical Fascist long considered a German trusty – indeed probably their main source in the Fascist top echelons (Fig. 11.1). A group of 'old fascists', i.e. those party faithful who no longer had their Duce's ear, had gone to see their leader and demanded that, for a change, he listen to them. They complained that he had personal charge of too many ministries, and that the Fascist Council no longer met. Mussolini had accepted. When Mackensen had warned that he would have to report Farinacci's news, the latter had said the situation was so bad he had to take that risk. Mackensen stressed that the Führer needed total Italian commitment if he was to help with valuable German men and materiel. A radical change of attitude and behaviour was required of Italy. Farinacci had thought the King was completely behind Mussolini; but he was unsure about the Crown Prince, while Badoglio was firmly anti-Fascist. When Mackensen saw Mussolini himself on the 23rd to give him the German record of the Feltre summit, he found him impressed by Hitler's lecture but critical of Hitler's overestimation of the Italian forces' abilities. Mussolini had been shocked by the bombing of Rome, but he was calm and gave Mackensen no hint of going through a serious crisis. Mackensen duly sent a reassuring telegram to Ribbentrop, judging that Mussolini was in control and Italy would resist the Allies.

The King, too, had been shocked by the air raid on Rome and the tone of the Feltre summit. The arguments of the old pro-monarchy Fascists like Grandi, allied to those of the army High Command (in effect the source of power) could now finally prevail on the King. Mussolini tried to counter the tendency represented by Farinacci's 'old fascists' by calling in Grandi himself, as a grandee of the party, to help him at a Fascist Council meeting on the evening of Saturday 24 July. Grandi had not been party to the confrontation with Mussolini on his return from Feltre. But Mussolini acted too late: Grandi turned out to be on the King's side, and the King had finally taken his decision after weeks of

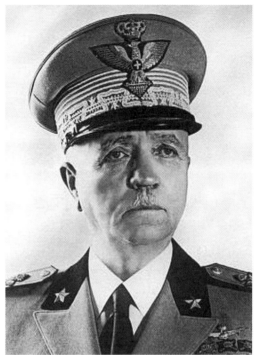

Fig. 11.1. Roberto Farinacci, a leading and extreme Fascist in Mussolini's regime, with strong pro-German leanings.

Fig. 11.2. Marshal Pietro Badoglio, prime minister of Italy 25 July – 9 September 1943.

hesitation. Grandi himself tabled the resolution designed to undermine Mussolini. Mussolini never forgave him, considering him from then on as the real traitor to him and to Fascism.

The King and Badoglio struck on 25 July; Mussolini was summoned in the afternoon to the Quirinal Palace, and went of his own free will, not suspecting that the King had determined on action. There – in an interview lasting only 20 minutes – he was dismissed, arrested as he left and spirited away ('for his own safety') in an ambulance. Marshal Badoglio was appointed prime minister (Fig. 11.2.)

Mussolini was at first taken to a nearby *carabinieri* barracks in via Legnano, in the Prati district, where he was held for three nights. Then, given the risk that supporters would try to 'spring' him, he was transferred on 28 July via the port of Gaeta to the island of Ventotene, then in quick succession to Ponza and on 7 August to La Maddalena at the northern tip of Sardinia. On 28 August he was taken back to the mainland to the foot of the Gran Sasso, and on 3 September locked up in the famous hotel on the top, Campo Imperatore, where he was guarded by 250 *carabinieri* and police. There, in a famous *coup de main* on 12 September, Otto Skorzeny and his commandos rescued him and flew him first, via Rome, to Munich, then to Berlin. Hitler, who did not want Mussolini and his hangers-on to tarry in Berlin, lost no time in brow-beating him into announcing and leading a new puppet Italian Social Republic based in Salò, northern Italy. Mussolini arrived there on 23 September.

Mackensen had been completely blind-sided by those who had successfully conspired to unseat Mussolini. He and Rintelen had believed that the meetings were about how to strengthen the Axis. Bismarck too had been in the dark; he heard about Mussolini's fall at dinner with friends in a *trattoria*. Dollmann in his memoir described how, during the afternoon of 25 July, after hearing concern from a senior Italian general about the way the previous day's General Council had gone, he had joined Mackensen in his study at the Villa Wolkonsky (which he described as 'dead and deserted, except for the ambassador's pet peacocks').[6] That tends to confirm the story Moellhausen recounted that Doertenbach, a political counsellor, had phoned the ambassador asking to see him to report urgent intelligence (he had heard the same concerns as Dollmann) but had been told to wait until 4 p.m. when working hours resumed!

First, they heard an account from a leading Fascist, Buffarini Guidi, of how, at the previous day's Grand Council, first Grandi had confronted Mussolini, then Ciano and others had deserted him. Mackensen typed away at his report to Ribbentrop as he listened. The Germans had expected other Fascist friends of Germany to come to consult them if the rumoured 'resignation' of Mussolini took place. Their staying away was a warning to the Germans that the wind had shifted very suddenly. Late in the day Farinacci did arrive, alone (and apparently straight from an afternoon at the beach at Ostia 'in little more than a swimming costume'!), but primarily to seek asylum. He had found his home surrounded by Badoglio's men, so had not dared to go home to change, fearing but not knowing that things had changed. As a pro-German he felt he was now a marked man, especially as he suspected Badoglio of wanting to conclude a peace with the Allies.

Against the backdrop of a 'superb tapestry on the red damask walls, telling the story of Alexander the Great, Darius and the beautiful Roxana, and over brandy, coffee and cigars' (according to Dollmann), they heard Farinacci's account, as he tried to justify his tactic of pushing Mussolini to revert to the true Fascist ways – which Mussolini's leading critics had easily exploited.[7] The meeting broke up around 5 p.m., roughly when Mussolini became a prisoner. Mackensen reported to Ribbentrop. Dollmann went home to his flat in the Piazza di Spagna, then returned to the Embassy as Farinacci was making his case for asylum. In a rare comic moment Mackensen's wife appeared, to offer not only tea but also women's clothing should anyone need a disguise in which to escape.

Farinacci, presumably still dressed as a man, was sent on to Kesselring (accompanied by Dollmann, who quickly saw the need to reinforce his links with the field marshal)[8] who arranged for him to leave Rome for Munich in a German aircraft. Once there he travelled on to Hitler's HQ at Rastenburg. Goebbels in his diary records how he and Hitler had both had high hopes of Farinacci as energetic, loyal to the German Alliance and capable of leading a Fascist recovery with German support (the fate of Mussolini being at that point wholly unknown to them). But the Farinacci who arrived proved to be a broken man, a total disappointment to Hitler.[9]

Late in the evening of 25 July (according to Dollmann) Badoglio telephoned Mackensen to introduce himself. Mackensen, as a 'legitimist', expressed himself relieved that Badoglio was the King's appointment. But Badoglio would say nothing about the fate of Mussolini. He maintained that Italy would remain loyal to the Axis with Germany. There was no concealing the fact that, at a stroke, the German ambassador had lost his main lines into the Italian elite, which he had worked hard to cultivate over nearly five years, and could see his mission crumbling before his eyes. He had failed to foresee Mussolini's demise, and he had sent the Führer a trusted leader (Farinacci) who turned out to be a busted flush. He immediately sought an audience with the King but was received only on the 29th, by which time he had a personal but oral message to deliver from Ribbentrop. The Führer had been shocked by the resignation of Mussolini: he had had no warning, and given the state of relations

he would have expected a message from the King about so major a change. Instead he had only had a formal notice after the event from Badoglio. Badoglio had refused to tell the Führer (i.e. Mackensen) where Mussolini was, contrary to all assurances of harmony between the King and Mussolini. Rumours abounded that Mussolini had been sacked and arrested: the absence of any word contradicting such rumours further undermined the relationship. Mackensen insisted he be allowed to see Mussolini the following day to deliver in person Hitler's birthday greetings to Mussolini: that would help to scotch the rumours and restore mutual confidence.

In response the King read to Mackensen a telegram from Mussolini claiming to be content to be protected against extremists in his own party and ready to go wherever he was sent. (It had sounded to Mackensen as if he were still in Rome.) However he was clearly upset by events. The King had not communicated with Hitler because of the latter's 'reserve' towards him. He would pass to Badoglio the request for a call on Mussolini. In other words, reported Mackensen, the King had stood his ground.

Behind this smokescreen of diplomatic exchanges Hitler himself had already taken decisions based on a conviction, expressed even on 25 July, that he could not trust Italian assurances of continuing the war 'at Germany's side'. He made no effort to contact the new government. He ordered Kesselring the same night to prepare to withdraw from Sicily, Sardinia and Corsica. He let it be known that he wanted the 3rd Armoured Division to take Rome, overthrow the government and take the King and his family. He assumed that the Fascists would support a puppet government under a released and reinstated Mussolini. On 27 July units of the 2nd Parachute Division landed at Viterbo (north of Rome) and Pratica di Mare (to the south), surprising not only the Italians but Kesselring too. While there were in practice no Fascists left to support, these manoeuvres put at risk Kesselring's army fighting the Allies in the south.

The Italians had expected some German response and were gathering their own forces around Rome, which Kesselring observed and reported to the High Command on 1 August. Hitler stuck to his view that Badoglio would betray Germany. But Kesselring continued to argue that Germany should appear to trust the Italians for as long as possible, so that he could get reinforcements in to the front – at least until there were clear signs of Italian treachery. Eventually Hitler accepted this logic (reinforced by news that the Italians knew of the plot) and agreed that the plan to take over by force was no longer feasible. The Germans however continued quietly to increase their forces around Rome over the next few weeks, in recognition of its strategic significance for Kesselring's lines of communications and supply from northern Italy to the front: he could not afford to have his army in the south cut off.

On 30 July Mackensen called on Guariglia on the first day of his brief tenure as foreign minister in Badoglio's government, ostensibly to deliver a protest at the attack by a mob on the German consulate in Turin. Guariglia (who had been Italy's ambassador in Paris in 1940 and subsequently in Ankara) told him that Italy wanted to continue the fight by Germany's side.[10] Mackensen asked why this was not reflected in Badoglio's public utterances or the press. The King sent for Mackensen on 2 August to discuss continuing the war together. He claimed the explosion of the crisis on 25 July had been a thunderbolt (*bolide*) for him.[11] Mussolini had accepted that the security of himself and his family was at risk, agreed to protection and asked to be relieved of his duties. The motive force appeared to have been Grandi. Mackensen opined that this account was an attempt by the King to acknowledge mistakes made after the 25th; but he offered no view on the reliability of the Italians as allies – indeed he was clearly in no position to judge the actions of the new government, as he had not been talking to them and they were not talking to him now. Mackensen certainly did not even air the possibility

that the Italians might change sides in the war.[12] The lack of any recognition of this possibility from Mackensen undoubtedly contributed to his removal by Ribbentrop a week later.[13]

Mackensen (following a conversation on 2 August – presumably by telephone – with Ribbentrop or even with Hitler himself) left Rome to attend a meeting with Ribbentrop and others on 6 August in Tarvisio near the Austrian frontier. At the end of the meeting Ribbentrop ordered Mackensen to return with him to Berlin in his special train: he would not be going back to Rome.[14] Although he was not under arrest, this was an ignominious end to his five-year tenure as ambassador. He was made an adviser to the Führer at the *Wolfsschanze* (Wolf's Lair) Headquarters. He is unlikely to have played any significant part there, but Hitler's entourage could at least keep an eye on him.

The Germans in Rome are caught out again

For three weeks the Embassy was in the charge of Bismarck, but, as it had been so identified with the Axis with Mussolini, it was now bereft of insider information on the intentions and actions of their Italian 'allies', i.e. Badoglio's government. On 17 August Italian and German forces withdrew from Sicily. The next day, at military talks in Bologna, the German High Command demanded that Rommel be appointed to command all Axis forces in northern Italy, answerable only to the King. On 19 August the Ministry of Foreign Affairs asked Bismarck to explain to Berlin that the King could only command through the Italian High Command.[15] But the reality was that the Germans were in control and the Badoglio government was already in initial secret talks with the Allies, which had begun in Lisbon on 16 August.

While opening the talks behind the Germans' backs, Badoglio's government appears to have given no thought to how to break off the alliance with Germany. They must have thought the problem unreal as they expected that the Allies would mount a landing north of Rome, cutting the German forces in Rome and the south off from their rear support and making a decision by the Italians superfluous and the risk of armed clashes between them negligible. Italian negotiators continually stressed the need for a landing north of the capital; indeed in the final phases of the talks they tried to make such a landing a condition of the armistice. Even when it became clear on 3 September that there would be no such attack, the Italians made no military preparations for possible clashes with German forces. They were more focused on dealing with social unrest generated partly by their failure to make any concessions to democracy or to persecuted groups such as the Jews, and with arguments about whether Rome could be declared an open city.

The negotiations in Lisbon (between Brigadier Giuseppe Castellano on the Italian side and General Bedell Smith for the Allies) were marked by lack of trust. The Italians demanded the landing by a divisions between Civitavecchia and La Spezia, revealing their fear of German action against the Badoglio government. The Allies insisted that the landing could only take place after the armistice had been announced: they did not trust the Italians in the light of their public and private assurances to the Germans. It took the King to break the impasse and decide that Italy should accept the Allies' terms and Castellano was sent to Sicily to sign on 3 September. The Italians would have to accept that an Allied landing would take place south of Rome, that the Italian forces there would not be spared from clashes with the Germans, and that the defence of Rome against them was up to the Italians.

On 23 August the German Embassy had missed one opportunity to warn Berlin at high level what was afoot. One of the 'old fascists' (Aquini) told the Embassy that negotiations were in train between 'the leftists' and 'the enemy' for a special peace arrangement; Bismarck reported this to Berlin

n a routine fashion with the comment that he had heard of no such negotiations. But he was also working on a general review of the situation, which he sent to Berlin on the 27th. In it he reported his assessment that Badoglio's government was heavily influenced by politicians of the left, who wanted a left-liberal government and the earliest possible peace 'at any cost' – aims inconsistent with Badoglio's professed intention to continue the war at Germany's side. The Fascist Party was broken; it might be rebuilt, but for the present they were all blaming each other. Respect for the King was shattered: his position rested on the High Command and Badoglio: when Badoglio went he would have to go too. The Communists were playing only a subsidiary role: they expected the Wehrmacht to take over, so were taking no action. Everyone thought that the war was lost. There was no chance of changing Italy's internal politics. This sensitive and well-argued analysis lacked one essential element: the specific idea that the Italian government might be already working on a separate peace with the Allies. The German files do not reveal what reception the report received: one can imagine it might have been buried as unacceptable to Ribbentrop and the Führer, who had in any case made up his mind. It was Bismarck's last shot. He left the post on 30 August.

Meanwhile a potential successor to Mackensen had been summoned to the *Wolfsschanze* at Rastenburg: Rudolf Rahn (Fig. 11.3), a career diplomat with a track record of early and active NSDAP membership, work in information and propaganda, and wartime postings in occupied Paris and Tunis where he had known Kesselring, who was shortly to be given command over all Axis troops south of Rome, i.e. the defence against the advancing Allies). Evidently Berlin regarded him as more trustworthy/loyal than the existing staff, including Bismarck. (They were not wrong if that was so, as Bismarck was close to many of the officers and other senior Prussians who were to become involved in the failed July 1944 plot to assassinate Hitler, though he was not a plotter and survived the subsequent purges.) Hitler had apparently been impressed by Rahn as a do-er during brief postings in Syria and Tunis, in both of which he had at his own request been supported by E.F. Moellhausen, linguist and career official with a somewhat unusual c.v. Rahn was, however, no favourite of Ribbentrop's, who tended not to trust people he had not selected himself. This may be one reason why he was, on 29 August, initially appointed to succeed Bismarck as minister-plenipotentiary and chargé d'affaires, rather than formally succeeding Mackensen as ambassador.

While at Rastenburg, Rahn had produced a memorandum, dated 19 August, on the administration of occupied territories.[16] Germany should line up as many supporters as possible – preferably supporters out of conviction and ready to convince others – and administer through them in the form of collaborationist governments. Such regimes would neither attack nor sabotage German occupation forces, and the local politicians would be seen to have taken the repressive decisions, not the Wehrmacht. Hitler may have been impressed by this approach, and it may have accounted in part for the way in which Germany followed the Vichy model rather than the brutal fate of occupied lands in the East.

The delay in Rahn's appointment was, by Moellhausen's account, occasioned by the uncertainty generated by Hitler's early order that the King and Badoglio be abducted in a *coup de main* (which was to have been mounted by SS Colonel Otto Skorzeny). Both Kesselring and Dollmann had opposed the scheme but been overruled, until the Italian chief of police spoiled things by telling Dollmann on August that they knew of the plot and had taken precautions. Kappler, the senior German police and intelligence official in Rome, at that stage based in the Villa Wolkonsky, was on his way by air to the *Wolfsschanze* to discuss a new plan to establish where Mussolini was being held and stage a rescue. He was able to confirm in person the news of the Italians' knowledge of the plot against the King. The idea of a daring rescue of Mussolini was clearly more appealing to Hitler than an attempt to abduct

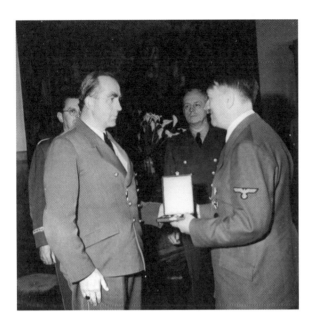

Fig. 11.3. *Rudolf Rahn receives his knighthood from Hitler, with Ribbentrop (centre) looking on.*

Fig. 11.4. *SS General Karl Wolff in 1937. I was appointed by Hitler as overall command of police and SS action in Italy after the fall Mussolini.*

the King and Badoglio. The switch gave Kesselring the breathing space he needed and allowed tl Germans to revert to normal diplomatic protocol with the King and Badoglio and confirm the choi of Rahn. He arrived in Rome the next day, 30 August, accompanied by Moellhausen, whom he h: summoned to the *Wolfsschanze* even before his own appointment had been confirmed.

Those same days also saw the arrival in Rome of another senior official, bearing a speci commission from the Führer, in this case as head of all police and SS operations in Italy, SS Gene Karl Wolff (Fig. 11.4). Although in theory a potential rival to Rahn – and indeed to the Wehrmac commander, Kesselring – the two men, once settled in the north, developed a close and mutua respectful relationship (possibly brokered in part by Rahn's wife), both proving to be realists, awa of the costs to Germany of excessive National Socialist zeal, harshness and excess. But in t turbulence of early September 1943 their almost simultaneous arrival added to the sense of confusi about which senior German was responsible for what. As things turned out, Wolff spent little tir in Rome. But he was a powerful figure in the background, in many cases a source of ultimate author at local level, although it was sometimes hard to divine just what he actually commanded.

The end of the German–Italian Axis

The Germans, at that point, were still in the dark about the new Italian government's secret negot tions with the Allies about an armistice, which were moving that very day at Allied request to Syracı

n Sicily. Agreement was reached there on 2 September; but Badoglio hesitated over the terms. British forces under Montgomery landed at Taranto on the mainland on 3 September.

Rahn was in action from his arrival. He formally took over at the Villa Wolkonsky on 1 September with an address to staff announcing that he was not there to wield the iron fist but to replace Mackensen.[17] He called first on General Ambrosio, Chief of the Defence Staff, reflecting the priority he accorded to restoring trust and working relations between the two countries' supreme commands. He offered to set up a meeting with Rommel, now in charge of all Axis Forces in Italy, with his HQ in the north. But Ambrosio did not jump at this. Then Rahn went to pay his courtesy call on Guariglia, the foreign minister. Neither Italian gave any indication that the Axis was finished.

On 3 September, accompanied by Moellhausen, Rahn met Badoglio. (By some accounts he was also accompanied by Wolff, but Moellhausen's memoir makes no reference to Wolff being present, nor would it have accorded with normal protocol on a first call by a new head of mission, even in those odd circumstances.) Badoglio was 'cordial but hostile', listening impassively to Rahn conveying German dissatisfaction with Italy's military performance and its recent stationing of forces as if to defend themselves against German attack from the north. Badoglio claimed that he was surprised to find himself prime minister but that had been what the Italian people wanted. He welcomed Rahn's offer to mediate between the two GHQs. He repeated his statement that Italy would fight on at Germany's side: his word as a marshal was not to be doubted. Rahn expressed himself satisfied and so reported. But the Embassy's labour attaché, an official whose range of contacts was quite different from those of the higher-profile senior staff, warned Moellhausen that they should not believe Badoglio.

While Moellhausen did the rounds at the Foreign Ministry from the 4th to the 7th, Rahn went to see Kesselring, now with 20,000 parachute troops under General Student concealed around Frascati ready 'to execute a secret plan', which we can presume was a reference to Hitler's plan of reaction to any threat of an Italian abandonment of the Axis.[18] The military High Command in Germany, but not Kesselring himself, thought that Badoglio had defected to the Allies. On 7 September Rahn (with Moellhausen and Doertenbach in attendance) had von Weizsäcker (ambassador to the Vatican) and his deputy, von Kessel, to dinner to review the political position. None considered an Italian betrayal imminent. Rahn thought the alliance with Italy could continue without the Fascists. (But, after the dinner, Moellhausen shared with him a report just received that two Italian officers had flown to Sicily to conclude an armistice with the Allies.)

Early on the morning of the 8th, Rahn and Moellhausen breakfasted on the terrace of the Villa before Rahn went alone to the Villa Savoia to be received by the King, a meeting to which the Germans attached much importance. In the event there was little talk of the political outlook. The atmosphere was calm and friendly. Only towards the end, when Rahn raised the undertaking given to him by Badoglio, did the King say that Rahn should raise such issues with Badoglio, who had the King's complete confidence: for his own part the King was convinced that Italy should remain loyal to its undertakings to Germany. This strengthened Rahn's view that the Axis could continue without Fascism. In practice Rahn was hearing only one side of an argument which was to continue for most of the day, and the King may have been only expressing his personal view of the moment before events later in the day dictated a different outcome.

On the night of the 6th senior US emissary Maxwell Taylor on an undisclosed visit to Rome had heard from Badoglio and Carboni that if no landing could be mounted north of Rome the armistice should be delayed. (Carboni was standing in for Chief of Defence Staff Ambrosio, who had inexplicably taken the previous day off with his family in Turin and was still on the journey back to

Rome.) The Allies would only commit to stage a landing (location not revealed to the Italians but including airborne attacks to take control of Rome's airfields) once the armistice had been announced. Did Badoglio hope to call the Allies' bluff and force them to agree to an immediate landing north of Rome? Was he conscious of having invoked his honour as a marshal too often in his protestations of loyalty to the Axis? At the end of the day, was the old hero trying to escape from the trap he found himself in? In any event on the morning of the 8th he had just – at the last minute – sent a cable to the Allied HQ refusing to ratify the armistice terms agreed in Sicily, telling the Allies to call off the landing plans and declining to make the simultaneous broadcast announcement with Eisenhower (the Supreme Allied Commander) that had been agreed for that evening. The King would no doubt have been aware of that and therefore unsure what would happen next.

Rahn had returned to the Villa Wolkonsky in time to watch, with most of his staff, from the roof terrace as the Allied air forces launched a destructive bombing raid at noon on Kesselring's Frascati HQ – a message of warning to the Italians perhaps. Eisenhower's reply to Badoglio, saying he was going ahead anyway with his broadcast, arrived only in the afternoon. By then the first leak had been picked up by Reuters who reported the Italian request for an armistice. Amazingly the news did not leak out in Rome. During the afternoon Ribbentrop rang Rahn several times to check on wire service reports of an Italian armistice with the Allies. Rahn first recounted his interviews with the King and Badoglio, but soon Ribbentrop rang again; Rahn checked with General Roatta (Army Chief of Staff, in Ambrosio's absence) and with Ambassador Rosso, the senior official available at the Foreign Ministry in Guariglia's absence – both denied the reports, as did Roatta when Kesselring also called him. Ribbentrop then relayed the report that Eisenhower was about to make a speech on radio. So Rahn went in person to the Foreign Ministry at 5 p.m., where Guariglia finally told him the truth – and got an earful from Rahn.

The Embassy had been as much taken by surprise as the rest of Italy when the news broke. Rahn and Moellhausen, of course, had few contacts after only a few days in Rome and had no direct knowledge of the internal Italian debate. Few senior Italians had been in the know, certainly not those Rahn and others had tried to contact during the afternoon, except possibly Roatta. In any case Badoglio's last-minute attack of cold feet would have left even those in the know unsure what was going to happen and in no position to gainsay the oft-repeated assurances to the Germans.

Eisenhower's reply prompted the King to summon an immediate council of all those (few) who were in the know. Several of those present, including Carboni, argued that Italy should stand by the Germans. There had been many statements of loyalty, including to Rahn. The opposing view was apparently advanced most powerfully by a relatively junior officer. The Allies would publish film and documents relating to the armistice negotiations. The Germans would exact reprisals for the duplicity. The Allies could bomb Italian targets, as they had just demonstrated. At 7 p.m. the King decided that they should confirm the armistice. Eisenhower had by then anyway forced Badoglio's hand by his unilateral announcement on Algiers radio at 6.30 p.m. Badoglio realised he had no option and followed suit at 7.45 p.m. His broadcast included the surprise instruction that Italian forces should cease action against the Allies but react if attacked by non-Allied forces, i.e. the Germans. There was now no avoiding confrontation with the erstwhile ally.

The Embassy evacuates in a hurry

Stunned by the sudden turn in the situation the senior staff of the Embassy gathered at the Villa. Perhaps food was provided, but they would not have been 'dining till the small hours'. Those present

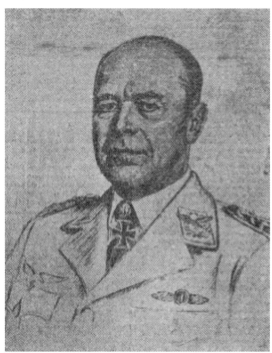

*igs. 11.5 & 11.6. Field Marshal Albert Kesselring, in these images not entirely living up to his nickname of *miling Albert'.*

included the new military attaché, General Toussaint, in place of Rintelen, and Doertenbach. Agreement was immediately conveyed from Berlin to the plan for the Embassy to close and the staff to depart quickly for the safety of the north. Everyone expected an early Allied invasion near Rome and their rapid appearance in the city. The Embassy must also have assumed that Kesselring (Figs. 1.5 and 11.6, who had said he could not guarantee the safety of the Embassy) would be withdrawing to more defensible lines to the north.

Doertenbach was despatched to the Foreign Ministry to organise the diplomats' withdrawal. The Ministry, with great efficiency, laid on a special train to ferry the diplomats to Verona: it was ready by a.m., though the embassy staff were not. They spent the night burning papers, cyphers and codes, packing some belongings and transferring bank accounts and cars to Italian friends. The bulk of them did leave in the train early on 9 September. Rahn was, fittingly, according to Moellhausen, the last to leave the Embassy.[19] By the time that the train safely reached Verona, three days later, it was clear that the Allies were not at Rome's gates after all, and the Germans had occupied it instead, much reducing any threat from remaining Italian forces. So Rahn was instructed to return, and an aircraft was provided to get him there. He decided to take with him a press attaché, air attaché, a counsellor (Leithe-spar, not otherwise identified) and Moellhausen.

Kappler and his team had not joined the train, being under instruction to make contact with their agents before leaving. These 'police attachés' (a euphemism for the SS/SD security police) were

responsible for security behind the German lines. After a long, roundabout drive they eventually reached Kesselring's HQ near Frascati, where he had taken over command of all German forces in southern Italy (including Rome). Others left behind at the Villa included two German gardeners (Erb and Arnold), who had been brought in to reinforce the Italian gardeners who, on security grounds, had been downgraded to 'helpers' after the announcement of the armistice; they were repatriated in October.[20]

Italian forces surrender to the Germans

The Italian flip-flop over the armistice announcement had reinforced US commanders' doubts about the Italians' ability to hold the line against the Germans while the Allies dropped troops to secure airfields around Rome and follow with airborne troops. The Allies' landing was first delayed by a day then cancelled altogether on the 9th. (Some units only heard of the change on the 10th.) Thus were the King, Badoglio and the Italian forces around Rome left to look after their own defence against the German forces. (The cancellation of the Allied air landings also allowed the Germans to use an airfield near Rome for Skorzeny to smuggle Mussolini out to Munich after the 12 September raid on the Campo Imperatore.)

The Italian forces had the numbers to take advantage of the situation. But they were poorly organised and led. Above all they had been conditioned to believe in German invincibility. And initially they were confused about Allied and German intentions. Although they would have been aware that since 25 July the Germans had been reinforcing their numbers around Rome, in effect positioning for occupation, they misjudged German reactions, assuming that Kesselring would rapidly take his forces to the north. At 8 p.m. on the evening of the 8th, while the German High Command also dithered – out of concern that the Germans did not have sufficient force nearby to act – Hitler took the bold decision to occupy the parts of Italy not controlled by the Allied forces (and to take the King and Badoglio's government).

In practice the Germans needed to make little movement. Six Italian divisions were available for the defence of Rome on behalf of the King. Had they moved immediately they might well have secured the city. But, under new orders from Ambrosio (just after midnight) to respond to German attack but not to provoke it, they stayed put. Kesselring too had hesitated, thinking that an Allied attack was inevitable – reinforced in this judgement by news from Dollmann, coming straight from the Embassy, that General Maxwell Taylor, Allied paratrooper commander, had been in town two days earlier.[21] By the small hours of the morning of 9 September Kesselring could detect no sign of imminent Allied action, and units of the German army duly began to advance on Rome, in a sense anticipating receipt of Hitler's order. The forces immediately available to Kesselring were on paper weaker than the Italians and the Germans expected the Allies to act swiftly to take Rome, so they started with caution, focusing initially on command posts and airfields outside the city. Indeed, had the Allies staged that landing which had been planned between Sabaudia and Civitavecchia, it could have been decisive. What the Germans and Italians in Rome all failed to see was that Kesselring knew he had to hold Rome in order to be able to withdraw his forces safely from the south to stronger positions in the Apennines.

At 4 a.m. on 9 September, learning from Roatta that the 15th German tank division was making for Rome, the Italian commander-in-chief, Ambrosio, realised that the Germans were not withdrawing to the north and suspected they were intending to encircle Rome, King, government and all. He acted decisively in this one instance, giving an order which sealed Rome's fate. All units were to concentrate east of Tivoli, the only safe route out of Rome, towards Pescara on the Adriatic. The King

Badoglio and others in the government and High Command only just slipped through the closing noose at 5 a.m., making for Tivoli and Pescara. There they took ship to Brindisi and linked up with the Allies, who the same day had launched their main landing at Salerno. At 5.15 a.m. Roatta translated Ambrosio's order into the abandonment of Rome, the disbandment of the Italian High Command and concentration on Tivoli. The High Command followed the King and government to safety. They left the six divisions under the command of General Carboni, commander of the motorised corps. The order, issued under pressure to ensure the King's safe escape, was not thought through: it resulted in the demobilisation of Italian forces in all of Italy and the Balkans, and, incidentally, the loss for Rahn of his one senior military source, Roatta. Carboni, in due course, also decided to follow the King and the High Command to the south.

Even without overall command the remaining Italian forces, primarily the *Granatieri di Sardegna*, helped by some civilians, did manage to put up some resistance. When the German force sent to capture Roatta reached and took his HQ, he was well on the road to Pescara. By then Kesselring's HQ at Frascati knew of the Allied landing at Salerno and decided it was safe to move on Rome. Italian resistance on the 9th and 10th was strongest in the south of the city and suburbs, peaking on the 10th around the Porta San Paolo, near the Pyramid of Cestius. It was not militarily significant: the anti-fascist leadership was ineffective and had no weapons. But it laid an important foundation to the resistance which developed to the German occupation, seen at the outset only in Rome and Piombino (on the Tuscan coast, the port for Elba).

By the evening of the 9th Kesselring (through Westphal, his Chief of Staff) succeeded in opening negotiations with one of the Italian divisional commanders, Calvi di Bergolo (the King's son-in-law, married to Princess Iolanda of Savoy), through his Chief of Staff, Giaccone. The Germans offered to disarm and send home the Italian soldiers in the city. While the Italians tried to keep alive the idea of Rome as an open city, with an Italian division to keep order, Kesselring insisted a) that German troops occupy the German Embassy, the telephone exchange and radio station, and b) that Italian commanders in the city report daily to him personally. Giaccone failed to convince Calvi, but Carboni intervened to send him back to Frascati to accept Kesselring's terms, provided they applied to the whole Italian corps, while secretly planning to double-cross the Germans and continue resistance. Giaccone reached Westphal by nightfall.

Meanwhile Marshal of Italy Caviglia (the hero of the Battle of Vittorio Veneto in 1918, Marshal of Italy and life Senator, who never compromised with Fascism) thought it his duty to emerge from retirement to fill the vacuum left by the departure of the King, government and High Command. He announced that he had taken over what was left of the government in Rome; he encouraged Romans to stay calm and tried on the same day to open his own direct channel to Kesselring, the Embassy having closed. At the same time (about 10 a.m. on 10 September) Giaccone was hearing new, tougher terms from Kesselring, reflecting the continued resistance around Porta San Paolo: complete capitulation by 5 p.m. or Rome would be bombed. Carboni might have accepted the new conditions but for the fact that he had just secretly ordered two of his divisions to attack German units and he could not accept responsibility for their capitulation. His action was also encouraging the Communist-led resistance and stirring the populace (by then confused and fed up) into further action. Caviglia saw the futility and danger of such a course. Both he and Carboni turned on Calvi, who had started the negotiations, and told him to sign; he in turn got Giaccone to go and do it. The unfortunate emissary/signatory reached Kesselring's HQ with half an hour to spare. The two-day battle for Rome was over. The German occupation of Rome had begun. Some wag said it was their last victory in the Second World War. The German forces were quick to secure the Villa Wolkonsky (Fig. 11.7).

Fig. 11.7. *German forces in charge at the Villa Wolkonsky, with a PAK10 anti-tank weapon in the pedestrian gateway. Italian soldiers loyal to Germany stand outside.*

Giaccone had in practice secured German agreement to Rome becoming an open city, at least as long as the situation allowed. Calvi di Bergolo became the Italian commander with a division under command to maintain public order, albeit under Kesselring's orders and with a German co-commander. He appointed two deputies, Giaccone for military matters and for civilian issues Colonel Giuseppe Cordero Lanza di Montezemolo, a staff officer who later became a leading figure in the resistance. This outcome resulted from the Germans temporary feeling of weakness and uncertainty: they still expected an early Allied landing making the occupation likely to be short-lived. That feeling did not last, and the Germans quickly reneged on the deal. Because they were able to resist the Allies' advance in the south, they (and the Italian resistance) realised that the occupation would last longer than expected.

On 11 September, less than 24 hours after Giaccone signed the deal Kesselring, with help from Kappler and Dollmann, temporarily based at his HQ, had limited Calvi's room for manoeuvre, even as he assumed his new role. Kesselring's order declared that, as Rome was a war zone, military law applied; crimes against German forces would be dealt with under that law, as would strikes – which were illegal (to prevent interference with German exploitation of Italian productive capacity in support of its war effort). Strike leaders, saboteurs and snipers would be subject to summary justice. Italian law and order authorities would be answerable to Kesselring and must prevent actions against German forces. On the positive side the Germans would see to public calm and food supplies, workers who volunteered to work for the Germans would be paid under German rules and administrative and judicial authorities would continue to function. Rail, ports and communications would continue to function but no private correspondence would be permitted and telephone calls would be strictly monitored.

After an absence of three and a half days, Rahn and his party landed at Ciampino airport on the evening of 12 September, to be greeted by the news that Mussolini had been rescued by Skorzeny' daring operation and was on his way to meet the Führer in Germany. But, returning to the Embassy, they found a shambles.[22] It had become a military camp. The newly appointed City Commandant, Luftwaffe Major General Rainer Stahel, a recipient of the Iron Cross with Oak Leaves and Kesselring's personal choice for the job, had set up his HQ there, and had taken in the SS, parachute units and stray members of the German community as well as some senior Fascist personalities, released from their early German capture following the rescue of Mussolini but in need of shelter from the mob. But no one was in charge. Offices and rooms in the main Villa had been taken over as rooms for 'refugees'; four dead German soldiers were laid out in one of the greenhouses. There was no food and water. Chaos reigned.

First Rahn had to see Stahel (Fig. 11.8), assert his responsibility for the Embassy and educate him on the realities of Rome, which was supposed to be a virtually open city, not least because of the presence of the Pope. But the meeting went badly, and Stahel refused to leave. A second front opened up: the German consul-general from Naples, Wüster, had set himself up in Rahn's office and claimed to have been appointed to be in charge by Kesselring (who had not expected Rahn to return). In doing so he had pushed to one side the long-serving – and 'irreplaceable' – counsellor/consul, Reisinger, who had been left in charge by Rahn as he lived in Rome.[23] Rahn had to get Ribbentrop to intervene and order Wüster home to Germany.

Dollmann and the 'police attachés', i.e. Kappler and his staff, who had driven to Kesselring's HQ in Frascati on the 8th, had returned on the 11th and presented themselves to Stahel at the Villa. Resting on their success in establishing where Mussolini was being held (and the operation to rescue him having thus been launched), they described their tasks as arresting hostile, especially Jewish elements. Their priority was to set up their

Fig. 11.8. General Rainer Stahel, Stadtkommandant of Rome September–November 1943.

offices in via Tasso. When Moellhausen returned with Rahn, Kappler seemed to have reclaimed his office at the Villa (or perhaps, like a good policeman he had carefully locked it before leaving). They were to find themselves involved over the next few weeks in much activity together, in spite of their quite different backgrounds, attitudes and aims.

The senior Fascists (gerarchi) who had been brought to the Embassy, fearing for their safety if they dispersed to their homes, were all ragged and unkempt. Kesselring had agreed to give them shelter in Frascati, but many of them did not want to go. Then on the evening of 13 September came a fortuitous (and false) report that two Italian columns were converging on the Villa Wolkonsky. Moellhausen recorded that he got the 'gerarchi' together in the main reception room (Grande Salone) and offered them the choice of being given a gun to help defend the Embassy or accept Kesselring's offer. To a man they agreed to go. But Stahel and the Wehrmacht stayed put. The Villa Wolkonsky was no longer an embassy.

Notes

[1] The events described in this chapter are recounted in many works. I have drawn on official files (as indicated) on memoirs (e.g. Moellhausen, La Carta Perdente) and have had the advantage of being able to check the personal accounts against detailed, unpublished research in 1998 (?) by a German scholar (unnamed for formal reasons), thanks to the director of the Deutsch-Historische Institut in Rome, Lutz Klinkhammer, whose own work I was also able to consult.

2 For details of the Embassy's 'routine work' see AA file R901/68623.

3 Plehwe, pp. 21–3.

4 These paragraphs draw on AA file Mackensen Nachlass, band 7, fol. 49.

5 The battle was a major defeat for the Italian army under Cadorna in the Great War. It took place from 24 October to 19 November 1917, near the town of Kobarid, now in north-western Slovenia, then part of Austria. Austro-Hungarian forces, reinforced by German units, were able to break the Italian front line and rout the Italian forces. The battle demonstrated the effectiveness of the use of stormtroopers and the infiltration tactics. The use of poison gas by the Germans also played a key role.

6 Dollmann (2), read as an e-book without page numbers.

7 Dollmann later reported that in 1945 Mussolini had explained to him at Lake Garda that, 'confronted by so much human cowardice, I was too tired'.

8 Dollmann (2).

9 Goebbels, pp. 328–9, 332.

10 Goebbels (p. 329), claiming that Guariglia was known in Berlin, guessed that he had been conducting the Italians' negotiations with the Allies.

11 This may, in the light of subsequent research, have been less than truthful, as there is evidence that the King himself finally decided that Mussolini must go, after dithering for months and paralysing the ability of those working for Mussolini's removal to execute a clear plan. But the King may not have finally made up his mind until the morning of the 25th, in the light of the outcome of the Fascist Grand Council on the 24th. (This probability is highlighted in the PhD thesis referred to at note 1.)

12 Goebbels' Diary quotes Hitler more than once as being certain from the outset that the King and Badoglio intended to 'betray Germany a second time [i.e. as in the First World War] and conclude a separate peace', e.g. p. 325.

13 Moellhausen – who had not yet been selected for Rome let alone arrived – stated that Mackensen's recall was ordered on 29 July, but that may at that stage have been no more than a summons to a meeting on 6 August with Ribbentrop. Moellhausen speculated that Hitler did not want to punish Mackensen beyond retiring him, given his previous loyal service.

14 The date of 6 August appears as Mackensen's departure date from Rome in the AA's published biographies of former diplomats.

15 The references in these four paragraphs are from AA file R901/68623.

16 Burgwyn, Chapter 2.

17 According to Dollmann (2), Frau Mackensen was still at the Villa, having been left to pack up when her husband was summarily removed: she flew back to Germany after a farewell party on 2 September.

18 This was the plan to take Rome and to capture the King, etc., modified to the occupation of Rome once the King had escaped. But Kappler also kept Rahn in the dark about the plan for Skorzeny to rescue Mussolini, which was by then activated, though the Germans were still not sure where he was being held. The two plans were also connected in that Skorzeny, who was developing a reputation for taking out recalcitrant heads of state/government for Hitler, had only just been diverted from that plan to the task of rescuing Mussolini.

19 Official German records did not specify how he left Rome, but correctly stated that he left in order to transfer the embassy to Fasano on Lake Garda, near to the German main headquarters (and as it turned out, near to where Mussolini was to set up his new government).

20 But the Italians were not forgotten. There is touching evidence of the efforts made by former embassy staff – some back in Berlin and others in Fasano at the new office of the 'Reich Plenipotentiary' to Mussolini's Salò Republic – to find and pay eight remaining locally engaged Italian staff, initially through the mission to the Holy See, then after June 1944 through the Swiss protecting power.

21 Katz, p. 31.

22 This account draws on Moellhausen, pp. 70–75, and Dollmann (1) and (2).

23 Today we would describe him as locally engaged.

12.
THE GERMAN OCCUPATION'S MUDDLED START

For some days after 9 September there was no government in Italy: the Wehrmacht was effectively in sole control of the parts not already liberated by the Allies. Quite soon other appointments were made, powers were allocated, and the result was a high degree of confusion. Initially the principal actors within the German lines of command were few. Strictly speaking many of them (and their activities) are of no direct interest to this chronicle of the Villa Wolkonsky. But the place acquired, and retained after the nine months of the occupation, a reputation as a place of villainy, repression and brutality, in sad contrast to the days when travellers and tourists sought out the peace and beauty of its gardens. So this part of the story has to take that malign reputation as the starting point and offer a brief account of what those principally responsible for the occupation in Rome, as opposed to fighting at the front, were doing, both in the Villa and elsewhere. The local population unsurprisingly did not make such distinctions.

The persistence of this 'bad smell' must owe something to the mystery that always surrounded this hidden spot in the heart of the city: it was practically invisible from the surrounding streets (and is even more so now that trees have grown up to a greater height around it). Most residents of Rome would not have known what was going on behind the Villa's sheer walls and gates even before the war. After 8 September 1943 it was quite naturally assumed to be an important element in the oppressive command structure of the occupation. The guards and swastika banners at the gates proclaimed no less. The base-line has to be that the former embassy was one of the places where the leading German figures could work and meet in secure conditions to deal with the challenges they faced as occupiers in what soon became all too obviously a losing military position with an increasingly hostile population. Whether or not it was where real physical and/or mental harm was inflicted on Italians, or whether those responsible for such harm operated from the Villa, are essentially subsidiary in the overall picture of the occupation. But the strength and durability of the commonly held myths give it some importance for a proper telling of the Villa's story.

The general unpleasantness of the nine-month German occupation of Rome, i.e. the background with which the Villa is associated, can be most easily summarised by looking at narratives of the most notable events and excesses, though with the caveat that the strands were often running in parallel or intertwined. These were:

1) The immediate takeover of the Embassy as his HQ on 9 September (in the absence of the recently evacuated embassy staff) by General Rainer Stahel, commanding the German garrison and the access he gave to the relative safety of the estate for some army units and German and Italian civilians needing refuge from what seemed likely to be an imminent Allied attack on the city. The HQ remained there until 15 November.

2) The alleged (very brief) internment in the grounds of the Embassy of some 320 young civilians rounded up as they protested against the German occupation forces on 10 September.

c) The operation led by Otto Skorzeny which resulted in the dramatic escape of Mussolini from the Campo Imperatore on 12 September.
d) The establishment of a skeletal governing structure for the occupied parts of Italy and in particular for Rome in the immediate aftermath of the armistice.
e) The removal of the Foreign Ministry's archives on 26 September and the removal from the Bank of Italy of the state's gold reserves possibly between 5 and 16 October.
f) The rounding-up for deportation of Jews in Rome on and after 16 October and the prior extortion from them of 50 kg of gold.
g) The reprisals at the Ardeatine Caves on 24 March 1944 for the killing in a resistance bomb attack of 33 German policemen on 23 March in via Rasella.
h) The Germans' measures to uncover and counter the resistance to the occupation.
i) The Germans' efforts to secure forced labour for use in Italy and elsewhere to support their war effort.

The top German officials involved in the occupation of Rome and therefore, at least by association, with the Villa's story, were:

- Rudolf Rahn ('ambassador', mainly to Mussolini's Salò Republic),
- Eugen Dollmann (Himmler's man in Rome for liaison with the Vatican and with Kesselring; translator/interpreter for everyone),
- Herbert Kappler (head of the German Security Police in Rome);
- Eitel Moellhausen (although relatively junior, consul and head of the Rome office after the 'Embassy' moved to north Italy – of extra importance to this narrative because he lived at the Villa throughout all but the first days of the occupation);

and among the senior military officers

- Field Marshal Albert Kesselring (Commanding all German and Italian forces in the south of Italy)
- Lt. Gen. Karl Wolff (Commander of all SS forces and police in occupied Italy), and
- Generals Stahel and Mälzer, successive commanders of the Rome city garrison (Stadtkommandant)

By following their activities in 1943–5 and their fate after the war, a picture of the occupation – if only partial – can be built up. All except Wolff and Kesselring could well have been in and out of the Villa Wolkonsky frequently during the months of the occupation. Only Moellhausen was permanently based there.[1]

Early confusion and abuse of diplomatic privilege

Most of the events listed would eventually have had a bearing on the decision of the post-liberation Italian government to confiscate the Villa from the Germans on the grounds that it had been used for purposes outwith the scope of the Vienna Convention on Diplomatic Relations. The lawyers in the AA back in Berlin did indeed quickly foresee something of the sort occurring, though related more to the presence of the army at the Embassy – as opposed to the 'civilian' occupation personnel; and they so briefed Rahn and Moellhausen, who had in any case tried to persuade the army to move out from

the very first. In the vacuum created by the sudden departure of Rahn and his embassy staff in the early hours of 9 September the military rode roughshod over the remaining (mainly locally engaged) embassy staff, secured the property (as they would have been bound to do) and gave shelter within it (including in the Residence) to assorted civilians, both German and Italian, as narrated in Chapter 11. Moellhausen recorded that he returned on 12 September to find his room occupied by a mother and her baby.

Moellhausen, however, quickly came to like and respect the commander of the garrison, Stahel, whose approach to his task he found disciplined but relatively humane. He even found some advantage in having him on the spot. Stahel impressed Moellhausen particularly when, once the system of Italian Commissioners for Rome, set up initially by Rahn, was set aside after the first few weeks, the *Stadtkommandant* (along with Kappler), was effectively left unchecked to deal with recruitment of labour and law and order issues in the city. Stahel accepted the benefits of a pseudo-open city regime – with German forces on duty and off duty largely kept out – and cooperated in its management, with Moellhausen's encouragement. The benefits were tangible: a degree of law and order allowing Kesselring to use the Rome rail hub as his strategic line of supply and movement without fear of Allied attack, while sparing the Wehrmacht the need to devote manpower to policing duties. Stahel had a role in everything important and could see the 'big picture' in a way which eluded his successor, Mälzer.

The need for a sensitive touch, given the nervousness of the German military as they tackled unfamiliar law and order problems, was illustrated by an incident at the Villa Wolkonsky on the night of 17/18 September. The Villa was then not only Stahel's HQ but also possibly still used by the 'police attachés', i.e. the Gestapo officers – even as they were setting up their own HQ in via Tasso. Shots were reported being fired from neighbouring properties at the Villa and the paratroopers guarding it. The soldiers fired back at the building from which the shots were thought to have come and sent a couple of armoured cars to the block, which they were able to pinpoint for Kappler. The latter had all the civilians removed from the block, but the shooting continued. Some witnesses said that the incident had been sparked by some motorcycle backfiring, others said the shooting was largely the work of the paratroopers themselves, panicking. (They apparently fired 1,800 rounds and threw 25 grenades in the two hours the incident lasted, though some of the grenades were reported as having been thrown at the German armoured vehicles.) The incident, real or not, provoked a strong warning from Kesselring about attacks on Germans, published in Il Messaggero on 21 September.

By the time Stahel was removed from his post in late October by the High Command, Moellhausen, by prior arrangement with the AA lawyers, had formally requested an instruction from Berlin to get the military personnel occupying the chancery building (the old *casino*) off the premises. On 29 October Schroeder at the AA duly sent a telegram on behalf of his boss, Schwager, to instruct Moellhausen to evict the military, as their presence removed the property's 'diplomatic character, with incalculable consequences' – foresight indeed. AA files show that one AA lawyer, Junker, warned that the military presence also called in question the mandate of 'Minister' Rudolf Rahn, formally in charge and still arguably benefiting from diplomatic status (in the Salò Republic). It was deemed particularly damaging that, at some of the embassy buildings (mainly the former chancery, it appears) visitors were subject to military security checks.[2]

Stahel's successor, Luftwaffe Major General Kurt Mälzer, made the next move on his arrival by simply setting up his HQ in downtown hotels, the Excelsior and the Flora, and his staff soon followed his example and left.[3] But the damage was done, and the Italian Foreign Ministry (by then of course no longer dealing with an ally) had carefully noted what had transpired. Mälzer's approach to his task

was the opposite of Stahel's 'softly-softly' style, and he showed little disposition to work with the Embassy. He persuaded Kesselring that it was safe to open the city up to the German troops, who under Stahel had not been allowed to roam the streets in search of entertainment. Their inevitable off-duty ill-discipline caused an increasingly serious security problem. Fights between drunken soldiers frequently got out of hand. Soldiers carried out robberies in broad daylight, gangs of them stole cars (on one occasion General Wolff's car). The disturbances even spread to the grounds of the Villa Wolkonsky: one night in March 1944 Moellhausen was wakened by shots at the swimming pool, where two young officers on Mälzer's staff had forced an entrance and fired a volley of pistol shots to rouse the two embassy secretaries billeted in the two changing rooms.

Such incidents produced clashes with and complaints from Italians, which Kesselring had sought to avoid, as he needed a secure city to the rear of his troops. The change in atmosphere also gave the resistance greater opportunities and made Kappler's task harder and his responses harsher. Eventually Kesselring changed his mind and ordered Mälzer to revert to the disciplined regime of Stahel's tenure of the command. That briefly relieved some of the tension. But Mälzer also enthusiastically used his troops to mount random round-ups of men for forced labour, so much so that the Embassy needed to get Kesselring to intervene to stop that practice too, which was dangerously raising the level of resentment in the city. But, as the months passed the residual influence of Moellhausen and embassy staff waned, as the Allies gradually came closer, the security situation in the city worsened, and Kappler became the key non-military figure in the occupation. Moellhausen however remained watchful and aware observer; his account, even though doubtless in some respects self-serving, does offer some impressions of what he and colleagues were doing at the Villa during the remainder of the occupation.

The alleged round-up at Villa Wolkonsky of 320 young protestors on 10 September 1943

In the confused first days of the occupation the German forces were dealing with resistance from the remaining Italian forces and groups of citizens, and the latter continued even after the Italian forces had been disarmed. The Germans were not organised or prepared for the occupation of the city, things were initially chaotic, and it was hard for anyone to know what was happening.

In such circumstances it was easy for fact and fiction to mix into a cocktail of myths, which, once they have taken root are hard to expunge. A tendentious and self-serving account of those first days (and indeed of the rest of the occupation) is contained in a book by Franco Napoli, who styled himself as a leader of the resistance.[4] According to this uncorroborated account, published 50 years later, Napoli was arrested on the street on 10 September among 320 Romans who had come out in protest against the German occupation of the city. He claimed that he and a small group of friends had set out to break into the German Embassy but found it already heavily guarded; they tried to run away but were caught and taken to the grounds of the Villa Wolkonsky, where they were held with some 300 Italian servicemen who had been rounded up and taken to the tennis court for several hours, then he witnessed fatal shootings by German guards, first when three of the detainees (all *carabinieri*) refused an order to dig (graves? latrines?) in the woodland, and then, subsequently, after 'Moellhausen' had told the remainder that they would die, when some others panicked and tried to escape and those corralled on the tennis court then 'demonstrated'. Napoli and his remaining friends were however saved from what they assumed would be execution when, after the surrender of the Italian forces

he late afternoon, 'Moellhausen', accompanied by an Italian officer, announced that they would all be released. Napoli asserted that some, including himself, were re-arrested as they left the Villa and taken by truck to Kesselring's HQ in Frascati for further interrogation.

In spite of the title of the book the Villa Wolkonsky hardly features in the rest of Napoli's tale, except that a) he claimed that, when re-arrested in April 1944, he was taken there for interview by Moellhausen (whom he saw as one of the villains) and Kappler; and b) years later, in 1988, in search of proof for his allegations, he was allowed to visit the Villa and, under the supervision of a British diplomat, saw – and photographed – much activity by gardeners, which he interpreted as covering up 'thousands of graves'.

Napoli's book contains no evidence to support his claims that either Moellhausen or, for that matter, Kappler was personally involved on either occasion: their names were well known during and after the occupation and could easily have been inserted in the story to add credibility. What is more, on 10 September Moellhausen (assuming his own account was true) was in the diplomatic train on the way to Verona, from which he only returned, with Rahn, on the evening of the 12th. There were no reports of any such incident in official documents from the time, nor were there any reports of bodies being found buried at the Villa either by the Special Forces who first entered and searched it in June 1944 or subsequently. Nonetheless the bare outline of the story is not wholly incredible: the round-up and temporary holding of a few young would-be partisans and some captured Italian soldiers could have taken place on that day of general confusion. The Germans involved could well have considered such an incident too unimportant to record. Given the threat Kesselring believed he faced from an imminent Allied landing on the coast near Rome, the guards assigned for the security of the Embassy in those first days might well have been from low-grade units made up of inexperienced Italian soldiers of German origin from the South Tyrol, loyal to Germany but with no training for guarding 300 scared young Italians; they could have felt under attack and outnumbered and fired their weapons in near-panic. The stories of shootings could have been embellishment in order to stoke up resistance to the occupation. Given the numbers of men allegedly rounded up and held, news (embellished or otherwise) of such an incident in the first days of the occupation would have quickly spread, encouraging both fear and bravado. Such a tale could also all too easily have led to the early identification of the Villa with the activities of the 'Gestapo' enforcing the occupation, which would have been hard to eradicate. The *Sicherheitsdienst*, or SD, often labelled 'Gestapo', actually took over that same day premises half a mile away in via Tasso – previously the Embassy's cultural office, now the site of the Museum of the Liberation, so it is even possible that Kappler might have been on hand, supervising the move and able to intervene, even if Moellhausen was not there. Indeed, Napoli may have confused Moellhausen and Kappler: he also attributes to Moellhausen the theft of the Bank of Italy's gold reserves, an operation which Kappler told his Allied interrogators he had carried out on the day Napoli specified – see below. All that said, at the end of the day we have only Napoli's word for it.

In search of further conspiracy Napoli claimed that Moellhausen, like SS General Karl Wolff and Adolf Rahn (whose name he spells 'Rahm'), was not a true diplomat: they had been sent to Rome 'by Hitler' in August 1943, and they, not the normal senior staff of the Embassy were with Badoglio and the King in the first week in September. As we have seen, this account has elements of truth: though both Moellhausen and Rahn were diplomats from the Foreign Ministry, Mackensen had left, and so had Bismarck as Rahn arrived – the newcomers were indeed not 'the normal diplomats'. Wolff had not yet arrived in Rome, but Rahn was there in the first week of September, if not on the 9th. All told, Napoli does not make a good witness, but it would not be safe to dismiss his story

entirely. And, true or not, its publication undoubtedly kept alive the long-lasting and widespread belief in the malign character of those at work behind the Villa's walls.

The rescue of Mussolini

Even before the armistice and subsequent occupation, Kappler, the senior 'police attaché' in the Embassy had, with Dollmann, received orders under strict secrecy in late July from General Student (who commanded the German Parachute Force) to establish and track the whereabouts of the newly dismissed Mussolini. At his interrogation after his surrender on 9 May 1945, Kappler claimed he had been due to return to Berlin in the summer of 1943, but the fall of Mussolini had 'made him invaluable' and caused his superiors to keep him in Rome, a decision he learned of at a personal interview with Hitler himself on 3 August.[5] At that stage Hitler's plan was to arrange the kidnap of the King and Badoglio by Otto Skorzeny and his commando unit – which came under General Student's airborne and special forces command – and their replacement by Fascist 'loyalists'. Kesselring opposed this and Hitler, once Mussolini had been found to be alive and his whereabouts known, eventually adopted an alternative plan, using Skorzeny to rescue Mussolini.

Kappler traced Mussolini to La Maddalena off Sardinia, but he was moved before Skorzeny could act. A source of Kappler's in the Italian Interior Ministry provided the crucial intelligence that Mussolini had been transferred to the Campo Imperatore resort hotel high on the Gran Sasso in central Italy, north of Rome.[6] Skorzeny's own account of the escapade suggests that he prepared for it mainly at an airfield which remained in German hands and Kesselring's HQ in Frascati.[7] It possible that at that period Kappler was still using his office at the Embassy, but as he and his team had gone on 9 September to Frascati it is also possible that he was working from there, especially as Skorzeny prepared for his mission there. He was back in Rome when Rahn and his reduced team returned from Verona on the evening of the 12th, the day of the successful rescue: Moellhausen records that the two agreed that day that Kappler would not carry out any of his police duties from the Embassy. Kappler undoubtedly contributed to the rescue operation, the success of which was all the more remarkable because of the general chaos around the departure of the King and Italian High Command as well as many Italian units, to say nothing of the fighting over Rome itself. The kudos he earned for his selection 'by Hitler' and his success in tracking Mussolini at the crucial moment may have given him a degree of status in relation to senior officers such as Harster (his immediate boss in Verona, under Wolff) and even Kesselring, who were always conscious of the need to watch their backs in case the likes of Kappler reported negatively about them.

Rahn in Rome and the north

When the occupation began the Embassy remained formally under the control of Rudolf Rahn, described as the head of the Rome office of the German *Reichsbevollmächtigter* (Plenipotentiary, though sometimes still referred to as 'ambassador'. That ambiguity was understandable: his status had been unclear since his arrival on 30 August and became more so after 8 September. Although he called on Badoglio on 3 September and on the King on 8 September, he had no formal letter of credence as ambassador to present. The timing of Rahn's arrival and his role in the occupation have led to his being seen as something other than a diplomat. In fact his c.v. was indeed that

member of the German diplomatic service, though his posts and work had been anything but normal.

Rahn was born in Ulm in 1900, the son of a lawyer. He studied political sciences and sociology at Tübingen, Berlin and Heidelberg universities, graduated with a DPhil at Heidelberg in 1923, then studied abroad, entering the AA Law department in 1928. He served twice in Ankara (1931–4 and briefly on an economic delegation in 1936) with time in between in the department of the ministry handling relations with the UK and USA. On 1 June 1933 he had joined the NSDAP, rather more promptly than many of his colleagues. In 1936 he was seconded to the Office of Power and Raw Materials before setting up a new counterpart department in the AA. He was posted for just over a year to Lisbon (1938–9) before returning for a year leading the Information and Planning offices of the AA, which ran the international propaganda work of the ministry. From there he was posted to a key role in the office of the AA's plenipotentiary to the military commander in France from August 1940 to November 1942, in charge of Press, Propaganda and Radio. It seems entirely possible that his work here brought him in contact with Wolff, then Himmler's Chief of Staff; and, as the official who in June 1942 took to the French prime minister, Laval, the requirement that 50,000 Jews be despatched to Auschwitz, he would have been well aware of measures against the Jewish population. (This action was cited against Ribbentrop at Nuremberg and led to Ernst von Weizsäcker, then still State Secretary at the AA, being found guilty of war crimes.) Rahn spent the summer of 1941 away on special mission in Syria and Iraq, buying French weapons for the Iraqi forces.

From November 1942 to May 1943 Rahn was seconded as the AA's representative in the office of the commander of the Afrika Korps in Tunis, where Kesselring commanded. Here he became involved again with Nazi policy towards the Jews. A special unit (*Einsatzkommando*) arrived in Tunis to carry out executions and deportations. After a couple of weeks Rahn, the unit commander and the city garrison commander met and decided instead to use Jews as labour to build fortifications – an initiative which did end the mass executions but nonetheless led to the death of some 2,500 Jews in labour camps in a mere six months. Rahn also reported to Berlin on the successful extortion from the Jewish community of some 50m Francs to pay for damage inflicted by Allied bombing, which he later claimed was distributed to poor Muslims who had lost houses. In his memoir, Rahn later claimed to have saved the Jews of Tunis.

For his service in that warzone Rahn was awarded a Knight's Cross – personally bestowed by Hitler on 26 July 1943 (Fig. 11.3). According to Moellhausen he was back at GHQ on 6 August to be told of his move to Rome. At that meeting Hitler also made clear his own conviction that the King and Badoglio intended to make a separate peace with the Allies – a point which the German political and military representatives in Italy had failed to grasp.

The official AA biographical directory shows Rahn as head of the German Embassy in Rome from 9 August to 9 September 1943. On 10 September Hitler issued an order assigning to Rahn (who was then in the train taking embassy staff north from Rome) the civil power in occupied Italy.

On his return to Rome on 12 September Rahn had seen the need to do something about the absence of any Italian government structure in the occupied area. He invited the various ministries to appoint Commissioners, whom he would have confirmed in office by Calvi di Bergolo, the Italian commander of 'Rome Open City'.[8] Each Commissioner had a German liaison official, but it was their duty to ensure that administration continued under Rahn's general 'protection'. Key departments were Foreign Affairs, Agriculture, Transport and Interior. At Interior Dollmann was initially appointed Commissioner, but he quickly had himself replaced by Police Colonel Hartmann. This system, which worked adequately during its brief existence, was not cleared with Berlin: Hitler was interested in the

establishment of Mussolini with a new neo-Fascist government and took little interest in provisional administrative arrangements. Perhaps also there was a sense that Rahn was a man who knew what he was doing.

Rahn succeeded in getting Calvi to disarm the Italian units remaining in the city, but Calvi then refused an order from Kesselring to provide hostages for attacks on German forces. Dollmann and Kappler had been warning that Calvi was not to be trusted and that units under his command in the Piave Division were plotting an attack to take back control of Rome. Hitler decided to have Calvi and his family brought to Germany. So on the day of the installation of the new Italian Social Republic (RSI) government (a useful pretext) Stahel, with Harster from Verona overseeing, took care of Calvi and the Piave Division, Kappler arrested two police chiefs who were not trusted and took over the Interior Ministry, and Rahn put the Commissioners in the picture. Giaccone escaped to the south and Montezemolo went underground. Two weeks into the occupation the Germans' planning left something to be desired.

Kappler related to his captors on 14 January 1946 that at the beginning of the occupation Rahn had asked him to fetch the Italian Foreign Ministry archives, which he did during 12–14 September 1943; they had 'probably been sent to Berlin a few days later'.[9] Another not dissimilar problem which faced Rahn was dealing with the order from Berlin (Himmler to Kappler) that the Italian Central Bank's reserves of gold and hard currency should be removed and sent to Germany. Kappler himself told his interrogators that, <u>on Rahn's orders</u> he had, on 16 October with an armed SS detachment, removed the Bank of Italy's reserves. It had emerged that the reserves stored there were greater than the sum the Italians had declared: L.2bn in gold and L.1bn in hard currency, all of which was transferred to Milan.[10] What Kappler did not say (but Moellhausen did record, possibly to scotch any rumours that he himself had been involved) was that as soon as the presence of the gold was known representatives of Goering, Funk (Economic Affairs) and Himmler hastened to try to take possession of it. Evidently Kappler won the race on Himmler's behalf. Rahn however successfully argued that the reserves should go to Mussolini so that he should not be a drain on German resources. He overcame a counterargument from Berlin that the Italians had cheated by under-declaring by threatening to resign if such immoral behaviour were countenanced. So the reserves were indeed sent to Milan on Rahn's instructions, but perhaps not quite in the way Kappler had intended his captors to believe. Whether it was temporarily stored at the Embassy en route – as some reports alleged[11] – not recorded but is unlikely as it must have weighed several tons.

Rahn's moral success was short-lived. On 'about November 5, 1943' he was instructed to dispatch the gold from Milan to Franzensfeste Fortress in the South Tyrol (a region which had been annexed directly into the Reich and did not form part of Mussolini's Salò Republic). Appropriate safeguards were to be employed. The gold could stay under Italian guards, aided by carefully selected Gestapo agents and men from the German Foreign Office. Rahn was further instructed to inform Mussolini in an 'amicable way' that these steps had been taken.[12]

Following Mussolini's rescue on 12 September and his arrival the next day at the *Wolfsschanze* Hitler, though depressed by Mussolini's lack of vision and energy, moved swiftly to establish an 'independent republic', the Repubblica Sociale Italiana (RSI) under Mussolini's leadership with its 'capital' in Salò, northern Italy. Mussolini was required to announce its establishment in a radio broadcast from Munich on 18 September.[13] Rahn was appointed plenipotentiary to it from September 1943 (and remained so until May 1945). In that role he presided in the Villa Wolkonsky 23 September 1943 over the process of putting together the new RSI government team under Pavolini, Mussolini not being present. Finding candidates for Foreign Affairs and Defence was sticky. After

failing to persuade Ambassador Rosso (the ministry's Secretary-General, nominated at long range by Guariglia) and other senior diplomats to take on Foreign Affairs, Rahn persuaded Pavolini to call Mussolini, still at Hitler's GHQ, and secure his agreement to take the portfolio himself. Defence was more difficult. Graziani initially refused, but he agreed to go to Villa Wolkonsky where the assembled senior Fascists plus Rahn and Wolff persuaded him that he would not be betraying his oath of allegiance. Thus did the Germans present to Mussolini his new government.

As that government was to be based in the north and Rome was in the military area of the front, Rahn initially managed to convince the new ministers not to interfere with the structure of Commissioners and German liaison officers in the city. But the Commissioners themselves were unhappy with their roles and by the end of the month had ensured that their roles be taken over by neo-Fascist undersecretaries. In October Mussolini further downgraded them to 'secretary-general' rank under the relevant ministries in his Salò government. Berlin had continued to take no interest in the issue, and when Rahn sought Ribbentrop's backing he got nowhere. In any case things had moved on and he was by then based mainly in the north.

The status of Rahn's new 'embassy' – based in northern Italy – was also formalised at that initial meeting in the Villa on 23 September of the government of the RSI. The next day he flew north to attend a conference convened by Rommel at his HQ. He emerged from the conference in the evening, tired and perturbed, having found the hero in defeatist mood, blaming Kesselring for all that had gone wrong. He decided to take the wheel of his official car himself and shortly after setting off for the airfield had a collision in the dark with a truck. The accident left him unconscious; he was taken to hospital, though he appeared not to have been badly injured. Instead of returning to Rome he decided to take over his new office in the nineteenth-century Villa Bassetti at Toscolano Maderno, near Fasano on the shore of Lake Garda; which he did on 27 September.[14] In November an RSI embassy was established in Berlin with Filippo Anfuso as ambassador: he presented credentials to Hitler on 13 November. Rahn took on the title of Ambassador to the Italian Social Republic from 15 November. But his presentation of credentials to Mussolini (now of course a head of state – of sorts) in Salò was delayed until the third anniversary of the Tripartite Pact on 11 December. It is no wonder that observers have been confused as to his status during his first three months in post.

Thereafter Rahn was no longer based in the Villa Wolkonsky, but it continued to be his official home base after his move north, and he was an occasional visitor. Clarity of lines of responsibility was not a hallmark of the occupation, and the AA's residual role was similarly hard to understand, whether in the north or in Rome. Details of Rahn's role in managing the tetchy relationship between Berlin and their reluctant protégé in Salò is in any event beyond the scope of this study – though it was certainly complex and sensitive. His own and Moellhausen's memoirs provide useful, atmospheric accounts.[15]

Whatever his formal role(s), Rahn was clearly a figure of some influence. He arrived with a well-established pedigree in the Party, embellished by his recent encounter with Hitler. While Rahn was at last dubbed 'Ambassador' to the Italian Social Republic, in practice he seems to have called the shots in the republic's management, more like a governor. The RSI was little more than a Nazi puppet, used by the Germans to legitimise some of their annexations of territory, to obtain cheap labour and to extort what they regarded as the costs of the occupation. These costs were estimated (by the Germans) at L.7bn on October 1943, L.10bn by December and finally L.17bn. The entire apparatus of the Salò Republic was in practice controlled by the German occupying power (civil and military in often uneasy cooperation), mindful of the 'betrayal' committed by the Italians through the 8 September armistice.

So it was relatively easy for the anti-Fascist parties forming the resistance to puncture the claimed authority of the Fascists. But the anti-Fascists were divided too: some were loyal to the King and Badoglio, but many were of the left and looked to a different future for post-Fascist Italy. These divisions were as stark among the resistance groups in Rome as in the north. The period is often described as an Italian civil war, not a helpful background to the German attempt to turn back the Allied tide advancing up Italy. When the German 'Embassy' near Fasano was knocked out by two Allied bombs on 5 December 1944 (with neither deaths nor injuries) the Germans suspected that the location had been betrayed by an insider.[16]

After Mussolini was murdered in April 1945 Rahn went to ground but was caught by the Allies in May trying to escape through the Alto Adige. He was held with other German 'diplomats' at Salso maggiore.[17] On 31 October 1945, a report on Rahn was filed which resulted in his being held for further investigations, including at Nuremberg. While in prison for four years, he wrote on Talleyrand supplementing earlier work from the 1920s, and his memoirs. In the preparation of the Wilhelmstrasse Trial (of diplomats who had served the Nazis), Rahn was listed as one of the German diplomats who should be prosecuted. Between 27 May and 4 December 1947 he was interrogated eight times. But while the likes of former State Secretaries Ernst von Weizsäcker (the wartime ambassador to the Vatican) and Steengracht von Moyland (his successor as State Secretary) were convicted, Rahn was classified as de-nazified and exonerated on 7 June 1949, largely because of his claim that through diplomatic channels he had saved about 1,800 supporters of de Gaulle who had been taken prisoner by the Gestapo in North Africa. Rahn died on 7 January 1975 in Düsseldorf, where he had been managing director of the Coca-Cola bottling plant.

Eitel F. Moellhausen

Rahn's appointment of the relatively junior Eitel Moellhausen (Fig. 12.1) as his deputy in Rome effectively in charge at the Villa with the title of Consul, but with only a handful of other German based diplomatic/consular staff, would not have added any clarity to the confused lines of responsibility. But Berlin had not objected to the appointment, in spite of the oddity of having a junior official in charge of 'Germany's most beautiful embassy', where, whatever Rahn's formal position in overall charge, it was he, Moellhausen, who would be dealing with those in charge such as Kesselring, Stahel, Mälzer, Dollmann and Kappler. He recorded after the war feeling understandably exposed and with reason, as will be seen from the following pages. But his experience of working with Rahn and Kesselring in Tunisia gave him the valuable advantage of access to Kesselring, the man who really called the shots.

Moellhausen's reputation was certainly tarred with the same brush as the Villa itself – in Italy at least. One allegation – a further mix of truth, half-truth and invention – is that in the early days of the occupation he used the property to store the Italian gold and other reserves stolen from the Bank of Italy before making off with a large portion of it for himself.[18] By Kappler's own account it had been his task (not Moellhausen's), under orders from Berlin, possibly through Rahn. After the war Moellhausen, far from disappearing to South America like so many in the Nazi hierarchy, seems to have spared no effort to restore his reputation; and he seems to have been largely successful.

Moellhausen was by no means a typical member of the Nazi hierarchy: indeed he refused to join the Party. He was born in Turkey, of a French mother and half-German businessman. In his childhood

he saw little of Germany and grew up mainly in Trieste, learning fluent Italian in the process. Speaking also Greek and French, he entered the Foreign Service as a translator. In that capacity he was taken under Rahn's wing during his mission to Syria. His pragmatic approach there had aroused some suspicion, and he was posted to a lowly position at the GHQ. But when the latter sent him on a mission to Dakar in Senegal with a senior officer, he was diverted to further service with the Foreign Ministry by Rahn whom he saw while passing through Paris. Soon after that they went together to Tunis. Moellhausen thus arrived in

Fig. 12.1. Eitel Friedrich Moellhausen, who remained in charge of the embassy offices at Villa Wolkonsky from September 1943 to May 1944.

Rome without the usual carapace of Nazi dogma and ambition and with an instinctive openness to Rome and the Italians, but also under the protection of Rahn, who was regarded as a Nazi insider. He very soon shot to prominence of the wrong sort in Rome when he and to a degree others more senior tried to mitigate the severity of the action planned against Italian Jews, dictated by secret order from the top of the Nazi hierarchy.

Moellhausen subsequently played a part in many of the events of the occupation of Rome (see the succeeding sections of this chapter), generally – not only by his own account – in an attempt to mitigate the excesses of the military and security authorities who were de facto in charge. As the situation got tougher for the German forces his involvement and influence diminished. He moved from Rome to Fasano in the first week of May 1944, leaving behind Borch and some younger diplomats recently appointed by the AA. He retained responsibility for them and was much concerned for their welfare as the Allies approached. But the Rome team were anxious not to pack up and go in a manner which would have them labelled as defeatists. They only just got out in time on 3 or 4 June, at which time Moellhausen had been summoned to attend on Ribbentrop at Fuschl in Austria to advise on a madcap scheme dreamed up by the Propaganda Ministry.[19] Ribbentrop in fact relayed to Moellhausen duff information that the Allies had entered Rome on 3 June, by way of implying that he had failed to get his team out in time and destroy cyphers and secret papers.

The round-up of the Jews in Rome

In the bitter atmosphere of the early days of the occupation, the decision was taken in Berlin, in spite of Mussolini's known disagreement, to include Italy in the Nazis' decision to extend their policy against the Jews to occupied territories. An instruction was sent on 25 September to Kappler, with a copy to General Reiner Stahel, the Army Commandant in Rome, from Himmler's Reich security HQ in Berlin, 'in agreement with the Foreign Office', requiring that 'all Jews of listed nationalities [with

Italy heading the list] should be included in the deportation measures'. They were to be rounded up and despatched northwards for 'liquidation' on 1 October. Kappler was to execute the order; Stahel was required to assist. Stahel, who had placed his HQ in the Villa Wolkonsky after the diplomats had left on 9 September, sought Moellhausen's help (in Rahn's absence) in deflecting the order. Moellhausen recorded that he immediately consulted Kappler, who also still had an office at the Embassy. Kappler claimed to understand the concerns of Stahel and Moellhausen but said that he could only desist if so ordered by Kesselring, as the local commander.

They saw Kesselring at his temporary HQ outside Frascati that evening. They reminded him that Moellhausen and Rahn had successfully argued when together in Tunisia that the Jews there should be put to work on military fortifications rather than being deported. Moellhausen argued for a similar solution in Rome. Kesselring's priority at that moment was to reinforce the fortifications of the coastal belt from Salerno to Livorno, and he needed every labourer he could get. (These were the fortifications that helped to bottle up the Allied landings at Anzio in January 1944.) So he may have seen advantage in supporting the plan, though not necessarily for humanitarian motives. But he gave his response, according to Moellhausen's account, by telling Kappler he could not spare any troops for the operation as he needed every soldier to resist the expected Allied landing at Ostia, which in a sense let Stahel off the hook.

Kappler, who had had advance warning from Himmler and Kaltenbrunner (his deputy and Head of the *Reichssicherheitshauptamt* – Reich Security Head Office, RSHA – in succession to Heydrich) that such a move was afoot and that he would be expected to carry out the orders, at this point indulged in a staggering piece of freelancing. Early on 26 September – before any planning on the ground could be done for the implementation of the order and without any order or other authority from the chain of command – he summoned the two principal leaders of the Jewish community to meet him that day. Some reports say that the meeting took place at the Villa Wolkonsky;[20] others that it took place at the office of the Jewish leaders in the ghetto. Kappler persuaded the Jewish leaders to collect 50 kg of gold and jewellery within 36 hours, in exchange for which he would ensure that 'they and their sons' would not be subject to any other measures by the German authorities. The gold was duly delivered the following evening (and the L.2m which had been given to the leaders in lieu of gold were subsequently confiscated as well). The treasure was sent to Kaltenbrunner in Berlin, with Kappler's suggestion that it be used for SD operations. This was corroborated by the discovery of details accidentally left behind in account books in the Villa when the Allies liberated Rome in June 1944. (Kappler told his interrogators that the gold had remained in Kaltenbrunner's office till the end of the war.)

Kappler's action brought Moellhausen (along with Weizsäcker and Kessel) to the conclusion that he had been less than frank when seeing Kesselring. They worked hard to devise a means of saving the Jews from deportation and 'liquidation'. Stahel had pronounced that he would only abet Kappler in carrying out this act of '*Schweinerei*' if so ordered by Ribbentrop. Consequently, on 6 October Moellhausen sent his now famous telegrams to the Foreign Ministry, aimed at persuading Ribbentrop personally to agree to intervene in support of the alternative proposal for dealing with the Jews in Rome. In the first (no. 192), addressed for the personal attention of Ribbentrop, he wrote:

> Obersturmbannführer Kappler has received orders to arrest the eight thousand Jews resident in Rome and bring them to Upper Italy, where they are to be liquidated. The City Commandant of Rome, General Stahel, informs me that he will permit this action only if it corresponds to the intention of the R[eich] F[oreign] M[inister]. I am personally of the opinion that it would be a better plan to employ the Jews for fortification work, as in Tunis, and, together with Kappler, I will propose this to Field Marshal Kesselring. Please advise. Moellhausen.

In the second telegram (no. 201) Moellhausen noted that Kesselring had asked Kappler to 'postpone the planned Jew-action for the time being. But if something has to be done he would prefer to use the able-bodied Jews of Rome for fortification work here.'

On 9 October Moellhausen received the following reply:

On the basis of the Führer's instructions, the 8,000 Jews resident in Rome are to be taken to Mauthausen as hostages. The Herr R[eich] F[oreign] M[inister] asks you not to interfere in any way in this affair, but to leave it to the SS. Please inform Ambassador Rahn. [signed] Thadden.

A separate message from Ribbentrop's office confirms this:

The Reich Foreign Minister requests that consuls Rahn and Moellhausen ... be told under no circumstances to interfere in this affair, but rather to leave it to the SS. [signed] Sonnleithner. [Ribbentrop's permanent representative at Hitler's HQ – and member of the SS.]

Later that day yet another message followed in even more explicit terms:

The Herr Reich Minister of Foreign Affairs insists that you keep out of all questions concerning Jews. Such questions, in accordance with an agreement between the Foreign Ministry and the Reich Security Head Office [RSHA], are within the exclusive competence of the SS, and any further interference in these questions could cause serious difficulties for the Ministry of Foreign Affairs.

Moellhausen's first telegram had caused a particular stir. He had abandoned the euphemisms the Nazis always used to describe the fate they intended for the Jews: he used the word 'liquidated' ('liquidiert'). In addition he had involved Kesselring without authority and reported to the highest levels what must have read as a mutinous act by the City Commandant, Stahel. It is arguable that the barrage of orders that rained down on Rome from Hitler's HQ and Berlin had more to do with Moellhausen's honesty (or mistake) in revealing in official correspondence that the Jews were being exterminated than with his unauthorised involvement of Kesselring or simply his trying to have the order modified. Rahn, busy setting up his new embassy in the north but nominally in charge in Rome, was particularly aggrieved that he was included in the rebuke from Berlin, having been unwittingly dragged into the affair by Moellhausen, who had failed to consult him. Moellhausen also recorded that Rahn, in his handwritten message of reproof, had told him he, Rahn, could have fixed things with Wolff. Rahn's note finished 'Very bad'. Stahel also paid a price for his reported insubordination: Kesselring had him removed, ostensibly for having written and circulated a self-laudatory memorandum about the successful and civilised policy he had implemented in dealing with occupied Rome and the Catholic Church. He did not survive his next command on the Eastern front.

A leading German historian of the occupation, Lutz Klinkhammer, reckons that Moellhausen's offending telegram might have been the only recorded occasion when an official openly dissented in official German correspondence from the policy of exterminating the Jews, in the process calling a spade a spade.

What Moellhausen, Weizsäcker and others did not know was that Kappler had also advised Kaltenbrunner that the round-up of the Jews would deprive the Germans of the intelligence about invasion plans available because of the Allies' contacts with the Jews in Rome.[21] He also wanted to avoid distraction from what he regarded as a more immediate need, namely to round up as many of

the remaining 6,500 *carabinieri* as possible for deportation as forced labour to Germany, to prevent them from plotting against the German occupying authorities. (This operation, contrary to the terms of the Italians' surrender but already authorised by Kesselring, was carried out on 6 or 7 October, though with only partial success, as the number of *carabinieri* actually despatched to Germany was only 1,500.) After the event Kappler's advice received a strong rebuke from Kaltenbrunner on 11 October; he argued that delaying the deportation of the Jews until the *carabinieri* were dealt with could no more have been contemplated than their use as forced labour: and further delay would give the Jews more time to take refuge with Italians or disappear altogether.[22] The officer charged with the evacuation of Jews – in other words someone more reliable – had been instructed to do so without delay. Indeed a *Waffen* SS officer, Theodor Dannecker, personally selected for the task by the now notorious Eichmann, had already arrived in Rome on 6 October with a small staff (but not a dedicated *Einsatzgruppe* or action unit) to supervise the operation.

After the war Kappler attempted to argue that he had been trying to encourage his superiors not to proceed with the round-up of the Jews in Rome, but that cut little ice. It is an irony that his secret telegrams, if available at his trial, could have lent some credence to his claim. But the view was taken that, had Kappler being trying to save the Jewish population, he could have used his meeting to warn their leaders more blatantly but chose not to do so. Indeed his extortion ploy must have seemed to them to confirm their own views that the Germans would not want to take serious action against them. In spite of dire forebodings on the part of other senior members of the Jewish community the two leading figures summoned by Kappler had set their minds against any policy of dispersal of the tightly concentrated community. They later said that they did not act on the implicit warning in Kappler's threat because the word would get around and that would have provoked the action they hoped to avoid by collecting the gold.

A further report has it that Moellhausen and Dollmann (who had a role in liaison with the papacy) tried to persuade the Pope to intervene to have the severity of the reprisals reduced; not surprisingly given Hitler's personal involvement, they did not succeed.[23] Whether he did so act or not, Moellhausen wittingly or accidentally placed himself in a category apart from all those officials who went along with the cover-up in Italy and elsewhere as well as the policy of repression which steadily worsened as the occupation of Rome continued. And he survived to tell the tale.[24]

After the fracas over the telegrams, not surprisingly Dannecker got, through Kappler, such men a Stahel could provide to implement the round-up on 16 October, without warning Moellhausen. Their success was limited. Of the 8,000 Jews the Germans estimated were in Rome just over 1,000 were recorded as being deported in this phase, but to Auschwitz, not Mauthausen, as originally instructed (Approximately a further 1,000 were deported by Kappler's men in the subsequent months of the occupation.) The failure to meet the target owed something to the delay and more to the fact that the level of harassment the Jews experienced began to increase from about 9 October, and many Jews feared the worst. When the famous library and the offices of the community were pillaged (and the register of Jews in Rome was taken away) many Jews ignored the message of reassurance which their leaders – those who had submitted to the order to gather up the 50 kg of gold – continued to spread and began to leave the ghetto. The shortage of manpower available to mount the operation must also have helped to ensure that the element of surprise was much reduced, even though it was launched at 5 a.m. A word started to spread of what was afoot on the morning the round-up began, many Jews were able t go into hiding, finding shelter with the non-Jewish population and in church properties, many of which had extra-territorial status, which the Vatican largely succeeded in preserving. The round-up was no carried out with notable energy, and it was discontinued after the first few hours.

Whether or not any part of the action against the Jews was in practice planned, discussed or directed in or from the Villa Wolkonsky, Moellhausen was clearly aware of the order (and at least tried, if naively, to mitigate its severity), and Kappler was directly in charge of the rounding-up and despatch northwards of over 1,000 more Jews from Rome (though he too went along with Moellhausen and Kesselring as they tried to divert the policy). By the time the action took place Rahn was also aware. Those not in the immediate loop would not have known precisely which senior German was where, but all three were widely assumed to be based at or connected with the Villa. The important point for the historical record is that Moellhausen, and to some extent Kappler, Kesselring and the diplomats at the Vatican, tried in varying degree to mitigate the severity of the action against the Jews; and that although they were slapped down by the high priests of Nazi doctrine, their pragmatic and quite daring behaviour did succeed to the extent that many Jews escaped the fate that Berlin had planned for them. Even such meagre signs of humanity were far less in evidence in the later phases of the occupation.

Forced labour

Another way the Germans made the Italians pay a price for the armistice with the Allies was through the exaction of forced labour. This was carried out in a chaotic way, marked by both severe and random action against the Italian population and, consequently, manifold opportunities for evasion. Of course it also gave a strong incentive to many Italians to disappear into the resistance.[25]

The occupation of much of the Italian peninsula by the Wehrmacht represented an immediate opportunity for the latter to lay hands on millions of workers. Some 800,000 Italian servicemen ended up in the hands of the German army, which transferred them to camps in Germany and Poland whilst deciding how to deploy them. The very first couple of weeks of the occupation saw a power vacuum left by the collapse of the Kingdom of Italy and the lack of even a semblance of a government until 23 September. So the Wehrmacht was the de facto government in the occupied territory, although Hitler had issued an order on 10 September giving Rahn civil powers in Italy.

Given that there was in reality no functioning Italian government, Hitler's order placed control over what was to become the new Fascist state in Rahn's hands, first simply as the plenipotentiary in occupied Italy, later as a sort of pro-consul with plenipotentiary powers to overrule Mussolini's government – which he frequently did. From the outset Rahn theoretically had the powers to govern Italy through the Italian prefects, who would have had to carry out the instructions handed down through his subordinates. However, just a few days later the military set up their own administration.

The Chief of Staff of the Wehrmacht, Keitel, gave orders for the establishment of a territorial administration in the whole of the occupied zone, to be run by military garrisons in the major cities (e.g. Stahel in Rome) and police stations in the smaller ones. These forces were required to work alongside the existing Italian authorities. On 14 September General Rudolf Toussaint (who had arrived as the embassy's military attaché days before the surrender) was appointed commander of the Military Control Board in Italy. From early October Toussaint created a series of local garrisons, the *Militärkommandanturen*, which were to exercise control over areas roughly corresponding to the provinces. The head of the Military Control Board became the chief German controller in Italy, with the remit to 'operate to all effects as a Control Board where the independent Italian government was concerned, both at constitutional and international levels'. However Toussaint had no control over those territories which had been annexed 'de facto' by the Reich, that is the 'operational zones of the Pre-Alps and the Adriatic Littoral'; these provinces had been placed on 11 September under the control

of two *Gauleiters* (local NSDAP party chiefs), Franz Hofer and Friedrich Rainer. Both the Italian authorities and German military authorities were excluded from these two 'operational zones'.

To try to sort out the confusion in the lines of command Rahn held a meeting on 1 October 1943 with Rommel and Toussaint on Lake Garda. They decided to use the newly constituted RSI government to run civil affairs (following the tactic promoted in Rahn's August paper). In this framework the RSI would legalise the recruitment of workers, including forced labour, in such a way as to reassure the workers themselves. But senior people in the new Fascist authorities realised that indiscriminate round-ups, forced labour and deportation to Germany would be damaging to such prestige as Fascism and the Republic still enjoyed. No one would have any confidence in a state which could not even guarantee minimum standards of personal security to its own citizens. It was no surprise that the institutions of the new republic were not a major source of labour for the Germans.

The confusion was if anything made worse, when on 10 October Kesselring was given the Supreme Command of the Southern Front, with civil and military powers over Rome and the provinces to the south, to enable him to resist the Allied advance northwards. He had already been recruiting labour vigorously for the construction of defences on the western coast between Naples and Livorno, as was clear from his line in trying (along with Moellhausen) to divert the order to send Rome's 8,000 Jews to the north.

On 29 November a further meeting took place at the Villa Wolkonsky, convened by Moellhausen. The German military commander of the city was represented, as were the Italian police and armed forces and the Prefect of Rome, Ricci. The Italian contingent was compelled to listen to some tough talking from Moellhausen, who argued that whilst the German soldiers were out there fighting 'young Italians were literally doing nothing'. At that point Ricci proposed to take away the ration books from those young people who had not responded to the labour call-up and also from their families. Moellhausen gave his approval to this proposal, but on 1 December, in the Prefecture, there was a further meeting at which only the Italians were present. They decided that the taking away of ration books would apply only to the citizens of Rome.

Mälzer, as already mentioned, thought he was contributing to the recruitment of candidates for forced labour by staging random round-ups on the streets, a practice which Kesselring was eventually persuaded (by Moellhausen among others) to put a stop to, as it was increasing the level of insecurity in the streets of the city which he needed to maintain as his secure rear, through which his troops would need to pass as they were slowly pushed north by the Allies. But by then the pall of the Ardeatine Massacre hung over the city, and the last months of the occupation were marked by discussion of much harsher German control and plans for severe retribution.

Proposals for retribution turned aside

In the final weeks before the liberation of Rome and directly following the via Rasella bombing a plan was hatched in Berlin and sponsored by Himmler to force an evacuation of the city of Rome. A meeting of all the senior Germans involved in security in the city was convened by Wolff the instant he arrived in Rome on the night of 24 March – the day after the via Rasella bombing – but Kesselring was neither invited nor informed. (The location of the meeting is unclear.) Wolff announced that the intention was to consider how the evacuation of the city could be effected. Moellhausen's attempt to argue against such a step was (by his own account) slapped down by Wolff as irrelevant. Mälzer supported the idea. Kappler though not in favour did not argue against his SS boss. A report would

go to Himmler indicating that the plan could be implemented. After a hint from Wolff's ADC Moellhausen dashed to see Kesselring, who was both against the idea because the chaos it would produce would severely hamper his forces' mobility and because no one had seen fit to consult him, the local commander-in-chief. Wolff was able to report to Himmler that Kesselring was blocking the plan.

As it became clearer that the Allies' advance on Rome was gaining ground the next German ploy was to ensure the destruction of essential communication and utility facilities, so that the Allies would find difficulty in operating and the populace would be resentful of their presence – apparently an idea spawned by Naumann, Goebbels' deputy at the Propaganda Ministry, that enjoyed Hitler's backing. Again Kesselring made his opposition known: it had been his policy to spare Rome from such destruction, partly because of the presence of the Pope and the Vatican. On this occasion, only days before the Allies actually entered Rome, Hitler decided to leave the decision to Kesselring.

Thirdly, in the last hours before the Allies arrived, Kesselring decided to disobey Hitler's standing orders that his forces should always fight to the last soldier before surrendering territory. He ordered the city to be evacuated by the German forces and relocated his HQ from Frascati to Bagni di Lucca in Tuscany. Before he left he acted on a message from Rahn, provoked by Moellhausen (by then in the north himself), ordering the closure of the embassy office in the Villa Wolkonsky and the departure of the remaining staff. They left safely on the night of 3/4 June and made their way to join Rahn and Moellhausen in Fasano. Thus ended a dramatic but inglorious chapter in the story of the Villa Wolkonsky.

Notes

1 Moellhausen's memoir is an important source for much of the account of events at the Villa and elsewhere in Rome.

2 The 'visitors' most likely included many of Kappler's informers.

3 The life of luxury did not last: Rahn refused to foot the bills for the hotels and Mälzer had to put his HQ in the Ministry of Agriculture on the Corso d'Italia.

4 Napoli, pp. 31–4.

5 If such meeting did take place, it may have coincided with Hitler's very restricted meeting with Himmler and the High Command about the rescue of Mussolini, but there is no evidence that Kappler was at that meeting. But Himmler briefed Skorzeny immediately after the session with Hitler and before Skorzeny and Student flew together to Rome; so Himmler might at that stage have put Kappler on notice. Kappler might however have been present when Skorzeny and Student had to fly back to Hitler's HQ in late August to have a misguided operational order rescinded by Hitler. Indeed Moellhausen records that the order to be rescinded was the plot to kidnap the King and Badoglio, and that Kappler had been needed to persuade Hitler to abandon it. That meeting resulted in a confirmed plan to attack the villa on La Maddalena (Sardinia) where Mussolini was being held. That plan had in turn to be suspended at the last minute, as Mussolini was moved back to the mainland. But Skorzeny was, with Kappler's help, able to mount an amended plan a few days later.

6 Dollmann later also claimed credit for this piece of intelligence.

7 Foley, e.g. p. 66.

8 Kappler and Dollmann (according to Moellhausen), concerned about the imminent possibility of an Allied invasion, worried about the continued presence of any Italian troops hostile to Germany in Rome. They trusted Calvi but not his subordinates, especially Colonel Montezemolo. Rahn and Stahel agreed to suppress Calvi's role and to place him and his senior officers under arrest. They took Calvi but Montezemolo slipped away (to reappear later in the occupation).

⁹ This conflicts with Moellhausen's version, that the SS without any word to the Embassy, sequestered the files on Himmler's orders on 14 September and sent them to Berlin, and the Embassy heard no more about them – except that the key documents had been hidden by the Foreign Ministry staff in the well at the Villa Torlonia! Kappler added that Italian intelligence documents had been systematically destroyed from mid-June 1943 in the Rome gas works.

¹⁰ To this sum could be added millions more, taken in due course from other private and publicly owned banks. The Germans justified this on the grounds that the new 'republic' needed to pay for the war which Germany was having to wage on its behalf since the armistice. The people also paid by the inflation caused by the use of occupation money (*Reichskredit Kassenscheine*), a feeble counterpart to the Allies' Am-Lira.

¹¹ E.g. Napoli, p. 43.

¹² Records of the Office of Strategic Services (RG 226) Interagency Working Group (IWG): Record Group 226, Boxes 440–442; Box 440, No. 63.

¹³ 'Lo Stato che noi vogliamo instaurare sarà nazionale e sociale nel senso più lato della parola: sarà cioè fascista nel senso delle nostre origini.' 'The State which we wish to establish will be national and social in the broadest sense of the word: so it will be fascist in the sense of our origins.'

¹⁴ None of the official documents gave detail of the reasons for Rahn's sudden absence from Rome at this time. Although there were reports of a car crash, they were generally advanced as an explanation for Rahn's absence from 9 to 12 September, which did not really add up. This more detailed version given by Moellhausen makes more sense.

¹⁵ Rahn (2); Moellhausen.

¹⁶ The fate of the Villa Bassetti came back on the table after the war when the British were ensconced in the Villa Wolkonsky. See Chapter 16.

¹⁷ Letter dated 18 January 1946 in TNA: WO 204/12798.

¹⁸ See note 10.

¹⁹ To commission some communist cells in Rome to destroy vital facilities in Rome as the Allies entered the city.

²⁰ Katz, p. 70.

²¹ As revealed in OSS files published in 2000 quoted by Katz, p. 76.

²² Also quoted in Katz, p. 77.

²³ Klinkhammer also relates that Moellhausen went so far as to travel in person to the north on 15 October to persuade Mussolini to intervene with Hitler. Rahn was in the north at the time. He may have been incapacitated otherwise it is not clear why it might have been necessary for Moellhausen to travel north himself; nor whether he and Rahn are thought to have seen Mussolini together. Moellhausen himself made no reference to this alleged visit.

²⁴ In proceedings at Nuremberg Wolff tried implausibly to claim he knew nothing of the fate of the Jews, in Italy or elsewhere, but it later became clear that Kappler had reported to him on implementation of Himmler's orders in Italy. And he was eventually found guilty of war crimes by a West German court.

²⁵ For more on the German agencies for the exploitation of forced labour in Italy in the autumn of 1943 see lavoroforzato.topografiaperlastoria.org/temi.html?id=6&cap=20.

13.
THE OCCUPATION RAMPANT

If in the early stages of the occupation those in charge were inclined to be pragmatic and moderate, to keep Rome calm and thus protect Kesselring's back, those intentions were soon compromised by the failure to avoid the action against the Jews dictated by Berlin, the deportation of the *carabinieri* and the confused efforts to recruit forced labour for the German war effort. On the shoulders of SS *Obersturmbannführer* (Lt. Col.) Herbert Kappler rested the main responsibility for security behind the lines in German-occupied Rome and surroundings. In this period he had showed himself to be fairly rational and undogmatic, if also ambitious and self-seeking – rather than the Nazi ideological fanatic he was later portrayed as. As the occupation dragged on and the prospect of an Allied landing came closer, resistance to occupation developed, and the harshness of the German response increased. Mälzer's crude labour recruitment drives added to the tension and the worsening of the relationship between occupiers and occupied. As the war inched slowly northwards, other civilian influence, including that of Moellhausen, faded, and the role of Kappler's security service departments became ever more prominent and extreme.

A concurrent, growing issue was the question whether Rome, largely because of the presence of the Pope and the Vatican, should be formally declared an open city and spared Allied attacks. The issues were linked, as the Germans' need of a secure rear and supply line for their forces impeding the Allies' advance was hard to meet if the resistance there had free rein to attack them, and keeping the rail and road routes through Rome and surroundings was vital to its ability to withdraw northwards to stronger defensive lines. After the Anzio landings on 22 January 1944 German troops had become commonplace in the city, causing disturbances when taking time out from the front, but also on operations to exact retribution, retaliate and round up ever more unwilling labour. This culminated in the partisans' major bomb incident against German troops in via Rasella in March and the subsequent massacre in retribution. In spite of the escalation the Germans however continued to exercise some restraint, and Kesselring remained true to his word on ensuring the city's food supplies even during the Germans' final retreat to the north, and on avoiding a scorched earth policy.

Pressure from and the mere presence of the Vatican no doubt contributed to this result. The Vatican's priority was to avoid Rome becoming a target of military attacks. Some observers judge this need to have been an important factor in their efforts to avoid open criticism of and attacks on the occupation forces – even in the face of major outrages such as the action against the Jews and the Ardeatine Massacre. Their reticence also seemed to be linked to the Germans turning a blind eye to the way in which the Church provided shelter to Jews and others wanted by Kappler and his team, including several resistance leaders. The resistance itself was much weakened by differences between the leaderships of the various groups, which seemed more interested in positioning themselves for post-war politics than actually fighting the Germans. Only the Communist Party and the GAP (*Gruppi di Azione Patriottica*) made any real impact. The via Rasella attack was their high-water mark but also a cause of their decline, as many of the leaders were killed in the subsequent retribution massacre. The

SD/Gestapo under Kappler, helped by the Italian Fascist police, did in effect keep the lid on the resistance. Rome was under full German control throughout the occupation. But the methods used to achieve this – infiltration and above all torture and killing – methods endorsed by the most senior generals as well as the Nazi leadership in Berlin, still colour the reputation of Germany in Italy, as elsewhere in other occupied territories and more widely.

Kappler and the police attachés

On 15 November 1943 Moellhausen reported that the military had finally departed from the Villa and that this left the Embassy with 'only 12 police attachés' from the *Sicherheitsdienst* (SD – Security Police). They were under the command of Kappler (Fig. 13.1), though whether he was included in that dozen is not clear. The inference one draws naturally from Moellhausen's wording is that those 'attachés' retained their base at the Villa. That is on the face of it hard to square with Kappler's claim in his post-war interrogation that immediately after the occupation of Rome he had surrendered his embassy passes and ceased to act under diplomatic immunity; but perhaps he did not need an 'embassy pass' any more to enter a property which no longer functioned as an embassy. He would obviously have remained a freely admitted 'visitor', so the point is largely academic. How much he and his colleagues used offices at the Villa after their accommodation in via Tasso opened is not recorded. Not surprisingly German and British files are silent on a question which at the time would not have seemed of any importance. But with few exceptions it seems likely that most of their operations were carried out at the via Tasso offices or elsewhere. One exception was almost certainly Kappler's use of the Villa to receive in relative privacy some of his highly placed Italian informants and possibly the Jewish leaders from whom he extorted the 50 kg of gold. Another is the SD's use of one of the huts for wireless work and training.

Kappler was born in Stuttgart in 1907, studied electrical engineering at school and worked in a number of local companies.[2] In 1931 he joined the *Sturmabteilung* (SA – the original Nazi paramilitary wing) and in 1932 was accepted into the SS (and the NSDAP). All his service was on the SD side of the SS: he saw no military service. In 1933 he joined the regional political police and after passing relevant exams was sent in 1937 as the first non-Prussian to attend the Security Police officer training college in Charlottenburg (Berlin). After graduation as an officer (2nd Lt. equivalent) and the annexation of Austria he was posted briefly to Innsbruck, where he would likely have come across Kaltenbrunner, a senior and rising star in the SS/SD. He was promoted to *Obersturmführer* on 1 January 1939 and sent to Rome as liaison officer and then police attaché at the Embassy following an agreement on police cooperation between the two governments in 1938, about which Heydrich (then Himmler's deputy) had sent Mackensen a warm letter of thanks – see Fig. 13.2. His responsibility was for liaison with the Italian security service but also for keeping watch on Germans serving in Rome, not least in the Embassy. In November that year he was recalled briefly to Berlin to help interrogate Hitler's would-be assassin, Georg Elser, as well as two kidnapped British officers.

In Rome Kappler worked initially under the cover of the German Cultural Office in via Tasso (premises he later took over). His promotions were rapid: within weeks he had set up his own office and after two more promotions he was by November 1941 in charge of the team of 'police attachés' in the Embassy at Villa Wolkonsky, with diplomatic immunity. He claimed that at that stage, with the exception of his running a few agents in the Vatican, he had no direct role in the spying and other disruptive activities of *Abteilung VI*, the SD's proactive operational division, which from 1942 were under the control in Rome of an officer called Looss, who had (embassy) cover as Kappler's assistant

g. 13.1. *Kappler in Allied hands in Italy on 9 May 1945.*

ut in March 1943 Kappler was ordered to set up a network in Sicily, in preparation for the expected llied landing, and that effectively widened his brief.

Immediately after the occupation on 9 September Kappler's direct superior, SS General Harster, t up a new Security Office in Verona to cover all of occupied Italy. Harster's immediate superior was olff, in overall charge of the SS in Italy, based 'on Lake Como' – so that he could be close to Locarno, useful place for discreet contact – though with a military SS HQ near Bolzano. They promoted Kap- er to the rank of *Obersturmbannführer* (Lt. Col.), to set up and command a local SD sub-HQ (*Aussenkom- ando*) in Rome responsible for

the security of German forces behind the front, i.e. the security police work done by *Abteilung* IV (Department IV) of the SD, focused on monitoring and disrupting the resistance to the occupation and

activity designed to delay and disrupt the Allied advance, the work of *Abteilung* VI.

ppler attended Harster's monthly coordination meetings in Verona and kept in close contact with m at other times. More men were sent to augment the SD personnel already in Rome. The unit was ainly based in the premises in via Tasso, previously a German Cultural Office (*Kulturbüro*) already ing used as cover by some of the SD personnel in Rome. (The place has since become the Museum

Fig. 13.2. Heydrich's letter of commendation to Mackensen of 25 October 1938 about police cooperation, Kappler's work.

of the Liberation.) On 10 Septembe[r] 1943 SS Captain Priebke, one of th[e] police attachés at the Embassy, wa[s] seconded to open up the new facility where he became notorious, no[t] least in the context of the Ardeatin[e] Massacre.[3]

British intelligence at th[e] liberation in 1944 had Kappler a[s] 'resident' in the German Embass[y] with cover as a Political Counsello[r]; his main office was in via Tass[o] but they asserted that he ha[d] retained an office in the Embass[y]. At his interrogation Kappl[er] seemed to deny that, when h[e] stated that he had immediatel[y] turned in his embassy passes an[d] ceased to operate under diplomat[ic] cover. But Moellhausen's accou[nt] and what was discovered at th[e] Embassy in June 1944 made it cle[ar] that some SD officials did rema[in] at the Villa at least some of th[e] time. Not all their functions a[re] known, but their activity wou[ld] have been contrary to the Vien[na] Convention, even though some [of] them may have enjoyed diploma[tic]

privilege before the occupation. It seems quite likely that Kappler did in practice retain an office [in] the ex-Embassy. One British intelligence report, sourced to an Italian agent of Kappler's, Filippi, h[ad] the latter bringing to the Embassy on 23 September 1943 four Italians to meet Kappler, one of who[m] separately related that he visited Kappler frequently there and also met others of the team – Ha[ss], Meyer, Priebke (who paid him his L.3,000 monthly retainer), as well as Boehm [sic] and Ring [si[c]], the wireless (WT) operators and trainers (see below). This information recorded that, apart from t[he] via Tasso office, Kappler had another in a small villa backing on to it in via Boiardo, where one sm[all] section busied itself under the leadership of Domislaff with information collation. In effect the S[D] took over the whole building and a neighbouring block, which was made to interconnect.[4]

Whether or not he still had quarters at the Embassy, Kappler would have been at the Villa also [to] attend meetings with Moellhausen and other senior figures or to meet Italians of some standin[g]. There is no evidence other than shreds of hearsay that he or the SD more generally used the embas[sy] offices, residence or other buildings to hold, interrogate or torture opponents of the occupation[: it] was for that purpose that they had set up the prison in via Tasso. That does not exclude the possibil[ity] that from time to time as a matter of convenience individuals were temporarily held there in baseme[nt] rooms before being taken on to via Tasso.[5] But that is little more than speculation.

A spin-off for Kappler from the Skorzeny operation was that one of the officers involved, Haas, stayed on in Rome and took over one of the two SD operational departments, *Abteilung* VI. (British intelligence portrayed him as Kappler's assistant as well.) The main tasks of this team after November 1943 were to build a post-occupation network and to execute Himmler's order, transmitted through both Kaltenbrunner in Berlin and Wolff, that sabotage operations be devised and mounted against the Allies as they confronted the German forces in Italy. Kaltenbrunner, unaware that Wolff had already tasked Kappler with this, sent an officer from Berlin, Hammer; but, in Kappler's laconic phrase, 'he soon returned to Germany'. Kappler and Haas went to The Hague that month to study sabotage work and came back with a Dutch woman, Ten Kate Brouwer, who was to become an agent under the codename 'Hoffmann'. Allied intelligence already knew of this agent before the liberation of Rome and claimed she was Kappler's mistress. Kappler said that she had been left behind by the retreating Germans in June 1944 but transmitted only once – and in a way which led the Germans to suspect someone else was making the transmission. He had reckoned, on the basis of 'his intimate knowledge of the agent', that she had gone over to the Allies.

From as early as March 1943 Kappler had had special wireless sets designed, built and supplied by an Italian electrical engineer, Lucci, to link up the network of agents he was building. He regarded them as very successful. Training in use of the sets had been carried out at 'the *Aussenkommando* WT station in the grounds of the Embassy', principally by Boehme and Rinkh but also on occasion by the other operators (whom he named). Lucci had also proposed a new ultra-shortwave (VHF) network for agents, protected by rapid frequency changes during operation; but lack of material prevented the plan from being put into effect. This account matches with the report of the material and equipment found in one of the huts in the grounds of the Villa when the Allied forces entered it on 9 June 1944 (see Chapter 14). It is possible that, when he was interrogated, Kappler already knew what had been found there.

Other *Abteilung* VI schemes which Kappler tried to launch met with little success. Those designed to place German agents behind the Allies' lines failed. Leaving 'Hoffmann' behind in Rome was a case in point. Some of his schemes were difficult for Kesselring to approve: for instance releasing infected rats in Anzio, or killing Allied generals in February 1944. On this last initiative the British intelligence report noted 'to this day Kappler has no idea what happened to his sabotage party'!

Allied intelligence knew also that the other main executive SD branch in via Tasso (*Abteilung* IV) was run by Captain Schütze, along with Captain Priebke and others. The total personnel in the complex numbered about 60. There was a steady stream of informers visiting, presumably not to the same entrance as the prisoners brought in for questioning (and worse). They listed three women considered key members of Kappler's team: his secretary, Fräulein Schwartzer; a Signora Grassi, secretary and interpreter for Schütze; and Fräulein 'Hoffmann', his WT operator 'and mistress'. British files contain some photographs of Kappler with colleagues and friends (who included some senior Italian police figures – Fig. 13.3).

Kappler had taken over the via Tasso premises (on Dollmann's recommendation), as a prison because the Regina Coeli, the main security prison in the city, was 'hopeless as a security jail' as it was far too easy to get messages in and out. Kappler's main activities during this period were to gather intelligence on and disrupt or suppress any resistance to the occupation and the new Fascist government, enforcing anti-Jewish measures, and running spies on the Italians in charge, their own people and the activities of the Vatican. As the Allied armies began moving north towards Rome, Kappler became significantly involved in hunting suspected Allied agents and Allied prisoners-of-war who had escaped from Italian POW camps after the Italian army capitulated. In these measures,

Fig. 13.3. Kappler (third from right) with colleagues and senior Italian police officials. On Kappler's right is Te *Kate Brouwer ('Hoffmann'). At far left is a senior Italian police officer.*

Kappler and the Germans more widely had strong suspicions that the Vatican was harbouring an helping Allied fugitives and escaped prisoners.

The Anzio landings in January 1944 had in one respect the perverse effect of making Kappler task of defeating the resistance easier. So sure were the resistance members that the Allies would b in Rome within days that they abandoned their disciplined and carefully honed security practice suddenly revealing themselves and their whereabouts to those monitoring telephone calls an watching for secret meetings. Among the pro-monarchist leaders brought into via Tasso during th wave of successful arrests were General Simoni and Colonel Montezemolo, both of whom, howeve held out against the torture inflicted on them. Even so, first the monarchists then the leftist resistanc movements were seriously weakened by their leaders' carelessness.

Some 2,000 people are known to have passed through the hands of the Gestapo in the via Tass centre in the short nine months of the occupation. Many did not survive; few escaped unscathed phy ically and/or mentally. Kappler claimed that the Italians had exaggerated the extent of the 'terror'. N torture had been carried out to his knowledge: the only form of 'physical persuasion' he had allowe was blows on the bare soles of the feet. He justified this on the grounds that Italians were afraid physical punishment and willing to talk to avoid it; and that it was justifiable in order to save the liv of thousands of German troops. He asserted that he had been unaware until long after the occupatio of Rome ended that Schütze was regularly exaggerating measures of physical persuasion against h orders – a claim which sat uneasily with his tale of the assent for such measures he claimed fro Wolff and Harster (see below).

Much of what happened at the via Tasso prison is well documented and accessible in the Museum of the Liberation: on some floors visitors can see the rooms turned into cells where prisoners were held and tortured. Some of the records kept survived the ransacking of the premises after the liberation, and other evidence has been collected. The story is a shocking catalogue of banal brutality, which to this day colours the view some Italians retain of Germans. Kappler, with an eye on the trial he assumed he would undergo, told his interrogators in 1945 that Wolff had rarely visited Rome, but that on one occasion he had visited via Tasso and asked Kappler about the rumours of torture, especially teeth-pulling. Kappler claimed that Wolff had implicitly approved his view that 'in order to save the lives of thousands of German troops at the front almost anything was justifiable' when remarking that Kappler would be well advised to build a soundproof room so that the screams should not be heard. Harster had also visited via Tasso and sat in on an interrogation. He had left the room during the 'persuasion part' but expressed no disapproval. So he, Kappler, had assumed that his superiors shared his views.

The via Rasella bombs and the Ardeatine Massacre

The reputation of Kappler and his team for criminal brutality is however generally dominated by their role – but especially Kappler's – in the atrocity known as the Ardeatine Massacre, which stands as the Germans' most notorious act of repression in Italy. This singular act was their reaction to a resistance bomb attack on 23 March 1944 on a battalion of German police marching through the via Rasella, 33 of whom were killed on the spot or died shortly afterwards.[6] The attack was intended as a spectacular indication that the resistance was not after all beaten. It was timed to coincide with a relatively low-key Fascist ceremony commemorating the date of the formation of the first of Mussolini's *Fasci Italiani a Combattimento*, 23 March 1919. Its organiser, the neo-Fascist governor of the city, Pizzirani, had wanted to hold it in a well-known public open space, but at a meeting at the Villa Wolkonsky convened by Moellhausen, he and Mälzer judged that a big public meeting would provoke a violent reaction against the Fascists, whom Romans now blamed for their plight. That would undo the work they had done to keep relations between the German occupiers and the Roman citizenry in a state which would not forever blight the possibility of working together after the war. Kappler, also present and true to his well-known disdain for the Fascists, opined (according to Moellhausen) that the only thing that could salvage any shred of German prestige in Italy would be the elimination of Mussolini. So at their insistence the event was held inside the Ministry of Corporations on via Veneto, with limited participation. Dollmann (for the SS), Moellhausen and Borch (embassy) attended – Moellhausen's last public appearance in Rome, he recorded.

Their precautions were in vain. As they emerged from the gathering they heard explosions not far away. Mälzer hastened to the scene; Moellhausen followed hard behind and arrived to find Mälzer ranting 'out of control' at the sight of some 30 dead policemen around the remains of their truck and the municipal rubbish cart in which the bombs had been concealed. A public row between the two Germans over Mälzer's threat to have all the dwellings in the street blown up forthwith ended with Moellhausen heading for the Embassy to contact Kesselring before Mälzer's second-in-command could do so. He met Kappler on the way and asked him to stop Mälzer from his rash intentions. Kesselring's staff (Beelitz and Westphal) and then the field marshal himself backed Moellhausen. Rahn got Wolff in on the act as well. Mälzer, cornered, sent Dollmann as a peace emissary to the Villa Wolkonsky that same evening, and himself paid 'a conciliatory call' on Moellhausen the next day at the Villa, as did Westphal. Rahn, though he had backed his deputy, let

Der Befehlshaber
der Sicherheitspolizei u. des SD
in Italien
E.K.Rom

5.4.44.

Giuseppe M o n t e s e m o l o ist am 24.3.1944 gestorben.
Evtl. zurückgelassene persönliche Gegenstände können bei
der Dienststelle der Deutschen Sicherheitspolizei in Via
Tasso 155 abgeholt werden.

I.A.

M. Domizlaff

SS-Hauptsturmführer.

Fig. 13.4. *The official SS notification to the family of the death on 24 March 1944 of Giuseppe Cordero Lanza di Montezemolo, ex-senior military officer and then leading resistance figure, dated 5 April 1944, signed by Domitzlaff. The note says that any personal effects may be retrieved from the SD office at via Tasso 115.*

him know privately that he himself would have handled Mälzer more subtly. While the immediate aim of avoiding a thoughtless slaughter by German troops of innocent women and children might have been achieved, it was rapidly overwhelmed by the Germans' reprisals, over which Moellhausen had no influence.

Knowing that Hitler always required reprisals for civilian attacks on German forces (a policy which Kesselring had endorsed as his own in a notorious order of the day), Kappler and Mälzer decided to recommend the killing of ten Italians for each German killed in the attack – at that stage 32. This was endorsed by General Mackensen (the Area Commander under Kesselring) and passed on that evening (23 March) to Hitler's eastern HQ. Hitler appears only to have insisted that the reprisal be carried out within 24 hours of the attack.

Kappler, having originated the recommendation that ten Italians be killed for each dead German, would have been in a position to prepare for the confirmatory order, by starting to round up suitable prisoners. He, Dollmann and Mälzer were summoned to Mackensen to receive Hitler's order. The Italian police were not to be trusted to carry out the reprisal executions, so Kappler said the job was one for the German army, but Mälzer claimed he did not have enough men of the right calibre to do the job (in effect disobeying Hitler's order). It was left to Kappler, who did not refuse the task but specified that he was doing it on behalf of the army. Not having enough prisoners on their own death row, they made up the numbers by scouring their jails, not least the cells in the via Tasso prison (including Cordero de Montezemolo – see Fig. 13.4), and adding 57 Jews (for which Kappler said he secured Harster's express permission) and a number of prisoners in Italian jails surrendered by the

Italian police chief, Caruso. When the thirty-third German policeman died Kappler added ten more prisoners, applying the same rule of thumb as ordered for the 32 first deaths, but entirely on his own initiative; and, in the race to fulfil Hitler's order by the deadline, a further five were also rounded up by mistake.

On 24 March the prisoners were rushed to a desolate spot outside the southern walls of the city, the Ardeatine Caves (an old quarry), by Priebke and colleagues from via Tasso. To save time the prisoners were led forward in small groups, made to kneel and shot in the back of the head; their bodies buried under rubble released by explosives. Kappler himself is said to have fired some of the first shots. Thus they contrived to round up and kill a diverse collection of 335 victims – actually 15 more than they had been originally ordered to take – and Kappler ordered (or did not stop) the killing of the five mistakenly included in the list; it is said that he did not want survivors to reveal the place of execution.

The barbarity of the reprisals, made worse by delays before relatives were told, made this massacre a symbol of the cruelty of the occupation. Even though – as Moellhausen asserted – the Embassy was not involved in any aspect of the decision, and the senior military and civilian figures who did play a role were mostly not based in the Villa Wolkonsky, the outrage inevitably added to the general sense that the place was at the heart of the Germans' organised brutality, on a par with the SD prison in via Tasso.[7] That association has been perpetuated by a prominent exhibit in the Museum's entrance (still in place in 2018): an image of the entrance to the Villa Wolkonsky festooned with swastika banners with a large caption blatantly linking the Villa with the occupation's regime of terror – for which the Museum's historical adviser admitted to the author that there was no documentary evidence.

The case against Kappler and the aftermath of war

When he was arrested by British forces trying to escape to Switzerland, Kappler, generally held to be the main perpetrator of the brutality associated with the German occupation of Rome and its surroundings, was considered quite a catch. After being held and intermittently interrogated for a long period he was handed on to the Italians, on the grounds that his offences would more appropriately be tried under Italian law than in a war crimes court. Post-war interrogation of Kappler and others offered an opportunity to probe further the question of what had occurred at the Villa Wolkonsky. A little of his role there had already been revealed when British Special Forces searched the Villa Wolkonsky in the days after the liberation of Rome in 1944 (see Chapter 14). And the records of his interrogation give some more detail about the general range of his activities, as we have seen.[8] But, in practice, little hard information about the use of the Villa premises was recorded or sought. The focus was rather on the allegations of specific major war crimes for which convictions might be obtained, mainly responsibility for the Ardeatine Massacre. No one doubted that Kappler was the one who executed the order. But the Allied prosecutors were clearly keen to ensure that the very senior officers involved did not escape their major share of the responsibility. Kappler himself argued that the army was responsible for that reprisal (and they were following a direct order from Hitler, of course). Apart from a sense of 'he would, wouldn't he', his line found an echo even in the eventual Italian judgement on him.

Kappler told his captors that he had taken care to destroy all documents in his own office before he left Rome on the Allies' arrival. He had gone north to Maderno on Lake Garda, ostensibly to effect liaison between Wolff and Harster on the one hand and the Italian Security Service and Chief of Police in the Salò Republic. But his real task then was to create an efficient Italian security police system. He claimed to have had no further contact with intelligence organisations or other activities of *Abteilung*

VI (by then under the command of SS *Sturmbannführer* Huegel) and therefore no knowledge of post-occupation networks in northern Italy.

In July 1945 Kappler was also interrogated by the US Central Intelligence Agency (CIA) (a certain James Angleton, no less, then a 1st Lieutenant,[9] later a well-known senior CIA officer) about his inability to remember the fate of three US POWs allegedly shot at the Ardeatine Caves, when he claimed to have vetted all the prisoners personally except the 60 from the Italian police. Angleton, by then a captain, tried again on 24 October but with no result. Kappler was soon sent off to the detention camp (C1 Compound) at Ancona, where Priebke was already held. While there he added little to what was already known about his activities.

His Allied captors seemed at that point almost to have lost interest in Kappler, knowing that the Italians wanted to charge him. So much so that, on 2 May 1946 he was mistakenly transferred to the US Zone in Germany – just possibly in the confusion of the time as a belated response to some earlier unfulfilled US request, so that they could look further into the case of the three missing US POWs. When on 9 August the *carabinieri* put in a request to be allowed to interrogate Kappler, Priebke and Dollmann, the Allied HQ in Naples could not locate Kappler and sent out an urgent signal on 27 August. Kappler was found to be in Dachau near Munich, from where he was sent back to Portici a Naples. Another Italian request on 27 March 1947 that he be handed to them met no response. The Italians repeated their request in a more formal manner on 7 June, and although the US also made a similar request a few days later (no doubt still hoping to learn more about the missing POWs), he was finally handed over to the Italian authorities on 15 July 1947. Priebke, on the other hand, managed to escape, and he would not face justice until 1996.

At the Italian trial in 1948 of Kappler and five main subordinates, all six were acquitted of the homicide with violence of 320 people in reprisal for the via Rasella bombing in ways which contravened the 1907 Hague Convention. Although the order to take reprisals at the outset by the execution of 320 civilians was indeed deemed illegal, the court judged that it could not be excluded that Kappler thought it to be completely legal at the time. Because it could not be proven that the accused had knowingly committed a crime, the killing of the 320 persons had to be disregarded and Kappler, Priebke and the others were found not guilty on this count. But Kappler's case was aggravated by his promoting, organising and directing the crime and for acting without superior authority in the killing of the 15 other victims in the two 'add-on' categories, and this ensured the severity of his sentence. For these cases, Kappler was held to be fully responsible. The first crime (the execution of the additional ten reprisal victims) was ordered by Kappler autonomously, whereas the second crime was due to his lack of humanity and control over the operation. Kappler received a sentence of life imprisonment, with four years to be in solitary confinement. He was also found guilty and sentenced to 15 additional years' imprisonment on the separate charge that, in late September 1943 and entirely on his own initiative, he extorted gold and money from the Jewish community of Rome against a promise that no action would be taken subsequently against them which he promptly broke and was thus also complicit in their deportation – 1,000 in the round-up in October 1943 and a further 1,000 or more in the following months. He was judged to have been acting in his own interests, out of ambition.

During his imprisonment Kappler was divorced from his first wife and in 1972 married his second, a nurse, Anneliese, who had carried on a lengthy correspondence with him, before marrying him at a prison ceremony. By this time, he had also converted to Catholicism, partly due to the influence of his wartime enemy, the priest and Vatican diplomat Hugh O'Flaherty, whom Kappler had long considered a British spy within the Vatican, helping to shelter escaping Allied servicemen. O'Flaher-

often visited Kappler in prison, discussing literature and religion with him. In 1975 Kappler was diagnosed with cancer. The Italian government denied several appeals for his release by the West German government as well as by his wife. In 1976, the Italian military tribunal granted him a pardon, but that was reversed by an ordinary court after public protests in Italy. In August 1977 Anneliese helped him to escape (in a large suitcase!) from the Celio military hospital in Rome where he had been allowed to go for treatment and she had been permitted to nurse him. She took him home to Germany, where the authorities declined to prosecute him further, reportedly due to his ill health, and refused to extradite him to Italy. He died in Soltau on 9 February 1978 at the age of 70.

Responsibility for the Ardeatine Massacre has been much discussed and argued over, not least in the course of the Allied and Italian post-war trials of those involved. The actions of Kappler, Priebke and those under their orders in carrying out the executions are not much in doubt. The narrative of who sought whose authority, gave which orders and when, is still not entirely clear. A memo about Kappler dated 6 June 1945 by Colonel Hill-Dillon, the man responsible for his interrogation (in Florence), noted that Dollmann (who had been involved in his role as liaison officer between Himmler and Kesselring) in a bugged conversation with a fellow prisoner, had said that the

> order for the executions in the Ardeatine Caves was given by Col. Gen Mackensen, GOC 14th Army at the time concerned, and carried out by Kappler in person. ... Kappler could have refused to carry out the order or could have done it differently ... [but] it would have been unjust to hold Kappler solely responsible; the real responsibility lying with the Army.[10]

The reference to the army reflected Kesselring's notorious standing order on reprisals and Dollmann's knowledge of the army's claim not to have had manpower to spare at the time. Dollmann's judgement seems to have been broadly what Kappler's interrogators concluded and chimed with the sentence of the Italian court which eventually tried and convicted him.

Recent research has strengthened the view that the order issued by Hitler on the night of 23 March implicitly endorsed but was not the source of the 1:10 ratio, and that this rather came from Kappler, Mälzer and Mackensen.[11] Between the order and its execution lay a chain made up of several strands of hurried meetings and telephone calls within Italy and between Berlin and Rome. In the rush generated by Hitler's order Kappler had the greatest difficulty in rounding up sufficient 'eligible' prisoners, with the result that the reprisal was carried out in a hasty, brutal and careless manner, exceeding even the level of cruelty envisaged by its originators. But in the process Kappler no doubt had the satisfaction of having got rid of many of the leaders of the resistance.

Eugen Dollmann

Dollmann, whose name has been frequently mentioned, was a shadowy figure. His family had lost its fortune in the First World War, and the young Dollmann headed for Italy to work as journalist and translator, in which role he had encountered Himmler on a tour of Italy. A long-term resident in Rome, therefore speaking Italian, he appeared to wear several hats (Fig. 13.5). He was said to be in charge of the NSDAP resident delegation to the Fascist Party (though no document has come to light to corroborate that). He was a link between Himmler and his Italian contacts and friends (and hence an honorary member of the SS – and deemed a reliable Nazi) and was thought to report direct to Himmler on the conduct and loyalty of Germans in Rome. But he was also responsible to Wolff,

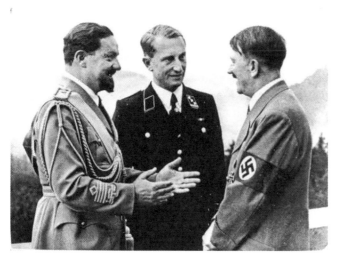

Fig. 13.5. Eugen Dollmann (centre) interpreting for Hitler.

whom he had known as Himmler's Chief of Staff before the war, and worked with him closely in the final stages of the war. He acted as liaison between Himmler and Kesselring. He translated for some of the SD officials at via Tasso (and it appears to have been his idea that Kappler should take over the whole building there to set up his enlarged prison/interrogation centre). Whenever anything happened he seemed to be around!

To his interrogators in 1945/6 Kappler said that Dollmann's role was rather vague, covering those activities, but he was adamant that he, Kappler, was in operational control of the SD and that Dollmann had had nothing to do with setting up the networks of spies. Moellhausen in his memoir asserted that Dollmann was no extreme Nazi and did not take part in any acts of brutality and violence; and that, while he and Kappler did not get on, the SS code prevented either from being disloyal to the other, even after the war. Indeed he painted a picture of a rather effete poseur, with few real friends, unmarried at 40, showing affection only for his mother, sensitive to insults and with no time for Rahn – but he knew the strength of Rahn's position and took no liberties (as Moellhausen said he had with Mackensen). Moellhausen's verdict was 'an oddball but not dangerous'.

While Dollmann crops up in many of the events and episodes described in these pages (e.g. the day when Mackensen and others gathered in the Villa Wolkonsky to digest the unexpected news of the King's coup against Mussolini) he never had a leading part. But as the war drew to a close he worked as interpreter/translator and adviser with Wolff in the latter's dealings with Allen Dulles, thus apparently earning himself a trusted status in Allied eyes. After his arrest Dollmann escaped from Rimini and made his way via Milan to US protection. He was permitted to return home to Rome but was spotted there by some Italians. The Americans are alleged to have imprisoned him for his own safety and then helped him to leave Rome again in 1947.

Karl Wolff

The last of the big names in the chronicle of the occupation was SS *Obergruppenführer* (Lt. Gen.) Karl Wolff, the senior SS general in occupied Italy (Fig. 13.6). He acquired an ever greater influence as the German position deteriorated, and it was he who negotiated the surrender of German and Fascist Italian forces in Italy on 29 April 1945. In practice, the process was held up by much mutual suspicion and changing of minds, so that the surrender occurred only two days before the end of the war in the West and after the Allied armies had more or less reached their goals in northern Italy. Nevertheless it can be argued that the surrender did save the many lives that could have been lost had the fighting

continued up to the frontiers of the Reich. But in the end that and the many other actions he took to mitigate the effect of the war on Italy and Italians did not outweigh the sense that he was party to many of the acts of brutality committed by the SS under his control.[12]

He had come from several years as Himmler's Chief of Staff, from which he was dismissed in April 1943, partly because, ignoring Himmler's refusal to permit him to divorce his wife, he had gone over Himmler's head to Hitler, divorced and remarried. He may not have had any direct responsibility for the Nazis' actions against the Jews in Germany and in the lands they occupied, for instance France. But, given his position at the heart of the Nazi machine, especially as 'Himmler's eyes and ears', it is improbable, to put it mildly, that – as he claimed – he knew nothing of that activity. (That is certainly the conclusion reached by the judges in Munich who finally sentenced him after his arrest in 1962.) And Kappler claimed that he made sure that Harster and Wolff were aware of the 16 October 1943 round-up of the Jews in Rome and the inclusion of Jews in the victims at the Ardeatine Caves.

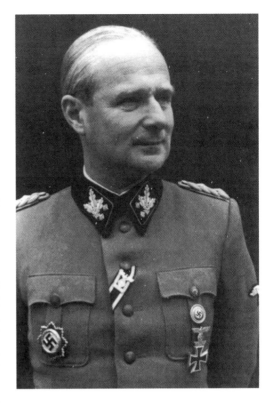

Fig. 13.6. SS General Karl Wolff.

Wolff's falling out with Himmler was clearly not terminal, given his appointment to Italy. In practice Wolff spent little time in Rome after the occupation began, basing himself in the north with easier access to Berlin and the Salò Republic as well as ready contact with the Wehrmacht Command and his own SS troops – and in due course contacts with the Allies in Switzerland. In northern Italy he worked closely with Rahn to manage the relationship between Mussolini and his ministers and their German 'allies'. According to Moellhausen, the two men shared an appreciation of the futility of continued German resistance to the Allied advance through Italy and both tried to adjust policy to avoid unnecessary further loss of life. In the final weeks Wolff even issued an order to all the German authorities in occupied Italy to cease obeying orders from Berlin, where no one wanted to see what was happening in Italy.[13]

Whatever his part in the action in Rome around the start of the occupation, Wolff became increasingly important during the military endgame in Italy. His actions have been the subject of much subsequent controversy. Although he had been so close to Himmler for years before the war and during its first two years, and had had such a leading role in the occupation of Italy, he became the main German interlocutor in an attempt, led on the Allied side by Allen Dulles (head of the US OSS office in Bern, Switzerland, from October 1942 to May 1945), to bring about the surrender of the German forces in Italy and thus save lives (and physical assets including artistic and historical treasures but also ports and other economic installations) on both sides.[14] After bearing witness in the trials of many other leading Nazis, he avoided immediate trial and imprisonment, thanks to his role and reputation in the

final stages of the war in Italy. Although he was released from custody, the Federal German authorities arrested him in the context of de-nazification and he spent four years in prison (1949–52). Sixteen years later he was re-arrested and sentenced by a Federal German court as a war criminal, for actions primarily related to the extermination of Jews in the early years of the war. He served six years of a 15-year sentence, and died in 1984.

Wolff very clearly took considerable risks in as much as he acted without authority from the highest level and therefore was guilty of breaking his oath of allegiance to the Führer. In early 1945 he spent some time at Hitler's HQ with his old boss Himmler present. He came away having heard confused signals, and the subject of specific orders to desist from his contacts with the Allies, but that did not stop Wolff from opening and keeping open a channel to Dulles (of which Himmler at least was aware).[15] A first meeting, arranged by the Swiss, took place in Zurich between Dulles's deputy and Wolff's representatives: Dollmann – from the original Rome team, known to be Himmler's man – acting as interpreter, and others. (Rahn was never part of the team, needing to stay publicly committed to the Nazi hierarchy, but according to Moellhausen, in sympathy with Wolff's efforts. However, as he spent much time trying to prevent the Wehrmacht from excessive zeal in their approach to the occupation, he would probably not have been trusted by them had he been overtly working with Wolff.)

Dulles himself first met Wolff (unaccompanied) over a Scotch in Zurich on 8 March 1945. Dulles decided to trust him after Wolff had, at his request, released two specified political prisoners; a gesture which Dulles later reciprocated. It was far from clear to Dulles that Wolff could in fact deliver a German surrender, as the forces he actually commanded were few and limited to the north-east of Italy (his HQ was in Bolzano). But Wolff was confident he could persuade Kesselring and the other commanders, believing that they wanted to end the war but were afraid to be the overt leaders of a revolt against Hitler – an act still regarded by some as against the traditions of the military. Rommel, in overall command of the Western Front, argued in favour of retreat in Italy to a line from La Spezia to Rimini; but Mussolini, outraged, appealed to Hitler, who relieved Rommel of his command and promoted Kesselring to the command.

Wolff met Kesselring in Frankfurt on 19 March, stressing that Himmler did not know of his actions. Kesselring decided he could not agree with Wolff's plan to surrender on the whole Western Front, as he did not have sufficient control over the individual commanders. But he acquiesced in the surrender in Italy. Kesselring's successor there, Vietinghoff, was judged to be 'without imagination' but he seemed to show enough interest in Wolff to arouse suspicion in the High Command (terrified of a repeat of the First War accusation of the generals' betrayal of the Fatherland) and was immediately suspended, which brought Kesselring back into the picture. Back in Germany on 19 April (by Wolff's own account) Hitler was non-committal on the idea of trying to end hostilities, while Himmler explicitly forbade any further trips to Switzerland under threat of *Sippenhaft* (a nasty practice whereby families of suspected traitors were detained). Wolff decided not to be diverted. But much time had already been wasted.

The stop-go on the German side was if anything exceeded by the Allies. When, respecting the Soviet Union's Allied status, the Russians were informed of the contacts to bring about a military surrender in Italy, they went ballistic. With Churchill's support Roosevelt ordered that the contacts cease, and Truman was equally suspicious when he inherited the presidential mantle after FDR's death on 12 April. But the momentum was such that contacts did continue under the guise of a Swiss initiative and finally the green light was given from Washington on 23 April for emissaries from Wolff to proceed to Caserta (Allied Forces Headquarters – AFHQ) to sign a surrender document. This they did on 29

April, but it took them 36 hours to get back to Bolzano via France and Austria. Wolff, who had had a narrow escape in an attack by Italian partisans on his way back from Lugano to Bolzano (rescued by an OSS officer), found himself faced with a serious struggle to get the generals (and Hofer, the *Gauleiter* of the Bolzano Province) to agree. He finally persuaded Kesselring to authorise the signature, but only after he had effectively sealed up the HQ with his tanks and news of Hitler's suicide had got out.

The end of the war in Italy on 2 May 1945 preceded by only a few days the general cessation of hostilities; but Wolff and Dulles could probably claim with some justice that they had saved many lives in Italy and that they encouraged German commanders in other theatres as well as the High Command that the time had come to end the war. Wolff was also proud of his role in ensuring that many artistic and architectural treasures of Italy were spared the destruction ordered by Hitler (e.g. the historic centre of Orvieto, including the cathedral, perilously close to the strategically important railway lines, which Wolff ordered should as far as possible not be used for warlike purposes);[16] and that the hiding places of many looted or hidden works of art, such as those from the Uffizi and Pitti galleries in Florence (and gold) were revealed to Dulles, so that they could be properly taken into custody rather than subjected to the general looting of victorious soldiers and civilians alike. In a manuscript letter to one of his interlocutors containing this information he included in the list some works which were his own property and revealed the whereabouts of some families of SS officers (on the shores of a lake in Austria), including his own wife and children.[17]

<p style="text-align:center">⋆ ⋆ ⋆</p>

Such a narrative is not the place for any sort of comparative, detailed analysis of the German occupation of Rome and the rest of Italy north of the Allied line or attribution of responsibility. Many other more expert historians have been busy at that task since the end of the Second World War, and much careful work is still being done. The need to plan for occupation of Italy was not foreseen, and the reality was not well organised. But the savagery and brutality of much of the occupiers' behaviour towards the local population cannot be seen as simply the actions of officials (in or out of uniform) low down the chain of command dealing with the unexpected in a disorganised framework. Most of the senior figures who have populated these pages were aware of what was being done in the name of the German Reich and could not avoid some share of responsibility for those actions. Some, of course, were leading perpetrators. The confusion in lines of command may have increased the degree of randomness with which brutal violence was used, but randomness was a feature of many German reprisal actions in occupied Europe. Incompetence, lack of training and lack of manpower must all have played a part too. But the sense that the end justified the means ran through many of the decisions and judgements made by even the most senior in the military and particularly in the world of the SS/SD – as it had indeed been a hallmark of the true believers in the Thousand Year Reich from the start.

Yet the row over the Moellhausen telegram's use of the word 'liquidate' suggests that some at least in the hierarchy retained a lingering awareness that extermination of the Jews was widely regarded as 'wrong' and therefore to be concealed. And Moellhausen's own actions – even allowing for his atypical origins – suggest that a few people in the system were prepared to take risks when they saw an opportunity to mitigate the savagery of the actions required by those ultimately in charge. Of course thousands of Romans and other Italians also took risks on a far greater scale in attempts to shield from the occupation authorities the Jews, resistance fighters and Allied POWs on the run. And the absence of serious action within the German hierarchy to put a stop to the regime's brutal methods,

in Italy as elsewhere, to say nothing of the response to the failed attempt on Hitler's life in July 1944, merely demonstrated to would-be opponents the scale of their own risk-taking.

Moellhausen is the only relatively prominent player who retained a connection with the Villa Wolkonsky throughout the occupation of Rome. The fact that he alone stuck his head above the parapet (accidentally or otherwise) and survived cannot lead to the conclusion that the Villa Wolkonsky was in some way an island of morality in a sea of viciousness. As noted above, all the main figures who worked or gathered there would have shared the knowledge of and in many cases responsibility for the actions later rightly denounced as crimes. So we can readily understand how the secretive Villa became tainted by its association with the brutality and violence perpetrated by the occupying power. But that does not make it a place where such horrors were routinely committed. Had it been so, the Allied forces who entered Rome in early June 1944 would surely have found evidence when they subjected it to a thorough search.

Notes

[1] AA files R 128218 1942–44, 132, 43 & 47. Moellhausen telegram to AA of 15 Nov. 1943.

[2] Much of this section draws on the records of Kappler's interrogations by the Allies in 1945 in the UK National Archives (TNA files WO 204/6321, 204/9917, 235/336, 204/12798, 204/943, 264/13034, 204/907).

[3] One generally well-researched history (Majanlahti & Guerrazzi, pp. 84–9) states that Priebke had held and interrogated detainees in the semi-basement rooms of the Villa Wolkonsky before the creation of the SS prison in via Tasso, i.e. before 10 September 1943; but no evidence is offered for the claim.

[4] In 1954, according to a contemporary press report (quoted in Klinkhammer) it was discovered that Kappler also had a 'safe house' with his own wireless communications to Berlin in a monastery of a Georgian Benedictine Order near the Vatican, thanks to a monk known as Father Michael Basilius. The location suggests it may also have had something to do with Kappler's efforts to create a network within the Vatican, where he firmly believed the Irish priest O'Flaherty was a key source for British intelligence.

[5] Indeed Napoli (op. cit.) claimed he travelled that path in April 1944, being re-arrested and taken first to Moellhausen and Kappler at the Villa – he does not say that he was tortured – before being moved to via Tasso.

[6] According to Moellhausen they were South Tyrol police, of insufficient quality to be sent to the front, who had only recently arrived in Rome.

[7] But Moellhausen did state that on the evening the order was received he had learned of it from Kappler and had gone to his office (location not given, but possibly in the Villa Wolkonsky) to try to persuade him not simply to round up anyone he could lay hands on; Kappler had responded that he would spend the night combing through the files and would not commit any acts of injustice.

[8] TNA: WO 204/12798.

[9] In a unit involved in interrogation of prisoners, known opaquely as Inf. CO SCI/Z.

[10] TNA: WO 235/366.

[11] TNA: WO 235/366. At the end of the war Kesselring was arrested and interrogated on suspicion of having committed war crimes through various orders he issued on treatment of the population in occupied Italy. This did not go down well with the elites in London and Washington, who regarded Kesselring as one of the few senior German commanders who were not so tainted. But the fact that the Ardeatine Massacre was committed in his area of responsibility and by officers under his command meant he had to be investigated. He was duly committed for trial on that charge and on a second more general one: 'inciting and commanding German forces under his command to kill Italian civilians as reprisals'. In spite of the political opposition his trial took place before a military court which assembled in Venice on 2 February 1947. He was found not guilty on the first charge (which left the finger pointing at Generals Mackensen and Mälzer) but guilty on the second, and initially sentenced to 'death by being shot'. After a submission of the proceedings by the Judge Advocate-General, Sir H.D. Foster-MacGeah, the death sentence was commuted on 3 July by Lt. Gen. Harding

ing (General Officer Commander in Chief Central Mediterranean) to a sentence of life imprisonment (meaning 21 years with effect from 6 May 1947). He was held in the military prison at Gaeta near Naples. The wheels, however, continued to grind in his favour, particularly in London, and on 23 October 1952 the Queen approved the suspension of his sentence, and he was released.

¹² Wolff's action in surrendering also the Italian Fascist forces was backed by the proxy letter he had from Marshal Graziani, the Italian defence minister and C-in-C, dated 26 April 1945. See https://commons.wikimedia.org/wiki/File:Graziani_Proxy_German.jpg#/media/File:Graziani_Proxy_German.jpg.

¹³ Moellhausen's appreciation of Wolff's role is not wholly favourable. While he acknowledged that Wolff took big personal risks with Hitler and Himmler, he questioned whether Wolff's motives were more a matter of self-preservation than a principled intention to save lives and spare destruction. The Americans' change of heart after Roosevelt's death and the difficulty Wolff had in persuading the leading generals to agree to the surrender resulted in a delay which much reduced the potential significance of his actions. Moellhausen, pp. 439–80.

¹⁴ The saga of looted art treasures is fully documented in file at TNA (and elsewhere) such as FO 1020/2766, T 209/28.

¹⁵ Around this time Himmler was losing his standing in Hitler's entourage and may have been hedging his bets in his ambiguous attitude to Wolff.

¹⁶ TNA: WO 204/13034: Report from British Resident Minister in Algiers to the Chief of Staff dated 6 May 1944, passing on news from the Vatican of this order from the Locarno Command, viz. Wolff:

'Last February the Secretariat of State of the Vatican wrote identical notes to the British representative and the German representative drawing their attention to the artistic value of Orvieto and of its cathedral and asked them to impress upon their respective governments the importance of the city being spared any action which might endanger its religious and artistic treasures.

2. The British representative now reports having been informed by the Vatican that the German representative has replied to the effect that the German High Command would do its best "as in the past" to preserve from the effects of war all towns of special historic and artistic importance but that they could give no particular guarantee in respect of Orvieto which was on an important railway. The German representative had however added that the Locarno Command had "spontaneously taken the initiative" in ordering that the upper part of the city where the cathedral stood should so far as possible not be used for warlike purposes.'

¹⁷ TNA: FO 1020/2766 Art Treasures in Austria. Folios 24 A & B + photos.

14.
ROME LIBERATED:
THE FATE OF THE VILLA WOLKONSKY

The Allies capture the German Embassy

The Allies' advance on Rome, when it finally came, took place against a background of vigorous political argument about whether Rome should be declared an open city, with Churchill refusing to agree, as it would undermine the ability of the Allied forces to defend themselves if there were a German counterattack. In effect, however, the Germans decided to leave the city rather than defend it. When the first Allied units arrived during the night of 5/6 June (a beautiful moonlit night for those driving to Rome through the countryside from the south) they found an eerie quiet, little sign of damage, few fires and a populace clearly uncertain about what was happening.[1]

When it became clear that Rome was now in Allied hands, there was a natural, but restrained feeling of relief, and the troops were duly welcomed. But this welcome was threatened by the unruly behaviour of many of the Allied soldiers. Their drunken and destructive rampages were contrasted in the Roman press with the comparatively disciplined behaviour of the occupying German soldiers (which was at times hardly a model), causing some concern to the Allied commanders.

A key component of the Allied forces which entered Rome on 5 June 1944 was a joint US/UK Special Forces unit known as S-Force.[2] After an earlier existence in Tunis in May 1943, it had been re formed in January 1944, with its HQ at 5th Army HQ in Caserta and a training base at Baia, in the expectation that the Allied landings at Anzio would quickly lead to the advance on Rome. Its task was to enter Rome with the main force, to identify and then take over key buildings in the city, to arrest German agents and others on a list of people likely to threaten the Allied forces, and to capture documents. It had researched and trained intensively for six weeks; and had set up a network of potential guides and helpers through the Allies' own intelligence services. When it became clear that the road to Rome was far from open (as the Allies slogged their way north past Cassino and got bogged down around Anzio), the unit was disbanded on 23 February, but for a skeleton staff. On 23 May it was reconstituted and on the evening of 29 May set sail from Naples, landing the next day at Anzio.

S-Force entered Rome with the advance units of the main force on 5 June, setting up its operational HQ in the Pincio Gardens on the northern flank of the city. Its secret briefing included a list of all official German and Italian buildings in Rome. Its sub-units immediately spread out to pre-planned command posts in their various zones within the city, each with its list of target buildings and persons. The operation's report records that they took 249 intelligence targets prisoner and dealt with 332 buildings of which they retained control of 61 under guard. Among the prisoners were '2 German diplomats' (no further information). Diplomatic premises were to be treated with extra care under S-Force's general orders: 'All German offices may be searched except the German Embassy in Rome.'

On the target list the entry for the Embassy (Fig. 14.1) contained the order: 'Place under exterior guard. Do not enter grounds or building for any purpose. Arrest all persons attempting to enter or leave. (Do not discourage such attempts.)' They acted accordingly on 6 June.

190	NAV/3	Classification of Merchant ships. Probably one floor in a very large building.	Seize and hold.	
—	NAV/2	Company for the construction of seaplanes. This is the company office, an apartment in a large private house.	Seize and hold.	*190*
				191
192	DIP/3	German Embassy. Consists of one or two villas in large park surrounded by walls.	Place under exterior guard. Do not enter grounds or bldg. for any purpose. Arrest all persons attempting to enter or leave. (Do not discourage such attempts.)	*192*
193	NAV/4	'FINMAREI. Society for financing shipping Co.'s. Modern bldg, has offices in large block of offices.	Seize and hold.	*193*

Fig. 14.1. Part of the target list of buildings in Rome for Allied Special Forces to take over on their entry into the city in June 1944; the German Embassy is at 192 in the centre of the page.

Intelligence quickly came to them that required them to act rather differently. The German Embassy was 'entered for cause' on 8 June – an operation of which a full report was made to the US State Department and the UK Foreign Office through Allied Forces HQ. The unit responsible for making secure the German Embassy – a high-priority target, given what was suspected about the use to which it had been put – was 30 Commando under the command of a (UK) Major Ward. On the morning of 8 June (as recorded by the Swiss Legation) he and his second-in-command presented themselves to the Swiss Foreign Interests Section and informed its head, Ruber, that Rome Allied Command had reliable intelligence (probably given to the US units in that sector of the city which first secured the Embassy externally) that there were explosives hidden in the garden of the former Embassy: in the interests of the safety of the neighbourhood they intended to enter and search the grounds. They were not asking permission. Any possible breach of diplomatic immunity was justified in view of the use that had been made of such privilege. They did however invite the Swiss to observe the operation and ascertain the extent of the violation committed.

The Swiss expressed reservations but agreed to be at the Villa Wolkonsky at 1 p.m. Mr Carlo Somaruga and Captain Leonardo Trippi duly turned up. The S-Force intelligence was obviously good. The report is silent on the identity of the informant, but it could well have been one of the gardeners, still in situ.) The unit was led straight to an iron door, giving access to a cellar built into the aqueduct described in the military account of the operation as 'the Roman Wall', see Fig. 14.2). The door was forced, and Captain Trippi was invited to enter first, to ascertain and witness whether the intelligence had been correct. He bravely did so and was lucky that there seems to have been no booby-trap. He reported not only that there was indeed a quantity of explosives and other munitions in what proved to be a cellar but that from the strong odour they were very unstable and dangerous. The main part of the find was plastic explosive, loosely packed in containers similar to 'airborne' containers; while Italian box mines and German stick grenades were encased.

Major Ward decided that the explosives must be removed immediately. Captain Shaw and his men worked far into the evening to stack them up outside, and they were left under guard for the night. On 9 June, given their volatile condition, Major Ward decided they must be taken by one of the unit's vehicles to be sunk in deep water in the Tiber. When some three-quarters of the munitions had been loaded, some of the remaining incendiaries began to burn. The driver of the vehicle, now loaded with explosives, drove it 100 yards off just in time. But explosions and fire

Fig. 14.2. A British Special Forces soldier in the entrance to the explosives store discovered under the aqueduct at the Villa Wolkonsky on 8 June 1944.

followed, and the team ran for cover just before the rest of the plastic explosive and the other charges went up. The fire near the entrance to the cellar set off the small arms ammunition, producing a hail of bullets in all directions. Fortunately no one was hurt, either within or outside the grounds. The fire was put out, and the vehicle was despatched to dump the main body of the explosives in the Tiber. One side effect of this incident was that the whole neighbourhood would have been left in no doubt of the extent to which the Embassy's diplomatic immunity had been abused.

Major Ward thereupon informed the Swiss that what had already been found clearly indicated a serious abuse of diplomatic privilege and meant that the whole property would have to be searched, not least for public safety reasons. Diplomatic papers would not be removed (but would be photographed); other papers and any unusual items would be taken into custody. The premises would be returned to the Swiss (who were invited to observe the search) when the search was over. It began the next day, 9 June, and ended on the 23rd, when a report was prepared. Further plastic explosives were found in 'underground passages, possibly leading to the catacombs' – possibly a reference to the excavations on the site, especially the colombario of Tiberius Claudius Vitalis, but maybe also a reference to disused water channels known to exist near the aqueduct.

Nothing of interest was found in the Residence (villino). A full inventory of the contents of the Villa was also attached to the report.[3] In the offices (casino) 'nothing unusual' was found in the six or seven safes which were forced.[4] Most of the other buildings likewise yielded nothing of interest. Figs 14.3 and 14.4 show the lists of explosives, equipment and documents found, the latter two categories almost entirely from one of the huts, which had turned out to have been a radio station (Funkstelle) containing radio transmitting and receiving equipment and a few documents – as well as private papers of some of those who had worked there, which enable them to be identified as SD radio operators/instructors (Fig. 14.5). The section of the report relating to this hut is worth quoting in full.

Material of interest to SCI found in German Embassy.

1. Training schedules, frequencies and call-signs for the W/T operators of an organisation of spies and saboteurs which was to function in the Rome area after the withdrawal of the German forces. The names of the W/T agents were already known to us and the documents merely provide confirmation that their training had been directed from the Funkstelle in the Embassy.
2. Chemicals and engraving materials used by Dr. Polidoro Benvenuti, known to have been employed for some time by the Sicherheitsdienst in the preparation of sympathetic inks, false stamps, and

```
        INVENTORY OF DOCUMENTS AND EQUIPMENT TAKEN FROM
        THE GERMAN EMBASSY, ROME.  PERIOD - 8TH - 23RD JUNE.
        ------------------------------------------------------

        Explosives.

        1.      1,400   lbs Plastic Explosive (Nobles).
        2.         80   Incendiaries (Various).
        3.          2   Drums Cordtex.
        4.          2   Drums Safety Fuse.
        5.         40   C.E. Primers.
        6.         50   Limpets.
        7.         20   Clams.
        8.         65   Flower Pots.
        9.          3   Drums Miscellaneous Explosives.
        10.         4   Boxes Matches Fuses.
        11.        36   'L' Delays
        12.        40   German Stick Grenades.
        13.        10   German Egg Grenades.
        14.        15   Prepared charges.
        15.        25   Italian Wooden box mines.
        16.         8   Electrical Detonators.
        16A.        4   Plastic charges placed in lumps of coal
                        for sabotage purposes.

        Radio Equipment.

        17.    -    1   Transformer 300 Watt.
        18.         1   Allocchio-Bacchini & 60 Receiver type 0-0-9.
        19.         1   Receiver type ARAT SAFAR.
        20.         1   Transformer Nedovielli Moussean 220-1220 Volts.
        21.         1   Rotary Converter Ercole Marelli Type RAC C/100/4
                                500-1600 volts    27-230 volts.
        22.         2   Italian Westinghouse 'Raddrizzatore' mains
                        Transformer.
        23.         2   German Filter.
        24.         2     "    Transformer (mains).
        25.         1   Transformer Rectifier SAFAR.
        26.         1   Allocchio-Bacchini wavemeter.
        27.         1   Italian agents Transmitting & Receiving set.
        28.         2   Italian Transmitting & Receiving Sets.
        29.         1   Receiver AR 5 (Italian Air).
        30.         3   Dual Frequency Transmitter Allocchio-Bacchini RA 350.
        31.         1   Italian Transmitter Allocchio-Bacchini.
        32.         2   Small Receiver & Transmitter.
        33.         1   Receiver Allocchio-Bacchini type 0.C. 9.
        34.         1   VHF transmitter.
        35.         1     "  receiver.
```

Fig. 14.3. The list of explosives and radio equipment found in the German Embassy by Allied Special Forces, June 1944.

faked documents for the use by agents and persons seeking to conceal their identity from the Allied authorities.

3. Account books showing the quantities of valuables taken from Jews and applied to Sicherheitsdienst funds (Note: I gave this to U.S. Navy to be photographed.)

4. Personal mail of members of Kappler's staff which showed in fact that they were all personnel of unit F.P. 13563, in other words the SIPO and SD unit which controlled Rome and ran the prison at the Via Tasso and the sabotage school at Viale Rossini.

(Above for Major Ward: To be included in 30 Commando report to Mr Caccia). GKY

is hut was the hub for a network of informers around the city of Rome, set up during the occupation ossibly even beforehand) by Kappler, in his efforts to monitor and defeat resistance to the German esence and, after the Allies' arrival, to provide a network of agents to make life difficult for the lib-tors. The agents were trained in the hut and then communicated with it on their individual radio

Fig. 14.4. List of documents found in the German Embassy by Allied Special Forces in June 1944.

sets. Nearly all the sets for the agents and the station's staff were specially made for Kappler by a Italian radio designer, Allocchio Bacchini.

While the hut and its contents were further evidence of abuse of diplomatic privilege, the offici report of the inspection, like the general inventory of items found on the site, contain no reference signs of prisoners having been held or abused anywhere on the premises. But the list of items interest in the hut suggests that, at least in the early weeks of the occupation, Kappler himself m have still been using his old office at the Villa. In his interrogation in 1945 he said that all his pape had been destroyed before the Allies' arrival: the fact that the documents about Jewish possessio: were still in the Villa seems to indicate on the other hand that he did not use any such office mu after October 1943.

A formal Note from AFHQ to the Allied Control Commission (ACC) dated 24 June 1944 record that the Embassy had been handed back to the Swiss that day, and stated bluntly that 'the Germ Embassy by using its premises ... forfeited all claims to diplomatic immunity for the properties the German Embassy in Rome'. Nonetheless the Swiss, as protecting power, took over th responsibilities and put in a custodian, Vogel, who took up residence in late June. On 4 Septeml 1945 the Swiss were relieved of their responsibility, and custodianship of 14 official Germ buildings in Italy was transferred to the Italian government as 'trustee for the US, UK, Russian a French governments'.

The archives still in the Embassy were collected by the ACC on 5 September and made available the Allied Research organisation in Rome.

According to the Museum of the Liberation the Allied Special Forces – in this case a US-led uni only began to inspect the premises in via Tasso made notorious by Kappler and his subordinates on

une 1944. Meanwhile Romans had taken the law into their own hands. Remaining prisoners were set free, and papers and other evidence were burned or strewn across the roadway.[5]

Assessing the abuse of diplomatic privilege

What is absent from the carefully recorded reports about the inspection and custody of the Villa is any evidence that the property was itself a place where acts of villainy, repression and brutality were routinely practised – and they would have been on the lookout for anything of that nature. Later accounts alleging 'blood on the walls of

Fig. 14.5. One of the huts – a radio station – in the grounds of the Villa Wolkonsky, June 1944, the inscription showing that it had been used by section D of Abteilung IV of the SD.

the cells in the basement' found no echo in the reports of the search and inspection of the property made by the Allied Special Forces in the days and weeks immediately following the liberation in June 1944.

Claims of mass graves in the 'woodland' part of the grounds hold no water.[6] Stories of tunnels to other parts of the city ignore the terrain and the obstacle presented by 8–10 metres of Roman aqueduct below ground level, to say nothing of the short duration of the occupation in relation to the time required to excavate such tunnels. The Special Forces' reference to the 'catacombs' indicated that they located the tomb excavated by Prince Alexander in 1866, but they made no mention of signs of recent workings. The tomb would by then have been in poor shape: it needed restoration after the British took over the Villa, but the works then neither involved nor revealed tunnels leading off underground. The 'cells' are nothing more sinister than the two storerooms equipped with bomb-proof and gas-proof doors in 1943.[7] The doors of those rooms open outwards into the corridor with handles on the outside.

A curved space in the basement under the main driveway and entrance portico to the *villino* is protected by a crudely made open-work iron grille gate which locks. This has aroused interest among those looking for evidence of cells and tunnels. It could at a quick glance be taken as the approach to a tunnel but is only the curved and diminishing storage space underneath the sloping approach driveway to the main entrance of the building, which had been enlarged and strengthened in the 1939–40 expansion project. But post-war attempts to dig into the ground at the end of that space yielded no evidence of any tunnel beyond what is visible today. That whole project was, of course, focused on the grandeur of the German Embassy, at a time when victorious Germany was sweeping all before it: there was no sense of any need for secret tunnels, for escape or for nefarious purposes connected with occupation; an occupation for which the Germans had been unprepared, just as the Embassy was caught by surprise by the demise of Mussolini and the Italian switch of sides (and by the need for gas-proof bomb-shelter doors).

Domestic staff at the Villa have claimed (to the author) to remember an occasion when one or more of them accompanied others down a tunnel from an uncertain starting point which became too wet and low after 50-odd metres for them to proceed. That does not sound like the water-channel built by Sixtus V (described in Chapter 1), nor does it smack of a workable escape route. The cheap looking construction of the gate in the basement does not reveal anything about when or for what purpose it was erected. If it was made at the time of the major renovation of 1939–40 (or soon after it) it could have been intended as a safe place to keep the German ambassador's valuable stocks of food and wine, etc., or other pieces of equipment which might have had value in wartime Rome, given that the basement area was fairly openly accessible to outsiders delivering to or servicing the Residence. In its current state it contains much antiquated electrical wiring and fixtures of unknown age and origin, which offer no obvious clues. But, if the gate is indeed a wartime construction (rather than erected by the British after 1947) it cannot be excluded that the space behind it might on occasion have been convenient for a detainee to be held there – as one can say of the other storerooms in the basement – before being transferred to the via Tasso security prison. But there is however no account, apart from Napoli's tale, of any prisoner having had that experience, even in the Museum of the Liberation's extensive archive of the experiences of those who were detained there.

The Allied Special Forces' discovery that one of the huts had been a radio station and training location, in which staff had left much personal property and papers, clearly pointed to one particular type of activity on the property, continuing right up to the end of the occupation. And their discovery on day one of their search that the grounds contained quantities of explosives and ammunition in volatile state indicates an intention by the occupants either to conduct sabotage and other hostile actions or to defend the property – or even to blow it up – in the event of Allied attack. Both find strongly suggest that the occupants in fact left in a hurry with little or no time to tidy up. It seems unlikely that they would have had time to clean up the traces left by brutalised prisoners but not to collect their own belongings and expensive equipment which could still have been used – even if they were happy to leave the explosives behind to catch the unwary.

This writer is therefore inclined, on the basis of the evidence so far available, to conclude that the Villa Wolkonsky was not a place of systematic or routine imprisonment, abuse and torture (let alone linked by secret tunnels to escape routes or other German buildings), but that it cannot escape association through its leading occupants with the wider regime of misdeeds and crimes committed in the name of the occupation. Its reputation during that occupation rests more on mystery, rumour and fear than on any evidence for the practice of acts of inhumanity within its high walls. But its use as military HQ in the early weeks of the occupation and its demonstrable use as a radio station/school for the Germans' spy network were sufficient to provoke the Italian government's sequestration of the Embassy at the end of the war on the basis that it had been used by the Germans for activities out with the Vienna Convention on Diplomatic Relations.

The Villa after the liberation

While all the rough action of occupation went on after the Embassy was formally closed on 9 September 1943, the administrative machine of the mission under Moellhausen continued to function in parts, thanks largely to a few loyal (but unidentified) locally engaged Italian staff. On 22 September the Italian gardeners were officially downgraded to 'helpers', apparently to make it possible for them as very lowly workers to remain employed in the garden without being regarded as security risks

Later in the winter Pannwitz in Berlin sought from the dispersed staff an account of the actual spend in 1943, acknowledging that some items might not have been completed. By 15 March 1944 responsibility for expenditure on the Villa had been devolved to Rahn in Fasano.

After the Allies entered Rome in June 1944 the Germans expected to rely on the Swiss protecting power in Rome for all dealings over the Villa Wolkonsky. In Berlin the Foreign Ministry on 23 June recorded that there were still eight Italian employees there, and arrangements were made through the German mission to the Holy See to continue paying them (presumably with the help of the Swiss). The Swiss formally assumed their responsibilities for 11 properties in Rome, including the Villa (see note 9) on 24 July 1944, the day after the Allied inspection of it had finished. They reported that the buildings had been searched by the Allies for explosives (without saying whether any were found). They undertook to report 'periodically' on the state of the buildings did not do so very often.[9] The Villa Wolkonsky had no function after the Allied liberation, and the Swiss formally looked after it until it was confiscated by the Italian authorities after the war, among other enemy properties.

The Swiss also noted the increased workload they would have from the need to protect 358 named Germans in Rome. A German Interests Section of the Swiss Embassy was set up in the German Archaeological Institute. In November and December 1944, the bureaucracy in Berlin was still trying to tie up loose ends in the minutiae of the Embassy's finances. Eight telephone extensions seemed to be missing: Mertz (in Fasano, under Rahn's command) explained that they had been on loan until eight new white ones arrived, when they were transferred to the 'Baracken' (huts, by then containing mainly ancillary services'). After that notably trivial exchange, the Villa seems to have dropped out of the sight of the remaining officials in the Wilhelmstrasse. Berlin was under constant Allied bombardment from the air, the Soviet army took Warsaw on 17 January 1945, and they had more important priorities.

Notes

[1] Reports by Major Manley, Chief Political Information Officer, Psychological Warfare branch, 6 June 1944; TNA: WO 204/6321.

[2] This account is taken from TNA: WO 204/943, 264/13034 and 204/907.

[3] Unfortunately the interesting parts (furniture and furnishings) are all lumped together rather than being listed room by room.

[4] As 'archives' were later returned to the Swiss protecting power, it is safe to assume that they were all photographed; but I have not found any report on the contents.

[5] The departing Germans had removed most of them, but some were murdered by the via Cassia as their guards headed north.

[6] There were in my time – both in the 1970s and the 2000s – and still are (2019) a few pet graves.

[7] As demonstrated by the documents relating to their purchase at a moment when the NSDAP office had asked the Embassy to obtain such protection for its staff in the office in the centre of the city.

[8] Document of 21 October in AA file: R128218. The two German gardeners (C. Erb and Hugo Arnold) had turned to Germany with the rest of the staff in September.

[9] The British Military Intelligence transcript of the Swiss list (classified SECRET), with original spellings, is:
 'LIST OF GERMAN-OWNED PROPERTY IN ROME

1. DEUTSCHE BOTSCHAFT (Quirinal)	Via Conte Rosso 25
2. EHEMALIGE ORSTERREICHISCHE GESANDTSCHAFT	Via Pergolesi 5
3. EHEMALIGE TSCHECHOSLOWAKISCHE GESANDTSCHAFT	Via Maria Luisa di Savoia
4. VILLA MASSIMO (ARHOLDSCHE STIFTUNG)	Via Nomentana

5. VILLA MASSIMO	Via Boiardo
6. ARCHAEOLOGISCHES INSTITUT	Via Sardegna 79
7. HISTORISCHES INSTITUT	Viale Martiri Fascisti
8. KUNSTWISSENSCHAFTLICHES INSTITUT	Palazzo Zucchari
9. DEUTSCHE SCHULE	Via Savoia
10. VILLA AMELUNG	Via di Villa Patrizi
11. DEUTSCHES EVANGELISCHES DIAKNOISSENHEIM	Via Alessandro Farnese 18'

The list omits the via Tasso SD prison/interrogation centre, which was originally rented from a noble family, but it is implicitly covered by the entry for the Villa Massimo in via Boiardo, which the Germans presumably expropriated.

15.
A 'TEMPORARY' HOME FOR THE BOMBED-OUT BRITISH

Before the Swiss left the Villa Wolkonsky the Prefect of Rome had placed it under a sequestration order on 8 June 1945. The sequestrator was named as Felice Della Monica.[1] After the Allies (including the Italians) had agreed to set up the Allied Control Commission (ACC), with responsibility for all German assets abroad, the Italians formally handed control to the Commission's Italy committee, which agreed early in November 1946 to the use of the *casino* (ex-German Chancery) as a Red Cross staff hostel. The Italian Treasury was also given permission to store its archives in the Residence. But suddenly there was a more pressing need. In an eerie parallel to the German experience after the First World War, the British found themselves, in an instant, in need of a new embassy, but not for the same reason.

1872: A new British embassy after the move of the capital to Rome

With the arrival in Rome of King Victor Emmanuel and the court, embassies moved in too. In 1872 the British government rented from a Baron Reinach the Villa Bracciano, on via XX Settembre by Porta Pia. It was not large, and other accommodation had to be rented for the Chancery. In 1877 the British government bought the building at a cost of £21,180. A further £17,300 went on alterations and enlargement; and £5,000 on furnishing the 'state rooms'.[2] The following year it was extended (in a matching style) to house the Chancery (Fig. 15.1). In 1882 part of the land still rented from the original owners as garden land was bought for £6,015, bringing the total owned estate to 6.5 acres and allowing it to extend up to its present south-east boundary, where a new road (via Montebello) was being built. An office/service block was built in the garden in 1921.[3]

The 1882 purchase was not without controversy. A young attaché, (later Sir) Gerald Portal, wrote to his mother in April that year complaining that the government was 'going to allow the Embassy to lose half its garden in the name of economy'.[4] Portal claimed that the government could have originally bought all the garden land for £12,000; it had bought half, for £8,000, and rented the rest. The remaining half was now valued at £22,000, as it was to be sold as building land. The Treasury had been prepared only to buy a small strip, to bring the embassy property up to the frontage on the new street to be built at that point, and had offered £6,000 while the owners were asking £7,200. So the Embassy was getting only £6,000-worth and having to allow housing to be built on a rectangular plot on the remaining part of the frontage to the new street.[5] As a result the privacy of the garden would be destroyed, and a wood was to be cut down on the land to be built upon, including a 300-year-old avenue of ilex trees. Nothing on the Rome diplomatic estate has ever been simple!

The Villa Bracciano was never much loved by its occupants, not least for the noise and pollution of its very urban position. The ambassador and staff were able in summer to escape to the Villa Rosebery at Posillipo near Naples, its use being a gift of the Rosebery family. But in the mid-1920s

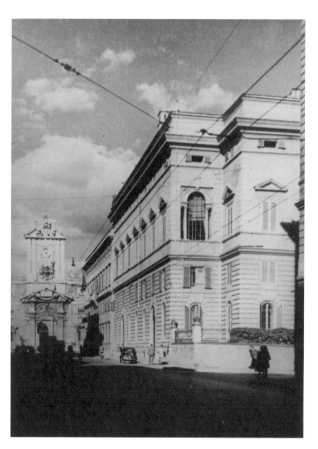

Fig. 15.1. The Villa Bracciano at Porta Pia, showing the British Embassy Residence (foreground) and Chancery (offices, beyond) before its destruction in October 1946 by a Zionist terrorist bomb.

the ambassador of the day felt constrained to give up the Embassy's possession of it, on the grounds that the Embassy could no longer fulfil its functions efficiently from so far away (in summer) and the annual cost of upkeep could therefore not be justified. So it reverted to the Rosebery family.[6] Thereafter, with the growing pace of work, as Mussolini's Italy became ever more wayward, serious consideration was being given to moving elsewhere because of the inadequacies of the property.

Returning to Rome after the liberation in 1944, the UK reoccupied its old embassy (Figs. 15.1 and 15.2a–d), initially as the seat of its representative on the Advisory Council responsible for administering liberated Italy. To begin with that responsibility was combined with that of the British minister in Algiers, Harold Macmillan. But by March 1944 as the Allies progressed northwards towards Rome, Anthony Eden, the Foreign Secretary, appointed the experienced figure of Sir Noel Charles as High Commissioner in the role, formally under Macmillan's supervision, soon to be resident in Rome thus sparing Macmillan the need to travel frequently to Italy. Following the re-establishment of direct relations with Italy in January 1945 Charles assumed the title of 'H.E. Ambassador Sir Noel Charles, representative of the government of Great Britain', in cumbersome recognition of the fact that Italy did not yet have the benefit of the sovereignty to be restored by the Peace Treaty, thus precluding full diplomatic relations.[7] His deputy (minister) was d'Aubigny Hopkinson and his commercial minister was Nosworthy.[8] A Major Fleming was responsible for Military Liaison and there were nine other UK-based staff. With the formal end of the war, the formation of a new Italian government and diplomatic relations, Charles became the first post-war ambassador and the staff numbers increased.[9]

The additional staff Charles needed to fulfil the responsibilities first of the occupation and then of implementation of the Peace Treaty (including fraught issues like the status of Trieste) meant that the offices were inadequate, even with the 1921 additional building at the eastern end and some huts. In addition the contiguous residence, hard on what had become a major thoroughfare, came to seem ever noisier and dirtier, even if still elegant in a faded way. And the Rome authorities had not abandoned their plan to widen the street at precisely the Embassy's location, to open up a proper vista of Michelangelo's

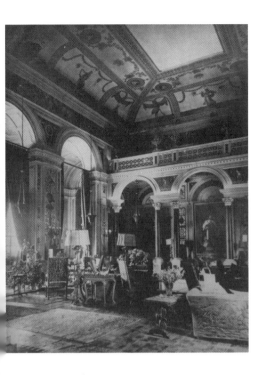
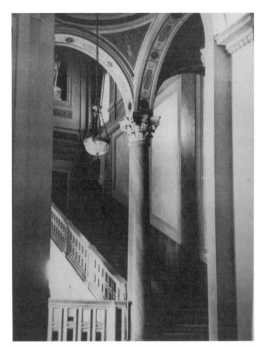
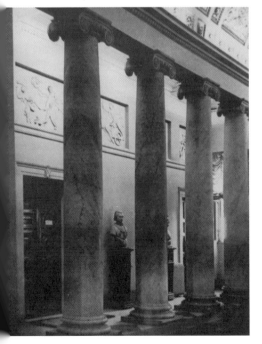
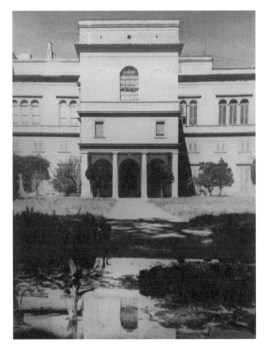

Fig. 15.2a–d. Villa Bracciano: (a) the main reception room, (b) grand staircase and (c) hallway with columns, and (d) the garden side before their destruction in 1946.

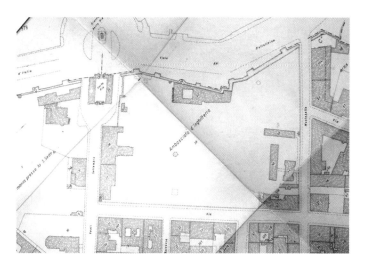

Fig. 15.3. A section of the official Rome City map showing the post-1921 layout of the British Embassy at Porta Pia: Aurelian Wall zig-zagging across the top, Residence and Chancery on the left, additional offices on the right, with the tenement block in the bottom-right corner of the plot.

Porta Pia. So it was agreed that a new residence should be found and a new office be built in the garden, using both office and residence premises as offices in the meanwhile (Fig. 15.3). Charles restarted the pre-war hunt for a new residence – with some optimism, given the likelihood that the fortunes (or misfortunes) of war would have induced owners of suitable properties to contemplate selling or renting. In the meanwhile he took lodgings in the Palazzo Sermoneta (ex-Orsini),[10] so that both parts of the embassy building could be given over to offices.

In practice there was surprisingly little suitable property available. The French had set the standard with the Palazzo Farnese, on which the Italian government had given them a 99-year lease in 1936 for a token rent. The Americans already had plans for a new embassy complex on the via Vittorio Veneto. One possibility, fairly quickly discarded (and just as well) was the Palazzo Barberini. The Swiss relinquished the Villa Wolkonsky to the Italians in September 1945, but it was not thought to be in the right part of town, and little attention was paid to it. The frontrunner was the Villa Aldobrandini, a large seventeenth-century property near the Quirinal Palace, its grounds truncated when via Nazionale was built in the 1870s, but still impressive. It housed the International Law Institute (later to become the HQ of the UN agency UNIDROIT), and was therefore not immediately available and had other drawbacks; but it remained the best option. (Ironically, the Villa Aldobrandini had been one of the possibilities considered when the Germans were looking for a new embassy in 1919/21, when they too still considered the Villa Wolkonsky to be in the wrong part of town.) Negotiations dragged on, with serious difficulties for both parties remaining unresolved, but agreement had all but been reached by the autumn of 1946: the Villa Aldobrandini was to be exchanged for a portion of the Porta Pia site (mainly for the road-widening), on the remainder of which a new chancery would then be built. But events dictated otherwise.

A Zionist bomb at the door

Britain's association with the Villa Wolkonsky started with a bang.[11] In the early hours of 31 October 1946 the front of the Villa Bracciano was shattered by two suitcase bombs. At 04.00 a telephone call alerted the Resident Clerk at the Foreign Office (FO) to a 'Most Immediate' telegram reporting that at 02.45 a bomb had heavily damaged the buildings of HM Embassy. The hall and front of the

Residence and half the Chancery had been wrecked or made unsafe. The damage was equated to that of a 500lb air bomb. While no injury had been caused to any embassy staff, two passers-by were reported seriously hurt. The telegram continued that the Italian minister of foreign affairs had come immediately in person to the spot and opened a 'rigorous inquiry'. The attack would cause serious disruption to the Embassy's work; the wireless was however intact.

Later in the day a fuller report revealed the damage as worse than at first thought – more like that of a 1,000lb bomb. The Residence's fine stairway and adjacent reception room (see Fig. 15.4) had been destroyed. The main walls were deeply cracked.

Fig. 15.4. The garden side of the Villa Bracciano Residence, 'made safe' in the aftermath of the October 1946 terrorist bomb attack. Compare Fig. 15.2d.

If the structure did not fall down it would need to be pulled down. The Chancery foundations had been badly shaken: the part nearest the Residence was probably dangerous. The escape of the staff on the spot had been in some cases 'miraculous': there was some shock among the security guards. Only one passer-by (rather than two) had been slightly hurt. The Embassy would be up and running in 24 hours.

A few days later Irgun Zvi Leumi (a terrorist element in the Jewish resistance to UK control of Palestine) claimed to have carried out the attack. Two (or maybe three) of its members placed the bombs at the main door in the early hours and made good their escape by train to Switzerland.[12] The bombs had duly exploded, killing no one but possibly injuring two Italian passers-by (although later reports stated there were no injuries).

The ambassador was in London (and in any case not living in the Residence), and the night-watchmen were not close enough to have been injured. But the building and particularly its foundations were sufficiently damaged to necessitate the eventual demolition of the whole edifice.[13] The UK was left diplomatically homeless in Italy, though it still owned the sizeable site.

The Villa Wolkonsky – just a temporary home?

By the time Charles returned to post the Italian president had confirmed the offer of the Villa Aldobrandini; and the Embassy had quickly found temporary office premises for rent in the Piazza Venezia. But the ambassador had other ideas, without wholly discounting the Aldobrandini possibility. By 8 November he was ready with his advice, embodied in a couple of telegrams. Britain had an opportunity to build new offices and a residence. In the short term the most suitable place for the offices and perhaps the residence would be 'the former German Embassy at Villa Wolkonsky near St. John Lateran'. Though it was not very central it offered reasonable security: it had a large

garden and a defensible perimeter. The 'large residence' had been 'thoroughly modernised after the German style in 1939'.

The office building and the huts were, Charles said, all in reasonable condition. The property was under the control of the ACC. The Italian Red Cross's permission from the ACC to use part of the offices could be revoked at any time. The Italians were keen that the UK should move in rather than take some other building which they might later want for themselves. He was checking to see if the large modern German switchboard was suitable. As for the ambassador, he could 'stay in the Palazzo Sermoneta (ex-Orsini)' (where he was already) or move to Villa Wolkonsky if the residence there were not needed for offices. For the longer term the UK could build a new residence at Porta Pia or rent/buy Villa Aldobrandini.

By 14 November the departments involved in London – Foreign Office (FO) and Ministry of Works (MoW) – had agreed to

a) abandon the proposal to take the Villa Aldobrandini;
b) build new offices and residence at Porta Pia, possibly using an Italian architect;
c) hire Villa Wolkonsky for the short term, building extra huts if necessary; the ambassador would move to the residence there;
d) instruct the embassy to approach the ACC urgently about the Villa, as the Italian police were keen to see the move as soon as possible on security grounds;
e) demolish the dangerous old buildings at Porta Pia (see Fig. 15.4) but surrender them to the Italian authorities in exchange for the land on which the tenement block stood – which they would need to demolish (this in the hope that the Italians would carry the costs of demolition and clearance, and in expectation of the road-widening going ahead);
f) make provision for the buildings at Porta Pia in a Supplementary Estimate.

The Embassy was instructed on 18 November i) not to reveal the long-term plan or the rationale of e) above to the Italians, and ii) to make clear that the Italians, in exchange for the strip of land along the main road (via XX Settembre), would be expected to deliver up the corner of the Porta Pia site occupied by the tenement block, which should be demolished.

Because of the taint which hung over the former German Embassy the Italian government had an embarrassing property on its hands. They were accordingly ready to see the British Embassy rehoused on the estate. Such a gesture could also have made it easier for them not to entertain the idea of compensation.

The Embassy secured French and US agreement in the ACC on 18 November, and the formal request for use of the Villa Wolkonsky was submitted that day to the Italian Foreign Ministry. By the 20th the head of the Red Cross (General Helbing) was appealing to the ambassador for help, as he could find no alternative accommodation for his 100 staff living in the office block (i.e. the enlarged *casino*). The MoW agreed that they could instead use the remnants of the Porta Pia chancery, but that did not happen: some sections of the Embassy had to remain there – for several years. Meanwhile on 19 November the Italian Treasury (perhaps just not up to speed) installed one of its departments in the *villino*, where they already stored some of their documents. None of this diminished the momentum: the Embassy took possession of the *villino* as Residence on 30 December 1946 and of the offices and remainder of the property on 20 January 1947, assuming on that day full responsibility for the physical custody of the property and its contents. The Certificate of Take-Over was signed by the Italian sequestrator and the Head of Chancery of the British Embassy (Angus Malcolm). The Italian government remained formally the overall trustee.[14] So, within less than three months, the Chancery (the main offices) had moved into the old German chancery (alias Princess Zenaïde's 1830 *casino*)

other sections had moved into the prefabricated huts which the Germans had erected in the grounds as their staff outgrew the available space, and the ambassador had taken up residence in the 'new' *villino*. Decisions were still being taken and executed with something like wartime urgency. In this manner, after a gap of just over three years, the Villa Wolkonsky regained its diplomatic function and status (Figs. 15.5a and b). But the name on the gate had changed.

In London the Treasury agreed on 22 January the plan outlined at the 14 November meeting, replacing the earlier Villa Aldobrandini scheme. Charles conveyed the UK proposal to the Italian Foreign Ministry on 1 April 1947 and reported a good reception. Only in June, when FO ministers were taken by surprise at Question Time in the Commons, did the minister of works, Charles Key, write to Eden to explain why the Aldobrandini scheme had been abandoned and give an estimate for the cost of the new buildings at Porta Pia of £350,000.[15] A brief, by R.A. Barker of the MoW, summarising the position for use in answer to future Parliamentary Questions, followed on 6 August.[16]

Those must have been busy weeks for the Embassy, as a visit by the (Labour) Foreign Secretary, Ernest Bevin, was planned for 20 January, requiring careful preparation, and there was talk of an early official visit to London by Nenni, the (Socialist) foreign minister – postponed because of the convening of the Constituent Assembly: not the easiest moment to move offices, perhaps. The Italians were worried by reports of British concern about political instability in Italy, which they believed to have been fuelled by a book by Sforza, the former foreign minister (after the First World War), arguing that politicians were discredited, the government had no authority and a reversion to monarchy would be the best solution for Italy. Sforza predicted a violent struggle between Catholics and Communists.[17] This edgy atmosphere may have strengthened the hand of those, including the Italian security authorities, who felt the Villa Wolkonsky offered good security for the embassy of an Allied power. It is not clear whether Sforza's book was at the seat of any British unease. But the background to the appointment of Nenni as foreign minister included the fact that Churchill had earlier been strongly against Sforza becoming prime minister or even foreign minister again, after his plotting the downfall of Bonomi, Italy's first post-war prime minister, whom Churchill had supported. Churchill considered that Sforza had broken his word to him and was 'a non-stop trouble-maker'.[18]

The Embassy physically moved into the Villa Wolkonsky (residence and offices) on 21 February, ten days after the signature of the Italian Peace Treaty (which was to come into force in September). By that time offices had been allocated as follows: Chancery (political and economic sections) in the offices created by the Germans in the *casino*; labour, press and administration sections in huts A, B and C respectively; the guards and the passport office in the 'consul's house' (also known as the 'German Minister's House' or 'Old Minister's House'); hut D was to be a store, and the Defence Section was to have a new hut built for it (E), designed by the Embassy's architect, Michaeloff. Plans for the new hut were submitted on 30 January – with a price-tag of £3,500 – and approved by the MoW on 13 February. The hut was occupied on 19 March: action still followed rapidly on decisions.

The Peace Treaty created the need for some 40 additional staff in a new Enforcement Section (not least to deal with Trieste). Initially Charles thought they should go into another hut, but that plan was dropped in May, and they remained separate in the crumbling remains of the old Porta Pia chancery. At least there was a squash court there: it was still just usable when I played on it as a teenager in the late 1950s.) Apart from any more serious considerations, it becomes clear from reading the files that staff in London remained bemused by many of the complex features of the property they were dealing with: the papers from which these paragraphs are derived are headed 'the Villa Volkonava'!

Not long after moving in, Charles was pushing things along again. On 31 March 1947 he wrote to the Deputy Secretary at the MoW, Sir Eric de Normann (the first of a pair of towering figures for this

A 'Temporary' Home for the Bombed-out British 223

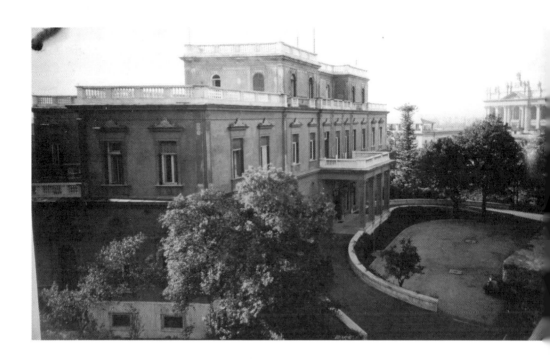

Figs. 15.5 a & b. The Villa Wolkonsky Residence at the time the British Embassy moved in (early 1947): (a) abov façade from the roof of the casino and (b) below, the entrance hall.

story in that post): 'The residence, which may not be beautiful, is certainly impressive and well found, and it makes a very creditable Embassy.' The garden was 'very pleasant' and the site more open and healthy than Porta Pia. While it was expensive to run, the one real drawback was its situation. In a separate letter he invited de Normann to stay and opened up the possibility of buying the Villa. The MoW recorded that 'The ambassador and Lady Charles are well satisfied and are considering purchase.'

Charles was no doubt also keen to exploit Italy's wish for a new relationship with the Allies in developing his tactics to sort out a satisfactory long-term arrangement for the Embassy premises. By April Sforza was once again Italy's post-war foreign minister, this time in de Gasperi's government, a post he occupied from 1947 to 1951. In spite of the UK Labour government's (and Churchill's) earlier opposition to his taking that post, a visit to London was quickly mooted and publicised. The Italians noted with some satisfaction an article in *The Economist* of 26 April urging Bevin to take Sforza's visit as a serious opportunity. The Farnesina's main aim for the visit was to persuade the British to stop hardening their stance on Italy's desiderata as it tried to re-establish a standing among the European powers (not least on the grounds that it had ended the war among the Allies). It wanted recognition for Italy's main aims, which included some revisions to the Peace Treaty, dealing with Italy's navy, its colonies and a place at the table for negotiations of the German peace.

Events conspired to delay the visit until 31 October, by which time Charles had been replaced by Sir Victor Mallet, the Italian Peace Treaty had entered into force, and the Italian Parliament had given the government authority to ratify it. Sforza was treated as a guest of government, the first occasion an Italian minister had been treated as an equal by any Allied government, and even had a meeting with Churchill. Relations were re-established, several agreements were reached (including on UK coal exports), but there was no accord on Italy's colonies.[19]

The case for purchase strengthens

Officials in London were already beginning to fuss by mid-April 1947 that there was still no clarity on the terms of the British government's occupancy of Villa Wolkonsky. The ACC Italy committee in Rome had been disbanded, and decisions were now up to the ACC headquarters in Germany. If rent was to be paid it would be based on an estimated capital value of L.328m. The valuation was done on behalf of the Embassy by Enrico Vallini, an Italian surveyor.[20] His valuation took account of serious cracks he observed at the joints between the old and new structures and the need to remove the swastikas from the decoration. The rent, at 6.8 per cent of the capital value, would be £15,000 pa.

No one wanted to be faced with a demand to pay a sum of this size for the theoretically outstanding rent for which there was no budgetary provision. But the problem was finally dissolved by a statement on 1 September from the German General Economic Department of the FO: 'There is no possibility of renting Villa Wolkonsky on a long lease, and the only means of securing tenure is to offer to purchase it.'

This was because the ACC had decided that German State property in Italy was to be liquidated by the Italian government acting on behalf of the four powers – with Italy taking the Russian seat. In other words the ACC had no authority to earn money on it by renting it out. The property was now administered by the Italian government, but it would have to be put up for sale. A case for priority could be made when the UK expressed an interest, but first the UK must decide that it wanted to buy. It was not clear how much time there was. Negotiations would be in the hands of Sir Quintin Hill, economic adviser to the ambassador in Rome.

The discussion initiated by Sir Noel Charles had in any case moved in that direction. Mallet, without waiting to succeed Charles, recorded his view on 23 June 1947 that the Villa would make an excellent home for the British Embassy: subject to his inspection, purchase should be considered. In July Charles himself agreed, in part. Keeping the offices at the Villa would save £200,000 of the estimated £350,000 cost of building a new residence and new offices at Porta Pia. But the German chancery (the *casino*) was too small and should be turned into staff accommodation. The other disadvantages remained: location and running costs. But the advantages were many: the environment, room to build new offices (forgetting the *vincoli*), security, welfare (nice place to work), good for entertaining, quiet for working, capital cost. Negotiations on enemy property would now shift to Washington. He recommended that no further thought be given to redeveloping Porta Pia. One other element was dealt with shortly after: on 26 July Rance, Head of the Finance Department at the FO told the MoW that there was no intention of claiming compensation from the Italian government for the bomb damage to the Villa Bracciano.

In early August Harold Caccia, Under Secretary at the FO, wrote to de Normann, bringing out into the light of day the dilemma which the government would have to resolve. Jumping the gun rather he formulated the problem on the assumption that the residence was to be in the Villa Wolkonsky so new offices would still be needed. Should they be built in the grounds or at Porta Pia? He asked de Normann for a recommendation. De Normann replied quickly: 'I don't see any prospect of Parliament allowing us to put up an expensive embassy in Rome. It looks therefore as if we shall have to continue in the Villa Wolkonsky.' This tone of reluctance may have been designed to appease the view of Hamilton Kerr, MP, expressed in 1945 to the minister, that 'the Villa Wolkonsky [was] a house of outrageous ugliness, standing in fine grounds, in a somewhat poor quarter of the city.'[21] Caccia and de Normann met on 19 August and decided not to dispose of the Porta Pia site but to keep open the possibility of allowing the Italians to widen the road. De Normann would visit Rome. A couple of days later Chapman-Andrews at the FO recommended he look at a package consisting of buying the Villa Wolkonsky, if the price could be kept to around £100,000, selling Porta Pia and building an annex office for £30–40,000, added on to the existing chancery (*casino*) at the Villa.

In mid-September the Embassy woke up and reminded the FO that the Villa Wolkonsky was scheduled as a private park (*parco privato*) and so <u>not</u> available as building land. They also recalled that its low capital value reflected the existence of cracks in the fabric of the Villa which could require costly repairs to the foundations and walls. De Normann, no longer moving so fast, asked Mallett in November to get a full valuation, suspecting that the sum of L.328m (*c*.£165,000) quoted in September by Vallini, was too low.

By 19 September the French and American embassies in Rome had agreed to send notes in parallel with the UK transferring the Italian government's trusteeship and custodianship of Villa Wolkonsky to the UK. The procedure from then on would be complex. Disposal had to be effected in accordance with the general arrangements for the disposal of German property in Italy set out in a Memorandum of Understanding of 14 August 1947 agreed in Washington between the US, UK and France (under the terms of the four-power peace treaty with Germany). A Four-Power German Assets Committee (GAC) was set up in Rome to supervise the disposal. Any disposal of the Villa had to have the committee's approval. France and the USA were favourable to the UK leasing or buying. But, in order to prevent exceptions being made to favour commercial interests, the committee needed to resolve that the governments of its members had the liberty to purchase at a fair valuation, i.e. not a sale to the highest bidder. These rules would also apply to the proposal that the UK buy for its Consulate-General in Naples the former German Consulate-General, Villa Crispi. At the end of the process Italian government legislation would be required to ensure the UK had full title under Italian law.

Hill, the UK Representative, added a note of caution for de Normann. The USA, first in line to chair the committee, did not favour a resolution on 'fair valuation'. Dealing with the proceeds of sales was for governments, not the committee. It was clear that the Italians wanted all the proceeds, and in general the US and UK agreed, while the French favoured reparations (with their eye on the Villa Bonaparte, across the road from the UK's Porta Pia site, which they wanted for their mission to the Holy See, the purpose it had served for the Germans). It was going to be difficult for governments to secure favours for themselves while ruling on disposals where others were interested.

In early October de Normann made his visit to Rome and reported on it in a memo of 8 October 1947.

a) Demolition at Porta Pia should proceed;
b) The Villa Wolkonsky gardens needed care and attention;
c) Villa Wolkonsky was not in good taste but it was not 'hideously ugly';
d) Big cracks in the Villa Wolkonsky structure needed to be investigated;
e) While the Villa Wolkonsky interior was 'not so bad … having regard to Teutonic heaviness and Italian exuberance, the ballroom and staircase might be a little trying to live with'. The fittings (bathrooms, kitchen, engineering, heating, etc.) were 'quite first class'.
f) Villa Wolkonsky was not a suitable site for a new chancery, nor should the old Villa Wolkonsky *casino* be used: it was too far from the centre for any office building;
g) A modern chancery was needed at Porta Pia on part of site, with the rest being sold;
h) He noted a suggestion from Hill that Villa Wolkonsky might be acquired as a partial set-off for the UK share of the proceeds from disposal of German assets, thus keeping the transaction off the Treasury/Parliamentary books;
The risk of a German claim on the property after a peace treaty could not be discounted: however the fact that the Italians did not return the Palazzo Caffarelli to the Germans after the First World War was a helpful precedent.

With that the die was cast. Battle with the Treasury would shortly be joined. The elements of the tortuous succession of plans, delays and economies over the next 25 years were in place. The Villa Wolkonsky attracted high-level support, in spite of its lack of architectural elegance and odd position. The habit of deciding not to decide about what to do at Porta Pia had put down a first, strong root. The *vincoli* had been dusted off but quickly put away: they would be forgotten again and again, but equally persistently emerge to thwart 'rational' solutions.

The protection of Italy's cultural heritage

The *vincoli* have already made several appearances in this narrative so far. But with the UK's acquisition of the Villa Wolkonsky and eventual decision to retain the Porta Pia site they come into their own in what to many British participants seemed to be a spoiling role. It is worth looking in some detail at Italy's approach to its cultural heritage, an 'elephant in the room', which so many involved on the British side apparently failed to understand over the years in which they tried to resolve the unresolvable puzzle. A step back to the late nineteenth century is needed.[22]

Post-unification Italy, spurred by the need to develop unifying links for the hitherto very separate elements of the new kingdom, placed a strong emphasis on the country's magnificent cultural heritage, much of it in Tuscany. (Rome was initially not part of the new Italy.) That heritage had been habitually

and comprehensively looted by private individuals and invading states alike. In the 1860s and 1870s the pressures on the new kingdom's finances encouraged more sales or even expropriation, e.g. of surplus Church-owned property, much of which was suitable for military or prison use. Resisting those pressures required the leadership of dogged visionaries able slowly to build the administrative machinery to match the strongly felt but weakly financed demand that the heritage be protected.

Inspired by Cavour the new parliament passed in 1861, the inaugural year, a law covering place of worship and works of art, but not other buildings. The state took over many Church properties and the practice of compiling lists of items and buildings to be protected began. Laws of 1866 and 1869 included some Church buildings under provisions for preservation. But as the government (in the form of the Finance Ministry, which 'owned' the state's property) was not prevented from selling property in its hands, a process the Ministry of Education had no say in, the haemorrhage continued through the 1870s. The 1866 Law established the category of 'national monuments' to be preserved, their importance being defined in terms of their historical or artistic value to the (whole) nation. Although that definition was extended in 1896 to cover items of regional and local value, that was as far as the legislation went until the early twentieth century. So although Education Ministers Bonc in 1875 and then Guido Bacelli in 1881 had set up the structures to monitor and protect they had minimal legislative backing, so enforcement was haphazard, varying widely by geography and political context. In 1891 those structures were disbanded, only to be reinstated in 1895. (This is of course just the time when the Campanari-Wolkonskys were putting up their mansion, near the aqueduct.) Yet the Ministry of Education was hard at work drawing up lists, and it did not give up.

The 1902 Law was the first serious effort to establish a systematic protection regime. It protected from sales and abuse private as well as publicly owned property categorised as monuments, and extended the definition to pre-1700 buildings. But the law failed to provide a remedy for the fractured monitoring and enforcement task it created. That was rectified by the landmark 1909 Law (no. 364 of 20 June) and its accompanying royal decree (listing categories of monuments to be protected); it finally provided the certainty needed to establish a firm base for the use of administrative law for the protection of cultural heritage, widely defined. (The list in the decree, it should be noted, included aqueducts as a category on its own: we shall never know if the shadow of Prince Alexander hung over the royal pen.

The main elements of the 1909 Law were:

- Coverage for all manner of objects, movable and immovable of historical, archaeological or palæ anthropological importance over 50 years old;
- Establishment of a safeguarding framework for buildings, prohibiting demolition and restoration without Education Ministry (viz. *Belle Arti*) permission and requiring planning permission for a proposed building near a listed building which might in any way interfere with it.
- Setting up a strict system of export licences for artworks (which many critics now argue hopelessly restricted the scope of the Italian art market, as it covered all works more than 50 years old).

The law unleashed a flood of notifications in 1910–11 to public and private owners of listed property and artworks requiring that the state be notified of any intention to sell, at which point the state reserved to itself the right of first refusal. It was followed by Law 688 of 23 June 1912 which extended the coverage of the 1909 Law to parks and gardens. The Villa Wolkonsky as a whole was cornered and its owners were so notified, as we have seen.

A decree in 1923 (under Mussolini) reorganised the administrative structure, but the staff were reduced to an extent which made it impossible for them to do their job, and the system fell apart. T'

meant that there would be no real supervision of German plans for the Villa in the 1920s and 1930s. After much pressure from those concerned (not least because of the growing interest of Italy's German allies in Italy's art treasures) a new Law 1089 of 1 June 1939 put Humpty-Dumpty back together again in theory, but in practice implementation had to wait until the end of the war. All this made it easy for the senior hierarchy of the NSDAP to buy, borrow or steal a massive number of Italy's artistic treasures. There were even recorded instances of Mussolini overruling his minister Bottai (a boy with his finger in the dyke if ever there was one) when Hitler or Goering insisted on having some particularly important Italian artwork. This weakness (which only reflected political reality) did nothing to enhance the hard-won respect for safeguards on Italy's cultural heritage, and at the end of the war those responsible in Italy were faced with a major challenge. It took several years of further haemorrhaging before some control and respect were reasserted on the basis of the 1939 Law. Post-war legislation has in effect confirmed the Fascist 1939 Law, which was firmly in line with the previous generations' growing success in developing a widely imitated framework for protecting cultural property/heritage.

Looked at another way, the failure to resist the predations of the German Nazi leadership was only an extreme example of the conflict inherent in the concept of cultural property. The difficulties encountered by the British government in its attempts over 40-plus years to capitalise on one or other of its two properties in Rome were another, less acute, example of the same thing. The Italian authorities had and have in fact established a fine reputation for their ability to balance the interests which clash in the idea of any private or public entity or person 'owning' a component of something as intangible as a national culture. They have been firm but ready to make concessions and do deals when the principles they affirm can be achieved that way. It may be no accident that Italy was in the vanguard of those incorporating the idea of 'enhancement' (*valorizzazione*) into legislation protecting the nation's heritage and, in 2001, into the Constitution. (They claim to have been the first to put a café into a museum – in the 1990s.) Given the issue's high political profile over a long period, an enduring puzzle is how the representatives of the several post-war British governments (including the ambassadors) so often failed to recognise the strength and depth of the Italian approach to the preservation of their cultural heritage.

★ ★ ★

With hindsight it is easy to be cynical or critical of the way officials and ministers in the course of the next 40 years or so handled the dilemmas let loose on the British by the terrorists' bomb in 1946. But it was a classic case of 'well, I wouldn't start from here'. In practice, room for manoeuvre had to be acknowledged as frustratingly limited (by Italy's protection rules and the UK's weak public finances) every time anyone tried to improve on the superficially wasteful and over-grand arrangement. The saga could be likened to a very long game of slow-motion rugby football. The British side set out with limited objectives but soon realised the prizes they could win. Surge followed surge, sometimes in a scrum or maul, sometimes with a long kick and chase, sometimes with a dash for the line. But they had an incomplete understanding of the strength and determination of the Italians' defence, were often unfit (short of money) and had to take time out, changed their managers too often, and rarely kept their players on the pitch together for long enough to put lessons to good use. Time after time the British were held short of the line. In those conditions successive ambassadors and – most importantly – senior officials in the Ministry of Works (and its successors) with considerable skill, imagination and determination delivered the best outcomes they could. These included a major conservation of the aqueduct, the building at

Porta Pia of a striking new chancery, and considerable improvement to the Villa and its garden, once their future status had been settled. And that had all to be done without being able to make any sale of land at either site. That is the story of the next chapters, a story of which the UK, like its German predecessors, can paradoxically be proud.

Notes

1 That decree 19449/236 remained theoretically in force while the UK was preparing its purchase in 1948 – and Della Monica played a constructive role – even if in many respects he had at least temporarily been superseded by the Allied Control Commission.

2 FCO Historical Branch ref B 3256/77.

3 See brief for visit by the Secretary, MoW, dated 4 March 1949 in TNA: WORK/10/115.

4 Correspondence passed on 17 April 1950 to Winter (MoW) from Codrington (FO) whose mother was Portal' sister: TNA: WORK/10/202.

5 That housing – often referred to as the tenement block – has remained an eyesore and one of the principa obstacles to the full development of the Porta Pia site.

6 See TNA: FO 266/814.

7 A list of post-war British ambassadors is included in Annex V.

8 Farnesina: DGP I/II b256.X.G2.

9 See Eden's private office papers, TNA: FCO 954/14A/120 (5061).

10 This curious building had been built perched on top of the Teatro di Marcello, before the latter was ful excavated.

11 The main UK source for this chapter is TNA: WORK/10/116.

12 Sir John Mason, 'Explosions in the Chancery, British Embassy, Rome'; article in *Password*, July 2006. Th reports what Mason was told later by two Israelis who claimed to have been the perpetrators of the attack. See als Mason, *Diplomatic Despatches: From a Son to his Mother*, Canberra: National Library of Australia, 1998.

13 The Embassy was made up of two adjoining buildings, the Chancery (partly damaged) and the Residence, b the latter had been turned over to office use with the ambassador temporarily accommodated in rented property els where.

14 Discussions between the Allies on relieving them of this trustee role were eventually overtaken by the UK purchase.

15 Exchange rates at the time were £1=L.2,000 and $1=L.220.

16 In TNA: WORK/10/116.

17 Farnesina: *Aff Pol 1946–50 Gran Bret Busta B20 fasc. 2 (1947)*.

18 Eden's private office papers in TNA: FCO 954/14A/312.

19 Farnesina, loc. cit.

20 On the basis of a total land area of 45,000 sq. m. or 11 acres, of which the Villa accounted for 1,250 sq. with a volume of 19,000 cu. m.

21 Quoted in the memo of 8 October 1947, cited on p. 227.

22 Some material for this section is drawn from publications found on the internet:

- Laura Benassi, 'Reuse of Historic Buildings in Italy', https://www.researchgate.net/publication/25826603 Reuse_of_Historic_Buildings_in_Italy_A_Conflicting_Policy_Based_on_Financial_Public_Strategy_and_H itage_Preservation.

- Elisabetta Povoledo, 'Italy Defends Treasures (and Laws) With a Show', *The New York Times*, 7 October 20C https://www.nytimes.com/2008/10/08/arts/design/08heri.html.

- 'The Creation of the Regional Architectural and Cultural Heritage Superintendancy', http://www.emilia magna.beniculturali.it/index.php?en/125/la-nascita-delle-soprintendenze-in-emilia-romagna.

- Lorenzo Casini, 'Italian Hours: the globalisation of cultural property law', academic.oup.com/icon/a cle9/2/369/649612.

16.
THE UK BUYS THE VILLA WOLKONSKY – SLOWLY

Not a straightforward purchase

The idea that the UK should buy the Villa Wolkonsky was rapidly gaining ground, but it was soon clear that any decision would get tangled up in the related questions of where to build new offices and what to do with the old embassy site at Porta Pia. Back from Rome in October 1947 de Normann tackled Crombie at the Treasury, searching for a way to purchase the Villa without spending cash which would require a Parliamentary vote.[1] While Hill, in Rome, still thought the price could just be deducted from the sum to be handed over eventually to the Italians, Crombie poured cold water on that: the cost of Villa Wolkonsky could not be set off against the UK share of the disposals of German property in Italy. De Normann therefore focused on the need to get the committee in Rome to agree to a sale at a fair valuation, even though the Italians still had no title to the property. Crombie agreed to the purchase of the Villa in this manner as the residence, with the chancery to be built elsewhere. He suggested using the sale of some of the land at Porta Pia to pay for the Villa and raised the possibility of claiming compensation from the Italians for the loss of the embassy buildings at Porta Pia. On 12 November de Normann asked Mallett – by then installed as ambassador – to produce a full valuation of both sites but stipulated that at that stage the purchase of Villa Wolkonsky should be kept separate from any deals that might be done on Porta Pia.

Mallett and de Normann had met on 27 October before the exchanges with Crombie concluded. Mallett was worried that the Residence at the Villa would be expensive to run and hard on the ambassador's 'frais' (his allowance for household staff and entertaining costs). It was too large, given that entertainment would not be lavish. The austere German influence in the decoration would have to be softened 'gradually' but would do. There was no linen room and not enough servants' bedrooms (an odd point, since the Germans had added a new top floor of just such accommodation – maybe he had not climbed up that far). That said, his list of requirements was low-key and included: changing colours; a better fireplace in the salon; large bookcases; and large paintings and tapestries (acquired or borrowed) – on which he had some contacts he could exploit. De Normann reassured Mallett that the Villa would be satisfactory. The house was not unnecessarily large, and the garden was excellent. The equipment and security were good. The problem of a linen room could be solved. Pictures and tapestries would certainly need to be obtained, but not through 'freelance' activity by the ambassador: the MoW would pursue, e.g. tapestries from the Duke of Buccleugh – the loan of which was in due course successfully arranged. Porta Pia should be the site of the new offices: Mallett agreed provided they were well away from the busy streets. He and de Normann seemed to have the basis of a partnership.

One important-seeming loose end remained: the cracks in the structure of the Residence. In late November a MoW structural engineer, G.H. Stewart, set minds at rest. The roof condition was not

serious, and the cracks in the walls were not structural faults, just unsightly. He had obtained sight of the records of Eugenio Miccone, the architect/contractor employed by Mertz to carry out his plans for the extension of the Villa. These showed that when the new west and east wings were added the problem of their likely movement relative to the existing building had been solved by means of 1½ inch cork joints throughout. The west wing had required a piled concrete platform for its foundations where soil had needed to be brought in because of the slope. Ten-inch chestnut piles had been used, 4–6 m high and 50 cm apart in each direction, with the ground being levelled up between them. An 80-cm-thick concrete pile cap had been added on top. No piling had been needed on the east side. While the joints on the roof needed attention the wall cracks would only need tell-tales and regular monitoring – some repair with steel mesh across the joints might then prove necessary, as would some cosmetic touching up internally and externally. The total cost would not exceed £100. There was no reason to reduce the valuation. Other small items were identified: a crack to the secondary staircase under the first-floor landing needed monitoring, and the perimeter wall needed some largely precautionary attention. In all, this was both reassuring and an endorsement of the quality of the work done by Mertz and his contractor.

In December de Normann told Hill he could use the valuation which took account of the state of the building but repeated his earlier request to see the detail of the valuation. His staff (Winter) asked the Treasury for permission to buy at a provisional estimate of £200,000. Mallett and Hill in Rome had not given up on the idea of avoiding paying over cash to the Italian government. They suggested that the purchase price in sterling should be placed in a special account set up by the Italians, who should agree to the money being paid back once the disposals settlement was made. The Treasury weakened, seeing merit in that idea: in January **1948** they agreed that the money could either go into a blocked sterling account or take in the form of a guarantee of payment once the decision was taken on the proceeds of the German property sales.

So far the post-war ability to get decisions taken and implemented fast had held up well. But as 1947 ended, so the steam escaped from the boiler. Not that either the MoW or the Embassy was idle. De Normann was focused on the valuation. He wanted to know how much the Germans had paid in 1922, which at that time no one seemed to be able to find. (We know from the Deed of Sale that it was L.4.5m.) Hannaford (the Embassy's locally engaged Legal Adviser) obtained an informal valuation from Professor Valle at the Italian Ministry of Public Works, which was available in March 1948. At L.300m this compared well with Vallini's L.328m. (Valle's note also correctly identified the effect of the *vincoli*, gave a rare description of the state of the *casino* – three floors, 26 rooms – and stated that the garden was 'in a state of complete abandonment'.) The MoW, having seen a valuation of the Villa Bonaparte, which the French were determined to have, thought that the cost of Villa Wolkonsky would be good value for money. They had noted (with apparent surprise) from the French documents that the *parco privato* designation meant that no more than 20 per cent of the surface could be built upon.

In May the Italians introduced a new complication: triggered by the process in the Allied committee, they presented to the UK a tax assessment on the transfer of the two properties (Villa Wolkonsky and Villa Crispi in Naples), which would add £23,000 to the cost. The Embassy reported to the FO and MoW that normally tax would be a bilateral issue, so tax-exempt status of the Embassy in Rome would involve reciprocity for the Italians in London. The Germans had apparently been exempt from tax on their purchase of Villa Wolkonsky in 1922. In any case, if the deal was part of an award of German reparations no tax would be payable. The FO, taking its time, replied at the end of August with the view that no tax should be paid and – in an unconscious echo of the German experience on buying the Villa Wolkonsky – reciprocity should be offered.

Tidying up after the Germans

The embassy staff meanwhile had embarked on a thorough review of all the details of inventories and potential claims (relating to the German occupation) in addition to the estate itself. When the Swiss were handing over responsibility for the Villa to the Italians Della Monica (the sequestrator) had drawn up an inventory of its contents – presumed all to be German – in November and December 1945. But, even with amendments made at the time of the Take-over Certificate of 20 January 1947, it turned out to be too unspecific to be of much practical use when the British Embassy moved in. The fate of various items on it could not be accurately determined. In a despatch of 30 April 1948 Mallett recommended that the Italians should be asked to take responsibility for disposal of non-original German items and claims. Valuation of original contents was difficult in the absence of a general policy, but a rough estimate should serve at that stage. The sale of scrap material found at the site had yielded L.599,790 (a mere £300) – which should be transferred to the Allied committee. Hill's memorandum enclosed with the despatch noted that Her Majesty's Government (HMG) was committed to taking responsibility for the following contents:

a) The items in the inventory compiled in November/December 1945 by Della Monica – as amended in the Take-over Certificate;
b) The inventories of furniture and other chattels from the German 'embassy' to the Salò Republic in Fasano, north Italy – also amended in the Take-over Certificate;
c) Unspecified items in unopened safes;
d) 'Valuables' held by commercial department (no details given);
e) Money from the sale of scrap (see above).

One item remained for disposal: a small collection of 'jewellery and trinkets', found in a steel safe on the 19 November 1947, which, though not bearing any means of identification, is assumed to be 'the private property of ... a diplomatic official', most likely Rahn. These items, contained in two leather cases, were carefully listed in the report.[2]

The paper also contained an intriguing list of claims, though evidently none would constitute a major problem:

a) The German Embassy to the Salò Republic had been housed in a furnished villa owned by an Ing. Alberto Christofori, at viale Zanardelli 21, Fasano, on Lake Garda. Although Christofori had asserted a claim to items which were his (valued at L.695,300) before the Brescia court in August 1945 and won his case, its contents were sent to Rome on 5–6 September 1945 by the Allied Military Authorities on the instructions of the Italian Foreign Ministry. They were duly received by Della Monica, though the inventory was not produced until December 1946. Christofori had visited the Villa to identify them (with Della Monica) in September/October 1947. However, the paper stated that the court's decision was invalid and could be disregarded.
b) Both the Czech and Austrian Legations had taken back on temporary receipts some items belonging to them, but the authority of the ACC in Berlin was needed for these transfers to be made definitive.
c) A firm called Superstampa claimed a large sum for stocks of paper stolen by the SS on 4 April 1944.
d) A Signor Carlo Betrignol claimed to have left a trunk and a box in the care of 'a friend' at the German Embassy when he had left Rome in 1943. The trunk was there; the box was not.

e) Property belonging to ex-'Ambassador' Rahn – a box containing L.380,000 'deposited at Villa Wolkonsky on the personal order of Field Marshal Alexander' – of which there was no trace. Rahn's lawyer had been told to apply to the Italians, as it was they who had taken over the building.

f) The Red Cross had taken away certain 'effects' over Della Monica's protestations.

On 31 May the MoW agreed to send an official from its Supplies Division, Jardine, to value the contents. But he did so only in late July, by which time the Italians had agreed to take over unwanted chattels, and he had to start from scratch. He valued the residence furniture at £2,526 and other contents at £900 and reported that the cost of replacing from London would be more than double. The Embassy was able to report successful disposals/decisions on the items in the Hill memorandum as early as 16 June, except for the money from the sale of scrap and the unopened safes.

An interesting by-product of this activity was that one memorandum on the valuations noted the development of exchange rates as follows:

1939 £1 = L.0.85
1945 £1 = L.1,850
1947 £1 = L.2,000

How to finance the purchase

Libby, a MoW surveyor looking in June at the valuations of the Villa, commented that the *vincoli* made the potential capital value of the Villa very low (correct, and all too frequently forgotten in subsequent years), that the obligation to maintain the retaining walls should be capitalised and subtracted, and that many of the figures were guesswork and should be reduced. He recommended a figure of L.250m. He repeated the plea to find out what the Germans had paid, though it was not at all clear what that could add, given the economic and financial turbulence of the previous 25 years. De Normann however was relaxed. The offer should be £100,000, justified by the location, the *vincoli*, the obligation for upkeep of the aqueduct and the vicinity of the police barracks (which the Germans had hoped to have moved). Neither Valle nor Vallini should be consulted further about the figures. It was more urgent to focus on the plans for the new offices.

Mallett, however, chose that moment to change his mind. In a despatch dated 26 June he announced that while, after some months in Rome, he still agreed to the acquisition of the Villa as the permanent residence, he now parted company with de Normann and echoed his predecessor, Charles, in advocating that the new chancery be built there too on the ground to the north of the aqueduct. He reckoned that both the purchase and the new building could be financed from the proceeds from the sale of the Porta Pia site at nil overall cost to the UK. (This might have been an occasion to apply the adage 'if it looks too good to be true it probably is'.) The cost saving was reinforced by his view that it was essential operationally for the ambassador to be on hand in case of emergency (or war); while the Villa offered much better security than the Porta Pia site. Mallett had, of course, wished away the *vincoli* in proposing the construction of new offices at the Villa. Caccia (the FO Under-Secretary) sent this on to de Normann on 2 July.

De Normann was not to be diverted. On 6 August he pocketed Mallett's approval of the purchase of the Villa Wolkonsky and agreed that it would be splendid if it could be obtained 'for free'. Turner (MoW superintending architect – by now an important player in the saga) had visited and would

report. But he did not think the Porta Pia site would fetch anything if it was not built upon: a decision needed to be taken quickly. Winter, also in MoW, rightly pointed out (as the Italian valuer Vallini had done) that the 4.5 acres of Villa Wolkonsky woodland north of the aqueduct was part of the overall *parco privato*, governed by the rule that no more than 20 per cent should be built upon – already reached – and there must be no disturbance of trees. De Normann opined that the Rome Municipality was broke and would not carry out its road-widening scheme on via XX Settembre, but a margin of land must be left in case they decided some day to do so. With some prescience he added that little or nothing should be spent on the Wolkonsky site. 'One day the Germans may demand their embassy back and the FO may want to agree.'[3] Expenditure would therefore be wasted. If the Germans bought a new embassy that could be taken as indication that they had acquiesced in the permanent alienation of Villa Wolkonsky; changes to it could then be considered.

On 25 September de Normann persuaded Caccia and Mallett that developing the via XX Settembre/Porta Pia site was the course of wisdom.[4] A MoW architect (Parr) produced a sketch for an office there (Fig. 16.1), and in November a schedule of requirements for such an office was drawn up. At the end of the month Mallett disturbed the water again by suggesting an exchange of the via XX Settembre site for the garden of the Villa Aldobrandini; but de Normann dismissed the idea. By March **1949** the momentum was sufficient to occasion a visit by the MoW Secretary (Sir H. Emmerson). His briefing contained the suggestion that an Italian architect would be chosen as consultant, implying that the arguments against selecting an Italian lead architect had prevailed. De Normann and Caccia confirmed the decision to keep Porta Pia and build on it: in addition to the embassy office they should build a house and office for the mission to the Holy See, and there was a fair case to put the British Council there too but not in a separate building. Parr proffered a new ground plan (Fig. 16.2) and a sketch of the possible opening of a bricked-up entrance gate in the Aurelian Wall to allow an additional access entrance. With the comfort of an apparent decision, ambition was already ahead of reality.

In spite of the priority de Normann had given the issue of new offices, a new bid of £150,000 for the purchase of the Villa had been submitted for the Estimates in December 1948. In response to a Treasury (Wood) query, MoW (Fraser) stated that the only adaptation needed was an additional bathroom. Emmerson on his visit had had time to discuss the ambassador's plea for a refrigerator for the family's use and the arrival of a purifier for the swimming pool, which would be recommissioned that summer.[5] More weightily they discussed demolition of the stables/garage block opposite the Villa's front door; but nothing ever came of that – and the building is still there, somewhat refurbished, a contender for the accolade of oldest on the site.

Thus, by **1949**, with the ACC wound up and the Villa Wolkonsky the property of the Italian State, the British were ready to decide to buy it. In April the Embassy reported that the US, UK and French governments had agreed to the Villas Wolkonsky and Crispi being acquired without actual payment, i.e. the value being deducted from the UK share of reparations in the reparations account now held in Brussels at the Inter-Allied Reparations Agency (IARA). However, in July the Treasury reminded everyone that it had not yet agreed the purchase of the Villa Wolkonsky, and in early December laid down that the it had to be sold and bought: Italy would get 75 per cent of the proceeds while 25 per cent went to IARA; the UK would receive 28 per cent of that residual 25 per cent. That meant that, whatever the three governments' representatives on the Rome committee had agreed, the UK would have to pay the purchase price of the property to the Italian government but could finance the purchase from the general proceeds of German reparations. And that is what occurred. (In other words the shorthand description often used to describe the transaction, that the UK took Villa Wolkonsky in reparations from the Germans, is not accurate: another myth.)

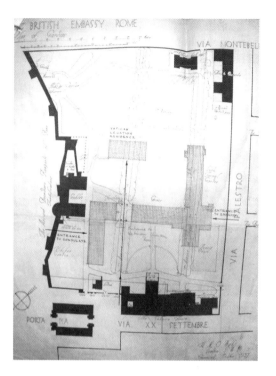
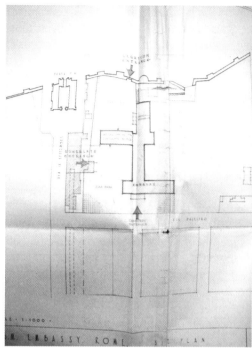

Figs. 16.1 & 16.2. Initial sketch plans for new offices and a residence for the Legation to the Holy See at Porta Pia, drawn in 1948 on a 1937 plan of the Embassy, and a revised plan showing the proposed reopened gate through the Aurelian Wall, drawn in 1949, both by Parr (MoW).

A German spur to action brings matters to a head

After that meagre return for a desultory year's work, the Embassy woke everyone up in London with a series of telegrams in late 1949 and early **1950** reporting new German insistence on retaining the premises of some of their cultural institutes and libraries in Italy – and Italian acceptance of these claims. West Germany had not yet regained the full attributes of statehood under the peace treaties, but the French were alarmed at the likelihood that US support for the French and UK interests in the three villas under discussion would evaporate if the Italians wanted to make concessions to the Germans over their former state properties. On 14 January the Embassy reported Adenauer making a 'test case' bid to have seven artists' quarters returned. The FO advised the US not to consult the Germans about the libraries, as they were now 'mounting a general offensive to get back assets of the former Reich abroad if and when such assets are released'. The Germans should be told that they could join the Union of the four cultural libraries if they set up their own cultural institute, for which the Italians should lease to them its previous site, the Villa Massimo, at a peppercorn rent; but the Italians needed to sort out their ownership of it quickly. (In the event the Germans did not regain their tenure of the Villa Massimo until 1956.)

In the light of this mild panic the French and British worked up a draft protocol to deal with the three properties and the taxation issue. But that approach was dropped when the US agreed to include

the issue in a draft Note which had long been under discussion between the Allies in Washington. The Note was ready in July 1950, but in September the FO told other interested parties in Whitehall that the Americans in Rome were holding things up on procedural grounds. By early October the Embassy was worried that the Germans were likely to reclaim their diplomatic premises when they restored diplomatic relations, which they were about to do. High-level action in Washington was needed.

The log-jam began to shift in November. The Italians were informed by the German Assets Committee (GAC) that the three properties would for the time being continue to be held free of any charge for rental. A UK paper on 22 November sought the sale of the two villas. A detailed inventory/valuation of the German chattels included in the sale was required, but the MoW had lost it and it was not put in till 10 January. While the Treasury had approved the purchase of the Villa Crispi in November 1948 it had not yet approved the Wolkonsky purchase and needed reminding on 20 December. Many eyes had been taken off the ball. Finally on 17 January 1951 the GAC agreed that work should begin on draft contracts and an independent (Italian) valuer should check the valuations. The UK valuations submitted, on an exchange rate of £1 = L.1,739, were:

	L	£
Wolkonsky	306,015,418	
Crispi	21,263,020	
Total	327,278,438	188,199

The GAC was to meet on 8 February with the results of the valuer's judgement. The sense of a cliff-hanger grew when it was postponed until the 12th, but the valuer's figures were obtained:

Wolkonsky (incl. chattels)	353,174,152
Crispi	32,958,410

And the UK indicated to the Italian representative that it could offer L.320m + 30m. When that was not accepted the UK, with Whitehall agreement, offered for Villa Wolkonsky the average of the three valuations on the table, and agreement was reached in the GAC on that basis:

Wolkonsky (incl. chattels)	331,151,859	190,426
Crispi	32,734,410	18,824
Expenses	725,500	
Total		210,000

Agreement was reached at the same time on the French purchase of the Villa Bonaparte.

The Treasury on 14 February confirmed authority to a total of £213,000. The Embassy's report of these negotiations (dated 26 February) noted that the crucial date of transfer of the properties would be determined by the date on which the Banca Nazionale del Lavoro (BNL) issued its receipt for the payment from the UK. The Embassy would draw the cheques as soon as the relevant funds reached the embassy account from the IARA in Brussels – still awaited on the date of the report. Formal confirmation of passage of title would need to be confirmed later in a Presidential Decree, a draft of which had already been sent to the FO. The report noted that the UK had had use of the two properties rent-free for four years and contained the necessary texts on tax exemption and reciprocity.

Fig. 16.3. *Receipt from Banca Nazionale del Lavoro for the British government's deposit on 28 February 1951 of the sum of L.363,886,269 for the purchase from the Italian government of the Villa Wolkonsky.*

Perhaps in all the excitement this activity generated no one noticed or gave much thought to a communication on 16 January 1951 from the *Belle Arti* (to the Land Registry) drawing to the attention of the relevant department of the Italian Finance Ministry the terms of the notification on 19 December 1912 to Wladimiro Campanari of the *vincoli*, stating that '... the buildings cannot therefore be demolished, removed, modified or repaired without the authority of the Ministry of Public Instruction [i.e. the *Belle Arti*]'. As the property had been in state hands (German and Italian) since then, no new notification had been issued, but the *vincoli* still applied. The Germans had sought such permission in 1933. (No explicit mention is made of the 1938–40 works so it is not clear what the permission was for: it might have been for the work on enlarging the Chancery.) In the case of a future sale the Italian government would have the right to purchase at the same price as that agreed for the sale.

Fingernails must have suffered when, on 21 February, Sir Ivone Kirkpatrick, the UK's High Commissioner in Germany (at Wahnerheide near Cologne), reported receipt of a letter from Adenauer requesting release and return to Germany of both the Villa Wolkonsky and the Villa Crispi. He had written that 'neither the federal Government nor the German public would understand the final loss of the buildings on the eve of the transfer to the federal Government of wider responsibilities in the foreign affairs field'. Kirkpatrick commented there was no evidence of Italian collusion in the timing of this missive; but the fact that he did so betrayed the assumption that must have been made. On 28 February Kirkpatrick was instructed by the FO to inform Adenauer 'with as much brevity and finality as appropriate' that his request 'cannot be entertained'. On that same day the Embassy in Rome had duly deposited the funds at BNL and obtained their receipt (Fig. 16.3), and the sale was complete. Mallett sent a BNL duplicate copy to the FO on 9 March, the original remaining on the Embassy's files.

In subsequent years officials in London and the Embassy have often been stumped by the need to check points 'in the deeds'. Unlike the sale to the Germans (by a private individual) in 1922, there

never was a contract of sale or equivalent title deed. As the Embassy pointed out in May 1951 in response to a request from London for 'the deeds', there would only be the Presidential Decree, the text of which had been agreed with the UK, to be published in the Official Gazette (*Gazetta Ufficiale*) and transcribed into the Land Registry (*Cadasto*). The decree was approved by the Italian Cabinet on 7 July 1951 and signed by the president on 20 July 1951. Probably because of the need for legally supervised translation into English, the last stage – publication in the Official Gazette – only occurred on 8 January 1952. Only then was the UK's title fully effective in law. The decree was formally transmitted to the Embassy by the Foreign Ministry on 18 January 1952. The deal was done. The price had been determined by the International Commission for the liquidation of German assets in Italy (on the basis of Italian official valuation); it was duly paid on 28 February 1951, and the purchase was sanctioned in the manner required by Italian law when property was to pass into the ownership of a foreign state). The UK thereby found itself the owner, as now, of not just one but two large tracts of land within the city walls of Rome, both governed by strict restrictions on their use and development potential (the *vincoli*).

All attempts to rationalise this seemingly extravagant state of affairs have come to nothing, usually because successive new generations of politicians, officials and diplomats, excited by the apparent possibility of realising the capital value of one or other of the estates, did not bring into the equation at an early enough stage the power and the inclination of the Roman authorities to require strict adherence to the *vincoli*. Aesop's fable of the Fox and the Grapes might have been useful required reading for all those who confronted this riddle without solution.

All this had to be rediscovered periodically, for instance when in 1957, in connection with the issue of responsibility for the costs of repair to the aqueduct, the Embassy lamented to the Foreign and Commonwealth Office (FCO) that they 'had been unable to trace a copy of the deeds on our files', to which the MoW rather than FCO was able to reply correctly that they could not send a copy of the deeds as the title was recorded in the Presidential Decree and registered in the Land Registry. With a letter of 20 November 1957 they helpfully supplied copies of the relevant documents, including the all-important receipt from the BNL, showing the sum paid in February 1951.[6]

After many years' hesitation and delay, a new office building (chancery) was built by Sir Basil Spence on the Porta Pia site. The delay and halting execution of that project, reinforced by intermittent expressions of German interest in buying back the Villa, had a profound and lasting bearing on the almost ceaseless reviewing of the UK's ownership and use of the Villa Wolkonsky itself in the ebb and flow of efforts to rationalise the UK's official property portfolio in Rome. One tempting means to that end was always the dream of selling the Villa Wolkonsky.

Notes

[1] For most of this chapter the main source is TNA: WORK/10/116 'Acquisition of Villa Wolkonsky'.
[2] 2 white silk ribbons with gilt tassles
 1 serpent ring
 1 medal
 7 miscellaneous coins (including 3 silver coins)
 1 gold 'Waterman' fountain pen
 1 gold pencil
 4 gold tie pins
 1 leather watch fob with gold mountings

1 empty watch case
4 dress studs in green stone
7 dress buttons in green stone
2 small brilliant ear-rings
3 small gold medallions and crucifix
2 pearls (?)
1 pearl (?) ring
1 box containing oddments of no value
1 pendant necklace

3 There were subsequently four instances of German interest in retrieving ownership of the Villa Wolkonsky, all of which came to nothing:

a) When Adenauer sought its return in 1950 (described in this chapter);

b) In June 1955, when the Germans' interest waned but the MoW worried about the FO wanting at some stage to cave in to German pressure in pursuit of some other interest – see Chapter 18;

c) In the summer of 1968 when some in the FO were keen to find a way to finance the building of a new residence at Porta Pia – see Chapter 20;

d) In the summer of 1972 when the issue of the Rome diplomatic estate was under investigation by a parliamentary committee (also in Chapter 20).

4 This passage dealing with the diversion of energy to the issue of building new offices draws on TNA WORK/10/115.

5 The briefing on this point had noted the tale that the pool was 'said to have been a present from Mussolini to the German Ambassador' – see Chapter 8.

6 Copies of those papers are also still held on Embassy files, though in the meantime even the Embassy has on more than one occasion had to ask the London HQ officials to supply 'the deeds'!

17.
THE RESPONSIBILITIES OF OWNERSHIP: CONSERVING THE AQUEDUCT

The 1956 survey and the story of the aqueduct

The 400-metre section of first-century Roman aqueduct which forms the spine of the Villa Wolkonsky runs from the north-east corner roughly west-south-west (with two slight deviations) across the full length of the grounds (Plate 35). Early in the British tenure the poor state of conservation of many of its 36 spans became evident. It was not on the brink of collapse. But as Italian law dictates that it is the responsibility of owners of ancient monuments to maintain them, but always under the supervision of the relevant authorities in the Italian State, the British government, in acquiring the Villa, faced an uncertain liability. The response could all too easily have been a toxic mix of insouciance, based on diplomatic immunity, and penny-pinching, given the economic climate of the early post-war years. Much to the credit of a handful of senior officials, mainly in the UK Ministry of Works, the responsibility was, on the contrary, taken commendably seriously. A major conservation project was undertaken between 1958 and 1961.

Aubrey Bailey, from 1954 the Ministry's Chief Ancient Monuments Architect, supervised the work. His achievement was summarised in *The Times* obituary after his death in December 2001 in the following lines:

> His most sensitive repair was not in England but in Rome, where he was called in to halt the perilous decay of the first-century Claudian aqueduct running the length of the British Embassy gardens at the Villa Wolkonsky. At the end of the works the aqueduct looked as it had at the beginning – a romantic ruin embowered in cascading creeper and roses. Even trees rooted in the structure were allowed to remain. This treatment, in contrast with the trim and tidy look of ancient monuments in England (where vegetation is usually considered a menace) was partly due to Britain's highly civilised ambassador at the time, Sir Ashley Clarke ... Invariably the success of [his] work was measured by its invisibility.[1]

Bailey was not a bureaucrat, and he habitually took on more work than he could manage, given the personal attention he devoted to the detail of the conservation he carried out. As funds were rarely voted without the proper documentation, including reports of work done, delay was a characteristic of his projects. Although he is supposed to have completed an official report some years after the work on the aqueduct was finished, no copy has been traceable. But he did write an official 'Interim Report' in July 1960 (reproduced in full at Annex III), and he did co-author a paper with his direct superior, P.K. Baillie Reynolds, Chief Inspector of Ancient Monuments, which was read to the Royal Society of Antiquaries in 1962.[2] The account in it displays a natural sense of pride in the conservation by the UK as custodian of a massive slice of Rome's heritage.

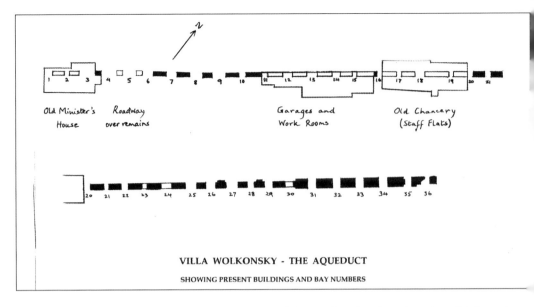

Fig. 17.1. Author's simplified sketch plan of the remains of the aqueduct (based on plans in Colini (Tav II) an[
Baillie Reynolds and Bailey), showing Bay numbers following those used by Bailey and in this book.

Reading that paper was one of the first impulses that led me to the view that a researched histor
of the Villa as a whole was needed. It was not for any deficiency in the fine quality of the report, le
alone of the work it described: rather, I already knew enough to recognise that its Introduction
containing a précis history of the property since the Middle Ages, contained several errors – not to b
laid at the door of its author, Baillie Reynolds, but simply reflecting the received wisdom of the time
and to be found repeated in numerous other official and academic writings.

In 1955 a fall of masonry from the arch connecting the Chancery with the stable/garage block (Ba
16 – see Fig. 17.1)[3] occasioned immediate repair on safety grounds and drew attention to the conditio
of the rest of the structure. 'A cursory survey ... showed that more serious treatment was necessary
there were not to be more, and more serious, falls throughout the length of the aqueduct on Britis
territory.'

The subsequent full survey recorded the then state of the aqueduct. Starting from its entry int
the property from the north-east, the first two bays (36 and 35) lacked their main arches, at lea
above ground; but from 34 to 8 the series of arches was unbroken. Bays 19–17 were embedded in tl
Chancery (see Chapters 3 and 7), while 15–13 were incorporated in low buildings housing garage
and flats on their south side and 16, over the path from Residence to Chancery (where the fir
masonry fell), stood free. Bays 7 and 6 had lost their main arches, and 5–3 had vanished altogethe
above ground where the entrance drive passes over their site, though their lower portions remain r
doubt underground. Bay 2, with parts of 3 and 1, stood to full height above the 'German Ministe
House', which by 1956 housed the Press and Visa Sections. The water channel remained visib
between Bays 26 and 8, though interrupted by the then chancery. What was (and remains) visib
above ground was, as already described, only about half the full height of the aqueduct. With a fe
exceptions on the south side in the Residence garden, the whole lower row of arches was hidden. .

the one point where excavations had been carried out near it (in 1866 by Alexander to uncover the *colombario*), the Roman street level was found some 9 metres below the current ground level. This put the water channel on top of the aqueduct at that point at 22 metres above the original ground level.

The authors noted that the height made the piers look very slender; and that their original designer had clearly underestimated the load they would bear. While they judged the finishing brickwork 'beautiful', they noted that the Aqua Claudia as a whole (from which the aqueduct through the Villa is but a spur) had been so badly built that Vespasian had had to rebuild the entire main course. They speculated that the Neronian spur may have been relatively neglected at that point and remained so until Domitian (who completed its extension to the Palatine) recognised the inadequacy of the arches and reinforced many of them. Indeed the survey showed that every single arch within the Villa had been repaired at least once in Roman times and that any weakness was not in the water channel but the arched carrying structure. The last major work on it was done by Septimius Severus, though some botched work from the fifth century was also identifiable (see Chapter 1).

Baillie Reynolds and Bailey recorded as fact that a government committee had visited the site and reported on its need of repair on 8 August 1826 and that the work was done in 1833.[4] This conflated two separate episodes, the first in 1826 when the estate was owned by the Massimos, and the second after 1830 when Princess Zenaïde bought the property and actually got the work done – possibly having been told by the Massimos of the outstanding procedure. They judged that the work had been

> sympathetically done and harmonise[d] quite well with the Roman work, but it was mostly mere refacing of the piers at low level, and no attempt seems to have been made to strengthen the arches and super-structure where they were weakened.

They were rather more critical in their view

> that what the princess wished to preserve was not so much the monument as a garden feature, and she had no compunction about building her villa round part of the aqueduct, and putting other parts of it to practical uses ... It has served principally as a trellis, for climbing plants.

In a final grudging comment they add that it

> could however safely be said that no more robbing of the aqueduct took place for 130 years after the princess acquired it, but equally next to nothing was done to protect it from further natural deterioration.

While neither the papal nor the Italian governments ever carried out systematic repair of the aqueduct section in the Villa Wolkonsky grounds, Baillie Reynolds and Bailey deduced

> that the Germans also did some repairs: several of the piers have been unsympathetically refaced with brick set in cement from existing ground level up to the springing of the arches, where there was a hideous cement weathering, which has now been removed.

They explained that, while there was no documentary evidence for the attribution to the Germans, it is unlikely that such work would have been done before 1920, i.e. during a period when the Italian government would have been able to intervene and to supervise. Finally, it was clear that when the Germans made Princess Zenaïde's *casino* into their embassy office or chancery, they carried out further

poor-quality work to the water channel, so that they could raise water tanks there, but also so that they could attach wireless aerials, electricity cables, etc.

In practice the structure had no major overhaul between the early third and mid-twentieth centuries. Whatever its faults and depredations, its survival even in its ruined form is a tribute to the skills of its Roman builders. Bailey's conservation project should have considerably extended that life.

The conservation project

The state of the aqueduct was already the subject of correspondence between the new ambassador Ashley Clarke, and the Chief Architect at the Ministry of Works, Bedford, in March **1954**.[5] During on of his visits de Normann had suggested having an expert survey done. The Italian Superintendent o Antiquities, Professor Romanelli, had then reported that work to the tune of L.10m was needed. While Clarke thought that too high, the Embassy architectural adviser, Michailoff, considered it reasonabl for high-quality work. Work could be spread out over time, and it might be possible to get the Italia State to contribute to the cost. Meanwhile a fall of masonry from the arch closest to the Chancery (Ba 16) occasioned the removal of some vegetation; and that revealed that the arch was in danger of crum bling. But the pace of reaction to this concern was not spectacular. Officials in the MoW questione its liability for the upkeep of the aqueduct. On 30 January **1955** the Embassy forwarded to Londo (FO) advice from Romanelli confirming that under Italian law (Law 1089 of 1 June 1939) the UK wa liable – just as France was liable at the Palazzo Farnese – for the costs of measures for conservatio and to prevent deterioration.

The fall of masonry at Bay 16 was then treated as an urgent repair, with Mills, an MoW architec arguing that if the arch were not repaired (re-form the crumbling arch, remove trees too close to th base and seal the top) the aqueduct would cease to be a monument, and Clarke suggesting that it b done without further contact with the Italian authorities. An Italian contractor was brought i November at a cost of £340 to do the work to Mills's direction. Bailey later recorded that 'the resul were not harmonious with the remainder of the repairs and further works were [later] carried out ' improve the appearance'. In other words it had to be done again.

The draft 1956/57 Estimates considered on 22 February **1956** contained £5,210 for the conservatic and repair work, but there was little agreement in London on the approach to adopt, so a week lat the figure was down to £1,550. Mills, arguing that the state of disrepair was the fault of the Italian favoured doing the minimum. De Normann's successor as the MoW Deputy Secretary (Muir) visite Rome in early May and took control. He ruled that work should cease, and no more trees should k cut down: what had been done was not up to the standards laid down by the Chief Inspector of Ancie Monuments, Baillie Reynolds, whose department should be brought in. In Muir's report, dated May, he pronounced that the Ministry had a reputation to protect on preservation of ancient mon ments, and use of the Ancient Monuments Vote should be considered.[6]

That put an end to a period of shilly-shallying and penny-pinching. Muir suggested a visit to Ror by the Chief Ancient Monuments Architect (Bailey). Baillie Reynolds endorsed Muir's view and p posal. He was clearly of the same mind as Muir about the correct way forward and would have truck with the line adopted by Mills. His forthright prose is worth reading.

> This is indeed a remarkable story, and I find it rather a jolt to our *amour propre*. We have hitherto rather
> fancied ourselves as having something of an international reputation in the preservation of ancient

monuments, and we find that it has not even penetrated our own Ministry. What would the Italians have thought of us if we had done as our architect actually suggested and demolished parts of the aqueduct? And what will they think of us if we let it fall down?

The aqueduct is an ancient monument of the highest importance on Crown Property, and it should be preserved and treated as we would preserve and treat a comparable monument in this country. The fact that it is situated in Rome and not in London or Edinburgh does not affect that principle: indeed it makes it all the more incumbent upon us to carry out the treatment, for we are, for the time being, in possession of part of the historical heritage of another nation, and we should be even more meticulous in caring for it than if it were part of our own story.[7]

This approach was endorsed by Hugh Molson, by then minister of works. The team comprising Muir, Baillie Reynolds, Bailey and Clarke proved unstoppable and remained together for the duration of a remarkable project which preserved and enhanced the UK's reputation in precisely the way Muir and Baillie Reynolds had signalled. Muir passed on the welcome news to Clarke but noted that the Italian and British methods of conservation were different and that Bailey, tasked with comparing what the Italian and British approaches would involve, would not be able to fit in a visit to Rome before October, which Clarke accepted.

British and Italian practice in treating ancient monuments did indeed diverge markedly. Baillie Reynolds, in the final published report, expressed the difference as follows:

The British practice has been that established by Sir Charles Peers, the first Chief Inspector of Ancient Monuments under the Act of 1913. It is, essentially, to avoid restoration, and to leave the monument, when the work is done, looking as nearly as possible the same as it looked before the work began. This means that much modern work, such as reinforced concrete ties, is concealed within the original structure, which has to be cut into in order to insert it.

The Italian practice, since the time of Lanciani, has been almost the exact opposite of the British. They have studiously refrained from introducing into the monuments any modern materials or structural devices which would not have been available to the original builders. And in making dangerous ruins secure they have used only the same or reproductions of the same materials as were used for the ancient structure. This practice is certainly archaeologically more purist than the British but aesthetically it is not always so happy; for it has involved a very great amount of restoration of missing face-work, with the result that quite often the original Roman structure is almost entirely invisible, being concealed behind a modern refacing. But it must look very much as it did when it was first built.

Back in Rome in November Bailey required urgent action to stop two large pieces of Bays 1 and 2 from damaging the roof of the Visa Section in the 'Old Minister's House', should they collapse, as seemed imminent; and to repair the arch at the eastern end of the Chancery (Bay 20) which was very loose and supported two large water tanks. The first part of this shopping list was approved in early 1957 in advance of the main project, as an essential preliminary to housing the Press Section in the refurbished building, hardly touched since the war.[8] (The arch supporting the water tanks by the Chancery seems at that point to have been overlooked.) It was agreed that the work be done by Professor Piccini (Superintendent of Aqueducts) and Italian staff, including his assistant, Sig. Testa. But it took Bailey from April till late September to authorise the funding of the £400 cost. The repairs were done with no British supervision, entirely to Italian standards and techniques, i.e. with new facing brickwork supporting the decaying core. The core of the water-channel walls above cornice level was similarly

Fig. 17.2. A screen of trees had to be planted to protect the Residence from being overlooked from a new eight-storey block of flats being built on via Ludovico di Savoia, 1957.

treated with new facing set back behind the original face-line and the top left with a straight and 'unnatural' skyline. Baillie Reynolds and Bailey later commented mildly: 'This example of preservation by restoration makes an interesting contrast to that done according to British standards on the adjacent arches.'

Attention was further diverted in September by the start of a slow-moving saga which began when the Embassy realised that a three-storey block of flats in via Ludovico d. Savoia, directly behind the Residence, was being demolished and replaced by an eight-storey block The Embassy never quite came to the point of protesting, as no laws or rules were being broken and planning permission had duly been given. But hands were wrung and disgruntlement expressed – at the time with one eye on the need not to upset the apple-cart on bigger issues to do with the future of the Wolkonsky and Porta Pia estates. In the end it was decided to reinforce the retaining wall, fill the slope behind it with more soil and plant rows of trees to screen the worst of the overlooking problem (Fig. 17.2), which posed a clear security risk as well as an invasion of privacy.[9] The *Comune* did provid some help over the trees, but the project ate into the MoW's meagre budget and the time available to the staff engaged with the aqueduct project, from the ambassador down.

Bailey however, through overwork, still had not finished his survey report on the aqueduct by late July 1957 and, even after intervention from Muir and Clarke, was only able to do so on 3 October. Muir reported this to Clarke on 9 October. Bailey estimated that using the methods used by Piccini on Bay 1 and 2 would involve a cost for the project of £10–12,000; the British approach would involve £7,000 but to use UK labour would cost too much in subsistence. At the very least there should be UK supervision on the spot. (Ward-Perkins, head of the British School at Rome, had agreed that Michailof informal architectural adviser to the ambassador, would not be suitable for the role.) The Director General of Works, Sir Charles Mole, thought £30,000 a better estimate of costs, including £2,000 for a UK foreman. Bedford, the Chief Architect, argued for using Italian methods which would be cheaper in the long run – and after all it was '<u>their</u> monument'. Mole supported that view.

When even Baillie Reynolds also wavered and came down on the side of Italian methods, Muir say that he had to knock heads together again. He began his meeting on 22 November 1957 by noting the 'disastrous effect on the Embassy garden if all the trees and creepers were stripped away'. He wanted to use the British methods so far as possible, but suggested that the Italian methods be used for the three endangered arches at the north-east end. Mole backtracked but pushed for a firm estimate of the cost of the Italian method. Muir 'guessed' it would be more expensive; Baillie Reynolds and Bailey the agreed the 'combined approach', as did the meeting. An Italian specialist firm would be used under

the supervision of an Ancient Monuments foreman. Bailey's suggestion that the tomb (of Tiberius Claudius Vitalis) be included in the conservation works was also agreed, as well as the clearing away of all the diplomatic wireless (German and British) cabling and supports. Muir insisted in early December that the funds recommended by Bailey for the major project (£7,000 – half being urgent, therefore for the 1957/8 Estimates) be made available. But work was not to start for another year.

Clarke fully approved of the Baillie Reynolds/Bailey approach but wanted to consult Ward-Perkins about the way forward, including the idea that using the Italian Ministry's usual specialist contractor to sugar the pill of following the British approach. In a letter of 10 December he described the approach of Muir and others in London in the following terms:

> [Sir E. Muir] considers that the work should be done by the British methods, though some parts will have to be repaired in the Italian fashion, as the British method might prove difficult unless the Ministry send over their own workers. By using our own methods he is convinced that the work as a whole, apart from costing less, would have the merit of preserving far more of the trees and vegetation of the gardens. He thinks we ought to treat the aqueduct as a garden ornament as well as a monument and that it would be undesirable to strip away all the trees and greenery and destroy the picturesque setting.[10]

In his response to Muir in January 1958 Clarke relayed Ward-Perkins' advice against using the main Italian specialist firm: it would be hard to get them to use British methods. And handling Piccini would need care. Care was the word also in connection with the choice of a foreman – especially his language ability. February 1958 saw Baillie Reynolds and Bailey back in Rome, but Bailey was recalled because of urgent work on Stonehenge, and in practice nothing other than a ministerial visit happened before August, when Bailey announced he had found a foreman, Tom Zavishlock, a Welshman from the Cardiff office. Bailey took him to Rome in November, and he stayed on to get to work – finally – on 27 November, the day after Bailey had left. The plan was to have a break for the summer after six months, with regular inspections by Bailey and Baillie Reynolds. But this schedule was soon ditched for one of carefully phased continuous working in order to keep together the workforce whose growing skills would otherwise have been regularly dissipated. During his visit Bailey had struck up a good working relationship with De Angelis D'Ossat, the Director General for Antiquities and Fine Arts (Belle Arti) in the Italian Ministry of Higher Education, who duly recorded his agreement to the approach proposed by the UK team on 8 December.

The complexity of the challenge remained daunting. Bailey's summary of the terms of reference for the project (essentially the conclusions of Muir's meeting), leave no doubt:

a) [To deal with] the very heavy growth of tree and bush roots against and into the structure, causing serious disintegration;

b) To preserve as many of the flowering creepers and to remove as few of the trees as possible in order to protect the 'romantic' architectural setting in the grounds of the Villa Wolkonsky;

c) [To rectify] the very dangerous condition of many of the arches, owing to lack of support to the exposed rough core through the robbing of the arch-rings and facing brickwork;

d) Consolidation of the loose and unsupported facing brickwork and large areas of disintegrating core;

e) The removal and, where necessary, rerouting of a multitude of both live and obsolete service cables which festooned much of the aqueduct within the Embassy grounds;

f) To carry out the work with the least possible disturbance to the functioning of the British Embassy, the garden parties, the ambassador's private garden and with all due regard to security needs;

g) To ensure the final acceptance of our methods and techniques of conservation by the Italian authorities;

h) To ensure understanding and harmony of working between the British foreman and the Italian workmen employed to do the repairs.

Just when all seemed ready in early December, Zavishlock, having just ordered the necessary scaffolding and other equipment, fell ill with bronchial pneumonia and colitis – though his condition was reported as 'not serious'! (This must have been the case as he was quickly back on the job.) Bailey sent the Embassy a letter commissioning the firm of Di Piero to do the work. The operation began well: in March 1959 Bailey sought and obtained an extension of the contract after the three-month trial on the basis of an estimate of £10,000 for the full operation. At this point the Italians said that they were happy for the three north-east bays also to be repaired the British way. This suggests that Zavishlock had mastered some Italian and displayed the right qualities to give the Italian team confidence and to keep them positively engaged.

Baillie Reynolds and Bailey visited in May. By August Bailey recorded that 8 bays and 8 piers – the most expensive ones to repair – had been completed, i.e. 35 per cent of the project. The total cost was by then estimated at £12,000. The completion proportion rose to 60 per cent by early September, but the Embassy reported that the arch by the Chancery supporting the water tanks was in a dire state – a problem which should have been rectified at the very outset. Bailey on his November visit confirmed the Embassy's judgement and the expenditure of an additional £300 was authorised within a day: the arch was repaired and the tanks replaced by reforming a tank within the aqueduct's water channel.

Bailey turned his attention to the wires and pylons installed by the Germans, not to mention the British additions for diplomatic traffic and to link the main chancery with the Visa Section along the aqueduct in the 'Minister's House'. He had the German debris removed carefully, but at this point of Bailey's visit his attention and some of the labour force had to be diverted to carry out emergency repairs to the main (Antonine) wall at the Porta Pia site, damaged by heavy rainfall. In early January it was agreed that the lines to the Visa Section would be buried in a ceramic pipe parallel to the aqueduct. The Diplomatic Wireless Service agreed to relocate their (confidential) aerials, etc., on which only they could carry out the work – but it took them three months and another prompt from Bailey actually to complete it. By mid-March 1960 Bailey had reported 80 per cent completion of the project, and in April he submitted the estimate for completion in 1960/61 at a cost of £2,200, making a total of £11,900 (including minor repairs to, plus cleaning and roofing of the tomb of Tiberius Claudius Vitalis) and went back to Rome to plan a formal event in June – a joint inspection and celebration – even though the completion was not due till July, when it would be too hot for an event outside.

At Clarke's insistence Bailey reworked the emergency repair to the Chancery arch (Bay 16) conducted by Mills in 1955, which showed up badly against the later 'invisible' restorations. This meant that the ceremony had to be put back from 22 to 30 June; the change fortuitously made possible the presence of Sir Edward Muir, the MoW Permanent Secretary and a real patron of the project. Acknowledging Clarke's report after having been able to attend the event, Muir, without false modesty concluded with the phrase 'particularly as I think I may say it was all my own idea!' The ceremony was reported very fully in the Italian press, with quotations from the speeches, not least noting the (genuine) mutual back-slapping and support for the British method of conservation.

The press and those attending the ceremony, celebrating 19 months of partnership between Italian and British teams, were treated to a written account of the project by Bailey. Four hundred metres of aqueduct had been restored; the first major work on the aqueduct since the 1830s and the first to b

undertaken abroad by the Ancient Monuments Branch. The work, a partnership between them and the Italian contractor, had been carried out, in agreement with the Italian authorities, entirely to British standards, and completed at a cost of £11,500 (some L.20m). The policy had been to repair what was left, doing as little reconstruction as possible, taking down and rebuilding only when structurally necessary and there was no alternative. There had been four main categories of problem:

a) Tree and bush roots – particularly expensive where the roots were under the concrete floor of the water channel;
b) Loose and unsupported facing brickwork – resolved by the insertion of bronze anchor bars and grouting behind the brickwork;
c) Lack of support for the core of many brick arches in danger of collapse – at the north-east end the core of three arches had been so weak that it had been necessary to embed new concrete beams from iron hangers and straps to avoid the need for new brick arches to support the existing (weak) ones;
d) The need to preserve as much plant growth as possible 'to protect the romantic architectural setting' – so only trees growing out of the aqueduct or touching it were removed.

In all 70 tons of earth and debris had been removed from the channel. The materials used amounted to 22 tons each of cement and lime, 3,500 new bricks and 3,800 arch bricks, and 750 kg of bronze. Many German-installed water tanks had been removed from the water channel; and in one section just north[-east] of the Chancery the channel had been relined to form a new storage tank, reasserting the original water-supply purpose. The remains of the tomb had been cleaned, repaired and fitted with electric light. The paper had a tantalising footnote: 'A few years ago when concrete piles were being driven down to reinforce the foundations of the Villa a paved street was encountered at roughly the same level as that adjoining the tomb.'[11] This does not appear ever to have been followed up.

The timing of completion held one additional bonus for Clarke: it was all done before the State Visit by HM The Queen in the autumn of 1960.[12]

Baillie Reynolds subsequently stressed the need for the Embassy to ensure the aqueduct had regular maintenance, not least controlling plant growth and keeping the channel clear. Bailey submitted a brief interim report, but, as we have seen, it was some time before a full report was written.[13] Yet Bailey had not lost interest. He had been at pains to clean up and reduce the number of openings, projecting add-ons, etc., in the in-fill under Bays 11 to 15 against which, on the south side, were staff quarters and garages. This involved replacing with a ventilator a bathroom window under Bay 13 which had weakened the arch. But clearly the occupants did not appreciate bathing in the dark (and with no air-conditioning, in very stuffy conditions), so in February 1963 he was persuaded to agree to the formation of a new window, 1-foot square. His inspection visit in April 1964 led him to propose a long-term schedule of tree-felling by the aqueduct, which, he said, 'would require great expertise in view of the risk to the aqueduct'. Such a schedule was authorised four months later, and work on the trees was still being done during the author's tenure of the Villa, though no mention was made of whether it bore a direct relationship to Bailey's model.

In January 1967 the renamed Ministry of Public Building and Works (MPBW) commissioned more substantial repairs to the tomb of Tiberius Claudius Vitalis which Bailey had foreshadowed when reporting on the initial minor work. The work followed a survey by Griffiths of the Ancient Monuments Branch, who also reported on the condition of the repair work done to the aqueduct. A further visit by Griffiths in June 1969 yielded a further £1,500-worth of repair to the aqueduct; work he claimed was left over from the main project, involving the removal of some unsafe support struts.

In more recent years work on the antique structures has been relatively sparse. The *tempietto* (not as such really an antiquity) had its rotten wooden roof beams replaced in 1991 at a cost of L.18m. In the same year some restoration work was done on the statues and other stonework by trainees at the Italian *Beni Culturali*; and at the same time the senior official there, Alessandra Zianelli, did a survey of the *colombario*, but nothing came of it.[14]

The more exciting tail-piece to this part of the story is that, under the stewardship of Christopher and Nina Prentice (**2011–16**), considerable new work was done tidying up the aqueduct in the area of the Villa's garden, recorded by a plaque commemorating a visit by the Queen, which had been affixed to the aqueduct before the change of plan which meant the Queen did not in fact make the visit! In connection with her work to reshape the garden, Nina Prentice also oversaw further control of the vegetation around the aqueduct. And, most impressively, many of the sculptures, inscriptions and tomb paraphernalia dotted around the grounds (by Princess Zenaïde and others), many of which were quietly disappearing behind the vigorous growth of the garden, were gathered together, restored, conserved and put on display in one of the greenhouses, converted into a museum space, with support from Shell Italia (Plate 36).

All the recent work seems to have been carried out in the spirit of the terms of reference set by Muir and Baillie Reynolds. The garden remains a charming and romantic oasis in the heart of Rome, and the aqueduct is, as ever, the feature on which the rest of the garden depends.

Notes

1. *The Times*, 18 December 2001.
2. Baillie Reynolds wrote the first half and Bailey the detailed account of the work. The paper was read on 8 March 1962 and published, with illustrations, as a reprint from *Archaeologia* Vol. C in 1966.
3. In this and other chapters, as in my sketch at Fig. 17.1. I use the numbering system in the chart in the paper at note 2.
4. They quoted *Atti del Camerlengato Tit iv, fasc. 941*, and Ashby (2), p. 247, n. 5.
5. This section draws on TNA: WORK 10/594 and 611.
6. His report also contained conclusions on:
 a) Porta Pia, where he wanted to keep the whole site if the Cidonio scheme fell through, and retain the squash court; but he had no objection to the ambassador moving another pillar to the Villa – one having already been moved
 b) Villa Wolkonsky should be kept but it needed a lift and a decent dining room; the Chancery block should be turned into staff accommodation once the office moved to Porta Pia.
 c) The Information Section should be moved from Porta Pia to one of the huts at the Villa.
7. Baillie Reynolds to Root (MoW) 12 June 1956, TNA: WORK10/594.
8. At the same time – late 1957 – the Embassy obtained MoW approval to add a second bedroom and a bathroom to Ersoch's gardener's 'lodge' nearby, which had already had a new roof, as the retiring head gardener, Orlando Ghazzi, was being succeeded by a younger man, Battiston, married and expecting a child.
9. Embassy file on Villa Wolkonsky 1957.
10. Embassy file on Villa Wolkonsky 1957.
11. Whether the Residence or the Chancery is not clear, but in any event being done by the Germans; given that we know a piled concrete raft foundation was used for the west wing added in 1939/40 that is most likely where the roadway was found.
12. The Queen also made autumn State Visits in 1980 and during the author's tenure in 2000.
13. Reproduced in full at Annex III.
14. The survey could be the origin of the fine diagram of the tomb reproduced at Plate 4, which the author found loose in a file at the Villa.

18.
WHAT TO DO ABOUT NEW OFFICES?

Buying the Villa Wolkonsky took almost exactly seven years to complete. It also in practice closed off the option – however theoretical – of rebuilding both the residence and the offices on a single site in any near future. And by early 1952 the remaining vestiges of the decisive mood of the months following the war and the 1946 bomb had given way to a mix of indecision and continuing financial stringency, which prevented those clear-headed enough to see it from pushing ahead with the only workable solution: to build the new offices on the Porta Pia site. In fairness, those responsible for planning how the Embassy should be replaced in the longer term faced an almost impossible conundrum: how to square the state of the UK economy and public finances, drained by the war, and the consequent negative power in this context of the Treasury, with the restrictive Italian planning rules (the *vincoli*).

In the months before the 1946 bomb officials in Rome and London had already been finding hard enough the task of 'simply' identifying suitable premises to replace the combined residence and offices beside the Porta Pia. A year later, the UK had grasped the opportunity to acquire a residence for the ambassador, even though it might logically only have needed a temporary replacement residence while new offices and a new residence were built at the Porta Pia site. And that was not so misguided, as it was clear that the government would not for years be able to afford to build two new structures at Porta Pia. Yet that fact was to ensure that the embassy offices, now 'temporarily' housed in buildings enlarged and used for that purpose by the Germans, would remain woefully inadequate and in a poor state of repair, and be condemned to remain so for nearly another 20 years. Meanwhile lack of funds and the Italian *vincoli* made even the idea of building new offices to replace the crumbling wreckage at Porta Pia seem a pipe-dream. Not surprisingly many involved hankered after the apparently common-sense solution of selling all or part of one of the two properties to finance building on the other.

Both sites had the special character and rare advantage that any substantial green space has in Rome, but that very blessing blighted the development potential of both in equal measure because of the stringency of the protection which ensured their preservation. The straightforward long-term objective of building a new residence in addition to new offices on the Porta Pia site was undermined by the protection rules directly (though this was regularly overlooked in London in the years to follow) and indirectly by their depressive effect on the value of the Villa Wolkonsky, the sale of which, in part or as a whole, seemed a potential source of the necessary resources. The alternative option of building new offices at the Villa site was similarly obstructed by the limits on what could be built there and the relatively poor development value of the Porta Pia site without permission to exceed the building limits imposed there by the *vincoli* – meaning that its sale too would not yield the resources needed to build at the Villa.

The Treasury and Parliament in the UK repeatedly over the years complained that ownership of the two sites was 'a scandalous waste of their enormous capital values', even though their acquisition costs had been either long amortised (Porta Pia) or very modest (Villa Wolkonsky) and everyone was

informed of the effect of the *vincoli*. Simply handing over either one or other site to the Roman authorities ('rationalising') would not solve anything either, because the resources released would be wholly inadequate to replace either the offices or the Residence. The apparent grandeur of the Residence was easy to criticise in austere post-war times; the ambitious plans for new offices and a residence at Porta Pia were similarly out of tune with the economic realities of the 1950s, 1960s and 1970s in the UK. So the pressure was constantly on officials and ministers to 'do something', but again and again they found their way barred.

In such an environment decisions could only be slow in coming, partial in character and controversial even when implemented. Each strand of the problem of managing and exploiting the estate was intricately bound up with other strands. Any account of what was achieved risks being oversimplified or repetitive. At one level this part of the tale might seem a catalogue of bureaucratic inertia and/or incompetence. To the writer the story is rather one in which many actors, each pursuing their own perceptions of departmental or national interests, managed over the years to squeeze out a series of steps which, if still frustratingly untidy overall, at least yielded a workable result, namely construction of a new chancery on the Porta Pia site of the old embassy, retention of the residence at the Villa, and conversion of the old chancery/*casino* into staff accommodation, the combination envisaged by Muir in 1956. That position was finally attained in the late 1980s. It owes much to a series of senior officials and ministers who had the vision and in some cases the courage to seize a moment and take just one of the necessary steps, as when they bought the Villa Wolkonsky.

New offices

Once the purchase of the Villa Wolkonsky had been accomplished the clear priority was to build new offices.[1]

Before the destruction of the embassy at Porta Pia the initial working assumption was that the existing site would be swapped for whatever new solution was found. The former German offices at the Villa Wolkonsky did not meet the requirements to which people had been working up to that point. Their inadequacies could not be corrected by refurbishment and repair, and neither demolition/replacement nor further extension would be allowed by the Italian rules.

Periodically over succeeding years officials argued that a new office block should be built at the Villa, forgetting or assuming away the *vincoli*, on which the Italian authorities were consistently unbending.[2] But those on the spot were rarely in favour of erecting a new office block there: the location, good for a residence and maybe some offices requiring privacy and security, was all along considered unsuitable for carrying out the Embassy's main public tasks (commercial, consular, information/press, political) – though every so often an ambassador spoiled the consensus with a different view. No one disputed that the offices needed to be all together on the same site. The accumulated experience of working at the Villa with its shabby huts and other adapted buildings only reinforced that view as time passed. So the strong preference was to build a new office at Porta Pia. The major advantages were that a suitable building, no greater in volume than the existing (destroyed) premises, should be permitted, and the Porta Pia location was considered ideal for offices but not a residence. As we have already seen, that concept was the frontrunner from the first weeks after the bomb. How come it took 25 years to realise?

★ ★ ★

In the early flush of decisiveness, the Ministry of Works (MoW) put in a bid to the Treasury on 22 January 1947 for £350,000 for the erection of new offices and residence at Porta Pia. The Villa Wolkonsky solution was still considered purely temporary. The Treasury allowed £5,000! Undaunted, de Normann asked the ambassador (Charles) to hurry up and nominate possible Italian architects. Charles duly sent four names to de Normann on 31 March, along with the proposal that the offer be made to the Foreign Ministry to release the strip of land wanted by the Rome municipality for their road-widening scheme; but that was the moment when he floated the distracting recommendation that the UK should buy the Villa, which caught on. After a month or two the MoW Chief Architect reported that the work of the chosen Italian architects was 'not distinguished'. He questioned the use of foreign architects: the Ministry could not recruit good architects if the best commissions went to foreigners. By October they had submitted their own plan to the Embassy, but Sir Victor Mallett, by then in post, thought the building had been located far too close to the road, leaving a huge garden space.[3] As the idea of buying the Villa was now taking shape, the bid submitted in October for new offices for 1948–9 was 'only' £100,000.

When, in early 1948, Mallett broke the early consensus by advising that the offices should be built at the Villa, not Porta Pia, de Normann sent the responsible architect, Turner, to Rome in July to get a clear list of the staff to be accommodated in a new office block and to look at its siting in relation to the roads around Porta Pia. Turner calculated the need at 90,000 square feet, a cost of £300,000. But he also noted that the mission to the Holy See wanted co-location with the Embassy to the Republic of Italy (and the need for provision of a cinema). He had seen the city's chief engineer who had told him that the road-widening scheme had not been approved (implying that the Embassy's offer of the necessary strip of land had no immediate negotiating value). Turner even volunteered that he saw some attraction in siting the new offices at the Villa. But in submitting his views up the MoW chain to de Normann, Winter correctly noted that this possibility was blocked by the *vincoli*, both the *parco privato* designation and the protected character of the old chancery, which could not be demolished.

These signs of wavering induced de Normann to put his foot down on 23 August in one of his magisterial minutes. The offices were to be at Porta Pia, and everyone should get on with making that happen. The road-widening scheme was a doubtful starter; provision of a cinema was accepted policy. There should be little expenditure on the Villa in case the FO decided to give it back to the Germans – a prescient thought, though the FO did not wobble when the moment came. The mission to the Holy See might be accommodated at the far end of the Porta Pia site, but that was for the longer term. (It may not be fanciful to wonder whether this point was intended to reinforce the case for buying and keeping the Villa Wolkonsky as the Residence, which he favoured, since any office construction on the possible site of a residence at Porta Pia would rule out the option of a move.) By the time they met on 25 September de Normann, Mallett and Caccia agreed that the Residence should remain at the Villa; the offices would be built at Porta Pia, along with a house and office for the mission to the Holy See. Parr, MoW architect, had a sketch plan ready (Fig. 16.1). It was developed into a schedule and plan by November.

Mallett, having caused the best part of a year's delay, had two more diversionary moves up his sleeve. On 26 November he launched his idea of an exchange of the Porta Pia site for the gardens of the Villa Aldobrandini, which produced a cry of alarm from Perowne (minister to the Holy See), as the site would not accommodate his mission's needs. Then in February 1949 he wondered whether the British Council offices might be accommodated at Porta Pia alongside the Embassy's information section. The very next day, perhaps signalling that he was only passing on the wish of the local British Council Representative, he slipped in a warning that the Rome authorities might not allow all this

additional building at Porta Pia. Again Perowne worried that his interests would be overshadowed by the British Council. The threat of the further delay all this would cause provoked de Normann into action again, by arranging for the MoW Secretary, Sir Harold Emmerson, to visit Rome. Before he went, de Normann warned Caccia not to let Mallett come up with any more proposals: there had been enough delay and shilly-shally.

By May both the mission to the Holy See and the British Council had gone cold on sharing the Porta Pia site, though the Council wanted to 'keep the option open', and Mallett was said by the FO still to favour including the Council. The Treasury livened up the summer torpor by reminding everyone that it had not yet approved the purchase of the Villa nor even agreed in principle to anything at Porta Pia. In September the MoW architects made clear that accommodating the mission to the Holy See (house and office) there would scupper any idea of eventually adding a new Embassy residence.

Ward at the Embassy on 14 September contributed a review of the pros and cons of putting the Holy See's premises at Porta Pia.[4] One concern was to avoid the Legation being affected by any breach between the UK and Italy. This (to us today) improbable scenario was explained in these words:

> If the Italian Government ... obeyed ... the rules, it would not invade or take over the building; but of course a Communist Government would go its own way.

No doubt the post-war experience of Greece weighed heavily on this consideration. The Italian Communist Party had not at that point taken its historic decision to act within the constitution and not seek the overthrow of the system. Although the two missions' premises might have been kept separate if the Holy See Legation had been able to use a separate entrance through a bricked-up archway in the Aurelian Wall, permission to do that had been refused, slightly surprisingly (though a tram line ran directly past the archway, so it would have been dangerous). Ward said 'The present is not a good period in Anglo-Italian relations; the Italians have a number of grievances, which they are ventilating in the press, and our much-advertised financial crisis has certainly weakened our prestige and given the Italians the feeling that they can stand up to us with impunity.' A high-level (i.e. ministerial) approach would be needed. The chargé d'affaires at the Legation thought the rejection was more to do with the Vatican's susceptibility if the Legation were to appear as a mere annex to the Embassy to Italy. Perowne on his return from leave still wanted to keep trying to get permission to have the archway opened up. But in October the FO decided not to pursue that option.

Unaware of Ward's views, Winter (MoW) had reported to the Treasury (Wood) on 12 September that negotiations over Porta Pia with the Italians were in abeyance, as the Italians had no money for their road-widening scheme and had made it plain that poverty and homelessness in post-war Rome were such that they could not evict the tenants of the tenement block on the plot (which the Embassy wanted in exchange for the land for the road-widening). But the new chancery would not be built close to either plot; and for the Embassy, now split between ten buildings on three other sites – all unsatisfactory – the new build at Porta Pia was urgent. The Holy See Mission, whose leases were expiring, also wanted to be accommodated there. The Treasury gave its agreement in principle on 20 September, including the provision of residence and office for the Legation to the Holy See. At least work on the Embassy chancery project could start.

In October the Rome Municipality made an offer to sell to the UK the tenement block which so disfigured the Porta Pia site. But the MoW said that would be acceptable only if the Municipality could assure the Embassy that the leaseholders could be got out; the price (equal to £35,000) was also twice what it should be.

The Embassy and MoW began a desultory conversation about the specification for a new office building. The Embassy also wanted a squash court. There was one there already which had survived the bomb and subsequent neglect, but it would go in the plans for reshaping the buildings on the site.[5] The MoW (Winter) queried the FO's list of cinema, conference hall, library and canteen; and revealed a general attitude: 'It would be most regrettable if we erected a new building only to find that it was too small for our requirements; even more regrettable if we found it was too large.' Shortly afterwards the MoW killed off the request for a new squash court, though it did briefly come back to life a few years later.

Quibbling over the specifications drained any remaining energy from the discussion. De Normann wrote on 10 January **1950** to Caccia's successor at the FO, Ashley Clarke, regretting the apparent fall-off of interest in the Chancery/Holy See project at Porta Pia, which he and the FO had been working on since 1946/7. Parliament objected when important schemes were treated light-heartedly, and they had constantly to re-vote small sums. The estimates needed to contain enough to make substantial progress. In reply Clarke pleaded unspecified 'urgent priorities elsewhere in a year of such extreme financial stringency'. Perowne, however, wrote on 28 March to Clarke saying he was 'pleased the Porta Pia scheme was in suspense indefinitely', as he had never liked it! De Normann, having seen the 1882 letter from Gerald Portal about the bungling of the purchase of the Porta Pia site, developed a strong opposition to selling off any part of it.[6]

Clarke decided to see for himself and visited in July 1950. His report backed the existing general policy, and recommended that Perowne should have one last chance to go along with putting the Legation on the Porta Pia site. His approach showed an awareness of the cultural environment missing from the official papers hitherto. He recommended seeing 'what we can do in the way of a fine modern building' for the Chancery and made sensible suggestions about the layout of the site, also making a point of preserving the formal garden. Provision should be made in the following year's estimates. At a meeting on 22 August de Normann, Clarke and Perowne agreed to proceed on a less lavish scheme than the MoW had been working on. Over the next few months the baton was in the hands of the MoW Chief Architect, Rutter, who noted Perowne's continuing unhappiness with various aspects of the scheme. At an Estimates meeting in January **1951** he remarked that the FO (perhaps recognising Perowne's persistence) thought the Legation to the Holy See should go on renting. And on 1 February he reported that no work had been done on the Porta Pia scheme: there had been no written decision from the FO, and Perowne was querying the Porta Pia scheme.

The 1951 election saw a change of government. Richard Stokes (Labour), ceasing to be the minister of works, took away with him strong views about the need to get value for money out of the two prime sites in Rome, which to him meant selling off the Porta Pia site – a seed for intermittent bouts of parliamentary interest in that line of thought. It is no great surprise that little progress was made to clarify what had become a muddled proposal. In early November Brown, a senior Architect, MoW, visited Rome to look at both sites. He noted that the Porta Pia site was becoming dilapidated but recommended that money should only be spent on weather-proofing and taking down some trees in poor condition. Turner followed this by reviving the idea of a temporary solution for the offices so poorly housed at the Villa. Clarke (FO) pointed out that there would be security objections to rented offices elsewhere, and a few days later he revived Mallett's idea of building new offices at the Villa to replace the huts. De Normann saw the benefit in repairing the huts (the chief architect thought £5,000 would suffice) but again turned down further capital expenditure at the Villa, which would be lost if it had to be sold. He signed off on a letter dated 28 February **1952** to Clarke with: 'I fear we shall never get out of the Rome imbroglio until you have had yourself appointed there. Kindly do so before I retire.' He was due to retire in 1954; Clarke arrived as ambassador in 1953, but the 'imbroglio' outlived them both.

For all the reservations, keeping the Villa as the ambassador's residence remained the central plank of long-term policy, even if no money was to be spent on it. It was now UK property. But 1952 was also the year in which Nancy Mitford wrote:

> After the war we saw fit to install our ambassador and his enormous staff in the former German embassy with its frightful architecture, inconvenient situation and what are now called unpleasant associations, in other words still-reeking torture chambers.

She also opined that HMG could have bought any of lots of available old palaces. Such well-publicised views helped to keep alive the option of building a new residence at Porta Pia as well as the offices, the *vincoli* notwithstanding. That possibility in turn blighted sensible planning for the Villa Wolkonsky as a whole (apart from the aqueduct) and even the Residence's maintenance. Indeed remarkably little work was done on an overall strategy or even on the idea of a new office building at Porta Pia in the early 1950s. Clarke's arrival as ambassador did not have any immediate impact – though he was quickly taken up with the state of the aqueduct and the development of ideas for an overdue refurbishment of parts of the Residence.

The attempt to sell part of the Porta Pia site: so near, yet so far

In February **1954**, pressure in Parliament from Richard Stokes MP about the disposal of the Porta Pia site provoked a spate of discussion between ministries.[7] The FO and de Normann reaffirmed the objective of building a prestige embassy there. But, with the idea of putting the Legation to the Holy See there off the table, they were conscious of the need to decide what should be done with the surplus land. Turner (MoW) commissioned another valuation of the site from Vallini. Gotch (Senior Estate Surveyor, MoW), discussing Stokes's interest and the request from a Select Committee of the House of Commons for Cunliffe (MoW Secretariat) to report on possible disposal of the site, noted in March that, according to the Embassy, the Rome Prefecture (the Prefect being the local representative of the Interior Ministry, i.e. the state) had offered £200,000 for the whole 6.5-acre site and that the Embassy had told Turner that within the previous two years another offer for commercial use of £250,000 had been made by people aware of the effect of the *vincoli*. He also reminded colleagues of the *vincoli* especially the 1:20 plot ratio and the height limit of 4–5 storeys.

Attention at headquarters was diverted in the same month to a more urgent issue: the state of the aqueduct (see Chapter 17). But the Embassy obtained a valuation in writing of the Porta Pia site from their helpful senior official contact in the Italian Ministry of Public Building and Works, Professor Valle, the source of one of the valuations of the Villa in 1948. He thought that, taking account of the *vincoli*, the value would be L.30,000 per square metre: the site's 26,600 square metres would thus yield L.798m (nearly £400,000). No compensation could be expected for the effect of the *vincoli*. Expropriation, e.g. for the road-widening scheme, would not yield more than L.15,000 per square metre, i.e. L.36m (approximately £180,000) for the 2,400 square metres affected. Vallini, in the private sector, in June came up with quite different figures for the whole site of £1.35m if the *vincoli* applied and double that, £2.71m, if they did not.

Against this uncertain background – little more than a guessing game of possible gains from part disposal – the MoW (Marshall) recorded on 2 July that ministers agreed that 'the' Porta Pia scheme should go ahead. One option had been aired for the Porta Pia site: the possibility that, in case a commercial sale

proved beyond possibility, the FO should see if any Commonwealth country would choose to share the site – in the belief that the Rome authorities might accept further building if it was for a prestigious additional embassy. The front (maybe only) serious runner was the Canadian Embassy. It was agreed that they should be offered a lease on a part of the site. With the support of the Foreign and Commonwealth Secretaries (the two ministries were separate until 1965) this was put to the Treasury as a way of responding to their reservation that the site was too large to house only the British Embassy offices.

Largely for financial reasons (but also because of an unwillingness to be a junior partner) the Canada option had evaporated by late 1954, triggering a revival of interest in the strategy.[8] De Normann's successor as Deputy Secretary at MoW, Edward Muir, took the opportunity to try to reinject some energy into the search for a way forward. He called a meeting of the MoW hierarchy and the FO on 12 January 1955 to check whether it was still right to advise ministers to give priority to building a new chancery at Porta Pia. The FO stated that the Foreign Secretary (Eden) supported that approach provided that the part of the site not needed for the offices could be sold off at a reasonable price; if not, then ministers should reconsider. That position was agreed, and Muir, in concluding, added that

a) The Rome authorities should be consulted on the scope for development of the site, and
b) The MoW should consider which part of the site to retain for embassy offices and the likely gain from a sale of the rest.

Clarke was duly instructed to follow up on a) of this not over-ambitious agenda. Alan Campbell, his number two, sought advice again from Valle. He recommended submission to the Rome authorities of a specific plan rather than a theoretical question. The plan should include the offer to waive compensation for surrender of the strip of land the City wanted for the widening of via XX Settembre at that point. A meeting in MoW, attended by Clarke, on 18 February then agreed to work up a plan for offices on the front of the site with a view to selling the back of the site, keeping the existing garages, squash court, etc. Bedford, (now Chief Architect, MoW) was asked to produce a plan maintaining the site's 'open, park-like appearance'. The Ministry quickly established that the Aurelian Wall adjacent to the site was not British government property (therefore the Rome authorities were responsible for its upkeep) but that the immediately adjacent land (known as the *pomerio*) was. And the Treasury were brought into the picture in a letter making much of the relationship between the restrictions on development and the sale value of that part of the site not needed for the offices. The Treasury, on 21 March, simply took note. The ball was at least rolling, though with little direction or momentum. So it could be easily stopped.

In June MoW sent Mills (Architect) and Gotch (Surveyor) to Rome to ascertain the attitude of the city authorities to the policy established by ministers; and to work out what a sale of part of the site might yield. They saw Valle (with Campbell, who was preparing for a call by the German ambassador – see below). Valle confirmed with the Municipality that the same *vincoli* applied to the Porta Pia site as to the Villa.[9] With the ambassador they called on Mayor Rebecchini. He said there were two options for the Embassy. The *Comune* could: a) 'buy' (in effect expropriate) some or all of the Porta Pia site or b), if the Embassy got a move on, raise the limits on building on a strip of land at the rear of the site via Montebello). Mills and Gotch reported that

There would be no relaxation of the restrictions unless there was a specific plan, preserving the open character of the site;
The *Comune* had the power to expropriate but no money to compensate, effectively wielding a veto;

- It might be possible to sell a strip on the via Montebello side;
- There were various options for the extent of the 'strip' which would yield differing gains, and this led them to plump for a sale of 33 per cent of the land.

As there were one or two credible potential investors hovering at the time, this report generated some excitement.[10] One of the possible investors, a contractor named Pietro Cidonio, had sustained his interest over many years. And the German ambassador's call in Rome in June had been no accident: he had come to ask if the UK would soon be vacating the Villa Wolkonsky and moving to Porta Pia, as he was having trouble finding suitable accommodation. He was told that the UK had no intention of building a residence at Porta Pia, and that the UK had full and clear title to the Villa. The German enquiry was first deemed 'a quite innocent enquiry', but it might not have been mere coincidence that the Bundestag had passed a resolution on the return of pre-war diplomatic and consular property on 27 February. That had caused Steel at the FO (who had been in the Rome embassy at the time of the purchase of the Villa) to bring to general attention in July the undertaking given by the Federal German government in the 1952 Convention on Matters arising out of the war and occupation 'not to raise any objections against measures carried out with regard to German external assets' (VI Art 3); but to opine – because of the Bundestag resolution – that 'we have not heard the last of this'. The German ambassador in London asked the same question on 4 July at the FO and got the same answer. In late July the MoW (Marshall), echoing de Normann, noted that it would be wrong to sell part of the Porta Pia site in case the Germans did eventually recover their former embassy and the UK consequently needed to build a new residence at Porta Pia. The Ministry suspected that if German pressure increased the FO might well want to oblige them by ceding the Villa.

The records show that everyone involved on the UK side agreed that there should be no office building at the Villa unless the Germans gave binding assurances that they would not ask for its return – a degree of overreaction which must reflect a wider level of concern and distrust about future developments in (West) Germany.

German interest in the Villa waned, as did that of the Istituto Nazionale delle Assicurazioni (INA) in the Porta Pia site. But Cidonio returned to the charge about Porta Pia. On 22 November Clarke reported to the FO that Cidonio, who had good political connections, had advised that a joint scheme involving the construction of a hotel on a part of the site had a good prospect of being passed. The authorities were keen to improve the number and quality of the hotel infrastructure in the city in time for the 1960 Olympics. He would be prepared to pay the equivalent of £300,000 for land to build 250-room hotel (2,000 square metres) on a site of 10,000 square metres. Negotiations over the division of the site were opened. In February **1956** the Treasury were informed. On 1 March Sir Edward Mu (by now Secretary but still leading on the Rome estate) informed his minister, Buchan-Hepburn, tha

a) 'we and the FO are agreed that we should not again contemplate building an embassy residence on the Porta Pia site;
b) 'the site is too large for use only for an office; so
c) 'land at the back of the site should be sold off.'

On 16 March Cidonio appeared to throw a spanner in the works by telling Libby, visiting Rome, that he could not build his hotel at the back of the site without the illegal removal of several monumental tree he needed a site at the front. His alternative plan was immediately condemned as 'wholly unacceptable and he returned the next day with a version, backed by a re-commitment to his offer, L.500m, whi

Libby accepted and recommended to his minister. On 27 March the Treasury both received and accepted the proposal. The Embassy sent in its planning application through the Foreign Ministry on 4 April in the hope of it gaining approval before the onset of an election season which meant the municipal council could be effectively out of action for several months. On 17 May the Embassy reported to the MoW that the City Planning Committee had approved the application, and it seemed 'that the final approval in June will not present any unforeseen difficulty'. But in spite of the wave of optimism about such uncharacteristic speed of handling by the *Comune*, silence descended on the scene.

Clarke remained cheerful through the summer. But he and officials in London had to deal with an unsavoury episode relating to the developing relationship with Cidonio. The son of a former (pre-war) ambassador was overheard in late May relating loudly to his companions in his London club how a member of the Embassy staff was in cahoots with Cidonio through a mutual friend (a lawyer) with the result that the Embassy's legal adviser was being shut out and that other bidders had not been given adequate information or opportunity to bid for the contract to build a hotel. He even alleged that Cidonio was trying to sell the land on at a steep percentage gain. This was relayed to the MoW minister by the Secretary of State for Scotland who had happened to be present. The accuser was invited in to the Ministry for an interview with Muir and Barclay (FO Under-Secretary) to be told the true situation. Muir nonetheless offered to seek a full report from the Embassy. Clarke, having had the necessary homework thoroughly done, then also saw the source on 12 June, who retracted nearly everything he had said in London. Clarke passed both the results of the investigation and the record of his conversation to the FO on 21 June. Ministers were told, and there the matter rested. But the mere whiff of something not quite right added to the growing uncertainty over whether the Cidonio scheme would come to fruition.

In late August Muir, overriding arguments from Cunliffe (MoW Secretariat) against retaining the whole site for UK use, revealed to the minister that he really did not want to sell off part of the site to Cidonio or anyone else but had accepted the need to keep faith with the deal Cidonio had offered; nonetheless there was no option but to await the *Comune*'s ruling on the application. In October formal negotiations were opened with the Planning Committee. The focus was a demand that the Embassy cede a strip 10 m wide along the inner side of the Aurelian Wall, the '*pomerio*', to enable access (public, technical and archaeological); according to Cidonio it would take the form of a road. The Ministry calculated that such a demand would amount to a quarter of the area under discussion, and Cidonio would doubtless not pay the full price. The garages situated right up against the Wall would have to go and there would be a loss of security. Muir on the other hand simply thought that the Comune should be asked for a statement of their intentions: if they were ready to buy the land he did not see the problem as insuperable.

The (new) mayor explained to Clarke on 19 November that the *Belle Arti* needed the *pomerio* because they wanted to excavate all along the Wall, especially where the garages were sited, believing that important remains would be found there. But there was no intention to build a road, just to ensure public access to any remains found. He reminded Clarke that the Embassy's proposal envisaged building on one-tenth of the site as opposed to the permitted one-twentieth, and stressed the need for the Embassy to make up its mind quickly. On the strength of that discussion Muir held yet another meeting and reported to the minister of works on 6 December that

the conditions from the Comune were unlikely to be deal-breakers: the most important – the 10-m pomerio – had the advantage of showing clearly that the Italians bore responsibility for the potentially onerous maintenance of the Wall;

b) Ministers' unease over the allegations of improper handling and insufficient public access to the bidding were recognised;
c) MoW and FO officials considered it wrong to retain the whole site and just build an office on it, while Muir himself liked the idea of keeping the whole site for the Embassy's use, but it was difficult to abandon Cidonio, and there was a risk of expropriation if there was no development;
d) it was agreed to continue with the joint project, provided that Cidonio was willing to stick to his price and the Comune was willing to pay enough compensation for the ceded land to cover the cost of replacement garages.

The minister agreed, but Clarke in Rome warned that the Comune would not compensate for the ceded land: they were permitting building on the site at double the currently allowed density. He also launched an argument over the tactics and timing of the cession of the pomerio and demolition of the affected buildings, or offering guarantees of access instead.

This argument was interrupted by the arrival on 13 February 1957 of the official communication of the City Planning Committee's decision, which would have to go forward for high-level approval. The deal on the table was:

a) Maximum building area of 3,000 square metres.
b) Cession of land for the widening of via XX Settembre.
c) Disencumberment and cession of the pomerio and the opening of the ancient gate in the Wall.
d) The hotel to be further away from the Wall and no more than 25 m high.
e) A triangle of land in the north-east corner to be sold to the Comune for archaeological excavation.
f) Plans to be submitted in the light of the need to alter the Piano Regolatore; the preserved building on the site to count as part of the permitted 3,000 square metres.

Libby, who was in Rome at the time, was busy obtaining Cidonio's agreement to stick to his offer and accept certain restrictive covenants (which he was), but his report was delayed until 1 March by other travel, in spite of the FO's reminder to the MoW that the main need was to move fast, as the mayor had indicated. The report said that to reject the conditions would be fatal to the Cidonio scheme in the light of the 1960 Olympics deadline. The alternative would be to accept the deal with reservations on some of the 'recommendations' it contained. He was however convinced that there would be no compensation from the Comune on any point. The recommendation to accept was accepted on 2 March by the new minister of works, Hugh Molson; Treasury approval on the basis that Cidonio's offer was worth £284,000 at the then exchange rate was forthcoming on 27 March; and Wilby (Senior Estate Surveyor, MoW) was despatched to Rome to submit the revised plan on 10 April. The embassy Note accepting the conditions was sent in on 7 May. Enthusiasm seemed not to be dampened by the news from the Embassy on 5 June that a variation to the Town Plan would now require full cabinet approval and a Presidential Decree.

After two and half months of silence the Embassy reported that the City Executive (Giunta) had approved the plan on 20 July but the full Council had now gone into recess until 30 September. The Embassy view was that approval could 'be taken for granted'. Clarke told Muir on 4 September that approval at the Council's next meeting was 'certain' – his greater worry was delay to the work on the aqueduct. But a veil of silence once more fell across the Porta Pia scheme. When in early December Molson had to admit in Parliament that he could not give any news in answer to a Question about the rumoured choice of Basil Spence to build a new embassy office at Porta Pia, the Embassy finally

abandoned its Panglossian stance and explained that the application had fallen foul of political difficulties not related to the Porta Pia project but to other applications. One in particular had caused a great stir, the permission finally granted for Hilton to build a hotel on a very prominent green, wooded site, overlooking the city.

Muir complained to Clarke about the City Council's delay. The new embassy assistant legal adviser (Arangio-Ruiz) judged that at least a further six weeks would be needed, not least because, as Clarke explained to Muir on 10 January 1958, the mayor had resigned (to stand for election as a senator) and the new mayor would have to be brought on board. In the same month Clarke dismissed the long-serving legal adviser, Serrao – the one allegedly by-passed in the dealings with Cidonio – and appointed the relatively young Arangio-Ruiz in his place. The soonest he was able to get to the new mayor was 9 March, but with no outcome. Muir recorded that he was 'beginning to despair', even though Clarke had said he would see the prime minister (a party colleague of the mayor). A month later the prime minister (Zoli, a stop-gap) told Clarke that the mayor had scheduled the application to be considered by the full Council 'within the next fortnight'. But then a general election called for 25 May intervened.

Amazingly, Cidonio was still in play. However, prompted by press interest – mainly the *Daily Telegraph* – the April edition of the 'Architectural Review' carried a short piece by that paper's Rome correspondent advocating in strong terms the abandonment of the plan to develop the Porta Pia garden, reflecting the views of opponents of the scheme who were holding things up in the *Comune*. On 16 August 1958 Clarke finally conceded to the FO and Muir that he had concluded that consent for the joint scheme with Cidonio would not be given, and the British government should keep the whole site. Cunliffe (MoW) warned that the Treasury would be unimpressed, Cidonio might seek compensation, and there would be a need to fill the site with something else as the office would only produce a 1:26 plot ratio. Parliamentary criticism could also be expected. The FO claimed always to have preferred not to split the site.

On 12 September 1958 Muir chaired another meeting with the FO and Clarke which agreed that:

) As there was very little chance of approval for the joint development scheme, the focus should now be on building a new office at Porta Pia;
) Perhaps in a few years the idea of building a new residence on the site might find favour (the FO having made clear that it did not at that point), a possibility that should not be closed off;
) The current residence was 'not distinguished but practical' and was 'likely to serve as the residence for a number of years';
) Consequently the Ministry should discuss the situation with Cidonio; the Italian authorities should be told in writing that that if no response had been given to the application in two months it would be assumed it had been refused (but the offer to sell the land needed for widening the via XX Settembre should be renewed);
the MoW would get on with producing a plan for the office building at Porta Pia, bearing in mind the possibility of i) a future residence at or ii) partial sale of the site; and meantime the MoW should maintain the site in good order.

With Cidonio's agreement the Italians were duly told the position. But the process did not stop. The *Daily Telegraph* reported on 10 November that a decision by the *Comune* was imminent, in spite of French objections on the basis that the project would adversely affect its mission to the Holy See in Villa Bonaparte across the road. On 2 December the Embassy formally withdrew the application and announced

that it regarded the proposals made on both sides as lapsed. The *Comune* let it be known that by then its planning committee had sent the application back with a number of (unspecified) objections. When Muir reported to Molson he approved but stressed that later building of a residence on the site must be allowed for.

Thus was buried the one potentially realistic opportunity that had (and indeed has) appeared of getting development value, at least in part, out of either of the two 'valuable' sites the British government owns in central Rome. As one official commented, the effort had been made to respect the Treasury's wishes, and that would help the case to move forward at last on a new office building. And of course several of those involved were quite pleased that work would, at least for the time being, concentrate on a new embassy office.

It is hard to know how realistic the opportunity had been. Cidonio behaved impeccably throughout, but his political influence did not in the end live up to expectation. If the political context had been different, both at *Comune* and national level, the outcome might also have been different, but the *Comune* was from the outset very conscious of the major breach in the rules they would be condoning. The Embassy judgements were regularly over-optimistic; with hindsight one might judge that they relied too much on the local knowledge of their own local staff and advisers and failed at senior level to 'work the circuit' of Roman politics in favour of the scheme. But that was probably a result of the traditional practice of dealing through a foreign ministry rather than going out to argue directly for one's interests in a more public way. A British embassy today might be in a position to mount a very different sort of lobbying exercise. But even that might not have breached the walls represented by the *vincoli*. Subsequent events have shown that the Italians cling to them tenaciously.

Notes

[1] The principal source for this period is TNA: WORK/10/115, 'Rome: proposed erection of new Embassy Residence and Offices'.

[2] That position could, of course, only change if for wider political reasons the Italians were to loosen the conditions incorporated in their laws governing monuments, listed buildings, private parks and archaeological parks.

[3] That would have been deliberate, following a brief to allow for the later construction of a significant new residence.

[4] Discussion of the possible co-location of the Legation to the Holy See is recorded in TNA: WORK/10/20 'Rome: Legation to Holy See and Huts at Villa Wolkonsky'.

[5] I played on it as a teenager in the late 1950s.

[6] See Chapter 15.

[7] The tale is taken up in TNA: WORK/10/611.

[8] Most of this section of the chapter is based on Department of the Environment files EO1 22803/3 Parts 1, and 5 (1955–6?) held by the FCO at Hanslope Park, i.e. not yet (2018) released to The National Archives, made available under the Freedom of Information Act.

[9] His enquiry seems to have led the *Comune* to realise that Porta Pia had never been formally placed under the *vincoli*: on 23 September the Foreign Ministry 'out of the blue' sent the Embassy a Note stating that the Ministry of Public Instruction applied the relevant laws (Law 1497 of 1939 and Regulation 1357 of 1940) to the Porta Pia site, and this would apply to future owners as much as to the current owners.

[10] The contractor Pietro Cidonio had been expressing an interest since 1949, and in August 1955 the head of the national insurance agency INA also came forward, though informally.

19.
THE SAGA OF THE BASIL SPENCE CHANCERY AT PORTA PIA

The new embassy office project takes centre stage

The Embassy confirmed to the Italian authorities in January **1959** the intention to submit a new plan for an office building at Porta Pia within the 1:20 building ratio limit. The Italian response on 23 March welcomed the news and restated the requirements relating to the street-widening and the *pomerio*. But that was not relayed to London until 25 April! And the unusual clarity did not last long. A decision was needed on what other building, if any, should be allowed for on the site.

In June, Wilby (MoW), looking at the future of the Rome estate, pronounced magisterially: 'We do not think that the permanent buildings at Villa Wolkonsky at present occupied by the Embassy Offices could be economically or satisfactorily adapted for residential use.' And in August Clarke repeated the view that Porta Pia was not a good location for a residence. There was no point in pursuing the options of housing a Commonwealth government's offices or those of the International War Graves Commission (a short-lived suggestion). He had no objection to locating 'menial staff flats' there, but opposed either a 'minister's house' or junior staff flats. Slightly confusingly Judd (MoW Architect) reported in the same month to Turner that on a visit to Rome Clarke had also been strongly opposed to building staff flats at the Villa. Wilby repeated his opposition to large-scale adaptation of permanent buildings there for staff accommodation, including a Minister's House; he proclaimed himself without a view on staff accommodation at Porta Pia.

On 1 September Clarke met Sir Denis Allen (FO) and Muir in London and agreed:

a) the Clarke and Allen view that a residence at Porta Pia would be unsuitable and bound to be opposed by the Municipality because of the limit on building;

b) that to develop Porta Pia only for offices, garages and 'menial staff' accommodation was the only practical line;

c) the wish of the minister of works (Molson) to employ a distinguished outside architect presented no problem;

d) it would be appropriate to build a block of staff flats at the Villa (without infringing on the privacy or amenities of the ambassador). Whether this was to be a new building or a conversion was not decided.

These conclusions, plus the added 'detail' that Sir Basil Spence was nominated as the chosen architect, were approved by the minister on 10 September; and a submission was sent to the Treasury on 6 October with a full specification (and the inclusion of £40,000 for staff flats at the Villa). The Treasury's first response (28 October) was to revert to questioning the need for two sites in Rome. The FO pointed out that, as the Italian Foreign Ministry had moved out to the northern side of Rome, the offices at the Villa Wolkonsky were even more unsatisfactory than ever. MoW staff set to work on constructing a package

which the Treasury could live with. By 4 December Newis, Under-Secretary in the MoW Secretariat, was able to tell the minister that the Treasury would agree the appointment of an external architect, provided that an agreed schedule of requirements was produced and the possibility of building some residential accommodation at Porta Pia was kept open. Muir thought it futile to go on talking about building flats at Porta Pia, as the office project would already take up the permitted area of building. He also pointed out that no building at the Villa could be contemplated until the office building was completed. One thousand pounds for preliminary work would be in the 1960–61 Estimates. The Treasury unexpectedly announced on 20 December that, while the architect at Porta Pia must be instructed to bear in mind the possibility of adding future residential accommodation at a later date, if that would seriously prejudice the siting of the office the proviso should be ignored. This read very like 'a free hand' – the Christmas spirit at work? But in May 1960 Jenkins (MoW) told the FO that Treasury acceptance of the retention of two sites was conditional on making full use of both. So the issue of flats had to be tackled seriously. Thus, it seemed, was the continuing interaction of the two sites assured (with the consequent blight on the Villa).

Meanwhile the FO and MoW were hard at it arguing with the Treasury about the scale of the new office project, agreement on which was an essential component of Treasury consent to proceed. The battle was only resolved when Selwyn Lloyd was moved from being Foreign Secretary to the post of Chancellor of the Exchequer at the end of August 1960 and found himself having to overrule his new officials and answer his own letter from the Foreign Office arguing for the figure of 23,000 square feet, the project costing £250,000. Ted Heath, newly appointed Lord Privy Seal (at the FO as the Foreign Secretary, Lord Home, sat in the House of Lords) accepted that outcome on 7 September, and the way was clear for the announcement on 22 November 1960 of the appointment of Basil Spence as the architect for the project. Press reports noted that a £500,000 scheme had been abandoned in 1950; a second project, put forward by David Eccles in 1954, costing £250,000, had been abandoned; as had a third, in 1957, because it involved selling half of the Porta Pia site.

FO, Treasury and the newly renamed Ministry of Public Building and Works (MPBW) argued in desultory fashion for months about whether staff flats or houses should be built and if so where. By May 1961 the Treasury's thinking at senior level had become more nuanced: the new Chief Secretary, John Boyd-Carpenter, after discussions with Lord John Hope, the minister of works, and Spence, had agreed the figures for Spence's project but with the proviso that there would be no additional provision for the MPBW Overseas Vote. The Chancellor agreed on 14 May. A threshold had been crossed; the new office would be built at Porta Pia. But again 'events' intervened, inducing a severe and prolonged attack of dithering.

In July 1961 the Treasury imposed a two-year freeze on capital expenditure on staff housing, even if it showed an overall saving. That included 'Rome offices and flats'. However, with Spence in the saddle (and drawing a fee), limited work was allowed to proceed on the design and local permission for the scheme. In September 1962 Spence made a well-received presentation to the two Comune committees who would rule on a new scheme (including flats) at Porta Pia. By November agreement had been reached, and prospects looked good again; and on 30 November the amendments to the Pian Regolatore had been inserted in the Comune's documents. This was confirmed formally on 14 December 1962, and the revised Plan for 1962 was approved on 22 December, covering the Porta Pia scheme including the flats. The next move was the presentation of detailed plans.

An inconvenient detail clarified by the Comune was that the 1931 Piano Regolatore, which was still in force, also needed amendment because the one-twentieth area limit and the height limit were imposed under its terms: that would take another year. So the euphoria was short-lived, only to be boosted again when Geoffrey Rippon, who had taken over on 5 November the expanded responsibilities of Secretary of State for the Environment, which included the MPBW, announced his intention to visit

Rome to meet the Italian authorities involved. He aimed to persuade them to authorise a start to building before the long process of amending the City Plan was complete and a formal licence could be issued. He, with Muir, duly visited in early January **1963**. The new ambassador, Sir John Ward, organised for him to meet not only the mayor and the other leaders of the *Comune* and the minister of public works but other leading politicians as well with whom he was able to discuss the UK's bid to join the European Community. (He had just been promoted from the job of minister for Europe in the FCO.) This produced the right result – authorisation by the minister of public works a month after submission of the final plans and 'fast track' for the issue of the licence thereafter – and was backed up by a snowstorm of letters of thanks to everyone concerned, which produced several written affirmations of Italian intention to be helpful. And Rippon was able so to report to the prime minister, Macmillan, who was about to visit Rome himself. Rippon predicted that it would be 'possible to begin building work towards the end of 1964' and provision for that would be made in the 1963–4 Estimates. The fact that Rippon's first visit on taking office was to Rome would not have been lost on the Italians. And his engagement with senior politicians for more general political discussions would have magnified the impact of his visit. It is tempting to wonder whether such ministerial engagement might have yielded a different outcome on the joint project with Cidonio. But then, as we have seen, not everyone on the British side had been wholly committed to that project.

Spence's plans were submitted in Rome on 13 February. Although the *Comune* immediately sent Spence's plans forward to the minister of public works, this was to be another cliff-hanger. A sharp increase in labour costs in the Italian building industry undermined the existing cost estimates of the project. Economic conditions in both the UK and Italy worsened. Momentum slackened again. The Treasury in July 1964 authorised a revised estimate of £650,000 for the Porta Pia project (of which the flats now made up £60,000). But, in what proved to be the last of 13 years of consecutive Conservative governments – with Lord Home, by then Sir Alec Douglas Home, as prime minister from October 1963[1] – the state of the public finances continued to prevent any real progress; so there was no reason to press the Italians, who still had not given their green light. The project was becalmed, and the Villa remained neglected.

So, in August **1964**, when the Italians at last gave their approval and Rippon had to submit Spence's latest increased estimates (£790,000 for the offices and £135,000 for the flats, £925,000 all told) Boyd-Carpenter asked if it was possible to 'scrap it all'. On 9 October Treasury officials met their MPBW colleagues – the FO was not invited – and agreed that the project should go ahead, but the flats should only be built if they could be occupied by more senior staff (i.e. produce a larger rent saving). The disadvantages of scrapping were identified as a) the Spence scheme had been well publicised; b) the Italians had bent over backwards to approve the scheme; c) £100,000 had already been spent; and d) it would take a long time to come up with alternative solutions, meanwhile staff were working in increasingly unsatisfactory temporary buildings at the Villa Wolkonsky.

That was the position inherited by Harold Wilson's Labour government which came into office one week later on 16 October 1964, with Jim Callaghan as Chancellor and Jack Diamond as Chief Secretary. Far from offering a prospect of progress, one of their first moves was to suspend the project for two years. Officials – this time including the FO – met on 7 December to explore whether there were alternatives to the Spence scheme and continued to work to reduce the scale and cost of the project in early **1965**.

Faced with this rapid unravelling of what had appeared at last to be a package which could enable some work to start and thus to secure the legacy which Muir so dearly wanted to leave on his imminent retirement, the Secretary weighed in on 25 January with a vigorous, even emotional defence of the Porta Pia scheme to Pannell, the new minister. He needed to ensure that his minister would not roll

over too easily before the powerful Treasury juggernaut. It is worth quoting from this remarkable example of advice from a Permanent Secretary to the minister in charge.

> I think that to draw back now from this splendid scheme – and I mean splendid – would be a tragedy. We quite deliberately appointed Sir Basil Spence as our architect knowing perfectly well that he was not the man to give us a cheap job. We did it precisely because a cheap job was not what we wanted on what everyone who has seen it must agree is one of the most superb sites in Rome – perhaps the most superb City in Europe. If we are to use this site, and I am sure we ought to, we must put a building on it which is worthy of the site, let alone worthy of ourselves – and I think we still have some reputation in the world.
>
> It is only because of the quality of Sir Basil's design, and, indeed, because of Sir Basil's reputation, that the Italian authorities were induced to give us permission to build here at all. Our site was scheduled in the plan of Rome as an open space. It took a great deal of persuasion and a great deal of work, including a personal visit by your predecessor, to persuade the City Authorities of Rome and the Italian Government to put in motion the complicated machinery necessary to amend the Roman plan so that we could put up our building. They did it. But there is no doubt whatever in my mind that if we were now to draw back we should never get permission to put anything else on this site, and British prestige with the Italian authorities would suffer a tremendous blow. And not only with the Italian authorities. Sir Basil Spence's scheme, with the approval of all concerned, has been given the widest publicity all over the world.
>
> You will see that I am personally very deeply committed to this scheme: of course I am – I have been closely concerned with it from its inception, and I have visited Rome on a number of occasions in order to do what I could to push it forward. I think that when we have Sir Basil's proposals for amending the scheme we ought to go into battle with the Chief Secretary with all guns firing – and I think that if we do we shall win. If we lie down under the Chief Secretary's tentative two-year delay the scheme is dead. Sir Basil could not keep his office going in Rome, and we should have to pay him off at very great expense. Sir Basil is a very distinguished man.[2]

Muir had the desired effect. Stiffened, Pannell, with the support of Michael Stewart, now Foreign Secretary, put to Diamond on 17 February the proposition that the project should proceed, but with the flats being deferred, saving £130,000.[3] The delay should not be for long, as the permission to build was valid only for three years. He argued that delay would only further increase costs, and a delay of two years would cause the abandonment of the whole scheme, wasting the effort made (Rippon's visit) to persuade the Italian government to approve the building. Holding back further would make the UK look ridiculous. At the same time Sir Harold Caccia, now Permanent Under-Secretary at the FO, intervened with Sir Robert Armstrong, his Treasury opposite number, pointing out that approval had been given to Spence's £1m design for the UK pavilion at the Montreal World Fair – essentially ephemeral expenditure.

Spence for his part was putting it about that the government wanted to kill off the whole project, while the government's public position about the effects of building cost increases and the balance of payments issue had to be played in low key in order not to undermine their efforts to maintain confidence in the currency.[4] Treasury officials could not agree advice to ministers, and Diamond decided on delay. This did not satisfy either MPBW or the FO. A meeting of Stewart, Pannell and Diamond on 2 June failed to reach agreement. On 17 June 1965 Diamond offered Pannell a green light but the overall cost must cover the flats too. Pannell accepted, but both ministers agreed the need for secrecy

for as long as possible, such was the level of government paranoia about the balance of payments. Spence was so informed on 15 July, in confidence.

The log-jam seemed again to have been broken, just. Steel (FO) wrote to Knight (MPBW) saying so, 'now that the Porta Pia scheme is to go ahead'. But the Chief Secretary decided to visit Rome and see for himself in October. He came away unconvinced of the need for two sites in Rome, convinced that Spence's design was not functionally efficient and determined that the whole setup, including the issue of getting rid of the Villa, should be reviewed during the delay on starting the Porta Pia works. This did not prevent Sir Basil Spence getting back to work on the design, nor the estimate reaching £950,000 by mid-November. But with the promised £100,000 in the Estimates to allow work to start in autumn 1966, the mood was still upbeat. The MPBW, a bit ahead of the curve, was arguing that, as Porta Pia was expected to be complete 'in three years', the FO needed to start thinking about what should happen to the Villa after the Porta Pia offices were complete.

Spence got on with the detailed design work, but then, after a government reshuffle, the new minister of public building and works, Reg Prentice, announced on 28 July that, following new restrictions on government expenditure, the project in Rome (and another in Brasilia) was to be deferred. Spence was again left high and dry.

In November officials discussed a joint FCO and MPBW note with the Chief Secretary (still Jack Diamond), with the incoming ambassador, Sir Evelyn Shuckburgh, present. Shuckburgh, almost alone among the succession of ambassadors whose tenure was blighted by indecision over the fate of the Villa, did not like the place and thought it should be given up.[5] He even opined that the Germans might buy it back.[6] On 30 November Rampton in the Treasury wrote to FCO and MPBW giving the Chief Secretary's views as follows:

a) The present office accommodation was inadequate;
b) The over-large, over-magnicent residence should be disposed of;
c) At least one of the two sites should be disposed of;
d) The relative costs of building on Porta Pia, the Villa or elsewhere should be considered;
e) Best estimates should be prepared of costs and benefits, including site values based on various assumptions about the scope for development;
f) If it was right to focus on Porta Pia, he would not rule out a start in mid-1967, i.e. the Spence scheme.

The review (conducted by R.P. Mills, now Assistant Chief Architect; L.G. Stevens, Superintending Estate surveyor and G.T. Wilby, Senior Estate Surveyor) reported quickly on 2 February 1967 that the right course would be to:

a) Proceed as soon as possible with building new offices at Porta Pia, which would be unsurpassed as offices;
b) The fullest possible use be made of the site, including for the construction of a residence, for which it was especially well suited, while the option of building new flats there should be abandoned;
c) Selling the Villa Wolkonsky would more than cover the costs of the new building at Porta Pia. (Savournin, Chief Estate Surveyor, wisely commented that he doubted it would sell that easily.)

This was agreed between departments on 14 March with the addition of

d) Lease a temporary residence to cover the gap.

On 2 March the prime minister was faced with a Parliamentary Question about the delay from Sir Geoffrey Rippon, who pointed out that preparations for the Porta Pia building had been 'ready in October 1964'. Wilson replied that while it was 'too early to forecast a date on which building will begin, provision of £100,000 has been sought in the Estimates for 1967–68 for this project'. The government was still acutely nervous about the public reaction to a decision to go ahead given the continuing strains on public finances. He had been advised not to mention that the delay had been occasioned by the Chief Secretary's review, nor the proposal to substitute a new residence at Porta Pia for the staff flats – a conclusion with which the FO and MPBW seemed happy to go along. The pros and cons still needed to be put to the Treasury. But the fate of the Villa Wolkonsky was up for grabs again.

A decision at last

The resulting MPBW (Newis) submission to the Treasury (Rampton) was not made until 16 May, estimating that the sale of the Villa would fetch £750,000. So the Treasury cavilled, but on 3 July Rampton responded approving the Spence project on condition that Villa Wolkonsky was sold as soon as the new offices were completed and temporary accommodation for the ambassador found. This letter became the bedrock on which future attempts to resolve the issues were based – some stretching the language or intentions of the Treasury.

Prentice was replaced as minister in late August by Bob Mellish. By early October the Treasury had agreed to authorise a call for tenders, and a press line was developed in case that became public. No mention was made of a new residence. It was hoped to invite tenders in October, which duly happened. On 15 November Stevens could report to the FCO that the Treasury had authorised £850,000 to fund the Spence scheme for new offices at Porta Pia. (He also complained that decisions on changes to the Porta Pia scheme were being made but not shared, including searching for a new residence so the Villa could be sold, Spence being told a residence might be built at Porta Pia.)

Jitters remained the order of the day. But a proper announcement was finally to be made by Mellish in the form of an arranged Parliamentary Question, on 27 February, following the Chief Secretary's agreement that the contract for the offices could be let at a cost of £850,000 (or £905,000 if certain Italian taxes had to be paid). The Minister's Notes provided for him to reveal that

a) Disposal of the Villa had been recommended by the Chief Secretary's review (and the economic case for the flats had not been made, and it had been decided to omit them). It was estimated to fetch at least £750,000. A new residence would initially be provided by leasing.
b) Despite devaluation the successful tender had resulted in a total cost just over £850,000 excluding taxes.
c) The contract was to be signed on 28 February, as the building licence expired on 2 March and at least 'symbolic work' could be done on 28 February.
d) The government expected to recoup the cost from the sale of other premises in Rome, which could be given up when the work was completed. (The words 'given up' caused frantic alarm at the Embassy in Rome who wanted to substitute 'vacated', but even their 'Flash' telegram arrived too late.)

Wilby advised on 1 March that the briefing material on the approval of Spence's plan should say the government 'anticipated that the sum achieved from the sale of the Wolkonsky property would exceed the cost of constructing the new offices'. No doubt this was designed to get the FO to commit to the

Treasury stipulation that the Porta Pia development would be followed by sale of the Villa, even though no residence was included in the Porta Pia scheme. In April Wilby pushed again: the Embassy should advertise for a temporary alternative residence. He must still have assumed that a residence could be added at Porta Pia, ignoring the *vincoli*.

A controversial finale: the Spence Chancery formally opened on 20 September 1971

Changes in the specifications and problems with the contractor meant that the contracted completion in 1970 was not going to happen. But in the spring of **1971**, with the prospect of imminent handover finally looming, the issue of publicity once more rang the alarms in Whitehall. Some of it was critical on aesthetic grounds rather than financial – see Plate 25. And there began a period in which continual if not very energetic efforts were made to find a suitable temporary or permanent residence for the ambassador, respecting the Treasury's injunction that such a move must occur as soon as the new offices were occupied – see Chapter 20.

The office transfer actually occurred over a weekend in the high summer, but the formal opening was kept until slightly cooler conditions could be expected, i.e. on the symbolic 20 September date. The level of hostility to the project (more in the UK than in Rome, though there was criticism there too) left a bad taste in the mouth which had not dissipated by the time of the official opening by Julian Amery.[7] But at least the second phase of resolving the Rome puzzle had been completed, and the focus could shift to the final question, which had been simmering uneasily on a back-burner for some time: what to do about the ambassador's residence.

The Villa Wolkonsky's condition had been blighted since the start by, first, the uncertainty over the priority project of creating adequate working conditions in new offices for the staff and the Treasury's refusal to spend money on the Villa while the Porta Pia project dragged on; and, second, by the strategic question of whether it would be possible and/or desirable to build a new residence alongside the new offices. In a way the problem became more rather than less complex with the vacating in summer 1971 of the old chancery offices, the 'Old Minister's House' and the huts, reinforcing the view of those who argued that the Villa should be sold. That tangled puzzle now needed to be addressed.

Notes

[1] Home decided to renounce his title as the Earl of Home in order to be able to sit, as prime minister, in the House of Commons.

[2] See TNA: WORK 10/597.

[3] Material in this passage is drawn from TNA: Treasury file T227/2433, and from MoW file EO1 22803/129 (confidential) 1963 – which in fact opens in 1965 – made available under FoI by FCO.

[4] Much of the narrative from this point of the chapter also draws on DoE file E02/22806/30 1966, made available under FoI by FCO.

[5] TNA: Treasury file T227/2433.

[6] Quoted by Knight (MoW/MPBW) in a briefing note for his superior Newis on 2 November 1966 (MoW file at note 4). Shuckburgh must have based that assessment on some conversation with his Federal German counterpart, perhaps setting off the train of events in 1968 described in Chapter 20.

[7] TNA: Treasury file T227/2433.

20.

WANTED: A NEW RESIDENCE – REALLY?

The Treasury had made the Spence project conditional on 'full use of both sites', later clarified as a commitment to sell the Wolkonsky property in order to cover the costs of building a new residence on the Porta Pia site or acquiring one elsewhere. So MPBW, FCO and Embassy were under an obligation to find a suitable alternative residence and/or come up with a plan for one on that part of the Porta Pia site not required for the offices and their services. A glance at the sites today shows that the objective was not achieved. Much energy and frustration had already been expended by ministers, ambassadors and London officials in the search for the best answer; yet more of the same was to follow. The search had many facets and many phases. If the end-result turned out to be the continued occupation of the Wolkonsky residence by a series of more or less contented ambassadors, there was high cost in terms of the blight many of them, as well as the buildings, suffered as the uncertainty continued, given the logical unwillingness of those holding the purse-strings to spend major sums on a building whose future was in constant doubt.

Trying and failing to fit the Treasury straitjacket and a revival of German interest

When work had started on the Porta Pia offices in 1968, Knight (MoW), following the requirements in the Treasury's letter of 3 July 1967, commissioned the planning of alternative residences on 28 February, opening a discussion about the timing of rehousing the ambassador and selling the Villa.[1] His eagerness was immediately dampened by colleagues' advice that, until standards for residences had been agreed with the Treasury, they could not do so. For the next dozen years officials in the department tried to keep policy loyal to the Treasury stipulation, first to protect the Spence project at Porta Pia, but also to preserve the possibility of constructing a new residence alongside it, consistently the preferred outcome for the estate management team. Potential buyers of the Villa Wolkonsky came and went (not least from a persistent Chaucer Estates), as did governments. There was never a settled policy to back a serious attempt to sell, and governments were always more focused on public expenditure constraints than the quality of the outcome.

One potential buyer tended to be taken more seriously than the rest. Golds (Head of Chancery at the Embassy in Rome) wrote on 24 April revealing 'slight signs of German interest over the preceding three years in recovering Villa Wolkonsky if the UK ever decided to dispose of it.'[2] The Germans might by now be less worried about the 'evil associations for the Italians being an overwhelming objection'. This revelation was occasioned by the need to report that on 19 April the Federal German Embassy had asked if Seeliger, an official from the *Bundesbauamt* (Federal Buildings Office) in Berlin, visiting to explore long-term options for the Embassy in Rome, could see the Villa Wolkonsky, which he knew from before the war. When told by Dixon that the Villa would be up for sale, he showed considerable interest. That 'news' introduced a new factor and would be considered very seriously. The Germans

had been able to overcome 'historical complications in Paris'. Ambassador Herwath would speak to Shuckburgh.

He had done so the same day, asking if Seeliger could see the house itself. Shuckburgh agreed but warned that a sale was not guaranteed to happen and anyway would not occur for 2.5–3 years. Herwath asked what had happened in 1944 at the Villa that was regarded as so terrible. Shuckburgh told him that, whatever it was, many Italians thought it bad enough to stay away. Herwath, clearly opposed to a German return, noted the point, but accepted Shuckburgh's advice to consult the Foreign Ministry. Asked about the price, Shuckburgh said it would be a market price, dependent on what development permission could be obtained. He thought it a little soon to enquire in London, but the German interest would be borne in mind. Herwath surmised that the price would be beyond the Auswärtiges Amt's means unless it could be bought under the 'Offset' provisions (for the costs of UK forces stationed in the FRG). On the following day four officials had turned up, but there had been no feedback. Golds advised the FCO to tread carefully and avoid stimulating German interest: if they made an offer it would be low. There was no UK moral commitment, e.g. to a right of first refusal.

Herwath asked to see Shuckburgh again, who received his instructions in a confidential telegram from the FO:

- Not to mention any figure for the value of the property;
- If the ambassador mentioned a figure below £750,000, to say it was too low;
- If he mentioned a figure around £750,000, to say he would refer it to the FO;
- An open-market sale was the government's preference over a private sale;
- If the original purchase was raised, to say that an independent valuation of a fair market price had been obtained.[3]

Evidently the idea of serious German interest presented an attractively easy way of meeting the Treasury requirements. If they thought about it at all, the FO officials may have assumed Italian acquiescence in a sale to another embassy. Herwath told Shuckburgh, when they met on 14 June 1968, that he had been asked to get the latter's advice on whether an approach to the FO might be appropriate. Shuckburgh conveyed the preference for an open-market sale but could not advise against an approach in London. Herwath, 'speaking personally', again wondered if a deal might be fitted in under the Offset arrangements, which could allow the Finance Ministry to pay over the market price, e.g. paying £5m if the UK was asking £1m. But, hearing that the Treasury opposed any use of Offset arrangements for such a sale, he quickly back-tracked. He then asked if reconstruction of the offices could begin while the UK ambassador was still in residence, perhaps using a separate entrance to the property, and whether reoccupying the Villa would be a wise (political) move for Germany: Foreign Ministry officials had indicated that the time-lapse had been sufficient to remove any problems – evidently not what Herwath had hoped to hear. Shuckburgh was non-committal.

Herwath's counterpart in London quickly followed up with a call on 1 July on the Permanent Under-Secretary (PUS), Sir Paul Gore-Booth – a step which carried a message of serious intent but was not reported to the MPBW until 13 August. Blankenhorn explained the German interest in a direct deal with the UK government: they wanted to avoid involvement in an 'auction'. Could their officials talk to the UK 'experts'? He too mentioned the Offset idea: so much for Herwath's 'personal' airing of this possibility! Roberts (newly in charge of the estate desk in the Diplomatic Service Administration Office – DSAO) told the MPBW that it would be important to get up-to-date valuations before considering the German approach. Wilby, on 21 August, suggested as a 'workable' figure £900,000, but

Knight in his response to the FO raised it to £1m, adding that the preference remained for the 'normal' open-market route. Whether the Germans received a further response from the FCO or simply failed to pursue the issue is not clear. But again their interest faded.[4]

Shuckburgh (who was nearing the end of his time in Rome and the Service) on 12 September addressed a broadside to the PUS at the FO, raising the risk of accusations of 'culpable short-sightedness and mismanagement of public funds'. Once Porta Pia was occupied (estimated then to be in 1970), there would be no justification for retaining the Wolkonsky residence. It was larger than necessary, but even a temporary alternative would need to be of an adequate scale, respectable and central; otherwise what was the point of building the Porta Pia offices? An annual cost of £15,000 to £20,000 should be reckoned with. Delay in looking at the market was inexcusable. Five or six years of renting would 'blow the cost of building a residence'. What would Parliament say? The market should also be tested for a sale, which could cover the construction costs.

On 18 September 1968 Knight reported Treasury approval for advertising for a temporary residence and noted that expressions of interest in the Villa were being received (including the one from the Germans in July). But he added that Shuckburgh's comments caused difficulty. Until his arrival the FO had argued that the Porta Pia site was too small for a decent residence. Now that they had changed position there were neither funds nor agreed standards to allow a building to be completed in time. The Duncan Review of the Diplomatic Service, launched in 1968, was a further complication, as it could further affect the standards to be applied to residences. Wilby, who preferred to keep the residence at the Villa until a new residence had been built, nonetheless withdrew his objections and instructed the Embassy on 19 September to advertise for a temporary residence, the course his minister, Bob Mellish, had decided upon. When the action was eventually taken, responses were however few and disappointing.

In a letter not coordinated with the MoW, the PUS at the FCO wrote back to Shuckburgh on 26 September noting the authorisation to advertise for a temporary residence. On a sale of the Villa he said that an up-to-date valuation would be £900,000–1 million. The Germans were now much less likely to be interested than had seemed possible following their approaches in July. (It is not clear on what this assessment was based.) The arguments in favour of starting to build a new residence at Porta Pia were not all shared, but were in any case complex enough to prevent immediate decisions. A few days later Knight added his own comments:

- the Treasury had been unconvinced as recently as 1967 of the case for building a new residence at Porta Pia;
- the options were therefore renting or keeping the ambassador uneconomically at the Villa;
- a minimum of 3–5 years of renting would be needed to justify in-goings.

Wilby continued to cast around for ways to finance building a new residence. He wanted to get a developer on board, partly to deal with the issue of planning permission for development of the Villa. A selling price would be agreed on the basis of the permission granted, with the 'vincolato' price (Wilby's figure was £1.25m) as a floor. Spence, aware that funds had not been allocated for a residence at Porta Pia (and probably fearing that his chances of leaving a real magnum opus on that superb showcase site in Rome were dwindling), came up with an imaginative but impractical idea. A Dutch development company he knew (the Hammerson Group) could be given an option on the Villa, to build a 30-storey hotel or office plus car park, and Hammerson would be responsible for getting the necessary permissions. On that basis Spence would put up a 10,000 square foot residence at Porta Pia for only £100,000. Shuckburgh administered the inevitable cold douche to Spence's ploy. The Municipality would

never agree. HMG should not be involved in any way with such a speculative scheme. He agreed with the view that Spence should not in any case be employed on a further building at Porta Pia, but he should be treated with respect. There was nothing wrong with a modest but proper building at Porta Pia. Patrick (later Sir) Hancock, Shuckburgh's appointed successor, but not yet on his way to Rome and talking with Cary about his options, concluded that a move in mid-posting seemed the most likely (as opposed to moving directly into rented premises or sticking to the Villa till the end). In any case, responses to advertising for a rented property yielded nothing acceptable.

Wilby, visiting Rome in January 1969, was nonetheless pushing forward the sale of the Villa Wolkonsky. He made a good start by taking the *vincoli* seriously. An official at the Municipality, Sinibaldi, told him that the Villa Wolkonsky was classified a *Parco Privato* G1, which meant that existing buildings (but not the huts) must be preserved. He thought it might be possible to have the rules modified to allow development within the existing volume of the buildings on the property (including the huts), not only for residential use but also for offices or even a hotel. Wilby also raised the possibility of bargaining permission for a commercial development against the gift of the remainder of the site as a public open space. The *Belle Arti* (Pacini) were less positive: all the buildings except the huts were of archaeological or historical merit and were therefore protected. They had been so scheduled in 1912. The addition of two wings by the Germans had been agreed in 1923: it was open to the Embassy to seek written clarification. Wilby reckoned that if permission were given for a development of 50,000 cubic metres, the site could be worth £1.25m. He had advised Shuckburgh to seek new clarification of the planning position, notifying the intention to sell.

Wilby had come away convinced that the only way forward would be for the Embassy to apply to the *Comune* to have the City Plan (*Piano Regolatore*) changed. When by 24 April the Embassy had not followed his 'instruction' on this Wilby concluded that there was no chance of selling the Villa before the autumn of 1971, by then the likely date for the Porta Pia offices to be completed; in other words the Treasury's condition would not be met. A few other expressions of interest in purchase were received but had to be batted into the long grass, given the absence of any agreed policy or approved plans.

Having heard nothing more from the embassy, MPBW confirmed to them that they should communicate to the authorities their wish to have the *Piano Regolatore* altered. By May the Embassy had again made no move. Instead, on 9 June Golds (Embassy) wrote that it would be unwise to write as proposed: the Italian State had the option to buy at the price offered in the event that the Villa was to be sold. Hancock, still in waiting and perhaps not up to speed, wrote to suggest selling a good part of the garden to finance the construction of the Porta Pia offices and the extra cost of remaining in the Villa. Knight commented immediately and with some vigour. The Villa could not be kept on. The Treasury had made a firm condition of approving the Spence project that a search be made for a leased residence and that the Villa would be sold as soon as the offices had moved. He was shocked that Hancock should be considering retaining it: it was agreed to be too big, and a commitment had been made to the Treasury.

Wilby, after another trip to Rome in June, confirmed that Shuckburgh had advised against a formal approach in the terms discussed in January/February. Wilby now thought that, while the critical element in any strategy had to be sale of the Villa, there was no rush: it could wait till maybe 1973, making direct move into a new residence at Porta Pia possible. A week later Wilby and Stevens changed tack: to save the cost of preparing plans and haggling over planning permission – tying up the capital for a couple more years – it would be best just to sell the Villa for the price of £1.25m and leave any purchaser/developer to go through the planning hoops. Knight accordingly wrote to FCO on 1 August 1969 asking that the Embassy be instructed to start advertising the sale in September. But at this point a new minister of works entered the scene: John Silkin, a lawyer with property development in his

blood. Hancock, at last about to take over in Rome, met him on 16 September, and they concluded (i.e. Silkin concluded) that MPBW should open negotiations on the Villa with two or three developers; Shuckburgh's draft standards for a residence at Porta Pia should be approved; and Spence should be asked without commitment if such a residence could be built for under £100,000.

Two days later Hancock saw Wilby who 'got the distinct impression that he intends to stay in the present house if possible'. Silkin and Cary visited Rome on 26 September 1969 and confirmed the 16 September line with Hancock and senior Embassy staff in the following terms:

a) the MPBW would enter into negotiations with two or three property developers on a scheme for the Villa Wolkonsky – the developers would choose the type of scheme and deal with the planning authorities;
b) Shuckburgh's schedule for a new residence would be used to draw up and cost requirements for a new 'embassy house', confirming the decision to build on the Porta Pia site;
c) Spence should be asked without commitment whether he could build such a house for £100,000; MPBW architects would produce their own estimates; a Warsaw-sized house would be all right at Porta Pia but not elsewhere – if elsewhere it would have to be very grand (Hancock);
d) The Embassy would establish the current land-value of the Porta Pia site and of comparable building sites elsewhere in Rome (the minister wanting to demonstrate that a new building at Porta Pia would be an economical solution);
e) The stable block should be used for the consular section and a shop – the case for a club had not yet been made.

Within the MPBW officials were quick to point out that the Treasury had never fully accepted the case for a new residence at Porta Pia. Rampton's letter of 3 July 1967 had been on the basis that 'the Villa Wolkonsky residence should be given up as soon as possible ... Approval to the Spence scheme is only given if every effort is made to find a leased residence to be available as soon as the new embassy is completed.' Knight, addressing some of the issues from the Rome meeting, volunteered that MPBW surveyors had in 1967 estimated the cost of equivalent land at £200,000–250,000; and the cost of purchase of an equivalent house at £370,000–450,000, plus £30,000 for in-goings. While it would not be possible to realise the full value of the site in a sale, building on it made sense; but in the short term leasing would be cheaper than building. This was not what Silkin wanted to be told.

Silkin and Cary confirmed the plan to dispose of the Villa Wolkonsky on 4 November. By 13 March 1970 Silkin became aware that months after decisions had been taken no approach had been made to the Treasury. The request went in on 26 March for approval for a house of 8,500 square foot costing £180,000. Hancock told Roberts and Walley (MPBW) in late May that he did not want to move out of the Villa Wolkonsky and claimed that had been agreed by Silkin and Cary. He would contemplate living in a hotel but only during the actual move to a new residence. Anything longer would make it impossible to retain the residence staff. But he was confident there would be delay, so he saw no immediate drama. The time to approach the Italian authorities about the sale of the Villa was when the Treasury had approved the building of a new residence (completion of which could be achieved by 1974). The Treasury surprisingly did that only days later, on the basis of the £180,000 estimate; in the dying days of the Labour government this passed almost unnoticed and the Embassy, under its unhurried ambassador, made no further enquiries of the Italian authorities, then or even in the rest of the year, while the new government settled in. In London Wilby became convinced that the Embassy was guilty of deliberate inactivity, designed to ensure that Hancock could remain at the Villa until a new residence was completed.

The change in June 1970 to a Conservative government and a new minister (Julian Amery) initially contributed to or even reinforced the apparent lethargy. Officials recorded in December that Amery preferred to buy a new house but that if a residence had to be built Spence should do it. But he did not immediately act on his view, which would overturn much of the basis on which officials had been working. So the year 1970 passed into history with no progress on either finding a temporary residence or deciding to build a new one at Porta Pia.

Wilby's long tenure as the lead surveyor ended in February **1971**, and the challenge was taken up by his replacement, Boyle. On his first visit to Rome in March, Boyle established that the Municipality would insist that a conversion of the old chancery to staff accommodation (after the offices moved to Spence's new building) would require agreement on a change of use, involving a Presidential Decree to revise the *Piano Regolatore*, taking 12–24 months. But he also came to the view that it would not be wise to make further enquiries until planning permission for a residence at Porta Pia had been granted.

New approach – Amery intervenes, and the Germans resurface

Julian Amery (since October 1970 retitled as Minister of Housing and Construction within the Department of the Environment, DoE) now turned his attention to Rome and began to shake things up. It is not clear whether he was party to the DoE's offer to Spence to have him design the new Porta Pia residence (recorded in a letter from Roberts, FCO, which had not been consulted), an offer which Spence had accepted in principle. Officials told Amery on 12 March that they were nearly ready to submit the proposed residence project to the Treasury. Boyle was to visit Rome again in May to check details. But Amery wanted to explore the option of a part-sale of the Villa. At the end of April he, along with Cary, travelled to Rome. They had in their briefing papers a good summary of the work done on the project for a new residence and the difficulties which were likely to lie ahead in commissioning Spence to build the new residence at Porta Pia on the basis of new rules governing payment of consultants as opposed to the more extravagant (and slackly enforced) rules used for the Porta Pia contract. Furthermore the way Spence had located the offices on the site had limited the scale of the house that could be built on what remained. That part of the brief concluded on space and cost:

> On this we have given Sir Basil an absolute ceiling of £170,000 [sic] for a total area of 11,000 sq.ft., but to judge from experience on his commission on the Chancery it could well be a struggle to hold him anywhere near that figure.[5]

On 1 May Amery and Cary had two crucial meetings: first with the ambassador and senior staff, then with Spence. In the first they agreed that

> There was advantage in retaining the Villa;
> Therefore the key problem was how to finance that;
> The Spence scheme for a residence at Porta Pia was inadequate, and no adjustment to Grade I standard could be fitted on to the plot – the issue of standards, ever contentious, was discussed in depth;
> Financing options were i) to sell part of the Villa (e.g. by the gatehouse); ii) to sell the part of the Porta Pia not to be used for a residence; iii) domestic use development of the old chancery to yield savings in staff rent costs; iv) to use the savings from not carrying forward the Spence residence project (£0.5m);

e) The minister would so write to the Foreign Secretary and Chief Secretary;
f) Spence should be told that no further work was to be done on a residence at Porta Pia.

Amery then duly told Spence that his price was higher than expected and that the site was now too cramped, so he should do no further work on a residence until he, Amery, had consulted colleagues. Spence naturally objected but had no choice but to accept. Amery reported to Sir Alec Douglas-Home, the Foreign Secretary, that his discussion with Spence had not 'allayed his fears that the Porta Pia site was simply not big enough to take the kind of residence we need in Rome'. He recommended that no more work should be done on that project. Instead, the desirability of retaining the Villa Wolkonsky, if necessary at the expense of selling part of the grounds, should be examined. This departure from the approach hitherto narrowly preceded the move of the offices to Porta Pia in early July 1971 (and Amery's attendance at the formal opening on 20 September) and represented a significant change of strategy. It goes almost without saying that the ambassador of the day, Hancock, did not demur.

On a mission to salvage the plan to build a new residence at Porta Pia Burrell (DoE) visited Rome in June to put numbers on the financing options defined on 1 May. He reckoned that, if a part of the Villa were sold for £250,000, it would still be £850,000 more costly to keep on the Residence there than selling the whole property (for £1.2m plus the saving in maintenance costs) and investing £350,000 in a new residence at Porta Pia. The Embassy added that the running costs of the Villa were £46,498 p.a. and were estimated to be £24,108 at a new Porta Pia residence – the first time such figures had been produced without apparent dispute from elsewhere in Whitehall. Officials also told Amery that, until the scope for development at the Villa had been established, no decision could be taken on building a new residence at Porta Pia.

Following Amery's lead, Hancock wrote to the FCO reporting confirmation from the Embassy's legal and architectural advisers that a sale of part of the Villa would require a change to the *Piano Regolatore* which would take at least two years. The area to be delisted would need precise definition, an exercise DoE surveyor (Burrell) should undertake. The application should be made without revealing the purpose (but being ready to show an outline plan) and with no mention of private development. The task of finding buyers should be entrusted to Moretti, who should be given wide discretion.

In November Burrell and the superintending surveyor, Stevens, made a renewed attempt internally in a memorandum to Stevens' director – to reinstate the solution of building a new residence at Porta Pia and selling the Villa as a whole as it was – the conclusion reached a year earlier by Wilby. This was discussed, but it only prompted Amery to pronounce at a meeting on 7 December that the Residence should remain at the Villa Wolkonsky, and a new residence at Porta Pia was no longer the preferred objective. Officials were commissioned to set out figures in the form of ranges, showing the consequences of that decision (including, for comparison, selling all or part of the Villa, the latter in Amery's mind a possible sop to the Treasury); and the minister himself would write to the ambassador and Sir Anthony Royle (Parliamentary Under-Secretary at the FCO), before figures were sent to the Treasury. With unusual speed Hancock replied on 30 December 1971, enclosing a long paper.[6] His main conclusions were:

a) He agreed the basic position but doubted the wisdom of selling off part of the Villa. That would make any later sale of the estate harder and permission, even if it could be obtained, would take at least two years.
b) Objections to selling off the back part of the Porta Pia estate were even stronger. It would close off the option of ever building a residence on the site in the future.
c) Consideration of the sale of the Villa should be deferred for ten years and reopened in the light of developments on standards and the wider diplomatic situation.

d) Effort should focus on using the buildings at the Villa, especially converting the now empty old chancery.

e) If some sale of part of the Villa were necessary to appease the Treasury, he agreed that the precise area should be defined, along with what development would be declared to the Municipality if they asked at the time when permission was requested.

In effect – and with exquisite timing – Hancock was recommending retention of both sites, at the very moment when Sainsbury, minister at the Civil Service Department, intervened aggressively in a letter to Workman at the Treasury dated 4 January 1972 about the 'gross under-utilisation of substantial assets' in Rome. This blast naturally provoked a flurry. Burrell produced the ranges of figures requested by Amery at the 7 December meeting. But Amery saw the danger of being on record with such a firm commitment to retaining both sites, and his Private Secretary withdrew the record of that meeting (making the figures redundant) and issued a new version, while Amery himself proposed following Hancock's advice on developing the old chancery as staff flats to save current expenditure and improve the value of the asset in the long term.

Burrell challenged this too: if the situation was to be reviewed in ten years as Hancock suggested, application of the Treasury's usual formula would show no saving over that timescale – though it would if it was recalculated on an 'in perpetuity' basis! As for the asset value, that was unpredictable as it would be the price it would fetch at the time. There were three options:

i) retain both sites in full;

ii) sell the gatehouse area at the Villa Wolkonsky to realise £250,000 if planning permission were granted – while the ambassador thought that would make it more difficult to sell the property he would acquiesce as it would get off the Treasury hook;

iii) also sell the area at Porta Pia not used for a residence, yielding a combined total of £500,000, but foreclosing any prospect of building a residence there in the future.

The problem with the empty buildings at the Villa Wolkonsky was that they could neither be pulled down (as they were a large part of the permitted development volume) nor allowed to deteriorate (as they were protected). This added to the strength of the original case for disposing of the Villa entirely in its present state. Depending on the planning permission the yield could be from £715,000 to £1,715,000; the costs of building at Porta Pia could be £500,000 – the result would not be that good unless the tenement flats could be bought (estimated cost £666,000). The balance would need further consideration once development potential was clearer. Burrell's advice was submitted on 1 February. It was to be his last throw. Meanwhile, on 3 February, the Treasury reminded those involved of its policy that the whole of the Villa Wolkonsky be sold.

Boyle and an architect colleague (Stout) went to Rome in mid-March. As a sign of the shifting probabilities Stout authorised (even insisted on) repainting of the exterior of the Residence, delayed at Hancock's wish on the grounds that it was supposed to be put up for sale (and most likely he did not want the inconvenience of scaffolding around the whole building). They concluded that the lease-holders at the Porta Pia flats would actually cost £500,000 to buy out; the condition of the flats would not warrant redevelopment so purchase to demolish would be too costly. It would in any case take too long to get rid of the occupants – the leaseholders lived all over the world – even if the Municipality agreed to compulsory purchase. (The Germans' experience in 1920–21 would have shown just how right that judgement was, but no one involved would have been aware of it.)

The din of battle was picked up by the antennae of the Expenditure sub-committee of the House of Commons Defence and External Affairs. They were to visit Rome in May 1972. Hancock reported that they intended to focus on a comparison between renting and owning a residence. He thought it would be silly to consider buying in Rome until the future of the Villa had been decided and pointed out that the cost of buying in Rome ranged between 12 and 16 times annual rents, against the Treasury requirement of 8 times. The FCO instructed him to tell the Committee the there was a prima facie case for selling the Villa and putting the residence at Porta Pia. But in practice it was not certain that a suitable buyer would be found, there were reservations about the adequacy of the Porta Pia site given the standards applicable to the Rome residence, and the block of flats on the Porta Pia site was a great disadvantage. He could draw on his 30 December memo, but should make clear that the final decision was for London to make.

The Embassy reported that the Committee had expressed support for the idea of turning the old chancery building into staff accommodation.[7] A hearing on 25 May showed that they judged that a residence could not be built on the Porta Pia site. Instead they wanted steps taken to develop both sites to the full or sell any parts that the UK did not need: for example, to develop the Villa and sell the surplus land at Porta Pia.

In early June, the Federal German Embassy in London, no doubt detecting the Committee's work on Rome, asked the FCO if there was any possibility of their government reacquiring Villa Wolkonsky before they had to decide where to build a new embassy. After consulting the DoE, Gladstone, Head of the Western European Department, told the German counsellor, Blau, that it would be some time before any decision could be taken on the future of Villa Wolkonsky. Blau thought he should revert in a year: Gladstone replied that the issue had been 'live' for 17 years. Learning of the approach, Hancock surmised that there was some confusion between office and residence. The Germans had intended to build a new chancery on via Nomentana (a main road heading north-east out of the city from Porta Pia). They had acquired a site but then scrapped their plan when faced with 'the magnificence of the Spence Chancery'. There had been no suggestion of replacing their residence, and the German ambassador had told him that he had no designs on the Villa. Hancock, concluding with a personal view at variance with official Italian advice, told the FCO that he thought it remained difficult for the Germans to take it back. He at least thought the 'smell' of the occupation still hung over the Villa. It is not hard to imagine that he may have shared his concern with his German counterpart.

The DoE professionals reluctantly spent much of the summer concocting, largely by guesswork, costings for vague schemes for developments on the site. In the course of that work Mills (in DoE) wrote a historical note in which he claimed that planning permission still existed for staff flats to be built at Porta Pia to a height of 21 m, a floor area of 2,350 square metres and a cube of 10,200: this could be adapted to allow a residence to be built instead.

A joint DoE and FCO team convened on 4 July to consider a detailed ten-year perspective, in the light of the likely conclusions of the Commons sub-committee. The outcome of this important meeting can be summarised as follows:

a) Two key restrictions to freedom action needed to be recognised
 i) The 'parco privato' designation of both sites meant that building volume was limited to the existing 'cube';
 ii) The added 'vincolato' designation meant that the buildings on the site were of historic interest and could not be demolished.

b) The present cube at Villa Wolkonsky was 34,000 cubic metres of which the residence accounted for 22,000 cubic metres. Seeking permission to exceed the cube would take a long time and was unlikely to be approved.

c) The old chancery (like the aqueduct) was of historic interest and would have to be preserved.

d) Development potential was limited by the site, its location, its layout, its single access point and the antiquities on and under it.

e) Rents were so low that the cost of building would be uneconomic except in the very long term.

f) Sale of part of Villa Wolkonsky would prohibit eventual sale of the rest, and any additional building would likely overlook the residence.

g) It could be better to leave Villa Wolkonsky as it was, and spend the minimum needed to maintain it.

h) There should be a new consideration of the possibility of building at Porta Pia to be followed by a joint DoE/FCO visit to Rome 'to consult the Ambassador', also on the possibility of renewing in September the search for a temporary residence.

On 31 July the FCO reported to the Treasury that the Foreign Secretary had agreed with Sainsbury's recommendation that DoE and FCO should conduct a study of Heads of Missions' accommodation requirements, especially in historic locations, such as Rome, Copenhagen and Athens. And Crawford proposed to Draper (DoE) the following approach:

a) The DoE should conduct an architectural study with designs of the possibility of building an acceptable residence at Porta Pia in about ten years;

b) If 'yes', there should be minimal development there of amenities (a pool), reconversion of two houses at the Villa to accommodation, and maintenance of the residence with a view to a sale in the 1980s;

c) If 'no', there should be permanent building of accommodation (houses or flats) and a pool at Porta Pia and refurbishment of the Wolkonsky residence against a defined long-term need to purchase or rebuild on that site.

d) DoE surveyors should consult the *Comune* about exceeding the current limits on the cube.

This level of detailed work was overshadowed by the reaction to the Commons sub-committee's report on 23 August from Patrick Jenkin, Chief Secretary to the Treasury, addressed to both Amery and the Foreign Secretary. He took particular exception to Amery's recorded view that the residence should remain at the Villa Wolkonsky, ignoring Treasury views. (Amery's withdrawal of the record of his decision in December 1971 had thus been in vain!) After Amery had been briefed on the FCO proposal of a joint study of the feasibility of building a Grade I residence at Porta Pia, he wrote back to Jenkin noting that the Committee Chairman had been strongly opposed to placing the residence at Porta Pia, defending his own view and explaining subsequent developments, including the Sainsbury review on which a joint study group was working.

Following the hiving off of the DoE estates organisation as a new Property Services Agency, a PSA architect and surveyor team (Hopewell and Boyle) visited Rome in early October and reported that a Grade II[8] residence could be built at Porta Pia, but, if that could not be approved, selling off parts of the Villa would be a dubious proposition because there was only one access point to the property, so there would be a negative impact on its value and amenities. However, building staff accommodation at the gatehouse (£10,000), the 'Minister's House' (£55,000) and the old chancery (£170,000) would be possible; and more could be done on the 'wilderness' – the north side of the estate – if the residence could be replaced by a smaller building, thus reducing the built area. At Porta Pia a minister's house

(£115,000) and 12 junior staff flats plus amenities could be built (£265,000), if the residence project had to be abandoned. Their recommendations were:

a) The first choice would still be to sell the Villa as a whole and build a residence at Porta Pia;
b) If that was not possible, keep the residence at the Villa in the short term, retain the property intact, create new accommodation on it by converting existing buildings and erecting new ones;
c) Develop staff flats and amenities at Porta Pia.

This package was submitted on 23 October. It would cost £840,000 and save £61,500 a year on rents. Building a new residence at Porta Pia remained by far the best option on estate management grounds. Long-term retention of the Villa risked the UK being saddled with an anachronism if joining the European Community reduced the importance of the mission in Rome. The only other valid option would be to build a new residence there (which would require the demolition of the present residence, which the authorities would not allow). Even if the 'surplus land' there and at Porta Pia were disposed of the benefit (estimated at £315,000) compared unfavourably with that from a new building at Porta Pia; and if the land were not disposed of there would be a net loss of £150,000. If any other decision were to be taken, i.e. ignoring estate management considerations, the economic disadvantages must be acknowledged.

The FCO would have none of it. The Foreign Secretary could not accept that the residence move to a 'town house' at Porta Pia until the diplomatic scene in Rome changed. In a city of grand embassies the UK currently measured up to those of Portugal and Switzerland. He would be prepared to build a minister's house which might later be adapted to a residence, plus some staff flats. The PSA's proposal to provide staff accommodation at the Villa was welcome, but of course if the residence were to move, the whole site would be abandoned. On 5 January 1973 its PUS, Sir Denis Greenhill, and the Head of the Property Services Agency (PSA), Sir John Cuckney, met. The upshot, recorded in a letter from Crawford to Roberts on 18 January, was agreement that the FCO should set out the reasons (as advanced in yet another new paper on 7 December 1972 from Sir P. Hancock in Rome) why the Villa Wolkonsky must be retained as the ambassador's house for the foreseeable future.[9] These reasons and the development plans flowing from them would be endorsed by FCO ministers. This was not the time to change the scale, quality or style of the UK's representation in Rome. 'We cannot contemplate the move (of the residence) to Porta Pia' while the diplomatic scene was as described in the ambassador's paper. But the time might come when change could be appropriate; so an extendable minister's house should be built on the Porta Pia site, plus a small block of flats and some staff amenities. The rent bill should be further reduced by converting buildings at the Villa. There should be no new residence there, nor should the partial sale of either site be pursued. Someone remembered to insert the thought that there was no certainty that such developments would be allowed.

By mid-March FCO ministers had duly approved the joint PSA/FCO approach but ruled that, as the plan would go to Parliament (and therefore be public) the reference to the minister's house at Porta Pia being big enough or extendable to house a Grade I ambassador should be removed, so that the tactics implicit in that idea should not be revealed. The joint report was finally sent to Parliament and to the Treasury. At a meeting on 17 May Treasury officials said that there should be more flats at Porta Pia and no minister's house; and the plan should be formally communicated to the Chief Secretary. On the evidence of a draft in the files, the letter to the Chief Secretary might have been less than frank. And the Treasury inevitably queried the methodology used to derive the figures presented. Meanwhile someone in Rome also remembered that the Rome authorities could scupper the plan; so Crawford (FCO) and Burrell (now PSA) went to see them in early October.

At the *Comune* on 2 October 1973 they learned authoritatively that:

a) At Porta Pia only building up to the unused portion of the authorised 'cube' could be undertaken. If it were so limited a new submission on change of use could succeed; if the cube were exceeded it would have no chance, as it would involve a change in the *Piano Regolatore*, which would take years.
b) The undeveloped portion of the Porta Pia site could be sold, but its value would depend on how much of the cube remained unused.
c) Any development at the Villa could only be for present purposes, and no new building could be allowed.
d) If the ambassador were to move from the Villa, it could only be sold if the buyer accepted the need to respect the current rules (including the *vincoli* and the limitation to current use) – and was clearly a lover of antiquities. Current use meant 'residential', and would preclude conversion to a school, offices or a hotel.

The next day the mayor added that the *Comune* would have to expropriate the property if the UK were to sell to anyone other than another embassy. The expropriation value would be based on the price of prime agricultural land in the province of Lazio, i.e. 'a field of artichokes'! Even if the sale were to another embassy, that would require approval by the Foreign Ministry, who would need to consult the mayor – so the *Comune* could still expropriate. Asked whether the terms of the expired licence for building at Porta Pia could be considered valid, the mayor offered to check, but warned that a new (1973) version of the law on the application of the 'cube' would mean even more restrictive limits.

Not surprisingly Crawford and Burrell concluded that the only way out would be the sale of the Villa to another embassy, and that it suited the *Comune* to keep things as they were because they could not afford to expropriate even at the agricultural land price. Back in London Burrell told his new director (Slater) that no new building could be put up at the Villa, and any buyer would have to continue the present use; that it might not be possible to build a residence at Porta Pia; therefore it might be necessary to consider conversion of the gatehouse, minister's house and old chancery at the Villa. Indeed preparatory work began on schemes to convert those buildings into housing.[10] In addition, if the ambassador was going to have to stay there indefinitely, that would need to be reflected in the estimates of rent saved by those conversions. Slater, however, after studying the by now voluminous files, was not inclined to follow the path indicated by Burrell: in his view a new residence should be built at Porta Pia, using Spence, and 'arguing past the 1973 Act on the cube' – which presumably meant persuading the Rome authorities to ignore their own recent legislation and apply the terms in the expired building licence.[11] By now, however, the Heath government was in increasing crisis, culminating in the three-day week at the end of the year, the government's demise in March **1974**, and the return of the Labour Party under Harold Wilson. No one was in a position to push forward any version of the options for a residence in Rome.

Another hiatus

The next few years saw much further nugatory work to find ways of, in effect, giving substance to the original policy agreed with the Treasury – to divest the Villa Wolkonsky and build a new residence on the spare land at Porta Pia. But in practice once again the state of the UK economy and body politic made the achievement of any such strategy unrealistic.

Having failed to win an outright majority, Wilson formed a minority government, knowing that a further election would have to be fought in a few months. But with inflation still high after the hectic Heath/Barber years, recession and unemployment, the outcome was barely more stable. By 1976 the economy was in full-blown crisis and the government had to borrow $4bn from the IMF, a humiliation of major proportions. Wilson retired on health grounds, Callaghan (who had been Chancellor) took over as prime minister, presiding over deep cuts in public expenditure. A pact with the Liberal Party in 1977 kept the government afloat for another 16 months. But in 1979 Labour was defeated, and the Conservatives under Margaret Thatcher formed a government. Its first few years were marked by continuing economic difficulty, with a push to reduce the power of the trade unions coupled with efforts to achieve a balanced budget.

The end of the road for the Treasury-approved strategy came in practice when an attempt was allegedly made by Margaret Thatcher, on an early visit to Rome, to persuade the Italian authorities to allow the building of a residence at Porta Pia without going through the well-known bureaucratic hurdles yielded no response.[12] In any event in 1981 a decision to keep all of both sites and try to make the best use of them was quietly recorded in a routine annual departmental report to Parliament, against the background of a strong possibility that there would be no second Thatcher term; but her victory over Argentina in the 1982 Falklands War left her unassailable, while gradually a sense of economic well-being returned to government and people alike. In that climate some projects could once more be contemplated. But despite the return of prestige and economic strength no one seemed ready to keep the embers of the original strategy burning and revive the idea of building a new residence at Porta Pia, which might have meant exposing the prime minister to a further rebuff in Rome. So, after a gap of eight years, attention refocused quietly on the plans to use the vacant buildings at Villa Wolkonsky

Notes

[1] The narrative in this chapter relies mainly on TNA: WORK 10/611 (DEMO) 'Rome (Italy), Villa Wolkonsky Embassy Residence Offices' and WORK 10/608 'Acquisition Of Residence For Ambassador'.

[2] Like several references in this part of the narrative this is to be found on MPBW file E01 22801/108 Pt.I (Conf. 1968. This file, like E02/22806/30 Pt.I (Conf.) (note 4), was made available by FCO under FoI. Together they are th sources for this account of the German interest in 1968.

[3] FCO tel 1787 to Rome of 13 June 1968, in MPBW file EO2/22806/30 Pt.I (Conf.).

[4] But individual Germans did not lose interest. When I was given lunch in 2000 by the then German ambassado in London (an old friend), before travelling to take up my post in Rome, he greeted me directly with the question 'D you have title?' Several other German friends have privately expressed keen interest in the writing of this account c the history of the Villa, though not with any obvious irredentist motive.

[5] In back docket of TNA: WORK 10/608.

[6] This paper is also in the Embassy's file 94/5 –1971.

[7] Rome tel 337 of 22 May 1972 (in first file listed in note 2).

[8] Grades I, II, etc., referred to the service grade of the ambassador's post in a capital: there was throughout th period much confusion over the Grade of the Rome post.

[9] The paper contains the most succinct version of the case for retaining the Villa Wolkonsky and is reproduce in full at Annex IV.

[10] See Chapter 21.

[11] Indeed Mark Bertram, the long-serving Head of FCO's Overseas Estate Department (in office at the time the eventual conversion of the old chancery), believes that the 1964 permission to build a further 6,000 cu. m. structu at Porta Pia may still be valid, even if the licence for a particular project has expired.

[12] No record of such a conversation has come to light.

21.
FULL CIRCLE AT THE CASINO

An almost exclusive focus on the main residence at the Villa Wolkonsky (the *villino*) and the influence on it of the long, drawn-out saga of Spence's Porta Pia project has allowed little but side-references to the fates of the other buildings on the site, apart from the relative frivolities of the swimming pool and the *tempietto*. The time has come to rectify that.

Prince among the 'secondary' buildings is the original *casino*, which, after its extension and use by Alexander, appeared only as the house which the Campanari-Wolkonskys abandoned in favour of their new *villino* at the very end of the nineteenth century. It did not disappear. It was in every list of the elements of the property in the Land Registry, always described as being on four floors, but, recorded as having 18 rooms in 1875 and 26 by the time of the German purchase. It could have continued to serve as a guest house, but we have no way of knowing if the family used it at all after 1890. We can assume it was neglected, but it did not tumble down, and the family seem not to have tried to remove it – which, under the *vincoli*, even in the 1870–90s, but certainly after the 1909 Law, would have required permission. So, when the Germans bought the Villa the old summer house was still there. As the Germans needed office space as well as staff quarters, their eye fell naturally on it, however unsuitable it must have seemed. And although it was well over 50 years old, the Italians appear to have allowed the German Embassy to make alterations which completely changed the nature and appearance of the building – or at least not prevented them.

When, to finance the building of the new villa in the 1890s and early 1900s, the Campanari family needed to sell most of the tracts of the estate added on by Alexander, the Italian government had not yet amended the previous papal law, but the Ministry would have been involved in any case. The law was clarified in 1909, and a letter was issued to the Campanaris, setting out the *vincoli*, in 1912. These were only obliquely referred to in Art. 5 of the Deed of Sale to the German Reich in 1922 (but respected, at least inasmuch as the Germans sought and obtained permission for a project in 1922/3, which we can only surmise related to both the extension of the *casino* and the doubling of the *villino*, neither of which took place at that time). Whether the works eventually carried out respected the terms of the permission is not clear, as no documents have come to light in the relevant archives. But the *vincoli* were alive and well when the UK purchased the Villa after the Second World War and duly featured in the Presidential Decree which serves as the UK's Deed of Ownership of the property.

The key provisions developed over the years can be summarised as:

a) No disposal, alteration, repair, addition or demolition to any building/structure on the property without prior permission from the Ministry (Education/*Belle Arti*);
b) Any additional volume of building authorised could not exceed the existing plot ratios and cubic volume (applicable to private parks) without a Presidential Decree to amend the *Piano Regolatore*;
c) No change of use would be allowed without permission of the *Comune* and the government, which would probably involve a Presidential Decree to amend the *Piano Regolatore*;

d) In the case of a sale, the *Comune* would have the right to expropriate the property even if the sale terms respected the *vincoli*.

Successive British ministers, politicians, journalists and others have done the Italian authorities no favours with their gratuitous assumption that such rules could easily be flouted if an appropriate deal could be reached. History of course does record instances where that proved to be the case – as in many countries. But it takes only a look at the way in which Rome and other historic Italian cities have developed, preserving ancient, medieval and Renaissance monuments, respecting the height limits on new buildings, while still placing quality modern architecture alongside the old, to realise that for Italy respect of the rules is a serious matter – and a considerable success.

Although ministers and officials in London had agreed in 1973 an approach which amounted to 'we must keep trying' (to get the rules bent in order to impose the Treasury's strategy), it did include a new emphasis on finding ways to use the properties, especially the Villa, to provide more staff accommodation. By 1975, however, the sense that the way forward for a major new project – new residence, new building of staff houses/flats – on either site was pretty much blocked was becoming stronger. The Treasury had softened to the extent of approving the retention of the Villa Wolkonsky until a new residence could be built on the Porta Pia site. But the Rome authorities had effectively blocked such a project (as they had 20 years earlier declined to approve the sale of a part of that site). And the prospects of selling the Villa in order to finance a new residence at Porta Pia remained low, as the authorities would in effect only allow it to pass to another embassy (and the Germans had lost interest). Even if the prospects of a sale had been better, the problem of finding and financing a temporary residence was a further stumbling block. And, as we have seen, the political and economic climate in the UK was anything but favourable for major capital expenditure projects. So attention shifted to the more modest objective of at least providing more staff accommodation. Achieving even that much brought the *vincoli* into the frame.

Various plans were prepared in 1975, one of which included the construction on the north side of the aqueduct (in 'the Wilderness') of a block of staff flats and two houses for first secretaries. Calculations revealed that the application of the limits of one-twentieth of the area of building on the site and not exceeding the current volume could not be respected unless the Residence (*villino*) were demolished and a smaller house built in its place. But, since the *villino* was a protected building, that would not be permitted either. The only way forward seemed to be a refurbishment and conversion of the 'Old Minister's House' (OMH) and the empty 'Old Chancery' (the *casino*), contrary to the tablet-of-stone pronouncement made in 1959 by Geoff Wilby, MPBW Senior Surveyor:

> We do not think that the permanent buildings at the Villa Wolkonsky at present occupied by the Embassy Offices could be economically or satisfactorily adapted for residential use.[1]

But the UK economic crisis of 1976 brought planning to a halt. At this stage of the story it will come as no surprise that it took the best part of another decade for any work to start. At least in those years a calmer acceptance of the modest strategy of keeping both sites intact and making the best of the status quo seems to have gained hold.

In the 1980s, when the UK economy was, for a change, a source of some optimism, the plans from the 1970s for the conversion of the Old Minister's House and subsequently the old chancery were dusted off and executed, first one then the other, with minor modifications. The results blended in well with the spirit of the place. And those proved to be the last significant changes to have been made

to the buildings at the Villa up to the time of writing, and they were only marginally structural. Residence, garden, and the other houses and flats have all at last enjoyed a period of stability and care which help to expunge the memory of the previous 60 years of looking the other way.

The Old Minister's House (OMH)

Although it is a dwelling of at least modest size, this house has not featured much in this narrative. It played a bit-part in that the German Embassy enlarged and converted it into accommodation in the early 1920s, and included it in some of the maintenance budget bids to have survived. In the late 1950s restoration of the aqueduct involved spans against which the house had been built at the south-west end of the property, and which by then were threatening to collapse through the roof of what were now offices below. In spite of the fine arch embellished with coats of arms which had formed Alexander's grand entrance to the estate, the house had otherwise received little attention, and indeed no one seemed to know much about it.

After the British took over the Villa the house was converted from its German use as staff accommodation to 'temporary' use for sections of the Embassy not requiring a high level of security, e.g. the Visa Section. In 1957 it was given a face-lift (Plate 38), and the Press and Information Sections moved in. It tended then to be known inaccurately as the 'German Minister's House': the Germans had referred to it throughout their tenure as the '*Beamtenhaus*' (officials' house). By some mysterious chemistry this appellation was then transmogrified into the 'Old Minister's House', the name by which the project was known when the time finally came to make some changes. Like the *casino* it lay empty once the embassy offices had moved to Porta Pia. As so little was known, the local architects who were eventually hired to refurbish it were asked to do some research into its origins.[2] The results were summarised alongside the designs they submitted.

Their note correctly described the house's location as adjacent and perpendicular ('*ortogonale*') to the first entrance to the Villa. The writer noted two different styles (and inferred periods) of building: the older part on the northern side of the aqueduct with arched windows and visible brickwork, and the larger, later part on the southern side of the aqueduct with rendered walls and larger, rectangular windows with shutters. The attempt to date the structure was fairly cursory. It referred to the Land Survey (*Catasto Piano*) of 1816–21, where the property was described as '*orto casaleno ed annessi*', but, like others before them, incorrectly labelled it as 'probably bought in 1830 by Prince Beloselsky for his daughter Zenaïde' who was (again wrongly) reported to have moved to Rome in 1834, the year she actually moved to the Palazzo Poli. (This sequence was attributed to Carlo Pietrangeli!)[3] The note asserted that the *Catasto Gregoriano* of 1819–22 showed the entrance to the property plus the predecessor to the *casino* backed on to the aqueduct, but gave no sign of the building by the entrance. Nor was it shown on the '*Planimetria of the Genio Civile*' map of 1900 or even the 1934 edition of the same map.[4] Because it did appear in the *Accatastamento* of 1935–9 as property of the German Embassy – the major enlargement of the Residence also appeared on it – the architects concluded that it had probably been built on to the aqueduct between 1934 and 1939 by the German Embassy, following the precedent of the *casino*. Bailey, in his report of the restoration of the aqueduct, speculated (admitting that he had found no documentary evidence) that the northern part might have originally been the gardener's cottage on Zenaïde's newly purchased vineyard and that it might have at a later stage been higher than it was in 1956. Both guesses seem now to be wide of the mark, while the architects' deduction is just wrong.

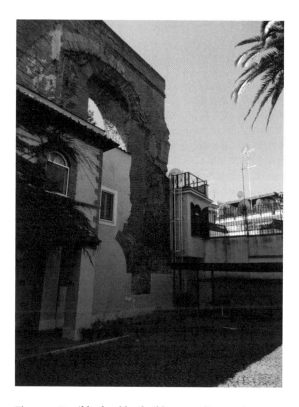

Fig. 21.1. Possibly the oldest building standing on the estate: the recessed former stable block incorporated into the aqueduct (mostly on the south side) and subsequently enlarged into the German Beamtenhaus, which became the 'Old Minister's House'.

The evidence, as so often, suggests a rather different story. The absence from land survey maps of a lesser building on a private estate evidently cannot be taken as proof that there was no building where the OMH now stands. Several nineteenth-century maps of Rome omitted the *casino* even years after Zenaïde had built it on to the aqueduct in 1830. Against that, successive legal and Land Registry documents contain lists of the Villa and its component buildings, each with a number corresponding to a building on the site. From early in the nineteenth century there were references to a structure bearing the number 272 shown against the aqueduct by the (old) entrance to the Villa, for example in maps dated 1818 and 1854, as well as the 1816–21 *Catasto Urbano* map (Plate 2). It was not part of Zenaïde's original purchase. But it was one of the neighbouring properties her son Alexander bought from the Basilica of San Giovanni in Laterano in November 1868 and incorporated in the estate, where it remained even after Nadeïde and Wladimiro had sold off much of his acquisition in order to finance the new *villino* 30-odd years later.[5] In 1899 the land register described building 272 as '*scuderia e rimessa*' (stables and coachhouse/garage). It was so described in the documents filed on the sale of the Villa to the Germans, and it was visible in maps and aerial photographs of the Villa in the 1920s. A document dated March 1923 in the Land Registry showed 272 as qualifying for tax exemption; it is noted as comprising eight rooms on two floors, which shows that no enlargement/conversion had at that date taken place.

That trail suggests that the stables, in a location no longer near the main entrance (which had been moved in the 1890s to the southern side of the estate) and made redundant by the arrival of the motor car, were converted and much enlarged by the Germans very soon after they bought the Villa – to accommodate humans rather than horses or motors. The first surviving reference in German records to the *Beamtenhaus* came in a request to Berlin in October 1927 for L.2,000 to put in new drains because of complaints by a neighbour (confirming that the house in question was located near the boundary of the property). That makes the window for its development 1923–7. It was also identified in an inventory of buildings which Neurath was required to send to Berlin in May 1930. In 1932 it was identified as providing 250 square metres of living space on two floors 'in good condition' (i.e. needing no expenditure). The records of annual budget bids from 1928 onwards contained nothing for it, though a plan of electrical rewiring work for all the outhouses

in 1935 did show the *Beamtenwohnhaus*, numbered 272, in existence and sharing in the work to be done – and incidentally confirmed that by then there was a firm plan to extend the office building in the former *casino* (see Fig. 5.7).

Because a few documents suggest that there was some building activity in the first years of the German tenure the likeliest date for the conversion and enlargement is 1923/4. But the date of construction of the original, older northern part of the structure (and its purpose, tucked in behind the *Scala Santa*, not within the vineyard Zenaïde bought) remains unclear. It might well be the oldest building standing on the site – apart from the aqueduct itself (see Fig. 21.1).

There is some evidence that the house was still being lived in by German officials (possibly Moellhausen) during the occupation, but the British had to use it as offices from the start, as they did the old German chancery. It had remained identifiably a house comprising two flats. So reconversion to living accommodation was not a complicated challenge, especially once the aqueduct had been fully repaired during the major restoration project. And the apparent lack of any evidence about the building's origins meant that it could be labelled 'modern', and its refurbishment could therefore be done without going through a major bureaucratic rigmarole. After a false start in the 1970s, aborted by yet another episode of the debate about whether the British government was going to divest itself of the Villa, detailed plans were finally produced in 1983–4, and the work was finished in 1988.

The two-apartment format was restored initially, with the larger one on the first floor being occupied by the Head of Chancery (see Plate 39). Ten years later the house was reconfigured as a single dwelling to be used as the Minister's House,[6] when the lease on the minister's splendid rented apartment in the Palazzo Doria Pamphilj in the historic centre of Rome could not be renewed.[7] At the time of writing the building has been re-divided into two apartments for senior officials.

The old chancery/*casino*

The rationale for the choice of the name 'Old Chancery' was stronger. Although it had been Zenaïde's original summer house, then Alexander's ramshackle family home, more or less abandoned in the 1890s for the new *villino*, it had been brought back to some sort of life as offices after the German purchase in 1922 – bearing the appellation *Kanzlei* or Chancery – and used as such by them and the British until the 'New Chancery' was opened at Porta Pia in 1971.

It is however hard to nail down exactly when the Germans enlarged the old *casino*. The staff which moved into the Villa in 1922/3 would not have been all that numerous, but they could have had difficulty fitting into the declared 18 rooms (some comprising a small two-room flat) on three floors. Schubert in 1931 (before any work had been done on it) gave the total dimensions as 270 square metres.[8] It must have been obvious from the start that the Germans would have to extend it to make it work as offices, and that such a project would need to be covered by permission from the *Belle Arti* – which may have been sought as part of the same application as that for the Residence, made in 1923. The absence of relevant archives leaves us to make uncertain inferences. We do know that in 1927 Neurath sought authority to spend some money on the old *casino*, i.e. the chancery building: but only for an automatic telephone exchange from Siemens at a mere L.10,700, to stop the operators of the Italian manual exchange listening to all their calls; and the removal from the ambassador's office of the Private Secretary's cubicle. Nothing was revealed about where the Private Secretary would be accommodated instead, but Dahms in Berlin approved on the basis that Neurath would finance it by not resurfacing the chancery approach road (a bid which therefore reappeared

for 1929). In a letter in 1930 Neurath described the Chancery as a three-storey office building. From that one might infer that the work had by then been done. Unfortunately he did not say how many rooms it had, and Alexander's own enlargement of the house might technically have made it already a three-storey building, even though the Land Registry gave four – which probably included the space at the top of the tower.

The archives are in slightly better shape for the 1930s. The Germans asked for Italian permission in 1933 to make certain 'alterations', but no detail of the request is recorded. It may or may not have related to the 1923 application. There are also references in subsequent papers to further major work on the offices in 1936–7. A clear statement of what was done in those years only appears in a 1942 memo, which states that the old Villa Wolkonsky chancery had

a) been enlarged by the addition of a cellar and 'an upper floor' between autumn 1933 and autumn 1934; and
b) had two storeys added between late autumn 1936 and summer 1937.[9]

If we put this together with the two facts that much of Hassell's formal bid for work in 1934 focused on the Chancery, which he wanted to 'extend' – even if the bid amounted to little more than adding a waiting room and secure file storage – and that the 1935 rewiring plan shows that the southern side of the building was already an extended joined-up structure while the north side had still to be done, we begin to see roughly what that 1942 memo meant (see Fig. 5.7).[10] Whether this work was part of what the Belle Arti had approved in 1923 or a new project covered by the permission for 'alterations' dated 1933 remains to be established.

However when the work was nearly complete (in February) Hassell put in a further bid for (re)furnishing/equipping the waiting room, the antechamber (ambassador's outer office), the cash office and the press office toilet on the ground floor plus a further waiting area, the registry and toilet on the first floor.[11] Assuming that too was completed in 1934, the accumulated evidence, such as it is, strongly suggests that the ambassador and chancery staff struggled through the 1920s and early 1930s in poor accommodation, anything but suitable for a major European power, even a defeated one. The 1936/7 addition largely accounted for the document in 1947 recording that the British Embassy chancery was on three floors with 26 rooms. But there was one further addition during the war (1942) of a new small third floor at the north-eastern corner of the building, enclosing a roof terrace – see below.

Mackensen, on arrival in 1938, might have been expected to have had a lot to say about the lack of grandeur of his office, even in the newly extended chancery. He did have his office redecorated. He also had a new safe room built into the old aqueduct, which meant inserting reinforced concrete into the ancient structure before the new steel door could be fitted. The old door was to be reused on a secure cash store also built into the aqueduct. (It would be a fair bet that officials of the Belle Arti were not consulted.) He stopped there. By that stage he was probably already involved in planning the project for a totally new embassy building, making further embellishment of the old one unjustifiable and he was soon temporarily residing elsewhere while the Residence rebuild was being carried out. Maybe even he thought enough was enough.

Post-war, very little was done to the building during the 25 years it served as British Embassy offices. It suffered a severe case of planning blight, as the prospect of moving to a new grand build at Porta Pia advanced and receded but never completely vanished. When I served there in 1970–72 it was an unloved and unlovely place to work. Once the move to Porta Pia took place it was easy for everyone

to put it out of their minds. But not everyone did. As with the Old Minister's House, plans worked up in the 1970s came to nought. Like the OMH it stood unused until the mid-1980s. It took that long for the steam finally to escape from the balloon marked 'New Residence at Porta Pia'. Only then was it politically possible to acknowledge the likelihood of retaining the Villa indefinitely as the site of the Residence and as much staff accommodation as could legitimately be created there, making the best of its distance from the office and the apparent impossibility of building anything further on the Porta Pia site. The buildings which had been the poorest of poor cousins from the 1940s to the 1970s suddenly became interesting again.

The shift of position, in practice a fait accompli for some time, was released into the public domain in a routine report to Parliament which noted that the government's policy was to make the best use of both sites in Rome. It was time to take some long-delayed specific steps to make proper use of existing but dormant capital assets. (I wonder if any civil servant was ever asked to calculate the costs to HMG over the 40 years of failing to use efficiently the assets it possessed rather than trying to swap the assets for others.) The plans for the conversions of both OMH and the old chancery are preserved.[12] In the case of the old chancery, they have the exciting benefit that they suggest that a plausible deduction of the extent and shape of the original *casino* is not impossible – a challenge for an architectural historian with an artistic bent!

The architects' Historical Note, for all its errors (even the date of occupation of the new Spence Chancery, put at 1978), recorded an analysis of the sequence in which the various parts of the building were constructed, based on their own technical observations:

Phase I (late eighteenth century): the original cottage (*casale*) built up against the aqueduct, on its north side, with ceilings/floors (*solai*) of wood;[13]
Phase II (1830): the first 'restoration' by the Wolkonskys – i.e. the construction of the princess's *casino*;
Phase III (1860–70): Alexander's repairs and extensions mainly on one (south) side of the structure, as (they said) was clear from the south-east prospect view, with floors with iron supports for the floors – one can deduce that he also extended the old cottage on the north side by a few metres to bring the eastern external wall level with the first arch to the east (no. 20);
Phase IV (after 1930): major enlargement by the Germans, resulting in the whole north side (north-west prospect view) being finished in a mix of bricks and reinforced concrete, typical of the 1930s, as was the addition of a new floor on the terrace of the old building on the north side, so that the whole roof on the north side was covered in Eternit. (The German addition incorporated Arches 17 and 18.)
Phase V (after 1947): this had involved no structural change.

The plans themselves however suggest that this summary did not interpret entirely correctly what had actually happened. Three of the extant pictures of the *casino* from the 1830s help a bit to visualise its extent and appearance. The first is a view from the northern side painted by a young Polish artist, Julian Karczewski, in 1831, i.e. shortly after Zenaïde had built her summer house onto the existing picturesque but modest structure – which stands in the foreground of the picture and is remarkable for its corner buttresses (Plate 30). It would have incorporated one arch of the aqueduct (Arch 19) and communicated through that arch with the new structure Zenaïde added or with an existing utility structure such as a tool shed. The second is the well-known watercolour of a party at the Villa, painted in 1834 by an unknown artist (Plate 31): it does not tell us much about the house but shows clearly the outside staircases, much commented on by contemporary visitors, as well as a ground-floor entrance and the wall leading to Arch 18. (The roof terrace appears to have been reached by a further

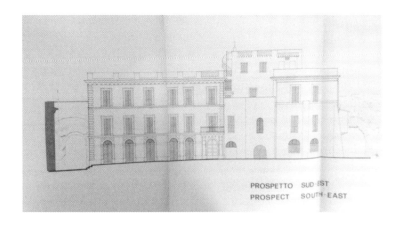

PROSPETTO SUD·EST
PROSPECT SOUTH·EAST

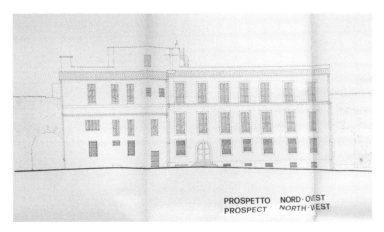

PROSPETTO NORD·OVEST
PROSPECT NORTH·WEST

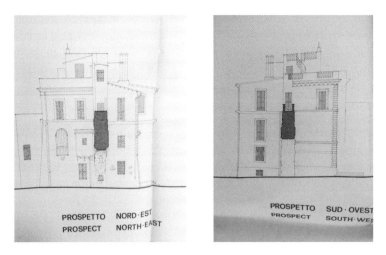

PROSPETTO NORD·EST
PROSPECT NORTH·EAST

PROSPETTO SUD·OVEST
PROSPECT SOUTH·WES

Fig. 21.2a–d. The four elevations of the old chancery, drawn by Italian architects in 1985 at the time of its conversion into staff accommodation.

partially external, partially covered stair on the northern side of the tower on which it sits.) The third is the Zhukovsky sketch of Gogol on the terrace (Fig. 2.8), which interestingly seems to confirm the impression given by some contemporary maps that a low outhouse (subsequently enlarged and used mainly as garages) on the south side of the aqueduct to the south-west of the *casino* itself was included in the 1830 purchase.

One small part of the German work on the building is fully documented in a plan by Mertz, dated 3 January 1943 (Plate 7). As the new chancery project launched in 1940 with completion expected by 1943, Mackensen had desisted from pushing for any further modifications to the old building. But by late 1942 the volume and extra security needed for communication with Berlin caused him to need extra rooms for the teleprinters and the cypher machines on what had been the second floor's roof terrace at the eastern end of the north side of the *casino*, thus requiring in a sense the completion of its northern façade.

Too much of the original structure has been absorbed into the building that now stands there for it to be possible for an amateur to attempt more than a rough sketch of the various building phases, based on the elevations and plans from the 1980s (Fig. 21.2a–d) and the current appearance of the building. The author's attempt here can be only a guess, but it may inspire a more professional effort. In the meanwhile the images at Plate 8 may help the reader's imagination.

The German additions were not beautiful, but neither were they offensive. They did however make it very difficult to identify the resulting edifice with the romantic little summer house built a century earlier by Zenaïde Wolkonsky: the *casino* was, in effect, swallowed up. Yet it is still there, and the concept of incorporating parts of the aqueduct into modern buildings was implicitly accepted not only by the papal authorities in the 1830s but also by the Italian government in the 1930s. A twenty-first-century government would almost certainly be less complaisant, and public and artistic opinion would most likely applaud the heightened sense of the need to conserve not just ancient monuments but their settings, too.

The British government's restoration of the *casino* to residential use in the late 1980s made no significant alteration to the external appearance of the building, other than tidying it up after 40 years of increasing neglect (Plates 40 and 41). The colour adopted for the walls helps to place it in the context of the Roman *campagna*, and the oldest part (roughly) is now helpfully painted in a slightly darker shade than the rest. Inside, the accommodation – of various sizes, including one apartment split between two floors – is of good quality and comfortable. The occupants by and large seem to enjoy the unusual experience of sharing an apartment with large chunks of Roman aqueduct, to say nothing of the outlook onto the gardens and park on both sides of the aqueduct. The building itself offers only minimal garden space for the residents, as it abuts the residence gardens close to the Residence itself, and receptions are held there, so it is not ideal for families with small children. Nor is the distant outlook remotely like the countryside onto which visitors to Zenaïde's *casino* could gaze. But the position is nonetheless charming and unique.

<p style="text-align:center">⋆ ⋆ ⋆</p>

Envoi

A series of small miracles (often disguised as procrastination or penny-pinching) and the guardianship of serried ranks of minor angels have combined to preserve in Rome's heart a large green space, maintained as a garden with woodland, showing off with great charm an impressive monument to imperial Rome's engineering skills.

Some people have argued that such a place should be freely open to the public. There is a case to be made on the grounds of political morality. But a walk through the Villa Borghese would provide a counterargument. As it happens, the initiative taken by a handful of German diplomats, exasperated with their Italian hosts' failure to provide an alternative to the Embassy of which their country had been deprived, was serendipity in action on the side of conservation. Embassies are places to show off your country, and a fine embassy or residence is a magnet, an incalculable asset in performing the diplomatic tasks. So keeping embassies looking their best, even to the extent of looking after arguably 'useless' monumental structures within them, is more likely to attract the additional resources required than is available to a city council with many higher priorities.

Over recent decades the residences of the UK's ambassadors abroad have increasingly become public platforms for the projection of the UK's political, cultural and above all economic interests. The process had begun before my time in the Villa. We quickly found that the flexibility of the spaces on the main floor allowed the organisation of every form of attraction for Italian and other visitors, from a private lunch à deux in a small room with a minister or business chairman to a dinner for 130 plus, mainly in the grand hall (known usually and misleadingly as 'the ballroom'); from a concert to an archaeological, economic or commercial conference or presentation in the grand hall to a simultaneous reception for several groups to meet a royal visitor, using all the rooms on the main floor; from a dinner at which a visiting British minister or chairman could meet senior Italians to a press briefing before a State Visit; from use by individual sections of the Embassy, such as the defence attaché's annual reception of his military world, to an exhibition of a visiting British artist's work to the launch of a new model of a British-made car (in the forecourt). The house becomes not the place where an ambassador lives in sumptuous luxury but an official guest house where British interests can be and are effectively promoted. Dare one surmise that the UK's exit from the European Union will make such a platform increasingly valuable?

Of course, the garden added a further dimension of attraction, given both its character simply as a splendid garden in the heart of the city and as a showplace for one of Rome's prized ancient monuments, which the UK has been careful to look after while maintaining its integration with the garden. One could not imagine a better place to hold large-scale events such as the annual celebration of the Queen's Birthday. In 2002 for the Jubilee we held the reception on two successive evenings with the band of the Royal Marines marching on the lawns and, on each evening, a very senior Italian delightedly taking the salute. That sounds like an anachronism, and it may be so: but it was a very effective anachronism. The current ambassador has made tremendously varied use of the Villa, including playing host to fashion shows, attracting British as well as local press coverage. With imagination the scope to use the asset in a targeted and ever broadening manner is limitless. Footfall is a crude measure of effectiveness but recent statistics show it is ever increasing.

So, hats off, first to Neurath, his German successors and Carl Mertz, then to successive British ambassadors (with a special mention for Ashley Clarke) and their wives, so often keen and skilled gardeners, and to senior officials in Berlin and London (such as de Normann and Muir) with the vision and the clout to ensure that just enough was done to preserve, embellish and, thanks in part to the awkward firmness of the Italian officials responsible for safeguarding their historical treasures, avoid destroying a fine exemplar of Rome's, Italy's and Europe's heritage. Living in such a combination of history and beauty for even a few years was an extraordinary privilege. May the line of my successors who are blessed to share in that privilege be long and contented. There are few finer settings in which to fulfil an embassy's functions.

Notes

1. Wilby, 15 June 1959, E0122803/3 Pt.2, held by FCO.
2. The firm of Campanini Ianozzi.
3. Other sources were given as Carlo Tritto, in *Architectural Digest*, No. 21 of February 1983, and Carlo Zaccagnini's *Le Ville di Roma*.
4. Published by Marino & Gigli.
5. It is possible but unlikely that he only then built the archway carrying the name of the estate, Vigna Celimontana, and the crests of the Wolkonsky, Beloselsky and Lilien families.
6. 'Minister' was the title given in larger embassies to the Deputy Head of Mission.
7. In the twenty-first century it nearly acquired the accolade of Residence, when a plan to house there the UK's ambassador to the Holy See fell foul of the Vatican's traditional objections to embassies to the Republic of Italy and to the Holy See cohabiting.
8. AA file 429-b.
9. AA file 1541a Vol. 2.
10. It is possible that the Germans built in 1934/5 on the existing outhouse with pergola visible in the sketch of Gogol by Zhukovsky (1839 – see Fig. 2.8) which was, in all likelihood, in existence as a vineyard shed when Zenaïde bought the property. Several maps of the period show a long thin structure built on to the aqueduct at that location.
11. AA file 429-c is the source of the narrative from this point.
12. OED file XA/364/ITR/901/002B – Rome, of 1988, containing plans and (inaccurate) historical notes about the refurbishment of the OMH and old chancery in 1985–8, held by the FCO at Hanslope Park; the file is not yet (2018) in the public domain.
13. This would be the building which is in the foreground of the Karczewski watercolour (Plate 30).

APPENDICES

I.
THE VILLA WOLKONSKY ANTIQUITIES COLLECTION[1]
by Raffaella Bucolo

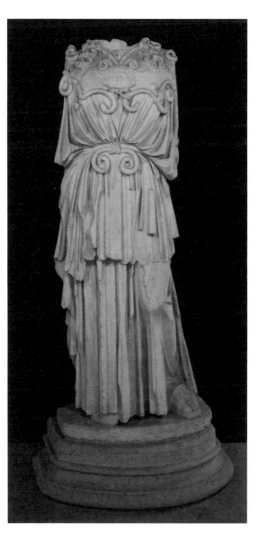

Fig. I.1. A headless statue of Athena Parthenos.

The gardens of the Villa Wolkonsky contain a large collection of ancient Roman marbles, whose complex stories in part followed that of the Villa itself.

Until recently the collection had never been studied. A real rediscovery occurred in 2011, when 360 ancient marbles were restored by Archérestauri, under the supervision of the architect Valentina Puglisi. The British Embassy, supported by a donation from a descendant of Princess Wolkonsky and financial support from Shell Italia, had launched a major project to upgrade the gardens and the marbles displayed in them, which were in clear need of conservation. In the course of these works some of the marbles were relocated in the garden, along the aqueduct, and others were placed under cover in two greenhouses, renamed Wolkonsky Greenhouses Museum.

The exceptional nature of this heritage was immediately highlighted by scholars of the British Museum and the British School at Rome, leading to a proposal for an in-depth analysis aimed at understanding the history of the collection. Following the restoration work, research began into that history and a professional photographic survey was carried out by the Deutsches Archäologisches Institut Rom – Fotothek. As a result an online catalogue of the collection is today available through the database of the German Archaeological Institute, iDAI.ObjectsArachne.

Following these surveys, it can be said that today the Villa houses over 500 artefacts, representing various periods of ancient art, from the late Roman Republican period to the Early Middle Ages.

A large proportion of the marbles are small and of a funerary character, not only the many inscriptions, but also an urn with a lid and some statues, like a *togatus* or the Aphrodite Louvre-Napoli. Among the most notable pieces in the collection are funerary portraits, representing single persons or family groups: the five Servili; the Sallusti, husband and wife; Apuleius Carpus and his wife Rufina; Cincius Chrestus; a group of four nameless people; and the child Didymiana. Of the other reliefs, we can pick out the one representing Mithras killing a bull in the sacred cave, as well as one of a merchant ship. Some small fragmentary statues are also of considerable interest for the subjects represented, such as an actor, a young man alongside a comedy mask on a log, or a boy with a little bird on his hand.

There are of course also larger statues such as a headless Athena Parthenos (Fig. I.1), a torso of Leda; a fragment of drapery tightened in one hand, probably from an Aphrodite statue; the torso of a young man, perhaps a Dionysus.

Diverse subjects decorate many of the funerary inscriptions and fragments of sarcophagi: for example mythological themes, such as Hippolytus riding a horse, Meleager hunting the boar, the rape of the daughters of Leucippus. Five juxtaposed fragments recompose what remains of two sarcophagi with scenes of military life, dated from the second and third centuries AD. There are also numerous architectural elements, most of which probably come from the garden itself.

The collection includes some modern artworks as well, imitating the ancient ones, like a Nike on the globe, an infant sarcophagus with marine themes, a colossal head on the aqueduct, copy of the so-called Juno Ludovisi, and an 'Esquiline Venus', created in 1954 in Paris by the sculptor Maurice Barbier.

The history of the collection

It is clear that the antiquities collection in Villa Wolkonsky was started by Princess Zenaïde Wolkonsky. No doubt some ancient fragments would have already been in the vineyard before she bought it, and many marbles were accidentally found in the soil of the property, but the princess specifically wanted to collect marble antiquities to arrange as a decorative theme in her romantic garden, and she bought some of them on the antiques market or from other collections in the city.

Unfortunately, without any inventory it is not possible to state which antiquities were part of this first stage of the collection, but I want to stress the point that the princess was a real collector of antiquities, even though she has never been thought of in this light. She was an art-lover, who thought seriously about her collecting. A passage of a letter she wrote to a friend immediately after moving to Italy says: 'My first letter is dated from Pompeii – I repeat my invitation. Come to Italy – the sea shortens distances. – Come and collect marbles, lava, memories, poetry, above all come and reflect under this cloudless sky.'

The Wolkonsky collection represents a perfect case study of nineteenth-century collecting practice in Rome, a time when the new bourgeoisie and aristocratic foreign collectors worked alongside and gradually replaced the collectors from the older papal aristocracy. The princess made her own aesthetic and decorative choices very precisely, and she probably exploited her many connections in the art world.

When Zenaïde died her son Alexander continued what his mother had started. He too was keen on antiquities and was probably responsible for the increase in the number of inscriptions, including the new epitaphs from the columbarium of Tiberius Claudius Vitalis, found in the property (1866).

Alexander cultivated antiquities scholars and experts, and it was probably he who bought some funerary inscriptions and perhaps a sarcophagus from a Roman teacher and antiquarian, Lorenzo Fortunati (1819–86), who personally carried out excavations in various parts of the city and its surroundings. The finds in question came from excavations carried out on via Latina, from 'Vigna Nardi-Fortunati' (between via Nomentana and via Tiburtina), and from Tor Sapienza.

The Wolkonsky antiquities from Vigna Nardi-Fortunati are numerous, among them the Sallusti portrait and the fragment of a sarcophagus bearing a Greek inscription and a flying Eros. And the sarcophagus fragments decorated with the rape of the daughters of Leucippus have been identified as coming from Fortunati's excavation on via Latina, specifically from the Tomb of the Valeri.

So far, the provenance of only a few other finds is known: the funerary portraits of Apuleius Carpus and his wife, previously kept in Vigna Sebastiani Lazzarini, close to Porta San Paolo; the funerary portrait of C. Cincius Chrestus, placed at the beginning of the sixteenth century 'ante Forum Piscarium' – Porticus Octavie – then in via del Pozzetto; a fragment of a funerary inscription from Veio, Isola Farnese; the funerary altar of Quintus Iulius Ianuarius, kept at first in the monastery of the Basilica of San Paolo, then in the house of Luigi Lante, and finally in the Orti Giustiniani on the Celio; another funerary altar, this time in Greek, kept by Orazio Candelieri on the Pincio during the sixteenth century, then in Villa Giustiniani outside Porta del Popolo; a fragment of a female foot on a round base bearing the famous inscription 'Translata de Schola Medicorum', maybe the same piece as that recorded as owned by the art dealer Francesco Capranesi in 1851.

The information which we now have shows that the collection was in part created by purchases from other collections dismembered and sold during the nineteenth century. For instance, at least two pieces came from the collection of the Marquis Gian Pietro Campana, sold off in 1859: an inscription and the funerary portrait of the child Didymiana – a case where the Wolkonsky collection benefited from the sale of a fine, well-known collection, because of its owner's serious financial and legal situation.

When urban development of the area surrounding the Villa began, the preparatory excavations brought to light mostly funerary monuments. In some cases, especially inscriptions from the structures being destroyed to make way for the modern city, the finds became part of the Wolkonsky collection, e.g. the grave reliefs with portraits of the Servili family (1881), or the epitaph of Baebi (1888), the only preserved evidence from these destroyed monuments.

One of the discoveries made in those decades deserves particular mention. In 1911, at via Emanuele Filiberto 144–146 – still described as Campanari property – part of a building came to light, maybe a private residence, decorated with three mosaic floors. Two of the mosaics presented a central shield depicting the Gorgon Medusa. The first, larger mosaic has four figures of birds in the outer corners; the second is similar, but very fragmentary and with drinking cups filling the outer corners. The third mosaic, made with black and white tesserae, shows a sea scene with Triton and a winged Genius riding a dolphin. The three floors never became part of the Wolkonsky collection: by this time the Campanaris had evidently lost interest, so much so that Nadeïde Campanari, co-proprietor with the Italian State, immediately sold her half, and the mosaics were transported to the National Roman Museum. Two of these floors – the first, bigger one with the Medusa shield and birds and the third (that with the sea scene) – are still kept in the National Roman Museum stores, while the second, more damaged mosaic with the figure of Medusa and drinking cups was taken out of Italy by an unknown hand at an unknown time and later acquired in 1971 by the J.P. Getty Museum, where, extensively restored, it is displayed.

When the Villa became the German Embassy, the Italian State commissioned the archaeologist Paolino Mingazzini to compile an inventory of the most interesting marbles in the collection and other scholars had the opportunity to take some pictures of the antiquities. As agreed with Germany, the Italian government received two marbles from the Villa: the head of an athlete and a fragmentary statue said to be of 'Hercules and the Hesperides', both taken to the National Roman Museum.

Immediately after the Second World War, the collection again became the subject of interest when the villa became the British Embassy: the antiquities collection was clearly highly prized, as demonstrated by official photographs, in which the sculptures figure prominently in the background. In those years, one statue was certainly added to the collection, the Musical Faun, which during the recent restoration works in 2011 was reassembled from 15 fragments (Fig. I.2). This statue had been found during excavations carried on in the garden of the old British Embassy at Porta Pia by Sir John Savile Lumley, later Lord, Ambassador of Her British Majesty to the King of Italy (1883–8) and member of the 'British and American Archaeological Society of Rome'. Sir John Savile Lumley's archaeological interests are well known above all through the studies he made of the important excavations in Nemi and Lanuvium.

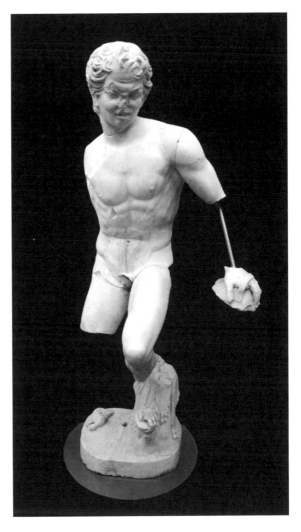

Fig. I.2. *The reassembled statue of the Musical Faun in the Villa Wolkonsky Greenhouses Museum.*

As stated in that body's chronicle, some members of the organisation, invited by Savile Lumley on 21 February 1888, had the opportunity to admire at the British Embassy in Villa Bracciano some antiquities collected during excavations promoted by the ambassador himself:

> (...) Among other objects of special interest exhibited on this occasion was (...) the statue of a Faun playing cymbals, found in the Embassy Gardens and judiciously restored by Mr. Macdonald.

Further confirmation of the identity of this statue, now in the Wolkonsky gardens, can be derived from valuable evidence preserved in the photographic collection of the archaeologist Paul Arndt

(1865–1937), in the Antikensammlung Erlangen of Friedrich-Alexander-Universität Erlangen-Nürnberg. The photograph shows the Faun intact and placed on an inscribed base, on which the discovery in 1884 by Savile Lumley is recorded, as is the restoration by Alexander Macdonald. The statue was probably moved to Villa Wolkonsky, following the temporary abandonment of the previous embassy building.

Missing antiquities

Despite the absence of proper inventories, other documentary material allows us to confirm the loss of several marbles belonging to the collection. The first useful texts for this investigation are the three volumes *Antike Bildwerke in Rom* by the German scholars Friedrich Matz and Friedrich von Duhn. They are the principal source for the identification of what is missing now compared to their survey in the second half of the nineteenth century.

Items now missing from among the statuary are: a headless figure of a young man with a ram – recorded by Mingazzini in 1922 and defined as Hermes; a fragment of a griffin, considered part of a statue of Apollo; a fragmentary small statue of Eros; a fragment of Hekateion; an Athena's head with high helmet; an Artemis Ephesia; the torso of a statuette, hypothetically identified as Artemis; a small statue of a winner; and a male torso of a dancing figure. Numerous fragments are missing from among the sarcophagi, such as: part of a satyr holding a stick; remnants of Heracles capturing the Mares of Diomedes; a scene of a shepherd milking a goat. On another relief there was a bearded shepherd sitting under a tree, resting on a stick and leaning forward, probably in the act of touching an animal's head in front of him. This last marble, described by Matz–Duhn, was photographed by the German Archaeological Institute in the early 1970s, attesting to its presence until quite recently.

A fragmentary relief of a woman holding a bowl with a roasted chicken was listed by Matz–Duhn and was shown by Mingazzini to have been still there in 1923. Another small fragment of a sarcophagus was listed by Matz–Duhn and later the subject of a small drawing: it showed the torso of an old woman identifiable as Jocasta, part of a larger composition of the war of the Seven against Thebes. The last sarcophagus fragment no longer traceable was decorated with a woman wearing a diadem and sitting in a cave, while behind her there was part of an arm on a bigger scale.

Other reliefs identifiable as missing are: a marble candelabrum decorated with masks; a winged female figure, maybe Psyche; a Mithraic fragment with inscription; a fragment of a relief of Ulysses and the Sirens; the upper part of a column with numbers engraved on it beneath a sphere above (possibly a milestone); finally a relief with Heracles sitting on a rock and only the legs of another figure behind him.

Different types of document attest to the loss of other marbles. One example is a photograph in the German Archaeological Institute in which, in addition to a sarcophagus fragment still in the collection, part of a black and white mosaic can be seen, with geometric motifs and a central flower. And in 1932 Joseph Wilpert published in his book a fragment, at that time in Villa Wolkonsky, rightly interpreted as a scene of the Adoration of a shepherd for Jesus held in the lap of the Virgin Mary.

As already mentioned, two small sculptures belonging to the collection were donated by the German Embassy to the Italian State in the 1920s: a small head of young man in archaic style and another

fragmentary statuette, defined as 'a group of Hercules with the Hesperides'. Both artworks are still preserved in the stores of the National Roman Museum. Apart from the above sculptures, at least 26 inscriptions are also missing.

Certainly, the dispersal of antiquities from collections cannot be considered an unusual phenomenon. As seen, some marbles were donated, others were probably sold and the garden had some years of neglect, which perhaps also facilitated theft.

Nevertheless, the Villa Wolkonsky still houses an impressive collection of ancient marbles, which, thanks to the British Embassy, now enjoys the protection due to this important historical and artistic heritage.

Bibliography

BELIS 2016: A. BELIS, Roman Mosaics in the J. Paul Getty Museum, Los Angeles 2016.

BUCOLO 2020: R. BUCOLO, Villa Wolkonsky. Storia della collezione di antichità (Pensieri ad Arte, n. 8), Rome 2020.

COLINI 1944: A. M. COLINI, Storia e topografia del Celio nell'antichità, Rome 1944.

CONSALVI 2009: F. CONSALVI, Il Celio orientale. Contributi alla carta archeologica di Roma, tavola VI settore H, Rome 2009.

ERPETTI 2020: M. ERPETTI, Lorenzo Fortunati 'intraprendente scopritor' di antichità a Roma e nel Lazio nel XIX secolo, Rome 2020.

HERDEJÜRGEN 2000: H. HERDEJÜRGEN, Sarkophage von der via Latina. Folgerungen aus dem Fundkontext, in RM 107 (2000), pp. 209–34.

KANSTEINER 2017: S. KANSTEINER, Pseudoantike Skulptur. Klassizistische Statuen aus antiker und nachantiker Zeit, II, Berlin 2017.

MARTINO 2015–16: C. MARTINO, La collezione epigrafica di Villa Wolkonsky (Tesi della Scuola di Specializzazione in Beni Archeologici dell'Università di Roma 'Sapienza'), 2015–16.

MATZ, DUHN 1881–2: F. MATZ, F. VON DUHN, Antike Bildwerke in Rom mit Ausschluss der Grösseren Sammlungen, I–III, Leipzig 1881–2.

MINGAZZINI 1922: P. MINGAZZINI, Iscrizioni di Villa Wolkonsky-Campanari, in BCom 50 (1922), pp. 72–81.

ORLANDI 2018: S. ORLANDI, Un nuovo cursus senatorio nella collezione epigrafica di Villa Wolkonsky, in Anu.Filol.Antiq.Mediaeualia 8 (2018), pp. 681–90.

ROBERT 1890: C. ROBERT, Die antiken Sarkophag-Reliefs. Mythologische Cyklen (ASR 2), Berlin 1890.

ROBERT 1904: C. ROBERT, Die antiken Sarkophag-Reliefs. Einzelmythen. Hippolytos bis Meleagros (ASR 3, 2), Berlin 1904.

WILPERT 1932: J. WILPERT, I sarcofagi cristiani antichi, II, Roma 1932.

Notes

[1] For a complete study on the history of the Villa Wolkonsky antiquities collection see: BUCOLO 2020.

I wish to thank for their support the British Embassy, the British School at Rome, the Deutsches Archäologisches Institut and for their precious help Dr Ralf Bockmann, Professor Ortwin Dally, Professor Stephen Milner, Professor Maria Grazia Picozzi, architect Valentina Puglisi, Sir John Shepherd and Professor Christopher Smith.

The first part of the project began with an idea by Professor Christopher Smith and architect Valentina Puglisi. It was carried out at the Deutsches Archäologisches Institut in Rome (2015–16) with the support of Dr Ralf Bockmann and financed by the British School at Rome, through private funds (Brunswick Group LLP). The project for the study of the history of the collection was awarded with a Fellowship at Sapienza University (2016–17) and carried out under the supervision of Professor Maria Grazia Picozzi.

Thanks to the permission granted by the British Embassy, the Fototek of the Deutsches Archäologisches Institut was able to conduct a professional photographic survey (2018–19) carried out by Heide Behrens and Daniela Gauß.

II.
MEMORIALS IN ZENAÏDE WOLKONSKY'S ALLÉE DES MÉMOIRES AND ALLÉE DES MORTS IN THE VILLA WOLKONSKY

by Sue J. Williams, MA Oxon

March 1990; Revised August 2019

This study, carried out during the years 1988 to 1990, records the inscriptions on the plaques and columns of the Allée des Mémoires and the Allée des Morts, first with translations of inscriptions in Russian, followed by those written in French.

This page displays a schematic sketch map of the memorials. The numbers on it correspond to those in the text. Illustrations of some of the memorials (as they were in 1986–90) are displayed before the relevant entry in the text.

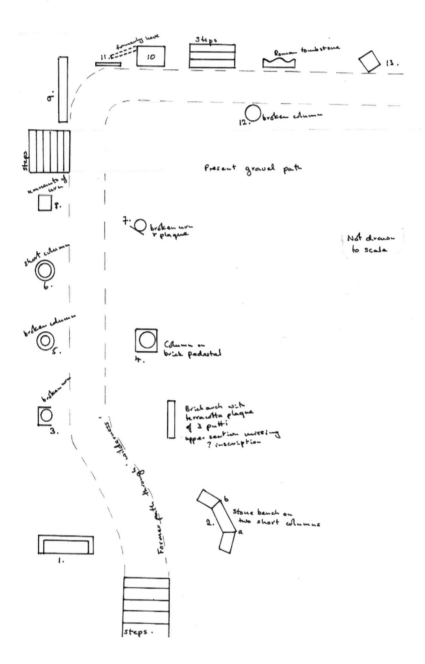

MEMORIAL TO ZENAÏDA, ERECTED BY HER SON

1. This, the largest of the memorials, is to **Zenaïde** herself, erected by her son Alexander. At the top in a circle, is inscribed

A la Princesse Zenaïde Wolkonsky [with a monogram]

> Elle dédia le souvenir
> de cette allée
> à la piété filiale
> à la reconnaissance
> à l'amitié
> -
> Le même hommage
> est offert
> à sa chère mémoire

2. Opposite the memorial to Zenaïde stood a curved stone bench (damaged during the clearing of the trees in 1988) and beside it two small plaques with inscriptions in Russian script to **Dashinka and Sashinka**

2.a Dashinka
 Amour souffrance
 Repos

2.b Sashinka
 La neige a gelé la fleur
 naissante. Ici du moins le
 vent glacé n'atteindra pas
 les roses que l'amitié
 cultive pour elle.

Beside the stone bench stands a brick arch containing a terracotta plaque depicting three cherubs – no inscription. No number on plan.

3. A marble column beside a broken urn bears the inscription:

> **Mme. Balley**
> A la vieille amie
> ses élèves
> reconnaissantes

4. Continuing the (former) path away from the aqueduct one finds a column on a brick pedestal, with an inscription to **Lisa Chernisevsky**: the Russian is almost entirely eroded but the French is still legible:

Russian:	Sister Lise Chern...
she.....
	Us.............he

French:	Elle essaya des amours
	de la terre mais elles
	n'étaient
	pas assez pures
	pour un ange

5. Opposite this is a broken column and an inscription to the **Empress Maria Fedorovna**:

Russian:Empress
	Maria Fedorovna
we thank
French:	Les jeunes filles dont
	elle était la
	protectrice répétaient
	en pleurant: qui nous
	bénira à notre entrée
	dans le monde

6. Another short column, this time with a dedication in Russian to Zenaïde's maternal grandparents, 'generous grandfather' **Jakov Athanasevich** and 'tender grandmother' **Maria Dmitrievna Tatischev.**

Russian:	To the beneficent
	Grandfather and tender grandmother
	Jakob Afanasevich
	and
	Maria Dmitrievna Tatischevna
French:	Ils ont transmis sur nous
	la tendresse qu'ils avaient pour
	leur fille chérie

7.

MEMORIAL TO GOETHE

7. The broken amphora and the plaque are in memory of **Goethe**, whom Zenaïde had met in Weimar in ?1812 whilst she was in the Emperor's suite accompanying her husband, and again in 1829 on her journey from Russia to Rome:

> Il fut l'auréole
> de sa patrie

8. The inscription here is to **Eropkin** in Russian and French, with lines 2–4 in French only. Eropkin's decisive measures restored order to Moscow during the plague riots:

> To Peter Dmitrievich Eropkin
> Heureux le citoyen qui peut
> dire j'ai sauvé ma ville
> natale 1771

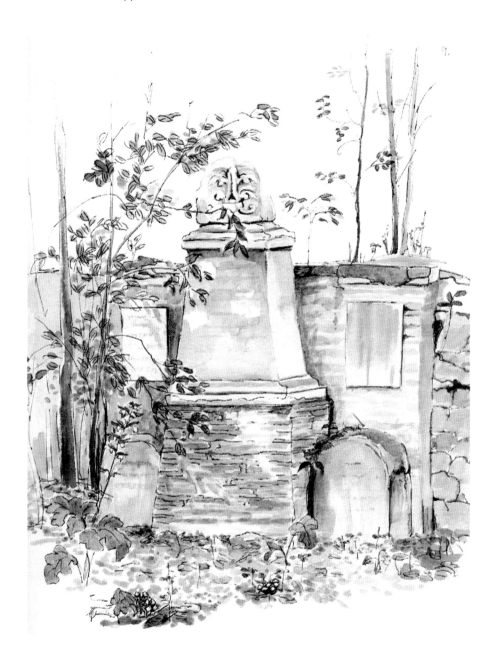

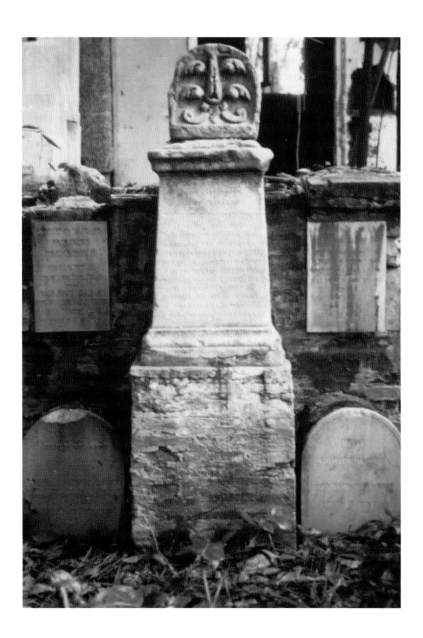

9. Here there is a collection of plaques and inscriptions addressed to Zenaïde's close family and servants, centred around the inscription in praise of her father, **Prince Alexander Mikhailovich Beloselsky.**

9.a
Russian: Prince Alexander
 Mikhailovich
 Beloselsky

Father and friend and mentor

French: J'ai vu sous son toit les
malheureux consolés les
artistes les poètes les
savants fêtés et caressés les
étrangers accueillis comme
des frères les serviteurs
soignés et heureux ses paroles
étaient éloquentes ses
actions généreuses et pures
Heureuse la famille
qui l'appelait son père

9.b To her mother **Princess Barbara Jakovlevna**, who died when she was a baby, Zenaïde writes:

Barbara

Elle était belle et
bonne comme les anges
mais ce n'était qu'une
tradition pour nous

(This is surely the inscription that Pietrangeli says he was unable to find: 'A ma mère inconnue et adorée' translates the Russian inscription above the lines in French.)

9.c To **Sofia**, presumably her mother's nurse:

Russian: (Wet) nurse Sofia
French: Je me suis assise sur ses
genoux j'ai caressé ses
cheveux blancs et n'ai
pas connu celle qu'elle
a nourri de son lait

9.d To **Natalia** 'sister and friend' a few lines in Russian on harmony and the immortal soul, then:

J'ai trop d'âme disait
elle pour vivre
longtemps et à vingt
trois ans elle
reposait déjà dans
l'humide terre

9.e Finally there is a plaque to **Peter**, **Kolmar** and **Parmen**:

Aux trois serviteurs
fidels de mon père

10. This long inscription in Russian is dedicated to the **Emperor (Tsar) Alexander I** (for whom Zenaïde had a deep affection, certainly reciprocated: throughout the gardens there are busts and pillars to his memory) and to the **Empress Elizabeth**.

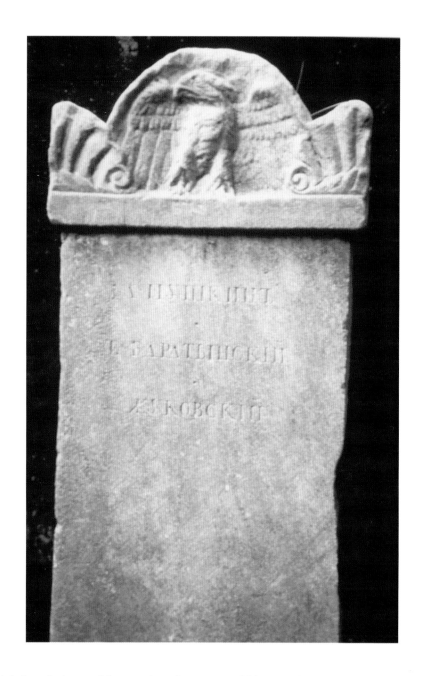

II. The triple inscription on this stone is to the poets **Pushkin**, **Baratinsky** and **Zhukovsky** (the second and third names having been added later). Like many of the inscriptions it is carved onto a piece of antique marble, this one with an eagle in bas-relief above. Pushkin had called Zenaïde 'Queen of the Muses and Beauty' and had been an ardent admirer of her sister Maria. Baratinsky and Zhukovsky had also admired Zenaïde and written in her honour, and Zhukovsky spent time at the villa sketching (including a delightful sketch of Zenaïde and Gogol on the terrace by the aqueduct).

MEMORIALS TO SCOTT & CAPO D'ISTRIA

12. Opposite the little flight of steps is a small broken column with a brief inscription to **Walter Scott** who visited Italy shortly before he died in 1832:

> La douce lampe
> de nos veilles
> s'est éteinte

In the background, left, is the stone identified as 'Roman Tomb Stone' on the plan.

13. Further on (in the same drawing) is a small squarish column and the name, carved in Greek lettering, of **Capo d'Istria**, Russian diplomat. He was Greek in origin, an ardent patriot who had tried to persuade Alexander I to favour the cause of national independence for Greece and Italy.

PLATES SECTION II

Plate 32. The new grand stairway to the upper floors: the decorative style worried early British ambassadors, but it now seems to be of a piece with the period.

Plate 33. The parquet floor of the main salon, added in the 1939/40 enlargement scheme (now – 2019 – again visible without carpet). The picture in the background (Tischbein's Royal Hunt at Persano) was hung after the Villa became the British ambassador's residence.

Plate 34. The marble fountain erected in 1942 (by the Medici company) seen from the terrace staircase of the same date, after cleaning in 2000.

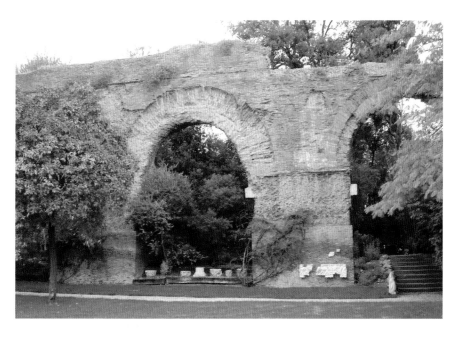

Plate 35. The aqueduct as main feature of the garden at the Villa Wolkonsky, 2014.

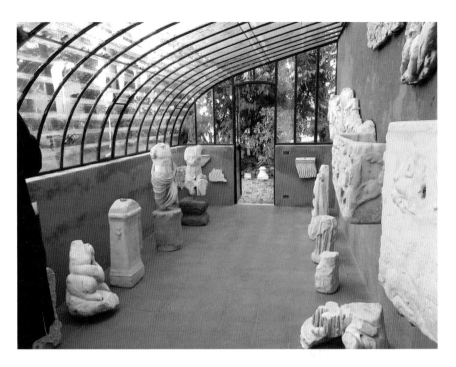

Plate 36. Some of the principal items in the Wolkonsky Collection of Antiquities were restored and displayed in a converted greenhouse in 2014.

Plate 37. The main reception room of the Villa Wolkonsky Residence in the first years of the twenty-first century.

Plate 38. The British 1957 conversion of the two German-built flats into offices produced an unexciting building, but it blended well with its surroundings; it was to be further modernised in the 1980s and 1990s.

Plate 39. The 'Old Minister's House' after the refurbishment in the 1980s, which revealed the arch, built by Alexander Wolkonsky, in or after 1848, when ownership was transferred to him by his mother, Zenaïde Wolkonsky. Above the arch are displayed the three family shields.

Plates 40 & 41. The south-east corner of the old chancery, incorporating the casino, as it appeared in 2019.

I.
PICTURES HUNG IN THE GERMAN EMBASSY, ROME, TO 1943

by Julia Toffolo

INFORMATION FROM OFFICIAL INVENTORY OF 12 AUG 1941 (AA FILE R12-8951)	POSSIBLE or ACTUAL ARTIST	TITLE	ORIGIN/FATE AS STATED IN INVENTORY	FURTHER DETAILS RESEARCHED	FURTHER INFORMATION RESEARCHED
'School of Ludovico CARRACCI (1555–1619)'	possibly: Ipollito SCARSELLA ('SCARSELLINO') (Ferrara 1550/1–1620 Ferrara)	[Ruhe auf] der Flucht nach Ägypten	Staatl. Gemäldegalerie in Dresden	inv. no. 147 oil on canvas, 53 x 78 cm	Destroyed in bombing of Dresden, 13 February 1945.[1]
'Ant. GRAFF'	Anton GRAFF (Winterthur 1736–1813 Dresden)	Bildnis der Frau Riquet	ditto	inv. no. 2180A oil on canvas, 70 x 56 cm	Given to the Gemäldegalerie Alte Meister, Dresden, by Louis Barfuss in Kötzenschenbroda; recorded in 1941 (or 1944) as being in an Auswärtiges Amt department; missing since the Second World War. Description: half-length to left, grey background. Black clothing, blue sash at waist, white scarf, grey hair, hands in lap.[2]

INFORMATION FROM OFFICIAL INVENTORY OF 12 AUG 1941 (AA FILE R12-8951)	POSSIBLE or ACTUAL ARTIST	TITLE	ORIGIN/FATE AS STATED IN INVENTORY	FURTHER DETAILS RESEARCHED	FURTHER INFORMATION RESEARCHED
'KERRINX'	Alexander KERRINCX (Antwerp 1600–1652 Amsterdam)	**Waldweg über eine kleine Anhöhe**	ditto	inv. no 1141 oil on panel, 57 x 99 cm	Recorded in 1941 as being in an Auswärtiges Amt department; missing since the Second World War.[3]
Thomas WOUWER-MANN'	Philips WOUWERMAN (Haarlem 1619–68 Haarlem)	Rast auf dem Marsche	ditto	inv. no.1448 oil on canvas, 51 x 63 cm signed bottom left: PHLS W	Provenance: 1749 from Le Leu, Paris; Recorded in 1941 as being in an Auswärtiges Amt department; missing since the Second World War.[4]
'KAYSER-EICHBERG'	Carl KAYSER-EICHBERG (Eichberg b. 1873)	Im Walde	National Gallery, Berlin	inv. no. A1790 oil on canvas	'In Chancery'; no other information so far uncovered.
'von MASTENBROCK'	Johann Hendrik van MASTENBROEK (Rotterdam 1875–1945 Scheveningen)	**Dampf und Rauch** c.1909	National Gallery, Berlin [also listed in inventory as 'der Deutschen Akademie der Künste in Rom, übergeben']	inv. no. A1 1075 also listed as being in the German Consulate, Tangier.[5]	Exhibited at Berlin Art Exhibition, 1909, apparently purchased by Prussian State; in 1945 (?) the artist stated that he did not know where the painting was.[6]

INFORMATION FROM OFFICIAL INVENTORY OF 12 AUG 1941 (AA FILE R12-8951)	POSSIBLE or ACTUAL ARTIST	TITLE	ORIGIN/FATE AS STATED IN INVENTORY	FURTHER DETAILS RESEARCHED	FURTHER INFORMATION RESEARCHED
'E. HILDENBRANDT'	Eduard HILDEBRANDT (Danzig 1818–69 Berlin)	**Schloss Kronborg bei Helsingör**	National Gallery, Berlin	inv. no. A I 202; signed E. Hildebrandt 1857; oil on wood, 81 x 116 cm; Purchased from the collection of A. von Liebermann, 1875.[7]	This can be seen on display in 'Blick in die Ausstellung der Nationalgalerie, Raum 21' photo, 1908, Ident. Nr. ZA 2.17.1./00264.[8] Description: 'in background and middle-ground, a single fishing vessel enlivens Örefund, to the left Schloss Kronborg with Helsingör; in the distance on the right the mouth of the Kattegat and the Swedish coast by Helsingborg. Staffage: more young fishermen. Sunset with clear sky.'[9]
'Meister?'		**Blinder Tobias**	'aus der Preuss. Akademie d. Kunste' [& separately on inventory as 'an das Auswärtige Amt abgesandt worden' – sent to German FO]		[The original Prussian Academy of Arts on Pariserplatz, Berlin, was badly bombed in the Second World War.]
Unknown	Unknown	'Neapel 170' [sic; 2 pictures]	Unknown	Unknown	Unknown

PAINTING SHOWN IN 1924 PHOTOGRAPH OF DRAWING ROOM	
Unknown Artist, probably first half of seventeenth century	**Woman with an Angel and Stringed Instrument** [possibly St. Cecilia]

Notes

1 Hans Ebert, *Kriegsverluste der Dresdener Gemäldegalerie: Vernichtete und Vermisste Werke*, Dresden: Staatliche Kunstsammlungen, 1963, p. 54 (illustrated).

2 Ibid, p. 102 (not illustrated); German Lost Art Foundation internet database: http://www.lostart.de/Webs/EN/Datenbank/EinzelobjektSucheSimpel.html?cms_param=EOBJ_ID%3D128385%26SUCHE_ID%3D27251990.

3 Ebert, op. cit., p. 111 (illustrated).

4 Ebert, op. cit., p. 162 (illustrated); German Lost Art Foundation internet database: http://www.lostart.de/Webs/EN/Datenbank/EinzelobjektSucheSimpel.html?cms_param=EOBJ_ID%3D134999%26SUCHE_ID%3D27252000.

5 Marianne Bernhard et al, *Verlorene Werke der Malerei in Deutschland in der Zeit von 1939 bis 1945 Zerstörte und Verschollene Gemälde aus Museen und Galerien*, Munich: Friedrich Adolf Ackermanns Kunstverlag, 1965, p. 43.

6 Van Mastenbroek website: http://www.vanmastenbroek.com/includes/modules/text.php?id=4.

7 Dr Max Jordan, *Katalog der Königlichen National-Galerie zu Berlin*, Berlin: Ernst Siegfried Mittler & Sohn, 1901, p. 53, no. 136.

8 *Staatliche Museen zu Berlin* online collections database.

9 Jordan, op. cit.

II.
REPORT BY MERTZ ON THE PROJECT TO EXTEND THE AMBASSADOR'S RESIDENCE IN ROME, 1940

A - Translation of text page of the illustrated report

Residence of the German Embassy to the Quirinale in Rome

The German Embassy, whose seat is nearby San Giovanni in Laterano, needed to undergo a rebuild, as it no longer met the needs of modern times. As a result it is, after the disappearance of the French Embassy at the Palazzo Farnese, one of Rome's most attractive embassies.

The Villa Wolkonsky, with its millennia-old memorials and the peace of its centuries-old trees, has witnessed the recent political and diplomatic work which has begun to build a new world. From 1830 to 1862 it was the romantic resort of Princess Nadeïde [sic] Wolkonski, beloved of Tsar Alexander I of Russia, Napoleon's knightly rival, whose bust adorns the Villa's garden.

The extent of the estate amounts to 45,000 square metres, on which stand various buildings of varying periods and styles. Among them are the ancient Neronian aqueduct beside the country-house style Chancery building and the new, small Palazzo built between 1890 and 1903 by Marchese Campanari.

Regierungsbaurat Mertz, sent out by the Reich, found himself confronted with the demanding task of ensuring that the new building was adapted to the various styles and nonetheless would do justice to the new demands of the times.

The most important works were carried out by the firm of Eugenio Miccone of Turin, with Italian labour. Thus were brought together in one building the crafts and skills of two friendly nations.

Colourful marble from the most famous quarries, cheerful ceramics from Vietri on the sea, quality silk from Caserta together with products of the best German manufacture, such as the parquet, doors and furniture combine in a display of exceptional taste.

The technical installations such as cinema, air-conditioning, kitchen and laundry, heating and electric power, all made in Germany, needed to be the most modern in the city.

These rooms have witnessed the diplomatic work of various diplomatic representatives of the Reich, including Baron von Neurath, currently *Reichsprotektor* [i.e. Governor] of Czechoslovakia, Kar

von Schubert, Baron von Hassel and the present German Ambassador in Rome, son of the Great War Field Marshal von Mackensen. The rooms are now to serve the close collaboration of the two countries.

Thus a building has arisen which can worthily take over the representation of the German Reich and of which the city of Rome can be proud.

Regierungsbaurat Ing. Karl Mertz; Contractor Ing. Eugenio Miccone; Rome 1940 xix

B - Photographs of the Report

Fig. II.1. Blue leather binding.

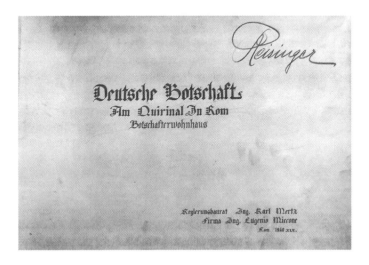

Fig. II.2. Title page.

Fig. II.3. Text of Report.

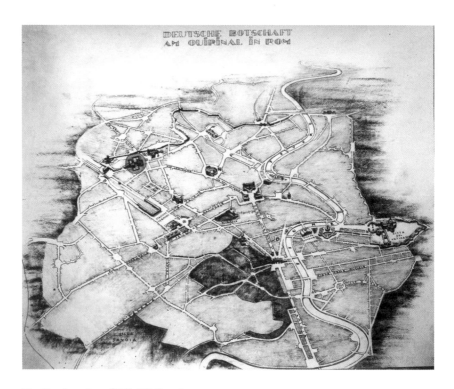

Fig. II.4. Location of Villa Wolkonsky.

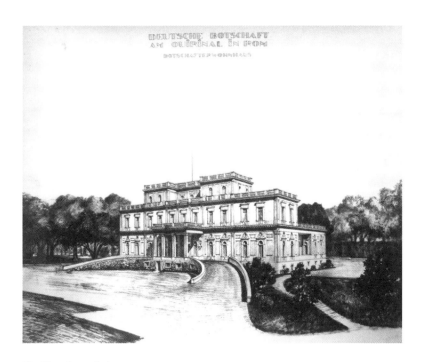

Fig. II.5. General view.

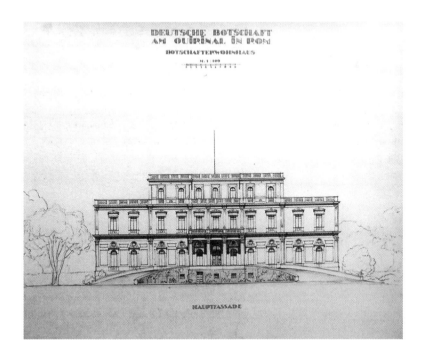

Fig. II.6. Front elevation.

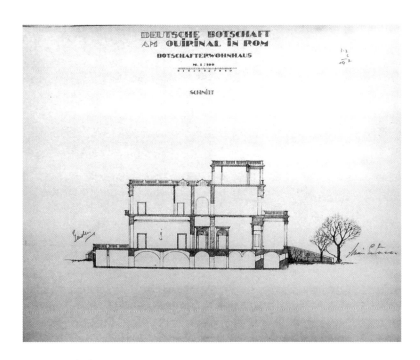

Fig. II.7. Side elevation.

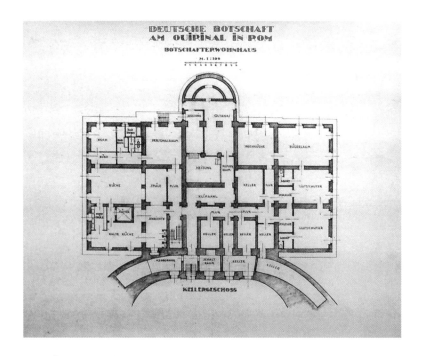

Fig. II.8. Basement plan.

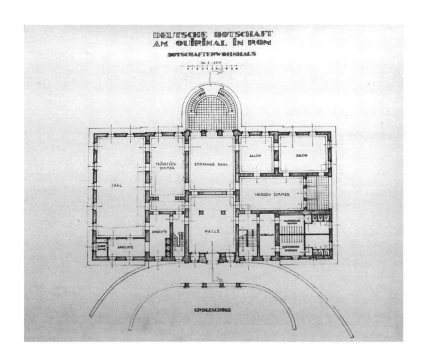

Fig. II.9. Ground-floor plan.

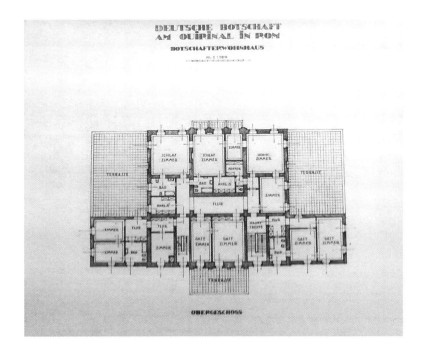

Fig. II.10. First-floor plan.

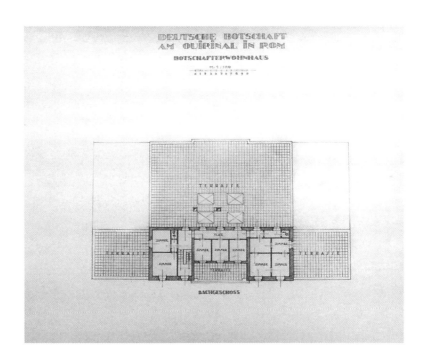

Fig. II.11. Top-floor plan.

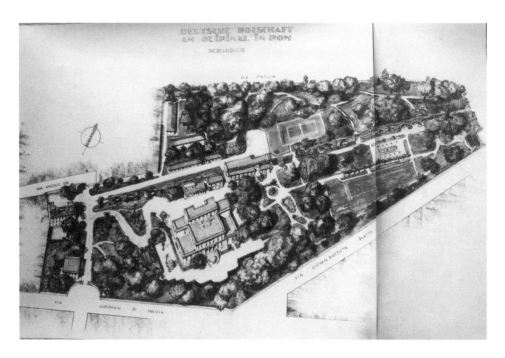

Fig. II.12. 3D view of the Villa Wolkonsky.

III.
BAILEY'S INTERIM REPORT ON THE CONSERVATION OF THE AQUEDUCT

19 July 1960

Mr K. Newis
<u>Under Secretary</u>

<u>Claudian Aqueduct</u>
<u>British Embassy, Rome</u>
<u>Interim Report on completion of repairs</u>

I first visited Rome in October, 1956 to make the initial inspection of the Aqueduct and to prepare my report. At that time my original estimated cost of the work was approximately £7,500 but by November, 1958 when the work began I was obliged to increase this figure to £10,000 due to considerable increase in labour costs in the interval of two years and to a re-appraisal of the work involved.

After the Secretary's meeting in November, 1957 at which the D.G.W. and C.A. were present to consider ways and means of putting the work in hand the Chief Inspector and myself visited Rome for the purpose of explaining in detail our proposals to the Ambassador and the Italian Authority and to obtain the latter's agreement to the use of British methods of techniques. At the Secretary's meeting it will be remembered that a long discussion took place on alternative methods that might be adopted in the repair of three arches near the north-east end of the Aqueduct which had lost their entire supporting brick arch rings. My own proposals were to cast in situ reinforced concrete beams across the top of the core remains of the three arches (the beam would be hidden beneath the floor of the original water channel) and to anchor up the dangerous core-work by a combination of both. During our meetings with the Italian Authorities the problem was discussed in great detail with a final result that the Italians agreed that we should use my original method which in any case would be much more economic and would leave the appearance of the damaged arches unchanged. This was successfully done and has met with complete approval.

In November, 1958 I again went out to Rome taking with me Mr. T. Zavishlock, one of our experienced Foremen of Works from Cardiff who was to supervise the work and to instruct the Italian labour in our methods. During this visit I prepared Contract Documents, negotiated favourable terms with a recommended Contractor, Michele de Piero and signed a contract to begin work in the following month December. In the three weeks interval, scaffolding etc. was purchased and Mr. Zavishlock made himself acquainted with the Aqueduct and made preparations to begin work.

It was agreed with H.E. The Ambassador that repairs should begin to that part of the Aqueduct which was most exposed to the garden in order that scaffolding and workmen would be out of the

way in time for the summer season for receptions. The original proposal was to carry out the work in three winter periods of about six months each to avoid our operations conflicting with the use of the gardens for receptions but by February, 1959 when we again visited it became obvious that this should be changed. In the first place, we should lose the labour who were being trained in our methods and secondly, such was the adequate screening by trees, it would be possible to alternate on the sections under repair in order to have those areas hidden behind tree belts during reception periods. I consulted Sir Ashley Clarke on this and he agreed to a continuous working programme of 18 to 20 months.

Two further visits were made during 1959 during which time that section of the Aqueduct lying N.E. of Chancery was completed. Every attention was paid to the preservation of trees and climbing plants and only a few trees which were actually growing out of the masonry and physically touching it were removed. The magnificent climbing plants which helped to make the Aqueduct so much a piece of garden architecture were reduced by cutting out dead wood, detached from the masonry and given temporary support on the scaffolding whilst repairs were done to the structure. Afterwards, they were re-secured of the Aqueduct and the Ambassador is very satisfied with the final result. The amount of tree and bush root growth into the tufa core of the arches far exceeded what is usually encountered in England and much of the increased cost is accounted for by having lift off in sections nearly the whole of the water-channel floor to extract roots of 6" to 12" girth growing beneath. The whole of the channel floor remains with its calciferous deposit were securely rebedded. Many tons of earth and debris had to be removed and carted away from the top of the Aqueduct.

It will be remembered that two large concrete water tanks of German origin straddled the channel walls above arches 20 and 21 and in 1956 I gave these a possible remaining 'life' of 3 to 4 years. By 1959 when we erected scaffolding to this area it was found that due to fractures in the channel wall and the splitting of the concrete by rusting of the iron reinforcement, the tanks and their support was in a very dangerous state. It was therefore agreed that the unsightly tanks be removed, the channel wall repaired and reinforced and a new tank provided by asphalting the walls and covering with a concrete lid below the skyline. This was done for a little under £300 and in some small measure the Aqueduct has in this section reverted to its original purpose of conducting water for local needs. This method, acceptable to all was far less costly than providing new tanks underground.

Towards the end of 1959 work began on the remaining half of the Aqueduct S.W. of the Chancery and running to the Visa Section and the main entrance. This is the highest part above present ground level and has garages and flats built against its southern side and several arches filled in to provide space of electrical plant. The arch blockings to provide these rooms were particularly ugly and contained many rough openings forming vents, flues, windows and a[p]pertures for cables. Since the present use of the various rooms had to remain, all unwanted openings have been blocked, others made more tidy and each blocking rendered over to give relative harmony to the whole. This full stretch of the Aqueduct, exposed as it is to both staff and visitors to the Embassy, now looks far more respectable. The repairs involved the cutting out of old iron girders and modern rough brick patching. Many serious fractures at the apex of each arch had to be 'stitched' and consolidated and as in previous sections, where the remains of arch bricks were unsupported, they have been tied back by hidden bronze anchors into the core of the wall. In this section above arches 8 to 14 the original concrete floor of the water channel is almost complete and above arch 9 the channel wall stands to a height of six feet to include part of the springing to the arched top of the duct. The depth of soil and debris which had to be removed from this section of the channel was 2' 6".

The most prominent disfigurement of this fine length of Aqueduct which is opposite to the Ambassador's Residence were the multitude of telephone, electric and other service wires festooned

across, along and down the whole structure. After lengthy consultation with the D.W.S. and the local engineer, it was found that 80% of these wires were obsolete and by laying new cables underground from Visa to Chancery at a cost of £250 we have been able to remove all the unsightly wires and poles from the Aqueduct.

During our many meetings with Sir Ashley Clarke he had expressed regret about the poor standard of repair of the archway adjoining Chancery which was done about 1955 and seen by the Secretary and Chief Architect during their visit shortly afterwards. My report and estimate did not include for the removal of this unfortunate reconstruction but last month H. E. The Ambassador expressed himself most strongly that it should be done. You therefore approved this extra work at a cost of £350. When was commenced, and the offending arch removed, we were alarmed at the number of cavities and roots which had been left between the old and new work and without doubt, the rebuilt arch would not have remained stable for many years. Both the Ambassador and Professor de Angelis, Director General of Antiquities, Italy, are very pleased with the final result.

Work was completed on the main section of the Aqueduct on June 28th and on June 30th the Ambassador invited about 50 prominent guests to inspect the final result. About four members of the press were present and we had a very favourable press mention in many Italian papers. The Minister of Education and Professor de Angelis d'Ossat were unable to be present but Senator Tupini, Minister of Tourism expressed himself as delighted with the results as did Professor de Angelis when he inspected the Aqueduct with me a few days later before I left Rome. I have previously expressed my appreciation of the help and understanding given by Professor V. Piccini and his assistant Sig. Testa throughout the work but I would also like to record how helpful the Administrative Officer, Mr J. K. F. Bamford and his staff have been throughout the work.

In December last it was reported that a small terrace to one of our flats adjoining the wall on the Porta Pia site was collapsing and this proved to be the roof of a tomb built into the Porta Pia wall. Water was pouring through and there was danger of the roof collapsing into the Embassy Garage workshop. You approved that this should be attended to and the necessary minimum work was completed for £60.

Work is now well towards completion on minimum repairs to the tomb opposite Chancery at a total cost of £400 and finally, we have found it necessary to carry out a few further repairs to the end section of the Aqueduct above the Visa Section roof which received attention under the Italian Authorities in 1957. You have approved a further £200 towards this work. To date, we have spent approximately £11,800 out of the final approval of £12,200. The break-down being as follows:–

Aqueduct repairs incl. materials and removal of 70 tons debris	£10,000
Purchase of Scaffolding and small tools, etc.	600
Provision of new water tanks	300
Re-consolidation of arch adjoining Chancery	350
Removal of Overhead Service wires and laying cable underground	400
	(in hand)
Further repairs to Visa Section of Aqueduct	240
	(July–Aug 1960)
Porta Pia Wall and tomb repairs	60
Total	£12,200

In the above schedule of costs, it was found much more economic to purchase the scaffolding rather than hire it over a 20 months period. Although it is still equal to new, upon enquiry it was found that we could expect something of less than half its original cost if it were sold and it has been decided to store both scaffolding and fittings at the Embassy for any further work either there or a Porta Pia. This will have the effect of reducing future expenditure on the hire of scaffolding for any work found necessary over the years and one could legitimately reduce the final cost to about £11,700 accordingly.

During my visits to Rome, most of my time was spent in dealing with the work in hand and although I have surveyed about one third of the Aqueduct for my final completion report, I shall have to make one further visit to complete the survey and to make my final notes for the report. I hope to be able to arrange this towards the end of the year.

The total number of visits made during this £12,000 project is as follows:–
1 Visit for initial inspection and report
1 Visit with C.I.A.M. for explanation to the Ambassador and Italian Authorities to obtain their agreement.
1 Visit to negotiate Contract and take our Foreman to discuss the whole programme of work.
4 Visits with C.I.A.M. to progress work (February, 1959 to April, 1960).
1 Visit with C.I.A.M. final inspection.

This report would not be complete without recording the good work done by our Foreman from Cardiff, Mr. T. Zavishlock. Not only did he master enough of the language to enable him to instruct the Italian workmen in our methods and ensure a sound job but he also fitted in splendidly with the personnel and social life of the Embassy. The Ambassador has spoken very highly of both him and his work.

All work should be complete about the middle of August and Mr. Zavishlock will be arriving in England again about September 1st.

[signed]
T. A. BAILEY
Senior Architect
Ancient Monuments
(Special Services)
19th July, 1960.

Copy to: Mr. C. G. Mant, D/D.G.W.
 Mr J. H. S. Burgess Asst. Sec.
 Mr. F. L. Rothwell, Supt. Arch.

N.B.
Although I took a number of black and white photographs to illustrate my report and have since taken normal progress photographs, I did, upon completion take a number of colour negatives which may be used as slides for lecture purposes.

To prevent further marked deterioration it will be necessary to issue to the Post an instruction or request that the Channel floor be kept clear of dirt and vegetation twice a year.

IV.
BRITISH EMBASSY ROME CASE FOR RETAINING THE VILLA WOLKONSKY

7 December 1972

ADMINISTRATION IN CONFIDENCE

DIPLOMATIC ESTATE: ROME

1. The use and development of the property owned by Her Majesty's Government in Rome must be seen as a whole. This paper starts from the assumption that full and effective use is not at present being made of this property and that there must be a demonstrably comprehensive plan to ensure effective use.

2. The report by Messrs Hopewell and Boyle is helpful in focussing attention on the possibilities. But it appears to take too little account of local conditions and requirements and to pay too much attention to what is described as "economic advantage". As the report recognises, any figures for costs and savings are inevitable approximate. The extreme case of this is the estimate for a possible sale of Wolkonsky which varies from £750,000 to £1.5 million.

3. To do his job HM Ambassador in Rome needs a house which is an instrument for two main purposes:–

(a) to attract Italian Ministers and other influential Italians to attend social functions so as to enable the Ambassador to establish and maintain useful contacts;
(b) appropriately to receive visitors, including large numbers of British Ministers, who must be offered facilities of a suitable house in which to stay and to meet Italians.

4. It should be made clear that the above purposes are not secured by means of a Chancery. Large and expensive as is Sir Basil Spence's new Chancery at Porta Pia, it does not fulfil a representational purpose. In the nature of things a Chancery is an office and a place of business. No Italian Minister or high official would, for instance, come to the Chancery. When business is done with them, members of the Embassy call on them in their offices, just as foreign diplomats in London come to the FCO or other Government offices, not vice versa. And, of course, such people come to Embassy entertainments at the Embassy house.

Villa Wolkonsky as the Embassy House

5. Villa Wolkonsky is large and expensive to run (the present cost is estimated at £40,000 plus £5,000 from the Ambassador's frais). But Roman Embassies are probably the grandest in the world. The illustrated book entitled "Ambasciate Esteri a Roma" demonstrates this and ought to be looked at. It is not suggested that, in the matter of our Embassy house, we need try to compete with the French (the great Palazzo Farnese and other historical buildings, eg the Villa Medici), the Russians (the Villa Abamelek, with its enormous park) or the Americans (Villa La Pariola).[*] Nor could we hope to outdo the Brazilian Embassy (Palazzo Pamphilj in the Piazza Navona) or the Egyptian Embassy (Villa Ada, formerly a Royal Palace) or the Spanish Embassies, either to the Quirinale or the Holy See. But we do not want to sink down too far in this particular competition. It is suggested that, in a capital where, eg the Swiss and Portuguese Embassies are on a scale not very dissimilar from the Villa Wolkonsky, we need to keep up a respectable standard in terms of local condition. Otherwise, as stated in paragraph 3 above, our Embassy will become less interesting to the Italians and fewer of them will come to it.

6. The Villa Wolkonsky represents no more than a respectable standard as things are now. There are no signs that standards in Rome are falling. It would be wrong for us to lead the way in lowering standards, especially when we are entering the EEC. The Italians would see a reduction on our part as a political decision.

7. The Hopewell/Boyle report suggested knocking down the existing Villa so as to replace it with something less expensive to run. There is no possibility of this in the foreseeable future. The Villa, like the whole of the Wolkonsky Park, is _vincolato_. There is therefore no prospect of securing permission to knock it down.

8. The report concluded that, in any circumstances, the sale of any part of the Wolkonsky Park would be a "dubious proposition". We agree. Apart from the adverse effect on the value and amenities of the house and park, there is the difficulty resulting from the fact that the whole property is _vincolato_. To sell off part of it for development would involve a change in its status which would in turn involve legislation. It is very doubtful whether the necessary planning permission would ever be forthcoming.

Embassy House at Porta Pia

9. Messrs Hopewell and Boyle appear to have gone beyond their terms of reference. In his letter of 18 July, Mr Scott said that had been agreed with the DOE that it would not be sensible to ask the Ambassador to change his residence either to Porta Pia or to some other house for ten years or so. Before firm decisions on future action could be made the Treasury would need to be convinced that all options had been examined. There would therefore be an "architectural feasibility study of the Porta Pia site to determine whether an acceptable residence could be built there to meet FCO requirements in about ten years' time". The Hopewell/Boyle report goes beyond that and recommends "construction of a new residence at Porta Pia and the sale of the Wolkonsky site in its entirety".

[*] Renamed Villa Taverna in 1977 (author's comment).

10. The report does however draw attention to some of the disadvantages of putting an Embassy house at Porta Pia. As stated in paragraph 2 "the new Chancery building dominates about 4 acres out of a total site ... of approximately 5 acres. In effect an Embassy house built at Porta Pia would be at the bottom of the Chancery garden. The site is overlooked by a large crumbling block of flats and even if a house were sited in the north-east corner, as suggested, there could be no guarantee that the flats would not dominate the view, at least from rooms on the second floor. It would be far too expensive to consider buying up the flats so as to demolish them, even if their owners, a condominium of about 40 people, were willing.

11. The conclusion is that an Embassy house at Porta Pia would be on a cramped, noisy site overlooked, even with all the expedients suggested in the report, by the flats on one side and by a five-storey school on the other. It would not measure up to the standards required for an Embassy in Rome. A move of this sort in the foreseeable future could only be seen as a cut-down at precisely the wrong moment, ie when we are entering the Common Market.

Buying or renting a new Embassy House

12. Thought has been given to the possibility of buying a suitable Embassy house so as to enable HMG to dispose of the Wolkonsky site in accordance with its undertaking of 1967 to the Treasury to meet the cost of the new Chancery by sale of Wolkonsky.

13. The difficulty is that we are unlikely to find anything suitable. There are more than 200 Embassies in Rome and anything suitable for a major Embassy has been snapped up long ago. In any case there is no reason to suppose that if anything suitable came on the market it would cost less than whatever price we might get for the Villa Wolkonsky. As is clear from the Hopewell/Boyle report it is not possible to make anything like an accurate estimate of a price for the Wolkonsky site, whose special status as a "parco privato vincolato" is bound to affect the attitude of prospective buyers.

14. Various properties were examined two or three years ago with a view to renting as temporary Embassy houses. Twenty-four were viewed and all were found to be unsuitable.

Conclusion

15. The best course appears to be to retain the Villa Wolkonsky as the Ambassador's house and to develop the Wolkonsky and Porta Pia sites to ensure that they are properly used. It would be undesirable, if no more, from a security point of view, to sell off any part of the Porta Pia site; and would close the option of constructing an Embassy House there if at some later date standards in Rome are lowered and a House at Porta Pia is thought suitable.

Wolkonsky

16. The proposals for providing staff accommodation in paragraph 5 and Appendix D of the Hopewell/Boyle report seem on the right lines, with the exception noted above of the plan to replace Villa Wolkonsky with a new building. The details will require further consideration. As stated in paragraph 5(d) of the report, something could probably be built on the site of the war-time huts, though

it may be difficult to secure planning permission since the huts (which were built by the Germans) have never been registered in the <u>Piano Regolatore</u>. It would be important to have a clear boundary between that part of the garden used by occupants of, eg the old Chancery, and the Ambassador's garden.

Porta Pia

17. The original plan was to build a Chancery and a block of staff flats at Porta Pia. Planning permission was secured for both.

18. While it would not be right at present to build an Embassy House at Porta Pia, the same objections need not apply to a house for the Minister. This is proposed in paragraph 5 of the Hopewell/Boyle report, together with the construction of a block flats. The outline plan includes the provision of amenities (swimming pool and tennis court) for use by all staff. All this seems right. If the house for the Minister could be designed in such a way as to permit expansion at a later date the option of building an Embassy House at Porta Pia need not be finally closed. The siting of the flats would require careful consideration to take account of traffic noise and the existing crumbling block. To avoid too much "compound life" the block should perhaps not be as large as that envisaged by the report. It should contain flats suitable for non-representational staff who would benefit from common services etc. Six such families would probably be about the right number given the fact that we already have two flats in the compound occupied by the AAC and the DOE representative.

BRITISH EMBASSY
ROME
7 December 1972

V.
PEOPLE AND DATES

A. Some Roman emperors

Claudius	41–54
Nero	54–68
Vespasian	69–79
Titus	79–81
Domitian	81–96
Trajan	98–117
Hadrian	117–138
Antoninus Pius	138–161
Marcus Aurelius	161–180
Septimius Severus	193–211
Caracalla	198–217
Elagabalus	218–222
Aurelian	270–275
Diocletian	284–305
Maxentius	306–312
Constantine I	306–337

B. German ambassadors to Italy 1920 to 1943

1920–1921	John von Berenberg-Gossler
1921–1930	Konstantin von Neurath
1930–1932	Carl von Schubert
1932–1938	Ulrich von Hassell
1938–1943	Hans Georg von Mackensen

C. British ambassadors to Italy after the Second World War

1944–1947	Sir Noel Charles
1947–1953	Sir Victor Mallet
1953–1962	Sir Ashley Clarke
1962–1966	Sir John Ward
1966–1969	Sir Evelyn Shuckburgh
1969–1974	Sir Patrick Hancock

1974–1976	Sir Guy Millard
1976–1979	Sir Alan Campbell
1979–1983	Sir Ronald Arculus
1983–1987	Lord (Thomas) Bridges
1987–1989	Sir Derek Thomas
1989–1992	Sir Stephen Egerton
1992–1996	Sir Patrick Fairweather
1996–2000	Sir Thomas Richardson
2000–2003	Sir John Shepherd
2003–2006	Sir Ivor Roberts
2006–2011	Edward Chaplin
2011–2016	Christopher Prentice
2016–	Jill Morris

D. British officials involved 1946–68

It may be invidious to single out individuals, but readers may like to have more information on three officials, all senior figures in the then Ministry of Works, who set the pattern for the management of the UK government's estate in Rome, its respect for the limitations imposed by the Italian conservation rules for monuments and buildings, and the blend of cultural and financial/economic criteria that has resulted in the UK owning and conserving one of Rome's finest mansions.

Sir Eric de Normann, Deputy Secretary, Ministry of Works 1943–54, Chairman Ancient monuments Board for England 1955. Born 26 Dec. 1893, died 1982. Ed. Chateau du Rosay, Switzerland & University College of S. Wales. Office of Works 1920.

Sir Edward Muir, Ministry of Works 1927; Under Secretary 1946–54, Deputy Secretary 1954–6, Secretary 1956-65(?) Born 20 June 1905, died 1979. Ed. Bradfield College & Oxford U. (Jurisprudence).

Professor Paul Kenneth Baillie Reynolds, Chief Inspector of Ancient Monuments, Ministry of Works 1954–61. Born 1896, died 1973. Ed. Hertford College, Oxford U. Lecturer in Ancient History, Aberystwyth U. 1924–34; Inspector of Ancient Monuments from 1934.

BIBLIOGRAPHY

Primary published sources

Baedeker, Karl (1867) *Handbook for Travellers: Second Part. Central Italy and Rome*, Coblenz: Karl Baedeker, and subsequent 1872, 1877, 1890.

Baillie Reynolds, P.K., and Bailey, T.A. (BR & B), *The Aqueduct in the Grounds of the British Embassy in Rome*, Oxford: Society of Antiquaries of London, 1966.

Berry, Mary, *Extracts of the Journals and Correspondence of Miss Berry*, ed. Theresa Lewis, London: Longman, Greens & Co, 1865 [online].

Buseghin, Maria Luciana, *Cara Marietta, Lettere di Alice Hallgarten 1901–1911*, Tela Umbra, 2002, esp. pp. 559–61.

Buturlin, Mikhail Dimitrievich, *Memorie del Conte Michail Dimitrievitch Boutourline*, eds. Wanda Gasperowiecz & Michail Talalay, trans. into Italian by Mar'ja Olsuf'eva, Lucca: Maria Pacini Fazzi Editore, 2001, esp. pp. 117–18.

Dollmann, Eugen (1) *The Interpreter: Memoirs of Doktor Eugen Dollmann*, trans. by Maxwell Brownjohn, London: Hutchinson, 1967. (2) *With Hitler and Mussolini: Memoirs of a Nazi Interpreter*, Skyhorse, 2017.

Foley, Charles, *Commando Extraordinary (Otto Skorzeny)*, London: Pan, 1954, pp. 54–77.

Gerarchia Cattolica, 1866, 1869, 1873, Vatican (consulted in Library of German Historical Institute in Rome).

Goebbels, Joseph, *The Goebbels Diaries*, ed. & trans. by Louis P. Lochner, London: Hamish Hamilton, 1948.

Hassell, Fey von, *A Mother's War*, London: John Murray, 2003.

Hassell, Ulrich von, *The Ulrich von Hassell Diaries 1938–44*, London: Frontline Books, 2011.

Moellhausen, E.F., *La Carta Perdente*, Rome: Sestante, 1948.

Moseley, Ray, *Mussolini's Shadow: The Double Life of Count Galeazzo Ciano*, New Haven & London: Yale University Press, 1999.

Murray, John (1867) *Murray's Handbooks for Travellers. A Handbook of Rome and its Environs*, London: John Murray (8th ed.) and 1888.

Mussolini, Benito, *Memoirs 1942–43*, ed. Raymond Klibansky (Weidenfeld & Nicolson, 1949), London: Phoenix Press, 2000.

Napoli, Franco F., *Villa Wolkonsky 1943–1988 – Il lager nazista di Roma*, published by its author, 1996.

Plehwe, Friedrich-Karl von, *The End of an Alliance*, London: OUP, 1971 (original German edition 1967).

Rahn, Rudolph (1) *Ruheloses Leben: Aufzeichnungen und Erinnerungen* [A Restless Life: notes and recollections], Düsseldorf: Diederichs Verlag, 1949. (2) *Ambasciatore di Hitler a Vichy e a Salò* [Hitler's Ambassador to Vichy and to Salò], Milan: Garzanti, 1950.

Schlözer v., K., *Römische Briefe, 1864–1869*, Stuttgart & Berlin: Deutsche Verlags, 1913.

Vassiltchikov, Marie, *The Berlin Diaries 1940–45*, London: Pimlico, 1999.
Wolkonsky, Zenaïde, *Quatre nouvelles*, Naples, 1828.

Secondary sources

Armellini, Mariano, *Le Chiese di Roma dal Secolo IV – XIX*, Tipografia Vaticana, 1891, p. 991.

Aroutunova, B., *Lives in Letters: Princess Zinaida Volkonskaya and her Correspondence*, Columbus, OH: Slavica, 1994.

Ashby, Thomas (1) *I Giganti dell'Acqua*, 1892–1925, Rome: Palombi, 2007 [on p. 136 perpetuates many of the 'myths']. (2) *The Aqueducts of Ancient Rome*, Oxford: Clarendon Press, 1935, esp. pp. 1–34, 90–192, 244–9.

Barsali, Isa Belli, *Le Ville di Roma*, 1970/1983, pp. 17, 460.

Bertram, Mark, *Room for Diplomacy*, Reading: Spire Books, 2011/2017, complemented with a website catalogue of British diplomatic buildings, https://roomfordiplomacy.com/italy.

Bočarov, Ivan & Glušakova, Julia, 'Un Memoriale Russo a Roma', in *Istorija*, Moscow: Molodaja Gvardija, 1985, pp. 70–82 (trans. into Italian by Evelina Pascucci).

Bucolo, Raffaella (1) *La collezione di antichità della Villa Wolkonsky. La documentazione fotografica del Deutsches Archäologisches Institut*, in QuadFriulA XXVI, 1 (2016), pp. 169–176. (2) *Una visita a Villa Wolkonsky, considerazioni sulla collezione di antichità attraverso documentazione letteraria ed iconografica tra XIX e XX secolo*, in Archeologia classica 69, n.s. II, 8 (2018), pp. 849–67. (3) *Villa Wolkonsky. Storia della collezione di antichità* (Pensieri ad Arte, n. 8), Rome: Artemide, 2020.

Burgwyn, H.J., *Mussolini and the Salò Republic, 1943–1945: The Failure of a Puppet Regime*, Palgrave (Macmillan), 2018.

Callari, Luigi, *Le Ville di Roma*, Rome: Lib. Scienze e Lettere, 1934, pp. 361–3.

Campbell, Alan, *Short History of Villa Wolkonsky*, unpublished memorandum, Rome, December 1979.

Claridge, Amanda, 'Adventures with Lucos Cozza: a conduit beneath the grounds of the Villa Wolkonsky – the Lateran branch of the Acqua Felice (1586–88)', paper given at a conference held at the BSR in Cozza's memory in 2012: in *Scritti in onore di Lucos Cozza*, eds. Robert Coates-Stephens and Lavinia Cozza, Rome: Quasar, 2014, pp. 192–7.

Colini, Antonio Maria, *Storia e topografia del Celio nell'antichità*, Vatican: Atti della Pontificia Accademia Romana di Archeologia. ser. 3. Memorie. vol. 7, 1944, pp. 380–403.

Fairweather, Maria (MF), *Pilgrim Princess: A Life of Princess Zinaida Volkonsky*, London: Constable, then Robinson, 1999.

Fiori, Nica, *Le Ville di Roma entro le Mura*, Rome: Tascabili Economici Newton, 1994/1999.

Frutaz, A.P., *Le Piante di Roma*, Rome: Istituto Studi Romani, 1962 (maps of Rome, consulted in the Library of the BSR).

Gasperowicz, Wanda, 'Zinaida Volkonskaya neopublikovannye materialy iz ital'yanskikh arkhivov', in *Russkaya usad'ba*, Moscow: Izdatel'skiy dom Kolo 19, 2014, pp. 213–27, quoted in Glushakova (below). See also: https://docplayer.ru/63633775-1-zinain-volkonsky-une-belle-de-bal-ya-3-andenken-an-gogol-i-s-h.html – in section 7.

Glushakova, Yuliya, 'Zinaida Volkonsky – Une Belle de Bal' in a collection entitled 'Andenken an Gogol', 1987, p. 3; or http://slavistik.phil-fak.uni-koeln.de/sites/ZOE/user_upload/Reader_ROMA_RUSSA.pdf on p. 2.

Gorodetzky, Nadezhda, *Princess Zinaida Volkonsky*, Oxford Slavonic Papers, V, 1954.

Hare, Augustus, *Walks in Rome*, Vol. 1, New York & London: Macmillan, 1871/1902.

Hoffmann, Paola, *Le Ville di Roma e dintorni*, Rome: Newton & Compton, 2001.

Huelsen, C., *Le chiese di Roma nel medio evo*, Hildesheim: Georg Olms Verlag, 1927, p. 401.

Katz, Robert, *The Battle for Rome: The Germans, the Allies, the Partisans and the Pope, September 1943–44*, New York: Simon & Schuster, 2003.

Kizilov, Mikhail, *Between Leipzig and Vienna*, www.academia.edu.

Klinkhammer, Lutz, *Zwischen Bündnis und Besatzung. Das nationalsozialistische Deutschland und die Republik von Salò, 1943–1945*, Tübingen: Niemeyer, 1993.

Lanciani, Rodolfo, *Forma Urbis Romae*, Rome: Quasar, 1991.

Madelin, Ian, 'The Caelian Aqueduct in Rome', unpublished paper, based on a MA thesis under the auspices of Royal Holloway College, University of London, April 2003.

Majanlahti, A. & Guerrazzi, A.O., *Roma Occupata, 1943–44*, Rome: Il Saggiatore, 2010.

Marzilli, Marco, 'The German Seizure of Rome, 1943', in *After the Battle*, No. 152, Battle of Britain International, UK, 2011.

NdS – *Notizie degli Scavi*, various years: esp. 1881, 1889, 1911, 1917.

Pietrangeli, Carlo, *Villa Wolkonsky* (1973) in *Miscellanea della Società Romana di Storia Patria* XXIII, pp. 425–35.

Pirzio-Biroli, Corrado, *Fortitude in Tragedy: The Defiance of my Grandparents Hassell and their Italian Relations, A Family Memoir*, in preparation 2020, scheduled to published (in French) in January 2021, by Michel de Maule, Paris.

Praz, Mario, *La Filosofia dell'Arredamento*, Longanesi: Milan, 1964, pp. 40, 62.

Schmölder-Veit, Andrea, 'Aqueducts for the Urbis Clarissimus Locus: The Palatine's Water Supply from Republican to Imperial Times', *The Waters of Rome*, No. 7, June 2011.

Spagnol, Mario, *Guida ai Misteri e Segreti di Roma*, Carnago: SugarCo, 2000.

Stourton, James, *British Embassies: Their Diplomatic and Architectural History*, London: Frances Lincoln, 2017.

Tucci, P.L., 'Ideology and technology in Rome's water supply', *Journal of Roman Archaeology*, No. 19, 2006, pp. 94–120.

Valeri, Marta, *Ambasciatrice di Russia*, thesis, Università degli Studi della Tuscia di Viterbo, 2015.

Williams, S.J., *The Allée des Mémoires at the Villa Wolkonsky*, unpublished, Rome, March 1990 (rev. 2019).

Zaccagnini, Carlo, *Le Ville di Roma*, Rome: Newton & Compton, 1976/1991 and new edition by P. Hoffmann qv.

Archives consulted

Archivio Storico Diplomatico del Ministero degli Affari Esteri, Rome, Italy (Farnesina)

Archivio di Stato, Rome, Italy (AdS)

Archivio Storico Capitolino, Rome, Italy (ASC)

British School at Rome, Italy (BSR)

Bundesarchiv, Berlin, Germany (BA)

Politisches Archiv des Auswärtigen Amts, Berlin, Germany (AA)

The National Archives, Kew, UK (TNA)

Houghton Library, Harvard University (HLHU) Zinaida Aleksandrovna Volkonskaia Papers, 1809–1879 (MS Russ 46-46.14).

INDEX

Illustrations are in *italics*, with pl referring to plates. Main discussions in **bold**. Memorials are listed as M.

Illustration acknowledgements

Every effort has been made to acknowledge correct copyright of images where applicable. Any errors or omissions are unintentional and should be notified to the Publisher, who will arrange for corrections to appear in any reprints.

Figs. 1.1, 1.4, 1.7, 1.8, 4.1, 4.2 & 4.3 **Istituto Nazionale di Studi Romani**; *Fig.* 1.2 **BSR Photographic Archive, Thomas Ashby Collection, ta-VI.044;** *Fig.* 1.3 **Thomas Ashby,** *The Aqueducts of Ancient Rome,* **Plate 1, edited by I. A. Richmond, Oxford, Clarendon Press, 1935;** *Fig.* 1.5 **Antonio M. Colini,** *Storia e Topografia del Celio nell'Antichità con rilievi, piante e ricostruzioni di Italo Gismondi,* **Atti della Pontifica Accademia Romana d'archeologia, serie III, Memorie vol. VII. Tipografia Poliglotta Vaticana, 1944;** *Fig.* 1.6 **Metropolitan Museum of New York, gift of A. Hyatt Mayor, 1977;** *Figs.* 2.1, 2.6, 6.1, 15.1 & 15.2a–d **Author/Villa Wolkonsky archive;** *Figs.* 2.2, 2.3, 2.4, 2.7, 2.8, 2.10, 3.4, 3.5, 3.7, 8.1–8.11, 10.3, 17.1 & 21.1 **Author;** *Fig.* 2.9 **Author/Private;** *Figs.* 3.1, 3.2, 3.3 & 3.13 **MS Russ 46.14 (2), Houghton Library, Harvard University;** *Fig.* 3.6 **Author's property (Blackie & Son, 1864);** *Fig.* 3.10 **Roma – Sovrintendenza Capitolina ai Beni Culturali – Museo di Roma;** *Figs.* 3.11 & 4.7 **Courtesy of the British School at Rome Photographic Archive;** *Figs.* 4.4 & 4.5 **Archivio Storico Capitolino, Rome;** *Figs.* 4.6, 7.2 & II.1–II.12 **Villa Wolkonsky archive;** *Figs.* 5.1, 5.2, 5.3, 5.6, 5.7, 9.1–9.4, 10.1, 10.2, 10.4, 10.5 & 11.3 **AA;** *Fig.* 5.5 **Wikimedia Commons (Jensens);** *Figs.* 6.2, 7.1, 11.4, 11.5 & 11.6 **BA;** *Figs.* 9.5, 13.1, 13.3, 14.1–14.5, 15.3, 15.5a&b, 16.1, 16.2 & 17.2 **TNA;** *Fig.* 11.1 **Archivio di Etnografia e Storia Sociale – Regione Lombardia;** *Fig.* 13.4 **Archive of the Museum of the Liberation, Rome;** *Fig.* 15.4 **British Government Licence;** *Fig.* 16.3 **TNA/Villa Wolkonsky archive;** *Fig.* 21.2a–d **FCO;** *Figs.* I.1 & I.2 **Istituto Archeologico Germanico – Roma**

Appendix II (all) **Author/Sue Williams**

Plate 1 **Wikimedia Commons (Cassius Ahenobarbus);** *Plate 2* **Su concessione del Ministero per i Beni e le Attività Culturali e per il Turismo, l'Archivio di Stato di Roma;** *Plates 3, 8, 13, 26, 27, 28, 32–35, 40 & 41* **Author;** *Plate 4* **Villa Wolkonsky archive;** *Plate 5* **Archivio Storico Capitolino, Rome;** *Plates 6, 7, 10 & 11* **AA;** *Plate 9* **TNA;** *Plates 12, 17, 36 & 38* **Author/Villa Wolkonsky archive;** *Plate 14* **Pushkin Museum, St. Petersburg;** *Plate 15* **Pietro Benvenuti (Italian, 1769–1844),** *Princess Zinaida Alexandrovna Volkonskaia (Wolkonsky) (1789–1862), née Belosselsky-Belozersky,* **1815, Oil on canvas, Georgia Museum of Art, University of Georgia; Gift of Marina Belosselsky-Belozersky Kasarda;** *Plate 16* **State Russian Museum, St. Petersburg;** *Plate 18* **Anton Graff (Swiss, 1736–1809),** *Portrait of Prince Alexander Mikhailovich Belosselsky-Belozersky (1752–1809),* **c.1790, Oil on canvas, Georgia Museum of Art, University of Georgia; Gift of Marina Belosselsky-Belozersky Kasarda;** *Plate 19* **Tula Museum of Fine Arts;** *Plate 20* **The Allied Sovereigns at Petworth,** **24 June, 1814, by Thomas Phillips, RA (Dudley 1770? – London 1845), 25841 © National Trust Images/Derrick E. Witty;** *Plate 21* **Author's photo of print in private collection;** *Plate 23* **Wikimedia Commons;** *Plate 24* **Wikimedia Commons (Achim Raschka);** *Plate 25* **Wikimedia Commons (Blackcat);** *Plates 29 & 37* © **Rienko Wilton;** *Plates 30 & 31* © **Roma – Sovrintendenza Capitolina ai Beni Culturali – Museo di Roma;** *Plate 39* **Sue Williams**